The Creative
Digital Darkroom

Katrin Eismann & Seán Duggan

O'REILLY®

Beijing · Cambridge · Farnham · Köln · Paris · Sebastopol · Taipei · Tokyo

The Creative Digital Darkroom

by Katrin Eismann & Seán Duggan

Published by O'Reilly Media, Inc., 1005 Gravenstein Highway North, Sebastopol, CA 95472.

O'Reilly Media books may be purchased for educational, business, or sales promotional use. Online editions are also available for most titles (*safari.oreilly.com*). For more information, contact our corporate/institutional sales department: 800-998-9938 or *corporate@oreilly.com*.

Editor: Beth Millett

Production Editors: Phil Dangler, Michele Filshie, Dennis Fitzgerald

Technical Editor: Jeff Greene

Cover Designer: Steve Fehler

Interior Designer: Ron Bilodeau

Print History:

December 2007: First edition.

 This book uses RepKover™, a durable and flexible lay-flat binding.

ISBN: 978-0-596-10047-6
[FBD]

[5/10]

"To everyone who sees the world more clearly when looking through a viewfinder."

\- Katrin

"To the memory of my father, James Duggan; Irishman, projectionist, history buff, camera lover, Dad."

\- Seán

Acknowledgments

As Winston Churchill said, "Writing a book is an adventure. To begin with, it is a toy and an amusement; then it becomes a mistress, and then it becomes a master, and then a tyrant." Or as we have experienced, starting a book project is easy – finishing it is much more challenging; but finished it is and we can never thank the many people enough, who had the faith in us to actually get this book done.

We would like to thank the photographers, both amateur and professional whose work we grew up with and that inspired us to become photographers – from Katrin's father whose careful compositions with a simple Rolleiflex hold some of her most treasured childhood memories to Seán's father whose fascination with old movie cameras and stereo cameras gave Seán his first early looks through a viewfinder. We thank the photographers who allowed us to feature their work throughout the book; Mark Beckelman, Jed Best, Brian Nielson, John McIntosh, Scott Loy, Brian Pawlowski, Michael Reichman, Jack Reznicki, and Jennifer Trenchard.

The O'Reilly staff is excellent, including: Steve Weiss who always had creative solutions to smooth any bump in the road; Michele Filshie, who meticulously prepped the chapters before they went to layout; Ron Bilodeau whose multiple takes of the page layout created this very legible book; Dennis Fitzgerald who literally whipped the final proof into shape; and Steve Fehler who came through at the 11th hour with a wonderful cover design. We also worked with Dawn Mann, Sarah Milstein, Betsy Waliszewski, and Colleen Wheeler – all of whom encouraged and helped us much more than they know. We know that there are a lot more people at O'Reilly who worked on this book and without ever meeting you – we send our thanks. We're sure you're just as glad to finally see this book in your hands as we are! Finally, behind every successful writer is an exacting development editor and we were lucky enough to work with Beth "cut that figure" Millett who paid tremendous attention to the flow and efficiency of our collaboration.

We appreciate the tremendous support that we received from the digital imaging community. We are indebted to the Photoshop and Lightroom teams. We admire their dedication to the continued growth of Adobe Photoshop and development of Photoshop Lightroom. Photographer Stephen Johnson found time in his busy travel schedule to review one of the final drafts and write the Foreword. We're honored to have his perspective in this book. Thanks also go to Dano Steinhardt from Epson; Fernando Zapata and Jim Christian from Noise Ninja; the guys at PixelGenius for making our images just sharp enough; and Jeff Greene from Microsoft whose technical editing gave us two Mac-heads peace of mind.

We are both fortunate to be involved in an art form that combines craft, vision, and inspiration. If an image is created with a plastic Holga or a high-end digital camera – we still respond to the vision of the photographer first – the choice of technology is a distant second. As photographers and artists we love what we do. We sincerely enjoyed this journey and we hope you enjoy this book – may it help you to create the photographs in your mind's eye.

Contents

Chapter 4
File Preparation
91

Chapter 5
Tone and Contrast
129

Chapter 6
Dodging, Burning, and Exposure Control
173

Chapter 7
Color Correction
227

Chapter 8
Creative Color 287

Chapter 9
Creative Enhancements 321

Chapter 10
Enhancing Focus 359

Index 401

Online Bonus Chapter
The Print

Go to *http://www.creativedigitaldarkroom.com/* and click on the Downloads link to download the Bonus Chapter PDF.

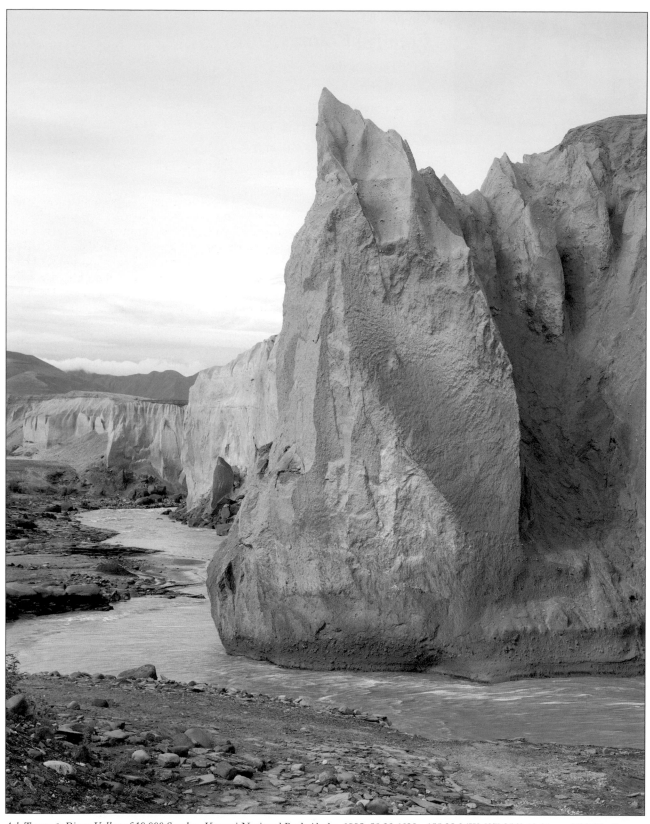

Ash Tower & River, Valley of 10,000 Smokes. Katmai National Park Alaska. 1995; 58 23 10N x 155 23 24W 697' 256° 12:01pm; 8/29/95; From the project and book "With a New Eye: The Digital National Parks Project" by Stephen Johnson. © *Copyright 1995 by Stephen Johnson*

Foreword

Digital photography has now become simply photography. Just as desktop publishing became simply publishing. We may still be in a period of transition, with many improvements and critical empowerments yet to come, but photography has clearly now become an electronic medium. Software programs and computers are the tools of photographic interaction rather than the darkroom. Film and the darkroom will remain with us for many years, but they are on their way to becoming historical processes.

It is an interesting time. A single company, Adobe Systems, is responsible for the most critical portal into our photographs, Adobe Photoshop, and for its up and coming sibling, Photoshop Lightroom. That has happened before in photography. Kodak was long the dominant player in the roll film market for a time, the Autochrome was the principal color process in the early years of the 20th century, and Kodachrome was practically synonymous with color photography for many years. More recently, Epson became the dominant digital photo printer company and even with Apple's fine entry into the photo editing market with Aperture, and HP and Canon's new digital printers, Adobe and Epson remain the big guys. Digital photography, explained through Photoshop, has become the norm. This makes a good understanding of their digital tools critical.

But the current tools are complex; many of the concepts seem brand new. The sheer number of choices can be daunting. Internet blogs and forums have people in a tailspin of convoluted procedures and in general have added to the notion of complexity. This has resulted in over-edited files, too much time is spent in front of the computer, and too much distraction from the inherent value of the photograph itself.

Respect for the photograph as a record of a moment before the lens is greatly needed. We've come to feel we must do something to the photograph in order to make it whole. Of course, this can lose sight of the only reason for the photograph to exist; the inspiration felt at the moment of making the image. Much can be done later to refine and craft the interpretation, but the photograph itself is the thing, not pixel-pushing later.

This state of affairs makes it all that much more important for a book of this kind to be in your hands. Clarity and simplicity are great needs at the moment. That is where this book enters the picture. It is a workbook for today's photographer, providing needed detail to process the image and the reasoning behind the procedure. Use the pieces that you need for a particular problem or vision. Don't feel compelled by some imperative of digital enhancement to over-work your photograph into something else.

I have known Katrin since she was a teaching assistant for me at the Kodak Center for Creative Imaging in Camden, Maine in 1991. I saw something special in her then, and before long she was helping to run the place. She has been speaking and writing on digital photography for many years and has truly made a contribution of the evolution of the medium. I may not know Seán nearly as well, but his sincerity and craft comes through the writing and examples provided in this book.

Katrin and Seán have put together a technical book that is a remarkably thorough and well-organized guide to the digital darkroom. It is a sincere book by two good people working to make photography more accessible. Much like the software tools discussed here, in and of itself, *The Creative Digital Darkroom* is a good tool to keep handy.

I am glad you have this book in your hands. I'm sure it will be very helpful.

Stephen Johnson
Photographer, author *Stephen Johnson on Digital Photography*

Preface

As visual artists, photographers are constantly practicing looking and seeing images. They make photographs, even when they don't have a camera with them. The eye is the lens and the mind is the camera. They notice things that others might miss, such as the way the light falls upon a child's hair, or the gentle gesture of a willow branch dipping into a stream. The small and often overlooked detail is just as important as the grand vista, and the unexpected afterthought often turns out to be far more significant than the carefully calculated idea.

Creativity is a journey. And as we journey along that road, we become better at seeing. Seeing not only what lies ahead, but also what *might* lie ahead, and which visual paths are more promising than others. As we become more experienced creative travelers we become more proficient with our photographic tools and learn how to use them to their best advantage. The camera and the digital darkroom are only some of the tools we use on our creative journey. Without the most important tool, however, the creative and curious mind, even the best camera and computer system are just lifeless jumbles of equipment and software code.

In this book we share some of the essential creative concepts and techniques that we use when working in the digital darkroom. To create a richer learning experience, many of the tutorial and example images featured in this book are available for download from the book's companion web site, *www.creativedigitaldarkroom.com* (whenever you see the icon of the mouse it means that image is available for download). By working on the same images that we feature in our examples, you can practice and perfect the technique and then apply it to your own photographs. When we didn't include the exact image used, you can practice the techniques on similar images of your own. After you've had a chance to explore our techniques with your images, we would enjoy seeing them and will post the best before/after examples on the book's web site. Please send them to *authors@ creativedigitaldarkroom.com* Please keep the attachments to under 3 MB in total. In addition to the tutorial image files, there is also a Bonus Chapter on printing in the downloads section of the companion website.

Although the book was written for Adobe Photoshop CS3 and Adobe Photoshop Lightroom you can apply the concepts and many of the techniques with earlier versions of Adobe Photoshop, as well as Corel Paint Shop Pro or the image editing and Raw processing software you are most comfortable working with. Of course this will require that you adapt some of our instructions, but we believe you'll learn a great deal in the process.

Our primary goal was to make this more than just a book of Photoshop recipes and quick tips. In addition to being photographers and writers, we are both teachers and we want to share with our readers not only the How but also the Why. And while there is plenty of in-depth, hands-on instruction in digital darkroom techniques covering a wide range of topics, we have also shared our thoughts about concepts that are photographic rather than Photoshop: How to look at the image and "listen" to it; how changes to the delicate matrix of light and shadow tones can transform the mood and meaning of a photo; how to sculpt with light and contrast; and how to imagine color and tonal changes that will best express your vision for the photograph.

One of the most rewarding and significant moments for any teacher is seeing the light of recognition glow in a student's eyes, knowing that a conceptual door has just opened, revealing new pathways and possibilities. We hope that you will experience moments like this as you journey through the pages of this book and that it will serve as a good travel companion as you continue your photographic explorations in the creative digital darkroom.

Learn from the Journey,

Katrin Eismann and Seán Duggan
authors@creativedigitaldarkroom.com

We'd Like to Hear from You

Please address comments and questions concerning this book to the publisher:

O'Reilly Media, Inc.
1005 Gravenstein Highway North
Sebastopol, CA 95472
(800) 998-9938 (in the United States or Canada)
(707) 829-0515 (international or local)
(707) 829-0104 (fax)

We have a web page for this book, where we list errata, examples, and any additional information. You can access this page at:

http://www.oreilly.com/catalog/9780596100476

To comment or ask technical questions about this book, send email to:

authors@creativedigitaldarkroom.com

For more information about our books, conferences, Resource Centers, and the O'Reilly Network, see our web site at:

http://www.oreilly.com

Colophon

The book design is a result of author and designer collaboration, reader comments, our own experimentation, and feedback from distribution channels. The text font is Granjon; the heading font is Optima.

About the Authors

Katrin Eismann

Katrin Eismann is an internationally respected artist, teacher, and author specializing in creative digital photography and the impact of emerging technologies upon professional photographers, artists, and educators. She received her BFA degree in Photographic Illustration from the Rochester Institute of Technology and her MFA degree in Design at the School of Visual Arts. Katrin is the author of *Photoshop Restoration & Retouching* (New Riders, 2006) and *Photoshop Masking & Compositing* (New Riders, 2004), and co-author of *Real World Digital Photography* (Peachpit Press, 2004). She is a featured columnist in *Photoshop User* magazine and is a popular speaker at the PMA, ASMP, PPA, PhotoPlusExpo, and Photoshop World conferences. In 2005, Katrin was inducted into the Photoshop Hall of Fame and her images have been featured in numerous books, magazines, and group exhibits. Katrin is the co-founder and chair of the Masters of Professional Studies in Digital Photography at the School of Visual Arts in New York City.

Seán Duggan

Seán Duggan is a fine art photographer, educator and Adobe Certified Photoshop Expert with extensive experience in both the traditional and digital darkroom. He is the co-author of *Photoshop Artistry* (New Riders, 2006), *Real World Digital Photography, 2nd Edition* (Peachpit Press, 2004), and he writes for national photography and imaging magazines. He has been helping photographers master Photoshop and digital darkroom techniques for over 10 years. He teaches online classes on Photoshop for Photographers at San Francisco's Academy of Art University, and leads workshops at venues across the country such as the Santa Fe Workshops, Maine Photographic Workshops, and the University of Hawaii. He also offers customized private and online consulting sessions. His web site can be seen at *www.seanduggan.com* and he posts images as well as technical tips and musings on photography, digital imaging and the creative process to his blog, *www.f1point4.com*.

Silver to Silicon

The longer we teach photography and digital imaging classes, the fewer students we find in our classes who have ever been in a traditional, chemical-based photographic darkroom. Granted, Katrin hasn't mixed developer or cleaned a darkroom sink since graduating with an undergraduate degree in photography from the Rochester Institute of Technology, and though Seán still has all of his darkroom equipment and paraphernalia, it has been boxed up in his basement for nearly a decade. But even after all the years, we can vividly remember the hours bent over a long, metal sink cluttered with trays, beakers, thermometers, and tongs, listening to the tick tick tick of the GraLab darkroom timer as we gently agitated rolls of film or watched images come up in the developer tray. The moments before opening the film-developing tank or letting the last drops of fixer drip off a print were always full of apprehension, anxiety, doubt, and hope as we wondered, "Did I get the shot?" or "Will the photo look as good later as it does in the dim light of the darkroom?"

In the traditional wet darkroom, cut off from the distractions of the outside world, it was very common to lose track of time as we balanced working between the dry and wet sides of the dimly lit darkroom—enlarger, contact sheets, and yellow Kodak paper boxes on one side, and running water and scuffed developer, stop bath, and fixer trays on the other. Please don't think we are waxing poetic or that we want to be back in the wet darkroom for one split second. We certainly don't miss the fumes, the stained clothing, or the clean-up at the end of the day when all we wanted to do was get outside for some fresh air. Yet, to this day, we both appreciate and rely on what all that time standing on the cold tile floors taught us about the craft of photography, the value of imagination, and how to nurture a photograph as it evolved from a circled frame on a contact sheet to becoming the final print.

This chapter is a summary of the tools, terms, and techniques used in our digital darkroom work. It provides an overview of our workflow from capture to print, reflecting the structure of this book.

- Seeing Images and Honing Visual Skills
- Committing to the Image
- The Digital Darkroom Workflow

Chapter 1

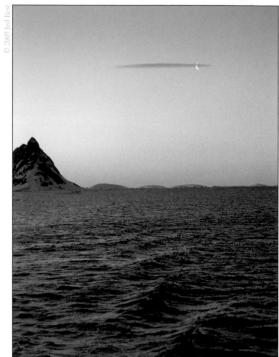

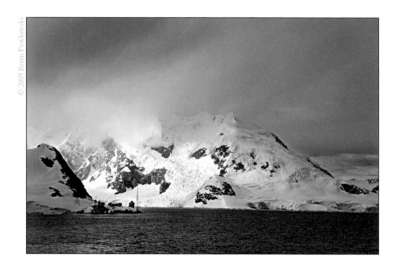

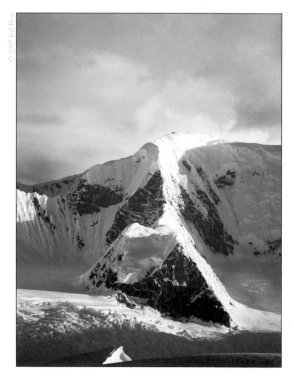

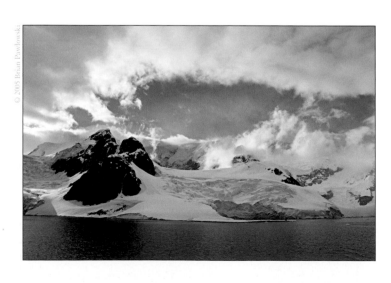

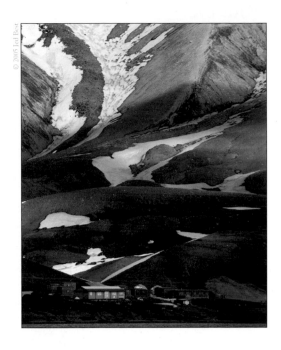

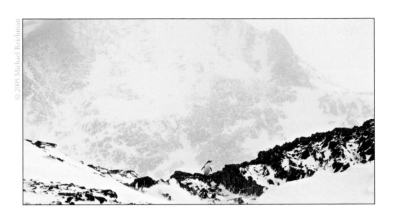

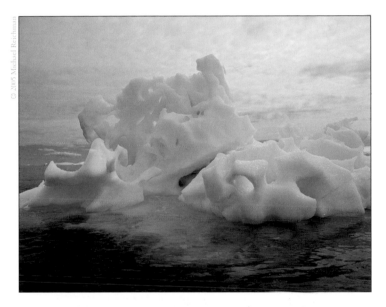

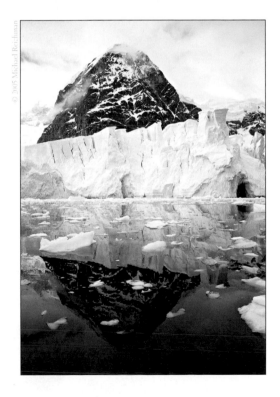

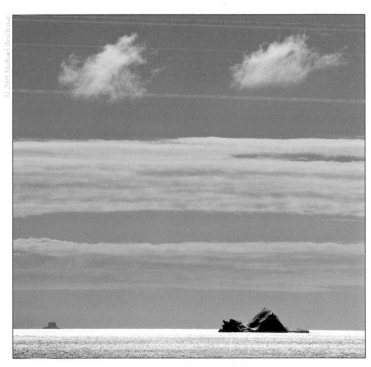

One photography expedition—many creative points of view.
All images were taken during a trip to Antarctica.

Seeing Images

Photography is seeing when we don't have a camera with us—seeing when we're watching a movie, seeing when we read a book, seeing when we visit a gallery, seeing when we close our eyes. By "taking pictures" even when you don't have a camera with you, you are more likely to be ready to create a successful image when you do have the camera within reach.

Photography is experiencing the light, the space, the concept, and looking up, down, and behind as you view the world to realize you're creating the world you are in. The world you are discovering is the world within yourself, and the camera enables us to see more clearly. Photographers prefer to see the world through a viewfinder, deciding what to include and exclude; deciding how to compose, focus, and render the scene; imagining the image as a print; and, in the case of the well-versed digital photographer, seeing software menus and selection outlines or alpha channels before gently pressing the shutter button. The images on the previous page illustrate how unique each photographer is. All of the photographers traveled on the exact same excursion to the Antarctic, visiting the same locales at the same time, and yet came away with three completely different collections of images.

To be a better photographer you need to practice seeing. Not looking, seeing. On your next visit to a gallery or a museum, find a photograph you've never seen before and look at it for five full minutes. In the first moments of looking at an image, most photographers, ourselves included, run down a checklist: black and white or color; film or digital; format or lens used; sharpness and detail. It's a pretty boring laundry list of technical components that takes a few seconds but that too often blocks us from seeing the image. To see an image, look at more than what the image is to see what the image represents. Ask yourself, why did the photographer create this image? Was it the light, the color, the moment, the feeling, an idea? How do I feel about the image? What words would I use to describe this image? Think vertically, not horizontally. For example, if the image is of a sofa, ask yourself what it represents. It may represent rest and comfort, which could lead you to think about whether or not the image is comfortable—do your eyes find a place to rest in the image or do they flit uncomfortably from point to point? If the image is part of a series, do the images flow and work together to create a whole? The photographer has taken the time and effort to create the piece; we should take similar time and effort to see, understand, and enjoy it.

Training Your Eye

One of the first assignments in Seán's online "Photoshop for Photographers" class involves no actual Photoshop work at all. It is purely an observational and evaluative assignment. Seán provides students with three images as seen in Figure 1-1; two have subtle color cast and brightness and contrast issues. The third, a night photo in which neon signs are present, has nothing really "wrong" with it, though the neon signs do create a colorcast (this ties in with the idea that not all color casts are bad). The object is for the students to look at the images, evaluate what they think is "wrong" with them, and write about each one, describing what they see and how they could go about fixing the images in fairly general terms. Seán encourages the students not to get caught up in Photoshop terminology or in steps but rather to think in broader strokes: this area is too bright, the sky needs to be bluer, the top is too dark. By identifying what is "wrong" with an image, you have created the first step in deciding what to do to improve the image. Learn to "read" an image, to see how elements of color, brightness, and contrast all come together to form that image.

To learn how to properly express what you see in an image, practice writing about what you see. Articulating how an image looks trains your eye and you become better at evaluating images. Once you become better at evaluating images, you become better at figuring out what will improve them. The more you practice seeing and reading images, the easier your digital darkroom work will be and the better a photographer you will become.

As you identify the essence of the image you'll also notice the flaws—distractions that need to be deemphasized or removed all together. Be aware of how your eye travels through the image: what it is drawn to, what it overlooks, and what it keeps returning to. Our visual cortex is attracted to light, contrast, color, and detail, so if you want someone to look at a specific area, enhance the light, contrast, color, and details to subconsciously guide the viewer's eye through the image. The best darkroom work (both traditional and digital) is the work that is not obvious or distracting and that encourages the viewer to enjoy the image again and again.

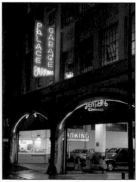

Figure 1-1. Identifying and describing image attributes develops visual acumen. © SD

Committing to Your Images

In the traditional darkroom, after processing the film we would make contact sheets, which were carefully studied as we circled potential images or x-ed out missed exposures or compositions with a red grease pencil (see Figure 1-2). Upon narrowing down the potential keepers, it was time to make a quick 8×10-inch workprint, which clearly revealed the strengths and weaknesses of the image. If the workprint revealed missed focus, or that the image wasn't as compelling as the small contact sheet led us to believe, then there was no reason to continue working with that specific image. If a workprint showed potential, then we'd giddily mark up the print with that same red grease pencil, sketching in a possible crop or a guide of what needed to be dodged up or burnt down (Figures 1-3 and 1-4). When working with traditional materials of silver-based film and chemicals, deciding which image to work with entailed a serious commitment to the image. There was no reason to spend hours and hours in the darkroom with an image that the workprint had revealed to be either technically, aesthetically, or conceptually unsuccessful.

If you are new to working in the digital darkroom, making a workprint can be a helpful tool. A workprint is an 8 × 10-inch print (some people would also say quick or rough) that you mark up with a Sharpie pen or grease pencil to circle or note the areas that need enhancement. You can even make a workprint on an inkjet printer or with less expensive color laser paper.

Figure 1-3. *Marking up the initial workprint served as a guide in the traditional chemical- and water-based darkroom.* © SD

Figure 1-4. *The final print.* © SD

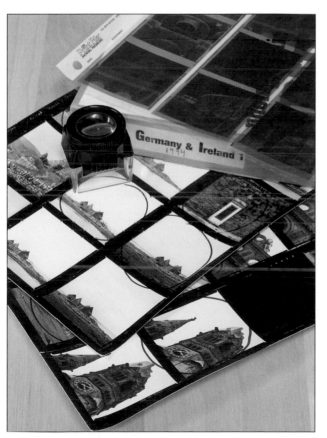

Figure 1-2. *Studying contact sheets and making selects was the first step to committing to an image.* © SD

In the digital darkroom, this critical "edit and select" process is often skipped. We find ourselves seduced by the luminosity and color saturation of the monitor as we listen to the call of the Photoshop siren that tries to convince us that with enough time, effort, and layers, we can fix the flaws in any image and rework the barely adequate into a stunning photograph. Now that more and more photographers are shooting digitally, and therefore taking more pictures, the edit and select process is even more important.

The most important aspect of working in the digital darkroom is the effort you take before diving into pixel editing to study, listen to, and learn from your own images. Carefully consider your image before starting. What is the image saying to you? What are you trying to express with it? What does it mean? Ask yourself, "What is this photograph about?" Is it "just" a pretty picture (which is fine) or is there more than meets the eye? What ideas or feelings are you trying to explore and express?

If the thought of listening to an inherently silent collection of pixels makes you uncomfortable, or if you think we're treading on touchy-feely territory, remember why you composed the photograph in the first place. What caught your eye? Was it the light, a texture, a gesture, a color, or an emotion? Learn to read the image, to comprehend it, to express what you think about it before working on it. This exercise of reading the image to identify what is essential in it is the first step in making the most of your time in the digital darkroom.

In the Digital Darkroom

The strategy we use in the digital darkroom is very loosely based on our traditional darkroom experience. Since working digitally allows for greater experimentation, flexibility, control, and the ability to explore variations, clinging to the old darkroom workflow does not yield the most efficient or effective digital image processing workflow. Additionally, the digital darkroom includes image enhancements, which were either impossible or very difficult to achieve in the traditional darkroom (reducing noise and adjusting contrast in color prints comes to mind), with the ability to selectively sharpen and soften an image without impacting print exposure. In the digital darkroom, being able to see how the changes affect the image while you're working on it, rather than having to wait for the develop/fix/wash/dry cycle to be complete or the color processor to spit out a print, is the best learning tool, creative kick in the pants, and paper-saving advantage the digital darkroom entails.

Quantity and Quality

The two general approaches to processing digital images are: make a lot of pictures look very good, or use a lot of time to perfect a few images. Depending on your needs, both approaches are valid, and in our work, we bounce back and forth between both of them. The first approach—make a lot of images look very good—is ideal for the portrait, wedding, or catalog photographer who needs to process a lot of images in the shortest amount of time. The methods used to process a lot of images quickly include harnessing the speed and power of scripting and actions to automate tedious work; using dedicated digital camera software; or working with Adobe Bridge and Camera Raw or Adobe Photoshop Lightroom to import, make selects, and process large batches of images as quickly as possible. In many cases, making a lot of images look very, very good is best done with Adobe Camera Raw or Photoshop Lightroom as they both work on the metadata level, which is much faster and more flexible than working on actual pixel information in Photoshop.

For the second approach—use a lot of time to perfect a few images (fondly referred to as pixel massaging)—the image-maker uses a dedicated pixel-editing software package such as Adobe Photoshop to enhance and perfect a small number of images. This process can take 15 minutes, 15 hours, or 15 days—as the time required to enhance and improve individual files to make them pixel-perfect depends on the skill and dedication of the artist.

Master Image File

One of the biggest advantages of the digital darkroom is the ability to make identical prints and, if desired, make them in different sizes. In the traditional darkroom, printing 2, 10, 20, or more identical prints required a lot of skill and certainly more paper. This was especially true when darkroom work, such as the dodging and burning, was inconsistent or, as more and more prints were processed, the developer became exhausted and the print quality suffered.

To facilitate consistency and repeatability and to reduce file redundancy for each image we bring into Photoshop, we create a master image file, which is the file we concentrate our digital darkroom efforts on. The master image file starts with your original scan or digital camera file and is the layered file you put your time and creative energy into. The master image file is the one you return to in order to create derivative files or to make additional prints on a variety of papers or sizes. One of the most confusing and frustrating aspects of working with digital images is organizing, managing, archiving, and retrieving files. To keep file

confusion to a minimum when working in Photoshop, after you make an initial change to a file, select File→Save As, keep the original camera file name or scan file name, and add a master_descriptive_name.tif to the beginning of the file name. Creating the master image file and always returning to it reduces file redundancy, saves hard drive space, and, most important, avoids the frustration of wasting time looking for files.

Making the Selects

After downloading the files from the camera card and making an immediate backup onto a separate hard drive, use Adobe Bridge or Lightroom or the image browser of your choice to rename the files and make the initial image selects with a strict binary system. An image is either worthy of further consideration or it's not; it either merits being flagged or marked with the minimum one-star rating or it doesn't. This selection process is the equivalent of circling potential images on contact sheets. You can filter the images to show "flagged" or "1 or more stars" to hide the rejects and to concentrate on the stronger images.

Now, rather than making workprints, carefully inspect each "keeper" and decide if it merits more stars. Once again, be fairly specific—an image is now rated two, three, four, or, very rarely, five stars. The highest rated images are the equivalent of the images circled on the contact sheet to make the workprint from. Though we would love to take a lot of five-star images, it is an honor that only a few images ever receive. The four- and five-star images receive the most attention, care, and time. We do keep all the digital camera files (well, except the obvious bloopers such as pictures of our feet or lens cap!), but the higher-rated images are the ones to concentrate on in the digital darkroom. A high rating is a commitment that starts with imagining how the final image will look and continues with wondering if we should treat an image independently or if it requires a stylistic treatment to make it fit within a series of images. For additional information on working with Adobe Bridge and Lightroom to rank, rate, and organize your images, see Chapter 3, "Scan, Develop, and Organize."

After studying the ranked images in Adobe Bridge or examining the film with a loupe and imagining what the final image should look like, follow these basic steps: acquire, prepare, enhance, interpret, and output (Figures 1-5 through 1-9) to transform the initial recording of a scene into the image you envisioned while pressing the shutter. The following workflow overview illustrates our general digital darkroom workflow and serves as the foundation and structural guideline for the rest of the book, which delves deeper into the techniques.

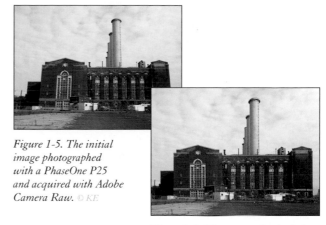

Figure 1-5. The initial image photographed with a PhaseOne P25 and acquired with Adobe Camera Raw. © KE

Figure 1-6. File preparation includes noise reduction, input sharpening, and correcting for optical and perspective distortion.

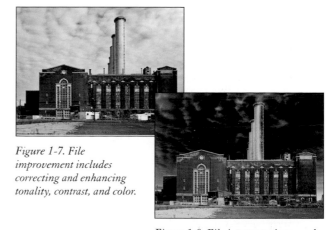

Figure 1-7. File improvement includes correcting and enhancing tonality, contrast, and color.

Figure 1-8. File interpretation may be subtle or more dramatic, as seen here.

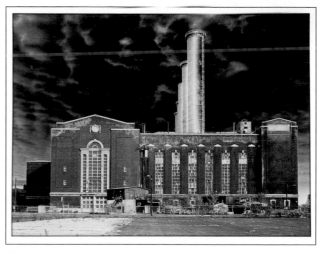

Figure 1-9. The final print on matte paper.

Part 1: Acquire

Similar to using the best ingredients to make a gourmet meal, image input involves scanning film or prints or acquiring the camera raw file and is the essential first step in producing the highest quality image. Chapter 3, "Scan, Develop, and Organize," addresses how to calculate the optimal amount of image information and bring the best file into Photoshop to insure the best results.

When working with film scans, unless you have a large number of scans to do or you are working in a fast-paced production environment, zero out all scanner software settings by disabling all auto corrections. By making a null scan, the scanner captures all of the image information, while not interpreting the file, which may force light tones to pure white or dark tones to pure black. A null scan will look very flat, as seen in Figure 1-10, but, as explained in Chapter 5, "Tone and Contrast," defining the desired black and white point is easily and effectively accomplished with Levels and Curves adjustment layers to create the results seen in Figure 1-11. Most important, make sure the scan is the appropriate size for your output, is in hi-bit, and no sharpening has been applied in the scanning process.

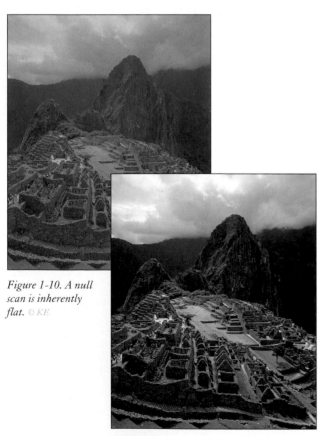

Figure 1-10. A null scan is inherently flat. © KE

Figure 1-21. The final file with the appropriate contrast, color balance, and image enhancements.

If your digital camera captures in the raw format, we highly recommend using it, especially when having the highest image quality and processing flexibility is of utmost importance. Working with camera raw files does entail the additional step of having to acquire or process the raw file so that you can work with it in Photoshop. But on that note, this processing step offers tremendous control and creative options. If you can use a raw processor such as Adobe Photoshop Lightroom, Adobe Camera Raw, Nikon Capture, DxO Optics Pro, or PhaseOne Capture One, then it is well worth the effort to take the time to learn how to develop the best image possible before opening the image in Photoshop. Camera raw files are so important that we've dedicated the majority of Chapter 3 to the topic of raw processing.

Part 2: File Preparation

File preparation is the initial image processing work applied to a file to ensure you start with the best image quality. Starting with noise reduction, a pass of input sharpening, clean up, and ending with distortion correction—file preparation can often be automated with Photoshop actions or improved upon with third party plug-ins that specialize in solving specific problems. Granted, this phase of the digital darkroom work isn't the glitzy or glamorous part of most projects but it is critical, similar to laying the foundation of a house. If this step is skipped, the rest of the image structure will suffer. Please see Chapter 4, "File Preparation," for a thorough discussion with numerous image examples on the following steps.

Noise Reduction

In an ideal world, digital camera sensors would produce noiseless files at high ISO settings and high-speed film would be as smooth as classic Kodachrome film. But sometimes the lighting or the need for a fast shutter speed demands a higher ISO. Noise is non-image information, similar to the static of a weak radio station—you can still hear the music but there is a lot of "snow" in the signal. Digital noise is more prevalent in the shadow areas and can be categorized as either luminance noise or color noise. Luminance noise occurs when shooting with a high ISO, and color noise is most visible in finely detailed, high-frequency areas such as winter tree branches or fine, flyaway hair. Reducing noise is always a balancing act between softening the noise and maintaining the fine detail. To judge the effectiveness of noise reduction you need to print out the file, as even the best monitor may not reveal subtle noise or visual grittiness.

Input Sharpening

Sharpening offsets the subtle softness caused by the stray light in camera and scanner optics or in the digital camera sensor's anti-aliasing filter. Capture (also called input) sharpening is a very light pass of sharpening that is controlled by a dense edge mask that sharpens image edges without sharpening noise, film grain, pores, or out-of-focus areas. For best results apply input sharpening to a separate layer set to the Luminosity blending mode as outlined in Chapter 4.

All images will benefit from a three-step approach to sharpening: input or capture sharpening, creative sharpening (this approach includes blurring and defocusing effects) and output sharpening (this approach offsets the softness created when ink is absorbed by the paper substrate). The folks at PixelGenius have refined this three-step approach for sharpening and Pixelgenius PhotoKit Sharpener is an excellent product, which Katrin uses on all her images.

Correcting Optical Distortion and Perspective

The process of flattening the three-dimensional world onto a two-dimensional film or digital sensor plane accentuates lens shortcomings and exaggerates the slightest "camera to subject" misalignment. Optical distortion is more noticeable with wide-angle lenses that add visible bends in straight lines, especially along the sides of the image. Lower quality lenses may also introduce color fringing, chromatic aberration, uneven sharpness, and light falloff. Using high-quality lenses will always payoff in terms of better image quality and fewer digital darkroom corrections.

Use the Lens Correction filter to offset optical shortcomings and correct vertical or horizontal perspective. Use the Perspective Crop tool and the Free Transform command to correct images that are misaligned or to refine individual image edges and corners via the Skew, Distort, and Warp controls, which help you bend an image into shape. We recommend starting the correction process with the Lens Correction filter and then refining the image with careful use of Free Transform, as illustrated in Figures 1-12 and 1-13.

Cropping and Straightening Images

Framing the scene requires the critical decision of what to include and, just as important, what to exclude from the image. Cropping can be applied in the initial file preparation phase or nearer the end of the digital darkroom process. The advantage of cropping early is that the file size is reduced and any edge burning (darkening) you apply will be accurate. Cropping is also used to remove distractions from the edge of the frame; to recompose the image (as seen in Figure 1-14, where cropping the original image underscores the contrast between the ancient marks on the lava and the flower bouquet); to apply the same size and aspect ratio to a series of images to unify them; and to correct for perspective. In Chapter 4, we'll show you how to crop and frame an image without deleting valuable image information.

Figure 1-12. Due to an ongoing television production, Katrin couldn't photograph the scene from the center point of the scene. © KE

Figure 1-13. After correction with Free Transform and the Lens Correction filter the scene is better composed.

Figure 1-14. Before and after. © KE

Spotting and Clean-up

Dust is the bane of everything photographic and needs to be kept in check around camera, darkroom, and scanning equipment. But somehow it always seems to make its way into or onto the most sensitive surfaces including processed film and digital camera CCDs. When we printed in the wet darkroom, all spotting was done directly on the print and at the very end of the process. Traditional spotting was done with very fine brushes and 2-ounce bottles of Spotone that came in a variety of shades to match the tones of black and white paper.

In the digital darkroom the real question is, should you clean up (also referred to as dustbusting or spotting) before further image processing or later in the digital darkroom workflow? The problem with dustbusting at the beginning of the process is that you may not see all dust or imperfections until image tone and contrast are enhanced. The advantage of dustbusting early on is that you get it over with and that adding contrast or applying creative sharpening effects will not enhance the dust and make it even more obvious. Our recommendation is to clean up the file early in the process and then, just after sharpening for output, inspect the file at 100% one more time to make sure all specks have been eradicated.

Part 3: Global Enhancement

After preparing the file, the digital darkroom work continues with enhancing overall tone, contrast, and color. The tonality of the image—be it color or black-and-white—is the basis for emphasis and interpretation. Global enhancements affect the entire image and are similar to determining the correct print exposure and development time in the traditional black-and-white darkroom. After determining exposure, adjust the image contrast to make sure that the shadows are rich but not so dark that all detail is lost and that the lighter areas are bright but not pure white.

When working with color images, start by finding a neutral and then refine the color aspect by adding warmth or coolness to the image to better convey the spirit of the image. Similar to how the musical score influences how we feel about a movie scene - color is the emotion of the image.

To achieve the most flexibility and control of an image, as shown in Figure 1-15, apply the global enhancements using three separate adjustment layers of Levels (Figure 1-16), Curves (Figure 1-17), and either Selective Color or Hue/Saturation (Figure 1-18). Using this three-layer strategy enables you to revisit the correction at any time to refine effects as needed.

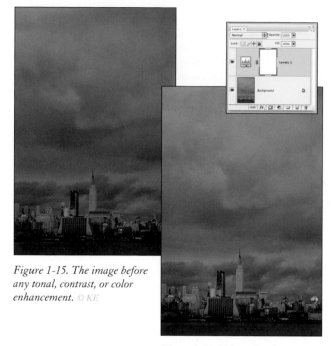

Figure 1-15. The image before any tonal, contrast, or color enhancement. © KE

Figure 1-16. Using a levels adjustment layer to refine the black and white points.

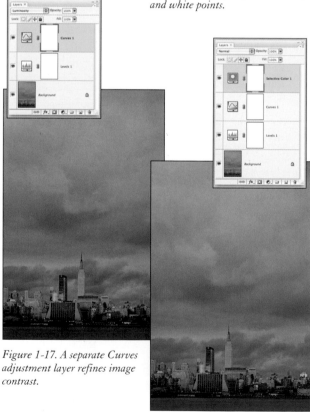

Figure 1-17. A separate Curves adjustment layer refines image contrast.

Figure 1-18. Enhancing the blue tones with a Selective Color adjustment layer creates greater depth and color vibrancy.

Improving Tonality

As we discuss in Chapter 5, "Tone and Contrast," we use a Levels adjustment layer to define the three tonal areas of an image: shadow point, midtone, and highlight placement. You can make an image pop right off the page just by setting new white and black points and adjusting the midtone gamma slider to the left to lighten or to the right to darken the image. Using the histogram as an aid to determine where tonal information starts or stops is the strength of the Levels (and in Photoshop CS3 also in the Curves) interface. Whether you work with Levels or Curves to determine tonality, we feel it is very important to keep the tonal enhancements separate from the next step, which is to improve image contrast.

Contrast

Curves is one of the most important features in Photoshop, and many a night has been filled with vigorous, long-winded debates that pitted Levels against Curves. The advantage Curves offers is control of more than 16 points of tonal information versus the three in Levels. With Curves, you can quickly enhance image contrast by applying a classic S-curve, or you can spend more time with the interface and use bump points to bring out selective tonal details, as we'll be doing in Chapter 5. When enhancing contrast in color images, we recommend changing the layer blend mode to Luminosity to avoid adding undue color saturation, which can block out important details. We'll remind you of this and illustrate the point in greater detail in Chapter 7, "Color Correction."

Color

On the most fundamental level, working with color encompasses adding, subtracting, or changing the overall color of the image. On a much more important scale, color is subjective and can evoke an emotional, deep-seated response from the viewer. Chapter 7 delves into working with Curves and selective color adjustment layers to neutralize colorcasts; that section continues with information on using Photo Filter, Hue/Saturation, and Replace Color to enhance the emotional aspects of the image.

Part 4: Selective Enhancement

In many cases, preparing the file and applying global enhancements is all that is required before making a perfectly acceptable print. But it is in the next section of the digital darkroom process that the image is interpreted and reaches its full creative potential. Selective enhancements can make the image sing as you choreograph how a viewer's eye travels through the image. As the name implies, selective enhancements affect specific parts of the image, and we've dedicated almost half the book to this aspect of the creative digital darkroom. Enhancing details is often accomplished with delicate dodging to lighten and with burning to darken specific areas, as addressed in Chapter 6, "Dodging, Burning, and Exposure Control," or by applying creative sharpening to make essential image areas appear sharper, as discussed in Chapter 10, "Enhancing Focus." But be warned! This aspect of the digital darkroom also causes sleepless nights and missed social activities as you happily delve deeper and deeper into creating the image in your mind's eye.

Selective Tonal Enhancement

Commonly referred to as dodging and burning, applying selective tonal adjustment—darkening the edges and lightening the subject—is what keeps the viewer's eye in the image. Of course, Photoshop gives you more than one way to dodge and burn, from working with adjustment layers and blend modes, to using neutral layers as a work surface, to harnessing the power of contrast and gradation masking techniques to enhance the dynamic range of the image, as seen in Figure 1-19. Chapter 6 illustrates the numerous approaches available to you.

Figure 1-19. Before and after. © KE

Selective Color Improvement

Adding subtle (Figure 1-20) or dramatic color effects emphasizes your interpretation and intent of the image. We've dedicated Chapter 7 to color theory and global and localized color correction techniques. In Chapter 8, "Creative Color," you'll learn how to experiment with color to create surprising cross process and color infrared effects, to investigate toning and split toning of both black and white and color images, and also to experiment with color in the raw acquire process to expand your color palette.

Figure 1-20. Warming the castle and cooling the sky emphasizes the castle.

Creative Enhancements

Refining the focus, atmosphere, and texture of the image includes applying selective sharpening and blurring, and experimenting with textures and creative edges to add a unique signature to your images. Of course, not every image requires a rough, gritty texture, but keeping your options open enables you to reinvent your photographic look and expand creative avenues, as seen in Figure 1-21, where adjusting the light and atmosphere creates a subtly moody image. Chapter 9 and Chapter 10 delve into changing and influencing the optical, textural, and structural aspects of your images.

Expand and Explore

Challenge yourself to make variations of the same image. Keep your options open and flexible by using adjustment layers and not resizing the master image file. Make a commitment to interpreting and improving your images, as seen in Figures 1-22 through 1-24. The ability to experiment and create variations of the same image without using a lot of print materials is one of the best aspects of working in the digital darkroom. Save your master image file often and keep exploring, pushing, prodding, and discovering what your photographs are expressing.

Figure 1-22. Before. © KE

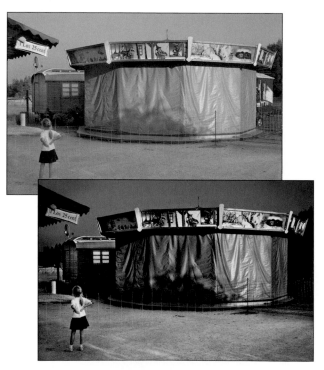

Figure 1-21. Before and after. © SD

Figure 1-23. A straightforward conversion from color to black and white is an appropriate interpretation of this image.

Figure 1-24. Adding a golden tone, lightening the center, darkening the edges, and roughing up the edges better reflects the photographer's original intent.

Part 5: Output

When the ink hits the paper is when the entire digital darkroom process comes to fruition. As addressed in the additional online resource section, "The Print," available on the book's web site at *www.creativedigitaldarkroom.com*, there is a lot more to making a good print than hitting the Print command, including: when and how to flatten, resize, and sharpen the file, which paper, ink, and color profile combinations to use, and how to work with offsite service providers to create the best large-format prints possible. From the casual 4×6-inch print taped to the refrigerator door to the exhibition-quality 30×40-inch gallery print, all are created to share with family, friends, and our contemporaries in the hope of savoring, learning from, and experiencing the magic of image making.

Learning and Forgetting the Rules

As in every creative process, rules should be learned and internalized and then just as furiously bent, broken, ignored, and forgotten. Very often an image requires tweaking the workflow to better fit the requirements and character of the specific image. Overall, if you start with a good original (well-exposed, low noise, sharp, proper resolution) and use our digital darkroom workflow as a guide, your final images will be more compelling and better express why you initially took the photograph.

As we work in the digital darkroom—or, as some call it, the digital lightroom—we are often swept so deeply into the creative process that meals are skipped, phones go unanswered, and day turns to night without our noticing. We love what we do and we welcome you to join us as we explore photography and image creation with the most exciting tools and techniques available to photographers today.

Digital Nuts and Bolts

Photography has always been influenced and shaped by the cameras, lenses, and processes of the time, and most photographers are very interested in keeping up with and trying out the latest equipment developments. Many milestones in the history of photography involve technological advances that influenced the aesthetic of photography, such as the shift from cumbersome plates to convenient roll film, from black and white to instamatic color, and now from film to digital. We consider ourselves very lucky to be active photographers during this paradigm shift, which includes instant feedback, creative flexibility, ease of distribution, and superb image quality.

Traditional darkrooms take on many forms—from the plastic drop cloth over the washing machine improvisation to the dream workspace with stainless steel sinks, temperature-controlled water, and archival print washers and dryers. The same is true of digital darkrooms; they can be as simple as a community college computer lab or as elaborate as a high-end service bureau workspace complete with professional scanners, high-powered workstations, and color-controlled viewing booths.

This chapter addresses the fundamental topics of:

- Building a Digital Darkroom
- Essential Photoshop Preferences
- Color Settings and Policies
- Efficient File Navigation

While reading this chapter keep in mind that if the image is conceptually strong and creatively successful, it doesn't matter if it was produced on an outdated laptop or on the latest and greatest power workstation. Too much emphasis on bells and whistles is simply a distraction from our true task—to make compelling images.

Chapter 2

Building a Digital Darkroom

We receive many queries about computer platforms, hard-drive recommendations, and purchasing decisions, and the advice we give is based on the process we use before we buy new equipment:

Identify your needs.

Is digital imaging your professional work or is it a passionate hobby? How many files and what size files do you work on regularly? How large will your prints be, on average? What type and size of originals are you starting with? Digital camera files? In a nutshell, the more and larger the files you work with, the higher end the computer needs to be.

Decide on a budget.

Unless you're Bill Gates or Steve Jobs, we imagine you'll have some budget considerations to take into account. We purchase our equipment with the full intention of having it perform well for three years. Keeping this cycle in mind enables us to distribute our expenditures over time. Rather than replacing everything at once, we evaluate our systems once a year and replace the weakest components at the end of each year.

Prioritize.

Put your money where it will have the greatest impact on the quality of your work. In most cases, this means buying the fastest computer loaded with RAM and the best and largest monitor you can afford.

Focus on research.

Ask your friends, join chat groups, and study sources on the Internet. Quite a few reputable sites are available, including *www.about.com*, *www.cnet.com*, *www.creativepro.com*, and *www.imaging-resource.com* that are constantly updating content. Resist the siren's call of every new gadget, widget, and plug-in by focusing on your true needs and priorities.

Buy one size larger.

Once you've mapped out a system for your needs, buy one better or faster, so that as your skills improve and your needs increase, the computer system can keep up. For example, if you decide that two gigabytes (GB) of RAM are plenty, get three or, better yet, get four. You'll never regret having more speed, a bigger hard drive, or the larger monitor when you are working on an important project.

The Working Environment

Your digital darkroom can be anything from as simple as a small laptop you carry with you when you're taking pictures to a dedicated room complete with multiple workstations, monitors, and large format printers. Before you start buying equipment, consider your work area a place you'll be dedicating to the creative process, so it makes sense to invest the time and money to make it as comfortable and productive as possible.

The digital darkroom environment should be a quiet area away from distractions and foot traffic. A room without windows or at least with good blinds is ideal. Windows allow the light levels in your work environment to change throughout the day, which can affect your perception of the image. Paint the walls a neutral gray and set up the lighting so there aren't any reflections in the monitor. Many professionals also paint the wall that the monitor is reflecting matte black to reduce possible color contamination. Also, when doing critical color correction work, do not wear your brightest, most colorful tropical shirt or your favorite red sweater; the colors may reflect off your monitor and influence your color decisions. In Figure 2-1, you see the digital work area that Katrin works in. To keep herself focused, Katrin uses a separate area for office work and doesn't have email installed on her high-end digital darkroom computer.

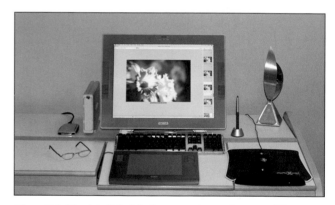

Figure 2-1. Katrin's digital darkroom work area features a Wacom Intous 3 and Cintiq 21UX interactive pen display.

Two of the most important components of your digital darkroom are the table and chair, which will enable you to work comfortably without back and neck strain. A good table without harsh edges, preferably one that angles down so your arms rest on the table or on chair armrests, and a chair with lower back and arm support are essential digital darkroom equipment. How often do you need to replace a good working table and professional chair? Not very often, so making the investment in good furniture will pay off in your health and well being for many years to come.

Speaking of health, you should know that uninterrupted, intensive computer use can be bad for your eyes, back, wrists, and more. But it doesn't have to be if you watch your posture, vary your computing activities, and take frequent breaks. An important tip for anyone working with a computer is to use these frequent breaks to focus your eyes on something in the distance. For more information about steps you can take to make your work area and work habits as healthy as possible, visit *www.healthycomputing.com* and *www.mayoclinic.com/health/eyestrain/WL00060.*

Hardware and Software

You should invest in the computer platform that you are comfortable with and can maintain with the least amount of effort. For some people, that means a Windows operating system, and for others, an Apple computer. Each platform offers advantages and disadvantages, but remember that once the image is done, it is impossible to say which platform it was produced on. Similar to the Nikon versus Canon arguments or the paper versus plastic grocery bag debate, a pixel is a pixel is a pixel. Whichever platform you use, the computer needs to have a very fast processor and bus speed, a lot of RAM with a 2 GB minimum, and two to four large, fast hard drives. At the time of this writing, the Apple Power Mac G5 Dual and the Power Mac G5 Quad are the top-of-the-line Apple computers, with the Windows-based AMD Athlon™ 64 X2 dual core processor computer bringing the equivalent performance.

If you are about to build a workstation for Photoshop work, consider these variables:

CPU speed

The higher the speed, the faster the computer. Be careful to watch the internal bus speed as well; the fastest CPU will not produce the performance increases you expect if the internal bus speed is slow.

Bus speed

Think of the bus as the pipeline that transfers information between the CPU and the RAM. The larger the pipe, the faster the data can be transferred between the two. To optimize performance, the bus speed should have a minimum of 800MHz FSB (front side bus) ideally with 1600MHz FSB and with as large a cache as possible.

RAM

Photoshop is a RAM-hungry program; the more you have allocated to it, the better it will run. How much RAM do you need? As much as you can afford! For professional use, 2 GB is an absolute minimum, and the present standard is 4 GB. On a PC, we recommend DDR2 SDRAM. Consider that often you'll have more than one image open and that, as you add layers, your RAM

requirements will increase. Adding RAM to a machine is the easiest way to increase Photoshop performance. Adobe recommends a default RAM allocation setting of 70% for both Mac and Windows computers.

As Russell Williams, a lead Photoshop engineer, wrote: "Before CS2, Photoshop couldn't use more than 2GB of RAM on a Windows machine. But with CS2 you have two options to have Photoshop access more RAM.

1. Booting a Windows machine with the "3GB" or "large address" switch on allows Photoshop to have direct access to most of the 3GB of RAM.

2. On Windows computers with a 64-bit processor running XP64 with more than 4GB of RAM, Photoshop will tell the OS to use that extra RAM to buffer access to its scratch files. This can greatly speed up Photoshop when working on very large files, since anything the OS finds in that cache doesn't actually have to be read from disk. If you're in this happy situation, you can leave the Photoshop RAM preference slider at its 55% default or increase it up to 100%, and see which setting works better for your workload."

Hard-drive space

This is a classic "bigger is better" proposition as long as you are choosing from the highest-performance drives. Photoshop wants fast hard drives to write data to when it runs out of RAM so, given the choice, go with a speed of at least 7200 rpm (rotations per second) over excessive gigabytes, and look for SATA multi-hundred gig drives or very fast FireWire 800 drives.

Ideally, you should have four fast hard drives: The computer operating system and applications should be installed on one hard drive; the images you are working on are on a second, large, fast hard drive; a third hard drive is for backup of the current working files; and the fourth drive is a dedicated scratch drive.

The scratch disk is free hard-drive space that Photoshop uses as temporary memory after it fills the RAM with image processing. The scratch disk needs to be at least twice the size of the RAM allocated to Photoshop and, more importantly, the space needs to be contiguous— that is, a scratch disk needs to be unfragmented and free of clutter. Setting the scratch disk to a drive other than the drive that contains your OS will help to optimize the speed of your computer.

RAID

RAID (Redundant Array of Independent Disks) is a group of multiple drives configured together to provide an advantage in performance and data redundancy. While a number of RAID configurations are available, there are two major types you may want to consider.

RAID-0 interleaves data across two or more disks or disk partitions but offers no data redundancy. It provides improved performance by treating two hard drives as though they were one, and it achieves faster read and write performance by spreading data across two drives with a process known as striping. Striping allows a file to be written to the drives twice as fast by alternating clusters written to the different drives. By utilizing both drives simultaneously, overall performance improves, providing an excellent method for faster data transfer rates and faster application loading times.

RAID-5 requires a minimum of three drives but offers the advantage of striping and also adds redundancy so that if a drive fails, the data can still be recovered. In fact, if a drive does fail it wouldn't cause any interruption in data access. It is an excellent choice to include for both performance and data redundancy.

Monitor

The monitor is the visual component of your system; no matter how fast or sexy your CPU is, if you are not happy with the image your monitor produces, then you will not be happy with your workstation. A good monitor will outlast one to two upgrades of your CPU. The only limitation on the effective life of a monitor is the accuracy of the color it produces—something that is usually in the range of three to five years. LCDs are taking center stage and they are much easier on your eyes, especially when working for long periods of time. The displays we lust after are the Apple 30-inch Cinema Display, and (when we win the lottery) either the EIZO ColorEdge CG220 or the NEC SpectraView Reference 21 would be perfectly welcome on our desktops.

Adding a second monitor will boost your productivity, as you'll spend less time rearranging palettes and documents. The primary monitor—dedicated to images—should be the newer, better, and larger one. The secondary monitor can be older and smaller if you're going to use it for Photoshop palettes and reference materials such as Internet pages or the very useful Photoshop help. If your budget allows, it's ideal to have two monitors of the same size and model: You can have the File Browser open on the second monitor and work in Adobe Bridge or Photoshop Lightroom on the primary monitor.

As Ivan Berger wrote in the *The New York Times*, "A monitor with a 24-inch screen offers about 50 percent more screen area than a single 19-inch model and takes up less desk space than two 19-inch monitors (less than two feet from side to side, versus about 33 inches for a pair of 19-inchers). A pair of smaller screens will usually cost less than a single big one. For about $200, you can attach two flat-panel monitors to a stand with a single pedestal, like those made by Ergotron, Mass

Engineered Design, Zenview, 9X Media, Ladybug and DoubleSight."

Adding more monitor outputs to a computer is usually not difficult. For Windows machines you can either add a second graphics card or replace your single-output graphics card with a dual-output model. Most desktop Apple computers support dual monitors right out of the box.

Monitor calibration

No matter how good the monitor is, it will not be an accurate representation of your image unless it is calibrated on a regular basis. For accurate profiling, invest in a monitor calibration system such as the GretagMacbeth Eye One Display 2, as seen in Figure 2-2, or a Monaco Optix XR, to accurately calibrate the monitor. As addressed later in this chapter, we calibrate all of our monitors once a month or before starting an important project. We both do a lot of work on our Apple Powerbooks and whenever Katrin changes locations, she calibrates the Powerbook monitor with the GretagMacbeth Eye One Display 2, which also allows her to measure the color temperature and ambient light intensity of the light and the ambient light intensity in the room she is working in or in which her prints will be displayed.

Figure 2-2. A hardware-based monitor calibration system insures the most accurate color.

Backup system

As your archive of digital files grows, having an organized system to back up and retrieve those images is essential. Gone are the days of throwing the negatives in the drawer. Media formats seem to come and go at an ever-increasing pace. Just a few years ago, 44 MB Syquest disks were all the rage, and now they are a useless relic in the same box with 8-track tapes and 126 film cassettes.

The storage capacity of digital media has been continually increasing, while the prices are falling. The three primary types of file backup are: optical CD and DVD disks, magnetic hard drives, and off-site online based systems. The CD is probably reaching the end of its life with DVD now costing about the same, making them a more efficient storage method. We strongly recommend "gold" CDs and DVDs for storage and backup purposes. Do not buy the cheapest brand available at the local office supply store as these are known to fail in as little as two years. Delkin (delkind.com) and MAM-A (*www.mam-a.com*) offer gold CDs and DVDs that are rated to last 100 to 300 years.

With large hard drives' prices falling to less than a $1 per GB, you can build in backup redundancy to avoid the inevitable damaged DVD or failed hard drive. A backup strategy needs to support how and when you access your images. Use a three level system as described here to insure that your files are accessible and safe.

Online: The image files you are working on at the moment and need access to very quickly should be on a fast internal hard drive.

Near-line: Recent images that you need convenient access to. In most cases, these images are less than one year old and can be placed on fast external hard drives.

Offline assets: Images you need to store safely but do not need quick or daily access to. These images can reside on DVDs and/or external hard drives that are not hooked up to your computer on a daily basis.

Using both hard drive and optical storage is a good idea. Storing your duplicate files in a different physical location is also recommended. Whatever format you decide to use for storage, think redundancy, as what can go wrong will.

Automating your daily or weekly backup habits is good insurance against sleep-deprived forgetfulness. On a Mac, use Apple Backup or SuperDuper; on a PC, use FileBack PC. Dantz Retrospect is a more rigorous program and supports both platforms.

> Peter Krogh's *The DAM Book: Digital Asset Management for Photographers* explains a practical strategy for managing your ever-growing collection of digital files, including organizing backups and archives. We highly recommend this book for developing a digital asset management strategy.

Mouse and mouse pad

Of course your computer came with a standard mouse, but these lowly rodents are not designed for doing critical Photoshop work. An optical mouse with programmable buttons and a scroll wheel will speed up your digital work. For the fastest mouse, look to the PC gamers who click, drag, shoot, and blow up thousands of aliens at a time with a Logitech® MX™518 Gaming-Grade™ Optical Mouse. Katrin uses a Razer Diamondback Mouse with a Razer eXact Mat mouse pad, and it is so fast that she had to slow it down in the software settings.

Pressure-sensitive tablet

A pressure-sensitive tablet lets you work with a stylus, and it feels just like working with a pencil or a brush. The harder you push, the thicker the stroke. Wacom is the leader in this technology, and their progressive improvements with these devices continue to be impressive. Wacom tablets range in size from miniature (4 × 5 inches) to huge (12 × 18 inches). Most photographers work best with the smaller (6 × 8 inches) tablets, which is also the size Katrin uses when traveling. Top of the line is the Wacom's Cintiq 21UX interactive pen display, which is a pressure-sensitive monitor you work directly on. It is difficult to describe the intensity of working directly on the image, but the relationship between you and your artwork is much more connected when working with the Cintiq.

Scanners

Look at the originals you will be scanning. If most of them are prints, purchasing a good flatbed scanner makes sense; if the majority of your work stems from film originals, a film scanner would be a better choice. It is difficult to make a general recommendation on scanners because they vary from very poor to very good and from cheap to expensive. Look for a scanner that captures at least 12 bits of data, and keep an eye on the optical resolution of the scanner—it should be 1200 to 6400 pixels per inch for scanning prints. If you plan on scanning a lot of film, be sure the scanner supports your different sizes of film. Many times, photographers will have a film scanner that handles the majority of their

needs, for example 35 mm, and they'll work with a service provider or photo lab for the lesser-used large format film scans. Though Katrin doesn't use film anymore and Seán uses it only with his Holga and pinhole cameras, we both still value our film archives; from a historical or image information point of view, film certainly isn't dead. Most recently, Nikon has been making great improvements in their scanners, with the Nikon 5000 series scanner for 35mm and the Nikon 9000 for up to 6 × 7 film originals, in which the quality and features are state-of-the-art.

Digital cameras

The camera is an integral aspect of the contemporary digital darkroom, and the more you know about Photoshop, the more you'll concentrate on composing and exposing the better image in-camera. Always start with the best original possible. The most important thing you can do to become better at Photoshop is to understand exposure and how your camera's light meter works. Knowing what you need to take away from the location, in terms of data captured and how the histogram reflects this is vital. It is always better to get the image right in the camera than trying to "fix it later in Photoshop." As Seán explains, "I don't take a photo and hope I get something good. I take a photo and know that I have something good (or not, if the lighting is too minimal to work with, or there are other problems)." See Chapter 3 for additional information on optimizing camera exposure, processing raw files, and extending a scene's dynamic range.

Printers

The quality of inkjet printers is skyrocketing while the costs are nose-diving. Issues to consider before buying a printer include the size of the prints you need and how long the prints will last once you've printed them. Desktop printers give us tremendous choices on paper and ink combinations, which we can take advantage of to support and express the significance of the image. The online section "The Print" (*www.creativedigitaldarkroom.com*) delves into the hardware, software, and process of making beautiful color and black-and-white prints.

Software

This book concentrates on Adobe Photoshop, Bridge and Camera Raw, and Photoshop Lightroom, since these are the primary pieces of software that we eat, breathe, and sleep. Katrin has heard from readers of her other books that many of the techniques achieved with Photoshop can also be created with Corel PaintShop Pro and Adobe Photoshop Elements. Since the final image is what matters, use the tools and techniques you feel most comfortable with to express yourself.

Consumables, plug-ins, and education

Make sure to budget for smaller yet essential expenditures including ink, paper, and backup media; productivity-enhancing plug-ins and maintenance software; digital camera batteries, media, and lenses; and online fees and services. As you know, keeping up with magazines, books, conferences, memberships, and workshops can add to your expenses, but if you choose your resources carefully, you should benefit from them for a long period of time.

All in all, building a digital workstation is an organic process; it will grow and change as your skills improve and new technology becomes available. The most important thing to keep in mind: Concentrate on the image, not the widgets.

Under the Hood: Essential Photoshop Preferences and Color Settings

Software preferences are never very exciting. It's hard to imagine people getting a new version of their favorite program and immediately opening up the preferences to see what's new. But even if your heart does not beat a little faster at the thought of this part of Photoshop (don't worry, ours don't either), it's important to know what options are available here and how they can affect your work in the rest of the program. This is even more critical when it comes to the choices you make in the Color Settings dialog, since this is where Photoshop gets its instructions on how to interpret the color in images as well as how to handle color profile discrepancies.

In this section we'll go over what we feel are the most important preferences and color settings for doing the type of digital darkroom work that this book is concerned with. There are a lot of preferences and not all of them are applicable to the work that photographers are involved with, so we'll be covering only the ones that directly affect working with photographic images or that have an impact on the overall performance of the program. If a preference is not mentioned, it's either self-explanatory or we don't feel it pertains to the digital darkroom.

Preferences

You can access the preferences from the Photoshop menu on a Mac (far left side of the menu bar) or the Edit menu on a PC. You can also get to them with Cmd/Ctrl-K. The first panel is General (Figure 2-3), which contains several options. Some are important, some are trivial, and others deal primarily with matters of convenience (for example, saving the location of palettes when you close the program).

Figure 2-3. The General Preference panel.

Here are the most critical preferences:

Color Picker

The default Adobe Color Picker is the best choice here. It offers far more functionality, control, and subtlety than either the Apple or Windows system color pickers.

Image Interpolation

Interpolation refers to the method by which new pixels are created or existing pixels are thrown away when an image is resized larger or smaller. Of the five algorithms on the menu, the three bicubic flavors are the best to use for working with photographs. We recommend using Bicubic as the default setting. The other interpolation choices are also available in the Image Size dialog, which is where we would normally use them on a case-by-case basis depending on whether we are making an image larger or smaller. For upsampling images (making them larger), Bicubic Smoother is the better choice. Bicubic Sharper will provide the best results for downsampling (making an image smaller). It's important to note that the interpolation method that is specified in the Preferences will affect how interpolation is done in other areas of the program where you don't have the option to choose, such as when you scale or transform an image (or a portion of an image) using the transformation commands, or if you resize using the Crop tool.

Automatically Launch Bridge

This is just a convenience setting but as conveniences go, it's a very useful one. This will launch Adobe Bridge whenever Photoshop is launched; making sure it is ready as soon as possible for browsing through your images.

Export Clipboard

When doing a lot of compositing work that requires you to copy large image information, turning off Export Clipboard is a very good idea. That way, Photoshop won't waste time and RAM to convert the copied file to a raster file whenever you go to a different application or quit Photoshop.

History Log

This allows you to save a record of your activity in Photoshop. You can choose to save this information to a file's metadata, to a separate text file, or to both. The details can be restricted to Session, which simply records when you open and close a file (useful for client billing purposes); Concise, which tracks session information in addition to itemizing every step you perform; and Detailed, which tracks session information and keeps an extremely detailed record of everything you do to an image, including specific settings used for filters, color correction, and other tools. For experimenting and to remember exactly what you've done to an image, the Detailed option can be very useful, especially for filter settings or precise transform amounts. Whether you use it or not, and how you use it, is largely dependent on whether any of this information is useful to you. If you do decide to use it, we feel the best way is to write the log directly into the file's metadata, so that the information travels with the file and you don't have to worry about keeping track of a separate text file.

If you will be delivering files to a client and you don't want them to know your secret Photoshop recipes, open a file and then choose File→File Info. Once in the dialog, select the Advanced option from the choices on the left, and then, in the center area, click the triangle arrow ("+" on Windows) for Adobe Photoshop Properties. Select the History line and press the Delete button in the lower-right corner. Then press OK. Your History log will be stripped from the metadata, but any other metadata that you want to leave in place, such as copyright notices or licensing information, will not be touched.

Interface

Color Channels in Color

We strongly recommend leaving this unchecked. When turned on, it displays the individual color channels with a brightly colored overlay of red, green, or blue. The problem with this is that the colored overlays actually make it much harder to evaluate the tonal detail in the channels, particularly in the blue channel, where the overlay color is darker than the others. It's much better to leave this unchecked and view the default grayscale versions of the color channels.

Show Menu Colors

Is useful if you customize Photoshop or to concentrate on a specific task such as working with video and film or to learn the new features in Photoshop CS3. For example, select Window→Workspace→New Features to have all the menu items highlighted that are new to CS3.

Show Tool Tips

A useful option to learn the tool tips or quick keys associated with a specific tool. We both turn this off as the yellow Post-it note popping up can become irritating.

File Handling

This section of Preferences contains settings (Figure 2-4) that control how Photoshop saves a file.

Figure 2-4. File Handling Preferences.

Image Previews

This is the preference that controls whether Photoshop creates small versions of the image for your operating system to use as icons or preview thumbnails. Note that this has nothing to do with the thumbnail previews generated by Adobe Bridge. In the past we have not recommended using the Full Size preview option since that added to the file size and was something we never used. There are some file-processing circumstances, however, where having a full-size preview can be highly useful. Some digital asset management programs make use of these large previews with automated functions that create files for proof prints or generate contact sheets and Web galleries. Yes, this will add to the file size, but hard drive storage is very affordable at the moment. To keep all your options open and be able to choose on a per-image basis whether these items are generated, select the Ask When Saving option.

If you're generating images for a web site, you usually don't want to save either previews or icons. No one visiting a Web page will see them and they just needlessly increase the file size.

Append File Extension

We feel this is always useful for the primary reason that it lets you see, at a glance, what the file format is, even if you're only looking at a list of files in a folder.

Prefer Adobe Camera Raw for JPEG Files

Allows you to open JPEG files in Adobe Camera Raw, which can be helpful, but we prefer to keep this option off as both Sean and I receive many JPEG files and most of the time we simply need to quickly view them without making any changes. To open a file in Camera Raw, control/right click on a JPEG file in Adobe Bridge and choose Open in Adobe Camera Raw as seen in Figure 2-5. Or if you prefer not to access your files through Adobe Bridge, in the Photoshop Open dialogue box select a JPEG file and change the file format (Mac) or Files type drop down menu (Windows) to camera raw and click Open.

Prefer Adobe Camera Raw for Supported Raw Files

If you use Adobe Camera Raw to process your raw files than this should be checked.

Ignore EXIF sRGB Tag

Some digital cameras will automatically add an sRGB color profile to the EXIF metadata of their images. While the sRGB profile may represent a correct interpretation for the images a camera produces, it's just as likely to be no more than a "default" tag by the camera manufacturer that doesn't necessarily reflect the best way to interpret the colors in the photos your camera captures. Use this preference to have Photoshop ignore the sRGB tag contained in a camera's EXIF data.

Figure 2-5. Opening JPEG files from Adobe Bridge into Adobe Camera Raw. © Jennifer Trenchard

Ask Before Saving Layered TIFF Files

This is primarily an issue if you have developed a file organization system where PSDs are the layered master file and TIFFs are used for flattened versions, or if you're using TIFF files in page-layout programs. (Earlier versions of some layout and prepress applications had a tendency to get downright cranky, and often seized up entirely, if they encountered a layered file.) If you want a reminder that you're saving a layered file in TIFF format, turn this option on. We leave it off.

Either PSD or TIFF is fine to use for your master layered files. Both support any type of "extras" you add in Photoshop, including layers, layer masks, vector masks, type layers, etc. Both use lossless compression (PSDs do this automatically and with TIFFs you get a choice). In fact, with its LZW compression option, TIFF files are sometimes smaller on disk than PSDs.

Enable Large Document Format (.psb)

This preference allows you to save very large files that were not possible in versions before Photoshop CS. These large files can be saved in either TIFF format (up to 4 GB) or the new PSB format with no file size limit. They can also be saved in Photoshop RAW (not to be confused with Camera Raw), but we recommend you avoid this format. The PSB format and the image size limits (300,000 × 300,000 pixels) are not backward-compatible with any version of Photoshop prior to CS2. If you can't see yourself working with such huge files, leave this option off, as protection against accidentally creating a file this big. If you do feel compelled to stitch together 50 or 60 8-megapixel photos into a single, monumental collage, however, this is the option you need to turn on before saving the file.

Maximize PSD and PSB File Compatibility

This option controls whether Photoshop will include a hidden, composite version of the image along with the regular layers when you save a file. The composite is essentially just a single layer that represents what the image would look like with all the visible layers flattened. The primary downside to having this turned on is that the extra composite layer will make your file size much larger—up to 33% larger—than it needs to be. While this is not much of an issue with small files, it can quickly become a big problem with larger documents.

In the past, it was easy for us to tell people to turn this option off and thus avoid needlessly bloated file sizes, but cheaper hard disk storage as well as changes in the software landscape and how people work with their images have caused us to reconsider this position. If you are working with your images only in Photoshop, then we still feel there is no good reason to have this on; turn it off and save some disk space. (If you are working with 16-bit layered files, however, you don't have the option to turn this off in Photoshop CS2. The full resolution composite will always be created no matter what you may have specified in Preferences.)

If you are using your images in other programs, however, there may be good reasons why you would want to use this option. The primary reason is that it allows layered PSD files to be used in other applications, such as InDesign, Lightroom, and Illustrator, and ensure that the all of the layer compositing and blending is properly rendered. Although many other programs support the PSD format, they rely on the extra composite layer in order to display the image properly. Of particular interest to photographers is the fact that photo cataloging applications such as iView Media Pro and Extensis Portfolio will use the hidden composite layer to create thumbnails and previews for their catalogs. If you are using cataloging software to maintain a detailed catalog of your photo archive, then having accurate previews for the layered files is a sound reason to use this option.

In a hypothetical future version of Photoshop, it is possible that some of the math behind the layer blending modes may be updated to compensate for rounding errors or other issues. This could conceivably cause the interaction of layers with blend modes to change, which in turn could result in your image looking a bit different from when you last saved it in an earlier incarnation of Photoshop. Using the Maximize PSD and PSB Compatibility option would provide a visual reference for how the image should look. As logical as this sounds, we don't think it is a particularly compelling argument since we usually archive a separate flattened file for this purpose.

Performance

The Preferences area controls more options for general memory allocation and the speed at which Photoshop updates the display of images.

Memory Usage

This section shows you how much available RAM you have and how much of it should be assigned to Photoshop. Both Windows and Mac OS X use dynamic memory allocation, which means that the operating system is constantly adjusting memory usage in response to the needs of the programs that are open. We generally use 70 to 80% of our available RAM for Photoshop. If you are running a lot of programs or find your system getting cranky, you may need to lower this amount, install more RAM (always a good idea), or try closing some applications. Of these three possible options, getting more RAM is the best one. You can never have too much RAM with Photoshop. Remember also that Photoshop should have plenty of free disk space available to use for its scratch-disk requirements.

Scratch Disks

When Photoshop runs out of RAM for its calculations, it grabs some empty hard-drive space on your computer and uses that as a scratch disk. This option lets you assign a first, second, third, and fourth choice for which hard disks Photoshop should use as scratch space, as seen in Figure 2-6. You should always assign your fastest drive, with the largest amount of free space, to be the primary scratch disk drive.

History & Cache

The History feature in Photoshop is an über-undo command that lets you move backwards through individual editing steps to undo changes. Photoshop refers to each separate change as a history state. A history state can be anything from a Levels adjustment to a retouching dab with the Clone Stamp to an application of a sharpening filter. As you can imagine, this provides great flexibility and insulation from "point of no return" mistakes. The default number is 20 history states, and the maximum number is a whopping 1,000. Whether you'll actually be able to get by with the maximum amount will depend on a number of factors, including image size, how much of the image has been altered by each history state, how much RAM you have, and how much free disk space is available for Photoshop to use as a scratch disk.

If you want to free up some system resources and don't need all the recent history states in your image, you can do some pruning by either dragging individual states to the trash can at the bottom of the History palette, by using the Clear History command found in the palette's sub-menu, or by accessing a similar command found under Edit→Purge→Histories. Until you get a better idea of how many history states is a good number for you, we suggest starting at 100.

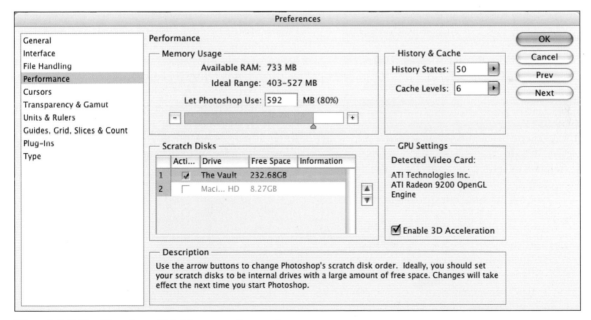

Figure 2-6. Telling Photoshop which drives to use for scratch memory.

Cache Levels

Photoshop uses the image cache as a way to increase the apparent speed with which it deals with large images. Using the number specified by this setting, Photoshop saves several smaller versions of the image at different zoom percentages: 25, 33.3, 50, and 66.7%. When viewing the image at a zoomed-out view, such as 25%, the program can apply the changes to the smaller, cached 25% version first, which results in a speedier update of the screen preview. The default setting for Photoshop CS3 is six cache levels, which works just fine for most images from digital cameras. If you find that you're working on really large images and you have a good allocation of RAM and scratch disk space, you can try increasing it to eight cache levels, which is the maximum.

Note for Photoshop CS Users

In versions prior to CS2, you will see a checkbox here labeled "Use Cache for Histogram in Levels." We recommend you turn this off. Although the time it takes to build the Levels histogram is shorter with this option, the reality is that you're not getting the histogram from the full image, but rather you're getting a histogram rendered from whatever cached version happens to be in use presently. We feel that if you're going to make the effort to understand what the histogram is telling you, then you should be getting the accurate data. The Histogram palette will always use the cached data until you tell it to do otherwise. It has its own interface and menu controls to render a new histogram from non-cached data.

Cursors

This section of Preferences contains options that influence the display of the pixels and the appearance of the mouse cursor (Figure 2-7). Not too exciting, but there are a couple of important ones here.

Painting Cursors

From a usability perspective, this is arguably the most important setting in this panel. By setting the painting cursors to Brush Size, you can see a circular cursor that is the size of the brush tip you're painting with. If the cursor is the default brush symbol icon, then you won't know how large your brush is until after you've painted on the image—very inconvenient! Seán uses the Normal Brush Tip, which shows the size of the brush out to 50% opacity (soft-edged brushes have a feathered tip that gives coverage that gradually fades out at the edges). Katrin opts for the Full Size Brush Tip that shows the coverage of the brush out to 0% opacity.

Other Cursors

This preference lets you choose between standard, which is the tool icon, and a precise crosshairs. Turning this on is purely subjective, and we use standard since you can have a precise cursor tool at any time by simply pressing the Caps Lock key.

Transparency & Gamut

In the grand scheme of things, these preferences are not that important, and we've rarely had to change the defaults here, but there may be times when you do need to change them, so having a basic understanding of what they do is useful.

Transparency Settings

When you have an image element on a separate layer, Photoshop uses a checkerboard pattern to represent the transparent pixels that surround it. You'll see the pattern only if you turn off the eye icons in the Layers palette of any underlying layers. Essentially, the program needs to have something there so you can see nothing's there. We have found that the default colors and grid size work fine for most images, but we can envision situations where it may be useful to change them. Clicking the colored swatches will take you to the Photoshop Color Picker, where you can choose new colors for the grid.

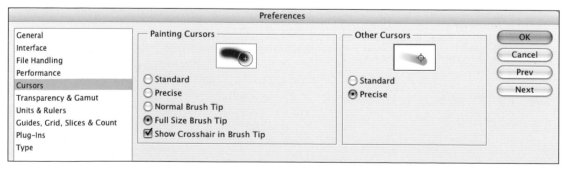

Figure 2-7. The Cursors preferences.

Gamut Warning

When the Gamut Warning is activated (View→Gamut Warning), Photoshop will place an overlay tone over any colors in the image that are out of gamut for the current CMYK setup as specified in the Color Settings dialog. Although its initial purpose in Photoshop was for prepress work, if you have selected an inkjet profile as the current proofing space, it will display the out-of-gamut colors for the printer and paper combination. For photographers making their own prints, this can be a very helpful tool for the final finessing of the image before making a print. The middle gray color at 100% works pretty well for color images and is not recommended for black & white images. Click the color swatch and choose a contrasting color to change it.

Units & Rulers

These settings are fairly obvious (not to mention moderately yawn-inducing) so there's really no need to explain what they do. But we can offer a few useful tips that relate to choosing ruler units in general and how the chosen units can affect other areas of the program.

Units

A much faster way to change the ruler units is to Ctrl-click/right-click inside the rulers on the top and left sides of your image window. You can also change the units by clicking the small crosshair in the XY section of the Info palette.

> The program's measurement unit is used by default when you enter custom values in the Options bar for the Crop tool. Be on the lookout for this to be sure that you are not inadvertently about to crop an image to 8 × 10 pixels when you really needed an 8 × 10 inch image. Simply change the "px" abbreviation to "in," and then apply the crop.

Column Size

If you need to resize images for a publication that uses columns for arranging text on a page, then specifying the exact size of your columns in Preferences will enable you to resize images or create new files based on the column width used in your publication. If you want to resize a photo to two columns wide, for instance, this Column Size preference tells Photoshop how wide to make your image.

Plug-ins

Most people are aware that Photoshop can be a demanding program in terms of memory usage (RAM). The most succinct words of wisdom we can impart regarding Photoshop and memory would be "the more the better!" Apart from the amount of RAM you have, Photoshop also utilizes actual hard-disk space as a scratch disk. A scratch disk is like virtual RAM that Photoshop can use for its calculations. These preferences control how Photoshop interacts with your computer in the vital areas of virtual memory as well as the location of accessory plug-ins.

Plug-ins

Photoshop normally looks for filters in its own plug-ins folder (located inside the Photoshop application folder). If you have third-party plug-ins you want to keep in a different folder, this is where you tell Photoshop where that folder is so that the additional plug-ins are accessible to Photoshop.

Photoshop Color Settings

A digital image is nothing more than a grid of numbers representing different color values (Seán likes to think of it as an electronic paint-by-numbers kit). Unfortunately, those numbers are pointless unless there is some standard definition of what they mean and how they should be interpreted. The Color Settings dialog is where you define what those definitions are and tell Photoshop how it should interpret the colors in the images you bring into the program.

We feel it serves no purpose to just include a screen capture of the dialog that shows you which checkboxes to check and which radio buttons to enable if you don't also have an understanding of the "why behind the how" of the Color Settings dialog and of Photoshop color management in general. So, before we cover the specific options in the Color Settings dialog, let's take a moment to get an overview of the terrain we'll be exploring.

How Photoshop Approaches Color Management

The core problem with having an image that is described by a grid of numbers is that it comes with a certain amount of ambiguity. To use the paint-by-numbers analogy mentioned earlier, a picture would look very different depending on whether you used watercolors, oils, acrylics, colored pencils, or pastels to create it. Working with digital color includes similar variables, but rather than types of paint it is the scanner or camera, monitor, and printer that all describe the color a bit differently. Even though you're working with digital values the actual color created, whether displayed on a monitor or printed by an inkjet or photographic printer, will vary from device to device, because different devices interpret the numbers and render color in different ways.

Color management in Photoshop uses profiles to standardize how digital color is displayed and printed. Profiles simply are information that is included with the file that defines how these colors should be interpreted. There are three key principles to a profile's functionality:

1. Having a properly calibrated display with an accurate monitor profile that tells Photoshop how your specific device renders color.

2. Using an RGB working space that's device-independent—that is, its interpretation of how a given set of color numbers should be displayed is not constrained by the limitations of a particular device, such as a monitor, printer, scanner, or camera.

3. Adding ICC (International Color Consortium) profiles, or color tags, to your image files that tell Photoshop and other ICC-aware applications how the color numbers in your file should be displayed. These color tags give meaning to the color numbers in your image.

Monitor calibration and profiling

The importance of having an accurately calibrated and profiled monitor cannot be emphasized enough. If your monitor has not been properly adjusted (calibrated) and the profile that describes it is not accurate, then no amount of color management diligence and use of image color tags farther down the line will give you predictable color. If you have never calibrated and profiled your monitor, then we recommend postponing any serious printing of your images until you've dealt with that vital piece of the puzzle.

The actual nuts and bolts details of the calibration process are outside the scope of this book, but there are plenty of other books (Real World Color Management, 2nd edition, by Bruce Fraser, and Color Confidence, 2nd edition, by Tim Grey, are two popular and reliable choices) and resources on the Web that do cover it.

At the very least, you can use software calibration to get your monitor in the ballpark, but since this relies on your subjective visual judgment, we don't recommend the software approach. On the Mac, use the Display Calibrator Assistant, which is accessed through the Display Preferences. While not the best way to calibrate and profile a display, it is much better than doing nothing and it's free. As of this writing, there is still no display calibration utility built into Windows, but you can use the very capable Adobe Gamma utility that is included with Windows versions of Photoshop. We feel that the best way to calibrate your monitor (read "Do Not Pass Go") is by purchasing a third-party calibration product such as X-Rite or Gretag Macbeth, as seen in Figure 2-8. Rather than rely on the subjective and fallible calibration approach used by the Apple calibration utility or Adobe Gamma, these packages use colorimeters to measure the actual colors on the monitor, which is much more accurate.

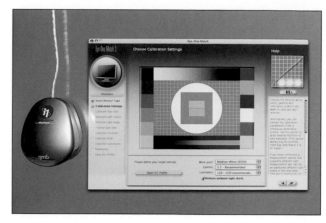

Figure 2-8. The GretagMacbeth EyeOne Display 2 is very straightforward to use and produces excellent results on both CRTs and LCD monitors.

Working spaces in Photoshop

A working space defines how Photoshop interprets the color numbers in any new file or in a file that you have converted from another profile. It provides visual meaning and consistency to the numbers that make up a digital image. The working space affects any new images you create in Photoshop as well as images that do not already have a profile associated with them (as is often the case with files from a digital camera).

The RGB working spaces that are available in Photoshop do not represent color as defined by a particular device, such as a monitor or printer. Because of this, they are referred to as being device-independent. We'll discuss the merits of the different working spaces a little later. As long as you're using an accurate monitor profile and saving an image with a color profile (more on that in the next section), then the display of the image will be consistent when viewed on other calibrated and color-managed systems as well as when printed using accurate printer profiles. (Printing issues will be covered in the online Bonus Chapter, "The Print".)

Color profiles: a digital guide print

If you have been photographing for a while, then at some point you probably have had to deal with photo labs to have some of your work reproduced. In some cases, when ordering an enlargement from a negative that had been previously printed, you may have brought a guide print to the lab and included it with your order to show the technician how you wanted the new enlargement to look. Without a guide print, the interpretation of a negative can be very subjective, but with a guide print, there is a reference for how the image should appear.

A color profile is the digital equivalent of a guide print. It describes how the colors in an image should be displayed or printed. Along with a monitor profile and a device-independent working space, it represents the third

component for how Photoshop manages the color in the images you work on. Every file should be saved with an embedded color profile (this option can be found in the Save and Save As dialog boxes). The presence of a profile, this digital guide print, tells Photoshop and other ICC-savvy applications how the colors should look. We can't stress enough the importance of having a profile associated with your image. Without an embedded profile, Photoshop has no idea how to display the colors, so it just interprets them according to the working space. This may represent a correct interpretation, but then again it may not. It's like ordering an enlargement from a negative with no guide print; the technician will simply make what she considers a good print. This hit or miss method may or may not be acceptable, while having a guide print, i.e., an accurate color profile, ensures that the image will look correct.

The Color Settings Dialog

Now that we have some of the important background information covered, let's take a look at the actual Color Settings dialog and discuss some of the options there. You can find the Color Settings near the bottom of the Edit menu (Cmd/Ctrl-Shift-K), as seen in Figure 2-9.

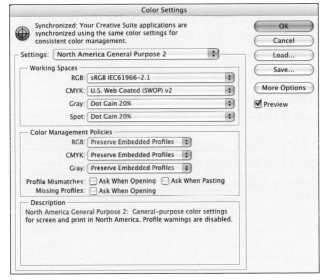

Figure 2-9. The Color Settings dialog box looks more daunting than it really is.

At the top of the Color Settings dialog box is the Settings menu, which contains some preset configurations tailored for different purposes. In Photoshop CS2 and CS3, the default settings are North America General Purpose 2. These default settings don't portend the end of the world in terms of color quality, but if you do care about tonal and color quality in your images, they're not ideal. As we will explain shortly, the primary downside to these defaults is the use of sRGB as the RGB working space.

As a shortcut to get to most of the settings that we recommend for photographic work, you can choose North America Prepress 2 from the Settings menu. In the following section, we'll address what these settings mean, explain why we think you should use them, and cover situations where using a different setting may make sense.

RGB Working Spaces

For the purposes of this discussion, we are going to focus on two types of RGB working spaces that you can use in Photoshop. The first of these are what we will refer to as the standard working spaces. These are the four working spaces that are available in the Color Settings dialog when it is in Fewer Options mode. The other working spaces are known as wide-gamut spaces because they encompass a much larger gamut than the standard spaces. These become available only when you press the More Options button. Although a larger gamut may sound like the way to go (after all, more is better, right?), larger gamut working spaces come with their own set of challenges and caveats. We will start off with the standard spaces and discuss the wide-gamut alternatives in a bit.

Standard RGB Working Spaces

In the default arrangement of this dialog box (Fewer Options), you have four choices for RGB Working Spaces in the pop-up menu. Of these, only two are serious contenders for photographers who care about good color reproduction. Unfortunately, neither of them is used in the default settings. Let's take a look at these choices in greater detail in the order in which they appear.

Adobe RGB (1998)

Of the four standard RGB working spaces, this is the one often recommended for most photographers. (If you chose North America Prepress 2 from the Settings menu, Adobe RGB is already selected for you.) This working space has the largest color gamut of any of the four *standard* spaces. For printed output of your photographs on RGB devices, whether on inkjet printers or on photographic printers such as a LightJet 5000, Adobe RGB encompasses a good portion of the color gamuts of those devices, and we feel it is the best choice of the *standard* vanilla RGB working spaces in Photoshop. Please see "Wide-Gamut Working Spaces" on the following page for additional recommendations.

Apple RGB

This is a legacy working space. In Photoshop 4 and earlier, the only color space the program used was based on an Apple 13-inch monitor, hence the inclusion of Apple RGB in the list of choices here. There is no reason to choose this as a working space.

ColorMatch RGB

This working space is based on the gamut of an actual device, the Radius PressView monitor that was once ubiquitous in prepress shops. Although the gamut of ColorMatch is much smaller than that of Adobe RGB, it does include most of the common CMYK gamuts, and it can be a logical choice in certain situations, especially if you're preparing images specifically for press reproduction. We also know some portrait photographers who prefer this working space because skin tones do not appear as saturated as they do in Adobe RGB.

sRGB

This is Photoshop's default RGB working space, so if you've never changed it, or if you just accepted the defaults when you installed the program, it's probably still set to this. Microsoft and Hewlett-Packard developed the sRGB space to represent the gamut of the "typical" monitor. Since the "typical" monitor is probably an inexpensive one that is not designed for imaging work, sRGB is less than ideal for people who are concerned about working with color photographs. For the casual photo hobbyist, sRGB is fine, but if you have purchased this book, your interest in photography and the digital darkroom is likely more serious than that of a casual hobbyist. We do not recommend sRGB as a working space.

sRGB clips substantial colors in the blue/green range that can be reproduced on even matte surface inkjet prints (matte papers have a smaller gamut than glossy). To be fair, Adobe RGB also clips some colors that are within the gamut of some matte papers, but the clipping is minimal compared to sRGB.

Wide-Gamut Working Spaces: ProPhoto RGB

If you press the More Options button, you will see a list of every RGB profile installed on your computer. Although seeing so many potential choices may be a daunting prospect, the good news is that nearly all of them are entirely inappropriate as an RGB working space because they are device profiles (that is, profiles that represent a specific monitor, scanner, or printer).

There is one RGB working space in this list, however, that you may want to consider as an option, especially if you are shooting RAW files and are interested in retaining all of the color and tonal range that can be captured by your camera. ProPhoto RGB is a wide-gamut space that was originally specified by Eastman Kodak as a way to describe all of the highly saturated colors that could be produced by E6 transparency films. It is much larger than Adobe RGB and encompasses nearly all of the colors in the visible spectrum (as well as some colors beyond it). Before you rush off and start using it, however, you need to be aware of the special handling that it requires. Although it is a very powerful color space, to lift a quote from Spiderman's Uncle Ben, "with great power comes great responsibility."

Advantages of ProPhoto RGB for raw files

The reason ProPhoto RGB is of interest if you are shooting raw is that it encompasses nearly all of the color information that your camera's image sensor can capture. Even though Adobe RGB is the largest of the four standard working spaces in Photoshop, converting a raw file into that space will clip significant amounts of color information that the camera is capable of capturing in some scenes, especially in the deep, saturated colors.

This does not mean that you can't get a great print from a raw image that has been processed into Adobe RGB, but it does raise this question: Why throw away all of this information if you don't have to, as illustrated in Figure 2-10? Several years down the road, we may have output options that will allow for larger color gamuts. Even today, the newer Epson inkjet printers and K3 inks are capable of printing saturated cyans, magentas, and yellows that lie outside the gamut of Adobe RGB. By intentionally clipping the file at the beginning, as it is converted to Adobe RGB for your master file, you are closing the door on those possibilities.

You can always return to the original raw capture and reprocess it, of course, but any work done to the layered master file will have been already forced into a much smaller color gamut. If the image is converted into the ProPhoto RGB color space at the beginning of the process, however, virtually all of the original color and tonal range will be preserved in the master file (Figure 2-11). This makes it ideal to use as an archive color space so that your master images are stored with as much potential information as possible. Working with your raw files in ProPhoto RGB enables you to "future-proof" your images.

Figure 2-10. The grid represents the Adobe RGB working space, and the color shape represents the color profile of the Epson 2400 when printing to Luster paper. Notice how the essential greens and yellows fall outside of the working space.

Figure 2-11. In ProPhoto RGB all of the possible colors of the Epson 2400 printing to Luster paper are maintained.

ProPhoto RGB disadvantages: Here there be dragons

When judged by the basic observation that ProPhoto RGB preserves a much fuller range of the captured information whereas Adobe RGB clips significant amounts, it may seem like a no-brainer to use ProPhoto RGB all the time. Although this is certainly a compelling reason to consider this color space, there are good reasons to proceed with caution. As a working space ProPhoto RGB is not for everyone or for every image. While it does offer more possibilities for preserving all the color and tonal information of a raw capture, when used incorrectly, there is also the potential for mistakes that can make an image look very bad. Let's take a quick look at some of the possible downsides and other issues to be aware of.

Using ProPhoto RGB with 8-bit files significantly increases the risks of posterization or banding, especially when major edits are performed. To get the most out of what ProPhoto has to offer, you need to be converting your raw images to 16-bit files (don't even bother using it with JPEGs). We should point out that we do not consider working in 16-bit to be a downside at all (in fact, we prefer it!), but some people may, and you do need to be aware of this as it relates to this color space.

ProPhoto RGB encompasses most of the visible spectrum, but it also exceeds it in some areas of deep blues and deep greens. (Some have referred to these as "imaginary" or "science fiction colors" because they do not really exist.) When editing an image, it is possible that colors can be shifted into these fictional ranges, which cannot be seen or reproduced, and this can cause major problems in the colors you can see.

Because wide-gamut spaces are so wide, they are far larger than what can be displayed on a monitor. This being the case, some changes you make to an image in the ProPhoto RGB, especially shifts in hue or saturation, may not be able to be distinguished on a display.

The debate about whether ProPhoto RGB makes sense in real-world situations (as opposed to the purely theoretical) continues to rage on in the photographic community. Many photographers question the relevance of using a color space that is vastly larger than your eventual output space. While this point has some merit, the following is also true and worth consideration: Some camera and "scene" gamuts can contain colors that fall outside of Adobe RGB, as seen in Figure 2-12. (This is especially true with highly saturated yellows and greens that are often found in flowers and foliage on a bright, sunny day.) If you convert a raw file to Adobe RGB as you bring it into Photoshop, the original character of those colors is lost when they are compressed into the smaller gamut Adobe RGB space. With the newer Epson K3 inks and printers, some colors that can be reproduced on those printers fall outside of the Adobe RGB space. And it is not improbable to think that future printers and inks will be capable of larger color gamuts than what is possible with today's models. If your goal is to capture and reproduce as many colors as faithfully as you can, then for some images, ProPhoto RGB may be a better choice than Adobe RGB. ProPhoto RGB does not clip those colors at the beginning during the raw conversion process, and you can exercise greater control over how the 16-bit ProPhoto image is converted into the printer space at the end of the process.

Figure 2-12. A raw file from a Canon 20d, as mapped into Adobe RGB working color space, reveals clipping in the greens and some yellows.

We do not recommend ProPhoto RGB for everyone. If you do not have a good understanding of working in 16-bit, color management fundamentals, profile conversions, rendering intents, and soft-proofing, this is probably not the color space you should be using at this time, and Adobe RGB would be a safer choice. But if you are interested in preserving as much of the original color captured by the camera as possible and have the requisite Photoshop experience to navigate the potential pitfalls, then ProPhoto RGB may be worth considering for your high-bit images that originate from camera raw files.

CMYK Working Spaces

You need to be concerned with choosing a CMYK working space only if the images you're working on will be reproduced on a commercial printing press and you will be applying edits and color corrections to the actual CMYK files. If you are working with RGB files only, then you don't need to trouble yourself with this setting and you can leave it at the default. Some people think they need to use CMYK for their desktop inkjet printers but this is not the case. Even though inkjet printers do use various combinations of cyan, magenta, yellow, and black inks, they are considered to be RGB devices because they do such a great job of converting the RGB information you send them.

While RGB working spaces are device-independent, CMYK is rigidly output-specific. The flavor of CMYK that you use is influenced by the type of inks and paper being used for a given project and, in some cases, the characteristics of the individual printing press. For these reasons, it's not as easy to give a one-size-fits-all recommendation for the best CMYK space to use. For general purposes, the default U.S. Web Coated (SWOP)v2 is probably as safe a choice as any for a default setting. Since CMYK settings are so tied to how the job will be reproduced, however, any setting you choose here should be thought of as no more than a placeholder that will suffice for the most common printing situations. Depending on the work you do and the type of publications in which your work appears, one of the supplied presets may be just fine, but you should always maintain good channels of communication with your publisher or printer and verify that you are using the right setting.

We believe that color images should be kept in an RGB working space as long as possible, and flattened copies converted to CMYK only for specific purposes (that is, it makes no sense to have a "generic" CMYK file that you provide to your stock agency because it may not be suitable for all types of CMYK reproduction). If you find that you need to delve into this area further, we highly recommend *Real World Adobe Photoshop CS2* by David Blatner and Bruce Fraser (Peachpit Press, 2005) as an excellent resource for anyone who needs to use Photoshop with CMYK.

Gray Working Space

Gray working spaces can be selected to reflect specific dot gain characteristics or to display gammas. Dot gain percentages refer to the fact that when printed on a press, a dot of ink will increase in size, and therefore become darker, as it is imprinted and absorbed into the paper. The gamma settings are designed for images that will be viewed on a monitor, but they also work well for images that will be printed on an inkjet printer.

If your primary output is to a printing press, then choose a dot gain that matches the same figure in your CMYK setup. A setting of 20 percent is a common percentage for coated paper stock, for instance, and is the default in Photoshop CS3. As with CMYK, however, dot gain may vary depending on the particular inks and paper being used, so consult your printer to get as much information as possible.

If you're printing black-and-white images to a desktop inkjet printer, we recommend setting the Gray working space to Gray Gamma 2.2. This is true even if you're on a Mac, which still uses a default display gamma of 1.8. A gamma of 2.2 (here and in your monitor calibration) will produce smoother gradients than a gamma of 1.8, and it more closely matches the tone response curve of most displays.

If you're on a Mac and open an earlier grayscale file created using a gray gamma of 1.8, you will be notified that the embedded profile does not match the current Gray working space of 2.2. In that case, just choose "Convert document's colors to the working space," and the tones in the photo will be converted with an eye toward preserving the appearance of the image.

Spot Working Space

Spot Working Space refers to very specialized prepress situations where custom inks (also known as spot colors) or varnishes will be used. This is even more of a prepress concern than basic CMYK and unless you find yourself having to deal with custom inks and varnishes (perish the thought!), the default setting of 20% is fine. If you need to use it at all, then do check with your printer about the specific dot-gain characteristics of the ink, paper, and press that will be used to print the job.

Color Management Policies

This section of the Color Settings dialog tells Photoshop how to behave when it encounters images that don't have a profile (untagged) or images that have an embedded profile that does not match the currently selected working space (mismatched). This is the place that controls those annoying messages that sometimes appear when you open an image in Photoshop. Well, some people feel they're annoying, but once you understand what they're telling you, they're not so bad.

There are three separate pop-up menus for setting the policies for RGB, CMYK, and Gray working spaces. All contain the same three choices: Preserve Embedded Profiles, Convert to Working RGB (or CMYK, or Gray), and Off. These choices are the same ones that appear in the warning dialogs when you open images (though the exact wording is a bit different). What you select here just determines which radio button is selected by default when the warning dialog pops up (you can still change it if you want to). Let's take a close look at exactly what these choices mean. We'll look at them in order of appearance:

Off

Before we get into the nitty gritty about what this choice does, let us state up front that choosing this is a bad idea (cue foreboding and scary music). If you open a file that contains an embedded profile, Photoshop will discard the profile and regard the image as untagged. The color

numbers in the file will be interpreted according to the currently selected working space, even though that may not be a correct assumption. Remember the analogy we used earlier about a profile being the digital equivalent of a guide print? Selecting "Off" here would be like the photo lab throwing away your guide print after you had placed the order! Since we believe that profiles (if they are accurate) are a good thing that can help you control the color in your images, it's probably no surprise that we don't recommend this option. By stripping the profile from the image, you are flying blind as to the true meaning of the color numbers, and Photoshop can display the file only according to the specifications of your working space. Apart from obscure color management testing purposes, there is no good reason to choose this setting.

Preserve Embedded Profiles

When opening a file with a color tag that is different from your working space, this option will honor the embedded profile, and no conversion will be performed on the color numbers in the file. The image opens in Photoshop, and you can work on it in its own color space without having to convert to your working space. Assuming that you have a properly calibrated and profiled monitor, the display of the image should be correct. This setting is useful if you get files from different sources and want to make a conversion to your working space only after you've had a chance to inspect the file.

Convert to Working RGB

When you open a file that has a color tag different from your working space, this choice will convert the image from the embedded profile into your currently selected RGB working space with the goal of preserving the appearance of colors in the image. If you're working in a closed loop system (in other words, you're generating all of your images with your camera) and you know where all of the files are coming from, you know they have accurate profiles, and you're using a working space such as Adobe RGB or ProPhotoRGB, then this is probably the best choice for most photographers.

Of the above options, we recommend Convert to Working RGB (or Working Gray) as the best choice in most circumstances. Remember that all these settings do is determine which button is preselected for you in the profile messages that appear when you open a file; you can still make a different choice if it is appropriate for a specific image. For the CMYK working space, it probably makes more sense to choose Preserve Embedded Profiles.

Profile Mismatches and Missing Profiles

These three checkboxes control whether or not you see those vexing "missing profile" or "mismatched profile" notices when you open a file (Figure 2-13). If you never want to be bothered by them again (and we hear this sentiment a lot!), you can turn them off here. We recommend that you leave at least two of them on, however, since we think it's always good to be informed about what's happening with the color in our file or how it's being interpreted. The most important are the Ask When Opening options that trigger a notice if you open a file that either has no profile or that has a profile that doesn't match your working space. We feel you can safely turn off the Ask When Pasting option. This triggers a notice when you paste from one image to another and the profiles of the two don't match. In nearly all cases, you will want to convert the color numbers so the image appearance is preserved. Since that is the default choice for this warning, we feel it's fine to leave this option unchecked and let Photoshop do the conversion without bugging you about it.

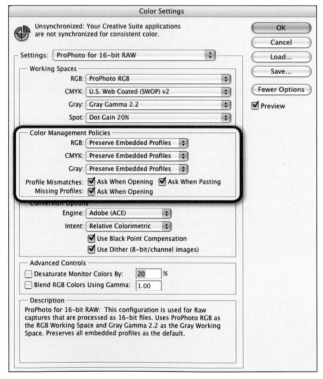

Figure 2-13. Checking Profile Mismatches and Missing Profiles informs you when a profile conflicts with your color settings.

Opening Files: How to Deal with Profile Warnings

One of the most common questions we get from students and new Photoshop users is what to do about the missing profile and profile mismatch warnings that often pop up when you open a file. If you don't know what they're telling you, or what the right answer should be, encountering these can be very frustrating. To make matters more perplexing, they use language that is slightly different from that used in the Color Management Policies section of the Color Settings. In an effort to clear up some of the confusion surrounding these warnings, here are some recommendations on what choices are appropriate when you run into them.

Profile Mismatch

Profile mismatch warnings are the easiest to deal with because Photoshop detects that there is a profile associated with the image and this gives it the necessary information to convert the color numbers from the image's existing profile to match your current RGB working space. Of the three choices presented to you, only the first two are really an option, as seen in Figure 2-14:

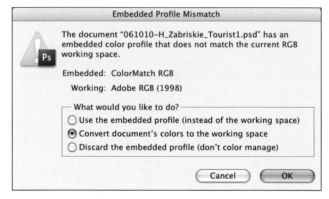

Figure 2-14. A profile mismatch is a common occurrence that should not induce cold sweats or uncontrollable panic.

Use the Embedded Profile

This option will honor the existing color tag and you will be able to edit the image in its native space, as if your working space had been temporarily changed to match the profile of the image. This choice is the same as the Preserve Embedded Profiles menu option in the Color Management Policies.

Convert Document's Colors to the Working Space

This option is probably the more logical choice for most photographers. In terms of digital photography, the most likely scenario you will encounter is opening a digital capture where the camera has tagged it with an sRGB profile. Since it's far better to edit an image in the Adobe RGB space than in sRGB, converting to

the working space makes a lot of sense. The conversion will preserve the image's appearance, so while actual color values in the image may change, it should look exactly the same as if you had opened it by choosing to preserve the embedded profile. This choice is the same as the Convert to Working RGB option in the Color Management Policies.

Discard the Embedded Profile (Don't Color Manage)

The final choice simply should not be used. This is the same as the Off option in the Color Management Policies. The profile is removed from the image and the colors in the file are interpreted according to the working space, which is essentially just Photoshop shrugging and saying, "I dunno, let's try this." The only reason we can think of to ever use this is if you know for certain that the embedded profile is wrong and you want to remove it so you can assign a new one.

Missing Profile

If you open an image that has no embedded profile, Photoshop has no reference to go on, and so it asks you how you want it to interpret the color numbers in the file. If you are only opening files from your digital camera, then you can usually figure out the right choice with a little testing. Consumer-level digital cameras create files that look good when opened as sRGB, while film scans can be opened into Adobe RGB files, as seen in Figure 2-15, or in ProPhoto RGB.

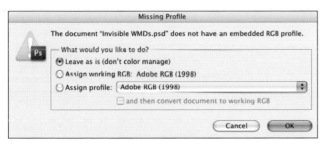

Figure 2-15. Files without profiles thankfully are becoming very rare.

Here are the three choices:

Leave As Is (Don't Color Manage)

This option is similar to Off in the Profile Mismatch warning dialog, with the exception that, since there is no profile to start with, nothing gets stripped from the image. Photoshop leaves the image alone and opens it up, interpreting the colors according to how the working space thinks they should be displayed, whether that is correct or not. We use this option quite a lot in conjunction with Photoshop's Assign Profile dialog (Edit→Assign Profile in CS3; Image→Mode→Assign Profile in earlier versions of Photoshop), when we want to explore how an untagged image can look when interpreted through a different profile.

Assign Working RGB

This essentially does the same thing as the previous choice, with the only difference being that it formally assigns the profile of the current working space onto the image. Since no color numbers have changed and the image is being displayed based on the specification of the working space, the appearance of the image will be identical to how it would look if you had chosen Leave As Is. The only difference is the addition of the working space profile. This choice is appropriate only if you know that the file matches your working space.

Assign Profile

The final option lets you choose a specific profile if you know what it is; this option allows you to then convert to the working space after the profile has been assigned. This is a good choice if you know, for example, that sRGB works well for your camera's images but they still open up as untagged. You can choose sRGB from the pop-up menu and then click the convert to working RGB checkbox. The momentary presence of the sRGB profile gives Photoshop enough information to make a correct conversion to the working space. The only thing missing for this choice is a preview so you can see how a different profile is affecting the image. But, since the image isn't even open yet, there's no way to see a preview. (Photoshop can do a lot, but even that is beyond its capabilities!)

Conversion Options and Advanced Controls

These settings (Figure 2-16) will be visible only if you have clicked the More Options button (or the Advanced checkbox in versions prior to CS2). There's a reason why these are tucked away and not immediately visible in the dialog—most people don't need to worry about them. In terms of general settings, the defaults are fine. They control the "engine" that is used to make the conversion from one color space or mode into another, as well as the rendering intent (how the conversion is made) and a couple of other items. The engine should be set to ACE and the rendering intent to Relative Colorimetric, and Black Point compensation and Use Dither for 8-bit images should be on. There are other places in Photoshop where you can initiate a profile conversion or explore how a different conversion method will affect your image. The rendering intent and Black Point compensation settings, which are the two you would be most likely to change, can be changed in those places including when soft proofing and when using Edit→Convert to Profile. This topic will be covered in more detail in the online section "The Print" (*www.creativedigitaldarkroom.com*).

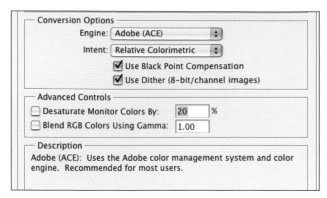

Figure 2-16. The behind-the-scenes settings influence how profile conversions are performed.

The Advanced Controls for desaturating the monitor colors by a certain percentage and choosing a different gamma for blending RGB colors are, as the name states, advanced options that should be left off unless you have specific reasons to use them and you know what you are doing. In the several years that these settings have been available in this dialog, we have never once had to use them.

Saving Your Color Settings

After you've gone to all the trouble of customizing the color settings, you can save them so they appear in the settings pop-up menu as a choice you can easily select later on (Figure 2-17). This feature is useful if you need to change color settings to work on different projects. We created special settings for preparing the images in this book, for instance, and we also have a special configuration for working with raw photos in ProPhoto RGB. To do this, click the Save button in the Color Settings dialog, and give your settings a descriptive name, such as "Adobe RGB-General Use" or "ProPhoto for Raw." In the Color Settings Comment dialog box, you can enter some text to give further information about the settings that will show up in the Description area at the bottom of the dialog as you roll your mouse over a settings option. When you've finished configuring and saving the color settings, you're ready to go to work in Photoshop.

Figure 2-17. Saving the color settings with a descriptive name is especially helpful if you work with a variety of color spaces.

File Navigation and Inspection

Before you can fix a problem, you have to see it and identify it, and in Photoshop, navigating and moving through a file quickly and accurately is an essential skill. The most important file navigation skills are zooming in to see details, inspecting channels, and comparing multiple files – all of which enable you to identify the best files and also to know which areas of an image require your digital darkroom attention.

Screen Modes and Viewing

Photoshop can position a file or files on the monitor in four ways. Standard Screen Mode is (sadly) the only viewing mode that shows multiple files, as seen in Figure 2-18. Maximized Screen Mode centers the image on a gray background with the Menu Bar visible. Full Screen Mode with Menu Bar isolates the active image on a neutral gray background , shows the Photoshop menu bar, and allows you to grab the image with the Hand tool and position it slightly to the left away from the palettes, as seen in Figure 2-19. Rather than accessing the Hand tool from the toolbar, press the space bar to change any tool (except the Type tool) into the Hand tool.

Full Screen Mode isolates the active file on a black field without the menu bar and is most useful when studying or presenting single images. To access the screen modes, either click the small buttons below the Quick Mask button on the toolbar or, for greater efficiency, cycle through the screen modes by pressing the F key. In Photoshop Lightroom, tapping the F key serves a similar function to hide the menu bar. Tap the tab key to hide the active panel and shift tab to hide all panels.

Figure 2-18. Comparing multiple images in Standard Screen Mode.
© KE

Figure 2-19. When working in Full Screen Mode, positioning the image to the left makes better use of the monitor space. © KE

Zooming in on and Panning through a Single Image

The most critical zoom ratios to view files at are:

- Actual Size, which displays one pixel of the file per one monitor pixel and is essential when inspecting a file for noise and sharpness.

- Fit on Screen, which allows you to see the entire image.

- 50%, which is best used when evaluating sharpening and focusing effects for offset printing.

- 25% for evaluating sharpening and focusing effects for files destined for inkjet printing (as explored in Chapters 9 and 10).

You can choose from numerous methods to zoom a file up or down, and learning the efficient keyboard commands to zoom and fit a file will make your digital darkroom work much more enjoyable; you are able to see and view the file as needed for a specific tasks.

To go to 100% view to see the true image information:

- Double-click the Zoom tool (magnifying glass) in the Toolbox.

- Cmd-Option-0/Ctrl-Alt-0. Note: That's a zero, not the letter O.

- Space-Control/ Space, right-click, and then choose Actual Pixels.

- Type 100 in the zoom percentage window in the lower-left corner of the file, and then press the Enter key. This works only when you are in Standard Screen Mode.

- Type 100 in the zoom percentage window in the lower-left corner of the Navigator window, and then press the Enter key.

To see the entire image on screen:

- Double-click the Hand tool in the Toolbox.

- Cmd/Ctrl-0. Note: Again, this is a zero, not the letter O.

- Space-Control/ Space, right-click, and then choose Fit on Screen.

To view the image at 50% or 25% view:

- Cmd-Option-0/Ctrl-Alt-0 followed by pressing Cmd/Ctrl and tapping the minus key twice for a 50% view, and tapping four times for a 25%.

- Type 50 or 25 in the zoom percentage window in the lower-left corner of the Navigator window, and then press the Enter key.

To zoom in or out on an image:

- Cmd/Ctrl-"+" to zoom in and Cmd/Ctrl-"-" to zoom out.
- Cmd /Ctrl-Space-click to quickly access zoom up and Opt/Alt-Space-click to zoom out by clicking.
- Use the slider in the Navigator window: left to zoom out; right to zoom in.

To pan through an image:

- In both Windows and Macintosh, holding down the space bar converts any tool (except the Type tool, if you are actively entering text) into the Hand tool, which enables you to pan through an image. This works only if the image is larger than your monitor can display.

To zoom in on a specific area:

- Cmd /Ctrl-Space and drag over the area you want to zoom into.
- Select the Zoom tool and drag over the area you want to zoom into.

Critical clean-up and image enhancement is done at a 100% or 200% view, which means that you are seeing only a small part of the entire file. Zooming in and out of a file enables you to see how the cleaned-up area is blending in with the entire image. Learning to use quick navigation skills will markedly speed up your digital darkroom work.

Zooming In on and Panning through Multiple Images

Working with multiple images in Standard Screen Mode allows you to tile, zoom, pan, and compare a sequence of images very easily. For example, being able to move to the identical area of multiple images is useful when comparing a series of portraits to identify the one with the sharpest eyes.

To navigate in and compare multiple open files:

1. Select Window→Arrange→Tile Horizontally (best used for horizontal, landscape-orientated images) or Tile Vertically (best used for vertical, portrait-orientated images).

2. Activate one file and zoom in with Cmd/Ctrl-Space-click to the area or detail you are interested in.

3. Select Window→Arrange→Match Zoom and Location, and all files will jump to the exact same location and zoom.

4. To pan through all images at once, press Shift-Space. The cursor will become the Hand tool, and you can synchronize scroll though all open documents.

5. To zoom in on all open images at once, press Cmd/ Ctrl-Shift-Space to zoom in, in sync with all images.

6. To zoom out on all open images at once, press Opt/ Alt-Shift-Space to zoom out in sync with all images.

Seeing Every Pixel

Removing dust is also called dustbusting; it's better to do the job once efficiently rather than skip over areas. To move through a file with utmost efficiency, use the keyboard commands to speed up your clean-up work. To see every detail, start by zooming to 100% view, and then use these shortcuts to move through the image one screen width or screen height at a time:

- Tap the Tab key to hide all palettes, and then tap the F key twice to enter Full Screen Mode.
- Tap the Home key to jump to the upper-left corner and inspect the file for dust. Use the Spot Healing brush to remove the dust one monitor-full of the file.
- Tap Page Down to move the view down one full screen. Continue cleaning up the file. Continue using the Page Down key to drop down one monitor-full at a time.
- Upon reaching the bottom of the file, tap Cmd /Ctrl-Page Down to move one screen width to the right.
- Tap Page Up to move up one full screen.
- Tap Cmd /Ctrl-Page Up to move one screen width to the left.

Inspecting the Channels

As addressed in Chapter 4, many weaknesses of an image such as noise or jpeg artifacts may lurk in the individual image channels. Learn to use the command keys to navigate through the channels. Cmd/Ctrl-1, 2, and then 3 will cycle through the red, green, and blue channels, and Cmd/Ctrl-~ (tilde) returns you to the composite image. This command is second nature to us, and we always inspect the channels of images coming off new digital cameras or scanners. Additionally, inspecting the channels enables you to identify which channels to take advantage of when creating a luminance mask or where the most appropriate grayscale versions of a file are as illustrated in Figure 2-20, in which the blue channel contains more of the desired grittiness for the old doll.

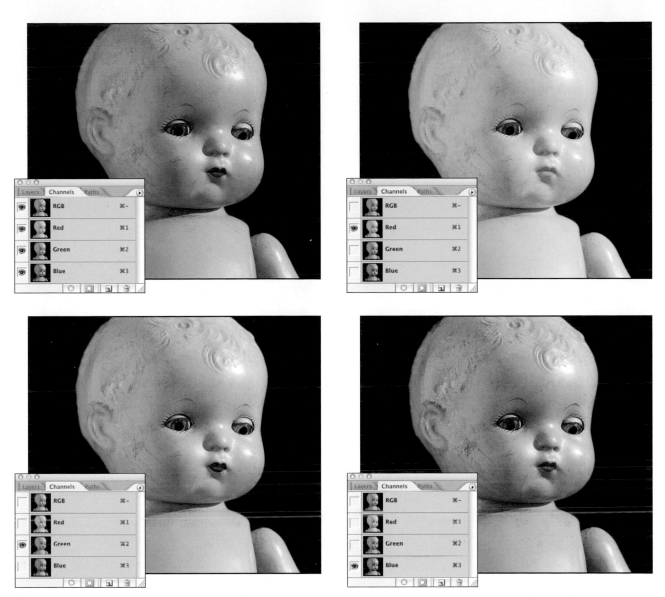

Figure 2-20. The composite view is only one way of looking at a file. Learn to inspect the channels to see the variety of image information each color image contains. © KE

Your Bags Are Packed

Setting up a new computer system, installing software, fine-tuning preferences and color settings, and learning file navigation are similar to preparing and planning for a long trip. The more you prepare and research the new locales before you leave home, the less likely you are to get lost or leave home without an essential inoculation. These preparations certainly aren't as fun as the trip, but they are the foundation of an exciting journey.

Scan, Develop, and Organize

Working with our photographs in the digital darkroom is one of our favorite things to do, but before we can summon the creative muse for inspiration to work on our images, a number of things have to happen first. While the act of photographing with a camera is the creative spark that initiates the journey of the image, some of the other steps that come early in the process, such as scanning, making selects, adding keywords, organizing files, and tending to the image archive are more procedural by nature, and therefore not as easy to get excited about. But these preliminary steps that are concerned with image acquisition, sorting, organization, file management, and initial raw processing, are just as important (and in some cases, more important) as the more "creative" ones that come later in the workflow. In this chapter we'll take a look at image processing in the first part of the digital darkroom workflow, the part that happens before you bring the image into Photoshop:

- Image Acquisition; the Path from Analog to Digital
- Starting with a Film Image, Starting with a Digital Capture
- File Organization and Archive Preparation
- Processing Raw Files with Adobe Camera Raw and Photoshop Lightroom

Understanding the nuances behind how an image is digitized, whether it is a film negative or a digital capture can help ensure that you record the best set of digital information possible. This, in turn will impact any further editing you do to the image. Start with a quality original and your editing in the digital darkroom will be of a higher quality as well. Taking the time to organize your files and properly archive them can make them easier to locate in the future, which will make working with your image archive a more pleasurable experience. And if you make a living from your images, or hope to, a well-organized image catalog is a more valuable asset to your business. The last of the pre-Photoshop workflow involves processing the raw file. The work you do here sets the stage for everything that comes after. We'll conclude this chapter with an exploration of working with raw files in Adobe Camera Raw and Adobe Photoshop Lightroom and sort out which adjustments are best made during the raw conversion and what is best done in Photoshop.

Chapter 3

From Analog to Digital

Whether you use the latest high-end digital camera or are concentrating on scanning and working with a collection of film images, in the big picture, the initial goal is the same: translating an analog image, either a real-world scene you're looking at with camera in hand or a piece of color or black-and-white film, into a digital format that you can work with on the computer.

Digital images, whether they're from a digital camera or a scanner, are all about information. In the translation from analog to digital, your goal is to capture as much tonal, color, and detail information about the scene as possible. Although the mediums respond in different ways, the goal of photographing a scene with film is not different from using a digital camera. The goal is essentially the same: to record the right set of information to enable you to produce a good print. For example, a film negative with a full range of tonal values is much easier to print in a traditional darkroom, or to work with in the computer if it is scanned, than a negative that is severely underexposed (Figure 3-1).

Figure 3-1. Two negatives of Berlin's Brandenburg Gate. The negative on the top is underexposed and lacking good tonal detail and will not print as well as the negative on the bottom. © SD

Similarly, a digital file with the optimal range of tonal information is much easier to work with in Photoshop or Adobe Camera Raw, as it will require minimal corrections or modifications. But a file with serious deficiencies in the captured tonal information, such as little detail in the darker shadows or blownout highlights, will be harder to work with and will never look as good as a well-exposed digital capture (Figure 3-2).

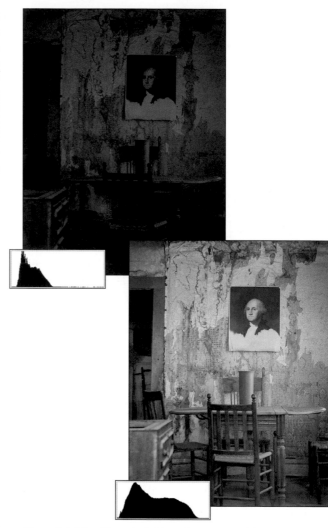

Figure 3-2. The file on the left is underexposed and does not have good shadow detail. Even though such images can be lightened, it is much better to start with a well-exposed original, such as the image on the right. ©SD

With a digital camera, the act of creating a good digital original relies heavily on your exposure skills and post-processing acumen. If you are starting with film, your skills as a photographer have already created the initial image and you'll need to create the best scan possible from that film original. In this section, we'll take a look at both methods for acquiring images.

Starting with Film

Scanning and printing digital files is a little like taking a road trip. Making a scan that captures the right amount of image information with good tonal and color values is like planning out your route for the intended journey. Knowing what your destination is will help you make the best scan and capture just the right amount of information you need to make a great print and this chapter is where the journey begins.

The quality of the original film sharpness and exposure, of course, impacts the quality of the scan you will be able to make, and the quality of the scan has a lot to do with how good the image will look at the end of the process, when you make a print. The computer lingo for this concept is "garbage in, garbage out." Although you can do a lot in Photoshop to greatly improve less than ideal originals, it is much better to make the initial exposure in the camera (and the subsequent scan) as good as possible. The care, planning, and quality of the scan that you begin with will affect the entire imaging and printing process.

Before the Scan

One of the most common questions we hear is, "How big should I make my scans?" The honest answer is, "It depends..." at which point, we imagine that the questioner is no doubt silently wishing that we would just have a simple answer such as "Scan everything at 300 ppi (pixels per inch)." Creating a quality image, however, is rarely well serviced with simplistic, one-size-fits-all answers. Several variables can influence the decisions you make in the scanning process, but the most basic thing to keep in mind is that the size of the scan will be dictated by how large a print you want to make and by the output requirements of the printer and the paper you're using. The variables to consider before making a scan include:

The Original Image

Starting with the best original possible is the first step to insure the best quality output. In a nutshell, "Get the picture right in the camera and don't rely on Photoshop to fix flaws that could be avoided by taking the picture properly in the first place."

Printer Technology

Inkjet, offset, and direct digital printers handle the translation of digital information onto paper differently. Knowing which technology you are outputting to (the "destination") will determine how much information you need to scan.

Print Size

Larger prints require more image information, but more important, larger prints require overall higher quality originals and more considered image processing. Starting with a slightly out-of-focus original or processing the file so aggressively that the highlights are blown out or the shadows are blocked up to pure black only becomes more apparent when the print gets larger. Bigger isn't always better—the bigger the print, the bigger the flaws will be. If you have ever had a 35mm negative enlarged into a large print, then you have seen this concept before; the film grain from a 35mm negative is much more noticeable (and in some cases, objectionable) in a really large print.

Quality Requirements

Depending on whom the file is for or where the print will be displayed, the subjective quality requirements will vary. For example, making a poster for someone's birthday party will not require the same quality as a print destined for gallery display.

Your Expectations

It all comes down to what looks good to your eye, which is an aesthetic appreciation developed by working with a lot of images and looking at many prints by different artists. The next time you visit a gallery, a museum, or a photographic tradeshow, take the time to look at the prints both to see the subject and to study the actual print. Look for details in the highlights, study the subtle gradations, explore the shadows, feel the toning and relish the color palette.

Types of Printers

The large variety of printers, papers, inks, and technology that are available today offer a wonderful palette of possibilities. In the following section, we'll discuss the most common types of digital output—inkjet, continuous tone, and offset—and show you how to use Photoshop to calculate the optimal file size and pixel dimensions for each type of output. For more detailed information on making the best print, see the online section "The Print" (*www. creativedigitladarkroom.com*).

Inkjet printers

Inkjet printers spray micro-fine droplets of colored ink onto the paper. Desktop inkjet printers designed for photographic printing are available from Epson, Hewlett-Packard, and Canon and are priced well under $1,000. More importantly, they produce astonishingly good results on a wide variety of papers. The type of paper you use affects the look and feel of an image and the chosen paper should support the aesthetic of the image.

For the best photographic prints, make sure that the inkjet printer is a seven- or eight-color printer designed for photo reproduction. In addition to the standard C, M, Y, K inks, these printers use light cyan, light magenta, and multiple shades of gray inks to insure true photographic-quality prints.

Printer resolution versus image resolution. Most inkjet printers print at output resolutions of 1440 to 2880 dpi (dots per inch), which yields true photographic print quality. Thankfully, your digital files do not need to be at such high resolutions. The important thing to keep in mind is that the output resolution (what the printer uses) is different from the image or file resolution (the pixels per inch setting that is set in the scanner software or in Photoshop). The image/file resolution needs to be only one-sixth to one-third of the printer's output resolution to achieve excellent results. Table 3-1 shows the recommended inkjet resolutions we use to create optimal prints without creating such large files that they are impossible to reasonably work with. As a general rule of thumb, we use 240 ppi when we print on matte paper and 360 ppi for luster or glossy paper. If push comes to shove and you just have to squeak out a bigger print than the rules say is possible, go for it. With appropriate resizing and sharpening (addressed in the online section, "The Print") you can make very successful prints with 180 ppi files.

Table 3-1. Recommended Inkjet Resolutions

Output	Resolution/ppi
Inkjet (Matte paper)	240, 360
Inkjet (Luster paper)	240, 360
Inkjet (Glossy paper)	240, 360, 480

To calculate the optimal scan size for inkjet prints, you can use this formula:

Print dimensions × 1/6 to 1/3 printer resolution = scan requirements.

For example, if we needed to find the scan requirements in pixel dimensions for an image that we wanted to print as a 13 × 19-inch print on matte paper, we would multiply 13 by 240 (one-sixth of 1440 dpi), which equals 3,120. Then multiply 19 by 240, which equals 4,560. So, the pixels requirements for such a scan would be 3120 × 4560.

If formulas and calculations seem too much of a bother, simply use Photoshop's New File dialog as a calculator, as shown in the sidebar, "Calculating Optimal Scan Size in Photoshop."

If you will be sending images out to a service provider for reproduction, you should always contact the provider before making your scans and see what the printer resolution is for the devices they use and what their recommendations are for the files you will be submitting. If the project is an important one, you may even consider making an initial scan and having a test print made at scale to ensure that your scanning formula is adequate for the reproduction requirements of the printers you will be using.

Continuous tone

Continuous tone devices (also referred to as contone devices) include thermal, direct digital, film recorders, and laser-based photo printers that all lay down pixel information without any perceivable dot pattern or screen rulings. The desktop thermal dye-sublimation printers and the thermal

Calculating Optimal Scan Size in Photoshop

Once you know what the likely output size will be and what the resolution requirements for that output are, you can use Photoshop's New File dialog box as a calculator to quickly and easily figure out how large of a scan (in pixel dimension or megabytes) you need. Choose File→New in Photoshop. In the New File dialog box (Figure 3-3), change the units to inches, enter the largest size print you intend to make from the scan and then enter the image resolution that is appropriate for the type of printer and the paper that will be used. Set the Color Mode to Grayscale or RGB Color, depending on what the image requires. On the right side of the dialog under Image Size, you will see how many megabytes of information you need. If you are scanning at a high bit-depth (recommended) then this number will be twice the size of an 8-bit file. If you change the units back to pixels, you will see the required pixel dimension.

Figure 3-3. Using Photoshop's New File dialog box as a calculator to determine the required file size for a scan. The example above shows the file size for an 8-bit image. If the scan was 16-bit, the circled image size would double.

development and dye transfer Fuji Pictrography printers are being usurped by the success and price point of desktop inkjet printers. For large format photographic prints, you should work with professional digital labs or online service providers that have the Kodak Professional Durst Lambda or the Cymbolic Sciences LightJet printers to make large display prints for museums, advertising, and trade show displays.

The third type of contone output involves imaging a file onto photographic film with a film recorder (Figure 3-4). Writing the file onto a photographic negative or a positive piece of film (that is, making a new negative) enables you to make standard photo prints while imaging to color slides lets you present your images using a slide projector. Granted, writing a digital file back to film is becoming less and less common as the quality of digital-to-print output is already excellent and keeps improving every year, but some photographers still prefer to make traditional wet darkroom prints if they already have the setup and many years of expertise in the darkroom.

Compared to inkjet prints, continuous tone output devices write at a much lower ppi resolution between 200 and 400 ppi. Calculating the resolution required for a contone device is refreshingly straightforward. For the best results, scan in one pixel for every pixel you are going to print. For example, if you were going to make an 8 × 10-inch thermal print to print at 200 ppi, you would use the following equation:

Print dimensions × printer resolution = scan requirements

So the result would be:

8 × 200 = 1600 pixels

Since the thermal head is built along the short end of the print, you can safely calculate the print resolution on the shorter end of the print rather than on the long end.

Thermal and direct digital printers are very forgiving and you can often "get away" with lower resolution scans and still achieve good results. Before you dedicate yourself to a project, test the technology by making a scan and having the print done. Katrin has printed 48-inch by 48-inch display

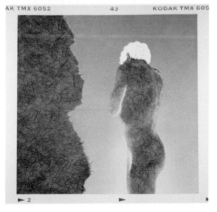
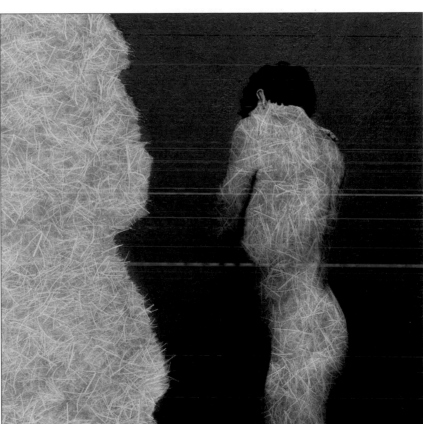

Figure 3-4. The original medium format negative (top left). A handmade paper texture was scanned on a flatbed scanner and added in Photoshop. The final file was output to a film recorder to create a new medium format negative (lower left), which was printed and toned in a traditional, chemical-based darkroom (right). ©SD

prints on the Kodak Durst Lambda with only 85 ppi files that measured 4080 by 4080 pixels and totaled only 48 MB. The Durst Lambda can output either 200 or 400 ppi files and the files she was working with represented only about one-third of the required resolution. But because the images were soft portraits without fine type, she got great results. If she had been working according to ideal specifications she would have worked on either 264 MB files for the 200 ppi prints or 1054 MB files to print at 400 ppi. By talking with the lab that was going to output the files and making a test print before continuing with the project, she was able to avoid the burden of huge file sizes.

Offset printing

Images destined for offset printing, such as magazine and books, are separated into four-color plates by half-toning the file. The pixels of the files are converted into spots on lithographic film, which are later used to form the dots of ink on the paper (Figure 3-5). This book and every magazine you read is a product of offset printing.

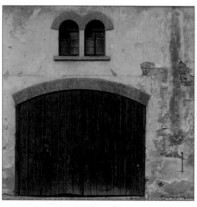

Figure 3-5. Images are reproduced in offset printing by overlapping dots of cyan, magenta, yellow, and black inks. The dot pattern can be seen in the magnified view at right. © SD

Answer the following four questions to determine the scanning resolution for offset printing.

1. *What line screen will be used to print the halftone?* If you're not sure what line screen the press uses, ask your printer. The most common line screens and their uses are:

 - 85 ls Newspaper
 - 120 ls Newsprint magazines
 - 133 ls Glossy weekly magazines
 - 150 ls Glossy monthly magazines and books with color images
 - 175 ls Display books
 - 200 ls Fine-art museum books

2. *What quality factor do you want for your images?* The quality factor takes into account the difference between how a pixel describes tone and how a halftone dot describes a tone in the image. You can ask your printer or use 1.25 (lowest) to 1.5 (safe) to 2.0 (recommended). There is no reason to go above a quality factor of 2.0 and in some cases 1.5 may be just fine.

3. *What is the size multiplication factor?* Are you printing the original at exactly the same size or are you enlarging or reducing it? To calculate the multiplication factor, divide the length of the final image by the length of the original. For example, if you start with a 3 × 4-inch original and need to make an 8 × 10-inch print, the multiplication factor is 2.5 (10÷4=2.5)

4. *What is your actual scanning resolution?* Your scanning resolution is the answer to all of the above questions as described in the formula below.

LS (Line Screen) × QF (Quality Factor) × MF (Magnification Factor) = Scanning Resolution (× print length)=Final scan resolution

For example, an original 4 by 5-inch image is going to appear in a magazine using glossy paper stock printed at 150-line screen as an 8 × 10-inch print (a size multiplication factor of 2). Since the image is very important and you want it to look its best, use a quality factor of 2.

$150 \times 2.0 = 300 \times 2 = 600$ pixels per inch scanning resolution

The final file will be 2400 by 3000 pixels and will be 20.6 MB in file size. When in doubt, use the Photoshop File→New to calculate the file size as described earlier in this chapter.

What About the Web?

Rather than scanning and working on the low-resolution files required for efficient Web display, we create and work on all our files in print resolution, usually at sizes that can accommodate a large print. After finalizing the master layered file, we make a flattened copy and use Image→Image Size with Bicubic Sharper interpolation to downsize the image file in 50% increments until the file is at the desired display size.

Resolution summary. Scanning at a slightly higher resolution is always better than scanning in too little information. A higher resolution file will give you more image information to work with and make the retouching process easier to see and do. Once you're done retouching, sizing the file down tends to smooth out retouching artifacts.

- *Inkjet:* Scan at one-sixth to one-third of the printer resolution (dpi).

- *Continuous Tone:* One pixel in the file for every pixel on the output.

- *Offset:* 1.25 to 2.0 times the line screen of the halftone screen.

Scan Resolution and File Size for Film Scans

Rather than stress about calculating the precise resolution for scanning a small piece of film, first figure out the target size of the final output. To give yourself the greatest flexibility, use a size that is large enough to create the biggest print you can realistically make from the image. Use the Photoshop New File dialog box to calculate the file size requirements for the print you want to make. Then, simply enter a high resolution to arrive at an equivalent file size in your scanner software (Figure 3-6). Or, if your scanner does not scan that large, as is the case with some 35mm film scanners, simply make the largest scan you can.

Figure 3-6. The scan software for a Nikon Coolscan 4000, showing the settings for scanning a 35mm slide at 4000 ppi to yield the correct file size in megabytes.

For example, when Seán scans 35mm slides and negatives using a Nikon Coolscan 4000, he scans at actual size at 4000 ppi, which is his scanner's highest resolution. The document or print size is the same as an actual 35mm slide or negative, but the file size in megabytes and the pixel information in the file contain all the information needed to make a good print (Figure 3-7). The master file is kept at the original scan resolution of 4000ppi and only when a flattened duplicate copy is made and then resized to make a specific size print is the resolution changed to what is appropriate for the print requirements.

Figure 3-7. The Image Size dialog box on the top shows the size and resolution of the original scan from a 35mm slide. The dialog on the bottom shows that when Resample Image is unchecked (meaning the same pixel dimensions are used) at a standard matte paper inkjet resolution of 240ppi, there is enough information to make a 22 × 15 inch print.

> When creating the scan, turn off all sharpening and auto corrections in the scanner software. If the original film is dirty, damaged, or grainy, gently clean or dust off the film before scanning and/or use the Digital ICE feature if your scanner supports it.

Scan Once for Different Purposes

Spending a lot of time or effort on a file that is only big enough for a 5 × 7-inch print when you really want a 13 × 19-inch or larger print is an exercise in frustration. Our safety rule of thumb is to work on a file that is at least one size larger than the planned-for print. In other words, if you plan on the final being an 8 × 10-inch print, it is safer to work

with a file that has enough image information resolution and pixel information for an 11 × 14-inch or 13 × 19-inch print. It has been our experience that if the image sparkles as an 8 × 10-inch print, you'll want a bigger print. Another way to approach this is to create the scan to accommodate the largest size print you can envision making from the neg. That scan can then serve as the starting point for a master image file that can be used for many different purposes (Figure 3-8).

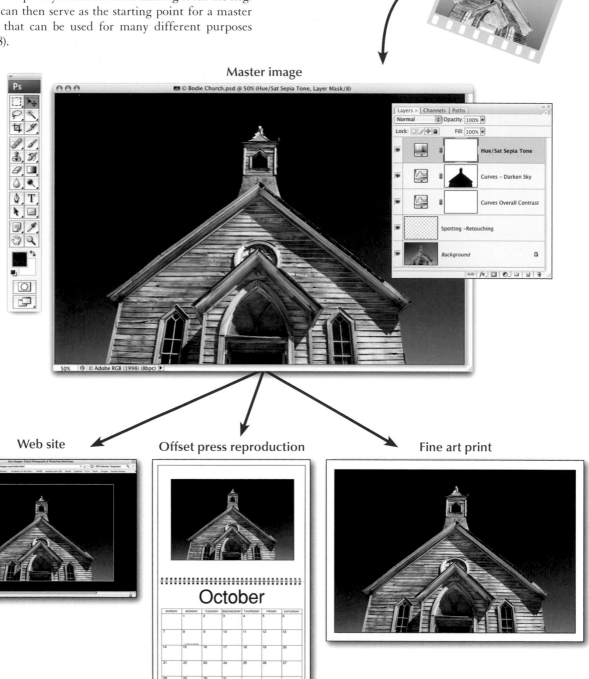

Figure 3-8. Scan once at a size large enough to accommodate the largest size print you plan to make. Then that master image can be repurposed for many different projects. ©SD

Working with reasonably larger sizes gives you the leeway to make larger prints. When working with an art director or designer, working on files that are up to 25% larger than requested allows for some cropping or enlarging in the page layout phase. Using a larger file to make smaller files will always look better than taking a small file and sizing it up to make a big print. Of course this doesn't mean that every file you work with should be big enough for a billboard, but you should consider making the master file larger than you think you'll need, as you'll never regret the extra information.

Starting with a Digital Camera

The megapixel resolution is the main feature bantered about when a camera's technical specifications are mentioned. This number refers to how many millions of pixels can be recorded by the image sensor, and there is a direct correlation between the sensor's resolution and the size of the file it produces. But resolution and the quantity of pixels are only two aspects of digital capture that affect image quality. Additional variables that impact image quality includes lens quality, ISO, camera file format, lighting, shutter speed, whether a tripod was used to steady the camera, and atmospheric conditions. Knowing the others and how to control them is an important first step in ensuring that you are starting out with the best image possible.

Digital Camera Resolution

Determining a digital camera's resolution is a simpler undertaking than calculating scanning resolution and file size because there is a specific limit to how many pixels your camera can capture. The image sensor is a specific size measured in X and Y coordinates, from the tiny sensors in your camera phone to the multi-megabyte resolution of the professional medium and large format scanning cameras. But just as film resolution is influenced by photographic variability so is digital camera performance. In fact, you could use a pinhole body cap on a high-end digital SLR and produce a file with less image information than the simplest disposable camera would deliver.

We respectfully partake in a moratorium on the debate that compares film to digital solely on the grounds of resolution. There is more to a photograph than resolving line pairs or rendering test targets or bragging about file size. Photography is an art form and a means of creative expression and we should use and explore all available tools and techniques to express our aesthetic. One of our mottos has always been to learn the rules, learn them well, and then break them ruthlessly as Figure 3-9 illustrates. Seán photographed a scene and then re-photographed the image with a variety of technologies to create a soft, low detail image that is quietly melodic.

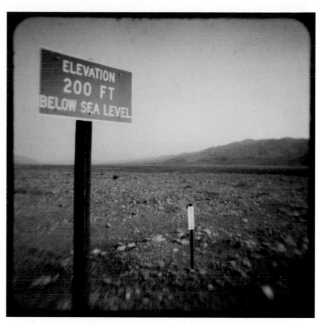

Figure 3-9. This image was originally shot with a 12-megapixel digital SLR. The file from that camera was then displayed on a laptop screen and rephotographed with the same digital camera through the domed glass viewfinder of a Kodak Duaflex twin lens reflex camera dating from the 1950s. ©SD

How many pixels do you need?

The most useful strategy we can recommend is to always shoot at your camera's maximum image size since that gives you the most flexibility in terms of what you can do with the image. This is especially true if you are interested in making large prints, or if you need to crop and show only a portion of the frame. The more pixels you can capture, the more options you will have. We advocate shooting in raw for most images, and raw files are always captured at maximum size. But even if circumstances dictate that you shoot in JPEG (i.e., fast-moving sports, party pictures or quick snapshots), you should always choose the largest resolution and highest quality setting (least amount of compression) available. You probably parted with a lot of money to buy your digital SLR, so it makes no sense to use only a portion of the capabilities you paid for by shooting at a smaller image size.

Use all of the viewfinder

Since the number of pixels you can record is directly related to how large a print you can make and still expect good quality in terms of detail resolution, it makes the most sense to compose and frame your images using all of the area in the viewfinder. Any time you shoot wide and crop later, you are essentially lowering the camera's resolution (Figure 3-10). Whenever the situation allows, fill the viewfinder with the composition you want to achieve, to take advantage of all the pixels your camera has to offer.

Figure 3-10. Rather than rely on cropping in the computer, capture as many pixels as possible by using as much of the viewfinder as possible for your compositions. For the close-up view of the door, Seán took a second photo and filled the viewfinder with the window and the bell, rather than rely on cropping the wider view. ©SD

File Formats

Three primary file formats are available to users of digital SLRs and even some compact cameras: JPEG, TIFF, and raw. The main difference between these formats is that both JPEG and TIFF are "finished" images, where the camera has processed the file before writing the file to the memory card. With JPEG, there is also additional file compression that discards color data to reduce the file size written onto the camera card. A raw file is not a finished image; it is the recipe to make an image and you have a tremendous amount of control over how to interpret the recipe when you convert the image using Adobe Camera Raw, Photoshop Lightroom, or other raw conversion software. It is this ability to interpret the image with such a high degree of control that makes raw our preferred file format.

Depending on the type of photography you do, there may be situations where the lighting is controlled and never changes, such as high-volume catalog photography, in which JPEG makes more sense, or in which shooting in raw would be overkill for the demands of the job and what the client requires. But if you want to be sure that you are capturing the best set of image data possible, then using raw is the best approach.

It's not that you cannot get good images when shooting JPEG, but your exposures need to be much more exact since JPEG does not have the tonal flexibility of a raw file. For those with experience shooting film, JPEG is like slide film, while raw is more akin to color negative film. With slide film, you have to be more exacting about your exposures while negative film offers greater exposure latitude and much more flexibility for interpreting the negative and making a print. And, like a color film negative, a raw file can be reinterpreted many different ways.

Finally, only by shooting in raw can you gain access to the high-bit data that your camera's image sensor can capture. At the time of this writing, most high-end digital SLRs that shoot raw can capture a 12-bit file, whereas the JPEG format can support only 8 bits of data.

The value of high-bit files

The highest possible number of discrete tonal levels that a standard 8-bit file can contain is 256 per color channel. Adjusting the tonal range of a digital image involves some loss of data as you move the existing information around the tonal scale to get the image looking the way you want. For images that require critical, high-quality tonal and color correction, 256 tonal levels per channel do not offer you a lot of editing room to enhance tone and color without degrading the tonal information. This is especially true on images that have less than optimal exposure and require what Seán refers to as "heroic" color correction (see the sidebar "The Vegas Syndrome: Why Bit Depth Matters"). Working with high-bit data—files that contain more than 256 shades of gray per channel (see table 3.2)—gives you more tonal values to change the tonal and color character of an image. Maintaining your files in a high-bit state as long as possible ensures visually higher quality prints, especially in the delicate highlight transitions and subtle shadow areas.

Table 3-2.

Bit-Depth per Channel	Tonal Levels
8-bit	256
10-bit	1,024
12-bit	4,096
14-bit	16,384
16-bit	65,536

The Vegas Syndrome: Why Bit Depth Matters

An 8-bit file can contain no more than 256 separate tonal levels per color channel. A 12-bit raw file can contain up to 4,096 tonal levels. This is significant because all pixel-based, digital tonal adjustments in Photoshop involve loss of tonal information as you shift the values around to correct the exposure.

Think of it this way: Let's say you're playing blackjack in Las Vegas and you have $256 to gamble with. After a while, you have lost $100. That represents a large chunk of your entire gambling budget. If you come to the table with $4,096 in gambling fun money, however, then the loss of $100 is not such a big deal. You still have plenty of dollars (tonal values) left to play with (Figure 3-11).

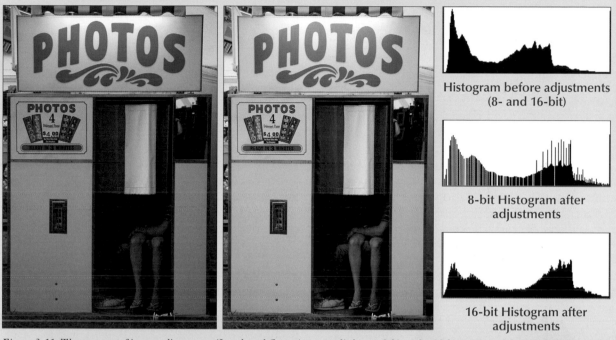

Histogram before adjustments (8- and 16-bit)

8-bit Histogram after adjustments

16-bit Histogram after adjustments

Figure 3-11. The same set of image adjustments (Levels and Curves) was applied to an 8-bit and a 16-bit version of this image (original on the left; adjusted version on the right). The top histogram is how the tonal range looked before the adjustments. The middle one is the 8-bit file after the adjustments and the bottom one is the 16-bit file after the adjustments. The gaps in the 8-bit histogram indicate a loss of tonal data, which could show up as posterization in the shadow areas. © SD

A digital camera that shoots in raw can capture high-bit data (12-bits), and we recommend you take advantage of the additional tonal information that high-bit data provides. Most good scanners also enable you to access high-bit data. As the old saying goes, it's better to have it and not need it, than to need it and not have it. At the very least, try to perform all tonal and color corrections and dust-busting on the high-bit file before converting a copy (save the master 16-bit version with adjustment layers intact) to 8-bit for further editing. With a raw file, as many global corrections as possible should take place in the raw conversion process. From a tonal quality perspective, the best workflow would be to keep the file in high-bit for the entire digital darkroom process.

Working in high-bit does require larger hard drives and a healthy amount of RAM, however, because 16-bit files are twice the size of 8-bit files and the addition of a lot of layers can cause the file size to expand rapidly. Additionally, not all the filters work on high-bit files, though the most important ones for photographic work are supported. With our own images, we try to work with the high-bit information as long as the file size and processing time is manageable. If we reach a point where we no longer need to have a high-bit file (such as when all tonal correction is finished and we're ready to start compositing data from multiple images), then we choose Image→Duplicate and check Duplicate Merged Layers Only to flatten the duplicate file. We then convert to 8-bit with Image→Mode→8-bit and make sure to save this new file with a new name.

Exposure and Histograms

Resolution and file formats are technical settings that you choose in the camera. Capturing a good exposure and correctly understanding what the camera's histogram is telling you is more closely aligned with your skill as a photographer. And just because Photoshop exists to help you finesse your images to perfection, we strongly believe that it's best to try to get it right in the camera first and not rely on "fixing it" in Photoshop. The less you have to do to an image in Photoshop, the better. Your work in the digital darkroom will go faster and smoother, leaving you more time to be out creating photographs with your camera, which is much better than sitting in front of your computer! This is not a book about digital photography, but since this section of the chapter is about image quality at the beginning of the process, it's worth a little page space to review a few important concepts.

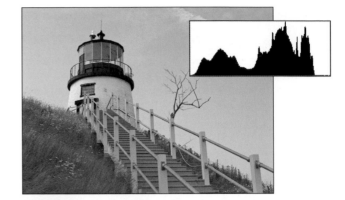

The histogram

The histogram display on a digital camera is a powerful tool for analyzing exposure immediately after you have taken a photo, enabling you to make changes to either aperture or shutter speed that will result in a better exposure. It is just a simple bar graph that shows how the tonal values are distributed across the tonal range (Figure 3-12). On the far left is a total black with no detail (level 0) and on the far right is a total white with no detail (level 255). The height of the bars indicates the number of pixels present in that part of the tonal range.

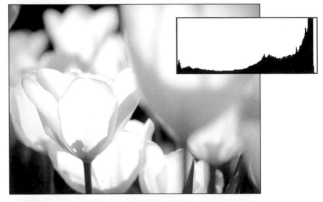

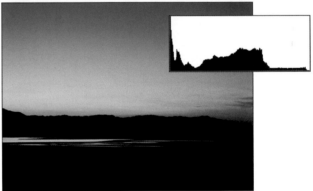

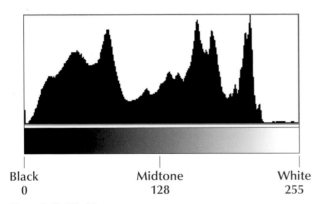

Black Midtone White
0 128 255

Figure 3-12. The histogram.

The histogram is the tonal signature or fingerprint for an image. There is no universal perfect histogram shape that you should strive for, since each image is different and contains its own specific arrangement of shadow, midtone ,and highlight values (Figure 3-13). In a very dark image, such as one taken at night, the histogram would naturally have much of the data grouped on the far left side, just as a bright, high-key image would show more of the tonal information on the right side.

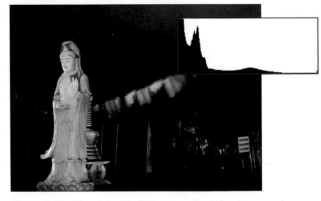

Figure 3-13. There is no ideal histogram shape that is appropriate for all images. Each histogram reflects the tonal signature of the photograph.

In working with the histogram to review and analyze exposure, there are three main areas to be concerned with: preventing highlight or shadow clipping; ensuring that you have a good exposure that captures a wide range of tones, especially on the right side; and if you are shooting in raw, for some types of photography there are additional exposure considerations for capturing the best possible set of tonal information.

Clipping control. In terms of exposure, the important thing is to make sure that there is no clipping (tonal values that have been recorded as either a total black or a total white) in areas of the image that contain significant detail. If clipping does appear in an image, it shows up in the histogram by the vertical bars running right up against the left or right sides, and ending abruptly, almost as if they had been cut off (Figure 3-14). Clipping is usually more of a problem in the highlight areas simply because they are lighter tones and are immediately visible in a print. However, if vital detail is present in the dark shadows that you want to preserve, you need to keep an eye on the left side of the histogram as well. If you see clipping when you review the histogram on the camera, adjust the exposure to give the shot either less or more exposure as the situation demands. This can be accomplished in several ways, including using exposure compensation if you are shooting in a semi-automatic mode, manually adjusting aperture or shutter speed, or even metering and exposing the scene in a different way.

Controlling clipping, especially in the highlights, can often be a challenge in high-contrast scenes. The current collection of digital SLRs has a dynamic range that is closer to slide film than negative film. If you have ever shot slide film, you know that brightly lit, high-contrast scenes can be difficult to expose, and often a compromise must be made where the exposure is biased towards controlling the highlights while sacrificing some of the shadow details. This is another reason to shoot in raw, as you have many more options during the conversion process for creating an image where the highlights are not blown out but you still have good detail in the dark shadows. Even though both Camera Raw and Photoshop Lightroom do have the ability to recover some detail in blown-out highlights, there are limits. Get your exposures correct in the camera and you'll have better results.

Capturing good tonal detail. By following good exposure practice in the camera, you minimize the chance that your images will have problems that need further corrections. This is especially relevant in terms of images that are too dark. It is much easier to darken a photo that seems too light than it is to lighten an underexposed, dark image. Brightening up the dark areas of an underexposed scene can introduce excessive gapping into the histogram, which can manifest itself in the image as posterization or banding, where you don't have a smooth transition between tonal levels. And when an underexposed image is lightened, there is also a very good chance that you will reveal noise in the shadows. While Photoshop and other software have noise reduction solutions that may be able to minimize the problem, the results are never as good as you get with an image that had no noise to begin with. The best strategy is to avoid as much noise as possible in the first place and one way to do this is to shoot properly exposed images. This may not be possible in all shooting situations, of course, especially those where you find yourself in "available darkness," but it's a worthy ideal to aim for. Please see Chapter 4 for numerous techniques in avoiding, hiding, and reducing noise.

Exposure considerations for raw files. Digital sensors record data in a linear fashion. This means that the brightest "stop" of exposure, which is represented by the data on the far right side of the histogram, contains fully half of the available tonal levels. In a typical camera with a dynamic

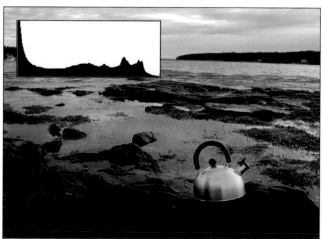 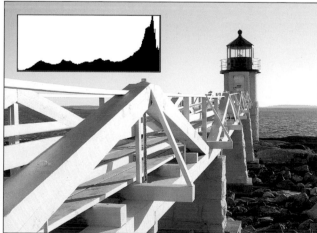

Figure 3-14. In the image on the left, shadow detail in the darkest areas of the rocks is clipped. In the image on the right, the highlights in the railing and parts of the sky are clipped. © SD

range of approximately six stops, this translates to 2,048 values, half of 4,096. In basic aperture theory, each time you stop down the lens to the next smallest aperture, you let in half as much light. This applies to how a sensor records data, too. Since each stop of exposure below the brightest represents half as much tonal information, the next stop after 2,048 tones would contain 1,024 values and the next stop down from there is halved to 512. The stop after that contains 256 values, then 128, and finally 64 levels in the darkest shadows.

You may have heard that it is a good idea to underexpose your photos so you do not risk the highlights being blown out to total white. While this practice will control the highlights, it also means that you are not taking advantage of all the available tonal levels that your sensor is capable of recording. If the histogram data does not extend into the far right-hand side, you are using far fewer tonal levels than the camera is capable of capturing. While an underexposed raw file can certainly be lightened in the raw conversion process, this means that the 64 to 128 levels that represent the darker shadows need to be stretched out and redistributed into the brighter areas of the tonal range and on some exposures this may result in noise and posterization appearing in the midtones or shadows.

You want to have the data in the histogram as far to the right side as possible without any clipping (Figure 3-15). Using this method, the image may appear too bright and washed out on your camera's LCD screen, but this can easily be adjusted in the raw conversion process without any of the side effects that come from trying to lighten up the dark shadows on an underexposed shot. This method of exposure is well suited for landscape and fine art photography. Since it relies on recording scenes with more exposure, however, and more exposure is achieved either by opening up the lens or using a slower shutter speed, it may not be a feasible practice for photographic situations where you need to capture fast

action, or where good depth of field is required and a tripod is not practical.

Digital exposure is all about capturing the best set of information about the scene. The expose-to-the-right method is one way to structure the exposure to capture the fullest range of tones possible, but it often requires more post-processing in the raw conversion step. Whether you choose to use the expose-to-the-right method or not, it's important to understand that a good digital exposure is similar to a film exposure in that the goal is to place the tonal values for very light and very dark subjects so that there is good rendition of those details. With a good set of tonal information recorded you have more latitude and flexibility in processing that information as you work towards the goal of creating a file that the print media can handle.

Exposure considerations for JPEG files. If you are shooting JPEG, your goal should be to expose the image so that it looks the way you want it at the time of capture or is slightly overexposed without any highlight clipping. It is better to bias the exposure more towards the light side because, as explained in the previous section, digital sensors record more tonal values in the highlight range than in the shadow range. If an image is a bit too bright (but the highlights are not clipped), it is not a problem to darken it down. But brightening an image with significant underexposure problems can reveal even more problems.

Using Color Reference Targets

A fair amount of color correction practice is built on the foundation of identifying neutral tonal values. Simply put, if you can locate a tone in the image that should be a neutral (that is, no color cast at all—a gray, white, or black) and then apply adjustments that ensure that the tone is neutral, much of the color cast problems in an image can be quickly solved. One way to speed up this process is to shoot the first images of a setup with a color reference target in the frame.

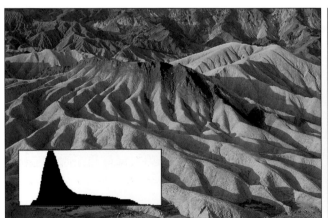 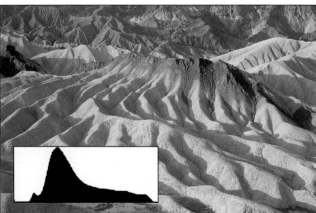

Figure 3-15. The exposure for the image on the right is biased more towards the important right-hand side of the histogram, which means it has used more of the sensor's available capacity for recording tonal data. © SD

Color references are available at any good professional photography resource and usually consist of a card that contains a grid of precise color and gray patches. The most well-known color targets are the Gretag Macbeth ColorChecker, WhiBal®, Kodak Q-13, and ExpoDisk. By referring to the neutral and color patches on the chart as you evaluate the image that contains the chart, you can see how well color is being reproduced in the image. The gray patches are especially useful since you can use them to quickly establish a good white balance setting for an entire session of photos. First, you adjust one image that includes a color or gray reference that was photographed in the same lighting and same setup as the rest of the shoot or in a series of shots. Then you can save that group of settings or a particular subset of settings. In Adobe Bridge or in Adobe Photoshop Lightroom, you then select all of the other images that were shot in the same conditions and batch apply the settings from the color reference image (Figure 3-16).

Although it may seem that color reference targets are suited more for studio-type photography, they work well for any type of photographic situation where you have the time to take a couple of test images that contain the reference card at the beginning of a series and are especially useful when you are working with mixed light sources.

File Organization and Archive Preparation

If you have been shooting with a digital camera for even a short amount of time, you know how easy it is to amass a huge quantity of images. And with the megapixel count on the march upwards, this also translates to larger file sizes and more storage requirements. Before we get to the creative image enhancement part of the book, we feel it necessary to spend some time on the essential file management part of the process. While this may not seem as exciting as transforming an image with careful use of adjustment layers and some well-placed layer masks, it is an essential part of the workflow if you want to easily find your images again and also if you want to ensure that they are thoughtfully prepared for an archive that is well organized and as future-proof as possible.

Figure 3-16. Using a color reference target can help in determining a white balance setting that can be quickly applied to a group of images that were all photographed in the same lighting. © SD

There are several steps in this process and whether you decide to do them in sequence all in one session or parcel them out in stages over several days or weeks depends on the number of images you have to process as well as how much time you have to devote to the project. In this section, we'll take a look at some of the key tasks related to importing images and initial file management and organizational matters.

- Importing
- Batch Renaming
- Making Selects with Ratings and Labels
- Applying Keywords
- Initial Adjustments to Select Raw Files
- Converting to DNG

As an important part of this section, we'll discuss broad concepts rather than the details of specific software programs. Although we will be referring to current programs such as Adobe Bridge and Adobe Photoshop Lightroom to illustrate how you can choose to manage the first phase of working with your images, it is the nature of software that it does change and evolve, especially in this developing field of digital photography workflow. Any file management protocols you decide to adopt should be flexible in that the basic tasks are not specific to any one software program.

Importing

This is the stage when your images are the most fragile, because they exist only in one place—the memory card. When importing your images, you should create a duplicate set of all the files on a separate hard drive as soon as possible. Some photo utility programs, such as PhotoMechanic or ImageIngester, will import images from your memory card and automatically copy them onto other drives. Photoshop Lightroom also offers this functionality. In addition to their laptops, Seán and Katrin both travel with compact Firewire and USB hard drives for creating multiple image backups. The laptop and harddrives are never kept in the same bag, in case one bag is lost or stolen. Digital "wallets" that allow you to download directly from a memory card without a computer are also quite useful for this purpose. If a separate hard drive for backup is not available, then consider burning CDs or DVDs as temporary backup.

The important thing is to make sure that right from the start you have a minimum of two copies of your downloaded images, preferably on separate hard drives. You should not reformat the memory card until you have verified the integrity of the imported files. An easy way to do this is to have Adobe Bridge or Adobe Photoshop Lightroom build thumbnails and previews of the files. Since these are generated from the actual files and not from camera thumbnails, if Bridge or Adobe Photoshop Lightroom is

able to create the thumbnails and previews, you know the files are OK. The memory card can then be reformatted in the camera with the camera software.

Batch Renaming

The file names assigned by the camera are not that useful. After the photos have been downloaded to your computer (and backed up to at least one other location on a separate drive), the first thing to do is to rename them with a more meaningful name. Many programs, including Adobe Bridge, have batch renaming features where you can select an entire folder of images and apply a new name with variables such as custom text, date created, and sequential numbers in a variety of configurations. Some applications, such as Adobe Photoshop Lightroom, let you rename files as they are downloaded from the memory card. If you are using such a program in your file management workflow, renaming the files may be handled at the initial import stage (Figure 3-17).

Figure 3-17. In Adobe Photoshop Lightroom, you can rename files as they are downloaded from the memory card and create a backup copy to a separate hard drive.

The initial inclination may be to rename the files using a content-based description that tells what the photo is of, where it was taken, or what the name of the client is. Specifying content in a file name can get cumbersome at times, however, and adding keywords to the file's metadata is really a more flexible way to attach content descriptions and other terms that can help you find the images quickly. Seán uses a naming system suggested by Peter Krogh in his excellent title, *The DAM Book: Digital Asset Management for Photographers* (O'Reilly, 2005). His file naming convention is his last name, the date the image was created, and the original camera identifier number. So an image shot on August 24, 2007, would be named like this: "Duggan_070824_3825. CR2" (the date is listed in the YYMMDD format).

Making Selects with Ratings and Labels

After renaming the files, the next step is to sort through them and apply some form of notation to distinguish the great shots from the near great, the good ones, the merely so-so ones, and the ones that are obviously destined for the trash. Doing this early in the process is a very valuable investment of your time that pays off down the road when you need to review groups of images and narrow your search by targeting only those images with specific labels or ratings (Figure 3-18). By restricting the image search to only those that have three or more stars, for example, you immediately have a smaller group of images to review that you have already ranked as good shots. Adobe Bridge and Adobe Photoshop Lightroom both use the color label and a star system with the ability to apply up to 5 stars to an image. When using color labels, you may for example designate the red label as Move to Trash. While sorting through your images, this red label is applied with a single keystroke. Later you can choose to view only the images with a Move to Trash label to review them one final time before actually deleting them.

Figure 3-18. Once ratings have been applied to a group of images, it is easy to view only a subset of those shots that have a higher rating. Above: The Filter pane in Adobe Bridge.

When applying star ratings, you should use the higher star ratings sparingly. Such a rating system is only effective if you are giving high-star ratings to only the very best images. And not all images need to have a star rating. Images with no ratings applied essentially have a "neutral" value – they are neither good enough to have a positive star rating nor are they bad enough to be labeled as an outtake or a reject.

Applying Keywords

Labels and ratings are the first level of metadata information you can add to your images to help you organize them. The application of keywords is yet another, more detailed level that lets you add to your files specific information that can be used in Photoshop Lightroom, Adobe Bridge, as well

as in cataloging applications such as Microsoft Expression Media (formerly iView MediaPro) and Extensis Portfolio. The addition of keywords can help you locate images very quickly, enabling you to perform searches based on keywords rather than looking for a specific image by file name or date created. For instance, you may have several images of covered bridges but are looking for one special shot. If you have adopted a keywording system you could do a search for all images tagged with the keyword "covered bridge" and your image catalog program would display only the images that had that keyword. With all of your covered bridge images displayed, you could quickly locate the special shot that you had in mind. Searching for the keyword "covered bridge" in an image catalog program quickly displays all the image files in the archive that have been tagged with that keyword (Figure 3-19).

Figure 3-19. Keyword searches quickly find tagged images.

Keywords can be applied in Adobe Photoshop Lightroom, Adobe Bridge, and other programs either individually or, more efficiently, to many images at once. Depending on the program you use, you may also be able to apply keywords when the images are downloaded and imported into your digital workflow program (Figure 3-20). Like the application of ratings and labels, adding keywords during the initial image organization process does take a little extra time, but it is a worthwhile time investment that pays off very quickly once you start searching your image catalog based on the keywords you have added. The addition of keywords to your files gives you a great deal of control over your image collection that makes it easier to manage and increases its value. Additionally, you get more enjoyment from your image archive once you can locate files without spending hours searching for that one perfect shot.

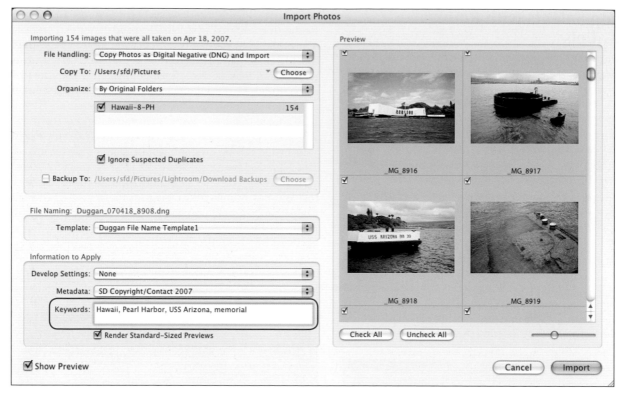

Figure 3-20. Applying general keywords as a group of images is imported into Adobe Photoshop Lightroom. In this case, the four keywords being used can apply to all of the photos being imported. Later, more specific keywords can be added as needed.

For personal work, you should be able to find an image with a few basic keywords. Katrin uses a general to specific approach: Place – Location – Subject – Attribute – Emotion. For example for the image seen in Figure 3-21 – the place is Germany, the location is the Black Forest and the name of the town (spelled in two different ways) and the subject is crucifix. In this case, she uses Lightroom to easily find all images of crucifixes as seen in Figure 3-22, which also includes two shots taken in San Francisco. For professional image stock work, each stock agency requires a very specific keywording method that can easily require 20 to 30 keywords per file.

For a thorough discussion of keywording and file naming strategies, check out *www. controlledvocabulary.com.*

Figure 3-21. The general-to-specific keywords for this image are Germany, Black Forest, Salzstetten, Salttown, and crucifix. © KE

Figure 3-22. Using Lightroom to perform a search for all images tagged with "crucifix".

Initial Adjustments to Select Raw Files

After labels, ratings, and keywords have been applied, the next step is to make initial adjustments to select raw files. This is when your work applying star ratings starts to pay off since you should finesse only the images with higher star ratings. This approach saves you a lot of time since you can ignore most of the images from a specific shoot and concentrate on only the very best ones.

Adjustments to raw files are global in nature, meaning they apply to the entire image. Your aim here is to quickly address global issues such as setting highlight and shadow points, overall brightness, contrast, and color saturation. For specific local corrections, such as lightening or darkening particular areas, you have to wait until you bring the image into Photoshop, where selections, adjustment layers, and layer masks can be used.

Where possible, you should minimize your work by seeing how many images can benefit from the same set of adjustments. Using this approach, you can adjust one file that is representative of the entire group, and then, in Adobe Photoshop Lightroom or Adobe Bridge, apply those settings to other files that can benefit from the same adjustments (Figure 3-23). We'll cover making adjustments to raw files in both Camera Raw and Adobe Photoshop Lightroom a little later in this chapter.

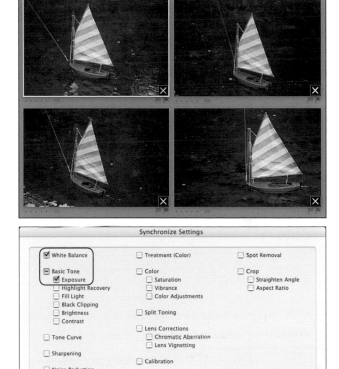

Figure 3-23. In Adobe Photoshop Lightroom, the adjustment settings for the first sailboat image are synchronized to the other sailboat images.

Proprietary Conversion Programs

More and more camera manufacturers are using their own software conversion solutions as a way to sell cameras. A good example of this practice is Nikon's Capture NX, which lets the user make local areas adjustments to raw files. Just as with regular global adjustments that can be made in many raw conversion programs, these local adjustments are not permanent and can be changed at any time. The one caveat, however, is that you can use the software only on Nikon raw files. While the program may deliver on everything that it promises, and from a marketing standpoint it may be an effective strategy, we are a little leery of the proprietary nature of such applications, especially in terms of creating and maintaining image archives that will be accessible in the future (more on that in the next section). For that reason, our focus in this book is on software that can be used on files from a wide variety of cameras, and not just those from a single manufacturer.

Converting to DNG

One of the most important steps in our import and organization workflow is to convert our camera-specific raw files to the digital negative format (DNG). Depending on your workflow, this can be done at the beginning of the process or at the end. The DNG format is of special interest to digital photographers because it is an openly documented raw format that has distinct advantages over the proprietary raw format that your camera creates. Before we get into how to convert files to the DNG format, let's take a brief look at just what the DNG format is, why it was created and what it offers you.

Can your raw files be opened in the future?

Every camera that can shoot in raw uses its own file format that is specific to that camera model. Every time a new camera comes out, a new raw file format is introduced. These formats are proprietary and not openly documented, which means that the camera makers do not divulge all the details about how the files are written or any special capabilities that are engineered into them (some raw formats have features that can be accessed only by software created by the camera manufacturer). If the camera makers do not share the details of the file format, then companies that make raw conversion software have to get hold of a camera, create test images, and reverse engineer the files to figure out the best way to decode the files. The concern among many photographers, curators and historians is that the undocumented nature of raw files does not guarantee that those files can be accessed in the future. If the camera vendor were still around, one would hope that they still support files from older cameras, but there is no guarantee that they will do so, or that third-party companies will always write software that supports older raw formats. Software that converts raw files may also be tied to specific operating systems.

DNG: an open source raw format

In 2004 Adobe Systems created the DNG format specifically to deal with concerns about the future accessibility of raw files. It is an openly documented raw format and the information required to program a DNG converter can be obtained by anyone at no cost. This reason alone makes DNG very attractive as an archive format. It is more likely that you will be able to open an openly documented raw format many years into the future than the undocumented, proprietary formats created by camera vendors.

Advantages of DNG

The fact that a DNG raw file is openly documented and more likely to be accessible for many years into the future is the primary advantage, but there are others.

No XMP files. Camera-created raw files require a separate XMP (Extensible Metadata Platform) file to hold added metadata and adjustments applied in Camera Raw. This separate sidecar file is not required for DNG because the format was written specifically to be able to include such information, without ever permanently altering the actual raw data. Additionally, keywords and other metadata can be written back into a DNG file after it has been created, even from other applications, such as asset management programs like Expression Media.

Ability to embed the original raw file and previews. If you are unsure of totally getting rid of your original camera-vendor raw format (that is, the .NEF format for Nikon or the .CR2 format for Canon) you can choose to embed a copy of the original camera vendor raw file in the converted DNG file. This original raw file can then be extracted later if you needed it. The only reason to do this would be if at some point you wanted access to vendor-specific metadata tags or functionality that the vendor's raw conversion software offered, or prove that the original camera file had not been altered. The one potential weighty downside to this is that it does increase the file size, but the option is there for those who want it. Unless you work in an evidence based field such as forensics, police or museum reproduction and have to prove that the file is the original camera file, you probably don't need to embed the original raw file into the DNG file.

You can also choose to embed a full-sized JPEG preview that can be used by some asset management programs to quickly generate proofs, web galleries, or display your adjusted raw file accurately in a photo-cataloging program. Those programs do not understand the XMP files generated by Camera Raw so any adjustments you make in Camera Raw, or other programs such as Adobe Photoshop Lightroom or Apple Aperture, are not reflected when they create thumbnails and preview images. If you want to use other programs to quickly generate proofs or content such as web galleries or presentations from the DNG file, then we suggest saving a medium-size JPEG preview when the file is converted to DNG. If you will be generating 8 × 10 or larger sized prints from the embedded JPEG image, then the full-size preview would be the better choice.

Disadvantages of DNG

While the DNG format has many advantages, there are some things to be aware of. The main one is that at the present time, the major camera manufacturers do not support it. This means that once a Nikon NEF file has been converted to DNG, you cannot use Nikon software to adjust it (if the original raw file was embedded into the DNG, then this can be extracted in order to work with it using camera maker software). While a few camera manufacturers do currently offer DNG as an in-camera raw format, it really needs to

be adopted by the major players—Nikon and Canon—as a raw format in the camera. The scene is a bit different for raw processing and photo workflow software, however, and at the time of this writing nearly 50 programs offered varying levels of DNG support.

DNG Conversion in Photoshop Lightroom

In Lightroom, there are two methods for converting your raw files to DNG. To convert at the time the photos are imported into the Lightroom library, open the File Handling menu in the Import Photos dialog and choose "Copy Photos as Digital Negative (DNG) and Import"(Figure 3-24). This gets the DNG conversion out of the way at the beginning of the process and is one less thing to do later on. Also, since DNG files are approximately 30% smaller than raw files, you'll save some hard disk space as well.

The one disadvantage to converting to DNG as the photos are imported is that it takes longer than simply importing the raw files with no conversion. If you're under time pressure to quickly review the shots from a photo shoot then converting at the time of import may take too long.

To convert a group of images to DNG after they have been added to the Lightroom library, choose Library→Convert Photos to DNG (Figure 3-25). Since the DNG format is designed as a raw format, it is best to leave the option to "Only Convert Raw Files" selected. If you want Lightroom to delete the original raw files after successful conversion to DNG, there is an option for that.

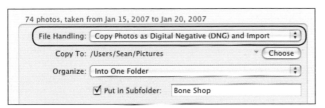

Figure 3-24. Copying and converting files to DNG upon import into Lightroom.

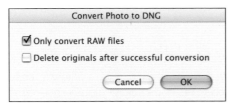

Figure 3-25. Converting to DNG after images have been added to the Lightroom library.

Any changes you make to image files in Lightroom (i.e., image adjustments, keywords, etc.) are stored as a set of instructions in the Lightroom database. In order for these changes to be visible in other applications, such as asset management programs like Extensis Portfolio, those changes need to be written back into the file. For raw files, the changes are automatically written into an XMP sidecar file. For DNG files they are written directly into the DNG "wrapper."

There are a few under-the-hood settings and menu options regarding XMP metadata to be aware of. The first is in the Metadata section of the Catalog Settings (File→Catalog Settings). It controls whether changes are automatically written into XMP (Figure 3-26). We recommend that you turn this off since Lightroom has to write every change you make at the time you make it and with DNG files this can really slow the program down. With this preference unchecked, however, you need to be sure that you Export the XMP data into the raw or DNG files once you are done working with them (ideally at a time when you are not using Lightroom to process images and the program can update the files without the slowdown impacting your work). To do this, choose Metadata→ XMP→Export XMP Metadata to Files.

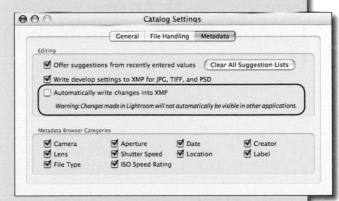

Figure 3-26. To avoid workflow slowdowns with DNG files, uncheck the option for automatically writing changes to XMP. Just be sure to export the XMP data into the files once you are done working with them.

The DNG Converter

Although you can use Lightroom and also the Save dialog in Camera Raw to convert files to the DNG format, for batch processing large numbers of files, the free DNG Converter available at *www.adobe.com/products/dng/* is much more convenient (Figure 3-27). You can specify an entire folder of files and place them into a separate destination folder without overwriting the original raw files. Plus, as a stand-alone application, the DNG Converter can work on the conversions while you are free to do other work in Photoshop, Bridge, or Camera Raw.

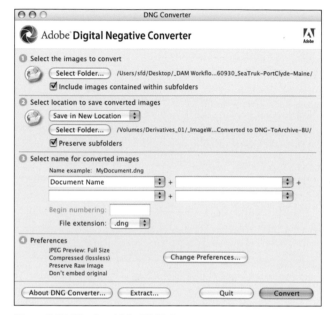

Figure 3-27. The free Adobe DNG Converter.

Working with Adobe Camera Raw and Photoshop Lightroom

The great flexibility to interpret files in different ways, create derivative versions of the same image, or salvage a less than optimal exposure is what makes the raw format so compelling for photographers. We are very fortunate to live at this point in photographic history, as this is the type of control over the image that photographers could only dream about before now.

The actual work of processing and interpreting the raw file can be quickly applied or it can be a more considered and meditative interaction with the image and can occur at different points in the workflow:

- Initial raw adjustments, quickly applied as part of the import and sorting process

- Batch adjustments to many images from the same session

- Adjustments to single images as a precursor to further work in Photoshop

Several raw conversion applications are on the market. Some are stand-alone, raw processors, and others work in conjunction with other products or as a part of a broader digital photography workflow solution. In this section we'll take a look at working with raw files in Adobe Camera Raw and Adobe Photoshop Lightroom.

Adobe Camera Raw

Camera Raw is a part of the Photoshop CS3 and Adobe Bridge software package. It works with either program, which means that you can work with your files in Bridge without having to launch Photoshop. Access the Camera Raw controls by opening a raw file from a supported digital camera. The easiest way to do this is to target a folder of raw images in Bridge. Double-click any raw file and Camera Raw interface will appear with a preview of your image.

Camera Raw is periodically updated to add support for new cameras that were released after the shipping version of Photoshop CS3. You should always check the Adobe Web site to ensure you are using the most recent version. This is especially important if you purchase a new camera that came out after the release of Photoshop CS3. Depending on how new your camera is and when the last update was posted, you may have to wait until the next Camera Raw update before you can use ACR with raw files from your new camera.

Camera Raw interface

When Camera Raw first opens you may see a yellow triangle with an exclamation point in the upper-right corner of the preview image for a few seconds. This is just an indicator that Camera Raw is still building an accurate preview from the information in the raw file. The image may appear a bit unsharp and pixilated while the preview is generating but it will look sharper when the preview is complete (Figure 3-28).

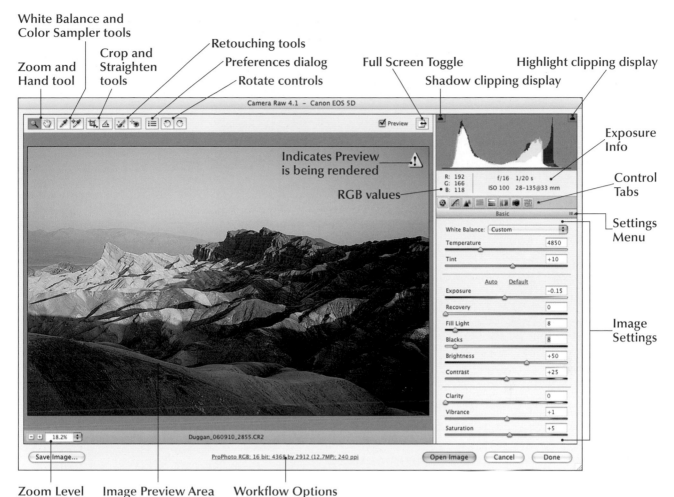

White Balance and
Color Sampler tools

Zoom and
Hand tool

Crop and
Straighten
tools

Retouching tools

Preferences dialog

Rotate controls

Full Screen Toggle

Shadow clipping display

Highlight clipping display

Exposure
Info

Control
Tabs

Settings
Menu

Image
Settings

Indicates Preview
is being rendered

RGB values

Zoom Level Image Preview Area Workflow Options

Figure 3-28. The Adobe Camera Raw 4.1 dialog box.

Camera Raw tools, preview and clipping displays. Just above the preview image on the left side is a series of tool icons. The first two control basic navigational tasks such as zooming and scrolling. The eyedroppers are used for setting a white balance and placing color sampler points to track important tonal values. The Crop tool lets you apply a non-destructive user-specified crop, or choose from a list or preset aspect ratios. The Straighten tool is used for straightening crooked images. The retouching and redeye tools are new to Camera Raw 4.0. The former lets you apply non-destructive and reversible dust spotting to your images. Even better, you can synchronize your raw settings and apply them to a group of similar images of the same scene, enabling you to effectively handle spot removal as a batch operation. The last buttons in the tool bar will open the Camera Raw preferences and rotate the preview image.

Controls for Preview and switching the dialog box to full screen view are to the left of the histogram. The Preview

toggles back and forth between the adjusted and original settings of the current control tab panel. You can also toggle the Preview by pressing P. To see an overall before and after preview open the Settings menu on the upper right corner of the control tab panels and switch between Camera Raw Defaults and Custom Settings

The small triangles in the upper left and right corners of the histogram turn on the Shadow and Highlight clipping display. This will show you when shadow tones are forced to black (blue overlay color) or highlights that are totally white with no detail (red overlay color). You can also activate the clipping displays by pressing U for shadows and O for highlights. These alert colors will be visible only if you're viewing an image where this loss of detail, or clipping, is present, or if your adjustments are forcing shadow or highlight values to be clipped (Figure 3-29).

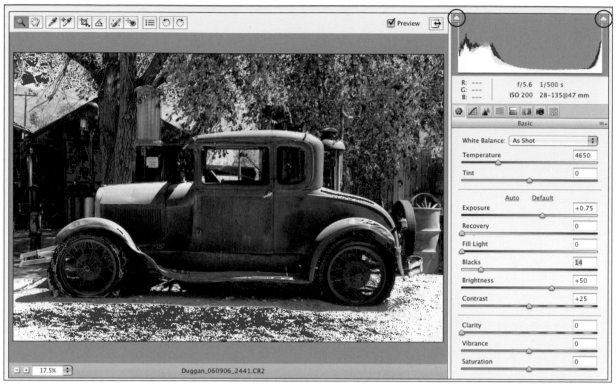

Figure 3-29. The overall clipping display colors shows red where highlight values are clipped and blue where shadow values are clipped.

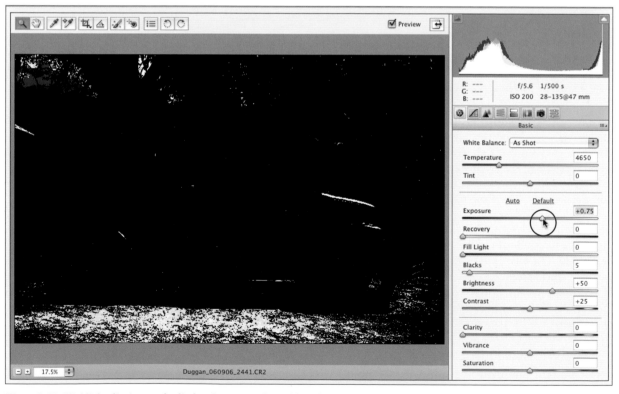

Figure 3-30. Highlight clipping can be displayed on a per-channel basis by holding down the Option/Alt key and clicking the Exposure slider. Areas that turn white indicate clipping in all three color channels.

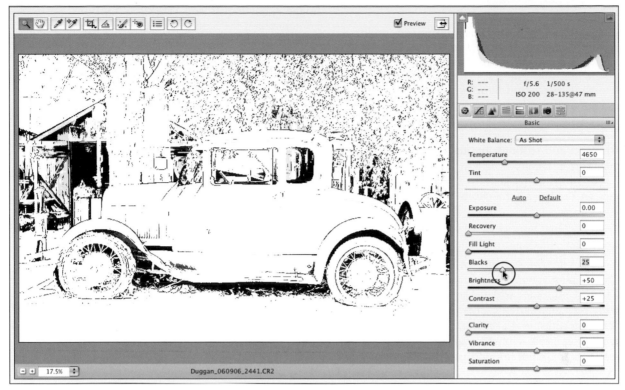

Figure 3-31. Shadow clipping can be displayed on a per-channel basis by holding down the Option/Alt key and clicking the Blacks slider. Areas that turn black indicate clipping in all three color channels.

Though the clipping warning can be useful and it is certainly important to know when this type of clipping is happening, the one drawback of this display is that it turns on the overlay color even if only a single channel is clipped, although there may be useable and recoverable detail in the other two channels. We prefer to show clipping by holding down the Option/Alt key while clicking and dragging the

Exposure or the Blacks sliders to threshold the image that uses a multiple color display to show you the clipping in each individual color channel or in channel pairs (see the sidebar "Decoding the Clipping Display Colors"). Figure 3-30 shows an example of highlight clipping while Figure 3-31 shows an example of shadow clipping.

Decoding the Clipping Display Colors

When the clipping display is activated by pressing Option/Alt and dragging the Exposure slider left or the Blacks slider right, the colors indicate where clipping is occurring in the photo and in which channels. Here's the key to unlock the color code:

Highlight Clipping: Black means there is no clipping. White indicates clipping in all three color channels. Red, green and blue indicate clipping in each of those channels. Yellow shows clipping in the red and green channels. Magenta shows clipping in the red and blue channels and cyan shows clipping in the green and blue channels.

Shadow Clipping: White shows areas with no shadow clipping. Black indicates clipping in all three color channels. Cyan shows clipping in the red channel, magenta in the green and yellow in the blue channel (cyan, magenta and yellow are the opposite of red, green and blue and indicate the total absence of those colors). Red, green or blue shows shadow clipping in the other two channels. For instance, red shows clipped shadows in the green and blue channels; green indicates clipping in the red and blue channels, and blue reveals clipping in the red and green channels.

The clipping display in Photoshop Lightroom works the same way. Holding down Option/Alt and clicking the Exposure slider will show clipping for the highlights and doing the same for the Blacks slider will show shadow clipping.

The histogram and settings menus. On the right side of the dialog is the histogram, which shows you how the tones in the file are distributed along the tonal range. Below the histogram on the left are the RGB values for the cursor location as you move it over the preview. Next to the RGB values is the exposure information for the image.

On the right side of the dialog box at the top of the adjustment tabs is a small button for accessing the Settings menu (Figure 3-32). This contains options to use Image Settings, which are settings that are associated with the current image if that file has already been adjusted in Camera Raw, or revert to the Camera Raw defaults for the camera that created the image. This latter choice will remove any adjustments you may have made to a file. Custom refers to any new settings you have made in the current work session with an image. You can also apply the Previous Conversion if those adjustments will work for the current image. The lower part of this menu contains additional choices for working with Camera Raw settings.

Figure 3-32. The Camera Raw settings menu.

Image Adjustments and Workflow Options. Below the histogram and the Settings menu are the eight tabs of the Image Adjustments (Figure 3-33). These are where you make the changes to your raw file. From left to right they are:

- Basic, which controls white balance, exposure (the white point), recovery (for rescuing overexposed highlights), fill light, blacks (the black point), brightness, contrast, clarity, vibrance and saturation, and fill light

- Tone Curve, for precise tonal and contrast adjustments using Curves

- Detail, which enables you to apply sharpening and noise reduction

- HSL/Grayscale, for adjustments to the hue, saturation and luminance of colors, as well as custom grayscale conversions

- Split Toning, adapts a classic darkroom technique to the digital age and allows you to apply a different color tone to the highlights and the shadows.

- Lens, for correcting lens-based errors such as chromatic aberration and vignetting

- Camera Calibration, which enables you to create custom profiles for how your camera behaves in certain lighting conditions.

- Presets is where you can create and save your own Camera Raw settings that can be quickly applied to images.

Under the preview image at the bottom of the dialog box is an underlined summary of the current Workflow Options. Clicking this will open the Workflow Options dialog box (Figure 3-34), where you set the Color Space that the image is processed into (for example, Adobe RGB and ProPhoto RGB), the bit depth of the file, the pixel dimensions of the file and the resolution. We'll discuss the Image Adjustments and the Workflow Options in more detail in the next section.

The Auto adjustments

In the Basic tab, two underlined options for Auto and Default appear above the Exposure slider (Figure 3-35). The one that is gray and unavailable as a clickable choice indicates the setting that is currently being used for the image. The Default settings are the base line Camera Raw interpretation for images from each camera, representing an initial translation of the raw file. The Auto settings attempt to improve the image by ensuring that there are bright highlights, dark shadows, a good range of midtones and a dash of contrast, all depending on the actual content of the image.

Figure 3-33. The eight control tabs in Adobe Camera Raw 4.1.

Figure 3-34. The Workflow Options.

Figure 3-35. The Auto and Default Adjustments links in the Basic tab.

Although the Auto settings work well on some files, they are only a formula adjustment that is not necessarily suited for all images, especially those shot in lower light, or where you have bracketed the exposures. Photographs made at night or twilight are usually rendered much too light by the Auto Adjustments since they are trying to remap the tonal balance to create a brighter highlight (Figure 3-36).

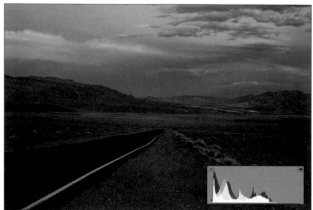

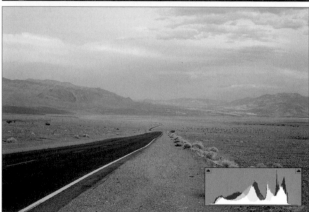

Figure 3-36. The sun was already below the horizon in Death Valley when this exposure was made. The version on the top reflects the light level that was really present at the time. The version on the bottom is how the image has been interpreted by Camera Raw's auto adjustments. ©SD

The Auto Adjustments affect only the overall exposure of the image and will have no effect on fixing a color cast if one exists.

How the Auto Adjustments impact previews in Bridge.
In the Camera Raw preferences, there is a check box that applies the auto tone adjustments as the default behavior for every image (Figure 3-37). When you browse a folder of raw files in Bridge, Camera Raw works in the background to create previews and thumbnails of the images. It applies

the base line interpretation for your type of camera and uses the default Camera Raw settings as well as any options that have been enabled in the preferences. As mentioned previously, if you have darker images that should be dark, the Auto Adjustments can create a false interpretation of the scene and this will be applied to the thumbnails and previews in Bridge. If you have bracketed your exposures, the Auto Adjustments will mask the differences in the bracketed exposures so that they all appear the same (Figure 3-38). Although the auto adjustments are certainly fine to try out for some images, we do not recommend the default application of these settings to all images, especially if you commonly use exposure bracketing in your photography.

Figure 3-37. In the Default Image Settings section of the Camera Raw preferences, turn off Apply auto tone adjustments so you can see the actual variances in your exposures when browsing images in Bridge.

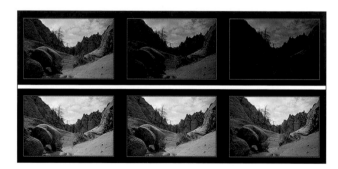

Figure 3-38. These three exposures were bracketed at one stop apart. The top row shows the thumbnail previews in Bridge accurately displaying the effects of the exposure bracketing. The bottom row shows the same thumbnails under the undesired influence of Camera Raw's Auto Adjustments.

Image Adjustment Tabs

Although the Camera Raw dialog has a lot of different controls spread out over a tabbed interface of eight sections, for many images, most of the adjustments we make are handled in the Basic, Tone Curve, and HSL/Grayscale tabs, with the occasional foray into the Split Toning controls. These areas represent the creative aspects of Camera Raw, whereas others, such as the Detail, Lens and Camera Calibration tabs, are really meant for technical adjustments such as sharpening, noise reduction, and compensation for optical deficiencies. Since the focus of this book is the *creative* digital darkroom, and since those are the areas of Camera Raw where we make most of our adjustments, we'll devote

most of this section to showing you how to get the most from those two sets of controls and then follow up with a more generalized overview of the remaining tabs.

The Basic tab

It's here that you set the white balance, set the shadow and highlight points, perform highlight recovery (if needed), add fill light to the shadows, adjust the overall brightness, contrast, and adjust color vibrance and saturation.

Adjusting white balance. By default, the White Balance menu is set to "As Shot" and uses the white balance that your camera recorded, whether this was a preset or an auto white balance (AWB). One of the great things about raw files is that while the white balance setting in the camera is noted in the metadata of the file, it is not a permanent setting and can be easily changed. The White Balance menu contains a number of presets that reflect common lighting conditions. You also have an Auto setting that prompts Camera Raw to evaluate the image and determine a white balance (Figure 3-39).

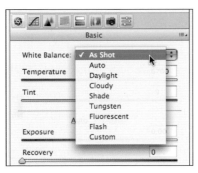

Figure 3-39. White Balance presets in Camera Raw.

Once you've settled on a preset, use the Temperature or Tint sliders to fine-tune the white balance for the image (Figure 3-40). You can also turn to these sliders first and ignore the presets in the White Balance menu. The Temperature slider shifts the color balance between blue (cool) on the left and yellow (warm) on the right. The Tint enables you to add green on the left or magenta on the right.

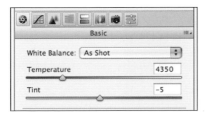

Figure 3-40. The White Balance controls.

The White Balance Tool. A White Balance Eyedropper Tool is found in the tool icons in the upper left of the dialog (Figure 3-41). This is perhaps the easiest way to set the white balance in an image where a tone that should be neutral (no color cast) exists.

Figure 3-41. The White Balance tool.

To use the White Balance Tool:

1. Select the tool in the Camera Raw dialog (the gray eyedropper)

2. Find an area in the image that contains a tone that you feel should be a neutral (like the item circled in Figure 3-42). This could include such items as gray metal, concrete, a gray cloud, a white shirt, or the whites of someone's eyes.

3. Click the selected tonal area with the White Balance Eyedropper tool and that tone will be made neutral, which will affect the color balance of the entire image.

4. If you feel the white balance produced by the eyedropper tool is not quite right, click other areas that should be neutral. Each one will give you a slightly different result.

5. You can also fine-tune the result by working with the Temperature and Tint sliders.

6. To clear everything and return to the way the image was when you opened it, choose "As Shot" from the White Balance menu.

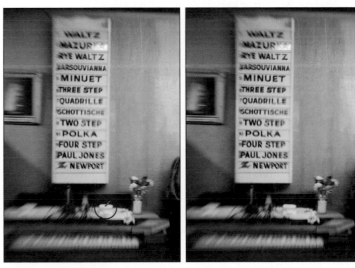

Figure 3-42. This image was photographed under strong tungsten light. Using the White Balance tool, on the white object on top of the piano (circled in red) remapped the image to a neutral tone (right). ©SD

If you have photographed a target image at the start of a sequence that contains a color reference such as a Gretag Macbeth ColorChecker, you can quickly set the white balance with this tool by clicking on the second-lightest white patch.

Since the White Balance settings appear at the top of the Basic tab, it may make sense to tackle that correction first. While this works well on images that are properly exposed, if an image is underexposed and too dark, it is often hard to see the subtle color differences that changes in white balance can produce. In this case, it is better to adjust the overall tone of the image first, using the Exposure, Shadows and Brightness sliders, and then come back to fix the white balance when you can see the difference.

Exposure. The Exposure controls the brightness of the highlights in the image by setting the white point. Remapping the white point will also have an effect on the overall brightness of the image. The values of the adjustments are expressed as fractions of a stop in order to make them familiar to photographers. For example, an Exposure value of +0.75 is approximately the same as three-quarters of a stop increase in camera exposure. Moving the slider to the right brightens the highlights and moving it to the left darkens the highlights. If you have the Clipping Display buttons enabled at the top of the histogram, you will see the red overlay appear when the highlight detail is being clipped. As you move this slider back and forth, pay close attention to how it affects the shape of the histogram; you'll get a sense of how the tonal values are being stretched and squeezed to remap them to different values. In Figure 3-43, the image was created using the expose-to-the-right method in order to place the brightest highlights as far to the right as possible with no clipping. This ensures that the right end of the histogram, where most of the tonal values are captured, is being fully utilized. In the adjustment made to the Exposure slider, the bright highlight tones are being reassigned to slightly darker values.

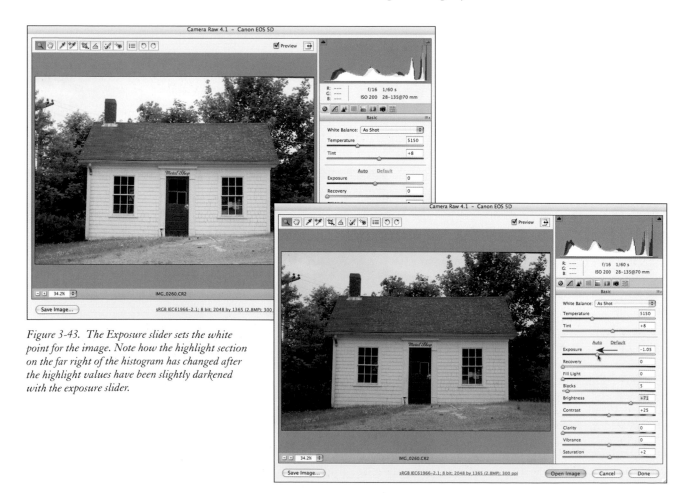

Figure 3-43. The Exposure slider sets the white point for the image. Note how the highlight section on the far right of the histogram has changed after the highlight values have been slightly darkened with the exposure slider.

Recovery. If you have an image where the highlights seem to be clipped, the Recovery slider can recover highlight details as long as some tonal detail is present in at least one, and preferably two, of the color channels (Figure 3-44). To check for highlight detail in the individual channels, Option/Alt-click the Exposure slider to show the per-channel clipping display. White reveals that there is clipping in all three channels, but the presence of red, green, blue, cyan, magenta or yellow means that there is clipping in only one or two of the color channels. (see the sidebar "Decoding the Clipping Display Colors" earlier in this chapter for a detailed explanation of the clipping colors).

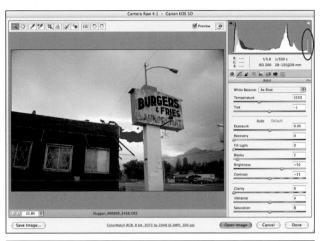

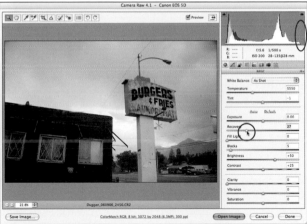

Figure 3-44. If there is detail in at least one of the three channels, the Recovery slider in Camera Raw can recover bright highlight detail.

Highlight Recovery with Curves. In addition to the Recovery slider, you can also use the Tone Curve tab to control overly bright highlights. In the Tone Curve tab click on the Point tab. Move the top-right curve point down to an Output setting of 245. If you have an image with blownout highlights and the red Highlight warning is turned on, you'll see this disappear (Figure 3-45). In the histogram, the tonal data is no longer slammed against the far right side (the gray

histogram inside the Curves grid reflects the original raw data and does not change). If the detail is seriously blown out to white in all three channels, nothing can be done to rescue image details, but at least you can ensure that those areas will not print as a paper white.

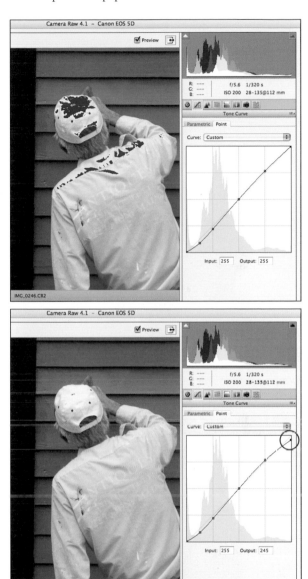

Figure 3-45. You can lower the upper-right curve point slightly to recover highlight detail, or, if no detail is present, to ensure that highlights don't print as a paper white.

Photoshop Lightroom, which under the hood uses the same code as Camera Raw to perform its raw conversions, also has a recovery slider for rescuing washed out highlights. The highlight recovery abilities of both Camera Raw and Photoshop Lightroom are another compelling reason to shoot in raw and do as much of your adjustments to the raw file as possible.

Fill Light. The Fill Light slider tries to lighten dark shadow details without affecting the blacks in the image (Figure 3-46). The functionality of this control is similar to working with the shadows section of the Shadow/Highlight adjustment. Just as with the highlight recovery slider, however, it is no magic bullet for areas where detail is clipped to black in all three color channels. It is also no substitute for exposing properly for the deep shadows in the camera. If you try to lighten the shadows too much with Fill Light, it is likely you will see noise in the areas that are affected by the adjustment (Figure 3-47).

Figure 3-47. A 300% zoom view of the rocks in the image from Figure 3-46 shows obvious noise in the file that has been lightened with the Fill Light control (top). The bottom image is a different file that was exposed specifically for the shadows.

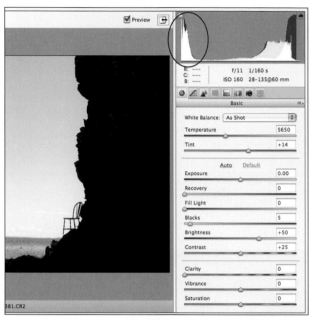

Setting the Exposure/White Point on Images with a Bright Highlight

On images where there should be a bright highlight, such as an image with bright, white clouds, hold down the Option/Alt key and move the Exposure slider to the left until you begin to see areas turning white in the clipping display. Then adjust the slider back slightly to the right until the white clipped areas turn to black (Figure 3-48). This sets the brightest point in the image to just below a total white. If you want to be really precise, you can use this clipping display to identify the brightest point in the image (white in the clipping display) and then use the Color Sampler tool to set a reference point that you refer back to so you can adjust the highlight point to a specific value. When you click the image with the Color Sampler Eyedropper, the values (for up to nine separate reference points) will appear above the preview image. If the image seems too bright or too dark, you can use the Brightness slider to adjust the midtone values (see Figure 3-49).

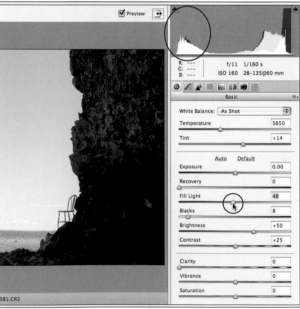

Figure 3-46. Lightening the shadows with the Fill Light slider. Note how the shadow section of the histogram (circled) has changed as a result of the Fill Light adjustment.

Figure 3-48. To set the highlight on an image with bright, white areas, hold down Option/Alt and click the Exposure slider. Move it to the right until you see areas turn totally white. Then, back it off until those areas turn black.

Figure 3-49. After adjusting the highlights with the Exposure slider. If the image is too bright or too dark, use the Brightness slider to adjust the midtone values.

Setting the Exposure/White Point on Images Without a Bright Highlight

If you have an image that is not supposed to have bright white points, the Exposure adjustment is more subjective and what you do will depend on what level of brightness you feel is appropriate for the image, as well as how the image was exposed. In Figure 3-50, a slot canyon in New Mexico, the image was exposed using the "Expose to the Right" method, so the tonal values are biased towards the right side of the histogram. Initially, the effect appears too light for how the light really was but if the Exposure slider is moved to the left, those all-important values from the right side (half of what the camera can capture) are moved to the left, pushing more values down into the shadow areas, allowing those darker areas to be described using additional tonal levels. The adjusted version shown in Figure 3-51 is a result of adjustments made to both the Exposure and Brightness sliders, as well as a slight increase in contrast made to the Tone Curve.

Figure 3-50. This image was made using the "Expose to the Right" method for maximizing the tonal values captured by the image sensor. Since it was taken inside a slot canyon on an overcast day, there should be no bright highlight in the image.

Figure 3-51. To adjust the highlights, the Exposure slider was moved to the left. The Brightness slider and Tone Curve were also adjusted to create a version of the image that more closely resembled the actual scene in the canyon. © SD

Blacks. The Blacks slider sets the black point in the image. The default setting is 5, which represents a slight darkening of the darkest tones in the photo. The effect this slider has on the image is very similar to the Input Shadow slider in the Levels dialog box. You can see the multi-colored clipping display by pressing Option/Alt and moving the Blacks slider. Most of the image will show as white, but areas that turn black reveal where detail is clipped in all three channels. Colored areas show clipping in one or two channels (see the sidebar, "Decoding the Clipping Display Colors" earlier in this chapter).

In most cases, setting the black point is a bit more subjective than setting the highlights, which often are governed by expectations of how bright a particular highlight should be. In many images, it may be OK to clip slightly the very dark areas where you wouldn't expect to see detail anyway, such as the crevices in an old stone wall or areas where no light is illuminating the subject. This is the case in the image of the tree and the old wall in Figure 3-52, Figure 3-53, and Figure 3-54. Although the Blacks slider has been moved quite a bit to the right and this move does create some shadow clipping (Figure 3-53), the clipping does not adversely affect the photo because it is very minimal and occurs in areas such as the cracks in the wall or the textured surface of the tree bark.

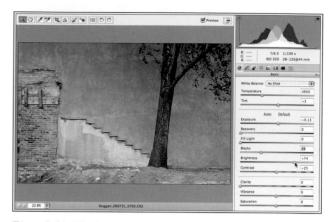

Figure 3-54. The final adjusted file. To compensate for the significant shadow adjustment, the Brightness slider has been moved to the right.

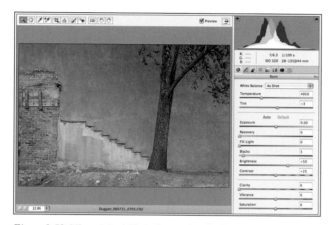

Figure 3-52. The original file before setting the black point. © SD

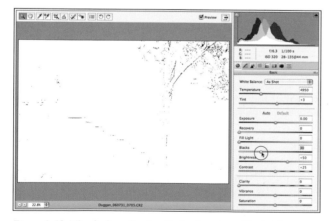

Figure 3-53. The shadow clipping display is activated by holding down Option/Alt and clicking the Blacks slider.

Brightness. The Brightness slider is a midtone adjustment, and once again a comparison can be drawn between this adjustment and the input midtone or gamma slider in the Levels dialog box. With this control, you can remap the midtone values without affecting the black or white points. The Brightness adjustment is wholly subjective and depends on the exposure and desired interpretation of the image in question.

Contrast. The Contrast slider applies an S-curve to the tonal data but it does so without affecting the very dark shadows or the very bright highlights. An S-curve works by lightening the brighter tones while darkening the shadows, so if the contrast is set to a positive value the result is that the values above the midtone point are lightened while those below it are darkened. The behavior of the S-curve applied by this slider will vary depending on how you have adjusted the Brightness slider, since the midpoint in the S-curve is determined by the Brightness adjustment. Unlike similar adjustments applied with Photoshop's Curves command, the Contrast slider does not create a shift in the hue of the colors. In most cases, we prefer to use the Camera Raw Tone Curve tab for our contrast adjustments simply because it gives us much more control. But for quick fixes, there is nothing wrong with using the Contrast slider.

Clarity. The Clarity control is an adaptive contrast adjustment that uses the tonal map of the image as a virtual mask to apply a contrast adjustment to the midtone values in the image. Since Clarity is targeting the middle tonal values, the deep shadows and brighter highlight tones are not touched. This enables it to achieve a very subtle contrast adjustment that is not possible with the other contrast controls in Camera Raw. By comparison the standard contrast slider seems downright heavy-handed. Even the Tone Curve controls cannot duplicate the exact effect since the virtual tone mask through which the Clarity adjustment is applied is not available with curves.

The best way to get an idea of what Clarity is doing is to open up an image with good midtone detail and try out some different settings. Most images can benefit from some increase in the Clarity setting and once you become accustomed to using it, the default setting of zero will probably look a bit flat. Set your zoom view to at least 50% or 100% to see how the midtone contrast is being affected. Figure 3-55 and Figures 3-56 through 3-58 show Clarity settings of zero, 35, 65, and 100.

The Clarity control was added to Camera Raw 4.1 after Photoshop CS3 had shipped. If you are still using the original installed version of CS3, then you need to download the latest Camera Raw update from the Adobe web site in order to take advantage of Clarity, as well as the new sharpening controls that were also added in Camera Raw 4.1.

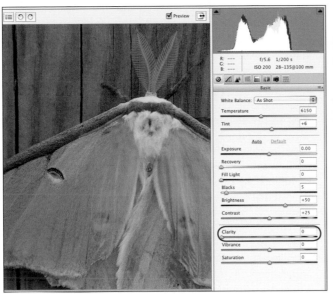

Figure 3-55. Clarity set to zero.

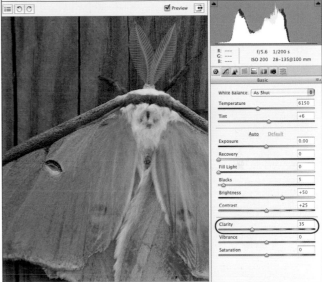

Figure 3-56. Clarity set to 35.

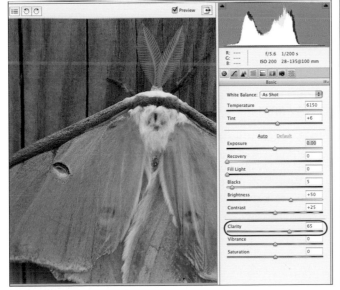

Figure 3-57. Clarity set to 65.

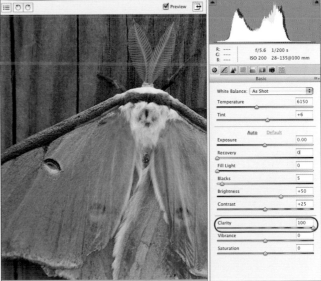

Figure 3-58. Clarity set to 100.

Vibrance. Vibrance is another adaptive control that boosts the color saturation in areas that have lower saturation with lesser impact on colors that are already highly saturated. It will also prevent skin tones from becoming oversaturated, which makes it very useful for portrait images (Figure 3-59).

Saturation. The Saturation slider will increase or decrease the saturation of all colors in the image. In this respect it is similar to the Saturation slider in the Hue/Saturation command in Photoshop though the changes it creates are more subtle. If you want a quick preview of how an image looks in black and white, move the Saturation slider all the way to the left to –100. There are ways to create a black-and-white effect that give you more flexibility and control in how to interpret the tones in the image, but using the Saturation slider (Figure 3-60) is a good way to get an idea if this is a direction you want to pursue with an image. A setting of +100 will increase the color saturation to double the original amount.

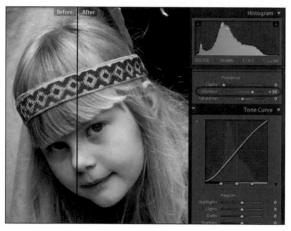

Figure 3-59. Increasing the Vibrance to 55 in Lightroom provides a subtle saturation increase in the girl's hair, headband and the blue feather, but there is very little effect on the skin tones. © SD

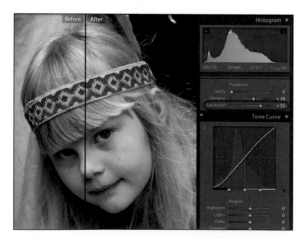

Figure 3-60. Increasing the Saturation to 55 in Lightroom creates a much more pronounced saturation increase on all the colors. The skin tones show signs of becoming oversaturated. © SD

Camera Raw and Photoshop Lightroom share a common raw conversion engine under the hood and though there are some minor functionality differences between the two, the controls are essentially the same in each program.

The Tone Curve tab

Although the Contrast slider in the Basic tab can provide a quick contrast fix, in nearly all cases we end up ignoring that setting and using the Clarity slider for a subtle contrast boost that enhances detail, or, when we really want precise control, moving over to the Tone Curve tab. Why? Because it provides us with a degree of precision and control that the standard contrast slider cannot offer.

Like an RGB curve in Photoshop, the tone curve in Camera Raw places the black point in the lower left and the white point in the upper right. The curve maps the tonal values in an image as XY coordinates. Shadows are controlled by the lower third of the curve, midtones the middle third, and highlights the upper third. The horizontal axis represents the original tonal values of the image (input values) and the vertical axis represents the adjusted values (output). Moving the curve up will lighten and moving it down will darken. A 45-degreee diagonal line indicates that no changes have been made to the original values. To accomplish these adjustments there are two tone curve interfaces that both allow for customized changes to the curve, but they each work a bit differently.

Parametric Curve. The Parametric curve lets you adjust specific tonal properties in the image using the sliders for Highlights, Lights, Darks, or Shadows. The split sliders at the bottom of the curve grid let you customize the size of the area that each of the properties sliders affects. Moving from left to right the four quadrants along the bottom of the graph represent the Shadows, Darks, Lights, and Highlights (see Figure 3-61). In the default configuration, each one represents 25% of the total tonal range. Move the split sliders under the graph to change the total percentage that the properties sliders affect. The Lights and Darks sliders will impact more of the middle part of the curve while the Shadows and Highlights will be more focused on the lower left and upper right sections. In Figure 3-62 the contrast is being increased slightly.

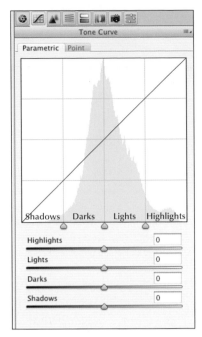

Figure 3-61. The Parametric Curve panel in Camera Raw.

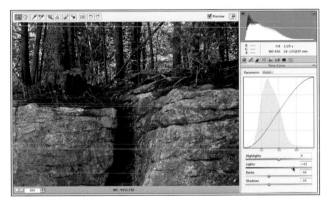

Figure 3-62. Adjusting contrast with the parametric curve.

Point Curve. The Point Curve functions much the same as an RGB curve in Photoshop, with the exception that it only affects the luminance values; you cannot access the individual color channels. A pop-up menu lets you choose between Medium Contrast (the default), Strong Contrast, and Linear, the latter being no adjustment to the curve at all (an unaltered diagonal line). If you make changes to any of the preset curves the menu will change to Custom.

You can click on the curve to place a point in a specific area. Each control point on the curve has Input (before) and Output (after) values, which are displayed below the graph. To see where on the curve a specific image tone can be found, move your cursor over the image and hold down the Command/Control key to show a circular indicator on the curve (Figure 3-63).

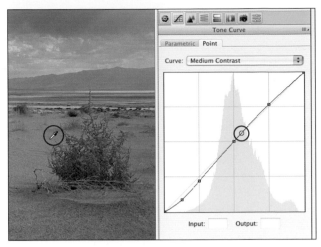

Figure 3-63. Hold down the Command/Control key and move your mouse over the preview image to see an indicator on the curve that identifies the location of the image tone you are measuring.

If you Command/Control-click while doing this, you can place a control point in that section of the curve. To remove a point from the curve, simply click it and drag it out of the graph box.

Dragging the curve up will lighten the image overall while dragging it down will darken it. Raising the upper section (highlights) and lowering the bottom section (shadows) will create a boost in contrast. You can see this if you try out the Strong Contrast curve in the Tone Curve menu, or create your own S-curve (Figure 3-64).

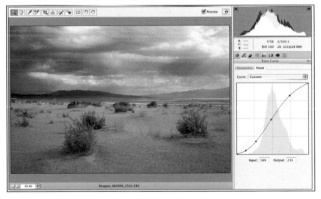

Figure 3-64. An S-curve to increase contrast. Brighter values are lightened while darker tones are darkened. © SD

When you lower the upper section of the curve (highlights) and drag up the bottom section (shadows), the result is a lessening of contrast since those tonal values are made less different and closer together. Such a curve can be helpful to tame an image that has too much contrast (Figure 3-65).

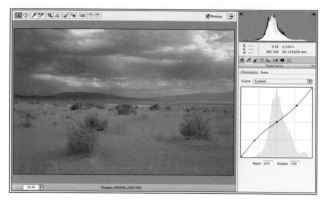

Figure 3-65. An inverted S-curve will reduce contrast. Brighter values are darkened and darker values are lightened.

Beware of dangerous curves. In most cases, the shape of the curve should be smooth and gradual. Try to use as few points as possible; a curve with too many points is harder to control. You should avoid adjustments that result in a section that resembles a sudden plateau or shelf, or a steep cliff. Plateaus and shelves show areas where a range of many different tonal values has been remapped to the same or a very similar value. This shows up in the image as blocked-up, grayish areas of a similar value that lack tonal separation and color saturation (Figure 3-66). A steep cliff-like section will result in an extreme and unnatural increase in contrast. The more steep the curve, the more drastic the increase in contrast. You also should be careful about curves that hit the "ceiling" or "floor" of the graph box. In images with a full range of tones, such adjustments can result in clipped highlights or shadows (Figure 3-67), though they can be effective at boosting contrast in overly flat images that have tonal detail grouped in the center of the histogram with no data at either end.

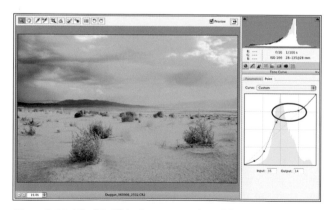

Figure 3-66. The "shelf" in the upper portion of the curve has created flat, blocked-up gray in areas of the image that used to contain different tones.

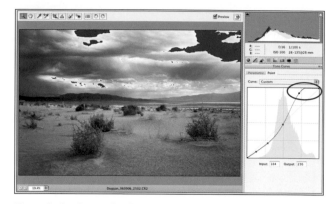

Figure 3-67. Curves that "hit the ceiling," as seen here, can result in highlight clipping. On the opposite end of the curve, when the lower portion "bottoms out" and snaps to the bottom of the grid, you run the risk of shadow tones being clipped to black.

Strategies for adjusting contrast. The power of the curve is that it enables you to precisely adjust the difference between specific areas of the tonal range to create more tonal separation in those regions. One way to think about this is to evaluate the image and try to pinpoint areas where you think there should be more difference between tones. More difference creates contrast. In addition to light areas, the human eye is drawn to areas of contrast, so you can use the curve not only to add tonal depth to the image, but also to guide the viewer's eye to important areas in the scene.

Once you identify areas that need more contrast, hold down the Command/Control key and move your cursor over the photo to locate those tones on the curve. Command/Control-click to place points on the curve, and then adjust the position of the points to add contrast to the targeted areas of the image.

Controlling the curve. One thing that will become apparent very quickly is that adjusting one point will have an effect on the rest of the curve, sometimes in ways you don't like. To prevent this from happening, place extra control points on areas of the curve that you don't want to move. For the most control, it works best to place the extra points before making your adjustments, though you can also add points after the adjustments and bring the errant sections of the curve back into control. This approach is often called a lockdown curve because it "locks down" the section of the curve that you do not want to affect (see Figure 3-68).

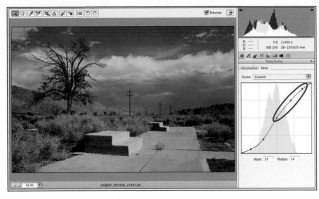

Figure 3-68. The three control points circled in red are locking down the upper part of the curve (the lighter parts of the concrete and the clouds) so that part is not affected by the adjustments being made to the lower part. © SD

Saving curves. If you create a curve that you think may be useful on other images (a really strong S-curve, for example, for those times when you want lots of contrast), click the button for the settings menu at the top of the Tone Curve panel and choose "Save Settings" (Figure 3-69). In the dialog that appears, open the Subset menu and choose "Point Curve," which turns off all the other settings, leaving only the selected setting as the one that will be saved (Figure 3-70). If you save this in the default location for Camera Raw curves (Mac: User/Library/Application Support/Adobe/Camera Raw/Curves; Windows: Documents and Settings\ Application Data\Adobe\Camera Raw\Curves) it will show up in the curve presets menu in the Point Curve panel and can be easily accessed to apply to other images (Figure 3-71).

Figure 3-70. The Save Settings dialog with only the Point Curve option selected.

Figure 3-71. The saved curve as a choice in the Point Curve menu.

Figure 3-69. Saving a point curve for later use.

The Tone Curve in Lightroom offers some additional feedback and functionality, which is covered in the Lightroom section near the end of this chapter.

The Detail tab

The Detail tab contains settings that address overall sharpening and two types of noise reduction. As we mentioned earlier in this chapter, this is one of the technical adjustment tabs in Camera Raw (the others are the Lens Corrections and Camera Calibration tabs). The adjustments you make here are not creative in nature but are meant to compensate for technical issues in the file.

Sharpening. Sharpening the image at this point in the editing workflow should be considered as input sharpening, applied to restore some of the sharpness that is naturally softened in the translation of a real-world scene into a grid of pixels. Output sharpening, which is meant to optimize the sharpness of the image for a specific type of printed output, is applied in Photoshop toward the end of the process. To really see how the sharpening is affecting the image, you can zoom in to 100%. Double-click the Zoom tool in Camera Raw, or use the zoom menu in the lower-left corner to zoom to 100%.

The sharpening controls in Camera Raw received a significant upgrade in the 4.1 update. Instead of a single Amount slider there are now 4 controls for fine-tuning the sharpening effect (Figure 3-72). The Amount slider determines the amount of sharpening and the other three sliders determine how that sharpening is applied. Radius controls how far out from an edge the sharpening is applied. Detail influences how fine details are treated and the Masking slider lets you create a virtual mask to target the sharpening more to the obvious edge areas of the image. Figure 3-73 shows how moving the sliders can sharpen the detail in a photo.

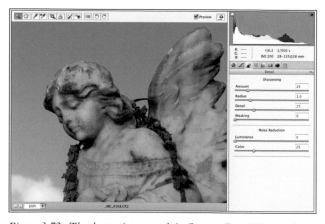

Figure 3-72. The sharpening controls in Camera Raw 4.1 set to the default amounts.

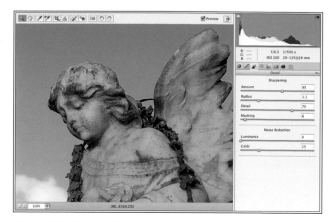

Figure 3-73. The detail in the image is noticeably sharper after working with the sharpening controls. © SD

The improved sharpening features in Camera Raw are a welcome addition to Camera Raw. The Lightroom 1.1 update also includes the same sharpening functionality. While the controls in Camera Raw and Lightroom are excellent for input sharpening, for the primary output sharpening as well as more precise creative sharpening, we generally like to have even more control over the process and the majority of output sharpening is applied towards the end of the process prior to making a print. If you don't want to have any sharpening applied to the images processed by Camera Raw, click the preferences button in the tool bar at the top of the dialog. In the General section at the top you can specify that the sharpening is applied only to the preview image that appears in Bridge. For more detailed coverage on using the sharpening controls in Camera Raw, see "Input Sharpening with Adobe Camera Raw" in Chapter 4.

Noise Reduction. Digital noise typically has two components. The basic structure of the mottling is referred to as *luminance noise* while the colored speckles are known as *chrominance noise*. The Luminance Smoothing slider in Camera Raw is for reducing the gritty sharpness of the underlying noise pattern. Unfortunately, while it can do this, the side effect is often that it softens (or, to use a "technical" term, smushes) actual image detail, too. On an image with soft focus, such as seen in Figures 3-74 and 3-75, this is not that critical, but on an image where the sharpness of details is important, the effects of this slider are usually a less-than-satisfying compromise between softening the noise while trying to retain the sharp edge to important details.

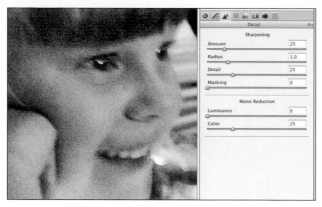

Figure 3-74. A 100% detail view showing the obvious luminance noise in an image shot at 1600 ISO. No luminance smoothing is being applied.

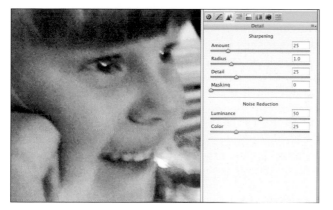

Figure 3-75. A luminance smoothing setting of 50 creates a noticeable softening of the noise structure. Since the photo is not super sharp to begin with, the luminance smoothing is fairly successful here.

The **Color Noise Reduction** slider does a much better job of reducing digital noise because it is removing only the colored speckles and not interfering with the underlying noise structure. The default setting of 25 is fine for most images (see Figure 3-76, bottom). You won't really see any difference with the noise reduction controls unless you open up a really noisy file and view it close up at 100% or more. Just set your camera to 1600 or 3200 ISO and shoot some underexposed images if you want to see these features in action.

For more detailed information on noise reduction techniques in Camera Raw and in Photoshop, see Chapter 4.

Figure 3-76. A 100% detail view of a 3200 ISO image.
Top: Color Noise Reduction is set to 0.
Bottom: Color Noise Reduction is set at the default value of 25.

The HSL/Grayscale Tab

The HSL sliders give you precise control over the nuances or "flavor" of the individual colors in an image. The Hue sliders enable you to shift a color between the two hues that create that color. For example, moving the red slider will shift the color red between a magenta red and a yellow-orange red (Figure 3-77). The Saturation slider is fairly self-explanatory, and allows you to either desaturate or saturate specific color ranges (Figure 3-78). Finally, the Luminance slider will darken or lighten the targeted colors in the image (Figure 3-79). In previous versions of Camera Raw, such precise control over specific colors was only possible through a clunky workaround using the Calibrate panel, so the HSL panel is a welcome addition to Camera Raw.

Figure 3-77. Shifting the Hue of the reds towards magenta.

Figure 3-78. Desaturating only the blues.

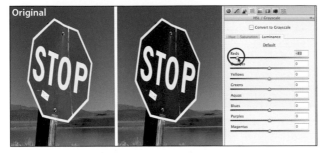

Figure 3-79. Darkening the reds by lowering the Luminance value.

Grayscale Mix. Clicking the Grayscale check box at the top of the HSL panel will apply a grayscale conversion to the image. The Auto setting is a good starting point (Figure 3-80) but the real power of this panel lies in the ability to customize how different colors in the image are translated into gray values (Figure 3-81). These controls here are very similar to the grayscale options in Lightroom and the Black and White adjustment layer in Photoshop. The main difference is that in both Lightroom and Photoshop you can drag left or right on a color in the image to darken or lighten its gray value. Converting color images to black and white is covered in more detail in Chapter 5.

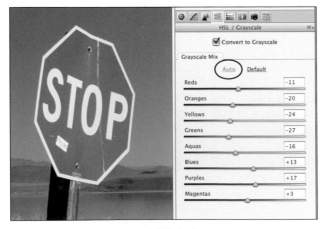

Figure 3-80. The auto Grayscale Mix in Camera Raw.

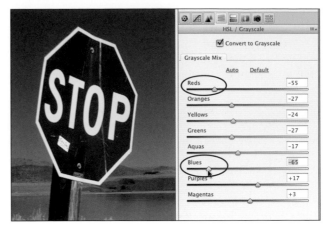

Figure 3-81. A custom grayscale mix created by darkening the red of the stop sign and the blue of the sky.

The Split Toning tab

With the Split Toning controls you can create toning effects that apply a different tone to the highlights and shadows. Those who have done this type of thing in a chemical darkroom will appreciate the ease with which these effects can be created, not to mention the absence of smelly toning chemicals! The sliders are pretty simple: choose a hue for the highlights and shadows and then set the saturation value for each. The Balance slider determines which of the toning colors and areas is more dominant. In the example seen in Figure 3-82, a sepia tone was applied to the highlights while the shadows were targeted with a cool, bluish tone. As with the other controls in Camera Raw, the same functionality is also available in Lightroom. Additional toning and split toning techniques are discussed in Chapter 5.

Figure 3-82. The Split Toning panel in Camera Raw. © SD

The Lens Correction tab

These controls are used to correct for certain types of optical flaws that sometimes are a factor in digital captures. The first, chromatic aberration, occurs when the lens does not focus the different colored wavelengths of light in the same

way, causing slight cyan and red fringes along high-contrast edges on opposite sides of the image. Vignetting occurs when the lens does not transmit even illumination to all areas of the image sensor and the corners of the file are slightly darker than the rest of the image. The controls in this tab can sometimes help correct these flaws.

To correct for **chromatic aberration** you should zoom into at least 100% (and sometimes you need to look at a higher zoom percentage) and carefully examine contrast edges on opposing sides of the file. If this condition exists, you will see a red and cyan fringe on opposite sides of high-contrast edges (Figure 3-83). In some cases you may see a blue and yellow fringe, but this is less common. Play with the Fix Red/Cyan Fringe slider until you see the color fringing corrected.

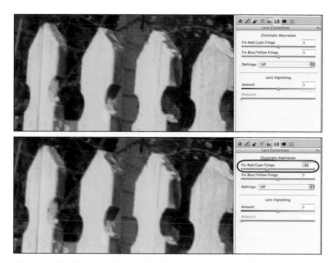

Figure 3-83. Top: A white picket fence viewed at 300% reveals the signature red-cyan fringing of chromatic aberration.
Bottom: Moving the Fix Red/Cyan Fringe slider to the left quickly corrects the problem.

To correct for vignetting (Figure 3-84) move the Amount slider. Positive values will lighten the corners while negative values will darken them. The Midpoint slider controls how far toward the center of the image the effect is applied, with lower values affecting more of the photo and higher values restricting the adjustment to the corners. Figure 3-85 shows the improved image.

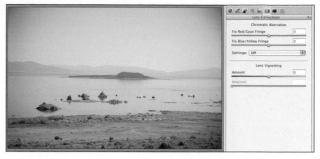

Figure 3-84. Uneven illumination has caused slight vignetting in this image.

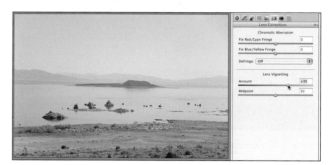

Figure 3-85. Correcting the vignetting.

The Defringe command attempts to correct for those situations where bright highlights cause the exposure for those areas to spill over onto adjacent pixels on the sensor, resulting in color fringing along edges of bright specular highlights (Figure 3-86). There are settings for defringing the highlight edges and all edges. While the former choice may do a good job in some cases of highlight edge fringing, for images where the problem is pronounced, you may need to use the All Edges option (Figure 3-87).

Figure 3-86. The sunlit rocks in this photo have a high amount of specular reflection. A closer look in the red highlighted area, as seen in Figure 3-87, shows the edge fringing that is a common problem with such conditions. © SD

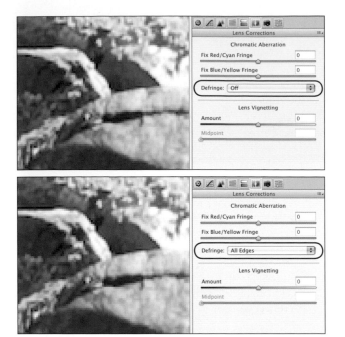

Figure 3-87. In the top view the Defringe control is off and the color fringing is clearly visible at a magnified view. In the lower view, the Defringe command is set to All Edges.

The Camera Calibration tab

As its name suggests, the Camera Calibration panel is for tweaking Camera Raw's default interpretation of your camera's files, especially under specific lighting conditions (heavy shade, for example), and saving a new setting that you can easily apply to similar shots. Although it does a good job in that regard, it is a feature that we don't use too often simply because our focus is more on fine art photography. We typically adjust our images the way we want them and if there are several that could benefit from the same settings, we synchronize those development settings in Camera Raw or Lightroom and apply them to all the chosen images at once. If there are Camera Raw settings that you want to save, including camera calibration settings, then using the Presets tab is the best way to go about that. See the next section for a short overview of working with Presets in Camera Raw.

Real World Camera Raw with Adobe Photoshop CS2 (Peachpit), by Bruce Fraser, includes excellent coverage of camera calibration in Camera Raw.

Working with Presets in Camera Raw

The last control tab is the Presets panel. This is where you can save a group of Camera Raw settings as a file that can be applied to other images. For instance, you might come up with an interesting recipe such as a hyper saturated high contrast effect or a black and white conversion that works well with certain scenes. By saving these settings as presets, you can build your own collection of creative recipes to use on other photos. Here's how it works:

1. Configure the different Camera Raw controls as desired. In the Presets tab, click on the new preset icon at the bottom of the panel or open the Camera Raw menu and then choose Save Settings.

2. The Save Settings dialog box will appear. Open the Subset menu, choose the group of settings you want to save in the preset. Further customize which settings are saved by using the checkboxes. Click OK.

3. Save the file with a descriptive name in the location prompted by the Save dialog, and then click OK.

Your saved setting will now be available as a choice in the Preset panel (Figure 3-88) and in the Apply Preset section of the Camera Raw menu. You can also access it from Adobe Bridge by choosing Edit→Develop Settings or by right-clicking on selected thumbnails and choosing Develop Settings from the contextual menu.

Figure 3-88. The Presets panel in Camera Raw

Changing the Behavior of the Open Image and Save Image buttons

At the bottom of the Camera Raw dialog are four buttons for saving the file, opening the image into Photoshop or simply applying the changes. Although these are pretty self explanatory, adding some keyboard modifiers into the mix will change the functionality of the these buttons.

Save Image...

This is essentially a way to export the raw file using the settings you have applied in Camera Raw and save it in the JPEG, TIFF, Photoshop, or Digital Negative (DNG) format. Option/Alt-clicking this button will skip the Save Options dialog and save the file using the previously selected options.

Open Image(s)

This will convert the file (or files if you have more than one selected), using the settings you have applied in Camera Raw and open it into Photoshop. The metadata for the file will be updated to reflect the settings you have applied to the image.

Open Copy

Option/Alt-clicking the Open Image button will open a copy of the file into Photoshop. The copy that is opened will show your most recent Camera Raw settings, but the changes will not be updated into the metadata of the file. This is useful if you want to experiment with different interpretations of the file but don't want to change the baseline interpretation of the image.

Open Object

Shift-clicking the Open Image button will convert the raw file and create a Smart Object from it. Placing a raw file as a Smart Object is a bit like having a raw adjustment layer. Double-click on the Smart Object thumbnail in the Layers palette to re-open the Camera Raw dialog and change the settings (Figure 3-89). You can also access the Smart Object feature in Camera Raw by choosing it in the Workflow options dialog box.

Cancel

Option/Alt-click the cancel button will change it to a Reset button. This will clear any settings you have made in Camera Raw but leave the dialog open.

Done

Clicking this will apply the settings you have made in Camera Raw and close the dialog, returning you to Adobe Bridge. The metadata for the file will be updated to reflect your most recent changes.

Figure 3-89. Opening a raw file as a Smart Object creates adjustment layer-type flexibility for raw files after they have been opened in Photoshop. Double-click the Smart Object thumbnail to open the Camera Raw dialog and change the settings for that file. © SD

Photoshop Lightroom

Getting the most from Camera Raw relies on working between Bridge and ACR. Adobe Photoshop Lightroom represents a new approach to the raw workflow in that it combines a database-driven image browser with the capability for enhanced raw adjustments as well as output options that neither Bridge nor Camera Raw currently offer.

Since Camera Raw is the engine under the hood of Photoshop Lightroom's Develop module, the basic theory behind the adjustments, as well as the names of the controls, is the same, but there are some differences. Our purpose here is not to set forth a detailed explanation of every Photoshop Lightroom feature and detail (there are other books that do that very well), but to give you the "big picture" of how Photoshop Lightroom fits into the overall landscape of digital workflow and applications that are targeted towards the digital photographer who shoots raw files.

The Photoshop Lightroom interface

Photoshop Lightroom is divided into five modules that are arranged to echo a typical workflow for working with digital captures. The five modules are Library, Develop, Slideshow, Print, and Web. The theory behind this organization is that first you work with the collection of images (the Library) to sort, rate, and cull, then you move on to "develop" specific images, which involves making adjustments to the raw files, and finally you progress to different ways to output and present your photographs.

The Library module. This area offers many of the same capabilities as the Bridge browser, but they are implemented much better and are more focused on the needs of photographers; Bridge is designed to function as a hub for all of the Creative Suite programs, not all of which use image files. In the Library pane (Figure 3-90), you can work with groups of images as Collections or organize them into folders and perform basic sorting, ranking, and culling. Keywords can be added and the image library can be filtered and searched using a range of criteria. There is even a Quick Develop palette for images that don't require major adjustments (Figure 3-91).

Figure 3-90. The Library module in Lightroom.

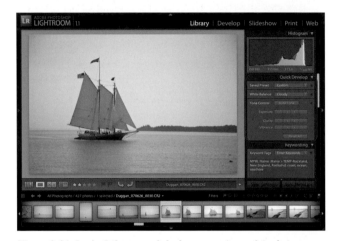

Figure 3-91. In the Library module, larger previews of single images can be viewed and a Quick Develop palette enables you to make basic adjustments.

The Develop module. The Develop module offers all the functionality of Camera Raw and then some. The controls are arranged in a single scrolling panel with different sections that can be collapsed when you're not using them (Figure 3-92). In addition to the same adjustments found in Camera Raw there are also features that are specific to Lightroom, such as the ability to drag in the histogram to adjust the tonal range (Figure 3-93), an enhanced white balance selector tool (Figure 3-94) and the ability to compare before and after views of the same image (Figure 3-95).

The Curve interface in Lightroom includes additional feedback as seen in Figure 3-96. The lighter areas on the curve reflect how far you can push or pull the curve before clipping the image. Additionally, after setting the curve you can adjust the shadow, midtone, and highlight slider directly under the curve interface to have Lightroom include or exclude tonal values in the curve adjustments. When the target mode button in the upper-left corner of the curve area

is activated, you can drag on a particular tonal region in the image preview to lighten or darken those tonal areas. The target mode feature is also present in the HSL and Grayscale Mix controls.

Just as with Camera Raw, any changes you make to files in Photoshop Lightroom are stored in a database or as XMP sidecar files, and the original camera file is never altered.

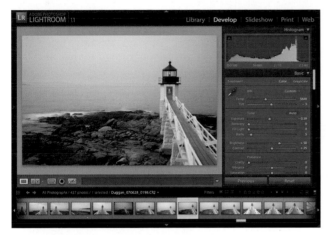

Figure 3-92. The Develop module offers a scrolling palette that contains a varied collection of controls for modifying the image.

Figure 3-93. In Lightroom's Develop module you can drag directly in the histogram to lighten or darken the image.

Figure 3-94. Adjusting white balance with the White Balance Selector tool.

Figure 3-95. Before and After comparative views of the original image (left) and a day-for-night interpretation (right).

Figure 3-96. The Curve in Lightroom offers additional feedback and functionality. When the Target mode button is activated (circled in red), you can click and drag on a tone in the image to lighten or darken those tonal areas.

The Slideshow, Print, and Web modules. The output modules in Photoshop Lightroom—Slideshow (Figure 3-97), Print (Figure 3-98), and Web (Figures 3-99 and 3-100)—all offer an impressive array of settings, too numerous to mention here, for presenting your images, either as onscreen slideshows, as printed output, or as Web galleries.

For an in-depth exploration of all the features available in Photoshop Lightroom, see Mikkel Aaland's *Photoshop Lightroom Adventure* (O'Reilly), or Martin Evening's *The Adobe Photoshop Lightroom Book* (Adobe Press).

Figure 3-97. The Slideshow module.

Figure 3-98. The Print module.

Figure 3-99. The Web module set to the default HTML gallery.

Figure 3-100. The functionality of a Flash web template can be previewed from within Lightroom.

Bridge and Camera Raw, or Photoshop Lightroom?

Which program you decide to use (and of course, there are others on the market) will probably be determined by how many image files you are generating, what type of capabilities and functionality you require, and whether you want to purchase (and learn) a whole new application. If you don't shoot a lot of files and, more importantly, if you don't shoot a lot of raw files, then Photoshop Lightroom may not be worth your time and you may be better off sticking with the still very capable combination of Bridge and Camera Raw. But if you are a high-volume photographer who shoots a lot of raw files, then Photoshop Lightroom is most likely better suited as a complete workflow solution for you.

Of course, in all of this discussion about working in Camera Raw and Photoshop Lightroom, you might be wondering where Photoshop fits into this brave new workflow. After all, if you can do so much to raw files in Camera Raw and Lightroom, what is left to do in Photoshop?

Working with Bridge and Camera Raw, or with Photoshop Lightroom (or similar applications) is all about making a lot of files look very good. Since the nature of these adjustments is global, the focus should be on the overall adjustment.

Since settings can be easily applied to several images at once in both Bridge and Camera Raw or in Photoshop Lightroom, the emphasis is more on workflow.

The key part of workflow is the "flow"—the movement of groups of images through the process to improve them, make them look good, and, in the case of Photoshop Lightroom, to prepare them for a variety of different presentations and output.

In Photoshop, the focus is less on volume production and more on taking a few images and making them perfect. With capabilities such as adjustment layers, selections, layer masks, precision corrections to specific image areas, the additions of texture and blending modes, multiple image composites, and a wide array of filter effects, Photoshop is the program for more individualized attention.

Adobe Bridge, Camera Raw, and Photoshop Lightroom represent the production-line model of moving a lot of images from point A to point B. True, the capabilities of these programs make it a very exciting and creatively stimulating production line, but it is a production line nonetheless. Photoshop is like the artist's studio where time is spent and care is lavished on the image in creative exploration and discovery. Both models are essential to the digital photographer and both can coexist, but it's important to understand where the strengths of each program lie so you can more efficiently focus your energies on the task at hand. In the rest of this book we turn our attention to the artist's studio—the digital darkroom—where creative exploration leads to serendipitous discovery and creative image making.

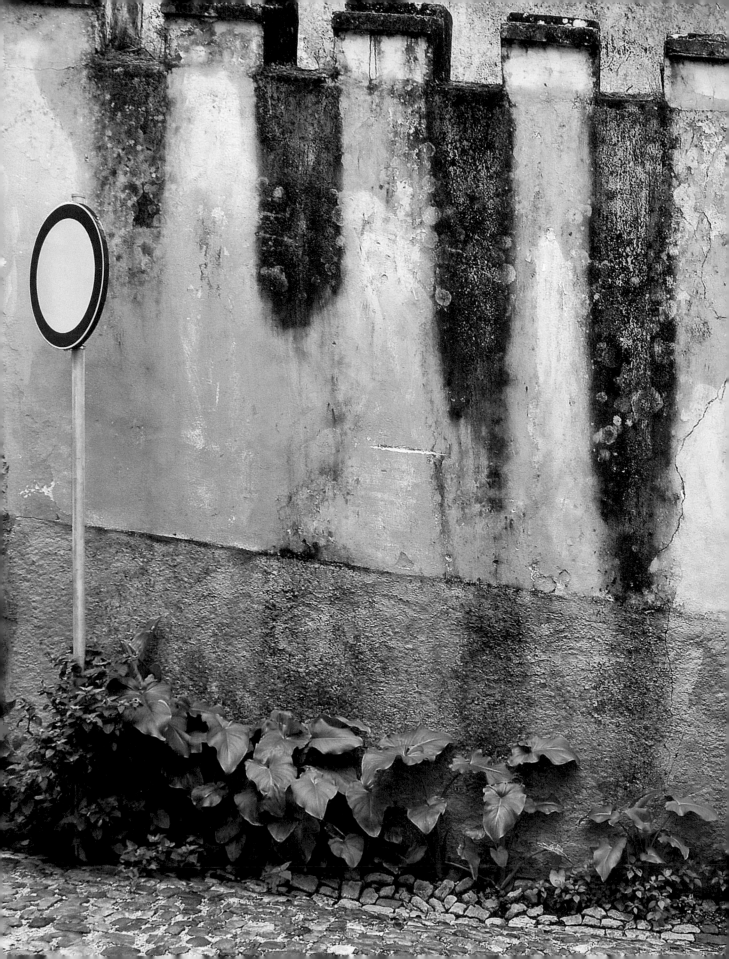

File Preparation

Before painters can create a masterpiece with oil paints, they prepare the canvas by stretching it onto a frame and priming the canvas with multiple coats of gesso. Before master chefs can create a gourmet meal, they take the time to prepare the ingredients: simmer the stock, julienne the vegetables, and trim the meats. Similar to the preparation traditional artisans do before getting to work, for photographers digital preparation is the foundation that insures the best quality image. While some of the preparation work in both digital and traditional realms may be tedious, thankfully a lot of the heavy lifting of applying the same improvements to many digital files can either be automated via Photoshop actions or made easier with third-party software.

This chapter emphasizes the importance of file preparation by addressing:

- Reducing and Avoiding Noise
- Developing a Sharpening Strategy
- Correcting Optical and Dimensional Distortion
- Cropping and Cleaning Up Files

Just as the idea of stretching canvas or peeling onions may not seem like the most exciting tasks, preparing a digital file before delving into the finer aspects of the digital darkroom may not sound pleasant but will yield the best results in the final product. Skipping this step will result in lesser quality images and prints. So lets stir the gesso, sharpen the knives, and learn to prepare digital files to make them look their very best.

Chapter 4

Essential Image Quality

Knowing what to look for when judging the quality of a file is an essential skill. Identifying a problem and its cause is the first step in ferreting out the weakest link in your image-making process, enabling you to avoid the problem in the future while also determining the best approach to remove the problem in software. Some problems may show up only in certain areas such as corners or individual channels, and this influences how you repair or alleviate the problem. The two general categories we look for are photographic and digital. With photographic problems often caused by incorrect exposure, shutter speed, and/or poor lens construction; while inferior sensors and overly aggressive image processing create digital problems that are most often revealed in the delicate tonal transitions and individual image channels.

Photographic concerns

Exposure is the most important technical consideration you make when holding a camera. The right exposure creates a file that requires less tonal adjustment and although you can recover over- or under-exposed images, it is always best to start with the proper exposure as addressed in Chapter 3. Lightening an under-exposed or dark image reveals undesired noise, and there is very little you can do to bring true detail back into those areas. If an image is so over-exposed that the highlights are pure white, reading 255, 255, 255, then there is no true detail in those areas that can be recovered. During image capture, use the camera's histogram to judge your exposure. In our experience, it is best to expose slightly to the right, since darkening an image that is approximately one-third to one-half stop lighter than a standard exposure conceals noise while maintaining highlight detail. In Adobe Photoshop, Photoshop Lightroom and Camera Raw, use the Histogram and Info palettes to judge exposure. The best exposures are not jammed up to the left or the right side of the histogram.

Underexposing images increases noise because the underexposed image received less light and less signal for the camera sensor to create the image with, as the second cropped image in Figure 4-1 illustrates. Séan photographed the museum still life at 3200 ISO and then accidentally underexposed the same scene by one stop.

Figure 4-1. Photographed in dim museum lighting at 3200 ISO, the properly exposed image contains some noise, while the underexposed image, which was lightened in Adobe Camera Raw, has so much color noise that the image is not usable. © SD

Lens Quality

It's a pretty simple equation—better lenses create better images. But better lenses—or as some manufacturers categorize them, professional versus consumer lenses—do have their drawbacks. Professional lenses are more expensive and, in most cases, weigh a great deal more and are larger and bulkier. If you don't plan on making prints larger than 8 × 10 inches, then the expense and weight of the high-end lenses may not be worth it. If you need to make large prints, then you'll need the best lenses possible. We feel that it's better to get the picture with a lens that you can afford and carry around all day than to not get the shot at all. Good lenses produce files that are: sharp without being overly contrasty; free of unwanted distortion; and don't reveal any optical weaknesses such as vignetting, flare, and chromatic aberration.

We've posted additional information on lens attributes on our web site.

🖰 ch4_LensQuality.pdf

Digital attributes

Often noise, over-exposed highlights, and unwanted artifacts are more apparent in individual channels. At 100% view, inspect each channel by clicking red, green, or blue in the Channels palette (or use Cmd/Ctrl+1, 2 or 3. Cmd/Ctrl+~ [tilde] returns the file to the standard composite view). Newer digital cameras capture a cleaner signal, even when shooting with higher ISO ratings.

- Highlight and Shadow Information: Look for highlights with detail and shadows that are not blocky or chunky. In most cases, the red channel, which carries the image contrast, is the one that is most likely to have blown out highlights. The blue channel, which has the weakest signal, has a tendency for an unpleasant chunkiness or texture, as Figure 4-2 illustrates.

- Tonality and Transitions: Each channel should be clean and look like a good black and white image. Of course, each channel will have different tonal characteristics, but in the best-case scenario, each channel should be clean with smooth transitions.

An image that is soft, noisy, off-color, or askew can be just as compelling as a tack-sharp, perfectly exposed image. An effective image balances technical attributes with composition, content, and concept. Technical, aesthetic, and conceptual aspects need to work hand in hand to create the best image possible.

Noise Reduction

The basic steps in file preparation are: noise reduction, alleviating chromatic aberration, capture sharpening, correcting optical and perspective distortion, cropping, and clean up. Over the years we've learned that the better the initial image is (optimal exposure, working with a low ISO, and investing in high-quality lenses), the less file preparation we need to do, and most of the remaining file preparation can be addressed in the raw processing stage. In the following section, we've cleaned out our digital closets and are showing you some worse-case scenarios. As digital cameras improve, your files will require smaller or gentler doses of file preparation.

The goal of noise reduction is to minimize the noise without obliterating fine detail. Noise can be divided into two primary categories: luminance and color (also called chroma) noise. Luminance noise is usually evenly dispersed across the entire image, although more visible in the shadows, and it is the easier of the two to conceal. Color noise is more prevalent in images shot with higher ISO settings starting at ISO 400-800 depending on the digital camera used. The color is mottled and the appearance of color artifact specks are much less attractive (in our opinion) than film grain. Color noise is the more difficult of the two noise types to clear up and either requires a few extra steps or it can be tamed with third-party plug-ins.

Reducing Noise in Raw Processing

Adobe Camera Raw and Photoshop Lightroom are the first place to go to reduce noise before the image is brought into Photoshop for further refinement. Upon opening an image in Camera Raw or Lightroom and setting the basic white balance and exposure parameters click the Detail tab. Make sure to work at 100% or 200% view to see the effect of adjusting the Luminance Smoothing and Color Noise Reduction sliders.

Start by moving both the Luminance Smoothing and Color Noise reduction to zero, and then move each slider in five-step increments to create pleasing results. In our experience, when working with digital camera files shot with 100 to 200 ISO, it's best to start with a Luminance Smoothing of 4 and set Color Noise Reduction at 15 to 20. For images photographed with 400 ISO or higher, start with a Luminance Smoothing setting of 10 to 20, and set Color Noise Reduction at 30 to 70. In Figure 4-3, the image was shot at 1600, and a lot of noise was revealed when we lightened the silhouetted statue. By using more aggressive noise reduction settings, the noise is reasonably reduced. If your images reveal more stubborn noise, then use more aggressive noise reduction techniques in Photoshop or work with third-party plug-ins.

The red channel is very clean.

The green channel also shows good tonality.

The blue channel contains uneven texture and noise.

Figure 4-2. RGB full frame view at 100%. © KE

Figure 4-3. Viewing a file at 100% or 200% view in Adobe Camera Raw provides an accurate and reliable indication of the noise removal effectiveness.

Concealing Luminance Noise

One of the easiest methods to reduce mild luminance noise is simply to cover it up. We learned this straightforward technique from Jack Reznicki and now use it all the time to quickly conceal noise in the shadows:

🖰 ch4_fish.jpg

1. Add a Selective Color Adjustment Layer and use the drop-down menu to select Blacks in Absolute Mode.

2. Increase the Black component by 5 to 10 to darken the shadow areas with black, as seen in Figure 4-4.

3. Adjust layer opacity to refine the effect.

Figure 4-4. Increasing the black component darkens the shadows, which conceals the noise without softening the rest of the image. © KE

Concealing Color Noise

To quickly hide color noise without obliterating detail, use this technique that Katrin learned from John Paul Caponigro.

🖰 ch4_fish2.jpg

1. Duplicate the Background layer, select Filter→Blur→ Gaussian Blur, and use a setting of 5.

2. Change the blurred layer blend mode to Color, as seen in Figure 4-5.

Figure 4-5. Blurring a duplicate layer set to Color blend mode effectively hides the color noise.

Increasing the ISO on a digital camera decreases the amount of light required to form an image and will increase the amount of noise in the file. Test your camera and your personal aesthetic noise threshold by photographing the same scene with each ISO setting your camera offers. Please keep in mind that the content of the image is more important than the possibility of noise and that getting the shot has priority over missing an important image due to fear of noise. One of the most important advances in digital camera performance has been the quality of the digital signal and the improved quality of files even when using higher ISO settings.

Working with Smart Filters

Introduced with Adobe Photoshop CS3, Smart Filters are a welcome feature that enables you to apply, experiment with, and—even after closing and reopening the file—readjust a filter to perfect the file. We recommend using these filters when flexibility offsets the need to keep file size small. Considering that Smart Filters are in their first incarnation in CS3, they are a wonderful feature that will be made even more useful in future versions. As they presently exist you can have only one layer mask on a Smart Filter layer, but you can use multiple filters and move the filters up and down similar to moving layers. We find them especially useful for creative image editing when influencing the sharpness and focus of an image. To create a Smart Filter layer, select Filter→Convert for Smart Filters or Layer→Smart Object→ Convert to Smart Object.

Stronger Noise Reduction

When concealing the noise isn't effective, it's time to be more aggressive with the Photoshop noise reduction filters by separating the noise from the color information in Lab Color mode, or, when the going gets really tough, using dedicated third-party filters or programs.

The two most useful Photoshop noise reduction filters are:

- Blur→Surface Blur: Includes control over both radius and threshold, which is very useful for reducing noise in individual channels.

- Noise→Reduce Noise: Provides a great amount of control, excellent JPEG artifact reduction capabilities, and the ability to save presets.

Figure 4-6. Original image (full and close-up), photographed at 3200 ISO and the close-up after using Surface Blur to reduce the noise © SD

Working with Surface Blur

The Surface Blur filter blurs fine detail while maintaining well-defined edges, making it quite useful for noise reduction. The Radius slider determines how much blur or softening will be applied, and the Threshold slider controls the number of tonal values that will be blurred. Start with a low Radius setting of 2 or 3 and slowly increase the Threshold slider to see how this filter works, as described here to create the results seen in Figure 4-6.

🖱 ch4_lamp.jpg

If you are working with Photoshop CS2 or earlier, which doesn't have Smart Filters, whenever we instruct you to Convert for Smart Filters, please duplicate the intended layer. This will allow you to work along and use the masking and layer techniques featured throughout the book.

1. Choose Filter→ Convert for Smart Filters in Photoshop CS3, and select Filter→ Blur→ Surface Blur. To see the effect the sliders are having, increase the Radius slider to 10, and then click and press inside the Threshold dialogue box.

2. Increase the Threshold slider to make the noise disappear. In this dialog box, it is safe to go too high because over-shooting the goal is helpful when deciding how much noise to remove.

3. To refine the smoothing effect, click in the Radius box, and use the down arrow to lower the radius to find the right balance. In our opinion, a Threshold setting of 8 with a Radius setting of 3 reduced the noise quite well while maintaining the details in the lamp, as seen in Figure 4-7.

4. To refine the noise reduction use a soft-edged black brush to paint on the Smart Filter mask and paint over important details, such as the pink decoration on the tablecloth, the prongs of the fork, and metal parts of the lamp, as seen in Figure 4-8. Painting with black will conceal the Surface Blur from impacting the details.

5. To camouflage the color noise in large, flat surfaces such as the wall, add a new layer and change the blend mode to Color. Sample the wall color and use a large, soft-edged brush to paint over color mottling on the wall. Option/Alt-click to change the Brush tool to the Eyedropper tool to sample a variety of desired colors to paint with.

6. To even out the brushstrokes on the Color layer, select Filter→ Blur→Gaussian Blur with a setting of 5 to create the results seen in Figure 4-9.

Figure 4-7. A higher radius applies more noise reduction while a higher threshold includes more tonal values in the noise reduction.

Figure 4-8. Painting with black on the Smart Filter mask allows the original image information to be visible.

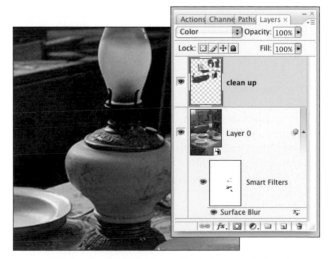

Figure 4-9. Painting on a color layer effectively conceals the color unevenness in the flat surfaces.

Working with Reduce Noise

The Reduce Noise filter allows for greater control over noise reduction, though it is a very slow filter to work with and the controls are not named intuitively. In its defense the Reduce Noise filter reduces both luminance and the tougher color noise well (as illustrated in Figure 4-10), and it includes a "save settings" option to save and reload your commonly used settings.

🖰 ch4_fashion.jpg

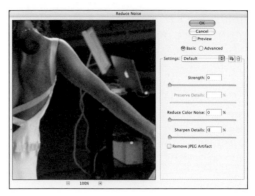

Figure 4-11. To understand how the Reduce Noise filter works it is useful to zero out all sliders and adjust them one at a time.

- Strength: The strength slider controls how much luminance noise is removed. Interestingly, even with a zero setting you can adjust the Reduce Color Noise slider to remove color mottling.

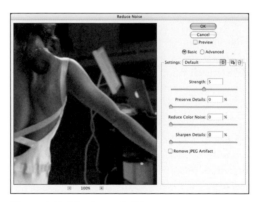

Figure 4-12. The Strength slider.

- Preserve Details: Use this slider to maintain details, which on a noisy file can be an exercise in frustration as fine detail and noise are handled in a similar fashion. For best results, work back and forth between the Strength slider and the Preserve Details slider.

Figure 4-10. Photographed at 1000 ISO, there is color noise in the shadows and undesired texture on the model's back. After Noise reduction the file looks much better. © Mark Beckelman

> To speed up the Reduce Noise filter and make changing the settings more responsive, make sure that the Preview checkbox is unchecked. This tells Photoshop to apply the filter only to the preview in the Reduce Noise interface, not to the actual file. For a quick before and after view, click and press the mouse button on the Reduce Noise preview to see before noise reduction, and then release the mouse to see the filter applied.

In Basic mode, the filter interface offers five controls, as seen in Figure 4-11 through Figure 4-17.

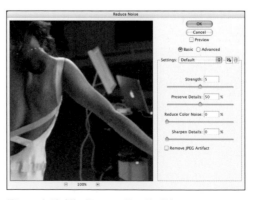

Figure 4-13. The Preserve Details slider.

- Reduce Color Noise: The most effective slider of all, this reduces the color noise. We prefer not to increase the slider above 50% as colors have a tendency to become too desaturated. If you require a higher setting, after using the Reduce Noise filter add a Hue/Saturation adjustment layer and increase the saturation by 10%.

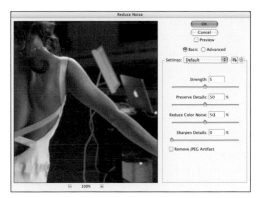

Figure 4-14. The Reduce Color Noise slider.

- Sharpen Details: Use this slider with caution, as it can add horrific artifacts and create more gritty problems than it solves. It is best to leave Sharpen Details at zero and to apply sharpening separately in the following Capture Sharpening phase of file preparation.
- Working in Advanced Mode: This mode enables you to apply additional luminance noise reduction and control the details on the individual channels. Keep in mind that these settings are applied on top of the settings applied to the entire file. In most cases, the blue channel needs more noise reduction.

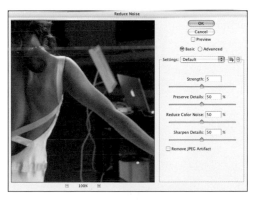

Figure 4-15. Working in Advanced Mode.

- Save Settings: With so many sliders, settings, and variations, we are very glad that there is a save settings feature. Click the tiny floppy disk icon to save worthwhile settings with useful names.

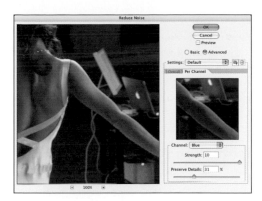

Figure 4-16. Save Settings feature.

- Remove JPEG artifacts: This setting is ideal for reducing the small, square artifacts that low-end digital cameras, cell phones, or overzealous compression can add to a file. Check Remove JPEG Artifacts and adjust the Strength and Reduce Color Noise sliders (Figure 4-18) to gently soften the artifacts away.

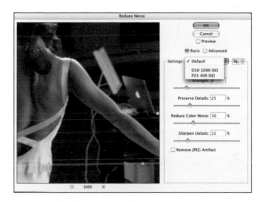

Figure 4-17. Remove JPEG artifacts.

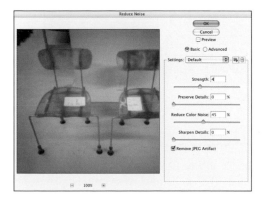

Figure 4-18. © *John McIntosh*

Working with Lab Color Mode

For files that show a lot of color noise, convert the file to Lab Color mode to separate the luminance information from the color information. Avoiding unnecessary mode conversions is recommended, but when you face extremely noisy files try this technique to achieve the worthwhile effects seen in Figure 4-19.

Before

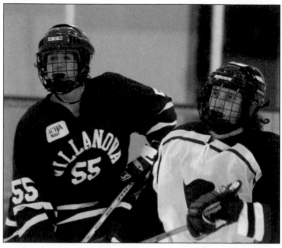

After

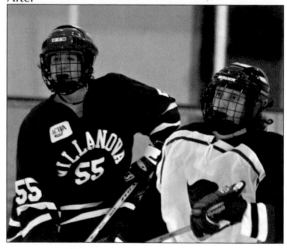

Figure 4-19. Before and After Lab Color noise reduction.
© Mark Beckelman

🖱 ch4_hockey.jpg

1. Choose Image→Mode→Lab Color and inspect the three channels: The L channel contains the tonality, and the A and B channels carry the color information and often contain the noise. Activate the A channel and also click the view column next to the Lab icon to observe the impact that the noise reduction will have on the entire file.

2. For moderately noisy files such as this one, select Filter→Noise→Dust & Scratches. Increase the Radius slider until the noise is wiped out, and then click inside the Threshold box and tap the up arrow key to bring back some of the original texture, which will look like a tight grain. In this example, we used a Radius setting of 8 and a Threshold setting of 5, as seen in Figure 4-20.

3. Select the B channel and Filter→Noise→Dust & Scratches again (or press Cmd+Option/Ctrl+Alt+F) to filter the B channel. In many cases, the B channel will show more noise and require a higher Radius setting, as seen in Figure 4-21.

4. To offset the softening that blurring may have caused, click the A channel and use Filter→Sharpen→Unsharp Mask to tighten up the luminance information. In this example, we used a low Strength setting with a high Radius setting to gently sharpen and improve the overall contrast (Figure 4-22). The Threshold setting of 5 is useful to avoid sharpening very small tonal differences that may look like noise in the final result.

5. For files destined for inkjet prints or Web sites, select Image→Mode→RGB. For offset printing, choose Image→Mode→CMYK.

6. To check your work, open the History palette and click the New Snapshot button on the bottom of the palette; it looks like a little camera. By clicking back and forth between the original snapshot and the final snapshot you can judge the effectiveness of this multi-step technique.

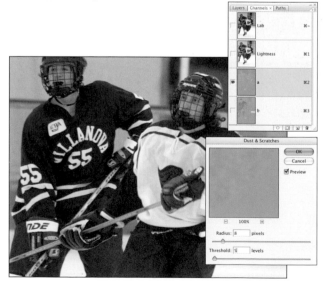

Figure 4-20. The Dust & Scratches filter effectively wipes out the noise without blurring the contours, which would lead to color bleeding.

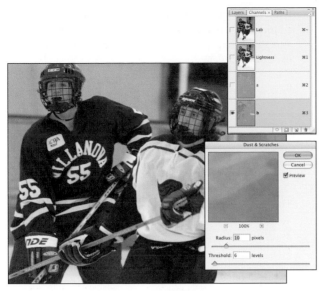

Figure 4-21. The B channel requires a more aggressive use of the Dust & Scratches filter to be effective.

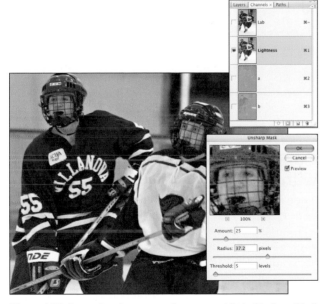

Figure 4-22. Increasing sharpness and contrast with the Unsharp Mask filter in the Lightness channel offsets unwanted softening.

For even more extreme noise situations, use the previous Lab Color technique, but use the Surface Blur on the A and B channels to smooth out the noise instead of using Dust & Scratches.

Third-party noise reduction

As you've seen up to this point in the chapter, taking pictures in low light with higher ISOs can create noisy files. If you face a lot of noisy files or if your photography is, by nature, in low or mixed light or requires a fast shutter speed to freeze motion, you probably have a lot of noisy files on your hard drive. If noisy files are the norm rather than the exception for you, it makes sense to invest in a third-party application or plug-in to be used in conjunction with Photoshop.

Some of the applications we've worked with and are impressed with include:

- Noise Ninja: Produced by PictureCode, a small company based in Austin, Texas, Noise Ninja (Figure 4-23) reflects the computer scientist research background of the developer in both results (Figure 4-24) and power. Using Noise Ninja is a three-step process of Noise Profiling that analyzes the image structure and can be made more accurate with downloadable camera noise profiles: Noise Removal, which is easily previewed and adjusted; and Noise Brush to fade or conceal noise removal. Reading the 30-second and 5-minute User Guide is highly recommended.

- Additional third-party solutions include Nik Software's dFine and Imagenomic's Noiseware, both of which have received rave reviews.

Figure 4-23. Noise Ninja is available both as a stand-alone and as a Photoshop plug-in. © Mark Beckelman

- RAW Developer (Figure 4-25) by Iridientdigital does a fantastic job of both removing noise from raw files and applying subtle hybrid sharpening that improves images very well.

Figure 4-25. Reducing noise in the raw acquire will save a lot of time and effort later on.

Controlling Noise Reduction with Masking

Noise is most visible on flat, evenly toned, darker surfaces such as skies, walls, floors, and darker clothing, none of which usually have a lot of detail or edge definition. Many times you may wish to reduce the noise in these darker, flatter areas while protecting the important image details. Channel and layer masks are the key to controlling where noise reduction takes place—and the most helpful types of masks are the edge and tone masks—which are also used throughout the digital darkroom process to control and refine creative sharpening and tonal and color enhancements.

Edge masking

An edge mask protects the delicate edges and valuable details of an image from being affected from noise reduction, blurring, or sharpening. In the example seen in Figure 4-26, the mask protects the fine tree branches from being blurred or softening while allowing the dark clouds to be improved with noise reduction.

Figure 4-24. The original file processed in Photoshop in Lab and Surface Blur and the Noise Ninja results.

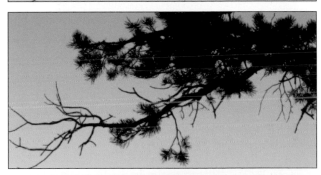

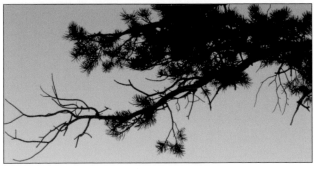

Figure 4-26. Before any noise reduction (full frame and crop) the image showed an undesired grittiness in the clouds.
Applying noise reduction without the edge mask has softened the tree branch details.
Applying noise reduction with the protection of the edge mask maintains the fine details. © KE

Creating an edge mask takes a few moments but it is well worth it, and we've included an action on the book's Web site that will automatically make one for you.

🖱 **ch4_tree.jpg**

🖱 **EdgeMask.atn**

Creating an edge mask

1. Inspect the image channels and identify the one with the greatest contrast. In this example, it is the red channel.

2. In the Channels palette, drag the Red image channel down to the New Channel button. Double-click the layer name ("Red Copy"), and rename the channel "Edge Mask."

3. Select Filter→Stylize→Find Edges.

4. Select Image→Adjustments→Levels, move the highlight slider to the left to force the lighter areas to white, and then adjust the midtones and shadows sliders to create a rich black outline, as seen in Figure 4-27.

5. To thicken the outline, select Filter→Other→ Minimum, and use a setting between 1 and 3; in this example we used 1.

6. Select Filter→Blur→Gaussian Blur, and use the same setting that you just used in the Maximum filter (between 1 and 3).

7. Return to the Layers palette and activate the Background layer.

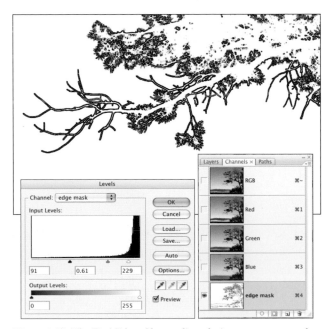

Figure 4-27. The Find Edges filter outlines the image contours, and the Levels enables you to increase the contrast needed to make an effective mask.

Using the edge mask

1. Duplicate the Background layer. Select→Load Selection, and use the Channel pull-down menu to select "Edge Mask."

2. At the bottom of the Layers palette, click the layer mask button to transfer the active selection to the layer mask. Before applying noise reduction, be sure to click the duplicated layer icon to make sure it is active (rather than the layer mask.)

3. Use any of the noise reduction methods described up to this point; in this example we used the Reduce Noise filter as seen in Figure 4-28. Upon close inspection we were very pleased to see how well the fine details of the pine trees were maintained while the clouds were cleaned up.

> To view a layer without the layer mask, Shift-click the layer mask icon. Shift-click again to turn the mask back on.

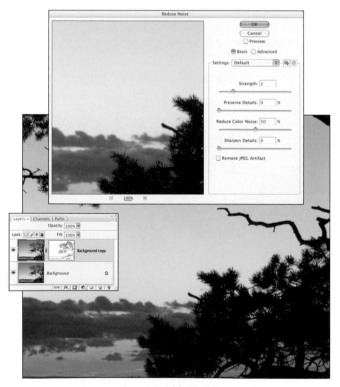

Figure 4-28. Applying the noise reduction through the edge mask maintains fine detail.

Tonal masking

Noise most often lurks in the shadows. A tonal mask enables you to reduce noise in the shadows while not affecting the midtones or highlight areas as seen in the comparison in Figure 4-29.

Figure 4-29. Using a tonal mask to protect highlights allows for more effective noise reduction in the shadows. © KE

🖱 ch4_leaves.jpg

1. Click the Channels palette and view each channel to find the one with the greatest contrast. Duplicate the channel by dragging it down to the New Channel button.

2. Select Image→Adjustments→Levels, and increase the shadow point to at least 50 and the highlight slider to approximately 200, as seen in Figure 4-30. This creates a very contrasty image.

3. Use the Gaussian Blur filter on the channel mask with a setting of 5 or higher to soften the transition from the shadow to midtone areas.

4. Return to the Layers palette, select the background layer, and then select Filter→Convert for Smart Filters.

5. Use the Noise Reduction filter to remove the noise, as seen in Figure 4-31.

6. Click the Smart Filter mask, and then choose Select→Load Selection. Use the Source Channel pull-down menu to select Alpha 4, or use the key command Cmd+Option/Ctrl+Alt+4 to activate the alpha channel as a selection.

7. Choose Edit→Fill Contents Black to block the noise reduction from affecting the less noisy midtones and highlights and creating the final results seen in Figure 4-32.

Figure 4-30. Creating a high-contrast tonal mask.

Figure 4-31. The shadow areas usually contain the most noise.

Figure 4-32. The light areas of the Smart Filter mask are where the greatest noise reduction will take place in the image.

Use tonal masks to control where tonal, color, and sharpening enhancements take place. By inverting the mask you can adjust either the lighter or darker areas of the image without affecting the other.

Avoiding Noise Before Pressing the Shutter

As you can see, a great many techniques and products are available for reducing noise. After wrestling with a wide variety of noisy files, we do our very best to avoid noise whenever possible, using these guidelines:

1. Avoid using the higher ISO settings unless absolutely necessary due to low light, to increase depth of field or to freeze motion.

2. With digital cameras, expose to the right by approximately half an f-stop. Darkening a light file conceals noise, while lightening a darker file reveals noise.

3. Use faster lenses and/or embrace a shallow depth of field and motion blur aesthetic.

4. Take a serious look at working with image stabilization lenses, which enable you to shoot at slower shutter speeds or lower ISO settings.

5. Consider buying a new digital camera as the newer ones have better analog-to-digital conversions and much better light sensitivity performance—both of which create higher quality and cleaner files.

6. Keep your camera cool as heat creates non-signal information. Leaving your digital camera in a hot car is a surefire way to create noisy files. Thankfully, once the camera cools down it will perform as before. We treat our digital cameras like film, protecting them from extreme temperature shifts, humidity, dust, and sand.

Sharpening Process

After applying noise reduction and flattening the image, it's time to enhance the detail of the image with the first step of a three-step sharpening process.

- Input or capture sharpening: Offsets the softness that lenses, anti-aliasing filters in digital cameras, and scanner optics add to an image. This first pass of sharpening needs to be done through an edge mask and should ideally sharpen only the midtones of an image and leave the shadows and highlights untouched.

- Creative or interpretive sharpening: Includes sharpening and blurring techniques to enhance image focus, depth of field, and atmospheric effects. Creative sharpening is applied after global and local tone and color correction and enables you to enhance the subjective and emotional impact of an image. This topic is addressed in greater detail in Chapter 10.

- Output or print sharpening: Each type of output, including offset and inkjet printing and onscreen output for the Web or for presentations, adds softness. Output sharpening takes the dot gain or dither patterns into account and creates a crisper image for reproduction. Sharpening for inkjet printing is addressed in the online section "The Print."

The folks over at PixelGenius have put a lot of thought, testing, and evaluation into creating PhotoKit Sharpener, a Photoshop plug-in that uses a three-phase sharpening method to help users improve their images quickly and easily. PhotoKit Sharpener considers the image source, file character, and final output to produce excellent results.

Input Sharpening

The key to applying delicate input sharpening lies in making an inverted edge mask that enables you to sharpen only the image edges as seen in Figure 4-33.

Figure 4-33. Careful input sharpening tightens up the image edges to create a delicately crisp image. © KE

🖰 ch4_caution.jpg

🖰 ch4_inputsharpen.atn

1. In the Channels palette, duplicate the green channel by dragging it to the New Channel button.

2. Select Image→Adjustment→Curves and, as shown in Figure 4-34, reduce the highlights to add a wash of gray and to deepen the shadows, which will later protect the shadows from being sharpened.

3. Select Filter→Stylize→Find Edges, followed by Filter→Blur→Gaussian Blur of .5 and Image→ Adjustments→Invert, to create the mask seen in Figure 4-35.

4. Return to the composite channel. In the Layers palette, use Cmd-Option/Ctrl-Alt+4 to activate the edge mask, and then choose Layer→New→Layer via Copy (or simply press Cmd/Ctrl+J).

5. Choose Filter→Sharpen→Unsharp Mask, and use relatively low values of 75/.75/0 to add crispness to the edges. Change the layer blend mode to Luminosity to avoid aggravating any possible color artifacts (**Figure** 4-36).

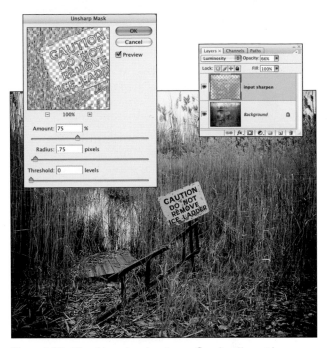

Figure 4-35. *After sharpening the edges, refine the effect with Luminosity blend mode and layer opacity.*

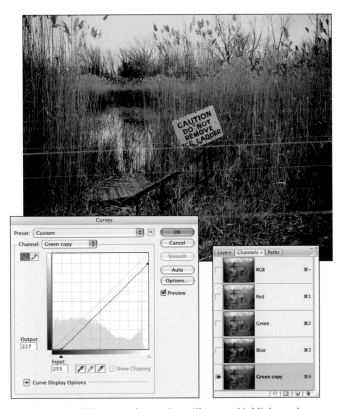

Figure 4-34. *Flattening the tonality will protect highlights and shadows from being sharpened.*

After applying capture sharpening, flatten the layers, delete the alpha mask, and use File→Save As to save a working copy of the sharpened file.

For additional information on image sharpening, please see *Real World Image Sharpening* by Bruce Fraser.

Input Sharpening with Adobe Camera Raw

One of the best aspects of working with raw files is that as the software is updated and improved, you can return to your image collection and reprocess images with more control and higher quality. With the release of Adobe Camera Raw 4.1 for Photoshop CS3, Adobe introduced very impressive raw sharpening with edge-masking controls that sharpens only the luminance information. In our opinion, the sharpening controls in Adobe Camera Raw 4.1 (and higher) and Photoshop Lightroom (1.1 and higher) usurp the need to apply global Input Sharpening in Photoshop.

The image seen in Figure 4-36 shows how subtle and effective the ACR sharpening controls are.

No sharpening

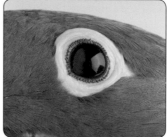
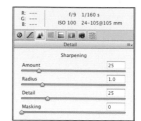

Default sharpening

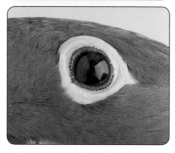
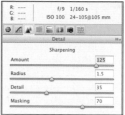

Image-appropriate
sharpening

Figure 4-36. Adobe Camera Raw provides controls for the strength and dimension of the applied sharpening. © Jack Reznicki

When adjusting sharpening in Adobe Camera Raw, make sure you are viewing the image at 100% to see the effect.

The controls in Adobe Camera Raw are:

Amount

From 0 to 150, with higher settings applying a stronger effect. The default for non-raw images is 0 and for raw images is 25. We find the Amount to be the least important slider of the four, as the remaining sliders offer finer controls. Start with a high Amount, such as 100, adjust the remaining sliders, and then return to the Amount slider to refine the overall effect of the sharpening.

Radius

Controls how many pixels (from 0.5 to 3 pixels) on either side of the edge are included in the sharpening.

Detail

The Detail slider controls how fine image areas are treated. Low settings apply a halo dampening on the sharpening edge set by the Radius slider and create a very tight fine-etched look. Higher settings make the sharpening perform more like the traditional Unsharp Mask filter.

Masking

Creates an edge mask, just as the edge mask built in Photoshop controls which image edges are included in the sharpening. Since this edge mask is created on the fly and can slow down the responsiveness of Adobe Camera Raw, we suggest leaving the mask setting at 0 (zero) while adjusting the previous three sliders and then adjust the mask as a final refinement.

To work with the sharpening effectively, make sure to view the image at 100% and also take advantage of the hidden preview. Press Option/Alt to view the effect that each slider is having as seen in Figure 4-37.

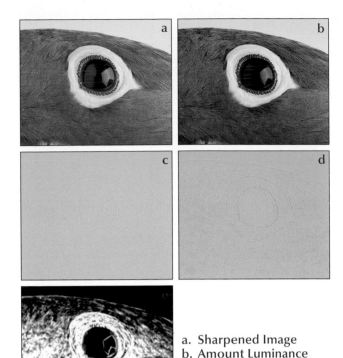

a. Sharpened Image
b. Amount Luminance information
c. Radius effect edge
d. Detail preview
e. Mask

Figure 4-37. Option/Alt-clicking each slider control reveals the internal effect being applied.

To study and adjust the effect of the Camera Raw sharpening, open the raw file as a Smart Object.

The sharpening in Adobe Camera Raw does not replace additional creative and output sharpening and is best used to enhance an image, not to interpret it. Take the time to adjust each slider so that the image looks good at 100% view, not crunchy as older sharpening procedures called for. Once you've found settings that work well for your camera, lens, and image types it makes sense to save the settings in the Presets section of Adobe Camera Raw.

Correcting Optical Distortion and Perspective

We live in a three-dimensional world made up of width, height, and depth, also called the X, Y, and Z axis. Photography is inherently a two-dimensional process in which the three dimensions are flattened onto a 2D surface when we press the shutter. It is at this point in the process of flattening three dimensions down to two that undesired distortions and perspective changes are created.

The focal length of the lenses we use impacts the flattening process. Longer lenses create a forced perspective in which the background is made larger in relationship to the foreground, while wide-angle lenses cause the background to recede and seem smaller. Wider lenses also have a tendency to introduce bowing of vertical and horizontal lines that are close to the edge of the frame. In Photoshop, you cannot change focal length, photographic perspective, or point of view, but you can correct some lens shortcomings.

The optical issues to correct include:

Image Levelness

The slightest misalignment caused by not positioning the camera perfectly perpendicular and level to the subject can cause the image to be slightly off-axis to the horizontal or vertical axis. Level the image first to make it easier to see other possible optical problems.

Keystoning

Unless you're working with a view camera or a shift/tilt lens, which allows control of the alignment of subject, lens plane, and image plane, the vertical or horizontal lines of the image will converge and become narrower the further away they are from the camera. Of course, the receding lines can be used for creative effect, but when photographing subjects that should be straight, such as architecture or product shots, proper alignment of horizontal and vertical lines are the mark of a professional photographer.

Barrel and Pincushion Distortion

Barrel distortion is a bowing out and pincushion distortion is a pinching in of image edges. Both of these distortions are more exaggerated with wider, lower quality lenses and zoom lenses on inexpensive point-and shoot cameras.

Vignetting and Flare

Vignetting is the darkening of the image corners, which may or may not bother you. Vignetting is best fixed in the raw acquire, while removing vignetting from a film scan or flare is a retouching process and can be concealed in the Spotting and Clean-up phase. Removing flare is a challenge as it not only leaves telltale sun splotches, but it also reduces image contrast.

Chromatic Aberration

Color fringing usually found near the image frame and more visible on high-contrast image areas. Lower quality and wider angle lenses have a greater propensity to create chromatic aberration. It is best to correct for chromatic aberration in the raw acquire phase of the digital workflow and before applying input sharpening.

The tools and techniques used to correct optical shortcomings include: Raw acquire software to remove chromatic aberration, vignetting, and straightening images as addressed in Chapter 3; Photoshop Lens Correction filter to correct distortion and keystoning; transform controls and the Crop tool to correct perspective and distortion; adjustment layers and retouching tools to remove vignetting and flare; and third-party applications such as DxO to process and correct a wide variety of lens shortcomings in the raw acquire, all of which are addressed here.

The Lens Correction Filter

The Lens Correction filter is an excellent tool to straighten, rotate, remove distortion, and correct vertical or horizontal perspective. The ability to apply a variety of corrections while seeing how each one improves the image is the strength of the Lens Correction filter.

Working efficiently with the Lens Correction filter

1. Before selecting Filter→Distort→Lens Correction, imagine the subject of the photograph imposed on a cube: a single face of the cube when the photograph was shot in one-point perspective, or an angled cube when photographed in two-point perspective, as seen in Figure 4-38. For us, imagining the subject on a cube makes it easier to see which lines need to be straightened or where distortion needs to be removed.

2. Set the grid to a useful size and color. The defaults of 16 and gray are usually too small and too subtle to be very helpful. We use 32 with a red grid. Use the Move Grid tool to position the grid along important lines such as the edge of buildings or along the horizon line to give you a reference for what should be straight and whether the corrections are improving the image.

3. Start the correction session by straightening the subject with the Straighten tool by dragging along a vertical or horizontal line. If the subject isn't straight, it will be more difficult to use the other correction features.

Figure 4-38. The same abandoned security house photographed in one- and two-point perspective. © KE

On the right side of the Lens Correction interface, work from top to bottom. Keep in mind that correcting one flaw may make others more apparent, which calls for a flexible working back and forth between the straighten, remove distortion, and transform:

Remove Distortion

Corrects bowing or pinching (officially called *barrel distortion*) when the image bows outward and *pincushioning* when the image edges pinch in.

Chromatic Aberration

Removes color fringing most often found near the edges of images in high-contrast areas. If you work with a digital camera that can capture in the raw format, it is better to remove chromatic aberration with Adobe Camera Raw or Photoshop Lightroom.

Vignette

Lightens dark corners that were created by large lens shades or zoom lenses. Vignette can also darken corners for a creative effect.

Set Lens Default

Useful when using prime lenses (not zoom lenses). After correcting an image, click Set Lens Default to save the corrections for the next time an image is opened that was photographed with that same lens.

Transform

Corrects perspective to straighten up buildings.

Edge

As the image is scaled and corrected, transparent areas are created. The options to conceal this are Transparency, Edge Extension (not recommended), and Background Color. We recommend either scaling to increase the image to hide the transparent edges or ignoring this feature and using the Crop tool afterwards.

Correcting lens distortion

When we use different focal length lenses, we often trade off an optical distortion for the ability to get the whole image within our viewfinder. This is very noticeable when a wide-angle lens is used. As the lens takes in a wider view, a noticeable bend is created in straight lines. The image of a contemporary building, taken with a 20mm lens, is distorted, which is especially visible in the vertical lines near the edge of the frame, as seen in Figure 4-39. With just a few adjustments inside the Lens Correction filter, the lines are straightened and the bowing is removed.

🖱 ch4_glassbuilding.jpg

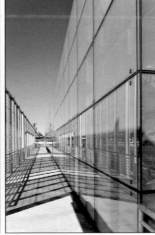

Figure 4-39. Photographing with a 20 mm lens caused the wall to bow inwards. After using the Lens Correction filter, the wall is less distorted. © KF

1. Duplicate the background layer.

2. Select Filter→Distort→Lens Correction. Check the Show Grid box for assistance in determining the lines that need to be straight. Place the mouse cursor in the Remove Distortion box, and hold Shift while tapping the up arrow key to remove distortion in one-step increments. In this example, we used a +4.00 to reduce the bowing.

3. Next, use the Vignetting slider to lighten the corners.

4. The Transform sliders can dramatically correct keystoning. Sliding the Vertical Perspective to +12 straightens the wall. Tweaking the Horizontal Perspective to –1 brings the left side of the building to the foreground ever so slightly, as seen in Figure 4-40.

5. After accepting the Lens Correction, use the Crop tool to crop out the extraneous edges.

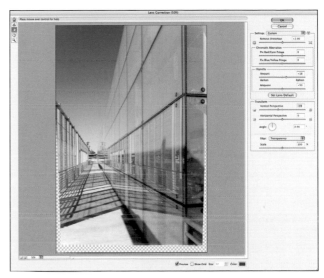

Figure 4-40. Fine-tuning and adjusting the building was achieved by removing distortion to straighten the building right out.

Correcting architectural perspective

If you use a 35 mm film or digital SLR camera to photograph a building, then you'll notice that the building looks as if it's falling backwards. But when you look at the actual scene, the building isn't tilting at all. Our visual system corrects the perspective just as a view camera does, by aligning vertical and horizontal lines to make the building look as straight as it really is, as shown in the before and after comparison in Figure 4-41.

🖱 ch4_convent.jpg

> Duplicate the image layer before entering the Lens Correction filter in order to use the Edit > Transform controls afterwards. Smart Filter layers cannot be transformed with skew or distort, which is why we duplicate the layer rather than convert for Smart Filter when working with the Lens Correction filter.

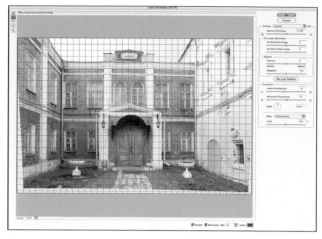

Figure 4-42. Do as much correction as you can in the Lens Correction filter interface.

Before

One essential control that the Lens Correction filter does not have is the ability to pull and push individual image corners into position. This is exactly why we recommend duplicating the image layer before entering the Lens Correction filter. After using Lens Correction, turn the visibility of the corrected layer on and off. If you feel that the image still requires adjustment, use Edit→Free Transform to pull and push corners into place, as seen in Figure 4-43, to create the final image.

> Control/right mouse button on the transform anchor points to access all of the transformation controls.

After

Figure 4-41. Before and after correcting the optical and lens distortion.
© KE

Although it's always better to create the best image in front of the lens and not rely on Photoshop to fix mistakes, Katrin doesn't travel with a view camera, which means she relies on the Transform and Lens Correction features to correct images that curve, bend, fall backwards, and generally are out of alignment. The Lens Correction filter interface seen in Figure 4-42 shows how she straightened the top of the building, removed distortion, and brought the building up via the Vertical Perspective slider.

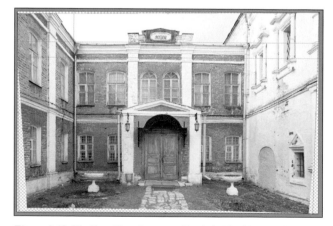

Figure 4-43. Use Free Transform to refine individual image planes.

When photographing a scene with the intent of correcting it with the Lens Correction filter, frame the scene in the viewfinder, and then take a few steps back to provide the space needed to correct and scale the image.

Cropping and Cleaning Up Images

At first glance, cropping may seem like a rather mundane and self-explanatory process. How hard could it really be? Click, hold, drag, and accept the crop. Cropping an image is actually a critical aspect of image composition. The essential question to consider is whether to crop early in the digital darkroom process or later on. The advantages of cropping early are you'll be working with a smaller file, and all image enhancements such as edge burning or adding neutral density filter effects will be accurate. Imagine if you took the time to darken down the edges of the image perfectly and then cropped the file. All of the burning work would be discarded and would have to be redone. The advantage of cropping late into the digital darkroom process is that you maintain all of the image information. Quite honestly, we both concentrate on composing the image in the viewfinder exactly the way we want the final image to be printed and use the Crop tool only to improve the image, not as an excuse for poor image composition. The Crop tool can be used to recompose and straighten images and correct perspective.

Before you grab the Crop tool and start slicing away at your images, always check:

- The Options settings: Make sure that they are zeroed out by clicking the Clear button to clear settings you may have used in a previous digital darkroom session.

- The Layer palette: Convert the Background layer to a standard layer by double-clicking it and renaming it or duplicating the Background layer. This enables you to hide the cropped image information versus deleting the image information.

- Tap F: Full screen mode provides better access to the Crop tool handles when refining composition and/or increasing canvas size.

Third-Party Optical Correction

It can be rather discouraging to realize how much distortion, vignetting, and edge softening even very good lenses may add to an image. In fact, until the distortion is removed you often don't even realize how contorted your images may be. One elegant solution to correct a variety of optical defects is DxO Optics Pro. Katrin has tested this product and uses it in her own work, especially when she needs to correct images taken with zoom and wide-angle lenses with dSLR cameras. Based on a highly scientific mapping and analysis of the most commonly used lenses, DxO Optics Pro corrects for lens distortion, vignetting, and overall and corner softness and enhances exposure and color in the raw acquire process. In Figure 4-44 you see the same image—once processed via Adobe Camera Raw and once with DxO Optics Pro in which DxO Optics Pro corrected the lens distortion, vignetting, and uneven softness quickly, easily, and effectively.

Figure 4-44. The lens used to photograph this scene distorted the horizon (image acquired in Adobe Camera Raw). After processing the original raw image in DxO Optics Pro, the horizon line is flat © KE

Recomposing images

Ideally, each image would be perfectly composed in the camera, but many times the fleeting moment requires quick reactions or modifications if, upon seeing the image in the raw acquire or in Photoshop, Katrin cropped the photograph in Figure 4-45 in Adobe Camera Raw to emphasize the freshness of green growth in the lava fields.

Figure 4-45. The tighter crop emphasizes the horizontal composition of the green ferns growing through the black lava. © KE

In Photoshop, to draw the initial crop, click in the upper-left area of the image, then drag diagonally to the right, and then release the mouse upon reaching the lower-right side. You don't need to make the perfect crop; you can move the crop frame around the image by grabbing the center area (not center cross hair) to reposition the crop, or use the handle points to refine the crop.

Cropping Tips

Before cropping, double-click on the background layer to convert it to a standard layer. After setting the crop but before accepting it make sure to click 'Hide' in the options bar to hide the extraneous image information without deleting it.

- When cropping to recompose an image, work with zeroed-out Crop tool settings that enable you to draw the crop freely.

- When working close to the image edge, press Cmd/Ctrl to turn off the snap-to-edge behavior of the Crop tool.

- Use the Crop tool to extend Canvas Size by dragging the crop handles outside the existing image frame and accepting the crop.

Straightening and correcting perspective

As simple as it sounds, straightening images takes care and practice. Learn to take advantage of Photoshop's Guides, Grids, and Measure tool to make short order of crooked pictures, creating the results seen in Figure 4-46.

🖰 ch4_bluewater.jpg

Figure 4-46. Straightening the horizon in the background emphasizes the composition in the foreground. © KE

1. Choose View→Show→Grid to superimpose a grid over the image to visually reference the horizontal and vertical lines in the image. In this example, the grid clearly shows that the horizon is crooked. Before proceeding, select View→Snap to→None to use the Ruler tool in the next step without being constrained to the grid.

2. The very useful Ruler tool is nested under the Eyedropper tool. Using the Ruler tool, click the left side of a line that needs to be straight. Click and drag to the right following the line that you want to be straight—in this case the horizon—and click the right side of the line, as seen in Figure 4-47.

3. Select Image→Rotate Canvas→Arbitrary. The measured value has been placed in the Arbitrary dialog box, and all you need to do is click OK to achieve the results seen in Figure 4-48.

4. The rotation necessitates that Photoshop add canvas size to avoid cutting off image corners. Before accessing the Crop tool, double-click the Background layer in the Layers palette to turn it into a standard image layer.

5. Use the Crop tool to recrop the image but before accepting the crop make sure to click the Hide button, as circled in Figure 4-49. Hiding the crop preserves the extraneous image information, which may be useful in later image editing. To see the entire image, select Image→Reveal All. As long as you save the file in a file format with layers (PSB, PSD, and TIF), the extra image data will remain intact.

Figure 4-47. Use the Ruler tool to trace along the line that you need to be straight.

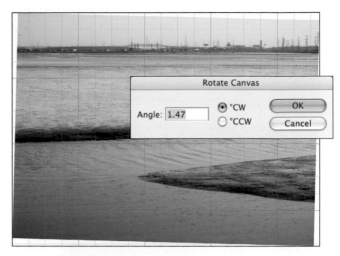

Figure 4-48. The Arbitrary Rotate command is precise to the hundredths of a degree.

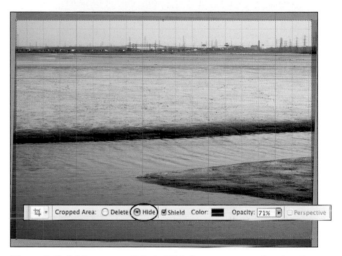

Figure 4-49. Make sure to click the Hide button to conceal rather than delete extra image information.

Perspective cropping

Sadly, the X and Y axis can both be askew, and when subjects are in the picture that you know were or should be straight, you may be facing a perspective issue, as seen in the example in Figure 4-50. The crookedness of the image was not planned—really it wasn't. Rather, Katrin saw the man coming out of the shadows and wanted to portray him as he strode purposefully into the light. In her rush to get the image centered, she didn't get the building straight, which is where the Crop tool with Perspective can be used to great effect to create the final image.

ch4_sweden.jpg

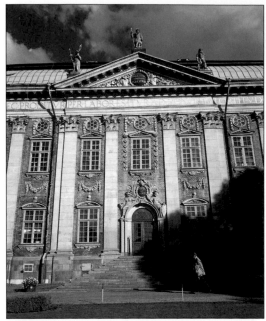

Before

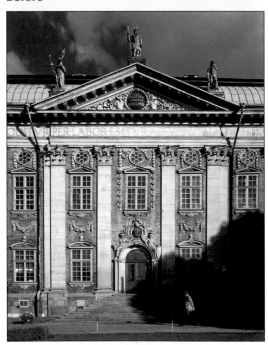

After

Figure 4-50. The original and the intended image. © KE

1. Draw a tight crop that frames the lines that should be straight, and then click the Perspective option in the options bar, as circled in Figure 4-51.

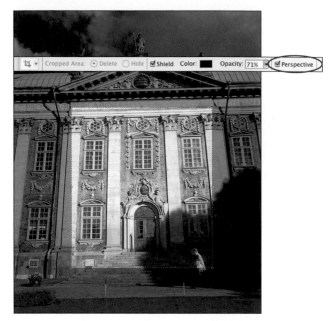

Figure 4-51. Draw the initial crop and check Perspective in the options bar.

2. Use the corner handles to position the Crop marquee along lines in the image that are both straight in reality and need to be straightened in the image (Figure 4-52).

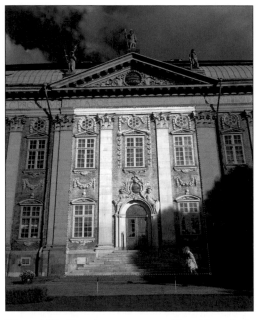

Figure 4-52. Align the crop marquee sides with vertical and horizontal edges that should be straight.

3. Use the center handles to pull the frame out to include as much of the image as needed. In this example seen in Figure 4-53, blank image information will be added to the file in the lower-right corner that will need to be replaced with the Clone Stamp after correcting the perspective.

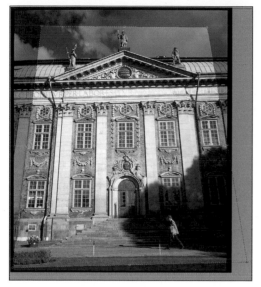

Figure 4-53. Frame the image to include as much of the file as possible.

4. Press Enter to accept the crop. Sadly, this tool is sometimes an exercise in frustration, and you may end up with oddball images, as seen in Figure 4-54. The best advice we can give you is to just Edit→Undo. We prefer to use the Lens Correction filter to correct perspective and avoid the Perspective Crop tool's unpredictable behavior.

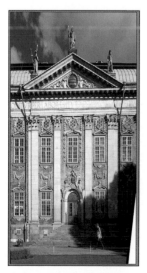

Figure 4-54. The Perspective crop tool can, in some cases, create unexpected results. Undo the crop and try again to achieve better results.

5. The Perspective crop cannot make up photographic information, and we used a combination of duplicated information and the Clone tool to rebuild the missing corner, as seen in Figure 4-55.

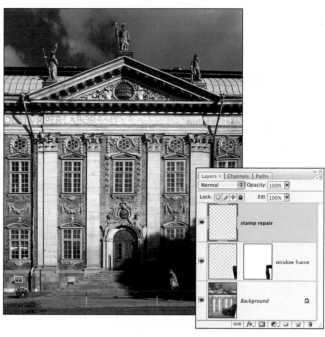

Figure 4-55. Duplicating and cloning repaired the image corner.

If you do a lot of architectural photography with a 35 mm camera, then purchasing or renting a perspective correction shift/tilt lens will improve your final image quality. Correcting the perspective before pressing the shutter will always yield better results.

Spotting and Cleanup

Dust, specks, streaks, scratches, flare, and vignetting are the bane of our mouse-clicking existence. In fact, upon leaving the wet darkroom—with its radioactive dust brushes, compressed air, and anti-static cloths—we thought we were done with dust forever. Sadly, like the Charlie Brown character Pigpen scuffing along, the dust issue has followed us into the digital darkroom as it settles onto camera sensors and film to be scanned, leaving its grimy little blobs and marks on our files. Dust is most visible in lighter, less detailed image areas such as skies and studio backdrops.

Dust Spotting

The term *spotting* has its origins in the traditional darkroom process. After the print was dry, the photographer would carefully use a dark dye called Spotone™ with a very fine brush to carefully dab or spot over specks caused by dust sitting on the negative or paper during enlarger exposure. It was a less than pleasant way to pass time, as you were just as likely to create larger, darker problems than conceal smaller, lighter ones. When working with Spotone™, there was no Undo command.

Most files from digital cameras need to be cleaned up at least once if not more often with a combination of the following approaches:

1. Conceal dust in the raw acquire with Adobe Camera Raw or Photoshop Lightroom. The spotting can be synchronized to remove the dust from multiple, similar files (as described below).

2. Upon bringing the image into Photoshop, many users do an initial file inspection and spot the largest most troublesome specks away.

3. Spot after all the tonal, color, and creative work has been done. By this time, any contrast-increasing layers may have revealed more spots, which you need to take out to create a pristine master file.

4. After applying output sharpening and before making a print, it's a good idea to make one more pass of the file at 100% view to check if the sharpening has revealed any unwanted specks.

As Seán explains, "I spot film scans before archiving the original scan file, so that my archived scanned image is clean when I save it for future use. That way, when I return to that saved file, I don't have to respot it every time I want to use it."

Spotting in the raw

With Photoshop CS3 and Photoshop Lightroom, Adobe introduced the ability to remove dust in the raw acquire step, which is a real time saver when working with many similar files in which the sensor dust is in the same place on every shot. We find this especially useful for cleaning up landscape files shot for panoramic images, as the dust shows more in flatter, less detailed image areas, such as skies, as seen in the before and after clean-up example in Figure 4-56.

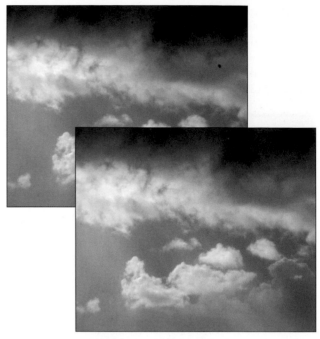

Figure 4-56. Before and after clean up in ACR. © KE

The big advantage of removing dust in raw processing is the ability to spot one image and apply the spotting to other similar images that were taken with the same camera at the same time. Of course, if one frame is a picture of the sky and the next image is a picture of a person, you can't expect the software to differentiate between the two and the spotting coordinates of the first image will be used on the second image, which may or may not produce pleasing results.

⏏ **ch4_dust1.dng**

⏏ **ch4_dust2.dng**

1. In Adobe Bridge, select the group of camera raw or JPEG images, and use Cmd/Ctrl+R to bring multiple images into Adobe Camera Raw.

2. Set the Retouch tool to Heal, as circled in Figure 4-57. Drag over a spot, which creates a red circle and, upon releasing the mouse, a green circle will appear. The red circle is the area that is being healed, and the green circle signifies the healing information source.

3. In most cases, the Retouch tool works very well automatically. To refine the healing, drag the green circle into a new position to sample similar textured and toned information (Figure 4-58). Repeat for each spot.

4. To apply the retouching to other similar images, click the Select All button in the upper-left corner, and then click Synchronize.

5. Use the Synchronize pull-down menu and drag down to Spot Removal. Clicking OK applies the spotting coordinates to all selected images.

Figure 4-57. Bring similar images into Adobe Camera Raw and set the Retouch tool to Heal.

Figure 4-58. Working at 100% or 200% view to retouch one image.

Spotting in Photoshop

Cleaning up a file in Photoshop is a common task and as odd as it sounds it can be a very relaxing endeavor. Clean up is done on a separate layer with a combination of the Healing and Clone tools. For the best results, use the Patch, Spot, and Healing Brush on areas with similar color or contrast values and the Clone tool on transitional and high contrast areas to create the results seen in Figure 4-59.

Figure 4-59. A terribly dirty sensor caused countless spots to appear on each and every file. © KE

🖱 ch4_field.jpg

1. Add a new layer at the top of the image layer stack.

2. Use the Spot Healing Brush set to 'Sample All Layers'. Select a brush that is slightly larger than the dust speck, and tap the brush once or twice on the dust speck. If you're not pleased with the results, undo

the last step, and use the standard Healing Brush to remove the dust spot by Option/Alt-clicking a good, clean area, and then dabbing over the bothersome dust, as seen in Figure 4-60.

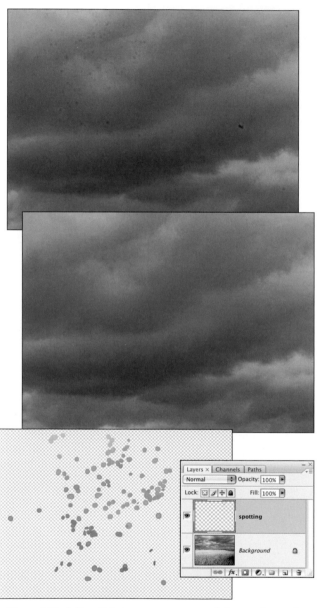

Figure 4-60. A dirty digital camera sensor caused the round specs that are very noticeable in the sky. © KE

Cleaning up the file with a separate layer enables you to refine the clean up by erasing less-than-successful spotting attempts and reworking the clean up until you are satisfied. After spending a few hours on one file removing the dust, we recommend cleaning the camera sensor to avoid the problem in the first place. Resources for sensor cleaning techniques and tools are listed on the book's web site.

> To maintain image texture, use a tap-tap brush action versus a dragging stroke. When cleaning up areas with great color or tone contrast, use the Clone Stamp tool rather than the Healing tools to avoid introducing tonal blurs.

Editorial clean-up

One of the great advantages of working digitally is the ability to perfect the file by removing distractions, such as bothersome backgrounds, birds that look like dirt specks, and irritating reflections. When the problem is small, like the black fleck on the white tulip and the tip of the leaf in the lower-left corner (Figure 4-61), you can safely and easily remove it at this stage. If the distractions require extensive pixel surgery, we recommend removing the distraction after enhancing tone and color. As seen in Figure 4-62, the tree coming out of the groom's head and the pedestrians behind the tree are very distracting. By removing them, the image is better-focused on the groom.

Figure 4-61. Removing the slight imperfections from the white tulip and concealing the tip of the leaf in the lower left corner strengthens the image composition. © KE

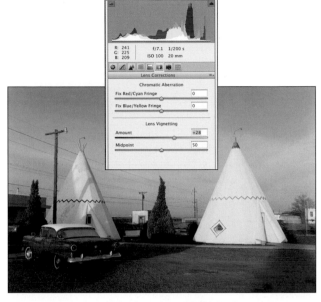

Figure 4-64. Removing the vignetting with Adobe Camera Raw provides a subtle and effective improvement.

Many times, one side of the image will be darker than the other and, in that case, the Vignetting controls in Adobe Camera Raw and Photoshop Lightroom are of little use. To correct one-sided density differences, you need to use image adjustment layers to create the results seen in Figure 4-65.

🖱 ch4_church.jpg

Figure 4-62. Removing the tree branches and strollers in the background allow the image to be about the groom. © KE

Removing vignetting and flare

Vignetting is a darkening of the image edges, caused by poor lens construction or lens shades and filters that are too small for the lens focal length that infringe on the image edges, as seen in Figure 4-63. When working with raw files, reducing the vignetting is best done before any file preparation in the raw acquire phase (Figure 4-64).

🖱 ch4_wigwam.dng

Figure 4-63. The edge vignetting was caused by a lens shade that was too small for the 20 mm wide-angle lens. © KE

Figure 4-65. Balancing the exposure in the sky balances the entire image. © KE

1. Add a Curves adjustment layer, and then click OK without making any changes. Change the layer blend mode to Screen, and select Image→Adjustments→ Invert or Cmd/Ctrl-I to invert the layer mask to conceal the change, as seen in Figure 4-66.

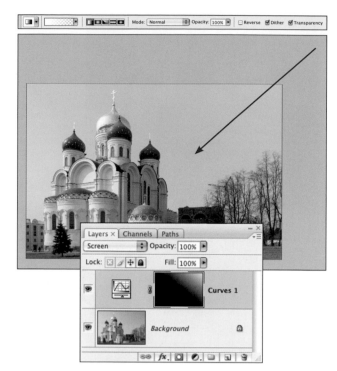

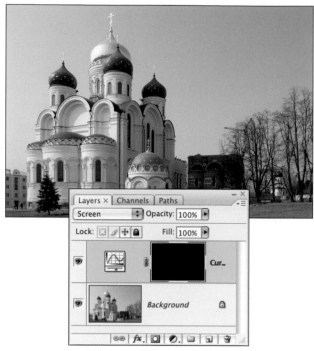

Figure 4-66. The Screen blending mode lightens images, and the black layer mask conceals the effect.

Figure 4-67. The foreground-to-transparent gradient builds up the effect with repeated pulls of the Gradient tool.

2. Tap D to reset the color picker to the default of black and white, and tap X to swap the colors so that white is the foreground color. Activate the Gradient tool, and make sure to choose the foreground-to-transparent gradient (the second gradient in the gradient editor in the Options bar).

3. Working in full-screen mode, start the gradient well outside the image area, and drag diagonally down to the left, as seen in Figure 4-67. Starting the gradient away from the image edge allows the transition to be very subtle. The beauty of the foreground-to-transparent gradient is that you can increase the effect with repeated clicks and drags of the tool to gradually build up the lightening effect.

4. In this example, the lightening effect also impacted the church. To conceal the lightening on the church, use a large, soft-edged black brush to paint on the Curves layer mask over the building, as seen in Figure 4-68.

5. If the lightening effect is too strong, reduce the layer opacity, and if it is too weak, duplicate the Curve layer and adjust the layer opacity.

Removing Chromatic Aberration

Chromatic aberration is created when the light rays do not focus on exactly the same plane, causing color fringing on high contrast edges, most often seen near the edge of the frame (Figure 4-69) and most often with wider and lower quality lenses. Chromatic aberration is best removed in the raw acquire step and should be removed or concealed before any sharpening is applied to the file. If the file is already in Photoshop and you cannot process it with Adobe Camera Raw or Photoshop Lightroom to remove the color fringing, you can retouch the chromatic aberration with the clone tool as explained later in this section.

🖱 ch4_chromatic.dng

1. Open the image in Camera Raw and zoom to 100% or 200% view.

2. After adjusting White balance and exposure, click on the Lens Correction tab as seen in Figure 4-70. Start with the worst color fringe. In this example, the red fringe is glaringly large. Move the Red/Cyan Fringe slider to the left to remove red or to the right to remove cyan. In this example moving the slider to −32 removes the red fringe very well as seen in Figure 4-70.

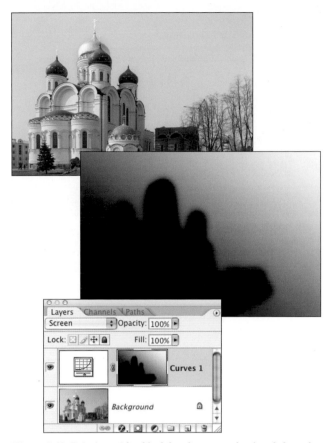

Figure 4-68. Painting with a black brush protects the church from the lightening effect.

Figure 4-69. Chromatic aberration is most commonly seen on the high contrast edges. © KE

Figure 4-70. Adjusting the Chromatic Aberration sliders changes the size of the individual image channels in sub-pixel increments.

In Adobe Camera Raw, press Option/Alt to see only one color when adjusting the Chromatic Aberration sliders.

Concealing Chromatic Aberration

Chromatic aberration can happen with film or sometimes you don't notice the color fringes until after the raw acquire. When removing the chromatic aberration isn't possible with the raw processing, try the following technique, which conceals the chromatic aberration very well as seen in Figure 4-71.

Figure 4-71. Concealing chromatic aberration in Photoshop is time-consuming, but effective. © KE

1. Add a new layer and change the blend mode to Color.

2. Use a small 50% hardness Clone Stamp with 'Current and Below' and Opt/Alt click on correct areas directly adjacent to the chromatic aberration. Paint with the Clone Stamp tool along the color fringing to conceal it with the correct color as seen in Figure 4-72.

Figure 4-72. Cloning onto a Color blend mode layer effectively conceals the color fringing.

Figure 4-73. Removing the lens flare and vignetting creates a useful file for panoramic stitching. © KE

Removing flare

Flare can creep into your images when you don't use a lens shade or when shooting at a steep angle to the sun. Flare reduces image contrast, and it can be soft and diffused or so defined that the shape of lens blades is visible in the image, as seen in Figure 4-73. When the vignetting falls on even blue sky, use the Patch tool to quickly repair the areas with the following technique.

🖰 ch4_flare.jpg

1. The Patch tool cannot work on an empty layer, which requires that you duplicate the Background layer. Use the Patch tool set to Source to generously select the first flare, as seen in Figure 4-74.

2. Drag the Patch selection to good sky and repeat with the additional flare spots, as seen in Figure 4-75.

3. To finish the image remove the vignetting with the Patch tool and Curves adjustment layer as previously explained and shown in Figure 4-76.

Figure 4-74. Starting with a generous selection gives the Patch tool and healing engine more image information to better calculate the repair.

Figure 4-75. Avoiding high-contrast areas such as the tree branches insures a better repair.

Figure 4-76. Where there is flare there is quite often vignetting, which should also be removed.

When flare falls on more complex image areas, a combination of adjustment layers, cloning, healing, and duplicating good information to conceal bad is required. Similar to involved image retouching, removing extreme flare can either be done now in the file preparation phase or after the initial tone and color correction steps.

Practicing for Tomorrow

The more photographs you take and the more images you work with, the faster and better you'll evaluate the quality of an image and know which tools and techniques to use to prepare the file. Learn how your camera equipment and photographic decisions are affecting the quality of your files. The best file is the one that requires the least amount of work, and getting the image correct in front of the lens reduces tedious, yet essential, file preparation while increasing the pleasure of working with your images. From concept to lighting to camera and lens choice to exposure and file format, the entire digital darkroom process is much greater than a single piece of software.

Figure 4-77. Photographed with a Canon 20d and Lensbaby 2.0 the file was prepared and processed in Adobe Photoshop Lightroom without the use of any third party filters or additional special effects. © KE

Tone and Contrast

Most photographers who have had experience working in a traditional chemical darkroom have vivid memories of the first time they watched the image gradually appear on the photo paper in the developer tray. The magic and mystery of this moment, and the impact that it has had upon photographers, cannot be underestimated. For many, it is this key moment that started them on the creative path of photography they would follow for their whole lives.

Since the photographic journey started in the black-and-white darkroom for many photographers (at least in terms of crafting a final image), it is with the black-and-white image that we will begin our discussion of the many ways you can enhance a photograph in the digital darkroom.

In this chapter we'll focus on some fundamental concepts and techniques for:

- Understanding Tone and Contrast
- Listening to the Image
- Applying Global Image Improvements
- Understanding Levels and Curves
- Toning and Split-Toning Effects
- Combining Color with Black and White.

The first step in improving any image is to consider the overall scene. Although specific areas may clearly need attention, it is only after making global adjustments that apply to the entire image that you know exactly what type of finessing to apply locally to certain areas. In this chapter we'll mirror this aspect of the tonal correction workflow and begin with an overall view of the nature of tone and contrast in general, and then narrow our focus to the specific ways these important image elements can be adjusted and enhanced in the digital darkroom

Chapter 5

© Seán Duggan

Understanding Tone and Contrast

Before we get into the details of how to enhance tone and contrast, let's take a moment to look at the big picture and discuss just exactly what tone and contrast are. This may seem a bit rudimentary, but many times when you take a closer look at something you think you already know, you see things you never noticed before, or you see them in a new way that contributes to a better understanding of the subject.

Tone

In a photographic image, tone refers to the level of brightness. This is true for both black-and-white and color photographs, but for the moment our discussion will focus on black-and-white. A photograph is made up of a collection of many different brightness values. It is the specific arrangement of brightness values that gives shape and form to an image, be it a landscape, a portrait, or a detail view of an object as seen in Figure 5-1.

Figure 5-1. The specific arrangement of tonal values in this photograph, from dark shadows through middle values to bright highlights, combines to create an image of a desert plant. © SD

The most common terms used to describe tonal values refer to three categories of brightness: shadows, midtones, and highlights. Within each of those three areas there are many different tonal levels. Learning how to work with the tonal range, both in terms of how to photograph it and how to manipulate those tones later in the digital darkroom, is the foundation for creating the image you want rather than settling for the image your camera happened to capture.

The Zone System

In black-and-white film photography, the Zone System is a way of controlling the tonal characteristics of the scene by following precise exposure and development procedures. Although photographers and scientists had worked for many years to understand and control the tonal response of their materials, it was Ansel Adams and Fred Archer in the 1940s who distilled previous knowledge along with their own experiments into the Zone System that most people are familiar with today, even if that familiarity is in name only.

The basic concept of the Zone System divides the tonal range of a scene into eleven separate tonal values or "zones", each identified by a Roman numeral. Zone 0 represents a total black, zone III a dark tone with perceptible shadow details, zone V a middle gray value, zone VII represents a highlight value, zone VIII bright highlights, and zone X is pure white with no detail (paper white if you were printing in a darkroom). To modify the tonal relationships in a scene, you can use camera exposure, which involves changes to light and time (aperture and shutter speed) or, when using film, development technique (changes to chemistry and development times). By exposing a photo so that certain areas of the scene were assigned specific zone values, you would end up with a negative that contained all of the information needed to make a good print. Further refinements were made with changes to the development procedure.

The digital Zone System

At the most basic level the Zone System is simply a way of better understanding the tonal characteristics of the scene you are photographing and how to control these characteristics so you end up with a better image. Though the Zone System is more commonly associated with film, large format cameras, and chemical darkrooms, the basic principles can also be applied to digital photography and the digital darkroom. In fact, you may already be using a variation of the Zone System in your photography, even if you are not aware of it. If you have ever reviewed the histogram on your digital camera, noted that the highlights were blown out to total white, and then adjusted the exposure to take a second shot where they were not blown out, then you've put the basic principles of the zone system to work. It may not be *the* Zone System that Adams wrote about in his many books, but it still represents a system of using camera exposure to consciously place certain areas of the scene into specific tonal zones.

In Adams' zone system there are 11 separate tonal zones. Digital images contain many more tones that you can access and manipulate, the most common range spanning from 0 to 255 and representing 256 discrete tonal values. Though the difference between 11 steps and 256 does not make for a smooth translation between the two, approximate digital

values can be calculated for corresponding zones, as shown in Figure 5-2. If an image is being evaluated using the traditional grayscale standard of percentage of black, then that can also be easily applied to the zone system.

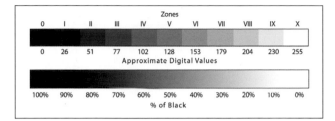

Figure 5-2. A zone system step wedge with corresponding digital values and grayscale percentages.

If you are comfortable working with the traditional zone system, then these comparisons can help serve as a bridge between the analog darkroom and the digital darkroom. In drawing comparisons between the two systems, however, it is important to realize that, from a creative point of view, trying to calculate exact mathematical equivalents is not as important as understanding the needs of the image you are working on and how to go about achieving those goals.

Contrast

Contrast can be a challenging element in photography. While the addition of the right amount of contrast is very good for many images, too much contrast can be ruinous. When working with the camera in situations where there is an overabundance of contrast, it can be difficult if not impossible to control the highlights without sacrificing significant amounts of shadow detail. However, a lack of contrast can make a photo seem dull, flat, and lifeless. Learning to control contrast, both when you are creating the photo with the camera and later in the digital darkroom, is the key to developing a mastery over your images.

But what exactly is contrast? Simply put, contrast is difference. Consider these definitions: "a juxtaposition or comparison showing differences; difference so revealed; a thing or person having different qualities." In a photograph, contrast is the difference between tonal values. The greater the difference in brightness between tonal regions, the more contrast there is. If there is not much difference between tonal areas, then the image is said to have low contrast. Increasing contrast involves making the light tones brighter and the dark tones darker. Figure 5-3 shows gray values with a tonal difference of only 45 levels and another set with a tonal difference of 170 levels.

Figure 5-3. Contrast is the difference between levels of tonal brightness.

The contrast needs of an image will vary according to the image itself, the subject matter, the amount of contrast already present, the limitations of the output device, and your own preferences. Some people prefer images with dramatic contrast, even when it means that blacks and whites are clipped to a tone containing no detail, while others prefer to have contrast that contributes to the image but doesn't take it over (Figures 5-4 and 5-5). In Photoshop, contrast adjustments can be used to emphasize certain areas in an image, guide the viewer's eye, and sculpt the overall tonal shape of the photograph.

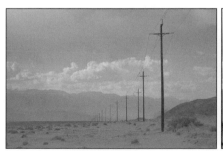 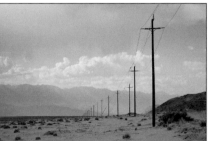 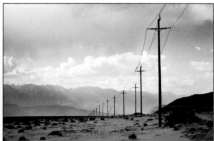

Figure 5-4. Since this was photographed in the desert, a very harsh and stark landscape, the high-contrast version suits this subject well. © SD

Figure 5-5. For a portrait photographed in soft light, the stronger contrast version (far right) looks a bit too harsh. © SD

Listen to the Image

The primary focus of this chapter is on how to apply global changes to tone and contrast. But before we delve into the details of how you can go about that in Photoshop, we want to share some concepts with you for determining what sort of changes an image may need. After teaching photography and Photoshop for several years, one thing that we both have noticed is that it is common for students to focus first on the details of how to do something in Photoshop rather than focus on the image itself. To use the old expression, this approach is putting the cart before the horse, and it can be very distracting. Before you even start pondering whether to use Curves or Levels, you should take a good look at the image and see what it tells you.

To help you concentrate on the image only, choose View→ Screen Modes→Full Screen Mode from the Menu Bar (you can also access this mode by pressing F to cycle through the different screen modes). This screen mode will hide any distracting desktop pattern or clutter that may be visible. Press the Tab key to hide all of the Photoshop palettes and tools. Now you are viewing only the image with no other distractions (Figure 5-6).

As you look at the image and consider what you can do to improve it, try to think in broad concepts rather than in Photoshop technical terms. The vocabulary you use should be limited to general terms such as lighter, darker, more contrast, less contrast. Try to imagine how making certain areas lighter or darker or adjusting contrast might change the image. The human eye is attracted to lighter areas and to contrast. How can such adjustments help to guide the viewer's eye through the image? Through adjustments to tone and contrast, can you more effectively emphasize certain areas of the image? Figure 5-7 shows a scan from

a low-contrast negative and the final version after changes to tone and contrast, applied both globally and locally, transforming the flat original into an image with a broader tonal range and a clear focal point that draws the viewer into the image.

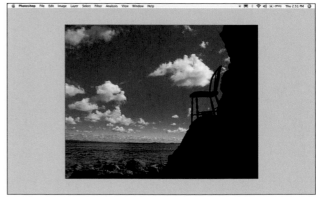

Figure 5-6. Hiding the palettes and using the Full Screen view modes lets you concentrate on just the image. © SD

After you have determined what the image needs, you can think about which digital darkroom tools and techniques can help you achieve those ends. When you begin with a clear idea of how you want to change the image, it is easier to choose the path that will take you there.

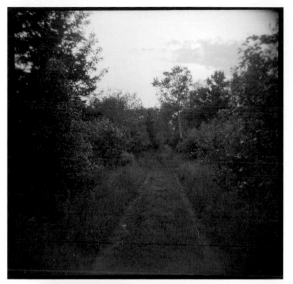

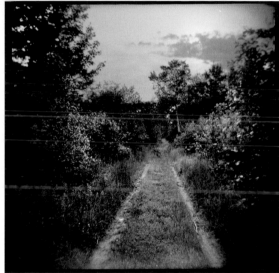

Figure 5-7. Creative changes to tone and contrast can transform even the most lackluster originals. © SD

Non-Destructive Editing

One of the biggest misconceptions about working with photographs digitally is that you can make as many changes as you want without harming the image. Unfortunately this is not true. While there are steps you can take to structure your files so that permanent, destructive changes are minimized, the basic truth of editing pixel-based digital images is that there is always some amount of impact on the data. Sometimes this impact is not significant; in other cases it may cause noticeable "tonal erosion" that can show up in prints as banding or posterization. Whether or not your editing produces negative results in the image depends on the original form of the image (a scan, JPEG, or raw file), the types of changes you are making, how drastic those changes are, and when and how they are being applied. To minimize any negative impact on the file, whenever possible you should apply all of your edits so that they are changeable and not destructive.

There are three main strategies to use in a non-destructive workflow: With digital camera raw files, do as much of the global adjustments as possible to the raw file; import the raw file, or create the scan, at a high-bit depth for more "tonal overhead"; and, once the image is in Photoshop, use adjustment layers for all tonal and color correction.

Start with the Raw File

The fact that a raw file from a digital camera is not a finished image but a "recipe" to make an image means that there is a great amount of flexibility for modifying the recipe before you "cook" it. By redistributing the raw tonal data in Adobe Camera Raw or Adobe Photoshop Lightroom, you can make significant changes without the tonal penalties that can sometimes result when making major edits in Photoshop. You should be making as many of your overall, global edits as possible to the raw file. The more you can do to perfect the raw file, the less you have to do in Photoshop.

The Advantages of 16-bit Editing

Whenever possible, you should take advantage of the expanded range of tonal information offered by high-bit files. Compared to the thousands of tonal levels available in a high-bit image, the 256 levels in an 8-bit file is meager by comparison (Figure 5-8). This can matter if you need to make major improvements or changes to the image. If you are starting from a raw file, this means importing it into Photoshop as a 16-bit file. If you are scanning negatives or slides, take advantage of the high-bit capabilities offered by your scanner.

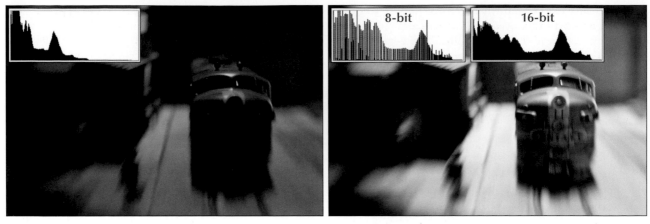

Figure 5-8. In this example, an underexposed image has been lightened. In an 8-bit file these changes result in a histogram with serious tonal erosion, while the 16-bit file, with thousands of tones instead of only 256, has weathered the adjustment in much better shape. © SD

The Advantages of Adjustment Layers

The other component in non-destructive editing is the use of adjustment layers for any type of tonal modification. Most of Photoshop's tonal or color correction commands (and certainly the most important ones) can be applied as adjustment layers, and we strongly recommend that you take advantage of this feature. The key to adjustment layers is that they are not permanent, and the adjustment dialog can be reopened at any time to revisit the changes you have made. Like any layer, the changes made by an adjustment layer can also be modified with the opacity slider, the blending modes, or the addition of layer masks to precisely focus the correction to specific areas of the image (Figure 5-9).

Figure 5-9. Adjustment layers are the primary way to apply non-destructive tonal edits in Photoshop.

Global Image Improvements

Most of the techniques covered in this chapter revolve around making global corrections or changes that are applied to the entire image. When it comes to tonal correction, your first priority should be to address the issues that can be fixed with adjustment layers that affect the entire photo. Typically, these are adjustments that make the image darker or lighter, or add modifications to contrast, which involve manipulations to both the dark and the light tones. In a color image you would also address overall color balance and fixing global color casts, but in this chapter we'll be concentrating primarily on the black-and-white side of the digital darkroom. We'll cover color correction in Chapter 7 and creative color in Chapter 8.

Levels and Curves are the two primary tools in Photoshop for adjusting brightness and contrast. There is also another command, Brightness/Contrast, and while it is one that we do not recommend, it does have a tempting name. We will discuss it simply to explain why using Levels or Curves gives you more control and, if you're using Photoshop CS2 or earlier, why using Brightness/Contrast is simply a bad idea.

Working with Levels

Levels can be applied directly to the pixels in the image from the Image→Adjustments menu (Cmd/Ctrl-L), but we do not favor this approach because the changes are irreversible once the file has been saved and closed. The smart way to use Levels is as an adjustment layer, which you can access through the main menu by choosing Layer→ New Adjustment Layer→Levels. You can also click the Adjustment Layer button at the bottom of the layers palette, and then select Levels from the drop-down menu.

In a grayscale image, or when used for overall adjustments in an RGB file, the Levels dialog really controls only three aspects of the image: the white point, the black point, and the

midtone value. The main controls are two sets of sliders, the Input Levels and Output Levels, and corresponding numeric fields for the slider values (Figure 5-10). There are also three eyedropper tools for assigning precise values for highlights, shadows, and midtones. Depending on the adjustments you make to the endpoints, increases or decreases in contrast can also be achieved with Levels, though you cannot emphasize one area of the tonal range over another as you can with Curves.

Midtone or Gamma slider · Auto Adjustment options
Channel selector · Save current Levels settings
Histogram · Load previously saved settings

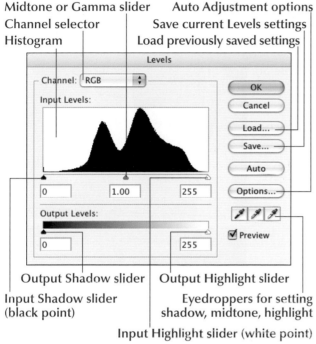

Output Shadow slider · Output Highlight slider
Input Shadow slider (black point) · Eyedroppers for setting shadow, midtone, highlight
Input Highlight slider (white point)

Figure 5-10. The Levels dialog in Photoshop CS3.

The Input Levels

As mentioned previously, you can only directly affect three tonal points in Levels, and the Input Levels provide the primary means to do this. Most of the work you are likely to do in Levels will be accomplished with these controls.

In simple terms, the effects of adjusting the three Input Levels sliders can be described this way: moving the black point slider to the right darkens the shadows by setting a new black point, moving the white point slider left lightens the highlights by designating a new white point. The midtone slider reassigns the middle tonal value in the image. Moving it to the left will lighten the image, and moving it to the right will darken the image. That's the quick explanation. Of course, there is more to it than that, and understanding how the tonal data is being affected is important to maintaining the tonal quality of your file.

Setting the black point. The Input shadow slider sets the black point (level 0) for the image. As you move the slider to the right, the darkest tones will gradually become a solid black. Since the midtone slider is moving at the same time (to always reflect the current midtone point) the rest of the image will also become darker.

When you change the position of the Input shadow slider, any tonal values on the histogram that are to the left of the slider will be remapped to 0, which is a total black with no detail. If there are any subtle shadow details in those darker areas, you will be losing that detail. The term most often used to describe what happens when tonal detail is adjusted to either a total black or a total white is "clipping" (think of a pair of scissors clipping off a part of the tonal range). You cannot make the shadow tones lighter with the Input black point slider; you can only make them darker (Figure 5-11). Figures 5-12 through 5-14 show the results of a Levels adjustment.

Clipped shadows shown in blue · Original midtone

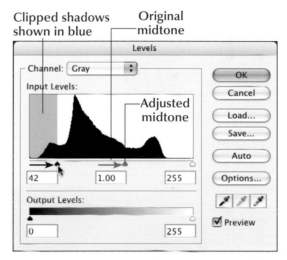

Adjusted midtone

Figure 5-11. In the illustration above, the black point slider has been set to 42, meaning that all values of 42 or lower will be remapped to level 0, a total black.

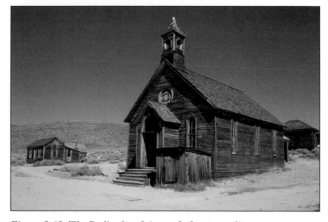

Figure 5-12. The Bodie church image before any adjustments. © SD

Figure 5-13. The Bodie church image, after the Levels adjustment seen in Figure 5-11. Detail in the darkest shadows has been clipped to black.

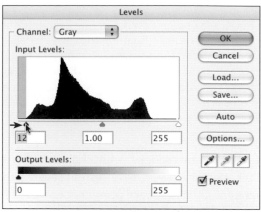

Before

After

Figure 5-15. By adjusting the Input Levels black point slider to where the shadow histogram detail starts (in this case, level 12), the deepest shadows become a richer black without clipping any important details.

Figure 5-14. As a result of the Levels adjustment shown in Figure 5-11. Significant shadow detail has been lost in the darker shadow tones.

If you want to retain all of the important shadow detail in an image, you should not move the black point slider past where the histogram detail (the mountain shape) starts (Figure 5-15).

Setting the white point. The Input highlight slider determines the white point (level 255) for the image. As this slider is moved to the left, bright highlights will start to become total white. Just as with the black point slider, the midtone point will also move along with the white point slider, and this will cause the rest of the image to become brighter.

When the position of the Input highlight slider is changed, any tonal data on the histogram that is to the right of the slider will be clipped to level 255, which is total white with no detail. A common photographic term to describe highlights suffering from such a malady is "blown out." You cannot make the highlight tones darker with the Input white point slider; you can only make them brighter. See Figures 5-16, 5-17, and 5-18 for examples.

Original midtone

Clipped highlights shown in blue

Figure 5-16. *In the illustration above, the white point slider has been set to 194, meaning that all values of 194 or higher will be remapped to level 255, a total white. The adjustment above would result in significant highlight clipping.*

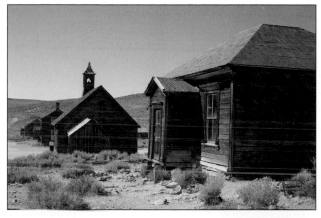

Figure 5-17. *The Bodie street image, before the Levels adjustment seen in Figure 5-16.* © SD

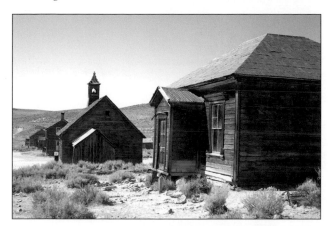

Figure 5-18. *The Bodie street image, after the Levels adjustment seen in Figure 5-16. Detail in the brightest highlights has been clipped to white.*

Levels clipping display. When making changes to the black-and-white points of an image, it is useful to see exactly what detail may be affected by your adjustments. To see a clipping preview, hold down the Option/Alt key while clicking either the black point or the white point slider. As you move the sliders to the left or the right you will see the following:

- When moving the white point slider, the image will turn black, and, as the slider is moved to the left, white will begin to appear wherever tones are clipped to 255 (Figure 5-19).

- When moving the black point slider, the image will turn white, and, as the slider is moved to the right, black will begin to appear wherever tonal values are being clipped to level 0 (Figure 5-20).

Figure 5-19. *The Levels clipping display shows white where highlight values are clipped to 255. In the Histogram palette you can see the clipping show as the adjusted histogram data is cut off on the far right side (the original histogram is shown in red).*

Figure 5-20. *The Levels clipping display shows white where shadow values are clipped to 0. In the Histogram palette you can see the clipping show as the adjusted histogram data is cut off on the far left side (the original histogram is shown in red).*

In a color photo, the clipping display uses different colors to indicate clipping in the various color channels or in all the channels. We will cover using Levels on color images in Chapter 7.

The Midtone slider. The Midtone or Gamma slider determines where the exact middle tonal value is (50% gray, level 128, or Zone V). Moving it to the left will lighten the image because that changes a current value that is darker than 128 to be the new level 128. Moving it to the right will darken the image because you are adjusting a current tone that is lighter than 128 to be the new level 128. Because it adjusts overall image brightness without affecting either the black or the white point, this slider is also sometimes referred to this as the Brightness slider (Figure 5-21).

The Output Levels
🖰 ch5_Bodie_Bed.jpg

As the name suggests, Output Levels are intended for making endpoint adjustments to compensate for the limitations of a specific type of output. The sliders do the exact opposite of the corresponding controls for the Input Levels. Moving the shadow slider to the right lightens the shadow tones, while moving the highlight slider to the left will darken the highlights and make them duller.

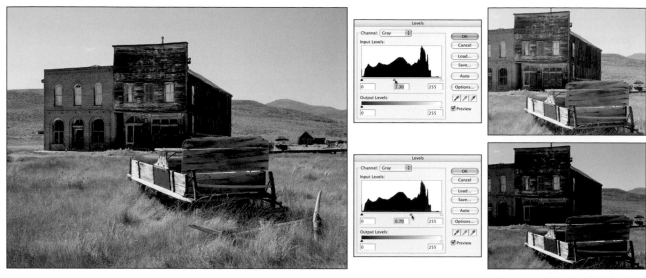

Figure 5-21. The Input Levels midtone slider sets the midtone point and adjusts the overall brightness of the image without affecting the black or white point. © SD

Figure 5-22. Output Levels, intended primarily to compensate for the more limited tonal range of an output device, will lighten blacks and darken whites in an image, but they cannot restore shadow or highlight detail that was never recorded in the original exposure.

When you set the shadow Output levels to 20, for example, any tone that is currently at level 0 (black) will be adjusted to level 20. All other tonal values will be adjusted proportionately, with the end result being a lightening of the image and a decrease in contrast, especially in the darkest shadow areas (Figure 5-22). If you were to move the Output highlight slider until the number above it read 240, then any current tone with a value of 255 (white) will be darkened to level 240. This will darken the highlights and reduce contrast.

> Although the Output Levels lets you remap a total black to a lighter tone or a blown-out highlight to a slightly darker tone, it will not be able to restore detail that was never captured in the original exposure or scan. If image detail in such areas was never recorded, then it's gone for good.

The Output Levels compress the tonal values so that they fit within a narrower range, essentially reducing the number of tones so that the image can be printed within the more limited parameters of a given output medium. You would use these controls to ensure that deep shadows don't block up to a total black or that a bright highlight with detail doesn't print as pure paper white. We usually prefer to make such adjustments by moving the endpoints in Curves, because it gives us more control over how the adjustment affects the midtones.

The Levels eyedroppers

The eyedroppers in the Levels dialog box can be used to target specific tones in the image and change them to a precise tonal value. Typically, these are most often used for targeting the white and black points for a certain output device. The middle Gray eyedropper, which is used to help neutralize color casts in areas that should be neutral, is unavailable when you are working on an image in Grayscale mode.

Though they can be used to set the endpoints for grayscale images, moving the endpoint sliders to where the histogram data starts on either end accomplishes the same thing, so it's debatable whether or not you even need to use the eyedroppers for grayscale files. The one situation where they do come in handy is if you need to precisely target the endpoint values for the limitations of an output process. Where the eyedroppers really shine is when you need to quickly correct a color cast in a color photo. We'll cover the use of the Levels eyedroppers as well as the auto correction options in detail in Chapter 7.

If you do decide to use the eyedropper to set the endpoints in a grayscale file, you should be aware that the default values are 0 (total black) for the shadows and 255 (white with no detail) for the highlights. As this will introduce clipping into the shadows and highlights, double-click each eyedropper to set a new target value in the color picker. Safe RGB values that do not cause clipping would be 10, 10, 10 for the shadows, and 248, 248, 248 for the highlights.

Auto correction options

Just above the eyedroppers are buttons labeled Auto and Options. The Auto button applies an automatic Levels correction based on the location of the brightest and darkest tones in the image. With a grayscale file, the default setting causes the shadows and highlights to be clipped by 0.10%. This action is essentially the same thing as moving the endpoint sliders to where the histogram data begins, except in this case a tiny amount of clipping takes place (Figure 5-23). Because this is a canned formula adjustment, and one that introduces minor clipping, we generally don't think much of it and don't recommend it. Clicking the Options button enables you to alter the default clipping values (Figure 5-24). With an RGB image, the Options button provides more choices, which can sometimes be useful.

Figure 5-23. The default Auto Levels adjustment. The shadow and highlight sliders are moved in to clip the endpoints by a value of 0.10%.

Figure 5-24. With a grayscale file, the only option for the Auto adjustment is how much clipping is applied to the shadows and the highlights.

Understanding Curves

The Curves dialog box is arguably the most powerful tonal correction tool in Photoshop, a veritable Swiss Army knife for shaping the tonal and contrast character of an image. Anything that can be done with Levels can also be done with Curves, but the latter provides much more control over specific areas of the tonal range since it enables you to adjust 16 different points anywhere along the curve instead of only three predefined points (black point, midtone, and white point) with Levels.

Anatomy of the curve

The use of a curve to express the tonal range of an image as well as the changes that are made to that tonal range exists in many image-editing programs. As a tool for mapping the tonal response of film emulsions, the curve even predates digital editing by many decades. Though we are using screen captures from Photoshop CS3, Adobe Camera Raw, and Photoshop Lightroom to illustrate how to work with a tonal curve, it's important to understand that the controls for manipulating the curve may differ depending on what program you are using, but the basic anatomy of the curve, in terms of how it affects the tonal range, is essentially the same (Figure 5-25).

The histogram that you see in the Levels dialog box is different for every image, but an unaltered tone curve is always a diagonal line over a grid running from the lower-left corner to the upper-right corner. Once you know how it operates, however, it's not so mysterious. When configured to represent the tonal range as levels of light (as opposed to percentage of ink coverage), the black point is in the lower-left corner, the white point is in the upper-right corner, and the midtone (Zone V) is in the exact middle of the graph. From a visual perspective this makes sense as more light occupies the upper part of the curve while less light is in the lower part. (Think of a dimmer switch that you slide up and down to change light levels in a room.)

Figure 5-25. The Curves interfaces for Photoshop CS3, Photoshop Lightroom, and Adobe Camera Raw.

The Curves dialog box in Photoshop CS3. In Photoshop CS3, display options at the bottom of the dialog let you change the size of the grid from 4×4 to 10×10 (Figure 5-26). You can also switch between viewing the curves as light or a percentage of ink coverage. We recommend using the former because the idea behind it, namely that you are adding and subtracting light, is essentially the same concept as working with increased or decreased exposure, either in the camera or in a traditional darkroom. Using the light option also displays the tonal values using the 0 – 255 tonal scale, while the ink option displays percentage values, and we feel it is simpler to stick with a single measurement system when working with images. When using the ink percentage mode, the layout of the tonal range on the curve is reversed: dragging up darkens the image (using more ink), while dragging down lightens it (using less ink).

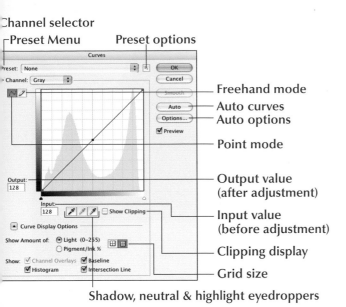

Channel selector
Preset Menu
Preset options
Freehand mode
Auto curves
Auto options
Point mode
Output value
(after adjustment)
Input value
(before adjustment)
Clipping display
Grid size
Shadow, neutral & highlight eyedroppers

Figure 5-26. The Curves dialog in Photoshop CS3.

In versions of Photoshop prior to CS3, switching between light and ink percentage displays is accomplished by clicking in the horizontal gray ramp under the grid. You can change the grid size by Option/Alt-clicking inside the grid.

Other display options new to Photoshop CS3 are a Show Clipping option, which displays the same clipping preview that you can access in Adobe Camera Raw or Levels by Option/Alt-clicking the Exposure/White Point or Shadows/Black Point sliders. There are also options (all turned on by default) that show a colored line to reflect how the curves in the different channels have been adjusted, a baseline that reflects the unchanged curve, a histogram, and intersection lines that track the point location in the grid as you adjust it. There is also a Presets menu at the top of the dialog with several common corrections and effects available. Clicking the Presets Options button to the right of this menu enables you to save your own curve adjustments as presets.

Curve and Levels: Comparable moves

Raising the curve above the initial diagonal baseline increases the light, brightening the image (more exposure), while lowering it decreases the light, darkening the image (less exposure). When such a change is accomplished by dragging up or down on the center of the curve (the midpoint), the effect is the same as moving the midtone or gamma slider to the left or right in Levels (Figure 5-27).

The corner points that represent black (lower left) and white (upper right) are the same as the Input and Output endpoint sliders in Levels (Figure 5-28). Moving the black point horizontally along the bottom of the curve grid determines the black point, darkening the image, as well as potentially clipping darker shadow tones. This is the same as moving

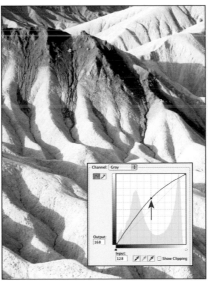
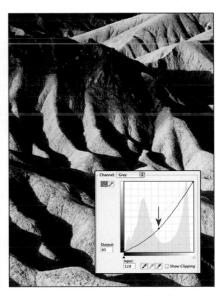

Figure 5-27. Raising the curve increases the light (or exposure) and lowering it decreases the light.

the Input shadow slider to the right in Levels. Moving it vertically up the left side of the grid lightens the black tones and is the same as moving the Output Levels slider to the right. Moving the white point horizontally to the left along the top of the curve grid sets the white point, brightening the image and potentially clipping highlight values. This is the same as moving the Input Levels highlight slider to the left. Moving the white point vertically down the right side of the curve grid darkens the white point and is comparable to moving the Output Levels highlight slider to the left (Figure 5-29). In Photoshop CS3, black-and-white point sliders at the bottom of the curve grid function the same as the Input sliders in Levels.

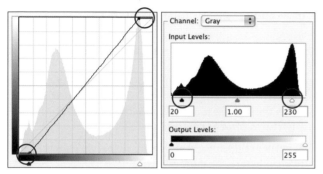

Figure 5-28. The adjustments shown above in Curves and Levels would each have the same impact on the image: Shadow values of 20 or below would be clipped, and highlight values above 230 would be clipped.

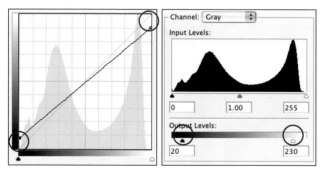

Figure 5-29. The adjustments shown above in Curves and Levels would each have the same impact on the image: Any black tones of level 0 would be lightened to level 20, and any whites of 255 would be darkened to 230.

Finding tones and working with control points

To locate a specific image tone on the curve in Photoshop, move your cursor over that area of the image and hold down the mouse button. A small circle will appear in the Curves grid, indicating the corresponding location on the curve (Figure 5-30). To place a control point there, Command/Control-click in the image. You can also place control points simply by clicking the curve itself. You can remove a point by clicking it and dragging it out of the grid.

Figure 5-30. Click a tone in an image to find the corresponding location on the tone curve. Command/Control-click in the image to place a control point there.

In Adobe Camera Raw, the way to locate an image tone on the curve is slightly different: hold down the Command/Control key and move your mouse over the image but don't click with the mouse button unless you want to place a control point on the curve at that location. Locating points on the tone curves in ACR differs between the parametric curve and the point curve. With the latter, if you want to see where an image tone falls on the curve, press cmd/cntr, mouse over the image area, and the location of the tone shows with a little circle on the curve. Clicking will place a control point on the curve. This is very handy and not possible when working with the Parametric Curve where it is much needed. In Adobe Photoshop Lightroom, simply move your mouse over the image and the corresponding location will be shown on the tone curve.

Control points can be adjusted by dragging them with the mouse, by using the arrow keys on the keyboard, or by entering values in the Input and Output numeric fields.

When using the arrow keys, a point will be adjusted in single-level increments. If you add the Shift key to the arrow keys, a point will be moved in 10-level increments. The up/down arrows change the Output (adjusted) values, and the left/right arrows change the Input (before) values. Pressing the Tab key will switch between the Input and Output fields, and you can select different control points by pressing Control-Tab to move up the curve, or Control-Shift Tab to move down the curve.

In the Curves dialog in Photoshop gray ramps appear at the bottom and on the left side. These are visual indicators of the input or "before" tonal values and the output or "after" tonal values. If you place a point on the curve and draw an imaginary line down to the bottom of the grid, the tonal value for that point corresponds to the brightness level in that section of the gray ramp (input). When the point is adjusted, draw an imaginary line from the point towards the left side of the grid and the adjusted values will match the level of gray on the vertical gray ramp (output, Figure 5-31).

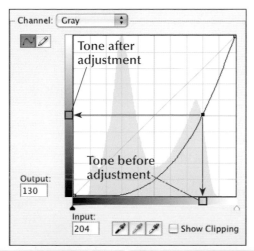

Before After

Figure 5-31. The gray ramps below and to the left of the curve grid show the level of brightness for the Input (before adjustment) and Output (after adjustment) values.

Controlling contrast

As we pointed out earlier in this chapter, contrast in a photograph is the difference between tonal values. To increase the contrast you make the lighter tones lighter and the darker tones darker. Curves is the ideal place to do this because it offers you the greatest control over how much the contrast is increased and also which areas of the tonal range are affected most.

The basic S-curve. One of the most useful adjustments that can add an essential snap to any image is the simple S-curve. To apply an S-curve, do the following:

1. Click in the center of the grid to place a control point. This will serve as the center pivot point for the S-curve.

2. Click in the middle of the top half of the curve and drag up slightly. This raises the value of the highlights, making them lighter.

3. Click in the middle of the lower half of the curve and drag down slightly. This lowers the value of the shadow tones, making them darker.

The shape of the S-curve, how much the highlights are raised and the shadows lowered, determines how much the contrast is increased. As you play around with this, it should be clear after very little experimentation that even a fairly subtle S-shape leads to a noticeable boost in contrast (Figure 5-32). The more exaggerated the shape of the S, the more dramatic and pronounced the increase in contrast will be (Figure 5-33). The objective when working with curves should be to keep the transitions in the curve as smooth and fluid as possible and to avoid using too many control points. The more control points you place on the curve, the more unwieldy it will be to manipulate.

> It is not necessary to use the center control point to make an S-curve adjustment, but it does provide a handy pivot point that makes this type of adjustment a little easier when you are first getting the hang of working with a curve.

A reverse S-curve. If you are starting out with an image that you feel has too much contrast, then a reverse S-curve can help to tame the contrast by reducing the differences between the tonal extremes (Figure 5-34). To apply a reverse S-curve, follow the same steps as with a normal S-curve except reverse the positions of the upper and lower halves of the curve. The lower half will be raised up slightly and the upper half will be lowered down a bit. In some cases you may find that one part of the tonal range will need to be adjusted more than the other.

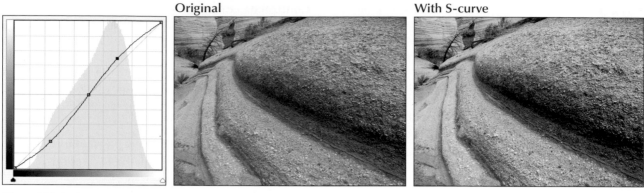

Figure 5-32. In this image of a desert canyon taken on an overcast day, a relatively flat original is improved considerably by a gentle S-curve. © SD

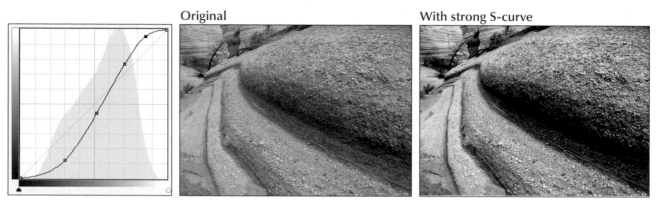

Figure 5-33. In this example, a stronger S-curve has been used to further accentuate the tonal differences between the shadows and highlights. The middle point has also been lowered a bit to darken the middle values.

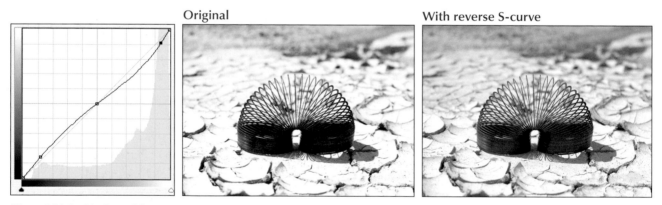

Figure 5-34. In this photo of the elusive desert slinky, taken in the harsh, midday sun, the contrast is very strong. A reverse S-curve helps to tame the high contrast, especially in the bright highlights, which were adjusted more than the shadows. © SD

Precise control with lockdown points. As you make adjustments in one part of the curve, the rest of the curve will move in response, often causing changes in areas that you did not want to affect. For more precise control over the areas you are adjusting, place a series of additional control points on areas of the curve that you do not want to be affected. This concept is known as a lockdown curve or lockdown points because they "lock down" specific sections so they are not affected by movements elsewhere on the curve (Figure 5-35). The ability to precisely target adjustments to specific tonal regions is one of the reasons why Curves has long been the tonal correction tool of choice for serious Photoshop users.

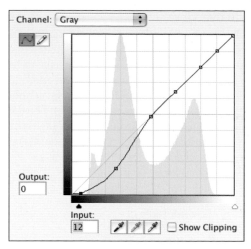

Figure 5-35. A lockdown curve in action: The upper part of the tonal range containing values brighter than level 128 (the midtone, or Zone V) is locked in place by the four control points. Only the tones darker than 128 are being affected by this curve.

If you find yourself using lockdown curves often, then you can save yourself some time by saving some of the curves as presets that can be loaded from the Curves Preset menu (Figure 5-36). To do this, open the Curves dialog, place a point at each grid line intersection (we recommend using the 10x10 grid), click the Presets Options button to the right of the Preset menu, and then save the curve with an appropriate descriptive name. You can save it anywhere on your hard drive, but if you want it to show up in the Presets menu, you need to save it in the Presets\Curves folder. The directory path for this on Mac is User \ Library \ Application Support \ Adobe \ Adobe Photoshop CS3\ Presets\ Curves. On Windows, the location is C:\Documents and Settings \ username \ Application Data \ Adobe \ Adobe Photoshop CS3 \ Presets \ Curves. In addition to saving a curve for the overall luminance and contrast, you could also save one curve for each of the color channels.

Here's a cool trick we learned from Jeff Greene of Microsoft's Rich Media Group: To quickly place lockdown points along the entire curve click the pencil button in the upper left to switch to freehand mode. Click anywhere on the curve to place a point, then click the curve button to switch back to point mode. A lockdown point will be placed at each intersection.

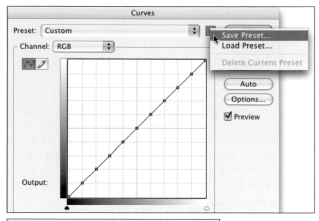

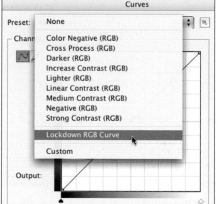

Figure 5-36. Saving a lockdown curve as a preset.

Resisting the Siren Call of Brightness/Contrast

Curves is a precision tool that gives you a great deal of control in targeting specific areas of the tonal range when making adjustments to the brightness and contrast of an image. We strongly encourage you to take time to learn how to use it. Photoshop has long offered another command, however, called Brightness/Contrast, which seems to offer similar capabilities as Curves but with a much simpler interface of two sliders. In the past (version CS2 and earlier), Brightness/Contrast was widely regarded to be a blunt instrument, a color correction "toy" that adjusted the tonal values in a way that often caused more problems than it solved by introducing unexpected clipping.

—continued—

In CS3, Adobe has given Brightness/Contrast a much-needed programming overhaul, and it is no longer the tonal correction outcast that it once was. It now behaves similar to the Brightness and Contrast controls in Camera Raw and will not introduce clipping into the histogram. The dialog is the same, with the one new addition of a "Use Legacy" checkbox (off by default) that makes it behave as it used to in previous incarnations of Photoshop, a dangerous, histogram-clipping rogue. It may seem a bit silly to intentionally downgrade the performance of a tool, but the reason it is included is that Adobe is loath to remove functionality that someone somewhere may depend on. The only reason you may choose the Use Legacy option is if you were adding a Brightness/Contrast adjustment layer that needed to be properly interpreted in a previous version of Photoshop.

While we applaud Adobe for finally addressing the serious issues with the Brightness/Contrast command, we still don't advise our students and readers to use it for the simple reason that Curves offers much greater pinpoint control. Take the time to learn Levels and Curves, and your images will be the better for it.

Using Blending Modes to Create Digital Contrast "Filters"

Blending modes influence how a color or tone interacts with the color or tone below it. This interaction occurs differently based on image brightness values, and it also occurs on a per-channel basis. So, in some cases, a blending mode can actually darken some areas and lighten others at the same time. The blending modes can be found in different areas of Photoshop, but one of their most useful applications is to use them in conjunction with adjustment layers to quickly affect changes to overall brightness and contrast. Not all of the blending modes are useful for this, and some can create downright psychedelic results, but several are useful for darkening, lightening, or enhancing contrast.

In the following section we'll take a look at the most useful blending modes and how to use them with adjustment layers. In many cases, you do not even need to make any actual changes to the adjustment layer controls. Simply add the adjustment layer (that is, Levels or Curves), and then click OK. The blending mode will do the rest. This concept is called using an "empty" adjustment layer because no adjustments have been added. Although using empty adjustment layers is common, keep in mind that you can also customize the effect by making different adjustments depending on what you want the effect to be.

Blending mode overview

At the upper-left area of the Layers palette there is a drop-down menu containing the 25 blending modes (see Figure 5-37). To access the blending modes you have to be working on an image that has at least one layer in addition to the Background layer (the last six blending modes are not available if you are working on a grayscale image). For the purposes of these examples you can simply add a Levels or Curves adjustment layer, and then click OK in the dialog box, without making any changes to the sliders or the curve.

Figure 5-37. The blending modes in the Layers palette are organized into functional groups based on how they affect the image.

The blending modes are separated into six distinct groupings based on the overall effect they have on the image. In this section of the book we will concentrate primarily on basic tonal effects such as darkening, lightening and increasing contrast. We'll discuss how blending modes can be used with color images and blending multiple images together in subsequent chapters. In some cases the initial effect may be too strong, but keep in mind that reducing the opacity of the adjustment layer can soften the impact of the blending mode effect.

Blending modes for darkening. The blending modes in the second group that begins with the Darken mode will create a darkening effect on the overall image. Another property of this group of blending modes is that the color white (255) on the active layer has no effect at all on the underlying image.

This is referred to as being a neutral color. In terms of using blending modes with an empty adjustment layer, Multiply is the most useful. Darken and Darker Color have no effect with an empty adjustment layer, and both Color Burn and Linear Burn will cause shadow clipping and over-saturated colors.

Multiply darkens the entire image. Of all the darkening blending modes, this is the one we use the most. From a photographic perspective, it is more or less equivalent to reducing exposure by about three stops. To tap into another photographic analogy, this mode is similar to taking two 35mm slides of the same scene and sandwiching them together; the result would be a much darker version of the image (Figure 5-38). When used with adjustment layers in conjunction with varying layer opacity, or with layer masks, the Multiply mode is useful for adding density to highlights and midtones, especially on images that are overexposed.

Blending modes for lightening. The blending modes in the third group that begins with the mode Lighten will all create a result that is lighter than the original image. The neutral color for the Lighten blending modes is black, which means that areas of black in the active layer will have no effect on the layers underneath. To achieve a lightening effect with empty adjustment layers, the most useful mode here is Screen. Lighten and Lighter Color have no effect when used with an empty Curves or Levels adjustment layer. Color Dodge and Linear Dodge will usually cause severe highlight clipping.

Screen is the opposite of Multiply and will dramatically brighten the entire image by approximately three stops. To return to the 35mm slide analogy, if you had two slide projectors and both were projecting a slide onto the same screen, the overlaid images on the screen would be washed out and much lighter (Figure 5-39). Such is the effect you will get from Screen. When used with an empty adjustment layer, this mode is useful for opening up dark areas of an image and bringing out detail in underexposed areas. Just as with the Multiply mode, the opacity slider in the layers palette is useful for scaling back the initial Screen effect.

Figure 5-38. When the Multiply blending mode is used with two image layers, the result is similar to two 35mm slides sandwiched together.

Figure 5-39. When the Screen blending mode is used with two image layers, the result is similar to two 35mm slides projected onto a screen at the same time.

Blending modes for enhancing contrast. The fourth group of blending modes (beginning with Overlay) increases the contrast in the image by lightening lighter tones and darkening darker values. Of the seven modes in this group, Overlay, Soft Light, and Hard Light are the most useful for photographic work. The neutral color for these blending modes is 50% gray. This means that any tone of 50% gray will have no effect at all on the image. Tones that are darker than 50% gray produce a darker result, while values that are lighter than 50% gray have a lightening effect.

Overlay, Soft Light, and Hard Light will increase contrast, but they do so by different degrees. Hard Light increases contrast the most, Soft Light the least, and Overlay is a combination of the two (though with some blends, the effect of Overlay and Hard Light is the same). Which one you decide to use will depend on how much you need to increase the contrast. Give each one of them a spin to see what looks best, and don't forget that you can always modulate the result by lowering the layer opacity.

Adjustment layers and blending modes in practice

Keep in mind that in terms of adjustments that apply only to tone (nothing pertaining to color), there are really only three things that you do to an image: darken, lighten, or modify the contrast. To give you a sense of how some of the blending modes can help you with such adjustments, we've prepared some examples. If you want to follow along, the images used in the following examples are available for download at the companion Web site for this book.

The type of adjustment that the blending modes offer is well suited to working on scans or digital camera JPEGs where the tonal quality of the image is less than ideal (too light, too dark, or low contrast). If you are starting from a raw file from a digital camera, these types of overall adjustments are best applied in the raw conversion software.

Darken and build density with Multiply. This technique works best on an image that is too light or washed out and that is lacking in contrast. The image in this example, *DC-3 Windows* is a scan from a negative produced by a Holga camera. Holgas are cheap, toy cameras with plastic lenses; the negatives produced by them are sometimes flat, and images made in bright sunlight, as was the case with this photo, are often slightly overexposed. The flat and washed-out state of the original scan makes this a perfect candidate for the Multiply blending mode.

↷ ch05_holga_dc3.jpg

1. Add a Levels or Curves adjustment layer. Do not change any settings in the dialog box and click OK. For this technique, any adjustment layer will do, but using Levels or Curves adjustment layer allow for additional tonal fine-tuning.

2. At the top of the Layers palette, click the blending mode menu and choose Multiply. You will see the image become significantly darker and detail on the bright aluminum side of the plane is much easier to see.

Original

Figure 5-40. The density of this flat, washed-out negative scan was greatly improved with an empty Curves layer set to Multiply. © SD

3. The Levels layer set to Multiply at full opacity definitely improves this image (Figure 5-40), but in some images the initial effect may be too dark. If this is the case, simply lower the opacity of the adjustment layer using the slider at the top of the Layers palette.

4. In many cases, a simple empty adjustment layer plus the blending mode is all you need, but don't be afraid to experiment with some of the settings if the initial effect is not quite right. For this image, we double-clicked the Levels layer thumbnail icon to reopen the Levels dialog, and then applied some fine-tuning by moving the endpoint sliders in a bit and adjusting the midtone. (We used the Levels clipping display described earlier in this chapter to make sure we were not losing any important details in the highlights or shadows.) This action darkened the image a bit more and added some contrast (Figure 5-41).

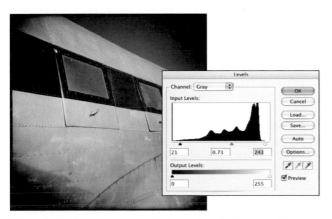

Figure 5-41. Fine-tuning the endpoints and darkening the midtones added a bit more snap to the DC-3 image. The blending mode for the Levels adjustment layer is set to Multiply.

Lighten with Screen. The Screen blending mode is best used with images that are too dark. Depending on how much of a lightening effect you need, you may have to scale back the effect using the opacity slider in the Layers palette. The image of a prison guard's key ring in Figure 5-42 is suffering from significant underexposure. Although we cannot make it as good as it would be had it been properly exposed in the first place, we can open up the shadows quite a bit and reveal image information in the darkest part of the photo.

🖰 ch05_keyring.jpg

1. Add a Levels adjustment layer. In the Levels dialog, click OK without making any changes.

2. At the top of the Layers palette, change the blending mode to Screen. The image will become noticeably lighter.

3. To further refine this, we double-clicked the thumbnail icon for the Levels adjustment layer to reopen the Levels dialog. We moved the midtone slider over to the left slightly to lighten the darker tones a bit more (Figure 5-43).

4. As a final touch we added a Curves adjustment layer (blending mode set to Normal) to add some contrast and further open up the lighter tones in the photo.

> Beware of lightening severely underexposed shadows too much. If the lightening adjustment is significant, then you may reveal ugly noise and posterization that is better off left hidden in the shadows.

Original

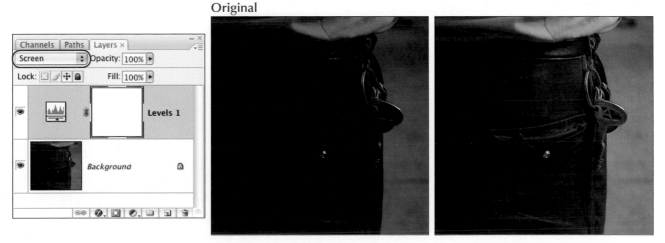

Figure 5-42. An empty Levels adjustment layer with the Screen blending mode helps to open up the underexposed shadows in this image. © SD

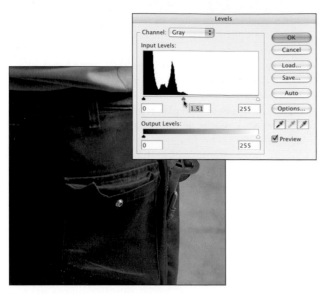

Figure 5-43. To further salvage the underexposed midtones, we made a significant adjustment to the midtone slider in Levels. The blending mode for the Levels adjustment layer is set to Screen.

Increase contrast with Overlay or Soft Light. Using Overlay or Soft Light to increase contrast works best on images that are obviously too flat and lacking in good contrast. The example that we feature here is a photograph taken with a pinhole camera in an old cemetery in upstate New York. The weather was overcast that day, and the initial scan of the medium format film negative is pretty flat.

🖰 ch05_ny_cemetery.jpg

1. Add a Curves adjustment layer. In the Curves dialog, click OK without making any changes to the curve. For the basic effect, a Levels adjustment layer would also work here, but using Curves will give you more flexibility to fine-tune the contrast.

3. At the top of the Layers palette, open the blending mode menu and choose Overlay. You will see a noticeable increase in contrast (Figure 5-44).

4. If the contrast increase seems too strong, you can reduce it by changing the blending mode to Soft Light and lowering the layer opacity. Experiment with both approaches to see how they affect the overall contrast in the image.

5. You can also adjust the curve to lessen the contrast. For this image we set the blending mode back to Overlay and the layer opacity to 100%, and then reopened the Curves dialog. The top half of the curve was locked down with control points, and the bottom part that represented the darker tones was raised to open up the shadows that had gotten too dark from the initial Overlay effect (Figure 5-45).

Using blending modes in combination with adjustment layers is no substitute for knowing how to enhance tonal information with Levels or Curves. That basic knowledge is essential for doing quality photographic work in Photoshop. There are times, however, when the solutions that the layer blending modes offer are all you need to jumpstart the tonal correction process. Rather than view these modes as a quick fix to be used in place of more conventional Levels and Curves adjustments, think of them as another useful technique that is available to you in the digital darkroom. We'll cover more blending modes as they relate to working with color images later in the book.

Original

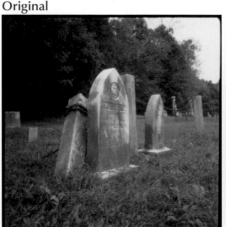
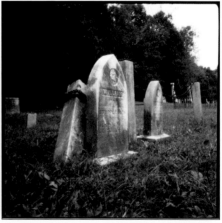

Figure 5-44. An empty Curves adjustment layer with the Overlay blending mode creates a strong contrast increase in this initially low-contrast image. The deep shadows have gotten a bit too dark, however, and need further adjustments.

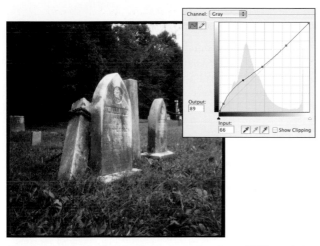

Figure 5-45. The Curve adjustment (set to Overlay at 100% opacity) is adjusted so that the darkest shadows are lightened to compensate for the results of the Overlay blending mode. Lockdown points keep the brighter tones from being affected. © SD

Converting Color to Black-and-White

Both of us and, we imagine, many photographers, have a sizeable archive of black-and-white negatives, and Seán still shoots a fair amount of black-and-white medium format film in his Holga, Diana, and pinhole cameras. But as more and more photographers switch to digital cameras, the new images they create are starting out in color even if their intention is for the final print to be in black and white. To address this aspect of working in the digital darkroom, we will venture into color territory briefly to cover some of the different methods for converting a color original into black-and-white.

Black-and-White Conversion with Raw Images

With raw files your objective should be to apply as much of the global color and tonal adjustments as possible in the raw conversion process, and this includes the conversion to a black-and-white image. The actual raw file created by the camera is never changed; any changes you make in a raw editing program creates a set of instructions for that visual interpretation and is applied as the image is converted into a file that can be worked on in Photoshop or other applications. If you know from the start that you want to treat an image as a black and white, then applying the black-and-white effect to the raw file makes a lot of sense, since the tonal qualities expressed by the raw image data are in a more malleable state than after they are converted to a bitmap image made up of pixels.

The black-and-white conversion options available to you will vary depending on the raw processing software that you are using. We will be covering the Grayscale Mixer in Photoshop Lightroom and Adobe Camera Raw. It's well-designed, easy to use, and a welcome addition to the raw processing features of both programs.

Black-and-white conversions with Photoshop Lightroom

The Photoshop Lightroom method is essentially the same approach as in the new Black and White adjustment feature in Photoshop CS3 (more on that a bit later). It enables you to lighten or darken the grayscale tonal values in the conversion based on the original colors in the source file. A set of eight sliders lets you control red, orange, yellow, green, aqua, blue, purple, and magenta.

Digital Camera Black-and-White Modes

Many digital cameras have program modes that will deliver a black-and-white interpretation of the scene before the lens. We do not favor using these modes, however, for a couple of simple reasons. First, any black-and-white effect created by the camera means that the camera has processed the image, which means that you can use it only with JPEG and not with raw files. For the most creative control over our images and access to the high-bit data captured by the image sensor, we prefer

to shoot in raw. Second, by choosing a black-and-white exposure mode you are letting the camera make the creative decisions on how to translate a color scene into black and white. There can be a lot of room for creative interpretation in the transition from color to black and white, and we feel that such decisions are far too important to be left up to the camera. Our recommendation is to shoot in color, preferably in raw, for the most creative control over your image.

1. Select an image either in the Library module or in the Filmstrip and enter the Develop module. Apply overall brightness and contrast adjustments to the color image (Figure 5-46) before using the Grayscale Mixer. A color photo that has been properly optimized will yield a better black-and-white conversion. In the Basic controls immediately under the histogram, click Grayscale.

Even when in Grayscale, adjusting the White Balance sliders will affect the gray value tonality since the color balance of the original image colors are being changed. This will result in slightly different translations into grayscale tones.

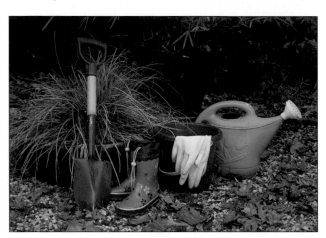

Figure 5-46. The original color image. © SD

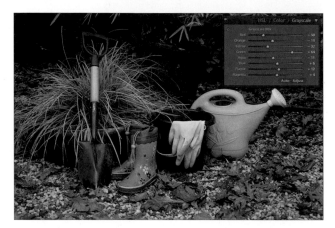

Figure 5-48. A custom conversion created with Photoshop Lightroom's Grayscale Mixer. The green watering can and the green areas on the boots have been lightened, the red color of the shovel and bucket have been slightly darkened, as have the blue colors.

2. Scroll down through the Develop controls until you come to the Grayscale Mixer. Move the sliders for the different colors (Figure 5-47) until you start to get something you like. Negative numbers will cause the adjusted colors to darken while positive numbers result in lighter gray values.

The Targeted Adjustment Tool. The Tone Curve, HSL, and Grayscale Mix controls in Lightroom have a Targeted Adjustment Tool that allows you to drag on the image preview to adjust colors or tonal values (Figure 5-49). This tool is a small circular icon in the upper left area of a control panel. Click on it to activate the targeted adjustment functionality and then drag on an area in the image. For the grayscale conversion, dragging up will create a lighter gray tone for that color and dragging down will darken it. To turn off the targeted adjustment feature, simply click the icon again.

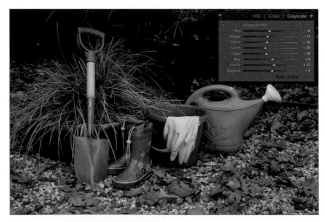

Figure 5-47. A grayscale conversion made in Photoshop Lightroom using the Grayscale Mixer's Auto-Adjust settings.

3. After creating the initial black-and-white mix, you may want to revisit the Exposure and Contrast controls for fine-tuning (Figure 5-48).

Figure 5-49. Dragging in the image with Lightroom's Targeted Adjustment Tool will lighten or darken that color.

Virtual Copies in Lightroom

In Lightroom, you can create "virtual copies" of the primary image file by choosing Photo → Create Virtual Copy. As the name suggests, these are not actual duplicates of the image file, but they exist as a separate set of develop instructions that have all the appearance and functionality of working on a separate file. By making virtual copies of a file, you can experiment with different Develop settings without actually duplicating the file and taking up additional hard drive space. The virtual copies are grouped with the source image file in the Library and are identified by a turned-up corner on the thumbnails. You can select the image and its virtual copies and then view them in Survey view to see the different versions side by side (Figure 5-50). This is a very efficient way to easily try out a variety of interpretations for a photograph.

Figure 5-50. The original color file and three virtual copies with different grayscale develop settings are compared in survey view in Photoshop Lightroom.

Black-and-white conversions with Adobe Camera Raw

Adobe Camera Raw 4.0, which ships with Photoshop CS3, includes several new features, one of which is a Grayscale Mixer that is nearly the same as the one found in Photoshop Lightroom. The primary difference is that there is no targeted adjustment tool that alters tonal values when you drag in the image preview. Open a raw file into Camera Raw. As with making black-and-white conversions in Lightroom, it is best to adjust the overall brightness, contrast, and saturation of the color image before venturing into the grayscale controls.

Any black and white conversion will be more successful when starting from a good color image (Figure 5-51). Once the adjustments to brightness, contrast, and saturation have been applied, click the fourth tab from the left to display the HSL/Grayscale controls, and then click the Convert to Grayscale checkbox.

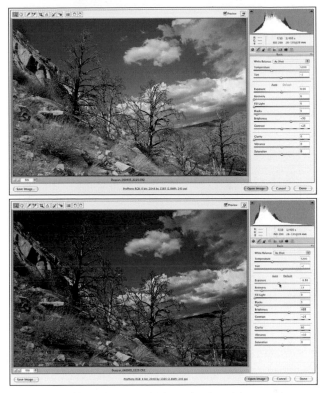

Figure 5-51. The original raw file (top) and the improved version (bottom) after adjustments have been made to brightness, contrast, and saturation. © SD

1. The initial grayscale mix is an auto adjustment and should only be viewed as a starting point (Figure 5-52). The real power of these controls lies in crafting a conversion that is customized for the needs of each image. Adjust the color sliders to shape the gray values based on the original colors. Negative numbers will darken the adjusted colors, while positive numbers create in lighter gray values. In the example seen in Figure 5-53, the bushes and grass on the hillside have been lightened and the blue sky has been darkened to create an interpretation reminiscent of classic black-and-white landscape photographs.

Figure 5-52. When you first enter the Grayscale Mixer panel, an auto conversion is applied.

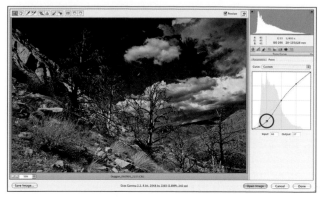

Figure 5-54. Adjusting the contrast to further darken the sky after applying a grayscale conversion.

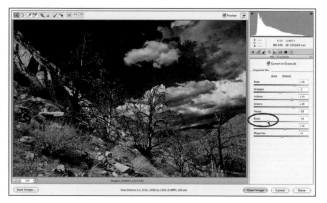

Figure 5-53. A custom grayscale interpretation resulting in dark, dramatic skies and light rocks and vegetation.

One of the most important things to understand about grayscale conversions is that with the removal of color values from an image, contrast relationships become even more important. It is through contrast manipulations that you shape the image once it has been converted to a black-and-white version. Consider the differences in the two versions of the photo seen in Figures 5-52 and 5-53. In Figure 5-53, the enhanced contrast from the darker sky and lighter vegetation creates a more dynamic image.

2. After we have the grayscale interpretation looking the way we want, we often return to the Tone Curve tab and make final adjustments to the contrast. This can be especially useful with landscape photos if you need to further darken a blue sky (Figure 5-54). As with Photoshop Lightroom, if you make changes to the White Balance sliders, this will affect the grayscale translation since the original underlying image colors are being manipulated and those changes show up as slightly different translations into grayscale tones.

Camera Raw: Saving grayscale settings with your image files. Since raw images are captured from a color scene, you may want to create a black-and-white interpretation of the file as well as preserve the original color version of the image as it is previewed in Adobe Bridge or in Camera Raw. Although this is much easier to do in Photoshop Lightroom with virtual copies (see the sidebar "Virtual Copies in Lightroom" earlier in this chapter), you can save a set of Camera Raw settings as an XMP file that can be recalled and applied to the file. You can also save a Preset that can be quickly applied to any raw file. We'll discuss the former approach first.

1. To save the settings for the grayscale conversion, use the Grayscale Mixer controls as described previously to adjust your file as you wish. Next, click the Settings submenu button in the upper-right corner of the HSL/ Grayscale tab, and choose Save Settings.

2. In the dialog box, open the Subset menu at the top and choose Grayscale Conversion to deselect all the other checkboxes. If a Tone Curve adjustment is an integral part of the grayscale conversion, select that check box so that it is also included. Then click Save (Figure 5-55).

3. If you want the grayscale settings for the image in question to be stored in the same folder as the original raw file, then navigate to that folder on your system and choose it as the location for the saved XMP file. Append the filename with a notation that denotes these settings are for a black-and-white conversion (for example, BW).

4. To load a previously saved Camera Raw setting, open the Settings menu, choose Load Settings, and then navigate to the folder where the file is stored.

Figure 5-55. By saving the Grayscale Conversion settings to an XMP file in the same folder as the original raw file, you can leave the original in color and still have easy access to the black-and-white version.

Camera Raw: Saving presets. You may also want to create a set of Grayscale Conversion settings that would work well on several different images, such as for a landscape photo with dark, dramatic skies. The procedure described below is not just for grayscale conversions and will work with any type of Camera Raw settings you want to save as a preset.

1. After adjusting the image as desired, click the Presets tab (the last one on the right), and then click the New Preset icon at the bottom of the panel. This will open up the New Preset dialog, which is virtually the same as the Save Settings dialog except that it lets you name the file at the top of the dialog. It contains all the other options that enable you to choose which parameters are saved, but it skips the Save dialog and immediately places the new saved preset in the Presets panel (Figure 5-56).

2. Once you name the preset and click OK, your preset will immediately appear in the list of saved settings in the Presets panel. To apply the preset to an image in Camera Raw, simply click it (Figure 5-57).

3. You can also open the Settings menu and click Apply Preset. A pop-out menu will appear with a list of the settings that have been saved as presets. Select the one you want to apply.

> Clicking another preset does not cancel out any of the presets you have already applied to the image; it simply adds to the effect, which often ends up being something you neither wanted nor expected. To remove an applied preset from an image, open the Settings menu and choose either Image Settings to use the settings previously saved with that file or Camera Raw Defaults to return to the default interpretation.

Figure 5-56. Saving a Point Curve setting and a Grayscale Conversion setting that will work well for making dark, dramatic skies from color images where the sky is a deep blue.

Figure 5-57. Once a preset is saved, it is listed in the Preset panel. Click it to apply it to an image.

Black-and-White Conversion in Photoshop

Although the Grayscale Mixers in Camera Raw and Lightroom offer a great deal of control for raw files, working with conversion techniques in Photoshop also offers some significant advantages, such as the ability to use adjustment layers, layer masks, and blending modes. There are numerous ways in Photoshop to create a black-and-white image from a color original. Some are fast and simple, with little or no fine-tuning options available, while others are more detailed, giving you a greater degree of control over how you can interpret the color tones as grayscale values and what areas of the image to apply them to. We prefer the latter and we will be covering these methods here.

As is often the case with interpretive modifications, there is no one right way to go about this, though with the introduction of a new black-and-white adjustment layer in Photoshop CS3, it is now much easier to quickly achieve good results. The important thing is to understand how the different techniques achieve the black-and-white conversion and which methods offer you the most control and ease of use. The aim of this section is not to show you every single possible way you can convert a color image to black and white, but to focus on what we feel are the techniques that offer the greatest creative flexibility. In the following section, we'll take a closer look at finessing the black-and-white conversion with toning and split-toning techniques.

Black & White adjustment layer

One of the best new features in Photoshop CS3 is the Black & White adjustment layer. Much like the Grayscale Mixers in Photoshop Lightroom and Camera Raw, this adjustment layer enables you to assign varying gray brightness levels to the original colors in the image, and offers a high degree of control for crafting the perfect black-and-white interpretation. This new feature is far superior to the capabilities of the Channel Mixer, which until Photoshop

CS3 was a very useful color to black and white conversion tool. In Photoshop CS3 the Black & White adjustment layer is an excellent feature to create a black-and-white version of a color photo.

🖱 ch05_BW_adjustment.jpg

1. Starting with a color original, click the Add Adjustment layer button at the bottom of the Layers palette, and then choose Black & White.

2. The default conversion will be applied as the Black and White dialog box opens. For a more customized approach, adjust the different color sliders to make specific ranges of color lighter or darker depending on how you want the image to look in black and white. Use the preview checkbox to toggle the preview on and off to see the original image colors.

3. You can also click a particular tonal value in the image and drag left or right. The underlying original image color will be changed in the dialog. For example, as seen in Figure 5-58, clicking and dragging right or left on the mountainside causes the blue values to be changed since the shadows on the mountain contain a high percentage of blue. This helps to create better tonal separation between the shadows and the highlights on the mountain.

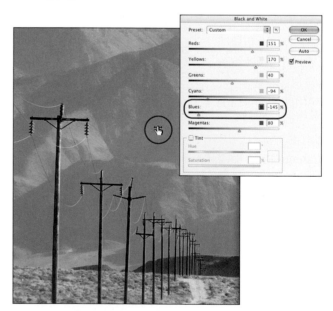

Figure 5-58. Dragging left in the blue shadows of the mountains increases the tonal separation between the shadows and the highlights on the mountains.

Using negative values for a given color will cause areas that have that color in the image to be rendered dark, while positive values will yield a lighter gray tone. For example, negative percentages for cyan and blue will result in a dark sky, just as positive values for red and magenta will cause a red rose to look very light.

Keep in mind that an individual color in this dialog is always composed of two other colors, so adjusting one color can affect other areas in the image. Yellow, for instance, is made up of red and green, so any adjustments to those colors can affect yellow as well. Figures 5-59 and 5-60 show the results of adjusting the black-and-white conversions and refining with Curves.

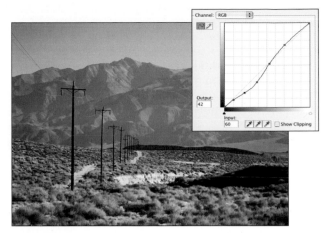

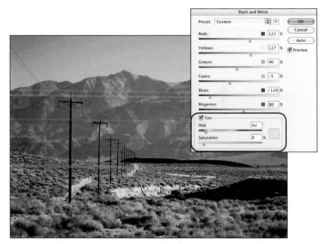

Figure 5-60. A final adjustment in Curves further boosts the contrast on the mountainside. © SD

Clicking the Tint checkbox in the bottom of the dialog enables you to apply a monochromatic color tint to the image. Choose a tint color by moving the Hue slider, and adjust the saturation or intensity with the Saturation slider. The default Hue is a sepia tone, but we find the initial saturation of 20% a bit too strong. Using the tint slider (Figure 5-61) applies a basic toning effect to an image. Other methods that offer more control and yield better results will be discussed later in this chapter.

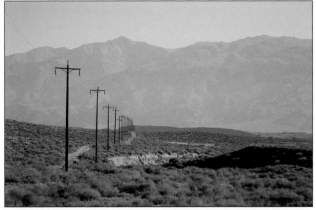

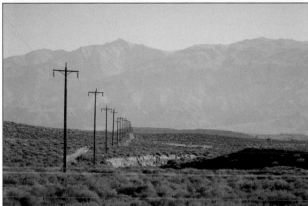

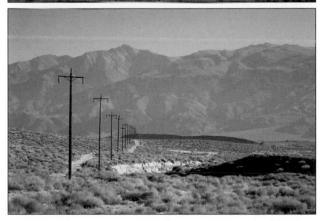

Figure 5-59. A Tale of Two Conversions: The middle image shows the default black-and-white conversion. The image on the bottom is the result of darkening the blue tones to bring out more tonal separation on the mountain and lightening the reds and yellows to increase the contrast in the sagebrush. © SD

Figure 5-61. The Tint sliders in the Black and White adjustment dialog offer basic controls for adding a monochromatic tone to an image.

The Black & White adjustment also comes with several potentially useful presets. Click Presets at the top of the dialog to see what's on the menu. As these grayscale effects are based on the colors in the image, your mileage may vary with these presets depending on the type of images you are using. The same preset may produce very different results on different images. As with all of the presets in Photoshop, you can also save your own custom blend of settings. To do this, just click the Preset Options button to the right of the menu.

Channel Mixer

In Photoshop CS2 and earlier, the Channel Mixer (Figure 5-62, Figure 5-63 and Figure 5-64) was one of the main methods for converting to black and white that gave you a good deal of control over the appearance of the image. In most cases, however, the introduction of the Black and White adjustment in Photoshop CS3 has surpassed the Channel Mixer as a method for converting a color photo to black and white. In fact, we think the main reason for using it now would be if you are using a version of Photoshop prior to CS3.

When you use Channel Mixer, you can brew your own blend of the three channels to fine-tune the black-and-white treatment.

1. In the Channels palette, click the name or the thumbnail for each of the three channels to see which ones have tonal qualities that appeal to you. This first step is not mandatory, but it can give you a clearer idea of which channels will have the greatest influence in the recipe you create in the Channel Mixer.

2. At the bottom of the Layers palette, click the Add Adjustment Layer button, and then choose Channel Mixer.

3. In the Channel Mixer dialog, click the Monochrome box in the lower-left corner. In Photoshop CS3 the default monochrome mix is 40% each from the red and green channels and 20% from the blue channel. If you're using an earlier version of Photoshop, the default is 100% from the red channel.

Figure 5-62. The default Monochrome settings for the Channel Mixer.

4. Adjust the amounts from each channel to create a grayscale version that you like (this is where your pre-Channel Mixer evaluation comes in handy, as you should already have a better idea which channels are the most important). For best results, try to keep the total of all three channels at no more than 100%. In CS3 there is a readout that informs you of the total percentage; with earlier versions you have to do the math yourself. The primary reason not to go above 100% is that you run the risk of bright highlights being clipped to a total white with no detail. On darker, low-contrast images, it is possible to go above that percentage, but on brighter images with more contrast it's best to keep the channel mix total to 100%. Also, avoid changing the value for the Constant slider; it tends to make the image either much too light or too dark and is not useful for creating a grayscale effect.

Figure 5-63. Top left: the original image. Top right: the default Channel Mixer monochrome settings. Lower left: the Black & White with Blue Filter preset. Lower right: a custom mixture targeted towards darkening the blue sky while keeping the ride cars a lighter tone, similar to how the scene may look if photographed with black-and-white infrared film. © SD

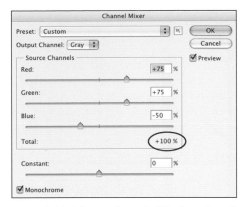

Figure 5-64. As long as the total of the three channels adds up to 100%, you can even use negative numbers in the Channel Mixer. The example above shows the settings for the lower-right image in Figure 5-63.

In Photoshop CS3 you can open the Presets menu in the Channel Mixer dialog to find a small collection of black-and-white presets that are designed to mimic the type of tonal renditions you would get when using colored filters with black-and-white film. These can serve as a useful starting point if you know that you want to base most of the conversion on one or two channels, or if you are familiar with how a certain colored filter would affect a scene when shooting with black-and-white film. If you find a custom mixture that you like, you can also save your own presets for future use.

Toning and Split Toning Effects

Photographs have been toned with color tints almost as long as photography has been around. Some of the toning we are used to seeing is a by-product of the chemical process or paper that was used to make the print, such as the rich brown tones of the Van Dyke process or the deep blues of a cyanotype print. Other types of toning are specifically chosen for the aesthetic qualities they bring to the image. And some of the apparent toning we see in antique photos may be the result of the gradual breakdown and fading of the chemically produced photographic image as seen in Figure 5-65.

However it is produced, the toned or tinted image has long been a part of the landscape of photography. Although any color can be used for toning, typically the most common types of toning are warm or cold tones. In this section we'll take a look at some different methods for digitally applying a tone based on a single color, as with sepia toning or cyanotypes, techniques for adding a split-tone effect to an image, as well as methods for applying irregular toning made of more than one "flavor" of a given color. We'll conclude with a look at methods to combine color and black and white to create a colorized or hand-tinted look.

Figure 5-65. Toned images have figured in photography for a long time. This portrait of the legendary stage actress Sarah Bernhardt was taken in 1880. (Seán Duggan Collection)

Monochromatic Toning

This is probably the most common type of toning and the one that most people are familiar with. The classic sepia tone, for example, has been used for many years to evoke the nostalgic qualities of days gone by, as the "old time" photos offered at county fairs illustrate so well. As with grayscale conversions, there are many ways to create monochromatic tints in Photoshop. Our aim here is not to provide an exhaustive toning encyclopedia, but to focus on what we feel are the best ways to apply toning effects, and the techniques that we use for our own work.

Toning with a Hue/Saturation adjustment layer

This method works well if you are starting out with a photograph that is already black and white, such as a scanned film image, or if you have already created a black-and-white effect using one of the methods covered earlier in this chapter. The Hue/Saturation command does not work with images that are in Grayscale mode, so if that is the case, be sure to convert your image to RGB first by choosing Image→Mode→RGB Color.

1. Click the Add Adjustment layer button at the bottom of the Layers palette, and then choose Hue/Saturation.

2. In the Hue/Saturation dialog box, click the Colorize checkbox in the lower right. The initial hue will be based on the foreground color or if the foreground color was black, white or gray, it will be red. Move the Hue slider to change the color of the toning. A sepia or brown tone can be found between 25 (reddish brown) and 42 (yellowish brown); anything above 42 is likely to start looking a bit green.

3. The default Saturation value when Colorize is checked is 25. If this seems a bit too saturated, move the slide to a lower number. For a very subtle effect that is barely noticeable as a sepia tone but evokes the look of warm-toned photographic papers, try a value between 6 and 12 (Figure 5-66 and Figure 5-67).

4. The Lightness adjustment is not useful since it alters the luminosity of the original image in a fairly heavy-handed way. If your aim is simply to add a color tint to the existing tonal qualities of the image, then you should leave this adjustment alone. It can be useful, however, if you want to drastically darken all tonal regions of the image to mimic the look of dimly lit night conditions or antique processes from the 19th century, which often yielded prints of a dark brownish color.

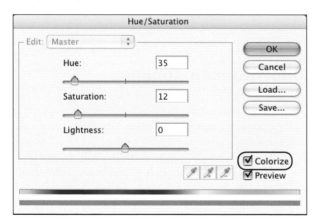

Figure 5-66. The Hue/Saturation dialog box, with values to create a subtle sepia tone.

Figure 5-67. Both images have been toned with a Hue/Saturation layer using a hue value of 35. The top image shows the effects of the default saturation value of 25, which is often too strong. The saturation value for the bottom image has been lowered to 12 to create a more subtle warm tone effect. © SD

Greg Gorman's warm-tone process

Noted portrait photographer Greg Gorman uses an interesting method to create his warm-toned black-and-white images by implementing a mask created from a negative version of the image. The first part of the process includes an alternate way of converting to black and white that is based on the Lightness channel in Lab mode. While many people favor this technique for converting a color image to black and white, we feel that the new conversion features in Photoshop Lightroom, Camera Raw, and Photoshop CS3 offer more flexibility and interpretive control. We'll include the Lab Lightness channel technique, however, just to give you some additional ideas and processing techniques for your digital darkroom.

ch05_steps.jpg

Use the Lightness Channel for a black-and-white conversion

1. Starting with a color photo, select Image→Mode→ Lab Color. In the Channels palette, click the Lightness channel to make it active.

2. Convert to Grayscale by choosing Image→Mode→ Grayscale.

That is the basic method for using the Lightness channel in Lab color to convert to black and white (Figure 5-68). The rest of the technique uses a negative version of the image luminosity to create a mask to control how the color toning is applied.

Figure 5-68. After converting an RGB file to Lab color, the Lightness channel is selected in the Channels palette prior to converting to Grayscale mode.

Load Luminosity selection, Inverse, and Add Color Fill Layer

1. Cmd/Ctrl-click the Gray channel icon to load a selection of the brightness values in the image. Lighter tonal areas are more selected and darker areas are less selected.

> If you are using this technique on an image that is already in RGB mode and that has had a grayscale conversion applied using another method, you can load a selection of the luminosity by Cmd/Ctrl-clicking the RGB channel in the Channels palette.

2. Inverse the selection by choosing Select→Inverse, and then convert to RGB by selecting Image→Mode→RGB Color.

3. With the selection still active, add a Solid Color Fill layer by choosing Layer→New Fill Layer→Solid Color (if you use the Add Adjustment Layer button at the bottom of the Layers palette, be sure to hold down Option or Alt before you click to prompt the New Layer dialog to appear).

4. In the New Layer dialog (Figure 5-69), open the Mode menu and choose Multiply. Click OK.

5. In the Color Picker, use the vertical spectrum bar and the large Saturation/Brightness box to choose a color for the toning, and then click OK. The Multiply blending mode multiplies the values of the blend color with the base color (in this case, the image) and yields a result that is darker than the original image, so you will probably need to adjust the layer's opacity slider to fine-tune the effect.

See Figure 5-70 for a view of the layer mask. Figure 5-71 shows the result of applying a Color Fill layer.

Figure 5-69. The New Layer dialog with the mode set to Multiply, and the Color Picker for choosing the color of the Fill Layer.

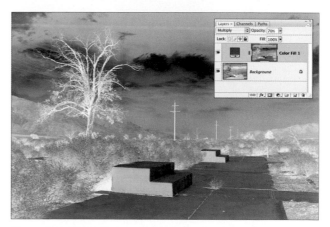

Figure 5-70. This is the layer mask that was generated from the inversed selection of the luminosity (brightness values) of the grayscale image. To see the mask in the main document window, Option/Alt-click the thumbnail of the layer mask. Option/Alt-click it again to return to the normal image view.

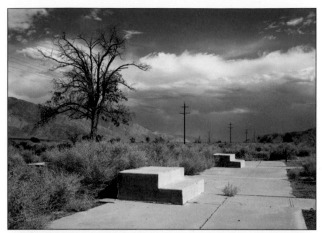

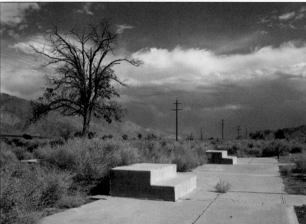

Figure 5-71. On the bottom is the result of applying a Color Fill layer set to Multiply with a layer mask based on the inversed luminance of the grayscale version. The initial effect was a bit too dark so the layer opacity was lowered to 70%.

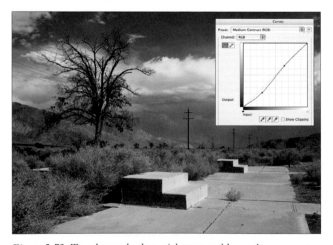

Figure 5-72. To enhance the deep, rich tones and boost the contrast a bit, we used the Medium Contrast preset in the Curves dialog. © SD

The elegance of this technique is its use of a layer mask based on the actual tonal values in the image to apply the color tone at varying strengths. Used this way, it could also be considered a split-toning technique since it applies the tone differently throughout the image and blends it with the neutral gray values of the black-and-white conversion. When using a layer mask to apply a tone such as with this technique, remember that a mask can be edited after the fact if you wish to customize how the toning is applied. We'll cover more masking techniques for toning in the following section on split toning, as well as in Chapter 6.

What About the Sepia Photo Filter?

The Photo Filter feature, which is available as an adjustment layer, offers a Sepia filter as well as numerous other toning choices and the ability to choose a custom color. While this feature may seem like a natural choice and is certainly a quick and easy way to apply a sepia tone, we have never been that thrilled with the results. If you do want to try it out, keep in mind that the default Density setting of 25 produces a barely noticeable result for the Sepia filter, and you'll probably need to increase this value significantly in order to see a stronger sepia tone. Clicking the Color swatch lets you choose a new color from the Color Picker. For most images you'll want to leave Preserve Luminosity checked or the image will take on the brightness value of the color you have chosen.

Split Toning

Split toning involves using the difference between tonal values in an image, typically highlights and shadows, to apply the toning at different strengths, or to apply two different tones to the different regions. In the classic application of split toning, this would typically involve a cold or neutral tone and a warm tone. In the traditional chemical darkroom, a split-toned effect could be created in a number of ways. One of the easiest and most common was to immerse a print in a bath of sepia toner for much shorter than the usual time. The result was that the highlight areas of the print, which contained less silver, would be toned first, and by interrupting the normal duration of the sepia bath, the middle values and shadows were left in the normal, neutral state. A further toning bath in a dilution of selenium toner would then shift the middle and neutral tones to a cooler tone or even a subtle violet shade if the selenium dilution were strong enough.

Thankfully, achieving a split tone in the digital darkroom is a much easier and more controlled process, not to mention one that doesn't produce smelly chemicals! In this section we'll show you a few methods for directing the toning to different tonal regions as well as ways you can apply more irregular split or multi-toning that is not based on tonal values.

Split toning in Photoshop Lightroom and Camera Raw

Both Lightroom and Camera Raw offer elegant methods to apply a split tone to images that are being treated as grayscale. The controls are the same for each program and consist of a set of sliders that enable you to choose a hue (tone color) and a saturation level for the shadows and highlights, as well as a slider for setting the balance between the two. Although the split-toning feature in either program can be used with color images to create color effects, we'll be focusing on using it with grayscale images in this section.

1. Use the Grayscale Mixer controls in either Lightroom or Camera Raw to create a grayscale conversion for your color image (see earlier in this chapter).

2. In Lightroom, the split tone controls are located just below the Grayscale Mixer (Figure 5-73). In Camera Raw, the split tone controls are the same as in Lightroom and are found in the tabbed panel just to the right of the HSL/Grayscale tab (Figure 5-74).

3. Choose a hue for the highlights and shadows, and then set the saturation (color intensity) level for each. If you want to create an effect that blends a color tint with the neutral gray areas of the black-and-white image, leave the hue for one of the tonal ranges (highlights or shadows) set to 0.

4. The Balance slider enables you to weight the toning more towards one area or the other. For example, choosing a negative balance setting will cause the toning color for the shadows to be more dominant throughout the image, and only the brighter areas will show traces of the highlight color. Choosing a positive balance value gives priority to the color chosen for the highlights, and only the darker values in the image will show the color that has been selected for the shadows.

> If you want to apply a monochromatic tone made up of a single hue in either Lightroom or Camera Raw, set the hue values to the same color for both highlights and shadows. The saturation values can also be set the same, or you can experiment with different saturation values for the different tonal regions.

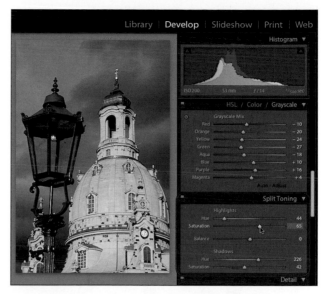

Figure 5-73. The tones for this photo of the Frauenkirche in Dresden, Germany, are split between sepia for the highlights and a bluish hue for the shadows. © SD

Figure 5-74. The highlights in this image have been toned a cyan green while the shadows are a deep blue. © SD

Split toning with highlight and shadow masks

The split toning controls in Camera Raw and Lightroom calculate the different tonal regions of highlights and shadows for you, which is one of the reasons they are so easy to use. Photoshop provides several ways to isolate the different tonal areas, however, and it's pretty easy to create your own masks based on information already present in the image (Figure 5-75). This first technique will show you how to use the Color Range command to create precise masks for the highlights and shadows that can be used in adjustment layers.

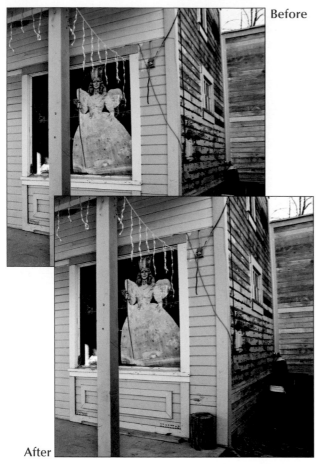

Before

After

Figure 5-75. Glinda's House. The original image and the version with sepia toning applied only to the highlights. © SD

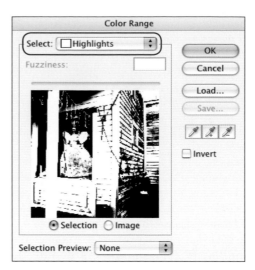

Figure 5-76. The Color Range dialog enables you to create a selection of sampled colors or specific tonal regions, such as the Highlights that are being selected here.

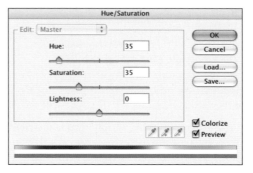

Figure 5-77. With a selection of the highlights active, add a Hue/ Saturation layer to create a sepia tone for the highlights.

🖰 ch_05-glindashouse.jpg

1. From the menu, choose Select→Color Range. In the Color Range dialog, open the Select menu at the top, and choose Highlights. Click OK to create a selection of the highlight tones (Figure 5-76).

2. Add a Hue/Saturation adjustment layer (Layer→New Adjustment Layer→Hue/Saturation). In the Hue/ Saturation dialog, click the Colorize checkbox in the lower right, and then adjust the Hue slider to get the tone you want. In the photograph "Glinda's House," we used a Hue setting of 35 and a Saturation value of 35 to create a warm, brown tone (Figure 5-77). Since only the highlights were selected prior to adding this adjustment layer, a layer mask has been created that shows only the toning in the selected areas (Figure 5-78). Click OK.

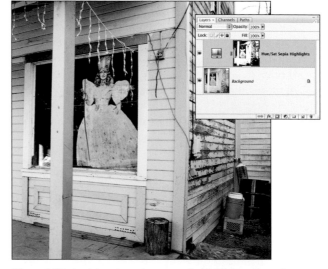

Figure 5-78. Applying the sepia tone to the highlights using a layer mask on a Hue/Saturation layer creates a split tone of the sepia and neutral gray tones of the original black-and-white photo.

If you want to have a split tone that is created from a single color tint, such as sepia, combined with the neutral gray tones of the black-and-white image, then you're done.

3. To add a different color tone to the shadows or midtones, repeat the above steps but select a different range of tones in the Color Range dialog, and apply a different tint in the Hue/Saturation dialog.

4. If you want to apply the second color tint to *both* the midtones and the shadows, Cmd/Ctrl-click the layer mask for the highlight tones to load it as a selection.

5. Select→Inverse to inverse the selection and add a new Hue/Saturation adjustment layer. For the Glinda image, we decided to go with a tint that is fashionable in the Emerald City and used a hue of 115 and a saturation of 10 to add a muted greenish tone to the midtones and shadows (Figure 5-79).

6. As a final step, zoom in to 100% (View→Actual Pixels) and inspect the mask to see if there are any areas that need touching up. To soften any hard edges on the mask created by the Color Range selection, choose Filter→Blur→Gaussian Blur from the menu, and apply a very slight blur of 1 to 1.5 pixels.

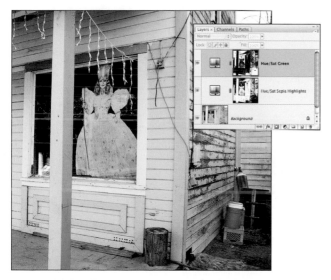

Figure 5-79. The final split-tone effect combines sepia for the highlights and a muted greenish tone for the shadows and midtones.

Irregular toning by painting in layer masks

The masking method in the previous technique works well when you want to apply any toning or tinting to specific tonal areas. If you want a more uneven, irregular application of the tone, however, you can use a simple brush technique on the layer mask for the toning layer. This works well for combining both a color tone with the neutral gray tones of the original black-and-white image, or for combining different strengths or "flavors" of a similar tone (Figure 5-80).

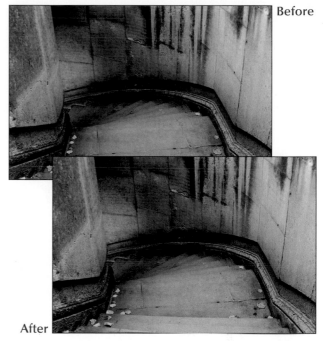

Figure 5-80. The Way Down. The grayscale version on the top and the final version showing irregular application of two different strengths of sepia toning combined with the neutral grayscale values. © SD

1. Add a Hue/Saturation adjustment layer and, in the dialog box, click the Colorize checkbox in the lower right. Adjust the hue to 35 and the saturation to 12 to create a foundation sepia tone that is not too strong. Click OK. Double-click in the name for this layer and rename it "Base Sepia" (Figure 5-81).

Figure 5-81. The base Sepia layer adds a foundation tone to the image that is noticeable but not overpowering.

2. Make a copy of the first Hue/Saturation layer by choosing Layer→New→Layer Via Copy (Command- or Control-J). Double-click the thumbnail for this layer to open the Hue/Saturation dialog. Using the same hue value, increase the saturation to 25 or 30 to create a much stronger application of the brown tone. Click OK.

3. Double-click in the layer name for the second Hue/Saturation layer and rename it "Strong Sepia." Invert the layer mask for this layer by choosing Image→Adjustments→Invert (Command- or Control-I). This will turn the layer mask black and will hide the strong sepia effect (Figure 5-82).

Figure 5-82. Inverting the layer mask to black hides the strong sepia effect.

4. Select the Brush tool. Click in the Options Bar to show the Brush Picker, and select a large, soft-edged brush. The brush size you use will vary depending on the size of the image you are working on, but a brush size of 300 to 500 pixels is often a good size to start with. Set the brush opacity in the Options Bar to 25%.

5. Press "D" on the keyboard to set the foreground color to white (when a mask is active, white is the default foreground color, but when a layer is active, black is the default). In an uneven and irregular fashion, begin to brush in the stronger "flavor" of sepia in different parts of the image. The idea here is not to tone specific elements in the image, but to add the toning in a seemingly random manner. Vary the size of the brush as needed (Figure 5-83).

6. Repeated brushstrokes over areas you have already painted on will cause the gray values in the layer mask to become lighter, which will in turn cause the tone to become stronger as more of it is revealed. Press "X" on the keyboard to exchange the foreground and background colors and paint with black to scale back the appearance of the stronger sepia tone.

7. Painting with black using a low brush opacity on the Base Sepia layer will dilute that tone and cause traces of the original neutral grayscale tones to show through (Figure 5-84).

Figure 5-83. Painting with white at varying opacities on the black layer mask causes the stronger tone to show through in an irregular fashion.

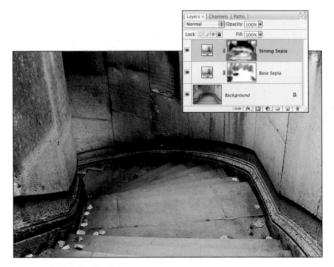

Figure 5-84. The final image © SD

Combining Color with Black-and-White

Like toning, accenting black-and-white photographs with color has been around for a long time. For many years the primary way this was achieved was by painting on photographic prints. Combining color with black and white can result in interesting creative treatments that enable you to focus the viewer's attention through visual signals created by the selective use of color. This effect can be achieved using the original image colors of a digital capture or a color scan, or by selectively adding color to a black-and-white image. In this final section of the chapter we'll cover using both of these approaches with your photographs.

Blending original image colors with black-and-white

Using original colors as accents in a black-and-white version of an image is really more about selection and masking techniques. No matter what technique you use, accurate selections and precise masks are required to reveal specific areas in color. Of course, you may choose to use a more painterly approach where exact edge fidelity is not that critical, such as in the previous example on irregular sepia toning, but however you do it, the use of layer masks will be required. The selections or masks that you use for this technique can be created either before you apply the black-and-white conversion or after (Figure 5-85).

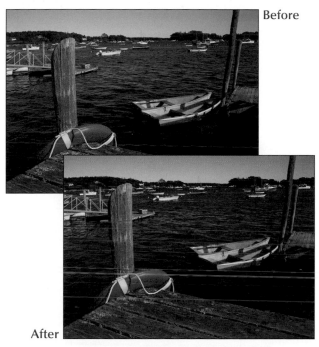

Before

After

Figure 5-85. By making only the life preserver in color, attention is focused onto that area of the image. © SD

🖱 ch5_life_preserver.jpg

1. Open the *ch5 life_preserver* image and add a Black & White adjustment layer. Create a grayscale conversion, and then click OK.

2. Click the view icon for the black & white layer so it is not visible, and then click the Background layer to make it active. With the Rectangular Marquee, drag a selection marquee around the life preserver (Figure 5-86). From the menu, choose Select→Color Range. By selecting a rectangle around just the life preserver before bringing up the Color Range dialog, it will preview only that area of the image and make it much easier to see what we are doing.

3. Set the Tolerance to 40 (the default), and click in the orange of the life preserver. Click the "plus" eyedropper (or hold down the Shift key), and click in areas of orange until the preview shows the life preserver as white (Figure 5-87). Click OK to create the selection (Figure 5-88).

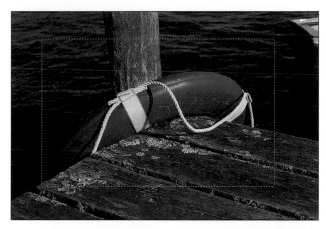

Figure 5-86. Selecting an area to target with Color Range will enlarge that area in the preview.

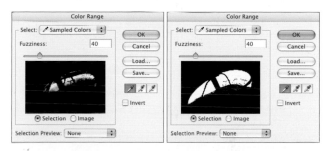

Figure 5-87. On the left is the initial selection previewed as a mask. On the right is how the selection looks after adding areas of orange that had not been selected by the first sample click.

Figure 5-88. The selection created by Color Range.

> The Quick Selection Tool also works great for areas of distinct color such as the orange of the life preserver.

4. Make the Black & White adjustment layer visible. Press "D" on the keyboard to make black the background color, and then press the Delete key to fill the selection with black. This masks the grayscale effect from the orange life preserver (Figure 5-89).

5. Zoom in to 100% (View→Actual Pixels) and inspect the mask to see if there are any areas that need touching up. To soften any hard edges on the mask created by the Color Range selection, choose Filter→Blur→Gaussian Blur from the menu, and apply a very slight blur of 1 to 1.5 pixels.

Figure 5-89. The mask protects the life preserver from the effect rendered by the Black & White adjustment layer.

Color tinting

Color tinting involves adding color selectively to a black-and-white image (or a color image with a grayscale effect) to create what is commonly known as the "hand-tinted" look. In the days before the wonders of the digital darkroom, this effect was accomplished by applying special photo oil paints directly to the surface of a print. It was time consuming, smelly, and the paint took quite a while to dry. Though adding color tints digitally is much easier and can be done with more control than by hand, for some artists the key factor about applying the colors by hand is the actual involvement of their hands. Many photographers who have done a lot of traditional hand coloring still miss that human touch in the art making process. Seán still has some of his photo oils, though the caps are firmly cemented in place due to years of neglect.

In this final section of the chapter we'll cover a few of the methods for creating a hand-colored look. As with our overall philosophy about working in the digital darkroom, the techniques that we'll show are designed to be flexible and non-destructive. This means that the application of color will be done with layers, adjustment layers, and layer masks.

Tinting with adjustment layers and layer masks. One of the easiest ways to add selective tinting is to use a series of Hue/Saturation adjustment layers with layer masks that target the color tint to specific areas of the image. The quality of your selections and masks will determine the quality of the tinting, so taking the time to make good selections and masks is important. If your image has only a few areas that need tinting, and the shapes are not too intricate, then completing the image will be relatively quick and easy. The more complex the image and the coloring requirements, the more time it will take you to finish the task. In order to concentrate on concept and not get too bogged down by a lot of detail work, the example we'll show here (Figure 5-90) has some fairly simple tinting requirements.

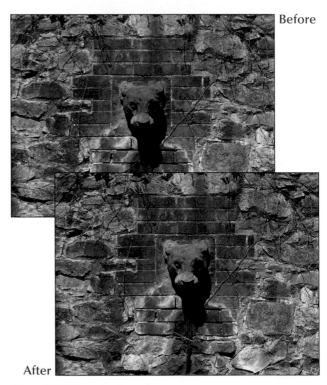

Before

After

Figure 5-90. The puma fountain. © SD

🖑 ch5_puma-fountain.jpg

1. Open the file "puma-fountain.jpg." This has already been converted to grayscale. To add color tinting, choose Image→Mode→RGB Color.

2. Use the Lasso tool with a feather value of 0 to make a selection of the center brickwork surrounded by the carved puma head. Total accuracy is not that critical. Hold down Option/Alt to subtract from the selection, and draw around the center square just behind the puma head. With the selection active, click the Add Adjustment Layer button at the bottom of the Layers palette, and add a Hue/Saturation layer.

3. In the Hue/Saturation dialog box (Figure 5-91), click the Colorize checkbox and move the hue slider until you get a reddish brick color. We found that a hue setting of 25 and a saturation of 20 worked pretty well. Click OK.

4. The mask edges are too hard, so we'll soften them with a blur (Figure 5-92). From the menu, choose Filter→Blur→Gaussian Blur. Enter a blur radius of about 8 or 10 pixels, and then click OK. This softens the edge just enough so the eye can't detect a hard transition.

Figure 5-92. Adding a slight blur to the hard edges of a mask disguises the transitions from one color to another.

5. Now make a loose selection of the puma's head with the Lasso tool. Add a new Hue/Saturation adjustment layer (Figure 5-93). In the dialog box, click the Colorize checkbox and move the hue slider until you get a tawny tan color that would work for a mountain lion (of course, you're also welcome to make a punk lion if the spirit moves you!). We used a hue of 42 and a saturation of 32. Click OK.

6. Press Command/Control-F to apply the same Gaussian Bur setting to the new layer mask and soften its edges.

7. Add a new Hue/Saturation adjustment layer (Figure 5-94). Click Colorize and move the hue slider to about 215 to create a bluish color that would work well for the wall. Set the saturation to 15, and then click OK. Don't be concerned that this layer covers all your previous tinting. We'll fix that in the next step.

8. Press D on the keyboard to set the default foreground/background colors, and then press X to exchange them and place black in the foreground swatch. In the Options Bar, choose a brush that is of a good size to cover up the center brickwork, and set the brush opacity to 100%. Paint over the center bricks to mask that part of the blue tint and reveal the brick color from underneath. Lower the opacity of the layer to 65%.

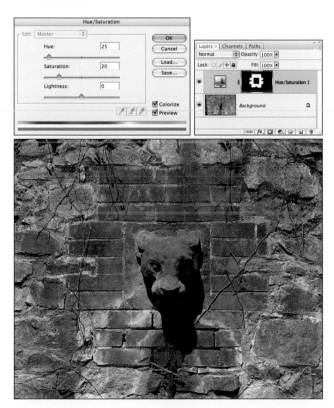

Figure 5-91. The first Hue/Saturation adjustment layer adds a tint to the brickwork.

Tinting by painting on an empty layer. To finish up this tutorial, we'll explore a different method for adding color tinting. This approach involves painting directly on an empty layer is above the main image and any other tinting layers you have added (Figure 5-95). For this to work, the blending mode for the layer needs to be set to Color. While the adjustment layer and masking method we have used so far with this example offers the greatest flexibility, it entails that each item that is a different color has to have its own separate adjustment layer and mask. By painting on an empty layer, you mix colors together as an artist may do on the canvas, making it ideal for adding small accents of different colors. Since very few things in life are all one color, the addition of other hues helps to break up the continuous tint of a single area. By keeping your color tinting on separate layers, as shown in this exercise, you can easily go back and change a specific color if you need to.

9. Add a new layer to the top of the layer stack (Layer→ New Layer). Set the blending mode for this layer to Color.

10. With smaller, soft-edged brushes, begin adding irregular splashes of tan and darker browns to the blue-gray areas of the wall. If a dab of color seems too bright or intense, switch to the Eraser tool (E), choose an opacity of 25%, and begin to gradually erase it until the saturation and density of the color looks OK.

11. Switch back to the Brush tool and choose a drab greenish color from the Swatches palette, or click in the Foreground swatch and choose a color in the Color Picker. Paint at lower opacities on the area just under the puma's mount, which is where the water spills from when this fountain is turned on. The goal is to add just a slight hint of green color here to suggest the idea of moss growing on the rocks (Figure 5-95).

Figure 5-93. The second adjustment layer adds a tan tint to the puma's head.

Figure 5-94. The third adjustment layer tints the stones of the wall with a blue-gray color.

Figure 5-95. The final tinting is painted directly on an empty layer that uses the Color blending mode. © SD

Figure 5-96. "Chips & Salsa with Frida Kahlo" is a 45-second exposure photographed with a homemade pinhole camera on black-and-white negative film. The tonal correction and color tinting was accomplished using nearly 30 adjustment layers with layer masks. © SD

Building a Solid Foundation

Developing a good understanding of how tone and contrast affect a photograph and what you can do to manipulate those qualities to find the image you see in your mind's eye is crucial to achieving your creative vision. In this chapter we have shown that most tonal corrections can be distilled down to the basics of darkening, lightening, adding contrast, or reducing contrast. That's all it really is. Everything else is just variations on those simple themes.

Learning these fundamental concepts of working with tone and contrast is essential to providing a solid foundation for further journeys of discovery in the digital darkroom.

In the next chapter we'll continue our explorations of masking and localized tonal corrections that we started towards the end of this chapter as we take a look at the concepts and techniques for dodging, burning, and exposure control.

Dodging, Burning, and Exposure Control

Human vision and cameras both create an image from the light that is reflected from the scene. The primary ingredients in any image are the varying levels of brightness that comprise the visible tonal range, from the darkest tones that describe shadows to the brightest values that represent the highlights. A key component in the framework of reflected tones that make up an image—and one that can have a great impact on the interpretation of a photo—is contrast, which is the difference between the dark and light values. Color, while certainly a key element in many images, is secondary to brightness and contrast.

Since the brightness values and contrast are so crucial to shaping the look of a photograph, it follows that having control over these qualities, rather than settling for what the camera recorded, is the key to creating the image you want. In the previous chapter we focused primarily on overall, or global, changes to tone and contrast. In this chapter we'll concentrate on making local changes to specific areas of the image by addressing:

- Dodging and Burning Techniques
- Identifying the Visual Components of a Photograph
- Non-destructive Dodging and Burning Techniques
- Contrast and Exposure Control
- Taming High Contrast with Multiple Exposures

Chapter 6

© Seán Duggan

Interpreting the Image with Tone

The delicate interplay of light and shadow is often one of the primary reasons we take a photograph. Enhancing the light and shadow in the form of dodging and burning allows us to effectively shape and interpret the image, emphasize certain areas, and provide a path for the viewer's eye to explore the image.

When considering the tonal aspects of a photograph, the origins of a good image always start in the camera with a good exposure in which both the highlights and shadows maintain detail and tonal information. The better the exposure is, the less work you'll have in a traditional darkroom or a digital darkroom. After that initial good exposure, however, the interpretive changes you apply to the tonal values in the traditional or digital darkroom can really transform an image.

To mix artistic metaphors, a good exposure, whether film or digital, is somewhat like a good chunk of marble to a sculptor. With that good piece of stone, the artist can carve and shape the stone into a new form, working with the structure of the stone to emphasize certain qualities to fulfill a creative vision. Working in the digital darkroom can lead to similar creative transformations, but the tools we use to shape and form the image are light and shadow. By sculpting with light and painting with tone, a photograph can be transformed into something much more expressive and meaningful than the initial exposure (Figure 6-1).

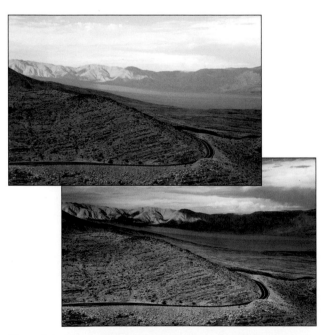

Figure 6-1. After shaping the tonal values with selective dodging and burning, the final image has greater tonal depth and subtlety. © SD

In traditional darkroom terminology, the practice of lightening or darkening specific areas of a print was known as *dodging* and *burning*. When printing in black and white, dodging was the process of protecting portions of the image from light, therefore lightening those areas, while burning referred to adding exposure (more light), which resulted in darker areas. In Photoshop, dodging and burning can be accomplished with a number of different methods, as explored in this chapter.

> Photoshop has long had a Dodge tool and a Burn tool and, although you can lighten and darken image areas with them, we do not favor their use simply because they cannot be applied non-destructively. The Dodge and Burn tools make their changes directly to the image pixels, and the effect cannot be undone or modified once the file has been closed. We prefer to use methods such as neutral fill layers or adjustment layers with layer masks to dodge and burn because they do offer a flexible and non-destructive way to shape the tones in a photo.

Non-Destructive Dodging and Burning

As with all our work in Photoshop, one of our primary goals is to structure our files so that any edits we apply are non-destructive. This means we can easily change the settings of the correction, edit a layer mask, adjust opacity, or delete the modifications entirely, if we so choose. The use of non-destructive editing is one of the primary characteristics of the "right way" to apply tonal corrections to an image and in this chapter we will look at the different ways this can be achieved.

Neutral Fill Layers

A neutral fill layer takes advantage of the fact that many blending modes have a neutral reaction to black, white, or 50% gray i.e. they don't 'see' or respond to black, white, or 50% gray. When a layer using Overlay or Soft Light blending modes is filled with 50% gray, and then areas are darkened or lightened, only the pixels that are darker or lighter than 50% gray will add the darkening or lightening effect to the image (Figure 6-2). The result of this bit of blending mode magic is the ability to combine dodging and burning on the same layer. When used with Overlay, the contrast-enhancing properties of that blending mode will also add a little contrast boost in addition to the lightening and darkening. Soft Light will be a more subtle effect, with less of a contrast boost.

⊕ ch06_MagicShop.jpg

Figure 6-2. The Magic Shop image before (top) and after modification using a 50% gray dodge and burn layer (bottom). © SD

1. Open an image where you want to both lighten and darken certain areas. If you want to work along with this example, it is available for download from the companion web site. Choose Layer→New→Layer. In the New Layer dialog box (Figure 6-3), select Overlay for the mode. When this mode is chosen, a checkbox will be enabled that lets you fill the new layer with an overlay-neutral color of 50% gray. Check this option, and click OK to create the layer.

[New Layer dialog box]

Figure 6-3. The New Layer dialog box with the settings for creating a 50% gray layer for dodging and burning.

2. Select the Brush tool and a soft-edged brush that is an appropriate size for the area you need to dodge or burn. Press D on the keyboard to make black your foreground color. In the Options bar, lower the brush opacity to 20%. Brush over areas in the image that you want to darken to de-emphasize them.

 In the adjustments we applied to this image, our aim was to enhance the tonal focus on the magician and deemphasize the bright background. We also wanted to bring more attention to the levitating figure, the frame around the window display and the words at the bottom of the image and this was accomplished by lightening those areas.

3. Press X to exchange the foreground and background colors and make white the foreground color. Leave the brush opacity set to 20%. Now brush over areas in the image that you want to lighten ("dodge") and emphasize. (Figure 6-4).

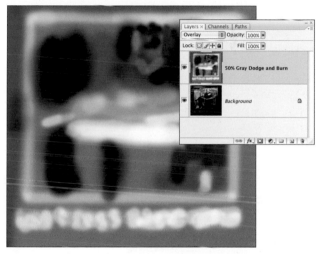

Figure 6-4. A view of the 50% gray layer after painting on it with white and black at varying opacities.

4. To tone back any lightening or darkening, simply paint with the opposite color. To remove the dodging and burning entirely, paint with 50% gray (RGB values of 128, 128, 128). You can also try setting the 50% gray layer to Soft Light, which will create a gentler application of the burning and dodging.

Layer Mask Essentials

Layer masks control which areas of a layer are visible in the photograph. This is true whether the layer contains image elements, as in a multi-image composite, or an adjustment layer that creates a color or tonal modification. We have already seen layer masks at work in the latter part of the previous chapter, but we'll take some time in this section to review some of the fundamental essentials of creating and working with layer masks.

Layer masks and adjustment layers

Whenever you add an adjustment layer to an image, you also get a layer mask. The white thumbnail to the right of the main layer thumbnail is the layer mask. By default, the layer mask is all white, which will show the adjustment throughout the entire image. In **Figure 6-5** the Curves adjustment layer affects the entire image of the clocks. If there is an area in the photo that you do not want to be affected, one way to modify the adjustment is to paint with black on the layer mask over that area. In the initial lightening adjustment to the clocks photo, the face of the foreground clock became too light and washed out. Using the Brush tool, we painted over the clock face with black on the layer mask to tone down the brightness in that area (**Figure 6-6**).

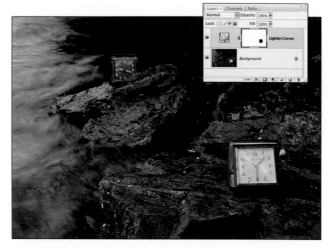

Figure 6-6. The initial adjustment lightened the face of the foreground clock too much, so those areas were painted with black in the layer mask to prevent them from being affected by the overall lightening adjustment.

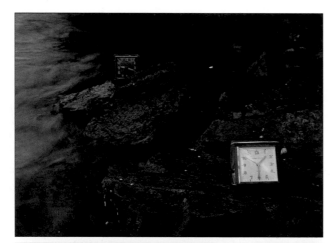

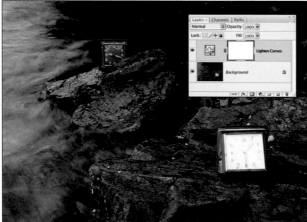

Figure 6-5. A white layer mask shows everything that a layer brings to the image. In this case, a Curves adjustment layer lightens the entire photo. © SD

If you have a selection active at the time you add the adjustment layer, the layer mask is based on the selection, with the selected areas rendered as white in the mask and the non-selected areas as black. Figure 6-7 shows how a selection was turned into a layer mask for a second adjustment layer that lightened and improved the contrast of the background clock.

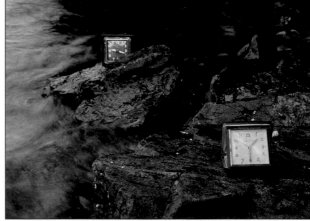

Figure 6-7. A selection is used to create an adjustment layer mask that only affects the background clock.

Controlling visibility with black, white, and gray.

Understanding the functional significance of black, white, and gray in a layer mask is key to controlling and perfecting them to suit the needs of the image. Black hides the content of the layer, totally concealing it from view. White reveals the content at full strength, and gray shows it partially. Darker levels of gray will partially conceal the layer or the effect the layer creates, and lighter levels of gray reveal more of it.

You can modify the black, white, or gray tonal value in a layer mask with a variety of techniques, including painting directly in the mask with the Brush tool; making selections on the mask and filling them with black, white, or any shade of gray; applying Levels or Curves adjustments directly to the mask; using the Gradient tool to create transitions; and applying filters to the mask. Any tool or command that enables you to modify the tonal values in a mask, and therefore alter how the mask affects the layer it is applied to, can be used when editing the mask.

The Invert command. There are times when adding an adjustment layer to an active selection results in a mask effect that is the opposite of what you need. If that happens, simply choose Image→Adjustments→Invert (Cmd/Ctrl-I) to invert the tonal values of the Layer Mask. Black will become white, and white will become black. The Invert command features prominently in a dodging and burning method we will be exploring shortly.

Feathering mask edges with Gaussian Blur. In the traditional darkroom, dodging and burning was accomplished by either blocking light from areas on the photo paper or by adding additional light to specific areas. To do this, the photographer used her hands, or tools such as dodging wands (a piece of black wire with a cardboard disk or other shape taped to the ends), or burning masks, which were pieces of cardboard with rough holes cut in them through which additional light (exposure) was added to the photo paper. To hide the edges of these tools and disguise the burning and dodging, during the exposure the hand, dodging wand, or burn mask was always moved in a gentle back and forth or circular motion. This motion prevented any hard edges from showing up in the final print.

Masking in the digital darkroom achieves the same effect through the use of feathering, blurring, or soft-edged brush tips. In fact, for tonal or color modifications that do not require a hard, precise edge, blurring or using a soft-edged brush at a reduced opacity is one of the most useful masking tools, and is probably the closest digital parallel to how these effects were created in the traditional darkroom.

In most cases, when we use the selection tools to create an initial selection that is turned into a layer mask on an adjustment layer, we do not pre-feather the selection. Although the Refine Edge dialog box previews how the edge is modified by a feather, it's often hard to judge how much feathering is needed until the actual mask is in place in the image. In most cases we prefer to make the selection with a 0-pixel feather, add the adjustment layer, and then choose Filter→Blur→Gaussian Blur to soften the edges of the layer mask. With this approach we have the best of all worlds: we can see the amount of blur/feathering that is being applied to the mask, and we can judge its effectiveness on how the adjustment layer is affecting the main image.

Figure 6-8 shows a layer mask that was created from a rough Polygonal Lasso selection. An adjustment layer is darkening the background, and the edges of the layer mask show up with an obvious, cut-out look. After applying a slight Gaussian Blur to the layer mask, as seen in Figure 6-9, the mask edges are no longer detectable.

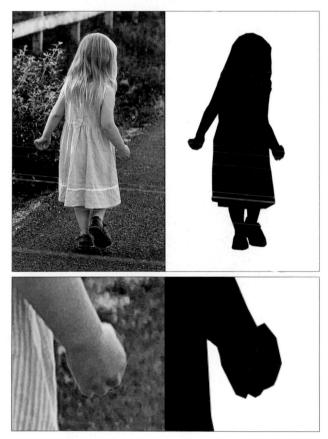

Figure 6-8. If you know that a mask will need a soft edge, then the initial selection does not have to be totally accurate.

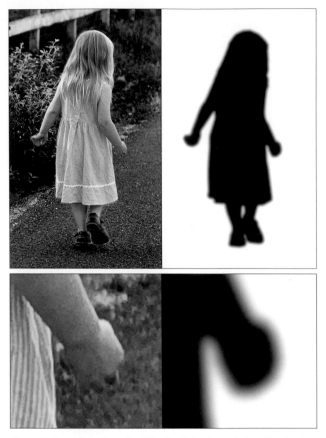

Figure 6-9. A Slight Gaussian Blur is all that is needed to disguise the hard edges of the layer mask.

Dodging and Burning with Adjustment Layers

One way to lighten or darken specific areas is to apply the correction to the entire image, invert the layer mask to hide the adjustment, and use the Brush tool to brush in lightening or darkening where you want the effect to show. In Figure 6-10 we lighten (dodge) the radiator of the car, but the same steps can be used to darken (burn) specific areas, too. Just apply a Curves adjustment that darkens instead of lightens.

🖱 ch06_OldFord.jpg

1. Add a Curves adjustment layer. In the example of an old car, we raised the curve up to lighten the shadow tones (Figure 6-11). The adjustment will affect the entire image, but we'll address that in the next step. Click OK to close the adjustment layer dialog box.

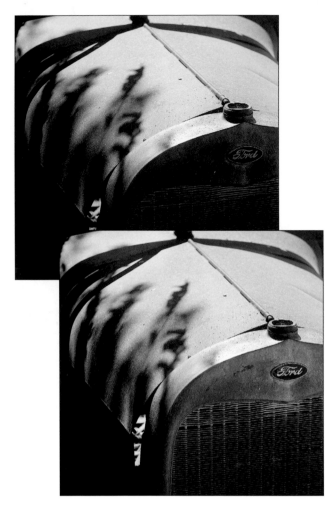

Figure 6-10. Old Ford, before and after: Only the darker areas on the grill have been lightened. The bright areas on the hood have not been adjusted. © SD

With this technique it is OK to lighten (or darken) the image a little more than is necessary; in most cases, you won't be revealing the full strength of the adjustment. You can also tone it down by lowering the opacity of the adjustment layer.

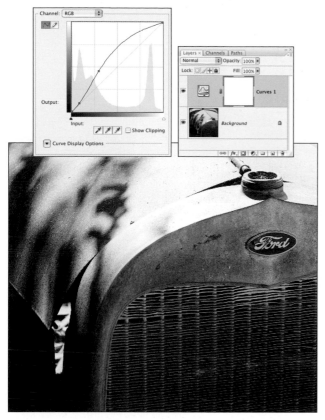

Figure 6-11. The effect of the overall lightening curve on the image.

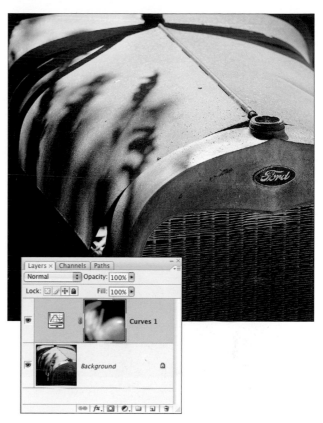

Figure 6-12. Painting on the layer mask with white at varying opacities will gradually reveal the lightening effect in the image.

2. Choose Image→Adjustments→Invert to invert the tones in the mask and change the white to black. This will hide the lightening adjustment.

3. Press D to set the foreground color to white. Select the Brush tool and choose a brush size that is an appropriate size for the area you need to work on. In the Options Bar, set the opacity of the brush to 30%.

4. With the lightening adjustment layer active in the Layers palette, brush over the area in the image that you want to lighten. When you release the mouse button and start again, you will be applying another brush stroke, which will increase the lightening effect on areas that you have already worked on (Figure 6-12). If you over lighten a part of the image, press X to exchange the foreground and background colors, and then paint with black at a reduced opacity to remove the lightening effect.

> Using a brush with a lower opacity lets you gradually build up the lightening effect and naturally blend it with the tones in the rest of the photo. With the brush set to 100%, the lightening will look too obvious.

Dodging and Burning with Empty Adjustment Layers and Blending Modes

In Chapter 5 we discussed the use of blending modes and empty adjustment layers (adjustment layers where no changes have been made) to lighten, darken or increase contrast in an image. These blending modes can also be used when you need to affect a specific area in the image (Figure 6-13). Although manually manipulating a curve may give you more precise control, with some images you do not need exacting precision, you only need to darken or lighten. Additionally, as we shall see a little later, the darkening or lightening effect created by a blending mode is something that can be easily recorded as an action to help automate the basic burning and dodging process.

Figure 6-14. An empty adjustment layer set to Multiply blending mode will darken the entire image.

Figure 6-13. Before and after. © SD

🖰 ch06_220Volts.jpg

1. Add a Curves or Levels adjustment layer to the image and click OK in the adjustment dialog box without making any changes. At this point the adjustment does nothing but a change in the blending mode will turn it into either a dodging or burning layer. In the case of this image of a train car, our aim was to darken the left side of the image, so we set the blending mode to Multiply.

2. The darkening adjustment created by the Multiply blending mode will affect the entire image (Figure 6-14). If the overall effect is too strong, you can lower the layer opacity. To apply the darkening to only parts of the image, modify the layer mask.

3. For the train image in this example, we used a large soft-edged brush and painted on the layer mask with black at 50% opacity on the right side of the image (Figure 6-15).

4. To further shape the tonality and guide the viewer's eye, we changed the foreground color to white (X on the keyboard will exchange the foreground and background colors) and painted over the electrical box and the large conduit pipes to darken those areas a bit more (Figure 6-16).

Figure 6-15. The darkening effect is toned down on the right side of the image by painting on the layer mask with black and the brush opacity set to 50%.

Figure 6-16. As a final touch we modified the layer mask with the brush tool to further darken the electrical box and create more visual emphasis in that area of the image.

In this example, we darkened areas using the Multiply blending mode. To lighten areas, use the Screen blending mode and modify the layer mask as needed.

Automating dodge and burn layers with an action

Using blending modes and actions, you can automate the initial setup steps for the previous technique and create actions to quickly create an adjustment layer with a black layer mask that will lighten or darken the image when you paint on it with white. You can also set the action to choose a soft-edged Brush tool and set white at a specific opacity as the foreground color.

Create a custom brush preset. Before we create automated dodge and burn actions, we'll make a custom brush preset. This step is not strictly necessary but it does make for a smoother action. The main reason for creating the custom brush preset is that you cannot record the brush opacity setting in an action (the omission makes no sense to us, but that's the way it is). But you can create a brush preset with the desired opacity and color, and then target that brush preset in the action.

1. Open any image and click on the Background layer to make it active. Press D to set the default foreground/background colors, and then press X to exchange them, making white the foreground color.

2. Choose the Brush tool in the Tool palette. In the Brush Picker in the Options bar, choose a soft-edged brush of 150 pixels. If you do not see a 150-pixel tip, choose the 200-pixel tip, and use the Master Diameter slider to adjust the size. Set the opacity to 30% (Figure 6-17).

Figure 6-17. Use the Brush Picker and the Options bar to configure the settings for a dodging and burning brush prior to making a new custom preset.

3. On the far left side of the Options bar, click the Tool Preset icon to open the Tool Preset picker. Click the New Tool Preset button (Figure 6-18), and give your brush a descriptive name (we called ours "Soft Round

150 30%op –White"). Be sure to click the checkbox for Include Color so that white will always be the active color for this brush preset. Click OK to create the preset, and then you will see it appear in the Preset picker.

Figure 6-18. In the Tool Presets picker, click the New Tool Preset button to save the dodging and burning brush as a preset.

Now that we have created this preset, we can create an action to automate the setup of non-destructive dodging and burning layers.

Automated dodge layer setup.

1. Open any image. In order for the action to properly record the selection of the Brush tool, click on any other tool to make it active. Open the Actions palette (Window→Actions). Click the folder icon at the bottom of the palette to create a new Action Set. Name it "Dodge and Burn." Click the New Action icon (circled in Figure 6-19). Name the new action "Lighten with Brush Tool." Click Record.

Figure 6-19. The new Dodge and Burn action set.

2. Choose Layer→New Adjustment Layer→Curves. In the New Layer dialog box, set the mode to Screen and the opacity to 50%. You may want to give the layer a descriptive name, too; we used "CRV Lighten-Screen-50%op" (Figure 6-20). When the Curves dialog box appears, click the OK button without making any changes. The entire image will be noticeably lighter.

Figure 6-20. The New Layer dialog for the Curves adjustment layer in the Lighten with Brush Tool action.

3. Choose Image→Adjustments→Invert to change the default layer mask from white to black, hiding the lightening created by the Screen blending mode.

4. Choose the Brush tool from the Tool palette. Open the Tool Presets picker, and select the brush preset you made earlier (Brush Soft Round 150 30%op –White).

5. Open the submenu for the Actions palette, and choose Insert Stop. This enables you to leave yourself, or others you may be working with, a message containing further instructions on how to proceed after the action is done. For example, for this action we chose to write the message shown in Figure 6-21. Click the Allow Continue checkbox in the lower-left corner, and then click OK.

Figure 6-21. The dialog for entering the stop message information.

6. Press the Stop button (the square) at the bottom of the Actions palette to stop recording.

The insertion of the Stop message is useful if you need a reminder of what to do next, or if you want to make an action for others to use, but it is purely optional. You can also easily delete it later by dragging that part of the action to the trashcan icon at the bottom of the Actions palette.

7. The basic setup steps are now complete (Figure 6-22). After you run the action on an image, brush over areas of the image that need lightening. If you feel you have lightened an area too much, press X to exchange the colors, and then paint with black to reduce the dodging in that area. You can also adjust the layer opacity to further refine the overall effect.

Figure 6-22. The finished Lighten with Brush Tool action.

Automated burn layer setup. With the exception of the setup for the Curves adjustment layer and the name of the action, the steps here are exactly the same as for the previous dodging action. To speed up the process and show you another way of working with actions that contain similar steps, we'll make this action by duplicating the lightening action and changing two settings.

1. In the Actions palette (Window→Actions), click the "Lighten with Brush Tool" action. From the Actions palette submenu, choose Duplicate. Double-click in the name of the new duplicate action, and change it to "Darken with Brush Tool."

2. Double-click the "Make adjustment layer" step in this action to reopen the New Layer dialog for that step. Change the mode to Multiply and change the name of the layer to "CRV Darken-Multiply-50%op" (Figure 6-23). Click OK to close this dialog, and then click OK in the Curves dialog.

Figure 6-23. Change the New Layer settings as shown here to modify the duplicate action into one that darkens the image.

3. If you have added a stop message, double-click the stop in the action to reopen the dialog and change the word "lighten" and "lightening" in the first and third sentences) to "darken" and "darkening." Click OK. The action has now been modified and can be used to set up a brush-on darkening effect.

At 100% opacity the Screen and Multiply modes apply a generic lightening and darkening to images of approximately three exposure stops. Usually this is much too strong, which is why we lower the layer opacity to 50%. For some dodging or burning you may need to use a more customized curve.

If that is the case, simply double-click the Curve layer thumbnail once the action is finished, and then adjust the curve and layer opacity as needed.

Identifying the Visual Components in a Photograph

In Chapter 5, we discussed our approach of making an initial evaluation or survey of the photograph and listening to the image to determine what type of tonal adjustments might improve it. With some images it is clear what changes will enhance the photo, while others are not so obvious. For those that fall into the latter category, it often helps to break the image down into the basic visual components that make up the scene. Once you have "taken apart" the image in this way, it can be it easier to see what type of adjustments each section might need.

Consider the photograph in our next tutorial, "Below Sea Level." This was taken just after the sun slipped behind the mountains in Death Valley, California. The original image is a bit flat and lacking in good contrast. But beyond increasing contrast, which is an obvious first step, what else might we do to improve this photo? What are the basic elements that make up this image? If you distill the scene down to the simplest "building blocks," there are three main components: the sign, the landscape, and the sky (Figure 6-24). The landscape could be further divided into the far mountains and the flat desert floor.

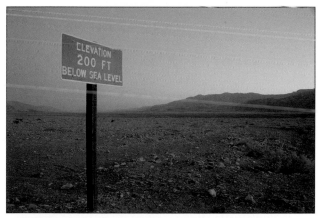

Figure 6-24. Below Sea Level. The three main elements in this photograph are the sign, the sky, and the landscape. © SD

Once you have identified the main visual components in the image, the performers in your visual "play," ask yourself some questions about their role in the image. Try to figure out how they relate to each other and how specific tonal modifications to each area might enhance or change those relationships.

In the Death Valley photograph, the "Below Sea Level" sign is obviously a key element. By increasing the contrast on the sign, we can make it more prominent by creating better separation between it and the rest of the scene. What about the other components in this image? What is happening in the sky that might give us a clue as to how to proceed? The sun has just gone down and twilight is approaching. Sunset is a significant time of the day and one that artists have always been drawn to. By making targeted tonal modifications in the areas where the sun has just gone down, we can accentuate the visual "feel" of sunset even though this is a black and white image. Finally, there is the landscape to consider. What is the relationship between the sky and the landscape? How does what is happening in the sky affect the mountains and the desert? In cases like this, Seán likes to ask himself a hypothetical question to help discover possible visual pathways; "What would nature do?" How might the landscape be affected if there was still a sliver of sunlight spilling over the mountains? Perhaps there would be a gentle wash of brighter light visible on the desert floor. With these questions and possible answers in mind, let's move on to sculpting the light in the Death Valley photo with some creative dodging and burning.

Enhancing an Image with Light

Our tool of choice for many tonal and color corrections is a Curves adjustment layer because it affords us so much precision and accuracy. When combined with the control of a layer mask, it is a powerful tonal correction and enhancement tool. In the following example, we'll explore the use of selections, Curves, layer masks, and mask editing techniques to transform the photograph of Death Valley by lightening specific areas (Figure 6-25). Since this exercise is more about the possibilities of working with light and shadow to enhance an image and less about making selections, we have already created a path of the sign for you to use.

⬆ ch06_BelowSeaLevel.jpg

1. In the Paths palette, Cmd/Ctrl-click the path of the sign to turn the path into a selection.

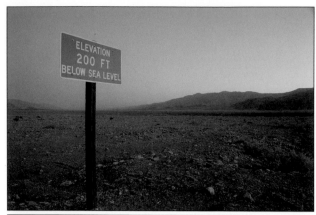

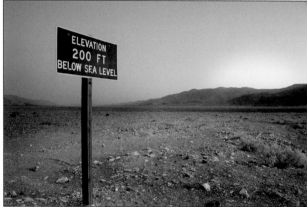

Figure 6-25. *The before and after view of the Below Sea Level image.*

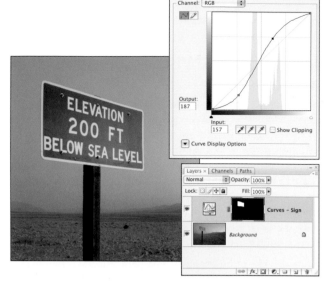

Figure 6-26. *The curve to increase contrast on the sign.*

Figure 6-27. *The initial elliptical selection.*

2. With the selection active, click the Add Adjustment Layer button at the bottom of the Layers palette and choose Curves. Move your mouse over the dark part of the sign and Cmd/Ctrl-click to place a control point on that area of the curve. Drag down on this point to darken those areas of the sign. Now Cmd/Ctrl-click the white letters in the sign to place a control point on the curve. Drag up on this point to brighten the letters. These adjustments create a strong S-curve, which brightens the letters and also boosts the contrast to better separate the sign from the sky (Figure 6-26). Click OK to exit Curves.

3. To add light to the horizon, use the Elliptical Marquee tool (it's nested under the Rectangular Marquee tool) to drag out an ellipse on the right side of the image over the light part of the sky and mountains. Approximately half the ellipse should cover the sky, while the other half covers the mountains (Figure 6-27).

4. Select the Quick Selection tool. In the Options Bar choose a brush size of about 50 pixels. Hold down Option/Alt and drag across the lower part of the elliptical selection that covers the mountains to subtract that area from the selection (you can also use the subtract modifier button in the Options Bar instead of using Option/Alt). Figure 6-28 shows the resulting selection.

Figure 6-28. The Quick Selection tool quickly subtracts the mountains.

5. Add another Curves adjustment layer. Cmd/Ctrl-click in the light area of the sky to place a control point on that part of the sky. Raise this point until the sky is lightened significantly. Our input and output values are 190 and 230. Click OK (Figure 6-29).

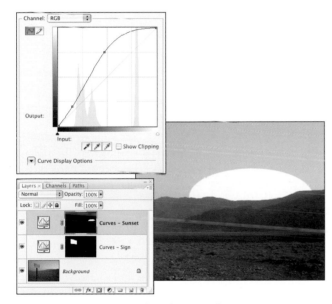

Figure 6-29. The curve to lighten the sunset glow.

6. The edge of the mask is too hard; to soften it, choose Filter→Blur→Gaussian Blur. To see the edge of the mask in the filter preview, click the edge of the mask in the main image window. Enter a radius setting of 30 to blur (feather) the edges of the mask (Figure 6-30). Click OK.

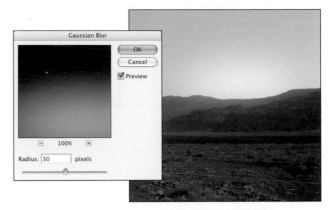

Figure 6-30. Blurring the layer mask for the sunset glow.

7. To further enhance the image, we'll create an adjustment that suggests the last rays of light sweeping gently across the desert. Select the Lasso tool and in the Options Bar make sure the feather value is zero. Draw a loose diagonal selection on the flat area of the desert floor from the background to the foreground (Figure 6-31).

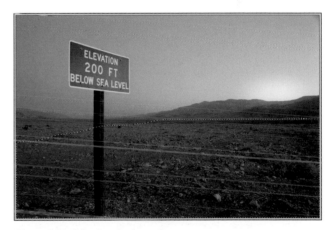

Figure 6-31. Selecting the desert floor.

8. Add another Curves adjustment layer. Drag the lower part of the curve up to lighten the selected area. Our input and output values were 35 and 70 (Figure 6-32). Click OK, and then repeat the Gaussian Blur step and blur as needed to disguise the edges of the mask (Figure 6-33).

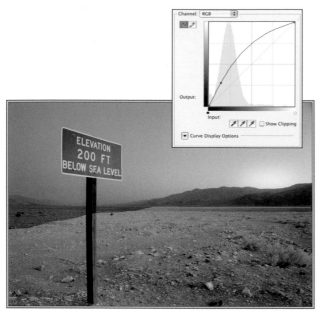

Figure 6-32. The curve to lighten the desert floor.

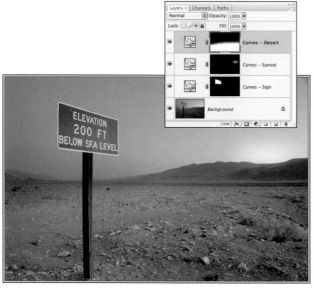

Figure 6-33. After blurring the layer mask for the desert adjustment layer.

9. The top quarter of the signpost is a bit too dark in relationship to the lower part. To correct this, we need to modify the layer mask that we just created to lighten the desert floor. Click the Background layer to make it active. Select the Quick Selection tool and choose a brush size of about 25 pixels. Drag down vertically over the top part of the post to select it.

10. Click on the layer mask that lightens the desert floor. Press D to set the default colors. Press Option/Alt-Delete to fill the selection with the foreground color (Figure 6-34).

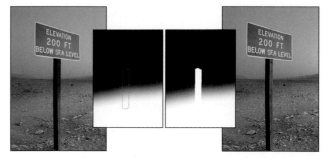

Figure 6-34. Selecting the signpost and using the selection to modify the layer mask for the desert floor adjustment layer.

11. As a final step, we added a Curves adjustment layer to the top of the layer stack and added an S-curve to increase the overall image contrast.

> Any time you have masks, or portions of masks, that were created with selections, zoom in to 100% (View→Actual Pixels) and double-check the edges of the mask. In many cases, you may need to add a slight Gaussian Blur to the mask to soften hard edges or touch up areas with a small-tipped, soft-edged brush or the Blur tool.

Darkening to create mood

Like lightening, darkening areas of a photo is another way to sculpt and mold the tonal qualities in the image. This can give more visual emphasis to certain parts of the photograph or suggest an overall mood for the image. For this example, we'll explore an image that is very similar to the previous photo of Death Valley (Figure 6-35). The primary components are essentially the same: a sign, the sky and a stark and desolate landscape. Unlike the empty sunset sky of the Death Valley photo, however, the sky here is filled with dark, threatening storm clouds, and a narrow dirt road leads through the landscape, disappearing in the distance. The sign in the Death Valley image offered information about the place; in this photograph, the sign is a warning, telling us to go no farther.

Just as we did in the previous example, we will look to the different elements in the image to be our guide in discovering a possible interpretation for the scene. The sign and the sky are both forbidding, the landscape dark and dreary. Darkness, not light, is the key to this photograph. To bring it to life, we need to tone down the overall key of the image and follow the tonal mood created by the sign and the approaching storm (Figure 6-36).

Figure 6-35. The forbidding sign and the threatening storm clouds set the tone for the scene. ©SD

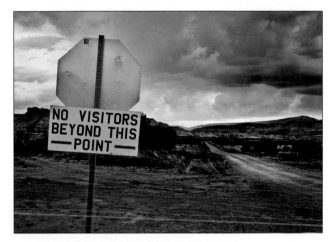

Figure 6-36. After darkening select parts of the image.

Adding emphasis through selective burning

The first step is to darken everything in the image except for the sign. Since the sign is an important element in the scene, we want it to stand out from the background. Darkening the background is one way to accomplish this, as well as lowering the tone of the image to create a darker, more foreboding mood.

🖱 ch06_NoVisitors.jpg

1. Use the Polygonal Lasso to make a selection around the stop sign and the "no visitors" sign (Figure 6-37). Don't worry about exactly tracing the edges, since a blur will be applied to the layer mask we create from this selection. Choose Select→Inverse to change the selected areas from the sign to everything else except the sign.

Figure 6-37. The selection of the sign was made using the Polygonal Lasso.

2. Add a Curves adjustment layer. Move your mouse over the image and Cmd/Ctrl-click in the darker dirt in the lower-right corner of the image to place a control point on the curve for that tonal level (an approximate Input value of 60 to 75). Now do the same for the light areas on the surface of the road (approximate Input value of 140). You should now have two control points on the curve (Figure 6-38).

3. Drag the first control point down until the Output value reads about 30. Now drag the upper point that represents the lighter areas on the road up until its Output value is about 150. The exact numbers are not as important as understanding what this adjustment does, which is to darken the landscape while preserving and slightly enhancing the lighter highlight values on the surface of the road (Figure 6-39).

4. To disguise the hard edges that are now visible in the layer mask of the sign, choose Filter→Blur→Gaussian Blur and use a radius of 20 pixels to soften the edge of the mask.

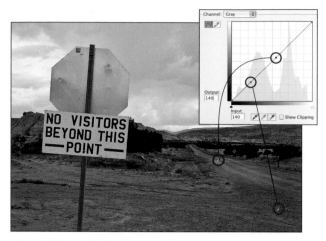

Figure 6-38. *Cmd/Ctrl-click to place control points on the curve.*

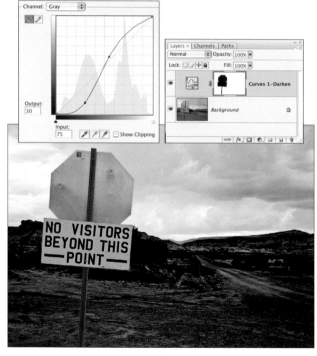

Figure 6-39. *Adjusting the curve to darken the landscape and preserve the highlights on the road.*

5. Now it's time to darken the sky. Cmd/Ctrl-click the thumbnail of the layer mask to load a selection based on the white areas of the mask. Select the Rectangular Marquee tool and Option/Alt-drag over the bottom half of the image to subtract the land from the selection (Figure 6-40). This does not need to be a totally accurate edge along the horizon since this will eventually be blurred in the next layer mask.

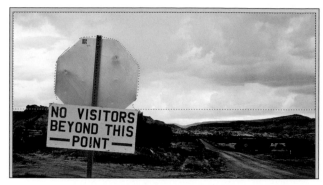

Figure 6-40. *The rough selection of the sky.*

6. Add a Curves adjustment layer. Place a point on the upper part of the curve (approximate Input value of 210) and drag down to significantly darken the clouds (our Output value was 150). Click OK (Figure 6-41).

7. Apply a Gaussian Blur to the layer mask for the darken sky curves layer. A Radius of 20 to 25 should work well to soften and disguise the hard edge. Click OK to blur the mask (Figure 6-42).

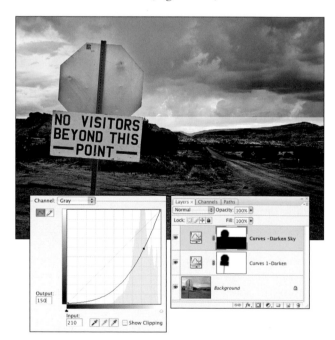

Figure 6-41. *Darkening the sky.*

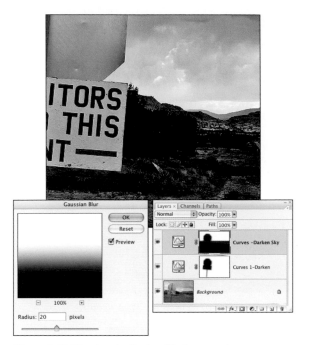

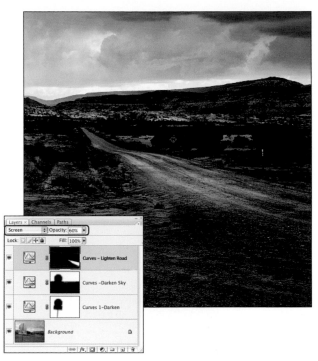

Figure 6-42. Blurring the Darken Sky layer mask.

8. The dirt road is another key element in this image. By lightening it slightly, it becomes more prominent. Use the Polygonal Lasso tool to trace a rough selection of the road (Figure 6-43). Add a Curves adjustment layer and click OK without making any changes.

9. Set the blending mode for this layer to Screen. Lower the Layer opacity to 60%. Soften the edge of the road layer mask by applying the same Gaussian Blur of 20–25 pixels (Figure 6-44).

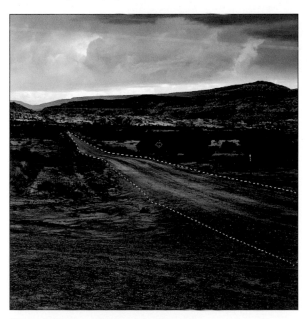

Figure 6-43. The selection of the dirt road.

Figure 6-44. The lightened road.

As with the Death Valley image, we have been able to transform the character of this photograph through the use of interpretive tonal adjustments. In the case of this image, most of those have darkened the scene.

The step-by-step instructions featured here will enable you to duplicate what we did to this image. Far more important than just following our steps is understanding the overall concepts of how to make these type of interpretive changes to your own photographs, and why you might choose to do so to enhance and interpret your own images.

Burning in the Edges

In the "No Visitors" image, significant darkening was used to suggest a forbidding mood. But not all darkening adjustments create a dark or gloomy feeling. In many images, darkening areas is another way to sculpt and mold the tonal qualities in the image and give more visual emphasis to certain parts of the photograph. While the emphasis created by lightening is obvious to understand, you can also draw the viewer's attention to key areas by darkening the regions around them, which will make the adjacent areas seem lighter. A classic use for such a technique is with portraiture. Creating an oval-shaped vignette or edge burn is an excellent way to darken the area around the subject's face and make the face the focal point of the image (Figure 6-45).

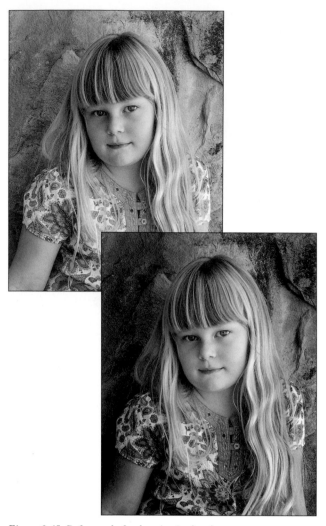

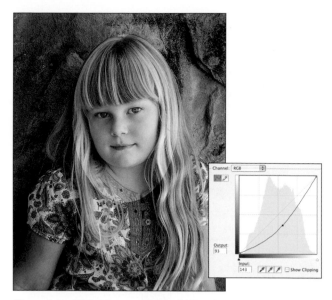

Figure 6-46. *The curve to create the darkened vignette.*

Figure 6-45. *Before and after burning in the edges.* © *SD*

4 ch06_portrait.jpg

1. Use the Elliptical Marquee tool to create an oval selection around the subject's face.

2. Choose Select→Inverse to select everything except the face. Add a Curves adjustment layer and drag down the center of the curve to darken the areas surrounding the face (Figure 6-46). It's OK to make the adjustment a bit darker than you think is correct, since this can be modified later using the layer opacity controls.

3. Remove the hard edge by applying the Gaussian Blur filter to the Curves layer mask. Blur to taste (we used a 60-pixel radius). The object of the blur is to disguise the edge so you cannot see where the adjustment begins or ends (Figure 6-47).

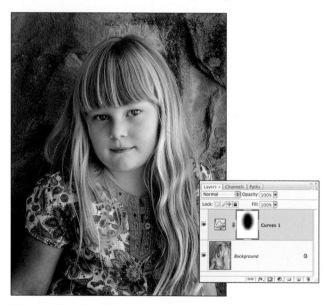

Figure 6-47. *A Gaussian Blur softens the edges of the layer mask.*

4. We decided to modify the layer mask by painting with black at a brush opacity of 40% to remove some of the darkening effect from the lower strands of the girl's hair (Figure 6-48).

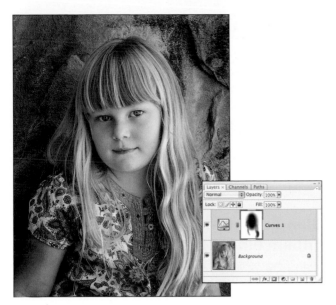

Figure 6-48. The layer mask was modified to protect the girl's hair from the darkening effect.

Using an oval vignette to burn in the edges of a portrait is a technique that has been around for nearly as long as photographers have been making portraits. And it works well on other types of images, too, so give it a try on some of your own photographs.

Irregular or painted edge burn

The previous example of burning in the edges works well for portrait subjects where you want the face to be the lightest element in the image. You can use the same basic technique with a rectangular marquee or an uneven lasso selection to create a burned in effect that is applied only to the outer edges of a photo (Figure 6-49).

🖰 ch06_ShipHouse.jpg

1. Use the Lasso or Polygonal lasso to create a loose, irregular selection just inside the edges of the image (Figure 6-50).

2. Choose Select→Inverse and add a Curves adjustment layer. Click OK without making any changes to the curve. At the top of the Layers palette, set the blending mode for the layer to Multiply to darken the outer edges of the photo (Figure 6-51).

3. Choose Filter→Blur→Gaussian Blur and set the radius to a high number (we used 50) to apply a strong blur to the layer mask. As an optional customization step, you can use the Brush tool and a large, soft-edged brush to further modify the look of the edge burn (Figure 6-52).

Figure 6-49. The Ship House image before (top) and with an irregular edge burn (bottom). © SD

Figure 6-50. The irregular lasso selection just inside the edges of the image.

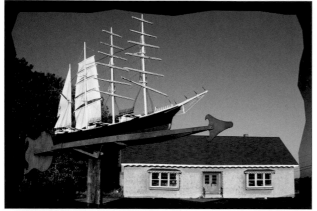

Figure 6-51. The effects of the empty Curves adjustment layer set to Multiply to burn in the edges.

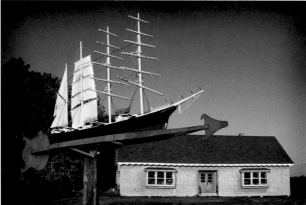

Figure 6-52. Blurring the layer mask to soften the edge burn effect.

Contrast and Exposure Control

Contrast is an essential ingredient in photographs and one that needs to be present in just the right amount. If there is too much contrast, the highlights are in danger of blowing out to total white and subtle shadow detail is lost. But if there is not enough contrast, then the image is flat and dull. And the right amount of contrast is not something that is easily quantified as it can vary from image to image depending on the subject matter, the purpose of the photograph, and the personal preference of the photographer.

Blending Mode Contrast Enhancement

Many times using Overlay, Soft Light, and Hard Light layer blending modes adds the needed contrast boost and color saturation. These modes work best on images that do not have a lot of existing contrast. If there is too much contrast in the original file, then the effect may be too pronounced, though lowering the layer opacity can sometimes help with this.

Empty adjustment layers and contrast-enhancing blending modes

In the example of the tree and the missing steps, the Overlay blending mode provides both a dramatic contrast boost as well as a significant increase in color saturation (Figure 6-53). Because the image was not overly contrasty to begin with, there are no major problems with using this blending mode.

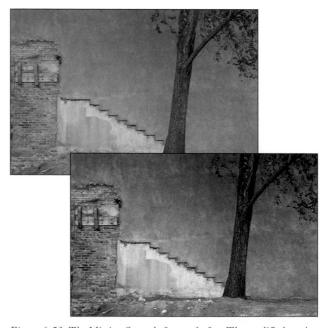

Figure 6-53. The Missing Steps, before and after. The modified version uses an empty adjustment layer set to Overlay blending mode. © SD

🖑 ch06_MissingSteps.jpg

1. Add a Curves or Levels adjustment layer and click OK in the adjustment dialog without making any change (Figure 6-54).

2. Set the layer mode to Overlay (Figure 6-55). If Overlay seems too strong, lower the layer opacity, or try the Soft Light blending mode (Figure 6-56).

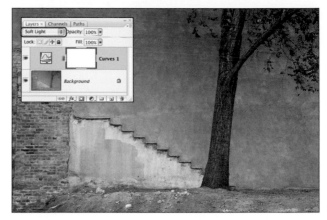

Figure 6-56. Changing the blending mode to Soft Light provides a more subtle contrast enhancement than Overlay.

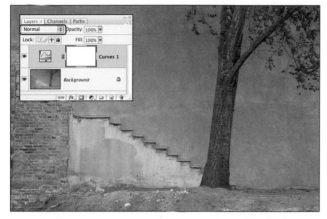

Figure 6-54. An empty (meaning no changes were made) Curves adjustment layer set to Normal mode does not change the image in any way.

Targeted adjustments with blending modes, the Blend If sliders and layer masks

Many times creating a tonal adjustment with blending modes may be well-suited for some parts of the tonal range but not others. The Blend If sliders found in the Advanced Blending Options dialog are one way to direct the effects of a blending mode to only parts of the image (Figure 6-57).

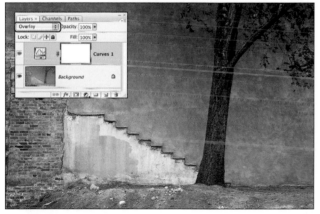

Figure 6-55. An empty Curves adjustment layer set to Overlay results in a significant increase in both contrast and color saturation.

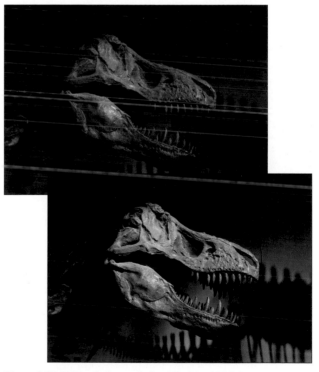

Figure 6-57. T-Rex, before and after. The Blend If sliders target only the brighter tones in the photo with a lightening adjustment . © SD

✐ ch06_T-Rex.jpg

A Tyrannosaurus Rex skeleton is always an interesting subject for a photo, but the quality of museum lighting for such displays varies widely and some bones are better lit than others. In the photograph for this example, although a spot light is directed on the skull, the lighter tonal values are still a bit dark and the separation between the skull and the background could be better.

1. Add a Curves adjustment layer and click the OK button without making any changes to the curve. In the Layers palette, set the blending mode for the adjustment layer to Screen (Figure 6-58). This will create a noticeable lightening of the entire image.

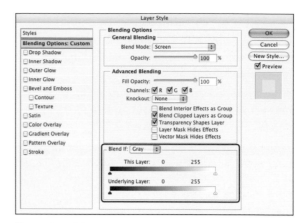

Figure 6-59. The Blend If sliders in the Layer Style dialog.

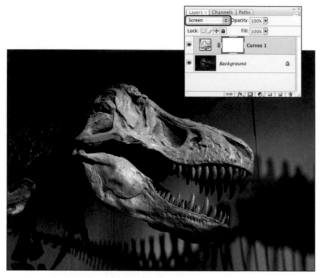

Figure 6-58. The initial lightening effect created by an empty Curves adjustment layer and the Screen blending mode.

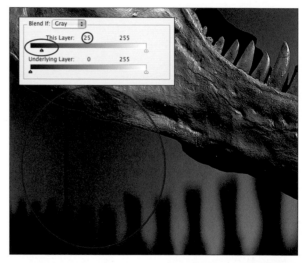

Figure 6-60. The initial adjustment of moving the shadow slider for This Layer to 24 results in posterized tonal transitions in some areas.

2. Double-click the area to the right of the layer's name to bring up the Layer Style dialog box. In the bottom section of this dialog are the Blend If sliders, which control which tonal values on the active layer are visible in the image (Figure 6-59). In the case of the empty adjustment layer used in this technique, it controls which tonal values in the image are affected by the adjustment.

3. In the Blend If section, move the This Layer shadow slider in to level 25 (Figure 6-60). This means that any tonal values of 25 or below are not affected. But this creates an abrupt, noticeable transition. To smooth the transition, split the slider by Option/Alt-clicking on the right half and moving it to the right until the split value on the right of the slash is 45 (Figure 6-61).

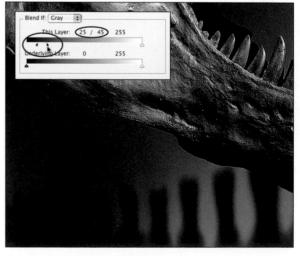

Figure 6-61. Option/Alt-click on the slider and drag to split it into two halves. This feathers the effect and creates smoother transitions between tones.

The split between the numbers creates a transitional feathering effect so the blend is seamless. In this case, the adjustment layer is affecting no tonal values darker than level 25. As the values increase above 25, they are gradually affected until level 45, when the adjustment is applied at full strength. The Blend If sliders allow the lighter areas of the image such as the highlights on the skull and on the wall, to be lightened, while protecting the darker areas from the effect.

4. At the top of the Layer Styles dialog box, you can try lowering the opacity to fine tune the effect. For the version we created, we chose to lower the layer opacity to 80%. Click OK to apply the blending changes.

5. Some areas on the skull or the background may still be too bright. Using a soft-edged brush tool, paint on the layer mask with black at 30% to gradually tone down the areas that need further darkening. And remember that you can also adjust the curve to refine the effect further. For our final version we lightened the image a bit more by adjusting the curve (Figure 6-62).

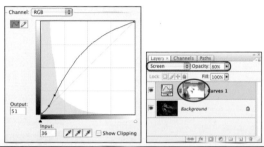

Figure 6-62. The final tweaks for this effect included lowering the layer opacity, modifying the layer mask and adjusting the curve.

Modifying contrast with blending modes, the Blend If sliders and layer masks

Now let's explore another variation of this technique using a different blend mode and more precise layer masks. Our subject for this example is a detail view of an old DC-3 airplane from the 1930s (Figure 6-63).

⌐ **ch06_DC3.jpg**

1. In the image of the DC-3, use the Polygonal Lasso tool with a feather value of zero to make a selection of the black area where the windows are located.

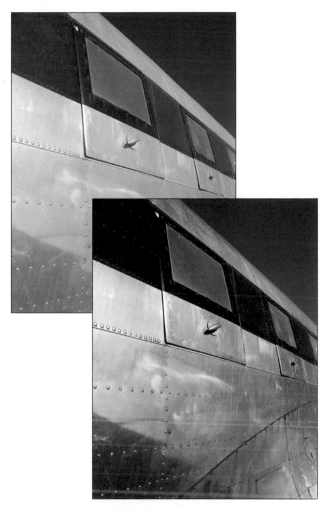

Figure 6-63. Before and after: the adjustments are accomplished using blending modes, layer masks, and the Blend If sliders. © *SD*

2. Select the Magic Wand tool, set the Tolerance to 32 (the default), hold down the Shift key, and click in the sky to add that area to the selection. Choose Select→ Inverse to reverse the selection so that only the light metal areas of the fuselage are selected.

3. Add a Curves adjustment layer and in the Curves dialog click OK without making any changes. Set the blending mode for this layer to Multiply. This provides a nice darkening effect that works well for the reflective metal (Figure 6-64).

4. Double-click to the right of the layer name to open the Layer Style dialog box. In the Blending Options panel, go to the Blend If sliders and move the highlight slider

for This Layer to 150. Option/Alt-click the slider to separate it into two halves. Move the right half to the right until the values for this slider read 150/200 (Figure 6-65). Click OK.

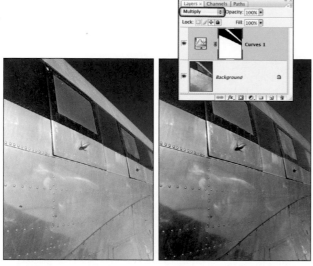

Figure 6-64. The empty Curves layer set to Multiply darkens the bright highlights (a layer mask protects the darker areas).

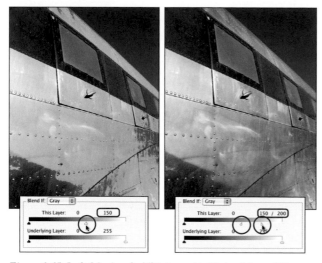

Figure 6-65. Left: Moving the This Layer highlight slider to 150 results in rough transitional edges. Right: Splitting the slider and placing the two halves at 150 and 200 create a smooth transition between areas that are being adjusted and those that are not.

The split between the numbers of the This Layer sliders means that no tonal values from the Curves Multiply layer brighter than level 200 are being used. As the values progress towards level 150, more and more become visible. The effect of the Curves Multiply layer shows at full strength from level 150 and below.

5. Cmd/Ctrl-click the layer mask to load it as a selection. Choose Select→Inverse. Select the Lasso tool, press Option/Alt, and drag a selection around the sky to deselect that area. The objective is to have a selection of only the black strip over the windows.

6. Add another Curves adjustment layer and click OK in the Curves dialog box without making any changes. Set the blending mode for this layer to Soft Light. You can also try Overlay but we liked how the windows looked with Soft Light (Figure 6-66).

7. If any of the layer mask edges look too hard, apply a slight Gaussian Blur to soften them.

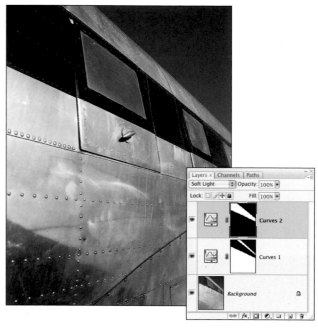

Figure 6-66. The final layers for the blending mode contrast adjustments to the DC3 photo.

High Pass Contrast Enhancement

As we have already seen in numerous examples, contrast is an important element in shaping the tonal qualities of an image. While contrast that is applied to the brightest and darkest areas of the image is perhaps the most noticeable, the contrast in the midtone areas of an image is especially crucial, and the effectiveness of any adjustments you make to this important area can have a great impact on the success of the image. In many cases, Curves is our preferred tonal correction tool when we need to apply adjustments to specific regions of the tonal range, but as precise as it is, it makes no distinction between textured areas, smooth areas, or areas that contain depth created by the contours of shape and form.

One way to achieve a contrast boost that affects only the contoured parts of an image is to take advantage of the High Pass filter, the Overlay blending mode, and the Blend If sliders (Figure 6-67). We first learned this great technique from master digital printmaker R. Mac Holbert. This is a modified version that takes advantage of the non-destructive flexibility of Smart Filters in Photoshop CS3.

Figure 6-67. *The original image (top), and after the High Pass Contrast technique (bottom).* © SD

🖚 ch06_highpass_contrast.jpg

1. Choose Layer→Duplicate layer to make a copy of the Background layer. If you have already applied any adjustment layers, the High Pass effect needs to be applied to the cumulative result of all your layers. To create a copy layer based on all of the layers, make sure that the topmost layer is active and hold down the Option/Alt key and choose Merge Visible from the Layers palette pop-out menu. Keep the Option/Alt key down until you see the new layer thumbnail appear in the Layers palette.

2. On some images, the end result of this technique can cause some slight color shifts along contrast edges. Since we only want this effect to apply to contrast and not to color values, we'll remove all the color saturation from the duplicate layer. Choose Image→Adjustments→Desaturate.

3. Convert the Layer into a Smart Object by choosing Filter→Convert for Smart Filters (Figure 6-68).

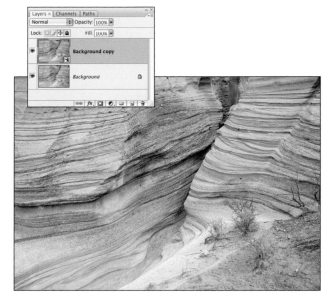

Figure 6-68. *The desaturated background copy layer converted to a Smart Object.*

4. Double-click the Background copy layer just to the right of the layer name to open the Layer Style dialog box. Set the Blend Mode to Overlay (Figure 6-69) and the Opacity to 75% (this is just a starting number that can be adjusted as needed once the effect is in place). In the Blend If section move the black slider for This Layer to 50. Hold down Option/Alt and drag on the right half of the slider to separate it into two halves. Move the right half to 80. Now move the white slider to 175, hold down Option/Alt to split the slider, and move the right half to 205 (Figure 6-69). Click OK to apply the changes.

5. Choose Filter→Other→High Pass and set the radius to 50 pixels. Click OK (Figure 6-70).

6. The Blend If numbers mean that no tone darker than 50 or brighter than 205 will be affected by the contrast boost from the High Pass layer. The split from 50 to 80 and 205 to 175 creates a transitional feathering effect, spanning 30 tonal levels where the contrast effect gradually becomes more visible. The end result is that the contrast increase is only visible in the middle parts of the tonal range and the effect of the blending mode and the High Pass filter enhances the existing contrast along the contours in the image

7. With the basic effect in place, you can now fine-tune the High Pass filter settings. In the Layers palette, double-click on the name of the High Pass Smart Filter. Experiment with different radius settings to see how the contrast is affected (Figure 6-71). We decided on a radius setting of 8 for this example, but it's important to understand that there is no "right" value here that works for all images.

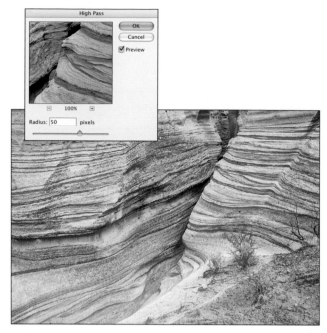

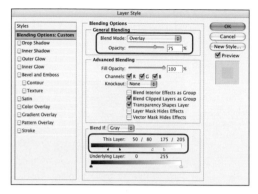

Figure 6-69. The blending mode, layer opacity and Blend If settings for the Background copy layer.

Figure 6-70. Applying the High Pass filter to the desaturated Smart object layer.

8. Adjust the layer opacity as needed to fine-tune the increase in contrast. For a slightly softer application, try changing the layer blending mode to Soft Light. You can also control the effect by adding a layer mask to the background copy layer and painting with black at varying opacities to minimize the contrast boost in certain areas.

> With the exception of the layer opacity and the High Pass settings, the basic setup for this effect is the same for any image and can be easily recorded as an action to save time. After the action has finished applying the effect, adjust the opacity and Smart Filter settings or modify the Smart Object layer with a layer mask as needed.

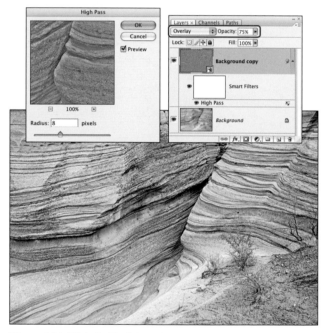

Figure 6-71. With the High Pass filter applied as a Smart Filter, you can refine the settings and fine-tune the contrast effect.

The Shadows/Highlights Command

One of the most effective tools for taming the extremes that can exist in high contrast images is the Shadows/Highlights command. You can use this command to lighten shadow areas or darken very bright highlight areas and in a way that does not affect other regions of the image. Once you define an area to be lightened or darkened, the Shadows/Highlights command analyzes the neighboring pixels around the targeted area and determines an average pixel value for a given radius. A compensation adjustment is then made based on this information. The corrections made by this tool are customized for each image based on the existing tonal map and the settings you choose. Shadows/Highlights is a good choice if you have useable detail in either the shadows or the highlights, but the tonal compression makes it hard to see (Figure 6-72).

Smart Filters with Shadow/Highlight

In Photoshop CS3, the addition of Smart Filters adds more of the program's features to the non-destructive toolkit. Smart Filters behave similarly to adjustment layers in that you can always double-click the filter name and adjust the settings as necessary. As an added bonus, in Photoshop CS3 you can apply the Shadows/Highlights command as a Smart Filter, even though it is not grouped in the filter menu. Since this is a very useful tonal correction command, the ability to use it non-destructively is a big plus. You can also use blending options to apply different blending modes, adjust the opacity of a filter effect, or edit the Smart Filter's layer mask. To apply a filter as a Smart Filter, you must first convert the layer you are working on to a Smart Object; we'll address the specific steps later in this chapter. If a tonal correction feature such as Match Color, Replace Color, and Variations, is not available as an adjustment layer or a Smart Filter, then we make a copy of the background layer and apply the changes to that copy.

Shadows/Highlights: Under the hood

In the basic configuration, the dialog box is very straightforward, with two sliders that will either lighten the shadows or darken the highlights. To really take advantage of the capabilities of this feature, however, you need to expand the dialog by clicking the Show More Options checkbox. The expanded dialog is divided into three sections: Shadows, Highlights, and Adjustments (Figure 6-73). The sliders for the first two sections do the same thing, but they apply only to either the Shadows or the Highlights. Let's take a closer look at these controls and how they affect the image.

🖱 ch06_HaciendaWindow.jpg

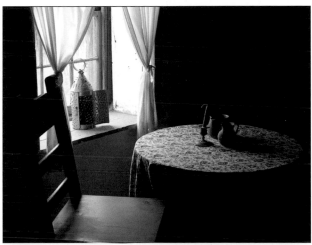

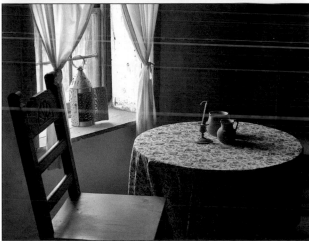

Figure 6-72. The Hacienda Window image before and after. © SD

Figure 6-73. *The expanded Shadows/Highlights dialog showing the default settings.*

Amount

This controls how much the targeted area of the tonal range is lightened (for the shadows) or darkened (for the highlights). The default setting of 50% is to get you started and shouldn't be interpreted as a value that is appropriate for all images. Move the slider to the right until the shadow areas you care about reach a desired level of brightness, or until bright highlights are darkened to where you want them to be (Figure 6-74 and Figure 6-75).

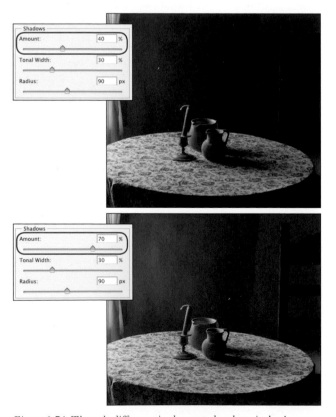

Figure 6-74. *The only difference in the examples above is the Amount setting for the Shadows.*

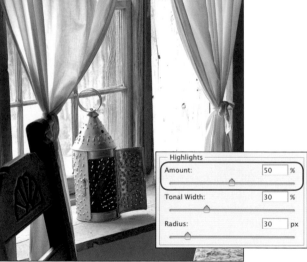

Figure 6-75. *The only difference in the examples above is the Amount setting for the Highlights, to restore some detail into the bright areas of the curtains and the areas outside the window.*

Tonal Width

This setting controls the range of tonal values that will be affected by the Amount setting. A lower percentage means that only the darkest shadow values or brightest highlight values will be adjusted. Increasing the tonal width value means that the adjustment will be applied to a wider range of either shadow or highlight tones (Figure 6-76).

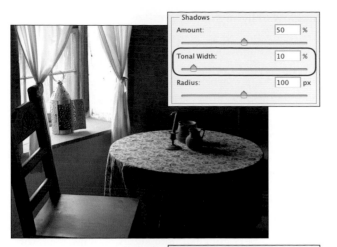

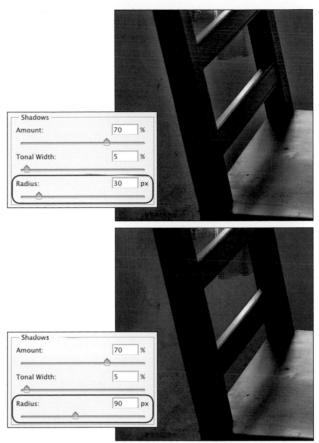

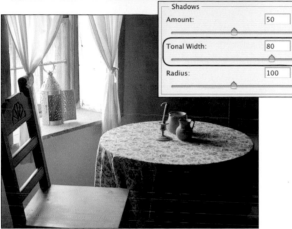

Figure 6-76. *The Tonal Width has been changed from 10 (top) to 80 (bottom).*

Figure 6-77. *A high Amount setting coupled with a low Tonal Width can result in visible halos using the default Radius setting of 30 (left). By increasing the radius to 90 pixels the halo is removed.*

Radius

The Shadows/Highlights command identifies the shadow and highlight regions by analyzing each pixel in the image and comparing it to the surrounding pixels. The Radius control determines the size of the surrounding area that is sampled when the pixels are identified as shadows or highlights and also how the effect created by the Amount slider is blended into those surrounding areas. The default value of 30% can be an adequate starting point, but you should experiment with this setting to see what works best for the image you're working on. Seán feels that the default 30% often produces too many visible halos and unnatural blending around contrast edges, so he prefers to use higher settings of 60% to 90%, depending on the image (Figure 6-77). Very low radius values tend to yield a flat, low-contrast result while very high values will spread out the effect so much that it is not restricted to just the shadows or the highlights.

Color Correction

This setting does not really correct color casts, which is what color correction implies in most cases; instead, it affects the color saturation in the areas that have been changed by the adjustment. Significant adjustments with Shadows/Highlights can sometimes produce unexpected saturation shifts, and this is one way to correct them. Negative numbers reduce color saturation while positive numbers increase it. If you are lightening a dark, underexposed area, it can help in adding some color saturation to areas that would naturally have less saturation due to the underexposure.

Midtone Contrast

As the name suggests, this slider targets the middle value pixels and is used to increase or decrease contrast in those areas. The primary reason for this is that sometimes the adjustments you create with this tool are not restricted only to the shadows or the highlights. In general, we prefer to apply contrast adjustments using Curves, but moderate fine-tuning here can produce good results. If you feel you don't have the control that

you would like in adjusting the contrast, however, then it's best to handle it with a separate Curves adjustment layer.

Black Clip, White Clip

The clipping values will force a portion of the darkest or brightest pixels to either pure black or pure white and prevent them from being affected by any lightening or darkening adjustments. For most images you can probably leave these numbers set to the defaults (0.01%), but the clipping control can be useful for those images where you do want to preserve some areas as either pure black or white. In the latter case, the only time you would want to do this in a photographic image is when there are bright, specular highlights that should be a pure white (for example, reflections on glass, water, or metal). Dimming these with highlight adjustments can adversely affect the natural highlight contrast in the photo. Use caution when you experiment with these adjustments, however, and be sure to use the Info palette to evaluate the brightest and darkest areas to ensure that important detail is not being lost.

Shadows/Highlights in practice

There are no "right" settings to use with the Shadows/Highlights command, since every image is different and will require a different approach depending on how you want it to look. The important thing is to be aware of how the controls affect the image and when certain combinations of settings might create a less than optimal result. Some of the main things to be on the lookout for are flat, reduced contrast that is common if a low radius value is used, or obvious halos that can occur when a high amount is applied to a narrow tonal width. And, as with any operation that brightens up darker areas, be aware that you may be revealing noise in those darker, underexposed areas. Generally, it's best not to go too far in trying to lighten darker areas of the image.

The Shadows/Highlights command is not only for images that require significant balancing of extreme shadows and highlights. It can also work wonders on color and black-and-white images that require a slight adjustment to open shadows or calm highlights (Figure 6-79).

> If you are applying the Shadows/Highlights command as a Smart Filter in Photoshop CS3, remember that the Smart Filter comes with a layer mask that can be edited to further customize how the effect is applied to the photo.

Figure 6-78. The improved Hacienda Window photo and the settings used to open up the shadows and tone down the brightness in the window area.

Figure 6-79. The Shadows/Highlights command is not just for severely underexposed or overexposed photos. It can work wonders on "normal" exposures, too. © SD

Fill Flash Techniques

The use of a flash or a fill light, either directed or reflected, to lighten the darker shadow areas in high contrast scenes has long been a tried and true photographic technique. In the digital darkroom there are also ways to achieve a subtle lightening of the darker shadow areas. As we saw in the previous section, the Shadows/Highlights command is one of the most successful ways to create a fill light or a fill flash technique.

Fill Light in Adobe Camera Raw and Photoshop Lightroom

Both Photoshop Lightroom and Adobe Camera Raw 4.0 (or higher) have a Fill Light control that targets the shadow values in an image (Figure 6-80). If your original is a raw file with some dark shadows that need brightening, then it makes sense to try out this feature when you are making your overall raw adjustments. In Camera Raw the Fill Light slider is found in the first tabbed pane of Basic adjustments, and in Lightroom it is in the Tone section of the Develop module. Using it is about as simple as these adjustments get: just move the slider to the right to brighten the shadow values. In Lightroom, you can also place the cursor in the shadow side of the histogram and drag to the left or right to change the Fill Light slider (Figure 6-81). Be careful about lightening dark areas too much, however, or you may reveal noise that the shadow tones were hiding.

Figure 6-80. The Fill Light slider in Adobe Camera Raw 4.

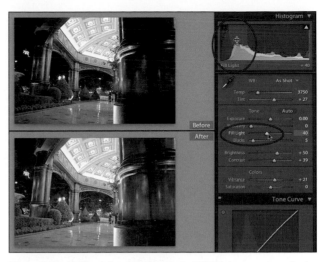

Figure 6-81. In Photoshop Lightroom the Fill Light control works the same as in Camera Raw with the added functionality of being able to drag left or right in the shadow side of the histogram to access the Fill Light adjustment.

Luminance Masks for Precision Contrast Adjustments

As we have mentioned before, whenever possible we try to take advantage of qualities that already exist within the image if we need to apply a tonal modification, or even cut a mask for compositing purposes. One of the ways that this approach can be applied to contrast adjustments is to use the luminance (brightness) values in the image as a basis for a precise mask through which to apply the contrast modification. In this example, we'll use a luminance mask created from the existing tones in the image to apply a contrast adjustment to the darker values in a photograph of old rope and tires washed up on a Hawaiian beach (Figure 6-82).

 ch06_Rope-Tires.jpg

1. Open an image you want to work on, or you can download the photo of the old rope and tires in this example. Make the Channels palette visible, and Command/Control-click the RGB thumbnail at the top of the palette. This will load a selection of the luminance values of the image.

2. At the bottom of the Channels palette, click the Save Selection as Channel button. The new channel will look like a black-and-white version of the image (Figure 6-83). Choose Select→Deselect.

3. Click on the new alpha channel to make it active. Choose Image→Adjustments→Invert (Cmd/Ctrl-I) to invert the tonal values and create a negative image of the alpha channel. The dark areas are now light, which is how we need them if we want to apply a Curves adjustment through this mask (Figure 6-84).

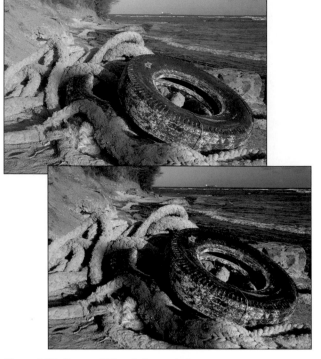

Figure 6-82. Rope and Tires, before and after. © SD

Figure 6-83. The selection of the luminance values in the image and the resulting alpha channel.

Figure 6-84. The inverted mask channel of the luminance values.

4. Edit the mask to further increase the existing contrast. To do this, choose Image→Adjustments→Levels. In the Levels dialog box, move the black-and-white sliders closer together to compress the tonal range and make the dark areas darker and the light areas lighter. Adjust the midtone slider to further fine-tune the effect. The objective here is to make the areas that you do not want affected as dark as possible and the areas that you do want to affect as light as possible (Figure 6-85). Gray areas will receive a partial adjustment. Click OK to apply the Levels adjustment.

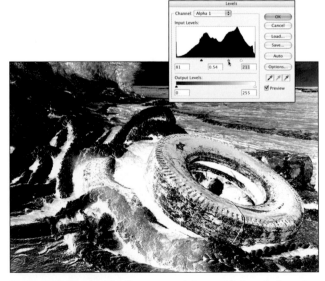

Figure 6-85. The Levels adjustment and the modified mask channel.

5. Load a selection of the modified mask channel by Cmd/Ctrl-clicking the channel name or thumbnail. Click the RGB thumbnail to return to the color view of the image (or the Gray channel if you're working on a grayscale image) and click on the Layers palette.

6. Add a Curves adjustment layer. The selection is turned into a layer mask. Adjust the curve to darken the shadow tones (Figure 6-86).

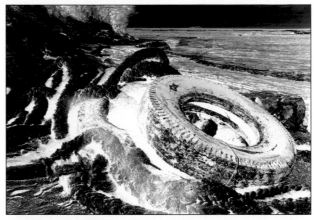

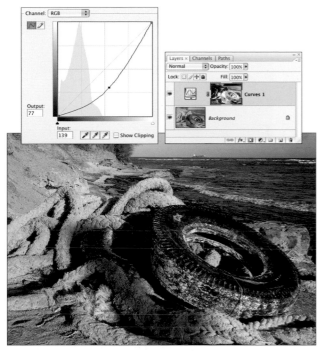

Figure 6-86. The modified luminance mask is turned into a layer mask and used to apply a Curves adjustment that applies most of the darkening effect to the shadow tones.

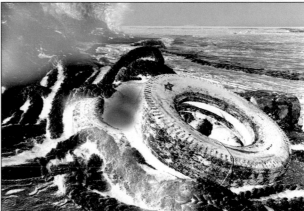

7. To soften any hard edges in the mask and help disguise any noticeable contrast transitions, use Filter→Blur→ Gaussian Blur with a low blur radius of 1.5 to 2 pixels.

8. To fine-tune the effect, edit the layer mask as needed. We chose to darken the sky and the sand in the background a bit by painting over those areas of the layer mask with white using a soft-edge brush tool set to 30% opacity. We also painted with black at 30% opacity to lighten the darkening effect in the deepest shadows in the center of the image (Figure 6-87).

Figure 6-87. Modifying the layer mask with the brush tool to darken the sky and the sand in the background.

Gradient Masks

After a polarizing filter, one of the most useful filters in a landscape photographer's camera bag is a graduated neutral density (ND) filter. These filters apply a neutral (meaning they do not change the color balance of the scene) darkening effect in the top half of the frame that fades away to clear in the lower portion of the filter. The versions that fit into grooved filter holders can be moved up and down and for custom placement of the darkened area in the frame. A graduated ND filter is used to balance the exposure in a scene where the sky area is much brighter than terra firma in the foreground.

With Photoshop you can create the digital darkroom equivalent of a graduated ND filter by using the Gradient tool to create a gradient in a layer mask. Gradients in layer masks can be very useful since they create a smooth transitional blend that gives the effect of gradually fading away. This simple technique works well if you need to darken the sky in a landscape photo (Figure 6-88), or even out light fall-off in some images taken with flash. The effect can be used not only for darkening and lightening, but also for color balance corrections and image compositing.

Although this technique is easy and very effective on some images, we're not advocating that you totally abandon the actual graduated ND filter you may have in your camera bag. We love our digital darkroom, but we're also firm believers in the philosophy that you should try to get the image right in the camera if at all possible. And if time and circumstance permit, that means taking advantage of things such as tripods, cable releases, fill cards, and graduated ND filters. The better the image you capture with your camera, the less you have to do to it in Photoshop and the more time you can be out taking new photos!

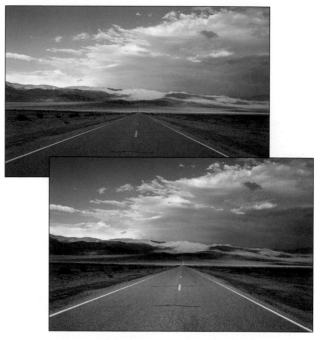

Figure 6-88. The original image (top), and the version modified with gradient masks to darken the sky and lighten the foreground (bottom). © SD

ch06_DeathValleyRoad.jpg

1. Add a Curves adjustment layer. Click in the image on the gray clouds above the mountain to see where that tone is located on the curve. Cmd/Ctrl-click there to place a control point on the curve and drag down to darken the image as needed. For the Death Valley road image the Input value for the point we adjusted was 175 and it was lowered to an Output of 145, Even though the entire photo will be darkened, pay attention only to what is happening in the sky. Click OK to apply the adjustment (Figure 6-89).

2. In the Toolbar, select the Gradient Tool. In the Options bar, open the Gradient Picker and choose the third swatch from the left, Black-to-White. Set the gradient style to Linear (the first style icon). Make sure the mode is set to Normal, the Opacity is 100%, and that Reverse is not checked (Figure 6-90).

3. Now drag a vertical line on the layer mask to define the span of the darkening effect. In the case of this Death Valley photo, start in the middle of the road, just above the first yellow line, hold down the Shift key (this constrains the line to be straight), drag up to just above where the road disappears in the mountains, and then let go of the mouse button (Figure 6-91).

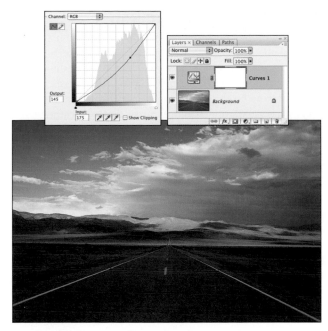

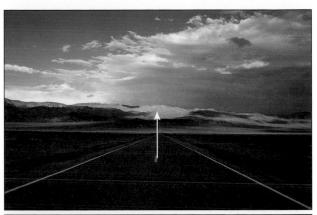

Figure 6-89. The entire image has been darkened with a Curves adjustment layer.

Figure 6-90. The options for the Gradient tool.

4. If you are not satisfied with the blend created by the gradient, simply drag out another one and the new one will replace the previous gradient.

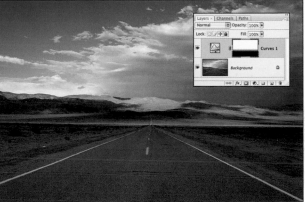

Figure 6-91. Dragging a gradient in the layer mask applies the darkening only to the top half of the image.

Two masks in one

In many cases, a mask that targets one area of the image can be inverted and used for the rest of the photo. This approach lets you get the most mileage out of your masks.

1. Continuing with the Death Valley road, hold down the Cmd/Ctrl key and click the thumbnail for the Curves layer mask to load it as a selection. From the menu, choose Select→Inverse.

2. Add another Curves adjustment layer and create a curve to lighten and boost contrast in the lower half of the image (Figure 6-92).

For this image of the Death Valley road, we also made a Polygonal Lasso selection of the road and added a Curves adjustment layer to further lighten and add contrast to the road (Figure 6-93).

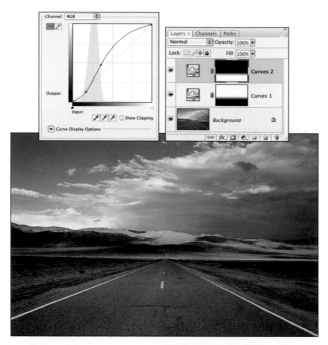

Figure 6-92. An inverted version of the first layer mask is used to apply a curve that lightens and adds contrast to the lower part of the photo.

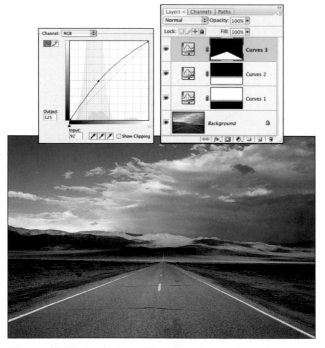

Figure 6-93. The final curves adjustment to lighten the road.

Controlling Dynamic Range

In photography, dynamic range is the range of tonal values from the darkest shadows with detail to the brightest highlights with detail. Cameras—film or digital—cannot record the entire dynamic range that is visible to the human eye, and it can be very challenging to deal with high-contrast scenes that contain a dynamic range that is greater than a camera can record in a single exposure. The current state-of-the-art of digital sensors have a dynamic range that is very similar to slide film, which is roughly about six stops.

In situations with high contrast, this limited dynamic range can mean sacrificing the detail at one end of the tonal scale to retain detail in the other. With digital capture, exposures are usually made to hold detail in the brightest highlights, which results in shadow detail that may be much darker than you would like. Fortunately, if your images originate as raw digital captures, there are ways to control high contrast and even artificially expand the limited dynamic range of your camera's image sensor.

Multiple raw processing of a single exposure

The flexible nature of a raw file means that it can be easily interpreted in different ways. Applying different conversions to a raw file and combining them in Photoshop is a useful technique for extending the tonal range of an image and it's one that does not require a tripod or shooting multiple exposures.

In an image with contrast problems, a raw file can be processed more than once to optimize the tonal range of specific areas (Figure 6-94). The first processing, for example, might be an overall treatment that preserves detail in the bright highlights and creates a good brightness level for the midtones (for this to work you need to make sure the highlights are not clipped when the exposure is made). In the second processing, the file could be significantly lightened to open up the darker shadows and reveal important detail in those areas. The highlights might be blown out in this second version, but only the lightened shadow areas would be visible in the final composite of the two images. Here are the basic steps for processing a single raw file twice and then combining the results into a single image with a wider contrast range.

Figure 6-95. Setting up the Workflow Options so the raw file opens in Photoshop as a Smart Object.

2. In the example of the drive-through wedding chapel photo, the goal of the first raw conversion is to optimize the overall appearance of the image without clipping any of the highlights. Click the word Default to use the Default settings as a starting point. Adjust the Recovery slider to +20 to reduce the small amount of highlight clipping along the far edge of the awning (Figure 6-96) and click the Open Object button to bring the file into Photoshop.

Figure 6-96. The first processing of the raw file is designed to control the bright highlights.

3. Once the file is open in Photoshop, choose Layer→ Smart Objects→New Smart Object via Copy (you can also right-click the layer and find the same choice in a contextual menu). This will create a copy of the first Smart Object that can be adjusted independently.

Figure 6-94. The original raw file (top) was processed twice using different settings to emphasize different parts of the image. The two versions were combined using Smart Objects and layer masks to create the finished version on the bottom. © SD

🖰 ch06_WeddingChapel.dng

1. Open the file in Adobe Camera Raw. Before we make any adjustments to the image, click on the blue workflow summary link at the bottom of the dialog to open the workflow options and click the check box for "Open in Photoshop as Smart Objects". Set the other settings as shown in the illustration and click OK to close the Workflow Options dialog (Figure 6-95).

 Placing the raw file as a Smart Object in the layered file allows you to double-click the layer thumbnail at any time to reopen the Camera Raw dialog and adjust the settings. It's essentially like having a raw file adjustment layer.

4. Double-click the thumbnail for the duplicate Smart Object to open the Camera Raw dialog. Adjust the file so that darker shadow areas are lightened. Highlight regions may start clipping but don't worry about that. In our adjustments to this image, we set the exposure to +1.40 and the brightness to +100 to reveal more of the angelic cherub details in the awning. We increased the vibrancy to +25 to punch up the colors a bit and set the Clarity to 50 to enhance the midtone contrast. Click OK to apply the changes to the Smart Object (Figure 6-97).

In Camera Raw, the Option/Alt key will change the Open Image/Objects button to Open Copy. This will open a copy of the file with the current settings, but it will not update the metadata that contains the Camera Raw processing instructions. This is useful if the settings you are applying are temporary as in cases where you are processing multiple versions of the same raw file with different interpretations. Pressing the shift key temporarily changes the Open Image button to Open Object, allowing you to create Smart Objects as needed rather than changing the default behavior.

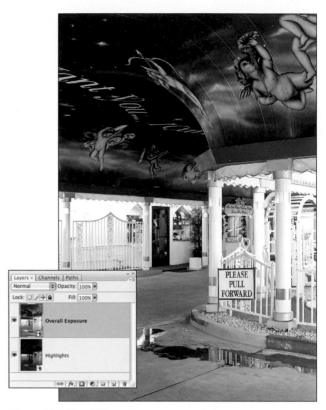

Figure 6-98. Two different interpretations of the same raw image stacked as Smart Object layers in a single file.

Figure 6-97. In the raw processing of the Smart Object copy, the goal was to reveal the darker shadow detail in the top of the awning.

5. Double-click in the Smart Object layer names and rename the lighter version "Overall Exposure," and the darker version "Highlights."

The first part of this process, opening a raw file as a Smart Object, then making a copy of the Smart Object and processing the raw file to emphasize different tonal areas in the image, is basically the same for all photographs. The exact nature of your raw adjustments will vary, of course, as will the placement of the Smart Objects in terms of whether the lighter or darker version is on top, but the basic procedure is the same. It is the type of layer masks that you use, and the selection techniques used to create and edit those masks, that will be different for each photograph. The layer mask for the drive-through wedding chapel photo is a pretty simple one.

6. Choose the Quick Selection tool (W) and tap on the right bracket key until you have a very large brush; for the 3072x2048 image in this example, we used an 800-pixel brush. Drag from left to right across the top part of the image to create a selection of the top half that contains the blue awning (Figure 6-99).

7. Now tap the left bracket key to make the brush size much smaller so you can use it in the blue area above the drive-through window that was not selected in the first pass of the Quick Selection tool. We used a 30-pixel brush. Drag over this area to add it to the selection (Figure 6-100). There may be some areas of the selection that need touching up but that can be handled later.

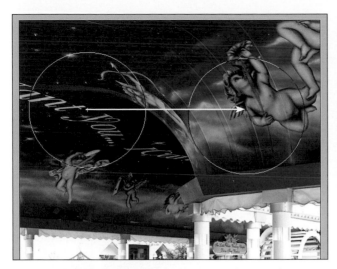

Figure 6-99. Using the Quick Selection tool and a large brush, drag across the top part of the image to select it.

Figure 6-100. Adding to the selection with the Quick Selection tool.

8. Make sure that the top Smart Object layer (the lighter version) is active in the Layers palette, and click the Add Layer Mask icon at the bottom of the Layers palette to create a layer mask that shows the selected area but hides the lower part (Figure 6-101).

9. To soften the edges of the mask, choose Filter→Blur→ Gaussian Blur. For this photo, we used a blur radius of about 2.5 pixels (Figure 6-102). The amount of blur you use will vary depending on the size of the image, the exact nature of the mask you are working with, and how precise the mask edges need to be. We also used the Brush tool and painted on the layer mask with white at 50% opacity to reveal more of the lighter version in the area of the kissing cherubs and the drive-in window sign (Figure 6-103).

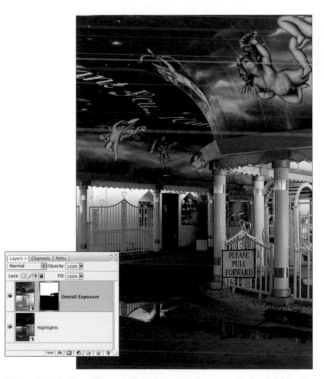

Figure 6-101. The addition of the layer mask creates the initial blend of the two Smart Object layers.

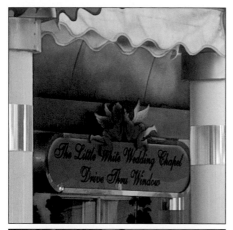

Figure 6-102. Applying a slight Gaussian Blur to the layer mask disguises some of the hard edges.

Figure 6-103. The layer mask was modified using the brush tool to show more of the lighter version over the cherubs and the drive-in window sign.

10. As a final step, we selected the "Please Pull Forward" sign with the Polygonal Lasso and added a Curves adjustment layer to increase the contrast of the sign. We also painted on the first layer mask with white at 25% opacity to lighten the driveway a bit (Figure 6-104).

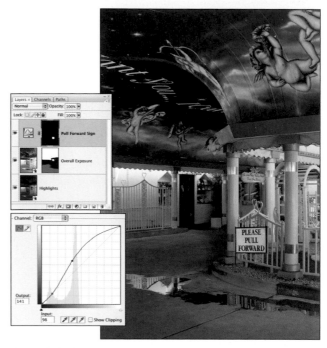

Figure 6-104. The Curves adjustment for the "Pull Forward" sign and the final composite of the two interpretations of the same raw file. © SD

The advantage of placing a raw file as a Smart Object is that you have the ability to revisit the raw conversion at any time without redoing any of the additional layers that you may have added after the original raw conversion. The raw data is embedded in the layered Photoshop file and is not linked in any way to the location or name of the original raw file. The only thing to keep in mind is that any local tonal corrections might need to be updated if you decide to go back and revisit the settings of the initial raw conversion.

Combining multiple exposures with layer masks

When you're facing a scene with high dynamic range and you have a tripod with you, photograph one exposure for the highlights, midtones, and shadows without changing the aperture. In Photoshop combine the different images as layers and blend them together with layer masks. In this technique all of the exposure modification is done in the camera with the capture of different exposures designed to optimize a specific part of the tonal range. After opening the images, the basic layer masking steps to composite the images together are the same as those used in the example of the wedding chapel photo. The masks you use, of course, as well as the methods used to create them, will be specific to each image.

Overall Exposure

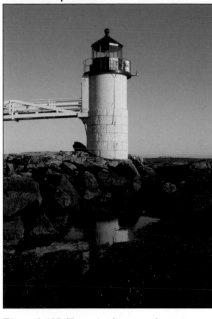

Exposure for Shadows

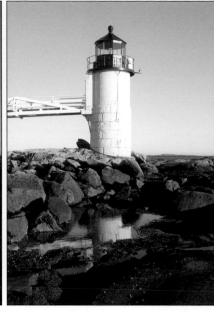

Combined Exposure

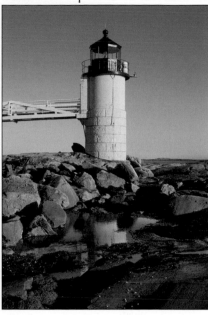

Figure 6-105. Two tripod-mounted exposures, one for the overall scene and one to show the shadow details, combined into a single image using layers and layer masks. © SD

⬦ ch06_Lighthouse-Overall.jpg,

⬦ ch06_Lighthouse-Shadows.jpg

1. Open both files into Photoshop and arrange them side-by-side. Make the lighter version the active file. Select the Move tool, click in the lighter image, hold the Shift key down and drag it over onto the darker version. Keep the Shift down until after you have released the mouse button. You should now have the lighter version of the image as a new layer on top of the darker version. Rename the layers: "Shadow Detail" for the lighter image, and "Overall Exposure" for the darker version (Figure 6-106).

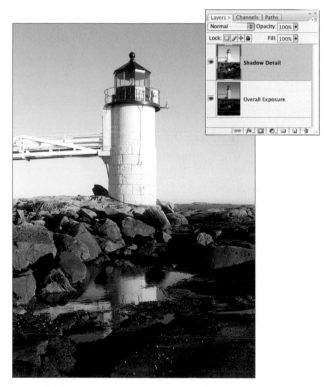

Figure 6-106. The two exposures of the lighthouse arranged as layers in a single file.

> Holding the Shift key down as you drag one file onto another will ensure that the image you are dragging is centered in the target file. When both images are the same pixel dimension and they are two exposures of the same scene, as in this example, they will be perfectly aligned.

2. With the Shadow Detail layer active, choose Layer→ Layer Mask→Hide All to add a black layer mask. The light version of the image will be hidden, revealing the darker image below it (Figure 6-107).

3. Choose the Brush tool and select a soft-edged 200-pixel brush tip from the Brush Picker in the Options Bar. Press "D" on the keyboard to set the default colors, which will make white the foreground color. In the Options Bar, set the brush Opacity to 30%.

4. Make sure the layer mask is active (look for the highlight border around it) and brush over the areas of the image where you want to show the lighter shadow detail from the top layer (Figure 6-108).

5. If you have revealed all of the brighter rocks and you still would like it to be a bit lighter, set the blending mode for the top layer to Screen. This will cause the area of that layer that are visible in the composite image to become even lighter (Figure 6-109). Fine-tune the effect with the layer opacity slider if needed.

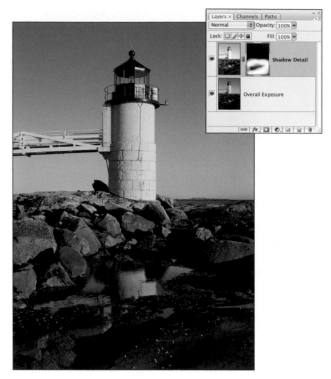

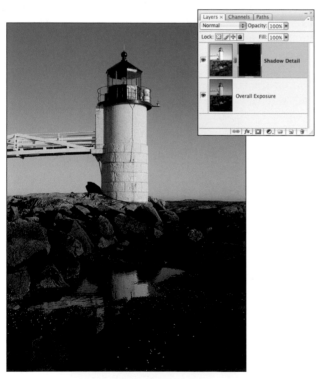

Figure 6-107. A black layer mask hides all of the lighter exposure.

Figure 6-108. The modified layer mask reveals the lighter shadows tones of the top layer.

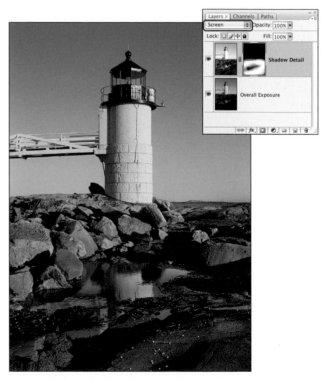

Figure 6-109. Setting the blending mode for the top layer to Screen will lighten the rocks even more.

If you are working with a high-contrast film image and are having difficulty capturing the full range of tones in single scan, you can use a variation of the multiple process raw conversion technique. In order for the different scans to align properly in Photoshop, the slide or negative, as well as the crop box you define in the scanner software, cannot be moved once you start the process.

Make two scans and use the scanner software to change the settings for each scan so that different areas of the tonal range are optimized (for example, a good overall scan with no highlight clipping and another one that lightens the shadow values). For the best quality, use the scanner's high bit-depth capabilities to scan at more than 8 bits per channel. Combine the two scans into a single file using the steps shown in this chapter (see "Multiple raw processing of a single exposure").

If you have multiple slides or negatives that were shot on a tripod with bracketed exposures, the success of aligning separate scans that are sized identically can be accomplished with the new CS3 Auto Align feature. File→Scripts→Load Files into Stack and check "Attempt to Automatically Align Source Images."

Combining multiple bracketed exposures with Merge to HDR

HDR stands for *high dynamic range*, and is used to blend a series of camera raw exposures into a single image that uses the best values of the different source exposures to create a final image with a dynamic range that would be impossible to capture with a single shot. In scenes where there is an extreme contrast range with dark areas that need to be visible and very bright highlights, this method can create impressive results.

Photographic considerations for HDR photography

The key to a successful HDR blend lies in how the photographs are made. A tripod is mandatory to minimize camera movement and an electronic cable release is also a good idea to avoid inadvertent vibration when the shutter button is pressed. Finally, if you are using a lens with a vibration reduction feature, it's best to turn this off for the tripod-mounted exposures. And if your camera has a mirror lock-up control, that's yet another way to reduce noticeable vibration, especially at slower shutter speeds. In terms of camera settings, your exposures should ideally be one f/stop apart, and the various f/stops should be achieved by changing the shutter speed and never the aperture. To keep the focus and size relationships consistent, the aperture needs to be the same for all the exposures. The number of shots needed will vary depending on how extreme the contrast range is in the scene you are photographing, but three to seven shots is a typical number of exposures (Figure 6-110).

The one thing that HDR photography does not do well is motion. While using a tripod can keep the camera stable, motion in the scene is beyond your control. If there is significant movement in the scene, such as trees swaying in the wind or moving clouds, then this could cause blending irregularities and ghosting in the finished result (Figure 6-111). In a classic landscape photograph, this is probably not an acceptable side effect for most people. For scenic elements such as rivers or oceans you can sometimes cover up the blurry, ghosted section by using a single image from the series with a layer mask after the initial HDR merge has been completed.

As tricky as motion can be, however, it's important to note that for some types of photography such blending "mistakes" are not necessarily a bad thing. In some cases, they can look very interesting, especially with people or bright lights moving through the shot and leaving strange ghosting effects as they pass. In the HDR photo of taxis leaving an underground garage (Figure 6-112), the transparent trails and saturated color artifacts created by the moving cars convey a sense of the hectic activity at a busy Las Vegas hotel.

Duggan_06091....CR2	Duggan_06091....CR2	Duggan_06091....CR2	Duggan_06091....CR2	Duggan_06091....CR2	Duggan_06091....CR2
2912 x 4368	2912 x 4368	2912 x 4368	2912 x 4368	2912 x 4368	2912 x 4368
1/400 s at f/8.0, ISO 200	1/200 s at f/8.0, ISO 200	1/100 s at f/8.0, ISO 200	1/50 s at f/8.0, ISO 200	1/25 s at f/8.0, ISO 200	1/13 s at f/8.0, ISO 200
9/11/06, 11:59:39 AM	9/11/06, 11:59:47 AM	9/11/06, 11:59:52 AM	9/11/06, 11:59:58 AM	9/11/06, 12:00:04 PM	9/11/06, 12:00:08 PM

Figure 6-110. To capture the full range of tones from the deep interior shadows to the detail in the sunlight-washed seat of the chair, six exposures were made. The aperture for all six shots was f/8 and the shutter speeds range from 1/400th of a second down to 1/13th of a second (ISO 200).

Figure 6-111. The clouds were moving during the exposure of the source images for this HDR file, resulting in obvious alignment problems in the final file.

Figure 6-112. For some scenes, ghosting and alignment irregularities caused by motion in the scene is not a problem, and can even enhance the image. This is a blend of six exposures. © SD

Merge to HDR pre-flight check

Before you start the Merge to HDR process, there are a few things to double-check. First, in Photoshop the HDR results will be best when you use raw files from digital cameras. This is because the raw files are already captured at a high bit depth, whereas JPEGs are limited to 8-bits of data. It does not work with scanned images. Second, the raw files should have had no tonal adjustments applied to them in Camera Raw. Fortunately, there is a "secret handshake" between Adobe Bridge, Adobe Camera Raw, and the Merge to HDR command that negates any previously applied adjustments when accessing the HDR command through Bridge.

Before you start with Merge to HDR, you should also double-check the image size in the Workflow Options of Camera Raw. This setting is sticky, meaning that it will always use the size that was specified the last time you processed a raw file. Double-click a raw file in Adobe Bridge to open it in Camera Raw, and check the Workflow Summary in the hyperlink at the bottom of the dialog. If the size is not what you want, click the link to open the Workflow Options, choose the correct size, click OK, and then click Done in the main ACR dialog. Since Merge to HDR can be a memory-intensive process with large files, you may want to consider using smaller versions during the initial proofing process to see how well the merge works. If all looks good, then you can redo the merge using the full-size files.

🖱 ch06_BodieChair (files 1 through 6)

Accessing Merge to HDR

You can initiate the Merge to HDR process from Photoshop or from Adobe Bridge. From Photoshop, choose File→Automate→Merge to HDR. In the initial dialog, specify which files you want to use and click OK. We think it's easier to do this from Bridge, however, because you can easily see the thumbnails of the images you want to use. Simply select them all by clicking the first one and then Shift-clicking the last one. Choose Tools→Photoshop→Merge to HDR. Photoshop will then open all of the files and load them into the initial Merge to HDR dialog. Depending on how

many files are being loaded, their size, and the speed of your computer, this can take several minutes.

Step 1: Merging the source files. Merge to HDR is really a two-step process (actually, it's more of a three-step process since you always have to apply further fine-tuning after the HDR conversion). The first step involves creating a 16-bit or 32-bit file that is a blend of all the source files you have chosen. The initial Merge to HDR dialog displays thumbnails of the source images and their exposure value (EV) on the left (Figure 6-113). You can remove an image by clicking in the checkbox. Ideally you want to use only enough files to cover the visible dynamic range in the scene. The more files you use, the greater the likelihood of misalignment and detail softening.

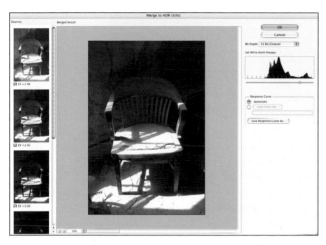

Figure 6-113. The Merge to HDR dialog box. On the right is the bit-depth menu and the white point preview histogram.

The initial merged file that is previewed contains a tonal range that is too wide to be displayed on your monitor at one glance. You can use the slider under the histogram to preview the different sections of the tonal range as well as set the white point for the final merged image. Each of the red marks under the histogram represents one stop or exposure value (EV). If you move the slider to the left you can see how much shadow detail the file contains (since the dynamic range is wider than your display capabilities, the highlights will blow out when previewing the shadow details). We usually prefer to set the white point preview so all of the highlight detail is visible with no clipping. With this setting, the previewed image will look quite dark since the monitor cannot display the full range, but the detail will be preserved in the highlights and detail will still be retained in the darker areas, even though you cannot see it (Figure 6-114). Balancing out the tonal values and revealing the shadow detail will take place in the second part of the process. Click OK to create the merged file.

Merge to HDR: 32-Bit or 16-Bit?

On the right side of the Merge to HDR dialog box is a menu for setting the bit depth of the merged file. The default setting is 32 Bit/Channel. For photographic images that will be printed or displayed on screen, a 32-bit file is more than you'll ever need. The ability to generate 32-bit files is intended for 3D imaging programs, such as those used in movie special effects or the creation of computer game graphics. If you choose to create a 16-bit file, then you will be taken directly to the HDR Conversion dialog box, where you can apply further modifications. For photographers, the primary reason to process the file as 32-bit is that you can save the 32-bit version of the file, which can then be processed in different ways for the final HDR conversion. Since the most time-consuming part of the HDR process is the initial merging that takes you to the Merge to HDR dialog, we think it's a good idea to be able to save the file for further HDR interpretations without starting the entire process over again. For this reason, we choose to create a 32-bit file and then save that in the Portable Bit Map format (pbm) or Photoshop (psd) formats.

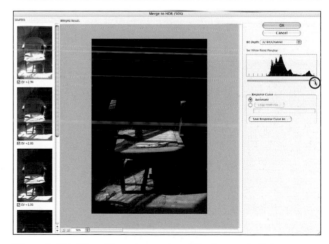

Figure 6-114. The white point preview slider is moved all the way to the right side of the histogram to show all of the bright highlight detail.

Moving the White Point Preview slider affects only the preview of the image. As long as you use the 32-bit option, all of the HDR data is preserved in the merged version of the file. When you open the 32-bit file in Photoshop, the preview adjustment is stored in the file but can be changed at any time by choosing View→32-Bit Preview Options. This dialog has an Exposure and Gamma slider that can be used to open up more shadow detail prior to the final HDR Conversion step.

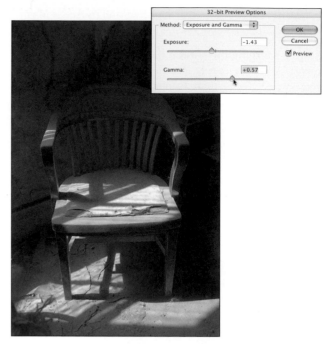

Figure 6-116. Using the 32-Bit Preview Options gives you more flexibility in adjusting the preview of the 32-bit merged file.

When the 32-bit file appears, it will look very dark, like the preview in the Merge to HDR dialog box (Figure 6-115). But fear not, more options to tweak the appearance of the image are just a step away. The first thing you should do is save the file so it can serve as a source for further explorations if you want to try interpreting it in different ways in the HDR Conversion dialog box. By saving the file you don't have to go through the time-consuming first part where the source files are merged into a 32-bit file. Choose File→ Save As and, in the Save dialog box, open the format menu and choose Portable Bit Map or Photoshop. After saving the file, you can also choose View→32-Bit Preview Options to further adjust the preview of the merged file (Figure 6-116). Remember that the tonal range of a 32-bit file is much too wide to display on a monitor, so all you are doing here is adjusting the preview of the file. The sliders in this dialog box provide considerably more control than the Merge to HDR dialog for getting the preview looking good.

Step 2: The HDR Conversion dialog box. The cool part of the Merge to HDR process comes in the next step, when the image is converted to a 16-bit-per-channel file. Unfortunately, when you start from a 32-bit file, there is no hint that further action is required. It would be nice if a message dialog appeared that informed the user that additional options could be found when the file is converted to 16-bit.

To allow for further conversion flexibility and the opportunity to return to the original 32-bit PBM file, choose Image→Duplicate, and then choose Image→Mode→16 Bits/ Channel to bring up the HDR Conversion dialog box. Of the four conversion methods available, only Exposure and Gamma and Local Adaptation give you any sort of control over how the image looks. The latter method is the one we use most of the time but we'll take a quick look at what the others offer.

Exposure and Gamma

These sliders are the same as in the 32-Bit Preview Options and if you adjusted the image there before converting to 16-bit, then the sliders will show the previous settings. The Gamma slider will increase or reduce the contrast in the image and functions similar to an overall midtone brightness control. The Exposure slider controls the overall brightness of the image in a way that is much more abrupt; you don't have to move it very much to see a drastic effect on the file. These controls are fairly blunt and in most cases we don't find them too useful (Figure 6-117).

Figure 6-115. This merged 32-bit file is very dark because the white point preview was set to show all the detail in the brightest highlights.

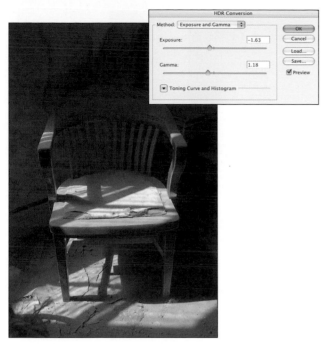

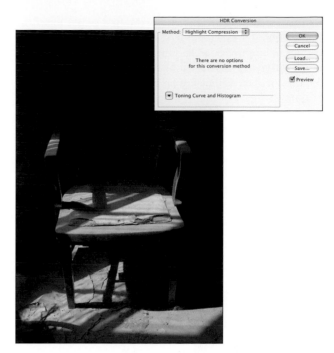

Figure 6-117. The Exposure and Gamma sliders allow for basic brightness and contrast adjustments but not much finesse in how those changes are applied to the image.

Figure 6-118. Highlight Compression is an automatic adjustment with no way to modify the effect.

Highlight Compression

This is an automatic setting and there are no options for modifying the effect (Figure 6-118). It compresses the highlights so they fall within the brightness range of the 8-bit or 16-bit file. While this method can open up the midtones a bit while still preserving all of the bright highlight detail, the shadow tones usually remain very dark.

Equalize Histogram

This control will remap the brightest highlight and darkest shadow points to the normal contrast range of a low dynamic range image (that is, 8- or 16-bits). The result here is usually better than either Exposure and Gamma or Highlight Compression, and it can sometimes look interesting, but as it offers no options to modify the effect, this method also leaves a lot to be desired (Figure 6-119).

Local Adaptation

This method gives you the most control and is the one that we use for nearly all of our HDR conversions. Click the triangle button to expand the dialog and reveal the tone curve and histogram. This is where the real conversion fine-tuning takes place.

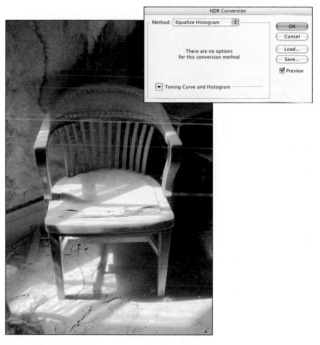

Figure 6-119. Of the two automatic adjustments in the HDR Conversion dialog, Equalize Histogram is the most interesting, but it's still a formula-setting feature with no fine-tuning available.

Before you adjust the tone curve, the first step is to set the Radius and Threshold sliders. Radius controls the size of the local brightness areas, and Threshold specifies how much difference there must be between neighboring pixels' tonal values before they are no longer included in the same brightness area. For many images, the default Radius value of 16 pixels is too high. Start with a fairly low threshold of 0.5 or 0.75, and then adjust the radius until the blending along the contrast edges looks more natural. As with the Shadows/Highlights command, which contains similar tonal separation functionality, there is no right setting to use. The important thing is to understand how the sliders affect the image and what artifacts to be on the lookout for. The main thing to be wary of with these controls is the creation of noticeable halos around high-contrast edges (Figure 6-120 and Figure 6-121). Zoom in to 100% (View→Actual Pixels) for the best view of the edge details.

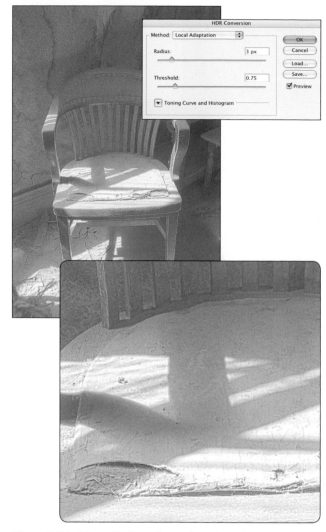

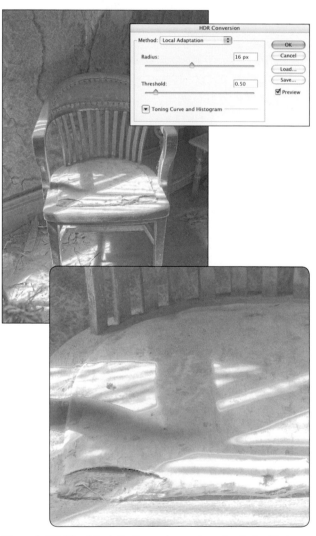

Figure 6-120. The default Radius setting produces hard-edged halos on the bright contrast edges in this image.

Figure 6-121. A lower Radius value results in better-looking contrast edges.

Adjusting the Local Adaptation curve. The histogram represents the brightness values of the original HDR image, and in many cases it will not span the entire tonal range (the example of the old chair does not have many values on the dark shadows). The red marks along the bottom of the curves grid represent increments of 1 EV (approximately 1 f-stop).

The object in this dialog box is not to end up with a perfect image in terms of brightness, contrast, and color saturation, but to create a version that has the full range of useable tones that you can work with in Photoshop once the 32-bit file has been converted to 16-bits. If there are no tonal values on either end of the histogram, then it's usually a good move to bring the highlight or shadow points in to just before where the tonal data starts. To ensure that the darkest shadow tones still hold visible detail, we placed two points on the lower section of the curve and raised them up a bit (Figure 6-122).

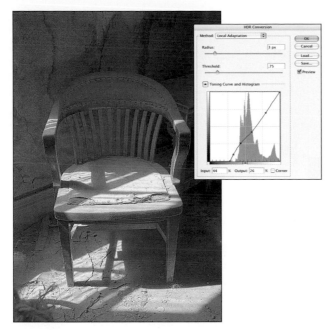

Figure 6-122. Fine-tuning the Local Adaptation curve.

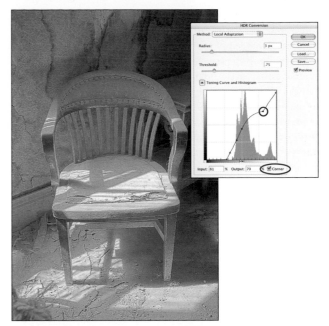

Figure 6-123. You can use the Corner feature to transform a normal control point into a corner point.

The default behavior of the curve is to try to equalize your changes across all the points. If you click a point to make it active, and then click in the Corner checkbox, the point becomes a corner point and no equalization will be performed when you insert and manipulate another point (Figure 6-123). The simplest way to think of the corner point is that it provides an easy way to lock down a section of the curve so that it does not move. But if the changes to the curve become too extreme on either side of the corner point, then you run the risk of introducing color posterization or hard halos along high-contrast edges.

Of course, if you're after a non-traditional look, don't be shy about doing wild things to the curve. You can create some pretty interesting color solarization effects simply by inverting points on the curve (that is, raising shadow values up and lowering highlight points; see Figure 6-124). It may not be what Ansel Adams would do, but Man Ray would certainly approve!

Click the Save button to save the tone curve setting to apply to other images or to reinterpretations of the saved 32-bit pbm version of the file. Use the Load button to access your saved HDR settings.

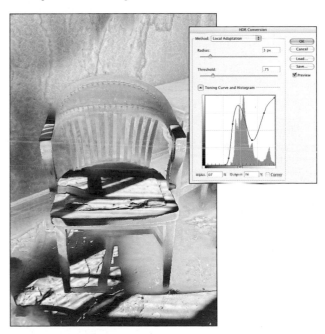

Figure 6-124. A Merge to HDR homage to Man Ray.

Step 3: Further adjustments to the 16-bit merged file.

Once you click OK in the HDR Conversion dialog, your adjustments are applied to the 32-bit version of the file, and it is converted to 16 bits (or 8 bits if you chose that option, which is not recommended). The results from the HDR conversion are typically flat and low contrast (Figure 6-125). If you regard this as the finished product you're likely to be disappointed. At this point you will almost always need to apply further modifications using adjustment layers and layer masks to improve the contrast and sometimes the color balance. In the image of the old chair, we added a Curves layer to slightly increase the contrast and warm the image up a bit, a Selective Color layer to enhance the density of only the black tones, and a final Hue/Saturation layer to slightly desaturate the image (Figure 6-126).

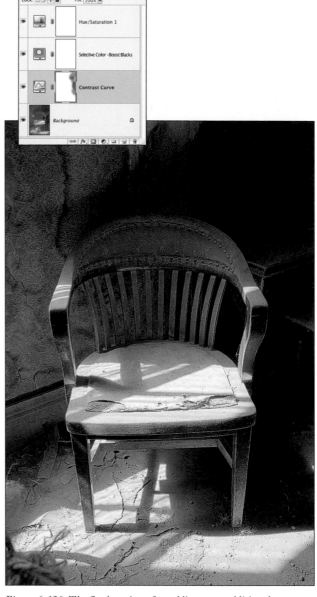

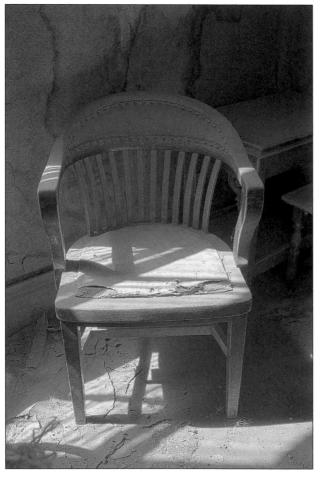

Figure 6-125. The initial result from the HDR Conversion dialog has a much fuller range of tones than any of the original source exposures, but it's very flat and dull.

Figure 6-126. The final version after adding some additional adjustment layers for contrast and color correction. The wide dynamic range present in the original scene could never have been recorded with a single exposure. © SD

Combining multiple HDR images

In some cases, the results from a single Merge to HDR may not be exactly what you want, and you may choose to combine two different HDR interpretations of the same file. Once you are finished with the HDR part, this is essentially the same technique as combining two interpretations of the same raw file. The type of masks that you use will be determined by the needs of the images you are working with.

Seán found the multiple Merge to HDR method quite useful in creating an image of the sunrise over Machu Picchu in Peru. He started with six exposures all recorded at one f-stop apart. The aperture was a constant f/8 and the shutter speeds ranged from 1/3200th down to 1/100th of a second. After creating the initial 32-bit HDR file, he saved it in the Portable Bit Map format so that he could try out different interpretations without having to redo the time-consuming merge process. After finding that a single file was not yielding the result he envisioned, he created one 16-bit conversion that emphasized the detail in the mountains and another that was optimized for the sky and rising sun (Figure 6-127).

He combined the two files into a single file as separate layers and used layer masks to blend the darker sky version with the one that revealed detail on the steep mountains. He used several additional adjustment layers with layer masks to further enhance each of the two separate images until he created a final version that better expressed his memories of watching the sunrise over that magnificent place (Figure 6-128).

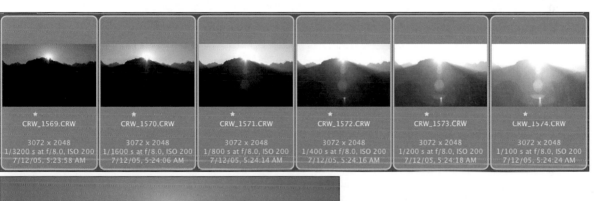

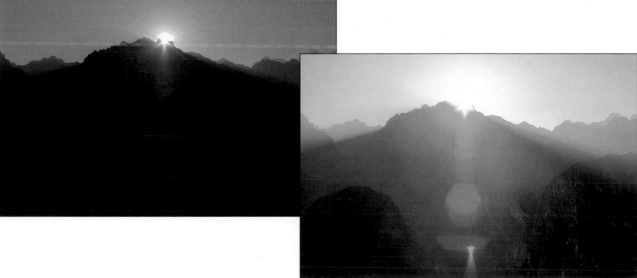

Figure 6-127. The six source exposures of dawn at Machu Picchu and the two 16-bit HDR conversions that were combined using layers and layer masks.

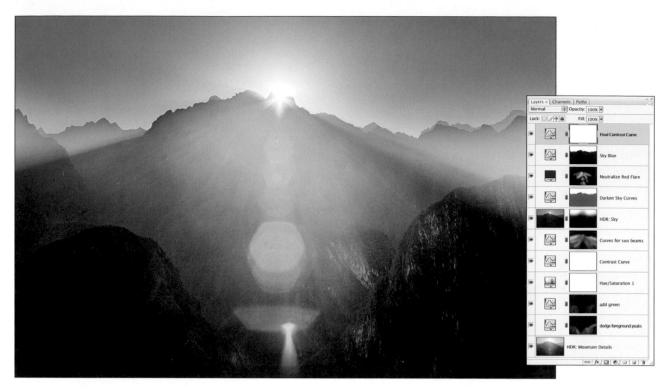

Figure 6-128. Machu Picchu Dawn: a blend of six exposures, two HDR conversions, and numerous adjustment layers. © SD

Seeing the Light

In this chapter, we have covered many techniques for manipulating the tonal values in a photograph. Although knowing the software specifics of these techniques is necessary for applying them to an image, perhaps even more important is a skill that is totally separate from Photoshop or even the computer. That skill is recognizing the crucial role that brightness values—the delicate interplay between light and shadow—play in a photograph and how the manipulation of those tonal values can dramatically transform an image. Learning how to see the tonal possibilities that are present in a photograph and knowing how to control these qualities through creative dodging, burning, and exposure blending is essential to creating the image you want.

Figure 6-129. Temple of the Sun, Machu Picchu. This is a 6.3 minute raw exposure taken on a very dark moonless night. A small flashlight was used to illuminate the ruins by "painting" them with light. The reddish glow in the sky is from the lights of a dam a few miles down river. The image has been enhanced with minor dodging and burning. © SD

Color Correction

Color is all around us. We perceive it whenever our eyes are open and sometimes, in the form of after-images or dreams, even when our eyes are closed. But for such a ubiquitous part of the world that is often taken for granted, color remains one of nature's most mysterious and wondrous phenomena. Perhaps it is this very mystery, coupled with delicate, nuanced subtlety and stirring interactions of hue and intensity that has long drawn artists to the world of color and to the colors of the world.

In this chapter we explore some of the important concepts and techniques for working with color in the digital darkroom:

- The Landscape of Color
- Global Color Correction
- The Power of Curves
- Color Enhancement
- Local Color Correction
- The Power of Lab

Seeking creative inspiration and pleasure from the color palette of our world is as simple as opening our eyes and looking around us, but capturing and reproducing the color we see, or the color we want, is sometimes not as easy. By developing an understanding of how color works, both in the real world and in the digital darkroom, you will be more successful at envisioning the color possibilities for an image and controlling the color through correction and enhancement.

Chapter 7

The Landscape of Color

One of color's great mysteries, and, in some cases, frustrations, is the fact that it is so imprecise and subjective. Another color truth is that there is really no such thing as "true colors." This is because the color that we perceive is the result of a combination of different variables. If any of those variables change, the color, or rather, our *perception* of it, is likely to change, too. Consider the examples of the classical face in Figure 7-1: These images were all photographed in natural light, yet the color of the face in each one is different. Some of these differences are subtle, yet some are quite pronounced. Which one represents the "true" color of the ceramic face? Considering the differences in how the light source (the sun) was affected by things such as shade, surrounding colors, filtration by trees, vegetation, a fiberglass awning, a reddish brown wall, and twilight, they are all true to the type of illumination that was present.

As far as our roles as photographic artists are concerned, color is a purely visual property and a very intangible, slippery one at that. We can describe color with language, but those descriptions are, at best, a rough approximation of what a color looks like, and we often fall back on referring to "memory colors" or descriptive adjectives, such as "fire-engine red" or a "deep violet blue." Color can be described with far more accuracy mathematically, and in some ways digital color, when properly managed, is far less ambiguous than the color we perceive with our eyes.

Light, Object, and Observation

You may have heard the statement that all color is created by light. You can easily see this concept in action by turning the dimmer switch on and off in a room at night. With no light, there is no color, and with less light, there is less color. The lower the light level, the duller and less saturated the colors are. Color needs light to breathe. Think of a flower garden in the sunlight, or even under midday, overcast skies; the colors are bright and saturated. But in the dimness of twilight, the saturation is gone, the hues are less distinct, and colors appear totally different than in daylight (Figure 7-2).

Figure 7-1. Each of these photos was taken in natural light, but which one represents the "true" color of the ceramic face? © *SD*

Figure 7-2. Irises in the late afternoon sunlight and a few hours later in the deepening twilight. © SD

While there is certainly some truth to the idea that light creates color, it's not the whole story. In reality, color is created by an interaction involving the light source, the object being illuminated, and the observation of this illumination. That room with the dimmer switch or the twilight garden contains not only the objects being illuminated, but also the person observing them. Each component in this interaction—the light, the object, and the observer—brings something to the equation that results in the perceived color of the object. And these three variables encompass a range of different areas in the natural world, including physics (light), chemistry (the object), and biology and psychology (the observer). Color is perceived by the observer as a result of the wavelengths of light and how that light is changed through its interaction with the object. Change any one of these three variables—the light source, the object, or the observer—and the perceived color will be different.

The Subjectivity of Color

Apart from the three primary components of light, object, and observer, color can also be influenced by the interpretive perception of the observer. We do not all perceive color the same way. The differences in color perception may be physical, as a result of the actual visual system of the observer, or they may be emotional or psychological. Gather a group of people together, ask them to close their eyes and imagine the color green, and it is highly unlikely that everyone will be envisioning the same green tone, partly because there are so many different types of green, but also because each person has a particular visual idea or memory of "green" that is sometimes influenced by a "favorite" green.

Memory and personal experiences can also influence our perception or recollection of the color in a scene. Many years ago, long before digital transformed the photographic landscape and when Photoshop was still in version 1.0, Seán worked at a photo lab. One day a customer complained that the sky was not blue in some of her photos of a visit to a mountain lake. In evaluating the images, the lack of any hard shadows and the overall low contrast of the light made it clear that the photos were taken on an overcast day and the exposure had blown out the sky to a featureless white. This was explained to the customer, but she insisted that the weather had been beautiful at the lake and that the skies were blue. While it is probably true that the skies were blue on some days, the photographic evidence in the prints she was questioning showed that when those images were taken, the sky was most definitely not blue. In an effort to explain this, comparisons were made between the scene in the photos and the actual conditions in the parking lot outside the lab, where the sky was clear and blue, and where there were the hard, distinct shadows and strong contrast that is common in those conditions. In spite of the evidence of physics, the customer was still not convinced. Her recollection and perception of the sky color in those photos was influenced by her memories of the visit and the beauty of the mountain scenery where the sky was undoubtedly blue on some days but not on the day the photos were taken.

The Components of Color

When considering color, it helps to be familiar with the basic building blocks and terminology so that you can evaluate images more successfully, and clarify your ideas about how the color should be changed. In terms of working with photographs in the digital darkroom, color has three primary characteristics that influence its appearance. Additionally each of the additive primaries (red, green, blue) and subtractive primaries (cyan, magenta, yellow) are created by a blend of two other colors. Understanding these characteristics and the relationship between colors is key to successful color adjustments. Before we explore the nuances of color correction, let's take a look at these basic color building blocks.

Hue, saturation, and luminosity

The three characteristics that we use to describe a color are hue, saturation, and luminosity, or brightness. For example, "At the car show we saw a classic old Corvette that was painted a really intense, bright, cherry red color." In that simple description, the three characteristics of color have been noted. The hue is identified as "cherry red." This not only specifies the general hue (red) but also narrows it down by including a reference to the hue of another item that most people can imagine (a cherry). The luminosity is expressed with the word "bright," and the saturation, the purity of the hue, is identified as "intense," which conveys a red color that is very saturated.

Technically, hue is expressed in degrees as a location on the color wheel. (Since a circle is 360°, the scale runs from 0° to 360°.) Saturation and luminosity (also known as brightness or lightness) are both expressed as a percentage from 0% to 100%. A great place to play around with these concepts (and a good place to learn about color in general) is Photoshop's Color Picker dialog box, which you can access simply by double-clicking the foreground color swatch in the Tool palette (Figure 7-3).

Figure 7-3. Photoshop's Color Picker is a great place to explore the HSB ingredients of color.

If you want to measure these three components of color, you can set the secondary display in the Info palette to HSB (the B is for Brightness). Click the small eyedropper next to the Info palette, and then choose HSB from the menu (Figure 7-4).

Figure 7-4. To easily measure the HSB values as you are working on an image, click the small eyedropper in the Info palette to change the right-hand display to HSB.

Color ingredients

There are countless colors in the world, and experiencing the wonderful variety of color is truly one of the great joys of life. In working with color in Photoshop, however, we manipulate all the different colors by working directly with only a few colors. These colors are the essential ingredients, and the various mixtures of them create all the other colors we see. Understanding the basic color ingredients and how to alter them is an important part of color correction.

Additive color: RGB. At the heart of this system are the three additive primaries of red, green, and blue (RGB). They are called *additive* as RGB is based on light and when starting with zero color (no light) you have black. As color is added, the result becomes lighter, eventually resulting in white when all three are combined at full strength (Figure 7-5). In addition to tracing its origins to the behavior of light, the RGB color model is also how human color perception works. Digital cameras, monitors, televisions, and scanners all create color based on the RGB color model. RGB is the most common color mode used for photographic digital images.

Figure 7-5. The RGB color model.

Subtractive color: CMY. Where RGB is an additive color model, cyan, magenta, and yellow (CMY) represent the three components of the subtractive color system. This is the color model that is used for the reproduction of images using ink on paper. The term *subtractive* refers to the fact that you start with white paper and as the amounts of each color are increased, the resulting color becomes darker. In theory, a blend of each of these colors at full strength will produce a black, but the reality is more of a dark, muddy brown, so black ink (the K in CMYK) is added to yield a true black. Combinations of two CMY colors will yield one of the RGB colors (Figure 7-6).

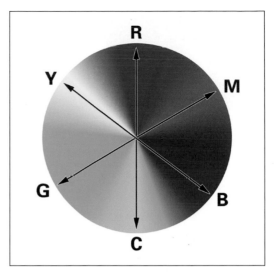

Figure 7-7. A color wheel showing the complementary (opposite) color relationships between RGB and CMY.

Figure 7-6. The CMY color model.

Complementary colors. One of the key aspects of color correction is understanding the relationship between the hues on the color wheel and what the complementary, or opposite, colors are. If you know the complement of a color, then it's much easier to narrow down how to correct an image with a color cast. The complement of red is cyan, the complement of green is magenta, and the complement of blue is yellow. So, for an image that has a strong yellow colorcast, such as from tungsten lighting, adding blue would reduce yellow. The complementary colors are positioned opposite each other on the color wheel. We find it interesting that the complementary relationships are composed of the additive (RGB) and subtractive (CMY) colors. The opposite of an additive color is always a subtractive color and vice-versa (Figure 7-7).

In its default arrangement, the Info palette shows the actual color of an image in the upper-left pane (that is, if your image is RGB, then that will be the display in the upper-left pane) and CMYK in the upper-right pane. In this configuration, the letters for RGB and CMYK line up to show the complement (opposite) of each color (Figure 7-8). You can use this as a handy cheat sheet until these relationships are committed to memory. You can also see the color wheel relationships in the previews in the Variations dialog box (Image→Adjustments→Variations). While we don't recommend Variations for actual color correction, if you're new to color correction, it can be a useful diagnostic tool to determine what might be causing a color cast (Figure 7-9).

Figure 7-8. The Info palette can provide a handy cheat sheet for complementary colors when configured with RGB on the left and CMYK on the right.

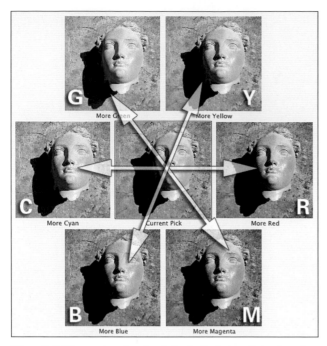

Figure 7-9. The preview thumbnails in the Variations dialog box also show the complementary color relationships.

Component colors. In addition to knowing the complementary colors, it's helpful to understand the components that create a color. The mixture of two additive or subtractive primaries will create another additive or subtractive color. The basic color recipes are revealed on the color wheel by looking at the two colors on either side of a color. Two additive primaries (RGB) mixed together will always create a subtractive color (CMY), and two subtractive primaries (CMY) will always mix to yield an additive color (RGB). For example, the mixture of yellow and magenta, which are subtractive colors, creates red, which is an additive primary. On the color wheel, red is flanked on either side by those two colors (Figure 7-10).

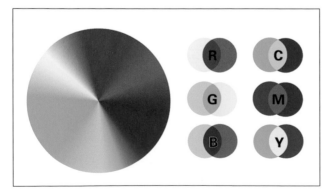

Figure 7-10. The mixture of two CMY colors creates an RGB color. A mixture of two RGB colors creates a CMY color.

Global Color Correction

Now that we've taken some time to survey the terrain before us, we can continue with an exploration of color correction in the digital darkroom. The act of color correcting an image can encompass many different procedures and techniques but one thing is true for most images: It is best to start with the global or overall corrections that can be applied to the entire image and, when those are complete, narrow your focus to more specific areas that may require different adjustments.

Color Correction Goals: The Big Picture

The goal of most color correction is to make the color in the image look "correct," meaning true to the actual scene, or to our memory of the scene. The term correction implies that there is something incorrect or wrong in the color balance of the image that needs to be remedied. No matter what the initial problem is, there are some common goals to global color correction. Neutrals should be unsullied by color casts, skin tones should look healthy and pleasing, green leaves should look green, and a blue summer sky should look like a blue summer sky, not a cyan-tinged delirium (unless, of course, the visual aesthetic of a particular project would be well served by a good dose of cyan-tinged delirium). Though not every image has these exact elements, of course, at a fundamental level, color correction is simply the act of adjusting a photographic interpretation of a scene to a state where it more closely matches what we believe the scene should look like. The original exposure created by the camera is one interpretation, and global corrective adjustment is another interpretation, though one that is designed to be more accurate in how the colors should look based on key visual guides within the image, as well as our own color memory, experiences, and subjective view of the scene.

The Power of Neutral Color

One of the great ironies in color correction is that the least colorful hue, gray, is also the most powerful. The reason gray is so significant is that it represents the absence of color, a neutral tone. A neutral value in an RGB file in Photoshop is expressed numerically when the values for red, green, and blue are the same (for example, R128, G128, B128 produce a middle gray value, or Zone V), but can also be equal higher values for lighter neutrals and lower equal values for darker neutral areas. A tone that is neutral is one that has no colorcast at all. So, if there is a color cast in the image, and there are also areas that should be neutral (areas that should be shades of black, white, or gray), then by measuring this reference tone and referring to the Info palette, you can determine which color might be causing the color cast problem and also correct the cast by neutralizing the reference tone. In Figure 7-11, the color cast caused by tungsten lighting over the model train display was quickly removed by clicking the painted white clouds with the White Balance tool in Adobe Camera Raw.

Figure 7-11. A neutral guide can be an effective color-correction tool. By neutralizing a tone that should be neutral, color casts can often be eliminated with a single click. © SD

The White Balance eyedroppers in both Adobe Photoshop Lightroom and Camera Raw work by applying this basic logic to neutralize the tone you click. If the image has a color cast, this one-click operation will often remove it entirely. Similar neutral Eyedropper tools are also available in Photoshop's Levels and Curves dialog boxes. Of course, you have to be sure to use these tools on areas that should be neutral; otherwise you will introduce a different colorcast to the photo.

Natural neutrals and target neutrals

Many different types of images have neutral tones in them, or tones that are close to neutral (Figure 7-12). The neutrals that you use as guides for color correction do not have to be limited to gray. They can also be highlight or shadow areas. Common items in images that can serve as neutral guides are white clouds, white clothing, white paper, the whites of a person's eyes, gray rocks or cement, sidewalks, the pavement on roads, and gray metal or steel. One thing to avoid when using highlights as a neutral guide is a specular highlight, which is a very bright, sometimes totally white, highlight created by light reflecting off water, polished metal, or glass, or lights that are blown out to a total white with no detail (Figure 7-13). Since specular highlights are usually already totally white and neutral, they fall outside the range of any color cast that might be in the image, and therefore will not help in fixing the color problem.

Figure 7-12. Many photos have areas that can serve as neutral guides. In the image on the left, the foam of the rapids, the paper, and the black of the typewriter are all good candidates. In the photo of the girl in the shopping cart, the bottle cap by her arm and the labels on the shelf are all good neutral guides. © SD

Figure 7-13. The light fixtures at the top of this old railroad mail car are specular highlights. Since they are already totally white and neutral, they will not be of any use in correcting the color cast in this photo. Some of the other white or near-white areas, however, could serve as useful neutral references. © SD

A target neutral is something that is purposefully placed in the scene as a reference for neutral tones or specific colors. The target neutral is used in a few setup shots at the beginning of a shoot and then removed as the photographer continues with the shoot. Later, a white-balance correction can be made using the neutral target in the setup shots and applied to shots taken in the same lighting conditions. The most popular reference targets include the GretagMacbeth Gray Balance Card, White Balance Card, or our favorite the ColorChecker chart (Figure 7-14), which offers six neutral samples (from black to white) and fifteen color samples for more precise color matching.

Color Correction Using Target Neutrals

The example images of a ColorChecker chart and the faerie house seen in Figure 7-14 were photographed in a forest under heavy shade. Since the overcast daylight was filtered by the canopy of green trees the images have a cool and slightly cyan color cast. The reference photo with the color checker enables us to quickly correct the white balance for that image and then apply the same correction to any other images from the same shoot photographed in the same lighting.

White Balance as Shot

Corrected White Balance

Figure 7-14. The second light square from the left in the GretagMacbeth ColorChecker is an excellent white-balance color correction reference that can be applied to other images taken in the same lighting conditions. © SD

⌐ ch07_ColorChecker-A.dng

⌐ ch07_ColorChecker-B.dng

Using Previous Conversion Settings

1. Starting from the Adobe Bridge browser, double-click on the file with the ColorChecker to open it into Camera Raw. Select the White Balance tool and click on the second light gray square from the left (Figure

7-15). You will see a noticeable warming of the color balance in the image. Click the Done button to return to Adobe Bridge.

2. In Bridge, select the thumbnail of the image with the faerie house. Right-click on the thumbnail and from the contextual menu, choose Develop Settings→ Previous Conversion to apply the white balance settings that were applied to the ColorChecker image (Figure 7-16).

Using the Previous Conversion option will apply all of the Camera Raw settings, so it may not be appropriate if you have made changes to settings other than white balance. If you want to choose specific Camera Raw settings to apply, then use the following method.

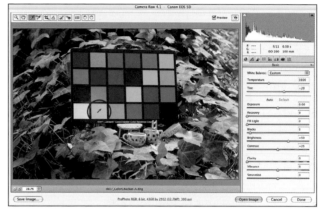

Figure 7-15. The cool, cyan color cast is corrected using Camera Raw's White Balance Tool on the ColorChecker chart.

Figure 7-16. Applying the previous Camera Raw conversion to another image from the same session.

Copy and Paste Settings

3. Correct the white balance of the target image as detailed in Step 1. In Bridge, right-click on the corrected image of the ColorChecker and choose Develop Settings→Copy Settings.

4. Now right-click on the thumbnail of the faerie house image and choose Develop Settings→Paste Settings (Figure 7-17). In the Paste Camera Raw Settings dialog box that appears, open the Subset menu and choose White Balance. All other settings will be unchecked, allowing you to apply only the White Balance settings (Figure 7-18). Click OK.

Figure 7-17. Copying and Pasting Camera Raw settings.

Figure 7-18. In the Paste Camera Raw Settings dialog box you can choose a specific subset of settings to use.

If you want to apply the white balance settings from a corrected target file to several images, follow the same steps but select all of the image thumbnails that you want to apply the same settings to. Then right-click on one of the thumbnails and paste the settings (Figure 7-19). In addition to right-clicking on the thumbnails, the Develop Settings options are also available in the Bridge Edit menu.

Figure 7-19. Pasting the copied White Balance settings from the ColorChecker reference file to several images from the same shoot.

Color Correction Using Existing Neutrals

While using a target neutral guide such as a ColorChecker chart can be very effective for removing color casts in planned, controlled situations, it's not an option for many images. In photographs that have an unwanted color cast, the existing neutrals in the image can be the key to removing it. Sometimes further work may be necessary, but it's surprising just how much better an image can look if key tonal areas such as the highlights and shadows are neutralized. In this section we'll explore working with camera raw images and a classic approach using the Eyedropper tools in the Levels and Curves dialog box to neutralize highlight, shadow, and, if applicable, midtone values.

The White Balance tool:
Working the neutrals in raw files

When starting with a raw digital capture, ideally most, if not all, of your global color corrections should be done in Adobe Camera Raw, Photoshop Lightroom, or the raw converter of your choice. As we saw in the previous example with the ColorChecker image, the simplest way to apply global color correction in Camera Raw and Lightroom is to

use the White Balance tool. For images that do not contain an included neutral reference target click an area in the image that you feel or know should be neutral (Figure 7-20, Figure 7-21). This will neutralize the tone you click, remap the color balance for the entire image, and remove any color cast that may have been present. If, however, establishing a neutral target tone yields a color balance that does not quite fit the image (or your intentions for the image) you can then adjust the Temperature and Tint sliders to fine-tune the color balance to better mirror your photographic intentions.

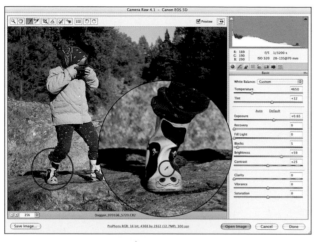

Figure 7-20. Using the White Balance tool on existing neutrals in Adobe Camera Raw. © SD

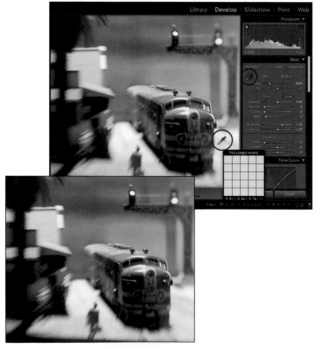

Figure 7-21. Using the White Balance Selector in Photoshop Lightroom on existing neutrals. © SD

Global color correction with Levels

One of the most basic procedures of color correction revolves around the idea of neutralizing the highlights, shadows and, where appropriate, the midtones in an image. Of course, not all photographs have a highlight, shadow, or midtone value that should be neutral, and in some cases a color cast might be an integral part of a particular image. However, a surprising number of images do have areas that are good candidates for this procedure.

By neutralizing a bright highlight and a dark shadow, a color cast can often be quickly removed from a photograph. This is easily done in Levels or Curves by identifying the brightest and darkest points in the image that qualify as a highlight or shadow that should be neutral, and then using the Eyedropper tools in those dialog boxes to remap the tonal values of these points to known neutral numbers.

In the following step-by-step section, we'll separate this procedure into three different tasks: Identify the brightest and darkest points in the image and mark them with color sampler points; set the proper target values for the eyedroppers; and use the eyedroppers to neutralize the chosen highlight and shadow points. We'll use a photograph scanned from a slide taken in 1990 of Mt. Silliman in California's Sierra Nevada range (Figure 7-22). This is a straight scan from the original slide, meaning no color adjustments were made in the scanning software.

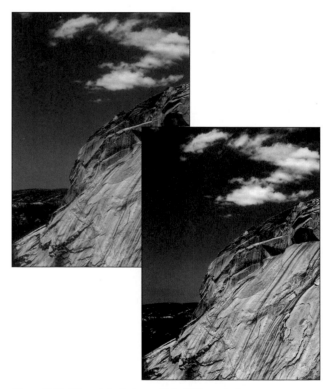

Figure 7-22. The original photo of Mt. Silliman is from an Ektachrome slide taken in 1990. © SD

☝ ch07_Levels-Eyedroppers.jpg

Preparing the workspace

1. Tap F twice to place the image into Full Screen with Menu Bar view mode (View→Screen Mode→Full Screen with Menu Bar). Press the spacebar and drag the image over to the left side of the screen to free up space on the right for the Levels dialog box. The first step before doing any color correction is always to evaluate the image to see if you can identify what the problem might be. The Mt. Silliman photo is a bit dark and slightly blue. The blue cast could have been caused by the high elevation of the location (a little over 11,000 feet), or it could be due to the aging of the color dyes in the original slide. Fortunately, there are obvious areas in this image that can serve as neutral guides.

2. Next, arrange your workspace so that you have a clear view of the Info and Histogram palettes (Figure 7-23). These two palettes are normally grouped together, so you may need to separate them. The Info palette is used for monitoring the highlight and shadow values, and the Histogram palette is always useful to see when applying tonal corrections to an image. In Photoshop CS3 you can open and close the palette icons and move the palettes around even if a modal dialog box such as Levels is open.

Figure 7-23. The Photoshop workspace set up so that the Info and Histogram palettes are clearly visible during the color-correction process.

3. Add a Levels adjustment layer (Layer→New Adjustment Layer→Levels). Before you proceed any further, double-check that the sample area for the eyedropper is set to an appropriate size for working with photographs. Move your cursor over the image and right-click to open the eyedropper contextual menu. Choose 3 by 3 Average, which is a good size to use for photographic work (Figure 7-24).

Figure 7-24. An eyedropper sample size of 3 by 3 Average is good for photographic work. This can also be set in the Options Bar for the Eyedropper Tool.

Setting eyedropper target values. Before using the Levels or Curves eyedroppers, you need to set the target values to something more appropriate for photographic work. The default values of 255 (total white) for each color channel for the white point eyedropper and zero (total black) for all three channels for the black point eyedropper, may be appropriate for images that are only presented on-screen, but they are not good numbers for neutralizing a highlight and shadow point where you need to retain image detail in those areas.

4. Double-click the highlight eyedropper in the bottom of the Levels dialog box. In the Color Picker, set the R, G, and B values to 248, 248, 248, and then click OK. This sets a bright white as the target color for that eyedropper—a white that can hold highlight detail (Figure 7-25).

5. Double-click the shadow eyedropper. In the Color Picker, set the R, G, and B values to 10, 10, 10, and then click OK. This sets the target color for the shadow eyedropper to a very dark tone, but not a pure black (Figure 7-26).

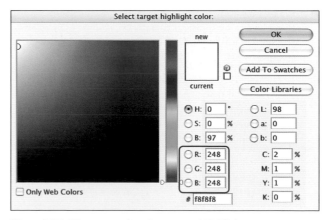

Figure 7-25. The target values for a neutral highlight tone.

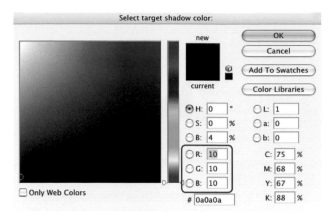

Figure 7-26. The target values for a neutral shadow tone.

Near the end of this exercise a message dialog box will appear after you click OK in Levels asking if you want to save the new target color as defaults. Go ahead and click OK to this since these values are good ones to use for photographic work. It's still a good idea to double-check the eyedropper target values before using them, especially if you work in an environment where multiple people use the same computer.

Identifying the brightest and darkest points

6. To identify the brightest point, hold down the Option/Alt key, and click the Input Levels highlight slider to activate the clipping display. The image will turn black. Keep the Option/Alt key down and slowly move the slider to the left until parts of the image begin to appear in bright colors. This indicates the brightest area in either a single channel or in two channels. The point where the image turns white first reveals the tone in the image that is the brightest in all three color channels. In this photo, it's no surprise that the white clouds are the brightest point in the image (Figure 7-27).

7. Release the Option/Alt key and press Cmd/Ctrl+ (plus) several times to zoom in for a close view of the area in question (press the spacebar and reposition the image if necessary). Press Option/Alt and the highlight slider again to reveal the brightest point.

8. Shift-click the brightest point for the highlights to place a color sampler point there. This will appear in the Info palette as #1.

When you release the Option/Alt key, the clipping display goes away. To help pinpoint the tonal area so you can place a color sampler, move the Levels dialog box, and use a corner of it as a "pointer" to show you where the brightest tonal point is (Figure 7-28). Once you have a corner of the dialog box pointing to the tonal area you want to mark, it's much easier to locate it again.

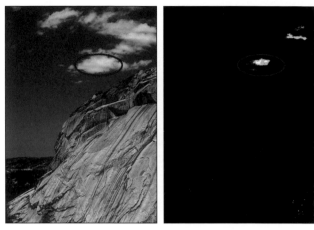

Figure 7-27. The highlight clipping display in Levels showing the brightest point in the Mt. Silliman image.

9. If you need to reposition a sampler point after you have placed it, move the cursor directly over it, and, when the arrow appears, Shift-click it to drag it to a different position. To remove a sampler point while you are still in the Levels dialog box, Shift-Option/Alt-click it.

10. Return the highlight slider back to the far right side of the Levels histogram. Now zoom out (Cmd/Ctrl-minus) and repeat the procedure described in steps 6 and 7 to identify the darkest tone in the image. The only difference is that you will be accessing the shadow clipping display by Option/Alt-clicking the Input Levels shadow slider. Once you have found the darkest tonal value in all three channels (in this image, it is in the trees in the lower-left side of the photo), Shift-click it to place a second color sampler point (Figure 7-29).

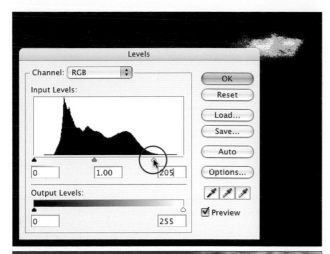

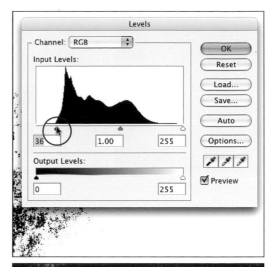

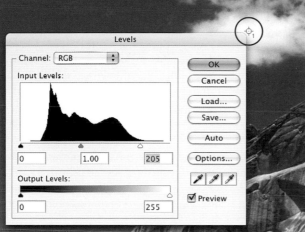

Figure 7-28. Top: Using a corner of the Levels dialog box to "point" to the brightest spot. Bottom: a color sampler point is placed to track the values of that precise area in the Info palette.

11. Important: After placing the color sampler points, remember to return the Levels sliders back to their starting positions. These adjustments were made only to reveal the brightest and darkest points and are not something that you will apply to the image.

Neutralizing the highlight and shadow points

12. Now zoom back in to 100% (View→Actual Pixels) to see the highlight point that you marked with color sampler point #1. Press the Caps Lock key to set the cursor to precise mode (a crosshair).

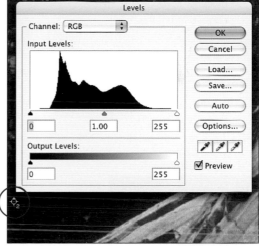

Figure 7-29. Top: Finding the darkest point in the shadows of the forest in the lower-left side of the image. Bottom: Placing a color sampler point at that location.

13. Click the highlight Eyedropper tool to make it active. Move the precise crosshair cursor over the existing sample point #1. When they line up perfectly, click once to remap the tonal values of that point to the new target values of 248, 248, 248. If you accidentally click in the wrong place, simply realign the cursor with the sample point and click again. When you have successfully set the highlight point, click the highlight eyedropper again to turn it off.

14. If you check the sample points in the Info palette, you should see two sets of numbers separated by a slash. The numbers on the left are the original values and those on the right are the adjusted values (Figure 7-30).

Figure 7-30. After clicking highlight color sampler with the white point eyedropper. The before and after values for the clouds highlight point are visible in the Info palette.

Figure 7-32. The Layers palette showing the overall Levels adjustment and a Curves layer that slightly lightens the top of the mountain.

15. Now zoom in on the area where you placed color sampler point #2 for the darkest point in the image. Once again, make sure that the zoom view is 100% (View→Actual Pixels).

16. Click the shadow eyedropper to make it active, align the cursor over the sample point as in step 13, and, once they are aligned, click once to remap the shadow point's tonal values to the new target values of 10, 10, 10. Once this is accomplished, click on the shadow eyedropper to turn it off.

17. Check the Info palette to see the adjusted shadow values for sample point #2 (Figure 7-31).

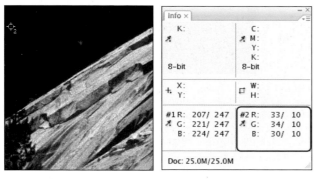

Figure 7-31. After clicking on the distant forest with the black point eyedropper. The before and after values for the forest shadow point can be seen in the Info palette.

The shadow areas at the top of the mountain became a bit too dark from setting the shadow point, so we added a curves adjustment layer with a layer mask to lighten only that part of the photo (Figure 7-32). This adjustment to the top of the mountain was merely some additional finessing. Most of the significant improvement in the Mt. Silliman image was created by the simple step of neutralizing the highlights and the shadows.

Remapping the highlight and shadow points to known neutral target values with the eyedroppers does two things. First, it sets the brightness value of the highlight and shadow point, which can often help improve the brightness and contrast of the image. Second, if a color cast is affecting the highlights or the shadows, it can be removed using this procedure. In the case of the Mt. Silliman photo, brightness, contrast, and overall color balance were greatly improved by this process. If a color cast is still noticeable after using the eyedroppers, then it's likely that it's lurking in the midtones and will have to be addressed with an additional correction.

Using this method to neutralize the highlight and shadow points in a photograph can also be achieved using the Curves dialog box. In fact, with the changes to Curves that were introduced in Photoshop CS3, portions of this procedure are easier in Curves than in Levels.

Good and Bad Color Casts

Before you venture too far into the neutral zone, one thing to keep in mind is that not all color casts are bad. Indeed, for some photos, a specific color bias might be a key element in the image (for example, the yellow glow of firelight, performance shots illuminated by colored stage lighting, a sunset photo infused with the orange pink glow of day's end). There are also times when an image just doesn't look right after you have neutralized the key tonal areas, and you may need to adjust it so that the color balance falls somewhere between a strict neutral and the original cast that you tried to remove. Neutralizing key values such as the highlights, shadows, and, in some cases, specific midtone values, is a very useful technique for removing color casts, but it is not always right for every image.

Setting neutral highlights and shadows with Curves

The Curves dialog box in Photoshop has long had the same Eyedropper tools as the Levels dialog box, but until CS3, using them to set neutral highlights and shadows has not been as efficient because the dialog box had no clipping display. In CS3, the Curves dialog box received a significant upgrade, and one item of new functionality is the ability to turn on the same clipping display as in the Levels dialog box. The Curves clipping display even offers some key functionality that Levels does not: The clipping display remains visible without having to hold down any keys or click any sliders or control points. This makes it much more efficient to evaluate the clipping and place the color sampler points than in Levels. Here's an overview of how to use the eyedropper neutralizing technique in Curves (Figure 7-33).

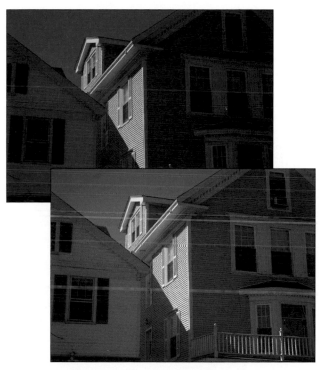

Figure 7-33. Before and after: A blue color cast corrected using the eyedroppers in Curves.

⌐ ch07_CurvesEyedroppers.jpg

1. Add a Curves adjustment layer. Click the Show Clipping checkbox. To show the highlight clipping, move the highlight control point (upper-right corner) horizontally along the top of the grid to the left. Keep moving the point to the left until you begin to see clipped areas (Figure 7-34). Using this method, the clipping display remains visible even if you are not actively moving the control point. (You can also Option/Alt-click the highlight or shadow sliders under

the curve as in Levels to show highlight and shadow clipping).

2. Shift-click on the brightest area (the place that turns white first) to place a color sampler point there. After the sampler point is placed, return the highlight control point to the upper right corner.

3. To show the shadow clipping, click the shadow point (lower-left corner) and move it horizontally along the bottom of the grid to the right. Keep moving the point to the right until you begin to see clipped areas. The place that turns black first is the darkest point in the image in all three channels. Shift-click to place a color sampler point on the darkest area (Figure 7-35).

4. Select the white point eyedropper and click on the highlight color sampler point to neutralize the highlights. Select the black point eyedropper and do the same for the shadows color sampler point to neutralize the shadows (Figure 7-36).

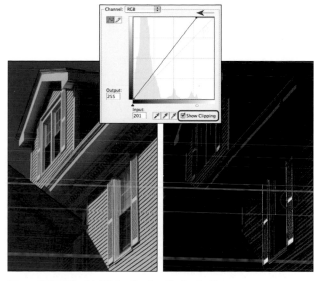

Figure 7-34. The highlight clipping display in Curves.

With the addition of a clipping display option to the Curves dialog box in Photoshop CS3, combined with the fact that it remains displayed even without having to resort to keyboard shortcut acrobatics, we feel there is less reason to perform endpoint neutralizing in Levels. After setting the highlight and shadow points, we typically move on to Curves for additional adjustments to the midtones, so it makes sense to take care of the entire process in Curves from the beginning.

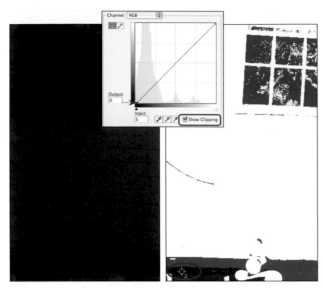

Figure 7-35. The shadow clipping display in Curves

Figure 7-36. The corrected shadow and highlight areas after they have been neutralized with the eyedropper tools in Curves.

Levels: Correcting midtone color casts

If you neutralize the highlights and shadows and there still seems to be a color cast in your image, then you need to address it by adjusting the midtone slider for the different color channels in Levels. This can also be done in Curves and we'll cover that shortly. There are a few ways to approach this adjustment, and the method you choose will depend on the image you're working with. The first two methods work well for an image where there is an obvious midtone area that should be neutral; the first technique using the midtone gray Eyedropper tool, and the second providing precise control via manual adjustments.

Using the gray point eyedropper. When using the gray point eyedroppers in either Levels or Curves to neutralize an image it is best used on areas that should be a middle value neutral, colorless tone. Once you identify an area in the image that you think might work for this purpose, be sure to zoom in close and double-check that there are no other color traces present that could confuse the gray point eyedropper and skew the results in unexpected ways. In the image seen in Figure 7-37, the power turbines are really gray and using the gray point eyedropper quickly alleviates the undesired color cast.

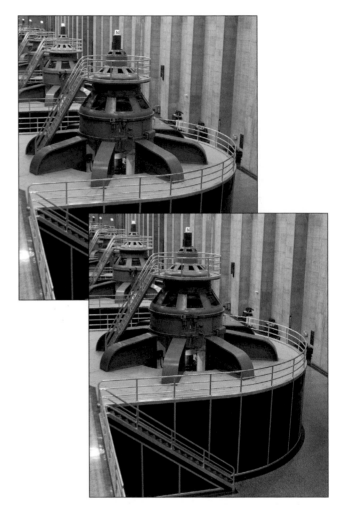

Figure 7-37. Before and After: In images with well-defined neutral areas, such as this view of the power plant at Hoover Dam, the gray point eyedropper works quite well. © SD

🖰 ch07_GrayEyedropper.jpg

1. Add a Levels or Curves adjustment layer, or double-click an existing Levels layer that you are using to apply global color correction. Identify an area in the image that represents a middle tone that should be neutral for example, concrete, metal, gray clouds, or in this example the grey metal turbines.

2. To track the changes that this correction will apply, shift-click on the area to place a color sampler point there. This step is not strictly necessary for this technique, but if you want to see numeric confirmation of the changes, it can be helpful.

3. In the Levels dialog box, double-click the gray point eyedropper. In the Color Picker you can see that the default target values for the eyedropper are 128, 128, 128—a middle gray (Zone V). Leave the values set to this default, and then click OK to close the Color Picker.

4. Click on the area you've identified as one that should be neutral. If you have placed a color sampler point, make sure the Caps Lock key is activated to display the precise crosshair cursor. Zoom in for a close view and align the cursor with the color sampler point, and then click once to apply the target values of the gray point eyedropper as seen in Figure 7-38.

5. If the area you clicked on was originally truly neutral, the color cast will be removed from the midtones. Check the values for the sampler point in the Info palette. The values should be neutral (or very close to neutral), but they will not be 128, 128, 128. This tool tries to balance the color so that the targeted tone is neutral but it does not affect the overall brightness level of the tone. (Figure 7-39).

6. If the color seems worse after clicking with the gray point eyedropper, this indicates that the tone you clicked really wasn't a true neutral, and a corrective adjustment has been made that introduces a different color cast. If this happens, try to find a different area and use the gray point eyedropper again.

Figure 7-39. After clicking with the gray eyedropper the targeted midtones have been neutralized.

If you intend to target a metallic area that might have some reflections on it the gray point eyedropper may cause unexpected results as the reflected tones could have colors in them that are not representative of a true neutral tone.

Manually neutralizing a midtone color cast. You can also correct a midtone color by placing a color sampler point onto an area that should be neutral and manually adjusting the midtone sliders for the individual color channels. The Info palette shows which channels need to be adjusted. Here's how it works to create the results seen in Figure 7-40.

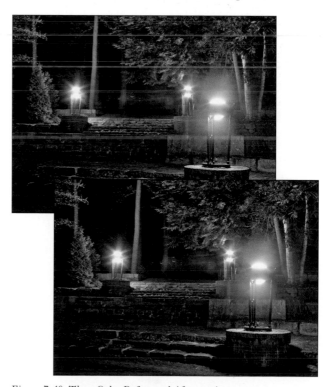

Figure 7-40. Three Orbs: Before and After versions. © SD

Figure 7-38. The midtone gray point eyedropper in the Levels and Curves dialog box will neutralize the tone you click but not affect the brightness.

ch07_Manual_MidtoneFix.jpg

1. Identify the area in the image that you feel should be neutral (or that you want to make neutral). If you are placing the point prior to entering Levels or Curves, make the eyedropper the active tool, and then Shift-click. If you are already in the Levels or Curves dialog box, shift-click to place a color sampler point on a neutral area. In the night image of the three glowing orbs, we chose one of the large stones near the center steps.

2. Take a look at the values in the Info palette. Remember that in an RGB file a neutral value is equal amounts of red, green, and blue. By seeing which color values are higher or lower, you can get a clue as to where you need to go to make the most of your adjustment. For example, if the blue value is lagging behind both the red and the green values, as is the case with this image, it means there is a yellow color cast in the midtones (red and green combine to create yellow, and yellow is the opposite of blue).

3. Add a Levels adjustment layer and open the Channel menu at the top of the dialog box, and choose the blue channel to begin your adjustments. You should start your adjustments on the channel that has the most deviation from the other two. For this example, we need to remove a yellow color cast, so the blue channel is the place to begin.

4. In the blue channel, move the middle slider to the left to add more blue to the midtones. Keep an eye on the adjusted values in the Info palette (the values on the right side of the slash). The aim is to adjust one or more of the channels until you arrive at a neutral tone (signified by equal amounts of red, green, and blue) in the Info palette. For the photo of the three orbs, we increased the blue midtone value and decreased the red midtone value until the values for the color sampler point were equal (Figure 7-41).

For fine adjustments, if you highlight the numeric value in the midtone box, you can use the up or down arrow keys to move the numbers in one point increments. To adjust them by ten points at a time, use the Shift key with the arrow keys.

Figure 7-41. To neutralize the stone wall and remove the color cast from the image, red was subtracted and blue was added by adjusting the midtone slider for those channels in a Levels adjustment layer.

To identify the mathematical neutral value, place the Eyedropper over the midtone area you want to target to display the RGB values in the Info palette. Add the three RGB midpoint values and divide by three to determine the average. This value can serve as the target point when adjusting midtones color manually.

While these techniques are good for ensuring that a midtone value is numerically neutral, keep in mind that numbers alone should not rule over your image. What counts is how it looks to you and whether you feel that the tonal and color balance is right for the image. We frequently use these steps to neutralize values in a photograph only to manually move them away from neutral to enhance the emotional and subjective value of an image. Not all color casts are inherently "bad," and life, perception, and memory are rarely neutral. Know how to identify these characteristics in your images and be familiar with the techniques for neutralizing the highlights, shadows, and midtones, but don't let by-the-numbers neutrality dictate what your images should look like.

Correcting a color cast with no neutral guide. While the presence of a neutral tone, or a tone that should be neutral, can be a very useful guide in determining the cause of a color cast and correcting it, not all images have tonal values that should be neutral. If you find yourself working on such an image and a color cast is present, you will have to manually adjust the Levels midtone sliders for each of the three color channels until you shift the color balance more to your liking.

Although there may be no neutral guide, you can make some preliminary determinations about the color cast that will help you decide which color adjustments are likely to be the most effective. First, try to qualify the color cast as warm or cool. Warm color casts are typically dominated by yellow, red, or magenta. Cooler casts are created by the presence of blue, cyan, or green. A color cast can be created by primarily one color, or it may be the result of two colors. For example, blue and green combine to make cyan. Some casts also can be a combination of warm and cool, such as a yellow-green cast, or a blue-magenta cast.

Once you have narrowed down what colors might be causing the color cast, knowing the basic structure of the color wheel, complementary (opposite) colors and component colors, is very useful for determining which color channels to adjust (Figures 7-42, 7-43, and 7-44). For example, if you determine that an image is suffering from a cyan color cast, the red channel would be the most likely place to try to fix it since red is the opposite of cyan. The presence of a cyan cast indicates that green and blue (the building blocks of cyan) are too dominant, and a little red is needed to lessen their influence. Of course, you could also reduce green and blue, which would cause an increase of magenta and yellow, respectively. And, if you're familiar with the structure of the color wheel, you know that magenta and yellow combine to make red, so it ends up being the same thing!

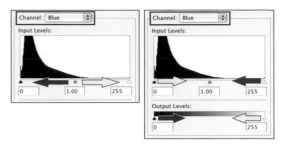

Figure 7-44. The midtone slider for the Blue input levels adds blue or yellow to the midtones. The input and output shadow and highlight sliders for the blue channel allow you to add blue or yellow to the shadows or highlights.

In the example photograph of a stained glass window on a luxury railroad car seen in Figure 7-45, the warm, yellow color cast is caused by interior display lighting and is typical for that type of illumination. No areas of the photo should be neutral, so any color correction is based on knowledge of the color relationships (that is, knowing what colors cause a cast and how to counteract them), as well as how you want the image to look.

Figure 7-42. The midtone slider for the Red input levels adds red or its opposite color, cyan, to the midtones. The input and output shadow and highlight sliders for the red channel allow you to add red or cyan to the shadows or highlights.

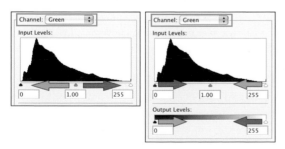

Figure 7-43. The midtone slider for the Green input levels adds green or magenta to the midtones. The input and output shadow and highlight sliders for the green channel allow you to add green or magenta to the shadows or highlights.

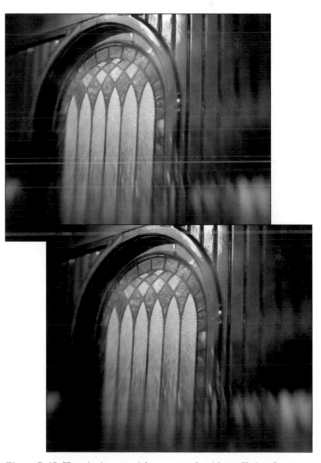

Figure 7-45. Top: An image with no neutral guides suffering from a strong reddish yellow color cast. Bottom: the corrected version. © SD

🖰 ch07_NoNeutralGuide.jpg

1. The first step in any color correction is to evaluate the image and determine what the problem is. For this image there is an obvious warm, yellow cast. Since yellow is the main problem color, you should first try working with the color that represents the opposite of yellow, which is blue.

2. Add a Levels adjustment layer and select the Blue channel from the menu at the top of the dialog box. Add a generous dose of blue to the midtones by moving the midtone slider to the left (Figure 7-46).

3. Since red is also a component of the color cast, select the red channel and subtract a bit of red from both the midtones and the shadows by moving those sliders to the right to add cyan (Figure 7-47). Since there is no neutral area to guide you, adjustments such as these are based on how you want the image to look.

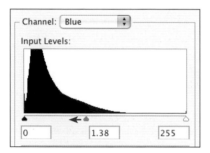

Figure 7-46. The Levels adjustments for the blue channel of the vintage train-car photo.

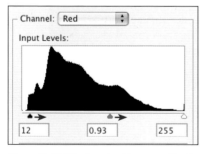

Figure 7-47. The Levels adjustments for the red channel of the vintage train car image.

The same modification to the individual color channels could be applied with Curves, of course, and with a great deal more control over which areas of the tonal range are affected. In the following section, we'll take a closer look at using Curves for color correction.

The Power of Curves

The Curves feature is one of the most powerful color control features in Photoshop because it enables you to target and adjust specific brightness and color values. This, combined with the ability to precisely direct the effect through a layer mask, makes Curves a very effective color correction tool. As has been noted throughout the book, anything that can be done with Levels can also be done with Curves, but Curves offers greater control and precision.

Under the Hood: Manual Color Correction with Curves

To apply manual color correction, you need to work on the individual channels that are accessed in the channel menu at the top of the Curves dialog box. The color relationships that can be affected in these individual channel curves are the same as the opposites on the color wheel and the same as the color relationships found in the individual channel controls in Levels. In an RGB image, adjustments to the red curve will affect red and its opposite, cyan; modifications to the green curve will affect green and its opposite, magenta; and changes to the blue curve will affect blue and its opposite, yellow (Figure 7-48 and Figure 7-49). Developing a solid understanding of these fundamental color relationships is a key ingredient for performing good color correction work in Photoshop.

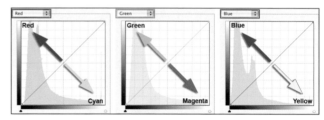

Figure 7-48. The color relationships controlled by the red, green, and blue curves.

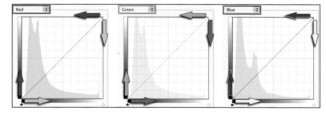

Figure 7-49. By moving the endpoints in the Curves color channels, you can add red, green, blue, cyan, magenta, or yellow to the highlights or shadows of an image.

Curves example 1: Cleaning the pond

As in a lot of digital darkroom work, the first step is to identify the problem and then decide how to address it. Identifying a colorcast is a skill you can develop and refine by looking at a lot of images. The advantage of looking at images in Photoshop is that you can use the Info palette to identify colorcasts that aren't obvious. At first glance the water in Figure 7-50 has an overall murky, greenish cast that in our opinion is not very pleasing at all. There is really no obvious

neutral that we can use as a guide here; the reflection of the overcast sky on the water is as close to a neutral as we're likely to find, but it will do nothing to help the color of the water. And although the depths of the water are probably not neutral, we can still use them to help us zero in on what might be causing the color cast.

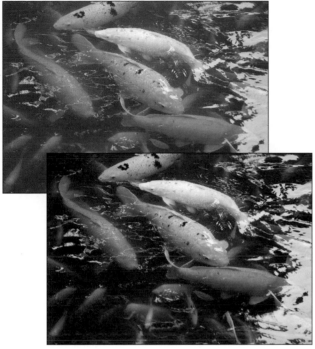

Figure 7-50. In the original image of the koi, the water has a murky, greenish-yellow color cast. The corrected version looks much better. ©
SD

ch07_CurvesExample1.jpg

1. Look at the Info palette (Window→Info) and move the cursor over a dark area of the water. The numbers reveal that red and green are nearly the same in value, and blue is lagging behind (Figure 7-51). This tells us that red and green are stronger and more dominant in the image. The result of combining red and green is yellow, and as an interesting coincidence, yellow happens to be the opposite of blue. So green is not really the offending color here, though it does play a supporting role. Yellow is the primary color cast affecting the water, which makes the water look less blue and less inviting and subjectively stated – murky and muddy.

Figure 7-51. By sampling an area that should be neutral, or reasonably close to neutral, the Info palette can help reveal the cause of the color cast. In this case, the lack of blue is creating a yellow color cast.

2. Add a Curves adjustment layer to the image. Find an area of dark water to use as a reference point. In this example we used the dark area in the center of the image just to the left of the swishing tail (see Figure 7-51). Shift-click to add a color sampler point there. Note, if the Info palette is not already open, as soon as you add a sampler point Photoshop will open it for you.

3. In the Channel pull down menu at the top of the Curves dialog box, choose Blue. Cmd/Ctrl-click the reference color sampler point in the image to pinpoint the exact location on the curve. With an eye on the values for the sampled point in the Info palette, raise the curve to bring the numeric blue value in line with the red and green values. The goal is not to try to make all values perfectly identical, but to increase the blue to counter the dominant yellow created by the higher values of red and green. For example, in the version of the image that we worked on and the point we sampled, the red, green, and blue values were 50, 47, and 25, respectively. By increasing the blue until its value was at 42, the yellow-green color was removed from the water quite nicely (Figure 7-52).

Figure 7-52. To reduce the strength of the yellow cast, the blue curve is raised until the blue value in the Info palette becomes closer to the red and green numbers.

4. While this adjustment works well for the water, it tends to make the more neutral reflection of the overcast sky look a bit too blue (Figure 7-53). Fixing that is fairly straightforward since Curves provides so

much control over where along the tonal range a color adjustment is applied. Click in the image on one of those lighter reflective areas to determine where on the curve that tone is located.

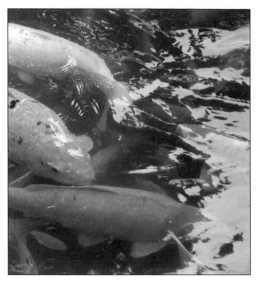

Figure 7-53. The initial adjustment to the blue curve causes the highlights in the water reflection to become too blue.

5. Place a point on the blue curve at that location and drag down towards the original baseline of the curve to prevent that tonal region from being affected by the blue increase in the darker areas of the water. For finer control tap the down arrow key to lower the highlights in the blue channel in one level increments (Figure 7-54).

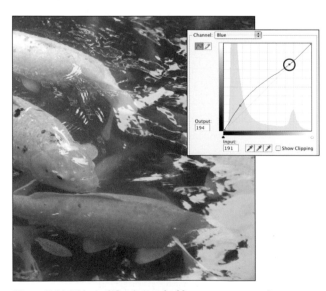

Figure 7-54. This modification to the blue curve prevents the highlights from becoming too blue.

6. To further suggest the cool temperature of the water, we also chose to access the red channel curve and subtract a small amount of red from the darker areas in the image (from input level 45 to output level 42— see Figure 7-55). This works well to create a color that is plausible for a koi pond. The main thing here is not to be obvious. You are not really adding cyan so much as removing a bit of red.

7. To strengthen the image and give it a solid visual foundation, we decided to increase the contrast by darkening the shadows and carefully lightening the highlights. Return to the composite RGB channel and increase the contrast by darkening the shadow areas and slightly raising the upper-middle part of the curve (Figure 7-56).

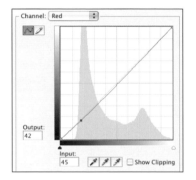

Figure 7-55. The adjustment made to the shadow areas of the red curve.

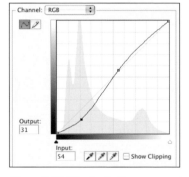

Figure 7-56. The final adjustment made to the overall RGB curve to darken the water and increase contrast.

Curves example 2: Backyard witch

The environment that a subject is in often influences the light illuminating a subject. For example, a brightly colored wall can kick in color reflections onto a person or as seen in Figure 7-57 in the photograph of a girl playing dress-up as a witch, there is an unpleasant cyan/green color cast from the surrounding environment. This is caused by the fact that there is so much bright green vegetation in the shot, it is completely in the shade, and the late afternoon light is being heavily filtered by the canopy of green leaves in the trees above the

scene. To make matters more challenging, there are no areas that might serve as a neutral guide in this photo. The house in the background is a muted green color, and the trim is not a neutral hue. The black of the dress actually has some blue in it, and using this area as a neutral guide would add too much yellow to the image. With no reliable neutrals to guide us, we have to proceed based on our initial visual evaluation. If you know the basic color relationships, however, then the recipe for fixing this color cast is clear. If too much cyan and green are present, then we must subtract those colors by adding in their opposites, which are red and magenta.

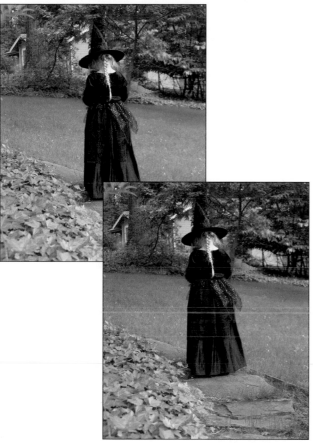

Figure 7-57. A predominantly green location, coupled with shade and late afternoon light filtered by a canopy of green leaves has created a cyan-green color cast in this image. In the corrected version, subtle adjustments to the red and green curves have removed the color cast. © SD

📷 ch07_CurvesExample2.jpg

1. Add a Curves adjustment layer, and in the dialog box, open the Channel menu and choose Red. Since this is an overall color cast and not specific to a particular tonal region, place a point right in the middle of the curve grid (level 128). Only a very slight adjustment is needed here, so use the up arrow key on the keyboard. Each tap of the arrow key will raise the control point by a single increment.

2. A good way to apply extremely subtle adjustments such as this one is to overdo it and then slowly back away from that point. Move the position of the point upward until you can see that red is obviously being added. Now use the down arrow key to back it off slightly until it looks good. Our input value was 128, and the output value was 133 (Figure 7-58). The goal is to remove the obvious cyan cast without adding an obvious red cast.

3. Since there is so much green in this image, it makes sense to see how subtracting green will affect the image. Choose Green from the channel drop-down menu. As before, click in the center of the grid to place a control point there (level 128). Press the Shift key and tap the down arrow once. The use of the Shift key moves the point in 10-level increments. If you can't see much difference, then Shift-tap the down arrow once more to move it down 20 levels (128 to 108). This is obviously too much, so now you can begin to reduce the magenta in 1-level increments until it is not apparent any more. From a starting input value of 128, our final green adjustment was an output value of 120 (Figure 7-58).

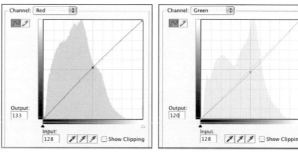

Figure 7-58. The red and green curves adjustments for the Backyard Witch.

Auto Color Correction Options

In your travels through the Photoshop interface, in the Image→Adjustments menu you may have seen Auto Levels, Auto Contrast, and Auto Color. While the promise of Photoshop's magic elves applying color and tone correction for you may sound enticing, we generally do not favor relying on the auto corrections simply because, depending on the color and tonal structure of the images you use them on, the final results are very hard to predict. Admittedly, for some images, the auto corrections can provide a jumpstart to get you headed in the right direction. But rather than access these commands from the Image→Adjustments menu where you have no control over them, you can access them in both the Levels and Curves dialog box, which allows you to apply them as an adjustment layer and fine-tune the results with the regular Levels or Curves controls (Figure 7-59).

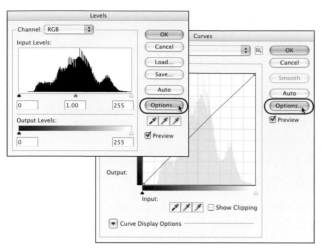

Figure 7-59. The best way to access the Auto Color Corrections is by pressing the Options button in Levels or Curves.

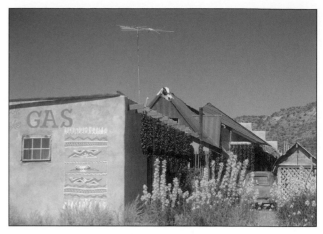

Figure 7-60. This scan from an older slide is low contrast and has an obvious yellow color cast. © SD

Auto corrections deconstructed

To understand when the auto correction options might be worthwhile, it helps to understand what's going on under the hood. To try these out, add a Levels or Curves adjustment layer to an image (the auto options are identical). Click the Options button to bring up the Auto Color Correction Options dialog box. The best thing about applying the auto options via an adjustment layer is that you can test-drive each one to see if it does any good, and when you click OK, you are still in the Levels or Curves dialog box where additional fine-tuning can be applied.

Algorithms. The three auto correction algorithms are exactly the same as the three auto options in the Image→ Adjustments menu. Enhance Monochromatic Contrast is equivalent to Auto Contrast; Enhance Per Channel Contrast is the same as Auto Levels; and Find Light and Dark Colors is the same as Auto Color. Plus there is also an additional option called Snap Neutral Midtones. To demonstrate how each of these affects an image, we've chosen a scan from a slide taken in New Mexico that has a definite color cast as well as flat contrast (Figure 7-60).

Enhance Monochromatic Contrast (Auto Contrast)

This algorithm will increase contrast in the photo by applying the same endpoint adjustment for each color channel (Figure 7-61). While this choice can sometimes work for a quick contrast adjustment, it does not address any color cast issues, which makes it the least useful of the three options.

Enhance Per Channel Contrast (Auto Levels)

This algorithm will apply different adjustments to each color channel with the goal of increasing contrast and fixing color casts (Figure 7-62). This is somewhat more useful, but the results are very image-dependent; sometimes it works well, but just as often it is likely to make the image look worse.

Find Dark and Light Colors (Auto Color)

This is the most promising of the three algorithms. It finds the darkest and brightest tones in the image and adjusts them to be a neutral highlight and shadow using the target values for the Levels or Curves eyedroppers as a guide (Figure 7-63). When the Snap Neutral Midtones is checked, it locates any midtone value that is close to neutral and adjusts it so it becomes neutral.

For images with a noticeable color cast, Enhance Per Channel Contrast and Find Dark and Light Colors work the best, and the result is often (but not always) improved if you turn on Snap Neutral Midtones.

Figure 7-61. *Enhance Monochromatic Contrast: The contrast is certainly improved, but the color cast remains.*

Figure 7-62. *Enhance Per Channel Contrast: The auto correction works very well on this image, though it is perhaps just a bit too blue.*

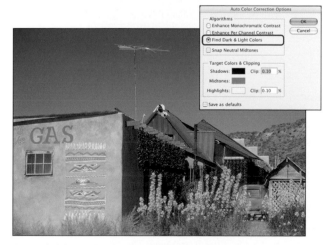

Figure 7-63. *Find Dark and Light Colors: This auto correction is also not bad, though it is more obviously too blue. (Note how cool blue the adobe wall is.)*

Target colors and clipping. The default shadow and highlight clipping values are 0.10%. This means that the auto corrections will introduce this amount of clipping (forcing tones to either total black or white) into those endpoint regions. In general, the clipping defaults are a good starting point, and they can help to improve the contrast of images, but if after using this feature you measure the bright highlights in your image and feel they are too bright, you should reduce the clipping setting.

To influence the overall color balance, click the Midtones color swatch and adjust the values for R, G, or B in the Color Picker to change the color balance to something different (it's best to make these adjustments in small increments). For example, if you wanted an overall warmer feel to images, you could use a midtone value that contained more red and yellow.

Auto corrections: The bottom line

Until you develop some understanding of what images are good candidates for this feature and how the auto corrections are evaluating and then adjusting a photo, the success rate may seem very arbitrary. Every image is different, with its own individual tonal and color matrix and, as the saying goes, your mileage may vary. If you are already comfortable with making adjustments in Levels or Curves, then you'll probably feel the auto corrections are too unpredictable. If you're new to color correction, however, then these might get you started if you're not sure how to proceed with a tricky image. The most important thing is that you should not rely on just these settings to make everything perfect. If you do use the auto corrections, they should be viewed as a starting point. Additional fine-tuning should always be applied with the Levels or Curves controls.

Color Enhancements

Once you have *corrected* the color in an image, the next step is to *enhance* the colors. This can be done to either the overall color palette of the image, such as by increasing or decreasing color saturation, or by changing the character or component values of a specific range of colors. There are many ways to enhance color in Photoshop, as well as some interesting features in Adobe Camera Raw and Photoshop Lightroom. Some are fairly general while others offer more specific and detailed controls. In this section we'll explore some of the most useful color enhancement tools to make your images look their very best.

Enhancing Color with Hue/ Saturation

The Hue/Saturation command enables you to change the "flavor" of colors (the hue) by adding or subtracting their component colors, as well as increasing or decreasing the intensity (saturation) and luminosity (lightness) of colors. All colors in the image can be affected when using the default

Master controls or you can access specific color groups by opening the Edit menu at the top of the dialog box. As with all such color and tonal modifications, the best way to apply Hue/Saturation is by using an adjustment layer.

Hue/Saturation controls

In Master mode, moving the Hue slider will cause all the color values in the image to shift dramatically (Figure 7-64). If you look at the color spectrum bars at the bottom of the dialog box in Figure 7-65, you'll see how the colors in the lower bar are changing in relation to those in the upper bar (think of these spectrum bars as a horizontal representation of the color wheel). The upper spectrum bar represents the original colors, and the lower one shows how they are changing.

Figure 7-65. The highlighted areas on the spectrum bars show how the colors of blue and orange in the Holiday Motel image have shifted to green and magenta.

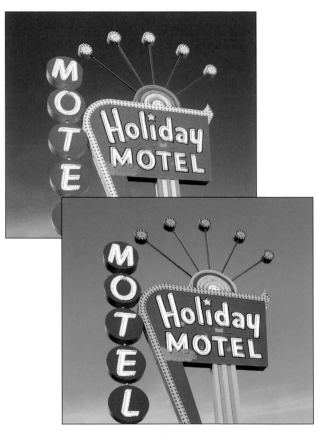

Figure 7-64. The radical change to the Holiday Motel photo was achieved by adjusting the Hue value to -100 in the Hue/Saturation dialog box. © SD

The Saturation slider increases or decreases the saturation (intensity) of the colors (Figure 7-66). It's easy to go over the top with this by adding too much saturation. Negative saturation values result in a more muted color palette, and moving the slider all the way to the left (-100) will remove all color values from the photo and create a grayscale effect.

Figure 7-66. Modifications to saturation: The center image is the original. The one on the top has been desaturated by -25. In the version on the bottom, the color saturation has been increased to +25. © SD

While totally desaturating an image does produce a grayscale interpretation that can sometimes work well, we do not favor using this method for a black-and-white conversion because of the lack of interpretive options (Figure 7-67). In addition to this, the brightness relationships between very bright colors sometimes do not translate well when this technique is used. See Chapter 5 for more effective techniques on translating color into black and white.

Creative uses for the Lightness slider

Though we feel that the Lightness slider is not very useful for most images when applied to the entire image, there can be exceptions to this. Using positive values, for example, is very effective for creating a ghosted-back look that is often employed for overlaying type on top of images, or collaging photos together where one image is clear and distinct and the other image serves as a faded background. In Figure 7-69, a Hue/Saturation layer with the Lightness set to +60 was used to fade back the image of the palace windows so the Dresden type layer is more visible. A layer mask was added to the Hue/Saturation layer with the silhouette of a famous Dresden church in gray to partially mask the lightening effect on the windows layer.

Figure 7-67. The version on the left was created by totally desaturating the colors in Hue/Saturation. The one on the right was created using the Black & White adjustment layer, which offers much greater control over how the individual colors are translated into gray tones.

The Lightness slider is the least useful of the three controls, especially for adjustments that affect all the colors, though it does offer possibilities for fine-tuning individual colors. The main reason it is not that effective for the overall adjustment is because it alters the brightness values in a way that interferes with the natural luminance and contrast relationships in the image (Figure 7-68). Adjusting the Lightness to positive values creates the effect of a translucent white overlay. Using negative values with the Lightness slider will darken the image, but not in a way that looks natural or convincing. If you want to brighten or darken an image, use Levels or Curves for both better effects and greater control.

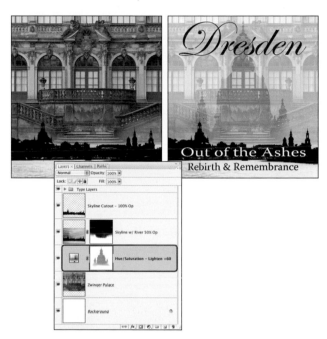

Figure 7-69. Using the Lightness slider with positive values can create a translucent white overlay that works well for some collage effects or for placing text over an image. © SD

Figure 7-68. The effects of the Lightness slider: The center image is the original photo. In the version on the left, the Lightness has been set to -40. In the version on the right the Lightness has been set to +40. © SD

For some images, especially black-and-white photos, applying significant darkening with the Lightness slider can create the look of an antique photo process (that is, dark and low contrast) or a dark, moody atmosphere (Figure 7-70). As with all things creative, the best way to find unexpected uses for the controls is to experiment to see if using them a certain way creates an effect that works well for a certain image or project.

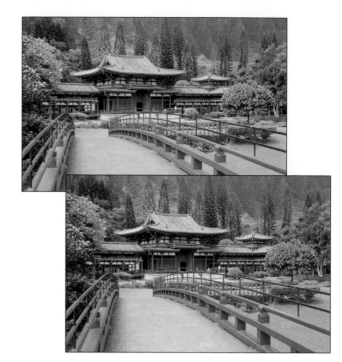

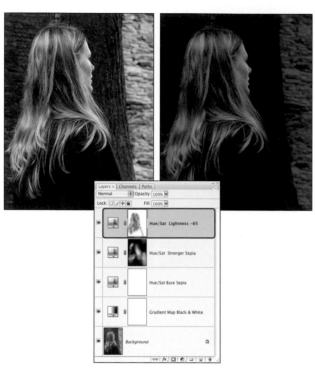

Figure 7-70. In this image, the top Hue/Saturation layer darkens the photo and lowers contrast with a lightness setting of -65. A layer mask is used to lessen the effect on the woman's hair. © SD

The effect of Hue/Saturation's Lightness slider on the underlying image is essentially the same as if you added a Color Fill layer of white (for lightening) or black (for darkening), and then lowered the opacity to make the Color Fill layer partially transparent.

Adjusting individual colors with Hue/Saturation

In the photograph of the Buddhist temple in Hawaii (Figure 7-71), the hues of the bridge and the temple came out looking a little dull and too orange for our tastes. The lawn and foliage was too yellow and we wanted to make them appear a richer green. In situations such as this, where you need to boost or tone down the saturation of specific colors in the image, or slightly adjust the character of a color, the Hue/Saturation command really shines.

Figure 7-71. The Byodo-In Buddhist temple on the island of O'ahu. © SD

🖱 ch07_Temple.jpg

1. Add a Hue/Saturation adjustment layer. Open the Edit menu at the top of the Hue/Saturation dialog box, and choose Reds. Increase the saturation to +18. This helps to intensify the colors.

2. Moving the Hue slider for the reds will shift the color between the two component colors that create red, magenta on the left and yellow on the right. You can preview how a color will change by looking at the spectrum bars at the bottom of the dialog box. Adjust the Hue slider to -6 to add a touch of magenta to the reds and make them less orange (Figure 7-72).

Figure 7-72. The red hue and saturation settings and their effect on the image.

3. Now go to the Edit menu and choose Greens. To see which areas of the image the green adjustment will affect, move the saturation all the way to the right to fully saturate the image (Figure 7-73). As you can see, not all of the grass is included, which means you will have to also work with another color. Set the green saturation to +25 and adjust the Hue slider to -8 to shift the greens more towards yellow and away from cyan.

4. The color that is usually present in foliage is yellow, so choose that color from the Edit menu. Move the saturation slider all the way to the right to see which areas of the photo will be affected by this adjustment. As you can see in Figure 7-74, there's quite a lot of yellow in the green foliage.

5. Move the Hue slider to +8 to move any yellow color in the foliage more towards green. Finally, decrease the Lightness slider for the yellows to -15. This last adjustment helps deepen the color in the lawn on the right side of the photo (Figure 7-75). Click OK to apply the Hue/Saturation changes.

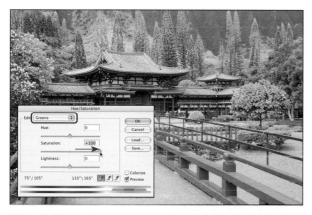

Figure 7-73. A temporary super saturation of the greens shows that there is not as much green color as might be expected in the grass and foliage areas.

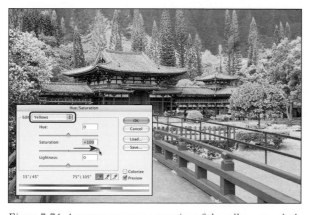

Figure 7-74. A temporary super saturation of the yellows reveals the presence of that color in the grass and foliage.

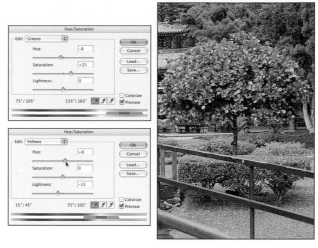

Figure 7-75. The final adjustments to the greens and yellows that modify the color of the foliage.

Fine-tuning specific color adjustments with Hue/ Saturation

For images where there is a distinct difference between the colors you want to adjust and the rest of the image, using the individual color choices in the Edit menu can work quite well. But for those images with more subtlety between colors, it is best to edit the range of a given color using the eyedroppers at the bottom of the Hue/Saturation dialog box. In the following example we'll explore this by making adjustments to a specific subset of yellows in a photograph of the old mine in the ghost town of Bodie, California.

This image was taken in mid-September, when the high desert hills are brown after a summer of hot, dry sun. The objective for the Hue/Saturation adjustment is to suggest a time in the late spring or early summer when the sagebrush is a bit greener. We can change the color of the hills by changing the Hue and Saturation settings for the yellows. The only problem is that there is also a fair amount of yellow in the old wooden buildings, so the adjustment will require some fine-tuning in order to make the hills greener without also affecting the structures (Figure 7-76).

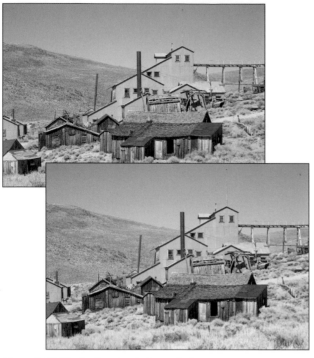

Figure 7-76. The Bodie mine, before and after. © SD

🖰 ch07_BodieMine.jpg

1. Add a Hue/Saturation adjustment layer. Open the Edit menu and choose Yellows. The first step is to see how tricky this will be by increasing the saturation to the maximum amount to discover where yellow occurs in the image. As you can see in Figure 7-77, in addition to the vegetation, yellow is also present in the weathered wooden buildings.

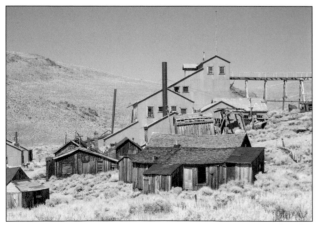

Figure 7-77. Applying maximum saturation to the Yellows reveals yellow in the vegetation, as expected, but also in the wooden structures.

2. Set the Saturation to +13 and the Hue to +23. The change in the Hue setting shifts the yellow more towards green. This works well for the vegetation, but

the presence of yellow in the buildings means that they also become a bit greener (Figure 7-78).

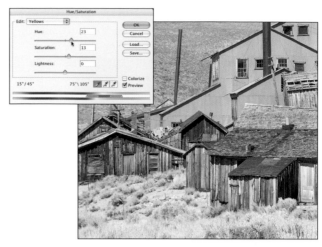

Figure 7-78. When the Hue slider for the yellows is shifted towards the green, both the vegetation and the wooden buildings are affected.

3. To narrow the range of yellows affected by this adjustment, choose the minus eyedropper at the bottom of the dialog box, and then click in the image on the walls and roofs of the wooden structures. This subtracts some of the yellow/red areas from being affected, but it still needs a further adjustment.

4. At the bottom of the dialog box, click the left gray section of the indicator that shows the range of yellows being adjusted. Move it slightly to the right so that the reddish yellows are not being affected. At the bottom of the dialog box, you can see the range of yellow color has narrowed (Figure 7-79, Figure 7-80).

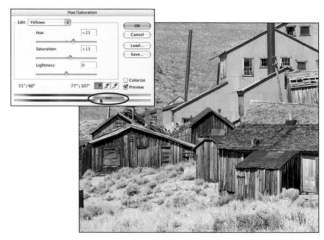

Figure 7-79. By narrowing the range of what Photoshop considers yellow, the reddish yellows of the wooden buildings are removed from the affected areas.

Figure 7-80. Top: The default range of what Photoshop considered "yellow." Bottom: The customized range of yellows that do not include the reddish yellows.

Vibrance vs. Saturation

One thing to be aware of when increasing saturation using the Hue/Saturation dialog box, or using the saturation controls in Camera Raw or Lightroom, is that the saturation levels are increased for all colors, even those that already may have high levels of color intensity. If your image does not have much saturated color, then this is not a problem, but if it does, then any increase in saturation might cause the over-saturation of certain colors, which can conceal important tonal detail.

Reading the Rainbow: What the Spectrum Bars Tell You

When you are adjusting individual colors, the spectrum bars at the bottom of the Hue/Saturation dialog box convey important information about the range of color that is being affected and how it will change. The small markers and areas of dark and light gray indicate the range of color that will be affected (Figure 7-81). The dark gray area in the center of these markers shows that range of a given color that will be fully affected by any adjustment you make. The lighter gray areas on either side represent the range of the targeted color where the effect is feathered and gradually reduced to zero. The degree numbers above the spectrum bars indicate the locations on the circular color wheel that will be affected by any change (Figure 7-82). In the example of the yellows shown here, areas that fall between 45° and 75° will receive the full effect of the adjustment. The areas where the change will be gradually faded to nothing are between 15° and 45° in the red-yellow range and 75° and 105° in the yellow-green range. In addition to changing the range of color by using the plus or minus eyedroppers, you can also manually adjust it by dragging on the light gray areas. To change the area covered by the falloff zone, move the small dividers and end tabs on either side of the light gray area.

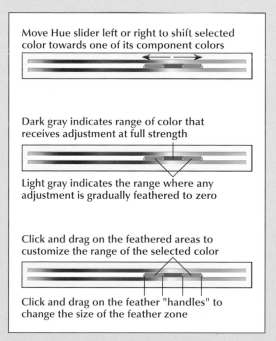

Figure 7-81. The color spectrum bars in the Hue/Saturation dialog box display information about the range of color being adjusted and also enable you to customize affected colors.

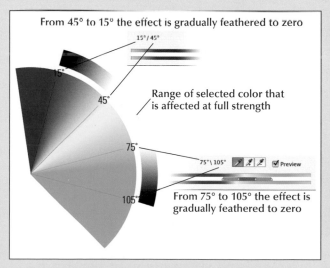

Figure 7-82. The degree numbers at the bottom of the Hue/Saturation dialog box show how the effect is feathered in relation to the position of colors on the color wheel.

One possible way around this is to use the Vibrance slider in Camera Raw or Photoshop Lightroom. Vibrance is a close cousin of the Saturation slider but its changes are applied more delicately. The saturation of less-saturated colors is increased with less impact on the higher-saturated colors, and clipping is minimized as colors approach full saturation. In the image of the man with the hyacinth macaw (Figure 7-83), increasing the saturation affects all the colors and makes the skin tones much too orange (Figure 7-84). The Vibrance slider in both Lightroom and Camera Raw improves the saturation of less saturated colors but does not affect the man's skin tones. This makes it especially useful on portraits, where a more subtle touch is required when adjusting the saturation levels of skin tones (Figure 7-85).

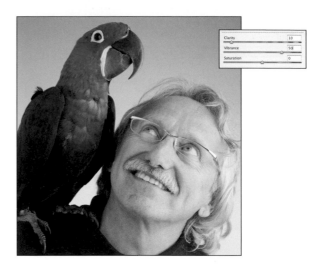

Figure 7-85. The Vibrance slider in Camera Raw (above) and Lightroom increases the saturation of more muted colors while leaving higher saturated colors alone.

Photo Filter Adjustment Layers

The Photo Filter feature (Layer→New Adjustment Layer→Photo Filter) is designed to mimic the properties of traditional warming and cooling filters that are used on lenses to modify the color temperature of the light in a scene. The first six choices in the filter menu in the dialog box are digital versions of traditional film-based color balancing filters that have been used for a long time. These can sometimes be useful for subtle adjustments to the overall color balance of an image, especially if it just needs a little warming or cooling. The remaining choices cover a range of different colors (Figure 7-86).

Figure 7-83. The original image with no adjustments. © SD

Figure 7-84. The Saturation controls in Photoshop, Camera Raw (above), and Lightroom increase saturation levels for all colors in the image. © Jack Reznicki

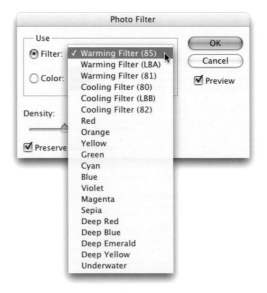

Figure 7-86. The Photo Filter dialog box showing the available filter choices.

The warming and cooling filters are the most useful and the ones we tend to use most often. The 85 and LBA (warming) and 80 and LBB (cooling) are color correction filters intended for applying minor fine-tuning to an image's white balance. These can be useful for images with a mild color cast caused by interior tungsten lighting, or images that are a bit too cool, such as those photographed under shady conditions. The 81 warming and 82 cooling filter create similar effects but are a bit stronger. In the photo taken inside a World War II-era submarine (Figure 7-87), the typical yellow color cast caused by the tungsten light sources is reduced by using the Cooling Filter (82) set to a density of 35%. Since this image has so many areas that could serve as neutral guides, this color cast could also be corrected in Levels or Curve using the eyedropper method shown earlier. For additional information on Photo Filters please see the section on Lab color at the end of this chapter as well as Chapter 8, "Creative Color".

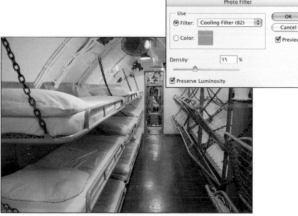

Figure 7-87. The Cooling Filter (82) at 35% Density proved effective at clearing up the color cast caused by the lighting inside the submarine. © SD

There's also a list of other choices based on specific colors, or you can choose the color option and specify your own custom color. Either the preset color choices or a custom color can be used to neutralize a color cast by selecting a complementary color. While this is not our first choice for removing a color cast (that would be Curves or, if a raw file, the conversion controls in Camera Raw or Lightroom), it

can be useful as a quick fix for JPEG files or older scanned images. The violin photo is a scan from a slide and suffers from an ugly green color cast caused by the fluorescent lighting in the display case. By choosing a Violet filter (an approximate complement color for a greenish cast) with a density of 35%, much of the unpleasant color cast has been neutralized (Figure 7-88). The color balance is not perfect, but it's a lot better than the original. We'll revisit this image in the next exercise to explore more precise ways to improve the color balance.

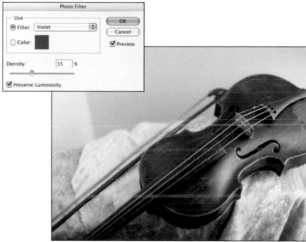

Figure 7-88. The Violet Photo Filter set to 35% Density does battle with a nasty green cast caused by fluorescent lighting. © SD

Local Color Correction

After you have applied adjustments to affect the global (overall) color in a photograph, the next step is to focus on corrections that are applied to specific areas. As with local modifications to tonal qualities of an image (that is, luminance and contrast), the use of layer masks will give you the greatest control and flexibility over how the local color corrections are applied.

Local Corrections with Curves

In addition to its prowess as an overall color-correction tool, when used with a layer mask, Curves is also ideal for applying local corrections to specific areas of an image. The important thing to understand about local corrections with Curves is that the only difference from overall corrections is that they are precisely targeted to affect certain areas. The basic methodology of evaluation, identifying the color issues that need correcting and determining the color recipe to use, is essentially the same that you would use for overall corrections. To explore one example of using Curves on a specific portion of a photo, we'll continue with the violin photograph that we used to demonstrate the Photo Filter adjustment layer (Figure 7-89).

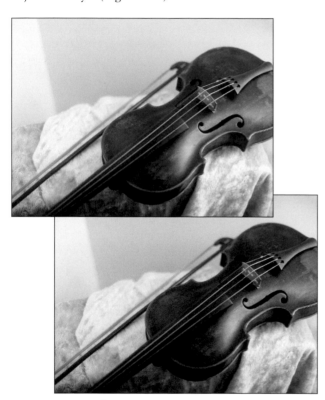

Figure 7-89. The antique violin, before and after.

🖑 ch7_violin.jpg

Local color correction with layer masks

1. If you have not already done so, add a Photo Filter adjustment layer to the violin photo. From the Filter menu, choose Violet, and then set the Density to 35% with Preserve Luminosity checked. Click OK. This creates a decent overall color balance, but the violin is still too cool and bears slight traces of the original color cast.

2. Use the Eyedropper tool to read the values in the tailpiece (the part of the violin on the body where the strings are attached). This is an area that can serve as a neutral guide and provide some clue as to what is causing the lingering color cast (Figure 7-90). In most of this area, green is the higher value, which makes sense for a color cast caused by fluorescent light (this is typically a mixture of green and cyan). Shift-click with the eyedropper to place a color sampler point there.

3. Use the Lasso tool with a feather value of zero to make a rough selection of the body of the violin (Figure 7-91). Don't worry about the neck of the instrument and add a Curves Adjustment layer.

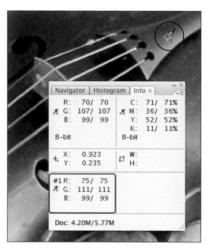

Figure 7-90. The tailpiece of the violin serves as a good neutral guide. The values from the color sampler point show that green is still causing problems.

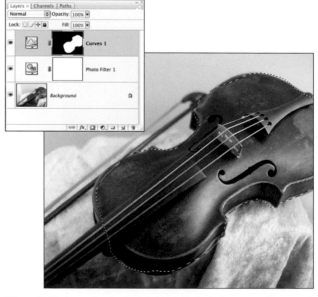

Figure 7-91. A rough selection of the violin body becomes a layer mask when a Curves adjustment layer is added.

4. In the Curves dialog box, go to the green channel. Click the body of the violin in the image to see where on the curve you need to make the adjustment. Since the instrument is primarily darker tones, this will be the lower part of the curve. Click the curve to place a point there and begin to lower it slightly to subtract green and add magenta (Figure 7-92). Remember that you can also tap the down arrow key to make fine adjustments to the active control point.

5. Switch to the blue curve and lower the curve to add in a bit of yellow (Figure 7-93). This lowers the blue value of the color sampler point on the tailpiece and also helps to warm up the violin to create a more plausible color for a fine wooden instrument.

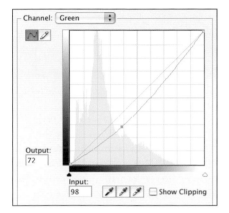

Figure 7-92. The green curve for the violin.

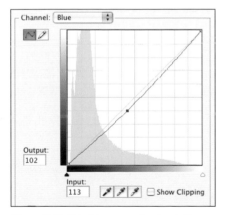

Figure 7-93. The blue curve for the violin.

6. You can also experiment with slightly increasing the red curve, but we felt this added too much red. Even though the values for the sample point on the tailpiece are not equal, our aim here is not neutrality of that item, but making the overall violin look good. Click OK to apply the Curve adjustment.

Fine-tuning the layer mask

7. The final steps are to fine-tune the layer mask for the violin. Use the Polygonal Lasso tool to make a selection of the violin's neck. Press D to set the foreground colors and then X to place white into the background swatch. With the Curves layer mask active, press the Delete key to fill the selection with white. This adds the color correction to the neck of the instrument. Choose Select→Deselect.

8. Choose Filter→Blur→Gaussian Blur to feather the edges of the layer mask. The blur radius that you use is always influenced by the resolution of the image; a photo with more pixels in it can use a higher radius value. For this image, a radius of 5 pixels works well. Click OK.

9. Depending on how accurate your original Lasso selection was, you might need to touch up some of the edges of the layer mask with the Brush tool. Double-click the Zoom tool to zoom in to a 100% view, and scroll around the image to check the edges. Use a soft-edged brush tip of an appropriate size to perform any mask touch-ups (Figure 7-94). Painting with white will show the color correction for the violin; painting with black will mask it.

Figure 7-94. The final layer mask for the violin after adding in the neck and the bow.

In addition to illustrating local color correction with Curves, this example also shows that you don't necessarily have to have a super precise selection or mask to apply changes to only a portion of the image. True, in some cases (such as collage work), a precise mask may be required, and for a shape such as this, the Pen tool would be the obvious choice for creating the initial selection. But for changes to color and tone, starting out with a looser selection often works fine, especially if you suspect that the mask edges may end up on the receiving end of the Gaussian Blur filter.

Color fill layers to neutralize color casts

There's one last thing about the violin image that needs addressing: The wall has an uneven color balance that looks a bit strange. To fix this, we'll take a quick side trip away from Curves and use an adjustment layer not normally noted for its color correction properties.

1. Hold down Option/Alt and click the Add Adjustment Layer button at the bottom of the Layers palette. (The Option/Alt key needs to be down *before* you click the adjustment layer icon.) Choose Solid Color at the top of the list. The addition of the Option or Alt key forces the New Layer dialog box to come up. From the Mode menu at the bottom of this dialog box, choose Color. Click OK.

2. In the Color Picker, move the cursor all the way to the left of the large color selector box to choose a neutral gray (Figure 7-95). The brightness of the gray does not matter, as long as it is a gray. If you want the wall to have a slight color flavor, such as a warm tone, you can choose a general hue range from the spectrum bar and then move the selector circle in slightly to the right. Click OK.

Figure 7-95. Top: The New Layer dialog box for the Color Fill layer with the mode set to Color. Bottom: Selecting a neutral gray tone in the Color Picker.

3. The Color blending mode creates an overall toning effect in the image. If you have used gray for the Color Fill, it becomes another quick way to create a black-and-white interpretation (Figure 7-96).

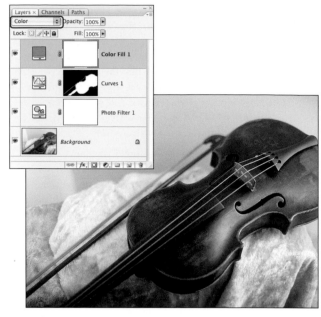

Figure 7-96. The initial effect of the neutral Color Fill layer will be a monochromatic version of the image.

4. Choose Image→Adjustments→Invert to invert the layer mask, turning it black and hiding this grayscale effect. Press D to set the default colors, which makes white the foreground color. Select the Brush tool in the Tool palette. In the Options bar, set the brush opacity to 50% from the Brush Picker on the far left of the Options bar; choose a large-sized brush that will let you cover the wall in only a few strokes (for this image we used a 300-pixel brush).

5. Brush over the wall to paint in the neutral tones created by the Color Fill layer (Figure 7-97). Take care not to paint over the edges of the violin or any of the fabric that it rests on. If you do, just press X to exchange the colors and paint with black using a smaller brush tip to remove the neutral tones from any of the violin edges.

Figure 7-97. Left: The layer mask for the Color Fill layer inverted to black. Right: After the mask has been modified with the Brush tool to blend in the neutral tones and hide the uneven coloring on the wall.

Figure 7-98. Left: The image before the uneven coloring on the wall has been fixed. Right: After applying the neutral color wash to the wall.

Figure 7-99. A Violin Concerto in Three Movements: Left: The original image. Center: After applying the Violet Photo Filter. Right: The final version after local Curves adjustments and correcting the color cast on the wall.

This technique is obviously not suitable for all images, but there are times when using this method of brush-on neutrality works quite well, especially when adjusting an area that might plausibly be a neutral tone, such as this wall (Figure 7-98). And, if you want to experiment with having a slight color to the wall, simply double-click the thumbnail for this Color Fill adjustment layer and experiment with a new color in the Color Picker. Don't go too far to the middle of the Color Picker box or the color you choose will become more saturated and less convincing.

Changing Color

Some color correction goes beyond simply correcting an undesired color cast and involves actually changing color. This can encompass altering the character of the color, or it can even mean changing a color into something entirely different, or matching the color between two images. As with other areas in Photoshop, you can use a variety of commands and techniques to accomplish color modifications.

Altering color with curves

The ability to target the components of a given color and manipulate the underlying "color recipes" is what makes Curves so useful. In addition to correction of unwanted color casts, Curves is also very useful for changing the "flavor" of specific colors. As we saw earlier, the Hue/Saturation command can be used to manipulate individual colors (for example, shifting red between its component colors of yellow and magenta), but when used with a layer mask, Curves is sometimes more effective for this type of adjustment.

In the image of the hull of an old sailing ship taken in Honolulu harbor, the reddish stripe at the top has a lot of blue in it, which is pushing the color towards magenta. Let's explore a Curves adjustment to alter the character of this red stripe (Figure 7-100).

Figure 7-100. *The original photograph of the hull of an old ship and the modified version* © SD

🖱 ch7_Harbor_Hull.jpg

1. Choose Select→Color Range. In the Color Range dialog box, make sure that Sampled Colors is specified at the top of the dialog box. The Fuzziness should be at 40 (the default). Click in the photograph on the red stripe of the hull to start the selection. Hold down the Shift key (or use the plus eyedropper) and click areas in the image that are still black or dark gray in the mask preview in the Color Range dialog box (Figure 7-101). Click OK when the mask preview is mostly white over the area of the red stripe.

Figure 7-101. *The Color range dialog box after building a selection mask for the reddish stripe at the top of the photo.*

2. With the selection active, add a Curves adjustment layer. The selection will be turned into a layer mask. In the Curves dialog box, select the blue curve. Cmd/Ctrl-click the stripe to place a control point on the blue curve, and then drag down to subtract blue and add yellow (Figure 7-102).

3. Switch to the red curve. Cmd/Ctrl-click the stripe to place a control point on the curve and raise it up to increase the red component. Switch to the RGB curve. Experiment with lightening or darkening that area of the image. We chose to slightly darken the red strip. Click OK.

Figure 7-102. *The Curves adjustments for modifying the color of the red area on the hull.*

4. As a final step, we chose to use Color Range to create a selection of the water and then adjusted each of the color curves to increase the tropical turquoise character of the water (Figure 7-103, Figure 7-104).

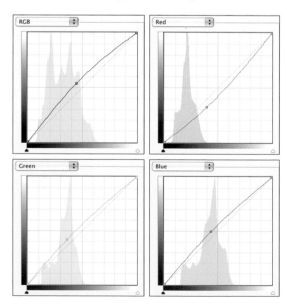

Figure 7-103. *The Curve adjustments used to change the coloring and brightness of the water.*

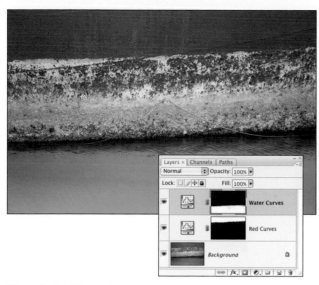

Figure 7-104. The final layers palette for the Harbor Hull photograph.

Selective color

The four sliders for Cyan, Magenta, Yellow, and Black in the Selective Color dialog box (Layer→New Adjustment Layer→Selective Color) are a hint that this command is designed primarily for fine tuning the colors of CMYK images, but it can effectively be used with RGB files. Like the Hue/Saturation command, it also allows you to choose from a specific color group and then adjust the component colors. In this case, those component colors are the four process inks used for offset printing. In addition to the six additive and subtractive primaries (red, yellow, green, cyan, blue, magenta), you can also target whites, neutrals, and blacks, which is a fantastic option when working on RGB files (Figure 7-105).

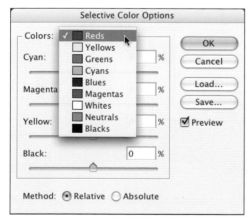

Figure 7-105. The Selective Color dialog box.

There are two methods for applying the color adjustments: Relative and Absolute. A Relative value will add or subtract color proportionally based on the total amount of that color already present. For example, if the amount of yellow in a given area is 50%, increasing the yellow by 20% will actually add only 10% because 20% of 50% is 10%. Using Absolute will result in the actual percentage amount being added, so in the case of the previous example, increasing a 50% yellow by 20% will result in 70%. Relative is the default setting and in most cases for making changes to colors in RGB images either relative or absolute are OK to use. The color changes created with the absolute setting are often much more pronounced than with relative. If you are using Selective Color to make subtle color tweaks to CMYK images that will be reproduced on a press, however, then absolute is the better choice since you have a better idea of what you are getting.

In the example image of the carnival ride control panel (Figure 7-106), both the red and the yellow share component colors. With Selective Color, these can be adjusted separately without the need for a layer mask. While reds and yellows can be adjusted individually in Hue/Saturation, you have only the Hue slider to make the color adjustment (we are referring to changes that affect the character of the color, not saturation or brightness). In the Selective Color dialog box, three different sliders (cyan, magenta, and yellow) can influence each color. The black slider will darken or lighten a color and, in this respect, is similar to how the Lightness slider affects individual colors in Hue/Saturation. In the following example we'll explore how Selective Color can be used to alter the character of colors, or change them into entirely different colors.

Figure 7-106. The original carnival ride control panel image. © SD

🖑 ch7_CarnivalControlPanel.jpg

1. Add a Selective Color adjustment layer to the image. We'll work in broad strokes here just to make it clear how these sliders affect the different colors in an image.

2. Red is the color initially selected, so we'll start there. Set the Yellow to -50%. Reducing yellow brings in more of yellow's complement, which is blue, making the red control panel pinker and more magenta (Figure 7-107).

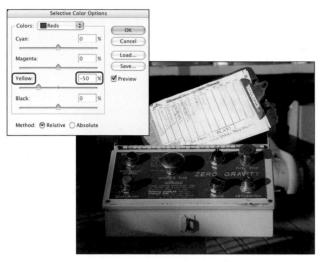

Figure 7-107. Subtracting yellow from the reds shifts them more towards magenta, one of the component colors in red.

3. Now decrease the Yellow to -75% and raise the Cyan to +50%, and the control panel becomes darker and more purple (Figure 7-108).

4. Try changing the method from Relative to Absolute to see how that affects the adjustment (Figure 7-109). You can also experiment with the Black slider to see how it lightens (negative values) or darkens (positive values) the color.

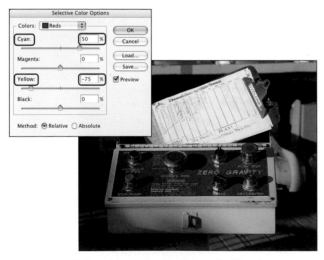

Figure 7-108. Subtracting even more yellow and adding in some cyan transforms the red to a light purple.

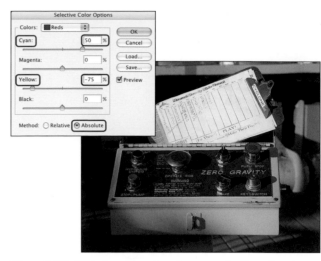

Figure 7-109. With the same settings for cyan and yellow, changing the method from Relative to Absolute creates a significant change in the character of the purple color.

5. Hold down Option or Alt to change the Cancel button to reset. Click the Reset button and change the Colors menu to Yellows.

6. Set the Cyan to +75% and the Magenta to –75%. This changes the yellow to more of a greenish yellow color (by subtracting magenta, we are adding green, as shown in Figure 7-110). Changing between Relative and Absolute with these settings causes the cyan-green color to shift into a hyper-saturated fluorescent green that is so intense it cannot be reproduced in the CMYK colors used in this book. If you compare the colors on your display to those in Figure 7-111, you'll see the difference.

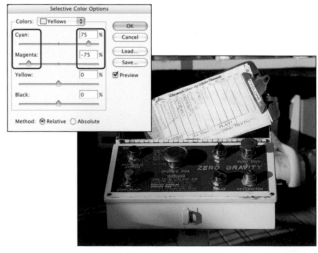

Figure 7-110. Adding cyan and subtracting magenta from the yellows causes that color to become more of a greenish yellow.

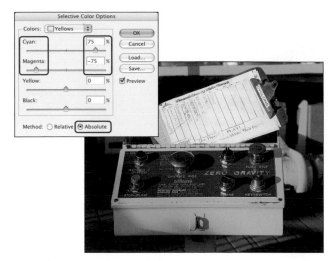

Figure 7-111. Using the same Yellow settings for cyan and magenta, but changing the method to Absolute creates a bright, fluorescent green that is beyond the gamut for CMYK.

Selective Color can be useful for subtle tweaks to images where there are distinct differences between colors, but where you need to increase or decrease a specific color that may be shared by more than one color. It is especially useful for final color refinements after you have converted from RGB to CMYK. The changes in this example have been broad, obvious strokes that are intended to show you how this color correction works. With most images, you will probably not be making such extreme changes. There may be times, however, when you might need to affect a profound change in a particular color, and becoming familiar with the different ways you can accomplish this in Photoshop is a worthwhile endeavor.

Replace Color

The Replace Color command (Image→Adjustments→ Replace Color) is specifically designed to replace one color with another, but a very significant drawback to this feature is that it cannot be applied as an adjustment layer. As such, we do not find it very useful. There is a workaround, however, that enables you to combine the useful functionality of Replace Color with the Color Range command to create an accurate selection of the areas you want to change. From there, the color can be replaced using an adjustment layer with a layer mask. Let's take a look at how this can be accomplished (Figure 7-112).

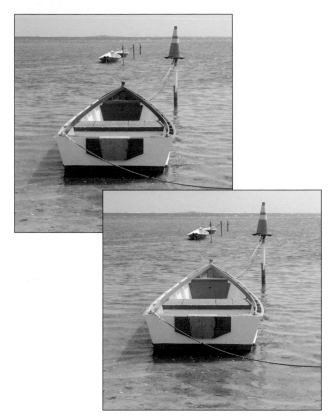

Figure 7-112. The red-and-white boat. We'll use a variety of techniques to change the red to blue (including the reflections on the water). © SD

ch7_RedBoat.jpg

1. To restrict the Replace Color command to only the areas we want to affect, first draw a rectangular marquee around the red boat and all of the reflections of the red color that appear on the water. With the marquee selection in place, choose Image→ Adjustments→Replace Color.

2. The controls in the Replace Color dialog box are a hybrid of Color Range and Hue/Saturation. Click part of the red trim on the boat, and, when the selection button is enabled, you'll see a selection mask appear in the small preview window (Figure 7-113). Use the plus eyedropper to add red areas that were not selected with the first click. You can also increase the Fuzziness amount to expand the selected areas, but we find that we have more control leaving it somewhere between 30 and 40 and just using the plus or minus eyedroppers to shape the selection.

3. Once you are happy with your selection mask, move the Hue slider to shift the colors in the targeted areas. If there is a specific color you want to use, click in the Result color swatch to bring up the Color Picker, where you can define a color (Figure 7-114).

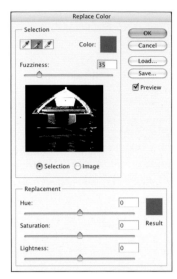

Figure 7-113. *The first step in using Replace Color is to click a color in the image and begin to build a selection mask for that color.*

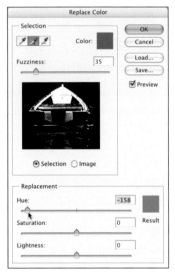

Figure 7-114. *Move the Hue slider to choose a replacement color. To access a specific color, click in the Result color swatch to open the Color Picker.*

The really useful aspect of Replace Color is that by actually changing the color, you can see where the selection needs to be improved. When we first changed the red to blue, for example, there were some obvious areas at the back of the boat and along the gunwales that had not been included in the initial selection mask (Figure 7-115 and Figure 7-116).

4. Now that the color change is in place, use the plus eyedropper (or Shift-click) to click areas where the color has not been replaced. Note that some areas of the red reflections on the water are also being included. This is good, but these areas will probably have to be fine-tuned a little later.

Figure 7-115. *Left: Areas on the back of the boat were not included in the initial Replace Color selection. Right: After fine-tuning the color replacement mask.*

Figure 7-116. *Left: The gunwales on the right side of the boat showing some holes in the selection mask. Right: After adding those areas to the replacement color mask.*

5. Click the Save button in Replace Color and save the settings (Figure 7-117). Remember where you save them because we'll access these in the next step. If you want to use the same color when we create an adjustment layer, make a note of what your Hue setting is. For the blue that we chose, the Hue value was -158. After the settings have been saved, click the Cancel button to exit Replace Color without making any changes. If you had clicked OK, then the color change would be applied to the image with no way of adjusting it later.

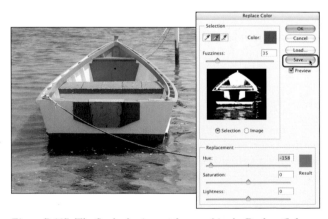

Figure 7-117. *The final selection mask created in the Replace Color dialog box is saved so that it can be loaded into the Color Range dialog box. The blue reflections are obviously too purple, but we'll fix those in a later step.*

Using Replace Color Settings with Color Range

6. Now choose Select→Color Range. Click the Load button and find the Replace Color file (the file extension is .axt). The selection mask that you created in Replace Color is loaded into the Color Range dialog box. Click OK to create the selection (Figure 7-118).

7. Add a Hue/Saturation adjustment layer. Move the Hue slider to the same setting that you had in Replace Color, or to whatever color looks good, and click OK (Figure 7-119).

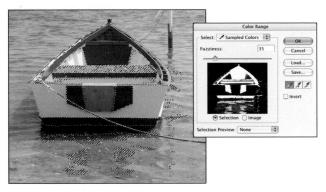

Figure 7-118. The selection of the red areas was created by loading the saved Replace Color settings into the Color Range dialog box.

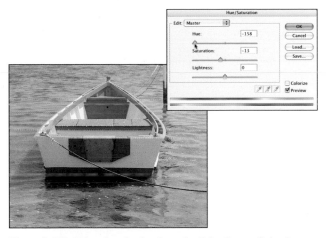

Figure 7-119. Using the selection from the Color Range dialog box, the actual color change is applied with a Hue/Saturation adjustment layer.

By making the actual color change with a Hue/Saturation adjustment layer, you gain the flexibility to make changes or refine the layer mask. For non-destructive editing, these important factors are not offered by the Replace Color command. But by saving the settings, loading them into the Color Range dialog box, and then using Hue/Saturation, you can get around this and apply the changes non-destructively.

Fine-tuning the water reflections. In changing the red parts of the boat to blue, the operation has worked pretty well, but there is still some fine-tuning that needs to be done. The blue in the water reflections doesn't look right at all. It's too dark, too purple, and too saturated. But we can't really change it without also altering the blue that colors the boat. The solution is to use two Hue/Saturation layers to color the boat and the watery reflections separately. This will require making a copy of the initial Hue/Saturation layer and then making some edits to each layer mask, but it's a fairly straightforward procedure. If you want to follow along with this part of the example, be sure the Hue in the adjustment layer is set to -158.

1. Make a copy of the Hue/Saturation layer by dragging it to the new layer icon at the bottom of the Layers palette, or by choosing Duplicate Layer from the palette sub-menu. The color of the boat will change, but this is only temporary. Double-click the name and rename this layer "Reflection Hue/Sat." Double-click in the name of the first adjustment layer and rename it "Boat Hue/Sat" (Figure 7-120).

2. Use the Lasso tool with a feather value of 0 to make a loose selection around just the boat. It doesn't have to be an accurate outline of the boat, but it should not include any of the reflections on the water. The place where you need to be the most careful is the curved back section of the boat on the right where it is close to one of the reflections (Figure 7-121).

Figure 7-120. The first Hue/Saturation layer is duplicated and both layers are renamed.

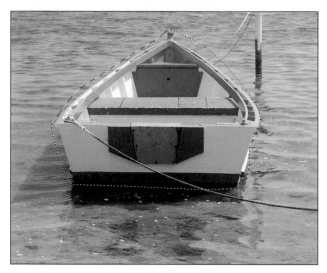

Figure 7-121. The boat selected prior to editing the Reflection Hue/ Saturation layer mask.

3. Click the Reflection Hue/Saturation layer to make it active. Press D on the keyboard to reset the colors to their defaults. When a mask is active, this will place black into the background swatch. Verify that this is the case, and then press the Delete key to fill the selection with black.

4. Click the Boat Hue/Saturation layer to make it active. Choose Select→Inverse to change the selection so that everything except the boat is selected. Press the Delete key to fill the selection with black. Choose Select→ Deselect. You now have two Hue/Saturation layers that affect the boat and the reflections separately (Figure 7-122).

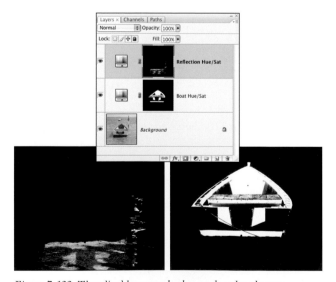

Figure 7-122. The edited layer masks that apply color changes separately for the boat and its reflection on the water.

5. Double-click the thumbnail for the Reflection Hue/ Saturation layer to reopen the Hue/Saturation dialog box. Move the Hue slider to -180 and lower the Saturation to -60. Click OK (Figure 7-123).

Figure 7-123. Top: The version before fine-tuning the boat's reflection. Bottom: A more believable reflection.

Match Color

The Match Color command (Image→Adjustments→Match Color) is used to sample and match color characteristics between different images, or within selected areas of images. Additionally, sampled color statistics can be saved as a reference file and then applied to other images. It is very effective for matching color between two images of the same subject where the coloring may be different due to a change in lighting condition. It can also be used with selections to create a match between elements that are different colors. We'll explore both scenarios in the following examples.

> Match Color is not available as an adjustment layer or as a Smart Filter, so to preserve your options and work non-destructively, it's best to either work on a copy of the file or on a duplicate layer.

Match Color Globally. The two close-up photographs of the old mailbox detail in Figure 7-124 have dramatically different color balances because the afternoon sun illuminated one side of the mailbox and the other side was in the shade. Match Color can fix this pretty quickly. The first step is to decide which image will be the source that you will use as a color reference. For this example, we'll use the warmer sunlit image as the source.

Figure 7-124. Two close-ups of an old mailbox—one side in the sun, the other in the shade. © SD

⌐ ch7_MailboxDetail-1.jpg

⌐ ch7_MailboxDetail-2.jpg

1. Arrange both photos in Photoshop so you can see them side by side with View→Screen Mode→Standard Screen Mode. On the bluer, cooler mailbox image (the one that shows the hinge), make a copy of the Background layer by choosing Layer→New→Layer via Copy, or use the very handy Cmd-J/Ctrl-J shortcut.

2. Choose Image→Adjustments→Match Color. The first thing you need to do is go to the lower part of the dialog box and specify the source (Figure 7-125). (We think this is a bit backwards; the first control you need to access should be at the top of the dialog box). Open the Source menu and choose the mailbox-1 photo. Match Color will do its magic and, for these images, it works pretty well (Figure 7-126).

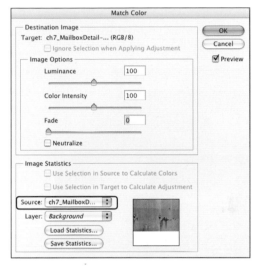

Figure 7-125. The Match Color dialog box.

Figure 7-126. The cooler, shady mailbox photo (bottom) matched to the sunny-side mailbox photo (top).

Match Color Image Options. The Image Options let you fine-tune the color match if such tweaking is needed. Luminance is a brightness control, and Color Intensity will boost or reduce the color saturation of the original image. Fade acts like an opacity control, as if the color match effect were on a separate layer, allowing you to fade the effect and create a blend of the matched color and the original appearance. Neutralize attempts to apply a neutral color balance to the image, though that will, of course, cancel out any color matching. Neutralize can be useful, however, for removing color casts on some photos (**Figure 7-127**) and can be very effective in neutralizing underwater shots.

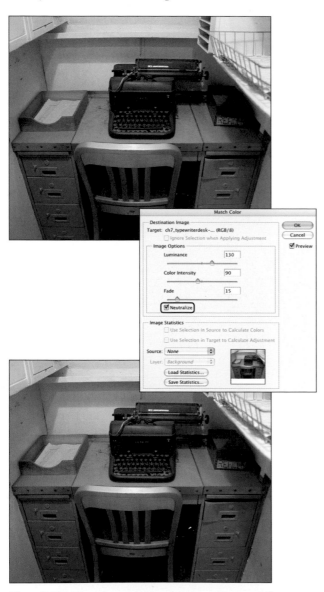

Figure 7-127. The color cast in the top image was successfully removed by clicking the Neutralize check box in the Match Color dialog box. Some fine-tuning was also applied using the Luminance, Color Intensity, and Fade sliders. © SD

Using Save Statistics. Save Statistics will save the specific color recipe of the image so you can apply it to other files without actually having the original source image open. You don't need to be actively matching two images to save statistics. If you have a file that you want to use as a reference file, just open it up, access the Match Color dialog box, and save the statistics.

In practice, the success rate using saved statistics can be hit or miss, and the result is often quite different from what you were expecting. It generally works best with images that are similar in content, overall brightness, and contrast. For example, the statistics from a close-up shot of a corroded beach shower produce interesting results when applied to the mailbox detail photos (also beat-up pieces of old metal), as seen in **Figure 7-128**, but the result is quite different when applied to a shot of the USS Bowfin at Pearl Harbor (**Figure 7-129**). The Fade option in Match Color is often useful in these situations for scaling back the intensity of the effect. In **Figure 7-130**, a Fade value of 50 created more of a strong warming filter effect.

Figure 7-128. The saved statistics from the grungy beach shower detail on the top were applied to the old mailbox detail photo on the bottom. Since both photos are of beat-up pieces of metal, the color match is an interesting result and quite plausible if you wanted to match the color "flavoring" in an entire series of such images.

Figure 7-129. In Match Color, the statistics for the grungy beach shower image from Figure 7-128 were applied to the submarine image (top). The results were a bit too orange (bottom).

Figure 7-130. By using a Fade setting of 50, the effect was fine-tuned to something resembling a warming filter. © SD

Match Color with selections. For those times when you need to affect only a portion of an image, such as when matching color between clothing or products, selections can be used with Match Color. As with most procedures that involve selections, the success is often determined by how good the initial selections are. In Match Color, the source selection does not always have to be super precise, but you do have to have an accurate selection for the target image. To explore this technique, as well as some of the problems that can arise, we'll apply the coloring of a small teapot to a ceramic vase (Figure 7-131).

Figure 7-131. The vase needs to be the same color as the teapot, which is a perfect challenge for Match Color to solve. © SD

🖰 ch7_vase.jpg

🖰 ch7_teapot.jpg

1. Open the teapot and the vase images. To cut to the chase, we have already prepared an alpha channel for the vase. In the vase image, choose Layer→Duplicate Layer. In the Channels palette for the vase, Cmd/Ctrl-click the vase alpha channel to load it as a selection (Figure 7-132). If you want to create the selection yourself, the Quick Selection tool works very well on the vase.

2. In the teapot image, make a Lasso selection of the side of the teapot (Figure 7-133). It does not have to be accurate to the edges of the item.

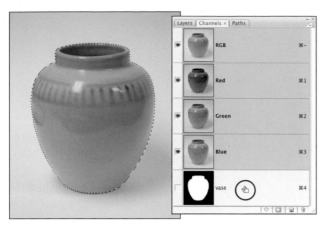

Figure 7-132. An alpha channel for the vase already exists in the file. Cmd/Ctrl-click it to load the vase section.

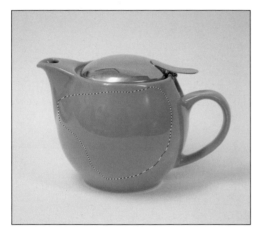

Figure 7-133. A selection of the green of the teapot.

3. Switch back to the vase photo and choose Image→ Adjustments→Match Color. In the Source menu, choose the teapot image. Make sure that both the check boxes pertaining to using the selections in the source and target images are checked (Figure 7-134). The initial match does a good job of matching the color to the teapot, but it does not preserve the brightness and contrast of the original vase. The highlight on the side of the vase has become dull and murky. This requires a different selection in the source image. Click Cancel.

The main problem with our selection in the source image is that it contained a fairly limited range of tones in terms of brightness. In comparison, the vase has a wider range of tones, ranging from the bright highlight on the shoulder of the vase, to the darker interior of the opening. By altering our selection in the teapot image to include a similar range of tones, we can get a better match.

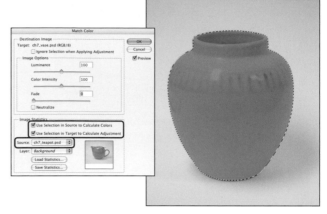

Figure 7-134. The first attempt creates a decent match for the color, but the original brightness and contrast variations on the vase do not survive the trip.

4. In the teapot image, hold down the Shift key and use the Lasso to add in some of the highlight on the metal lid, the shadow in the spout hole, as well as some of the white background and the shadow to the right of the teapot (Figure 7-135). If you want to use the same selection that we did, it's saved as an alpha channel called "final source selection."

5. Switch back to the vase image. The vase should still be selected. Open Match Color again and specify the teapot as the source image. The result this time is much better. But it's still not perfect. The highlight on the shoulder of the vase and the lighter reflections on the lower sides have a bit too much yellow in it (Figure 7-136). Click Cancel to exit from Match Color without applying any change.

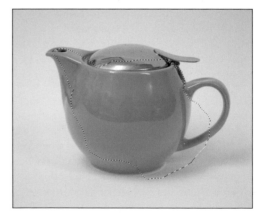

Figure 7-135. The second selection in the source image contains a more representative range of tones, including dark shadows and bright highlights, as well as some of the background area.

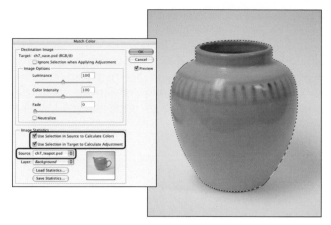

Figure 7-137. The oval selection for the teapot source image.

Figure 7-136. Match Color, Vase to Teapot, Take 2: The revised selection in the teapot source image has produced a much better match across the entire tonal range of the vase, but the highlights and reflection have a bit too much yellow in them.

> Using selections with Match Color is a great way to match the color and tone of skies in different images that you are assembling into a panorama.

Another way to use precise selections with Match Color.
In the previous example, we explored two different ways to use selections with Match Color. Both used a selection in the source image that was not accurate. As the example made clear, however, the range of colors and tones that you do select in the source has an impact on how the color change is applied to the target image. In the target image of the vase, we used a precise selection and directed Match Color to use that selection to calculate the color adjustment. But there is another way to make use of a precise selection for the target that, in some cases, may produce better color matching results. This technique involves a loose selection for both the source and the target images, but then uses the precise selection as a layer mask after Match Color has been applied.

1. In the Teapot image choose Select→Deselect to get rid of the previous selection. Choose the Elliptical Marquee tool and drag an oval selection over most of the teapot. It's OK if some of the gray background is included (Figure 7-137).

2. Switch to the Vase image. Deselect the previous precise selection of the vase. This technique requires that you have a separate layer of the image. If you already have that from the previous explorations with this image, then you're good to go. If not, use the Cmd/Ctrl-J shortcut to create a copy of the Background. With the Elliptical Marquee tool, make an oval selection that includes the entire vase. Some of the gray background will be selected also (Figure 7-138).

Figure 7-138. The oval selection for the vase target image.

3. Open Match Color again and, as before, specify the teapot as the source image. Make sure that the Use Selection in Source and Target check boxes are both turned on. The result this time is the best so far. Notice that the highlight on the shoulder of the vase and the lighter reflections on the sides are not as yellow as they were in the previous version. Of course, part of the background is now the wrong color, but since we already have an accurate mask of the vase, we can quickly fix that. Click OK to apply the Match Color adjustment (Figure 7-139).

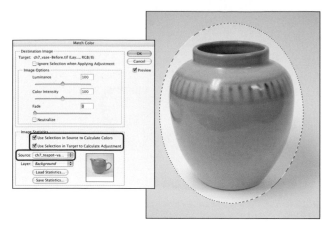

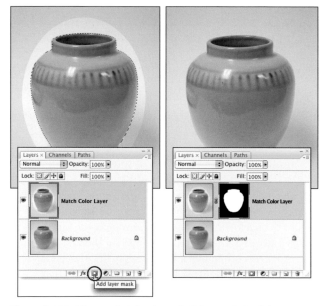

Match Color is not an exact science and the results can vary greatly depending on the images you are trying to match, as well as the selections you are using in the source and target files (Figure 7-141). And just because the oval selections were effective for the teapot and the vase photos, it doesn't mean that there is anything inherently special about oval selections. They worked well for these images, but they might not on two other images. As the saying goes, your mileage may vary.

Figure 7-139. The overall color matching as well as the highlights and lighter reflections on the vase are the best when using oval selections in both the source and target images.

4. Choose Select→Deselect to get rid of the oval selection. In the Channels palette, Cmd/Ctrl-click the thumbnail for the vase alpha channel to load it as a selection. At the bottom of the Layers palette, click the add layer mask icon to mask the Match Color layer using the selection (Figure 7-140).

Figure 7-140. The saved alpha channel of the vase is loaded as a selection and used to create a precise layer mask for the layer that Match Color was applied to.

Using precise selections for the target image is often a necessity with Match Color, but, as this example has shown, you don't always have to use the selection in the Match Color dialog box. By deploying the precise selection as a layer mask after the color matching has been accomplished, you gain more flexibility in terms of making refinements to the mask.

Figure 7-141. Three Match Color results: Top-Left: The first attempt, made using a small selection of the green teapot color and a precise selection of the vase. Top-Right: The second try, made using a larger selection of the teapot and a precise selection of the vase. Bottom: The final version, made using oval selections in both the source and the target files.

Fine-tuning the Color Match with Curves. Although Match Color can be pretty effective, sometimes you may need to apply additional fine-tuning using other color correction tools. For the vase image, we decided on a final Curves tweak to more closely match the brightness and color of the teapot.

1. Choose Layer→New Adjustment Layer→Curves. In the New Layer dialog box, click the check box for Use Previous Layer to Create Clipping Mask. This will apply the curves adjustment only to the layer immediately below it.

2. In the Curves dialog box, lower the center section of the RGB curve to darken the vase a bit (you should have the teapot image open and visible so you can refer to it as you make the adjustment). Place a point on the upper part of the curve that represents the highlights so that the bright highlight on the shoulder of the vase is not darkened. (This is the main reason why we chose not to adjust the brightness using the Luminance slider in Match Color; that highlight would have been darkened as well.)

3. Open the channel selector and choose Blue. Place a point on the center part of the blue curve and lower it slightly to add a bit of yellow to the vase. Click OK to apply the adjustment (Figure 7-142 and Figure 7-143).

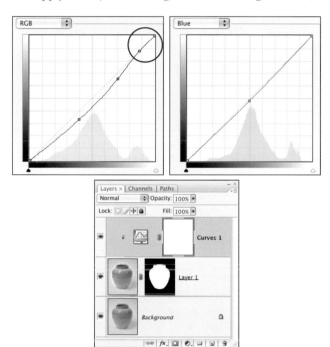

Figure 7-142. The final curve to fine-tune the results of Match Color: The circled area on the RGB curve shows the anchor point placed in the highlights so they are not darkened along with the rest of the vase.

The Power of Lab

The color correction techniques we have explored so far in this chapter have all been centered on RGB files. The reason most photographers deal with RGB files is that their digital cameras produce them and it is the best format to send to photo-quality inkjet printers. The other color mode that is often useful in some situations is Lab (pronounced as three separate letters, L-A-B, and not like a place where scientific experiments are conducted).

The structure of Lab color is fundamentally different from the other color modes because it separates brightness or luminance from the color values in an image. In both CMYK and RGB, the color channels contain not only color information but also brightness values. The separation of brightness from color makes some types of color correction much easier in Lab since you don't have to worry that a correction to the brightness will change a color value, or that a tweak to one of the color channels will alter the brightness of that color. But while this separation of luminance from color can make certain types of corrections easier, the familiar methods that work in RGB rarely yield the same results in Lab, and sometimes they can create ghastly changes that prompt one to quickly reach for the Cancel button. An understanding of the basic Lab terrain is necessary before you go exploring. In the final section of this chapter, we'll tinker under the hood of the Lab color space to see how to apply Curves to a Lab image, and then we'll take a look at two different scenarios where working in Lab can produce results that would be much harder to achieve in RGB.

Figure 7-143. Left: The results from using Match Color and oval selections in both the source and the target. Right: The version after fine-tuning with a Curves adjustment.

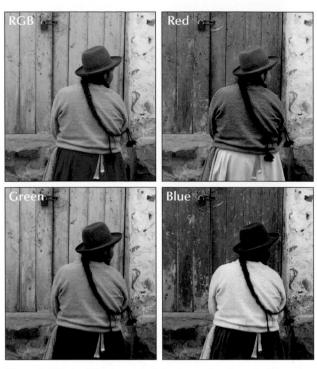

Figure 7-144. An RGB image and the three color channels that contain the brightness and color information. © SD

Lab Basics

In RGB images the brightness of the gray values in the channels directly correlates to how much of that color is present in a given part of the image. Lighter tones of gray indicate more of that channel's color, and darker values indicate less of that color (Figure 7-144). The brightness values of all three color channels combine to create the overall brightness and contrast in the image.

In an image in Lab mode, the brightness and color values are completely separate. The former is controlled in the L channel (L is for lightness or luminance). Because the L channel contains only brightness information, it resembles a normal black-and-white version of the image. While the L channel looks pretty familiar based on what we're used to seeing in an RGB file, the color channels in a Lab file are different beasts entirely. Since they contain only color information and do not carry any brightness detail, they can appear very strange when you first start working with them.

The a channel controls the magenta and green color balance, and the b channel controls the yellow and blue balance. Just as with an RGB image (Figure 7-145), the lightness of the gray values in the a or b channel tells you something about the color that it represents, but it uses a completely different code. An exact 50% gray in a Lab color channel indicates no color at all. So if there is an area in both the a and the b channel that is 50% gray (a value of 0 in Lab-speak), then that is a neutral tone. In the a channel, gray values lighter than 50% represent a magenta color and tones darker than 50% gray indicate a green color. In the b channel, light gray values represent a yellow color while those tones darker than 50% gray represent a blue tone. Positive values indicate warmer colors (magenta, red, yellow) while negative values represent cooler colors (green, cyan, blue). In both channels, the darker or lighter a tone becomes, the more intense and saturated the color will be.

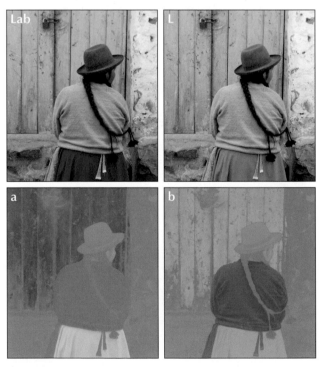

Figure 7-145. In Lab mode, the brightness values are contained in the L channel (L for lightness), and the color information is totally separate in the a (magenta-green) and b (yellow-blue) channels.

Working with Curves in Lab

If you are new to working in Lab mode, then making adjustments in the Curves dialog box is a mixture of the comfortably familiar and the totally foreign. The familiar part is making adjustments to the L channel. Since it contains only brightness and contrast information, it behaves very similar to the RGB curve in an RGB file (Figure 7-146). The foreign part comes when you have to venture into the a or the b channel to adjust the color balance of an image (Figure 7-147). The type of curves that you might use in an RGB file will rarely produce good results in Lab mode. Before we get to the main tutorial images, let's explore some curves basics for working in Lab.

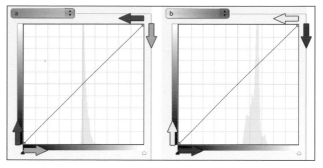

Figure 7-147. The basic opposing color relationships of the a and b curves (the color shading on the channel selector menu was added for this illustration).

The importance of the center point

An important thing to know about working with the a and b channels is the meaning of the center point on the curve grid. As long as the curve passes through this center point, there will be no change to the color balance of the channel. To accomplish such a move you need to move the corner points horizontally along the top or bottom by the same amount. Doing so will always ensure that the curve runs through the center point. The effect that this has on your image is to increase the intensity or saturation of colors; the steeper the curve, the more intense the colors (Figure 7-148 and Figure 7-149).

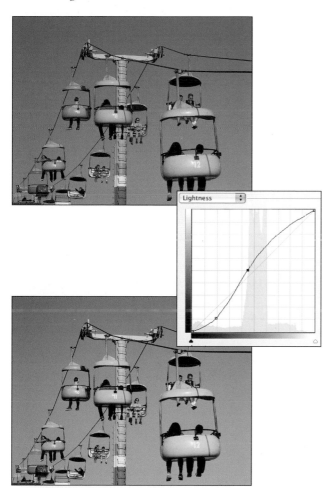

Figure 7-146. The L channel contains only brightness and contrast information. The curve adjustments you make to the L channel are similar to what you might do to the RGB curve.

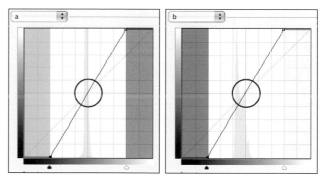

Figure 7-148. The importance of the center point: By moving the corner points the same distance along the top or bottom of the curve grid, the curve will always pass over the center point of the grid. This will increase the intensity of colors but will not change the overall color balance.

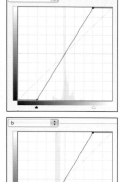

L: 60
a: 0
b: 0

L: 60
a: 0
b: 0

Figure 7-149. Left: The original image. Right: After applying the a and b curves shown at the far right. The colors have been intensified, but the overall color balance has not changed. Specifically, the 50% gray area at the bottom of the image has not changed in value. Values of 0 for the a and b channel indicate a neutral tone.

Controlling brightness and contrast with the L channel

The best way to become familiar with how making adjustments in Lab color can help with tricky images is to give it a try. In the following tutorial the problem photo has brightness, contrast, and color cast issues. The scene was photographed in the late afternoon shadow of the Andes in Peru, which yielded a low-contrast image. Adding to the overall blue tint from the shaded light is the fact that farmers were burning their fields nearby and clouds of bluish smoke were drifting through the scene. Some targeted adjustments in Lab color mode work very well for this image (Figure 7-150).

🖰 ch7_Lab-Plowing.jpg

1. Open the file and convert it to Lab by choosing Image→Mode→Lab Color.

2. Add a Curves adjustment layer. In the Lightness curve, move the shadow corner point horizontally along the bottom of the grid to a point where the histogram detail begins (approximately the third vertical gridline in from the left). Do the same thing to the highlight point in the upper-right corner: Move it along the top of the grid to where the histogram shape begins (one vertical gridline in from the right). The image in Figure 7-151 is looking better already!

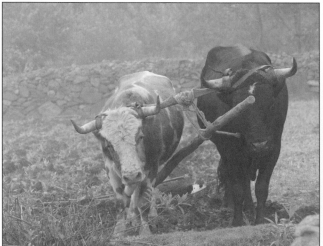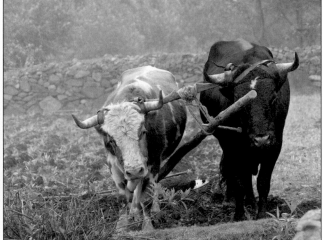

Figure 7-150. Plowing the field: A low-contrast original with a bluish cast caused by the late afternoon shadows of the Peruvian Andes and smoke from nearby burning fields. On the right, the Lab-corrected version. © SD

Now, if you're thinking that you could accomplish the same thing with the RGB curve, you would be correct...sort of. In order to adjust the brightness and contrast in an RGB file, the color channels have to be adjusted. In the worst cases, this can sometimes lead to color shifts. In the case of this image, no new color shifts have been introduced, but the existing blue colorcast is more apparent and the overall result is not as good as the same adjustment applied to the Lightness channel (Figure 7-152).

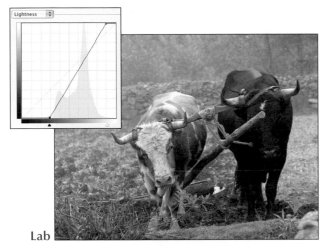

Figure 7-151. Moving in the endpoints of the L channel improves the contrast of the image and even helps remove a bit of the blue cast.

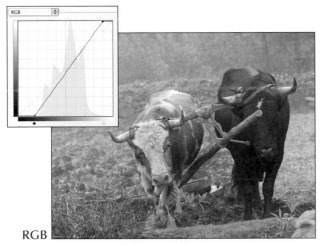

Figure 7-152. A similar adjustment applied to an RGB version of the file is certainly an improvement over the original, but the bluish color cast is even more pronounced.

3. From the channel selector at the top of the Curves dialog box, choose the a channel. Move both corner endpoints in one-and-a-half grid lines. Switch to the b channel and make the same adjustment. This helps boost the color saturation. You can see it most in the hide of the brown bull and in the green foliage at the bottom of Figure 7-153

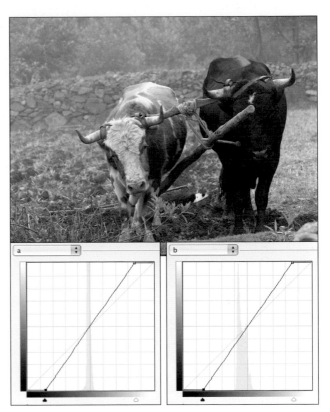

Figure 7-153. Moving the a and b channel corner endpoints in by equal amounts increases the color saturation of the image but also makes the blue cast more noticeable.

Removing a color cast with the a and b channels

4. The image still looks a bit too blue. Since we're already in the b channel, which is where blue can be influenced, we'll warm up the image a bit. Move the highlight corner point in a bit more to the second vertical gridline. This subtracts blue by adding a bit of yellow (Figure 7-154).

5. Now for some final fine-tuning. In the image, Cmd/Ctrl-click the trees above the stone wall to place a control point there on the b curve. Now add several other control points on either side of this point. These will serve as lockdown points so other areas of the curve do not move. Return to the point that represents the trees above the wall. Use the arrow keys to nudge it to the left and up a bit. This adds more yellow to the midtones. Switch to the a channel and do the same thing to add magenta-red to the midtones. The move in the a channel will be much more subtle and slight than the one in the b channel (Figure 7-155).

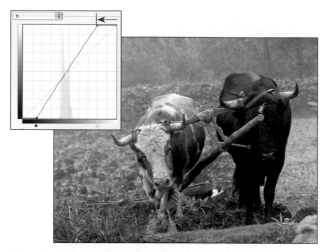

Figure 7-154. *Moving the highlight b channel endpoint in to the second vertical grid line subtracts some of the blue.*

Dodging the bull's face

6. As a final step for this image, we lightened the face of the black bull. Add a new Curves adjustment layer. Click the bull's face to see where that point is located on the curve. Drag that point up and lighten that area to taste. You might also want to place a point down near the corner and drag that down to preserve the contrast. The entire image will be affected, but we'll fix that in the next step. Click OK.

7. Choose Image→Adjustments→Invert to switch the layer mask from white to black. Choose the Brush tool and an appropriate-sized soft-edged brush tip (we used a 150-pixel brush). Press D to set the default colors which will place white in the foreground swatch. In the Options bar for the Brush tool, set the opacity to 30%, and begin painting over the areas of the bull's face that you want to lighten (Figure 7-156).

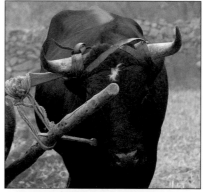

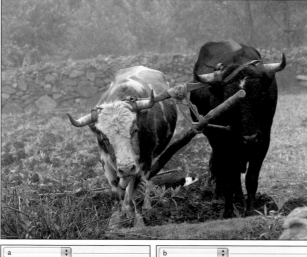

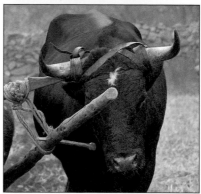

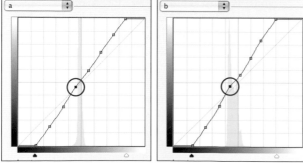

Figure 7-155. *Two subtle adjustments to the midpoint of the a and b channels add yellow and magenta to the midtones to warm up the image.*

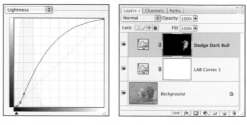

Figure 7-156. *A second Curve layer with a layer mask opens up the shadows on the black bull's face by raising the lower part of the Lightness curve.*

Build a Custom Color Correction Filter

The fact that the color values are separate from the brightness and contrast let you do some interesting things in Lab that are not possible in RGB. One technique based on this property of Lab is to add a Photo Filter adjustment layer, sample the color that is responsible for the cast, and then use inverted values for the a and b channel to correct the cast (Figure 7-157).

Figure 7-157. A strong color cast is corrected by using a custom Photo Filter layer based on inverted Lab values. © SD

🖰 ch7_TypewriterLAB.jpg

1. Open an image with an obvious color cast, or you can use the typewriter image featured here. Choose the Eyedropper tool and Shift-click an area that should be a neutral tone to place a color sampler point there. The top of the typewriter just above the manufacturer's name is a good place in this image (Figure 7-158). Jot down the values for the a and b channel.

2. Add a Photo Filter adjustment layer. Click in the color swatch to open the Color Picker. In the image, click the area where you placed the color sampler point to change the Color Picker to display this color. In the numeric fields that show the Lab values, invert the numbers for the a and b channels. Do this simply by adding a minus symbol if the number is positive (as is the case with this image), or by removing a minus symbol if it is a negative number (Figure 7-159). Click OK.

3. Back in the Photo Filter dialog box, raise the Density setting until the color cast begins to be neutralized. For the typewriter image, we ended up using a density of 80%. Click OK (Figure 7-160).

Figure 7-158. A color sampler is placed on an area that should be neutral or close to neutral. Inverted versions of the a and b values will be used to create a custom color correction filter.

Figure 7-159. After clicking the color swatch in the Photo Filter dialog box, the specified color in the image is sampled, and then the a and b values are edited in the Color Picker. In this case, 14 and 34 were changed to -14 and -34.

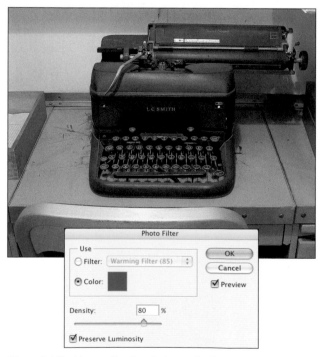

Figure 7-160. After configuring the inverted color values for the a and b channel, increase the Density setting as necessary.

If you like the effect of an adjustment layer, but would like it to be just a little bit more, duplicate the layer and see what a double dose looks like. In the case of the typewriter image, we used the Cmd/Ctrl-J shortcut to duplicate the Photo Filter adjustment layer. Then we double-clicked the layer thumbnail to reopen the Photo Filter dialog box and changed the Density setting for the duplicate layer to 60% (Figure 7-161).

Figure 7-161. This shows the result of duplicating the first Photo Filter layer and lowering its Density setting to 60%.

When to Use Lab

In the hands of a skilled technician or artist who is familiar with the ins and outs of working in Lab, that color space can be used with many types of images: the good, the bad, and especially the ugly. But for those who are new to Lab, it is probably best suited for images that have significant "issues" you are having trouble with using more conventional solutions. Lab is great at cutting through hazy indistinct shots, creating custom color correction "filters," and, when used correctly, working wonders on old scans that suffer from low contrast and an abysmal color cast.

The primary strength of Lab is the separation of brightness and contrast from the color values. And while the Lightness channel is easy enough to figure out, working with curves in the a and b channel can take a little getting used to. Though it might seem like rocket science at times, it's really not. It's just color. And with a little practice, even the mysteries of Lab color can eventually seem as commonplace as RGB.

A Journey Through the Landscape of Color

Color is all around you. You see it every day. Indeed, you have been looking at it your entire life. But looking at color and *seeing* color are two very different things. To look is to cast your gaze around you and to notice. To see is to go beyond looking and come closer to comprehending and understanding the color. And this comprehension of color, how it affects the delicate balance in a scene, and how you can best capture it with a camera and work with it in the digital darkroom, is of critical importance to a visual artist. It is the difference between what is and what is possible.

We feel truly fortunate to be able to use some of the most wonderful digital imaging software in the world in our digital darkrooms. But at the heart of our journey through the landscape of color, the numbers and math and nuances of software fade away, and we are left with the basic observations and questions that we started with when we first looked at a photograph we had taken. And these observations and questions are not framed in software terminology. They are the broad strokes of simple inquiry into what the image is now and how we might make it better. What is and what is possible.

Figure 7-161. Some photographs require very little adjustment and recognizing when not to edit is also an important digital darkroom skill. This 8-second exposure taken in Acadia National Park has only received minor contrast and saturation adjustments. © SD

Creative Color

As photographers look through the viewfinder to compose images, we are really seeing the image in our mind's eye, which is rarely the image that the camera records. A camera cannot appreciate composition, color, and detail, or revel in juxtaposition, irony, and beauty. For years, photographers have been using color correction and color balancing filters to refine how color film captures and renders a scene. In the digital darkroom you can enhance your images with subtle to dramatic color enhancements that mimic and expand upon traditional photography color filters and gels, as addressed in this chapter, to:

- Warm and cool a scene's hues

- Experiment with color temperature

- Explore image mode blending

- Create cross-processing effects

Color is the musical score of the image, and just as the musical score changes how you feel about a movie scene, the image's color treatment will influence or, more fittingly said, will "tint" the viewer's emotional response. The ability to experiment with image adjustment layers and creative raw conversions is a source of inspiration for us, and it is often surprising how the subtlest color adjustment can shift the emotional impact of an image. Please note: before delving into the wonderful world of creative color, it is essential that the image is properly exposed and free of any colorcasts, and that the density is correct. If the image is too dark or light or has a colorcast to begin with, you'll never be able to enhance the emotional aspect of the color effectively.

Chapter 8

The Structure of Color

Color can be perceived, shifted, interpreted, and twisted in many different ways. But rather than randomly moving sliders about, working with, experiencing, and thinking of color as being composed of the three attributes—hue, saturation, and luminance (also called brightness)—offers tremendous potential:

- Hue: What color it is
- Saturation: How much color there is
- Luminance: How much light is in the color

This triad approach allows you to refine and interpret color precisely, creatively, and flexibly. For example, if the hue is accurate while the saturation or luminance is off, the image will suffer, as seen in Figure 8-1, which shows the same image with separate hue, saturation, and luminance shifts. Applying creative color effects requires us to work with and think about not only "what color" but also "how much" and "how light or dark" the color is. The Photoshop tools and techniques used to influence color rendition include: image adjustment layers, layer blend modes, layer masking, image mode blending, and raw conversion settings.

When experimenting with creative color techniques, keep your expectations and adjustments within your printer's capabilities. Pushing color with extreme color gamut moves and an aggressive use of saturation can create images that simply do not print well. Make sure to maintain the layers in the master file to be able to adjust and refine the file after making a test print.

Working with Hue

Warming images with red, yellow, and orange tones makes them more appealing, and our eyes are naturally attracted to warmer colors. Cooling an image with blues, greens, and aquas creates a feeling of strength and power in an image. Working with layers and layer masks enables you to influence selective image areas, and using a complimentary color palette to cool the shadows and warm the highlights can add intriguing visual tension to an image.

Correct version

Too light

Over saturated

Too magenta

Figure 8-1. A variety of color problems can plague your images. © KE

The most straightforward creative color applications mimic the traditional photographic filters that photographers used to warm or cool images. When working with film, photographers would use an 81A filter to warm a portrait (Figure 8-2) or use stronger warming filters to enhance the colors of a sunset, while using cooling filters on images with a lot of sky or snowy landscapes to strengthen the icy effect, as seen in Figure 8-3. In the digital darkroom, you have the ability to easily and accurately enhance a variety of colors. In Figure 8-4, Katrin enhanced both the blues and the reds in the image to accentuate the complimentary colors of the antique car and license plate. Taking this concept of working in selective areas of an image a step further, you can also combine color interpretations with density and focus changes, as the progression in Figure 8-5 shows.

Figure 8-2. Using an 81A warming filter when shooting or, as seen in this example, adding warmth with the Photo Filter 81A, warms the skin tones nicely. © Jennifer Trenchard

Figure 8-3. Adding a hint of blue cools the image appropriately and offsets the drab grayness of the scene. © Brian Nielson

Figure 8-4. Enhancing the blue values and accentuating the reds in the license plate create a more dynamic image. © KE

Figure 8-5. Enhancing the pinks and blues and adjusting density and sharpness yields a more dramatic image. © KE

Which Photo Filter to Use and When

Professional photographers use color conversion and light balancing filters while taking color photographs to compensate for undesired color casts that can result from working at certain times of day, at higher altitudes, or in artificial lighting situations. The image adjustment Photo Filters mimic the filters that professional photographers use to correct for color temperature contamination and shifts. The two primary types of color compensation filters are warming and cooling. The warming filters are orange to amber in color and subtract blues and cyan. The cooling filters are blue in color and subtract red, green, and yellow.

- The 85 and LBA are warming filters. Amber in color, you can use them to accentuate the warm rendition of a sunset or sunrise and to enrich skin tones. The 85 name is a Kodak reference, and the LBA filter is an almost imperceptibly stronger filter with a Fuji film naming convention.

- The 81 filter is a milder warming filter. Pale amber in color, you can use this filter to remove blue tones in photos taken on overcast days or to clear up bluish shadows in sunny scenes. It is also an ideal filter for adding warmth to portraits.

- The 80 and LBB are cooling filters. Blue in color, you can use them to correct pictures with strong yellow to orange colorcasts created by taking the picture in tungsten or candlelight. The LBB blue has the slightest hint of magenta in it and is based on the Fuji LDD filter, while the 80 is based on the Kodak filter.

- The 82 filter is a milder cooling filter. Use it for waterfalls or snow scenes to turn them slightly blue, emphasizing the coolness of the subject.

Photoshop Photo Filters offer a subtle power to improve images. Since the Photo Filters are adjustment layers, you have the additional advantage of being able to adjust their strength with the layer opacity and layer blending modes, as well as control where the corrections take place with layer masks. We're not suggesting that you take bad pictures on purpose, but now you will be able to improve those photos that didn't turn out the way you expected.

Previewing Color Tints

Seeing a variety of color tints on an image can be a helpful aid to jumpstart the color tinting process, which is why many people use Image→Variations to view a color ring around their images. The problem with Variations is that it works only on 8-bit images and is not an image adjustment layer feature. This means you either have to duplicate the background layer to work non-destructively or use it as a quick preview to apply similar effects with other Photoshop features such as Photo Filter or Hue/Saturation adjustment layers.

A more flexible and non-destructive color preview can be achieved by adding a full spectrum gradient to your image, as explained here.

⌐ ch08_hawk.jpg

1. Choose Edit→Preset Manager, and use the pull-down menu to select Gradients. Use the fly-out menu to select Spectrums. After releasing the mouse, make sure to click Append to add the Spectrums gradients to your gradient palette without replacing the original gradients.

2. Select Layer→New Fill Layer→Gradient, and then select the Spectrum gradient, as highlighted in Figure 8-6. We find that Linear or Angled works best for this exercise.

3. Click OK and change the layer blend mode to Color and the layer opacity to 30% to preview the image with a wide variety of color tints, as seen in Figure 8-7.

4. In this example the blue/violet tinted areas gives the image a quiet strength. To apply this specific color to the entire image, in the layer palette, click the Background layer, and use the Eyedropper tool set to 3 by 3 pixels to sample the desired tint.

5. Discard the Gradient fill layer and add a Photo Filter adjustment layer. Click the color swatch in the Photo Filter interface, and then use the Eyedropper to click on the foreground color in the toolbar.

6. Adjust the density. In this example we used 35% to create the final image, as seen in Figure 8-8.

Using the Gradient Fill layer to preview color tints is a quick, non-destructive technique to explore color tinting.

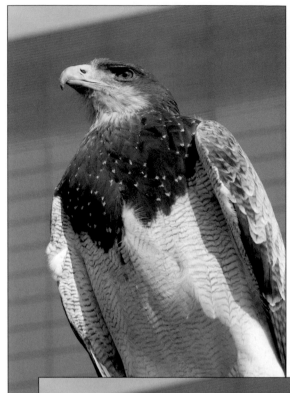

Figure 8-6. Use the Spectrum gradient to preview color choices.

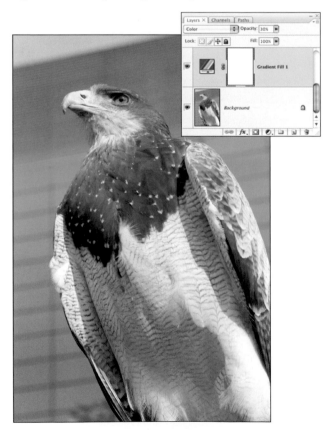

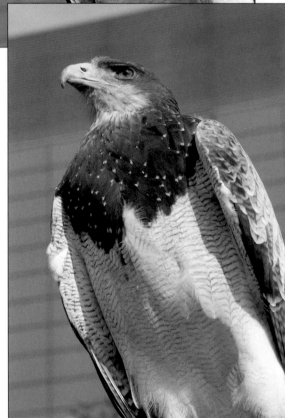

Figure 8-7. Viewing the image with the low opacity Gradient enables you to preview how colors influence the image.

Figure 8-8. Slightly cooling the image imbues the bird with a subtle undertone of nobility. © KE

Warming Images

Whenever there are people in an image, adding a subtle warming effect with the 81 Photo Filter will warm the skin tones and make the image more appealing, as seen in the before and after example in Figure 8-9.

🖑 ch08_2girls.jpg

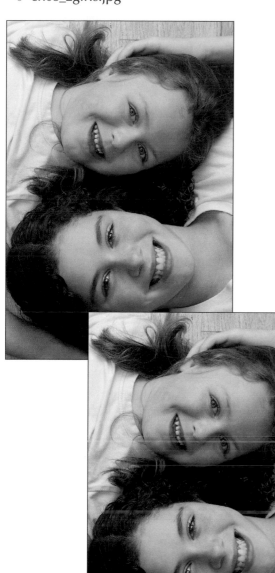

Figure 8-9. Warming the image livens up the skin tones. © Mark Beckelman

1. In the Layers palette, click the "create new fill or adjustment layer" icon, and choose Photo Filter.

2. Choose Warming (81) and adjust the density. In most cases when working with skin tones we keep the warming filter setting between 5-20% density.

> When using the Photo Filter keep the Preserve Luminosity checkbox checked to insure that the image density will not change as tints are applied.

Adding warmth selectively

Many times you'll want to warm a specific section of the image. Start with a selection, and Photoshop transfers the selection to the layer mask when you add the adjustment layer. Only the active areas (which appear white in the layer mask) will be affected, as shown in Figure 8-10 in which the door was warmed to contrast with the coolness of the winter day.

🖑 ch08_door.jpg

Figure 8-10. Just slightly warming the door and increasing its contrast gives it a stronger visual presence. © KE

1. To select clearly defined colors and shapes such as the door, use the Quick Selection tool and drag it around the entire door in a circular pattern to create the active selection.

2. In the Layers palette click the "create new fill or adjustment layer" icon and choose Photo Filter. Use Warming (85) in this example and increase the density to 50%.

3. To increase the effect of an adjustment layer we often cycle through the blending modes to what effect they will have. In this example, selecting Soft Light with a layer opacity of 50% pumped up the door to enhance the wood beautifully as shown in Figure 8-11.

Figure 8-11. The Soft Light blending mode increases contrast, which in this example adds a subtle pop to the image.

To learn how to blend colors based on tonal values to create more dramatic effects, see the upcoming "Sophisticated Color Blending" section.

Cooling Images

Cooling an image imbues the scene with serenity and strength. Industrial, urban, and snow scenes are the classic candidates for cooling effects. In the example seen in Figure 8-12 adding a Photo Filter with Cooling (80) at 40% density cooled the image nicely. To increase the effect, we changed the blending mode to Overlay to create the final image.

Figure 8-12. The cooler version with the Overlay blending mode enhances the mood of the winter day. © KE

Cooling images selectively

As mentioned previously, creating a selection before adding an adjustment layer is one method to control where a change takes place. But many times, you may not know ahead of time if the color tint should affect the entire image or only parts of it. In those cases you can paint on the layer mask described here to protect certain areas from being affected, as seen in Figure 8-13.

🖰 ch08_statue.jpg

Figure 8-13. Cooling the sky removed the drabness that the evening sky had. © KE

1. Add a Photo Filter adjustment layer and use the Cooling Filter (82) with a 30% density. This cooled the sky nicely but took the focus away from the angel figure.

2. To block the blue tint from affecting the figure, use a soft-edged brush with black as the foreground color to paint over the figure. If you go "over the lines," tap the "x" key to switch from black to white, and then paint over the edge spill.

3. Painting on a layer mask can be an imprecise undertaking. Therefore before moving on, Option/ Alt-click the layer mask (Figure 8-14) to see the mask in black and white. This view will clearly show any gaps in painting that need to be refined. You can paint in this black and white mode, and then click the adjustment layer icon to return to the RGB view.

Figure 8-14. View the layer mask directly to check for gaps that need to be painted out.

Enhancing Natural Colors

As explained in Chapter 7, "Color Correction," there are numerous methods to color correct and enhance an image. On a more creative note, you can also use the Photo Filter adjustment layer to enhance the existing colors very naturally, as seen in Figure 8-15.

🔊 ch08_cactus.jpg

Figure 8-15. Strengthening the existing color in an image emphasizes the photographer's original intent. © KE

1. Add a Photo Filter adjustment layer and use whichever color matches the primary subject on the image. In this example, Katrin chose the Deep Emerald and increased the density to 65%.

2. To focus the green enhancement on the foreground cactus plants, use a Black, White gradient set to Linear, and start the gradient at the top of the cactus in the far background and drag down to the tip of the cactus in the foreground. The black to gray to white gradient will create a blend from color enhanced to natural color, as shown in Figure 8-16.

3. If desired, repeat the gradient on the layer mask to create the desired effect. Working with the gradient tool in Normal blending mode on the layer mask allows the new gradient to overwrite the existing gradient.

Figure 8-16. The Black, White Gradient on the layer mask controls where the color is visible.

Combining Color Tints

As with everything creative, a one size or one color fits all approach is rarely the norm. In many cases you'll want to warm and cool separate image areas. To accomplish this we'll use a variety of layer masking, painting, and blending techniques, as described here, to create the effect seen in Figure 8-17.

🖰 ch08_birdhandler.jpg

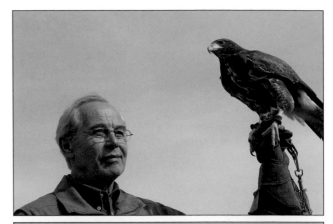

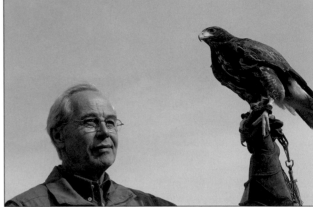

Figure 8-17. Warming the gentleman's face and cooling the sky created a more dynamic image. © KE

1. To warm the gentleman's skin add a Photo Filter Warming Filter (LBA) and increase the density to 33%. As you can see in Figure 8-18, this also warms the sky, which should remain blue. Making a mask for an image with so many important details as the man's hair and the bird's feathers would be a daunting undertaking.

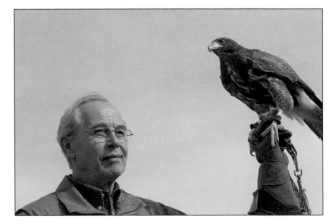

Figure 8-18. Warming the image improves the skin tones but ruins the blue sky.

2. To create an effective mask based on color, use the Blend If command on the adjustment layer to control where Photoshop applies the warming effect. Select Layer→Layer Styles→Blending Options. The area to concentrate on with this technique is the Blend If area in the lower part of the dialog box.

3. The topmost Gray sliders are excellent controls when blending images based on tone. To control how colors blend, use the Blend If pull-down menu and drag down to the color you want to control. In this example, it's blue, as we're trying to stop the sky from being warmed.

4. The This Layer sliders control the blues on the active layer—in this case, the Photo Filter layer—while the Underlying Layer sliders control the blues on the layer directly underneath. To bring back the lighter blue sky of the original image, move the triangular highlight slider of the Underlying Layer to the left, as seen in Figure 8-19.

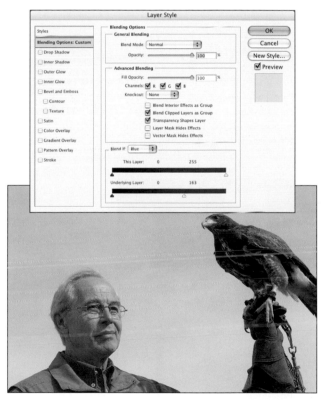

Figure 8-19. Pushing through the blue of the original sky allows the man to be warmer and the sky cooler.

5. There are no right or wrong numbers when using these sliders; simply move the appropriate slider until you see the desired effect, which in this case removed the warmth from the sky.

6. To refine the transitions, Option/Alt and drag the small triangles to separate the triangular sliders into two parts. The further you move the split triangles apart, the greater the transition you create. As you can see in Figure 8-20, the man's face and the hawk are warmed while the sky is the original blue.

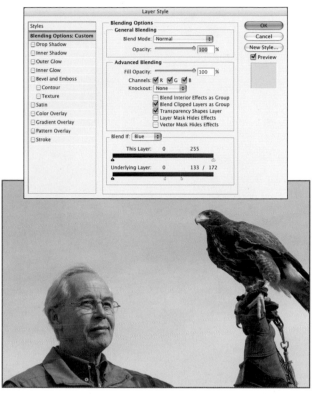

Figure 8-20. Separating the Blend If sliders creates an imperceptible transition that blends the colors together perfectly.

7. To enhance the blue of the sky repeat this technique by adding a new Photo Filter adjustment layer and choosing Cooling Filter (80). Select Layer→Layer Styles →Blending Options and, in this case, the desired blue color is cooling the darker areas of the man and the hawk of the image too much. By moving the This Layer shadow slider far to the right, the blue effect is concealed (Figure 8-21). Option/Alt and drag the shadow slider to split the slider and create an imperceptible transition.

The key to working with Blend If is to understand that moving the active This Layer sliders conceals the effect, while moving the Underlying Layer sliders reveals the layer's tones or colors through the This Layer.

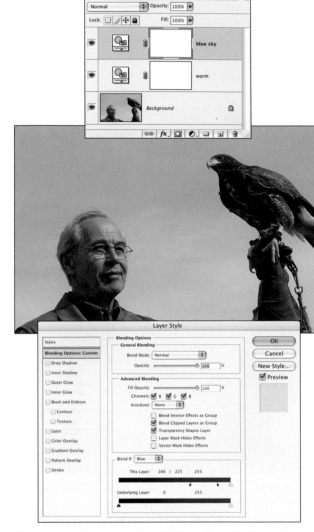

Figure 8-21. *Adjusting the Blend If sliders allows the blue to be enhanced, which frames the man and the bird beautifully.*

Neutral Density and Color Blends

Enhancing photographic color is emotionally similar to painting, in which a painter applies a brushstroke and then reflects, reacts, and responds to the brushstroke by adding complimentary brush strokes. In the process the image grows and changes and gains an identity of its own. In the case of sophisticated color blending, working with layers, masks, and blend modes enables you to experiment with the image and, admittedly, the final outcome often creates itself. It is best to start off subtly and build up the effect gradually. In the example seen in Figure 8-22, Mark Beckelman started with an early morning shot of the Chrysler Building in Manhattan and, with a few layers, created the much richer final image.

Figure 8-22. *Enhancing the image with color and contrast creates an intriguing morning mood.* © Mark Beckelman

🖱 ch08_Chysler.jpg

1. Photographed against the light on a warm summer morning, the air is thick with humidity, which reduces the image contrast. To push the less important buildings on the left out of visual interest, add a Curves adjustment layer and, as seen in Figure 8-23, push the shadow detail down to darken the buildings.

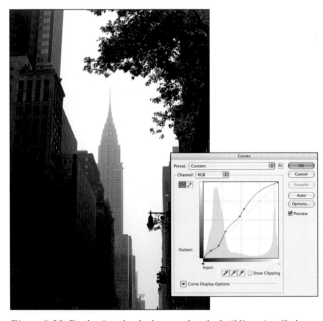

Figure 8-23. *Darkening the shadows makes the building visually less important.*

2. To enhance the morning light, load the pastel gradients by selecting Edit→Preset Manager, use the pull-down menu to select Pastels. Click Append to add them to the Gradient palette.

3. Add a Gradient Fill layer and use the Linear Yellow, Pink, Purple pastel gradient, which, as you can see in Figure 8-24, obliterates the entire image. Since this gradient is on its own layer, the Multiply blend mode with 23% opacity will enhance the image perfectly (Figure 8-25).

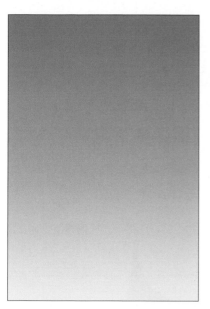

Figure 8-24. The pastel gradients mimic softer light.

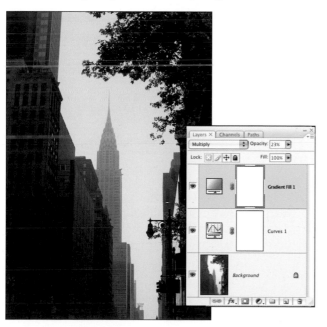

Figure 8-25. Changing the layer blend mode to Multiply and adjusting the layer opacity creates an early morning mood.

As is often the case, the creative process requires that you work flexibly and, in this instance, Mark wanted to add density to the sky and warm the buildings to better reflect the new color of the light.

1. To warm the buildings while not affecting the rest of the image, we need a selection that excludes the sky and included the buildings. Of course, there are many ways to make a selection, but in instances that are so clearly defined, you can let Photoshop do the work. Cmd/Ctrl-click the icon of the green channel in the channel palette to activate the tonal values of the channel into an active selection, as seen in Figure 8-26.

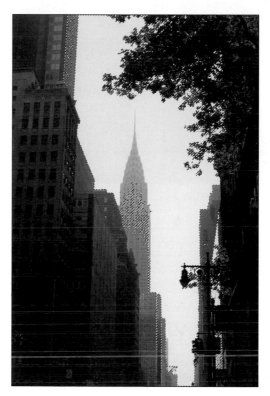

Figure 8-26. Using the channel tonality to effectively create an accurate selection.

2. In the Layers palette, click the layer beneath the gradient, and add a Photo Filter adjustment layer with the standard orange. As you can see in Figure 8-27, the lighter portions of the image are now orange, which is exactly the opposite of the desired effect.

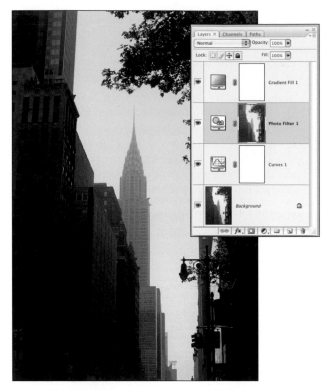

Figure 8-27. The channel luminosity is the start of a very accurate layer mask.

3. Choose Image→Adjustments→Invert to invert the tones of the layer mask, and then increase the mask contrast with Levels, as seen in Figure 8-28. This makes the buildings warmer without changing the sky. When you try this technique on your own images you may want to use a Gaussian Blur filter of 2-5 to soften the transitions of the mask. In this example, it's not needed, but we often use it.

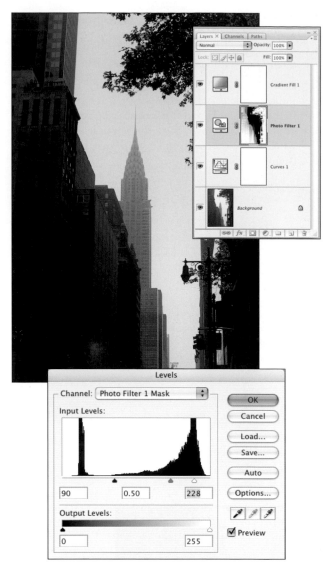

Figure 8-28. Levels enable you to increase the contrast of the layer mask very quickly.

4. For the final polish, add a slight neutral density effect, which is similar to a filter many photographers carry to reduce and balance the exposure of the sky. One way to create a neutral density effect is to add a new layer and sample an existing dark color in the image. Click the Gradient tool in the tool bar. In the options bar, select Foreground, Transparent, and then draw the gradient from the top of the image half way down the image, as seen in Figure 8-29.

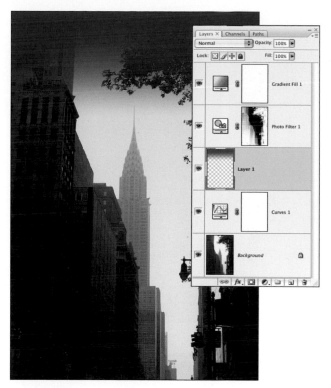

Figure 8-29. The neutral density filter darkens the sky.

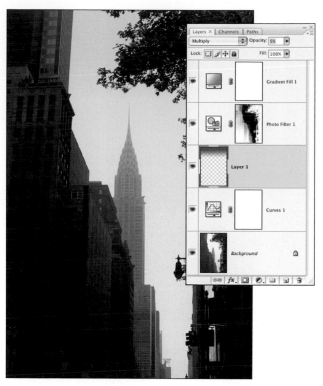

Figure 8-30. The Multiply blend mode darkens the sky, and the 5% opacity is all that is required to create the final image.

5. Changing the blending mode to Multiply and reducing the opacity to a mere 5% darkens the sky and brings the viewer's eye down into the image, as seen in Figure 8-30.

The next time you're paging through a travel magazine, take a moment to study the full color advertisements. We're sure you'll start seeing a lot of color enhancements and color gradients in the landscape and golf course pictures.

> When experimenting with gradients by changing blending modes and types of gradients, it is very important to double-check the Gradient tool settings in the options bar the next time you launch Photoshop. We dare not say how often a gradient didn't work as expected when we sheepishly realized that we were trying to use a Foreground to Transparent gradient set to Multiply with a white foreground color. Stymied: This is impossible as white never has any effect with Multiply.

Creative Color Temperature

We've all made the effort to wake before sunrise to take pictures in dawn's golden hour or stayed out late to shoot during dusk when the light is raking across the landscape. The amount, strength, size, direction, number of, and color of the light source determine the quality of light. Although Photoshop can't change the time of day in which you shot the image, it can influence the image's color rendition to infer moods and emotions.

The color of light is measured in Kelvin, which is based on a scientific 'black body' that changes color as it is heated up, similar to how a cast iron pan that is left on an open flame changes color from red to yellow to blue to white hot. In a theoretical light source, as the voltage increases the filament becomes hotter, and its color shifts from reds to yellows to blues to white. Table 8-1 shows a few of the most common light sources and approximate color temperatures. Most importantly, you want to be aware of how color temperature is an essential aspect of your photographic palette, as the images in Figure 8-31 show.

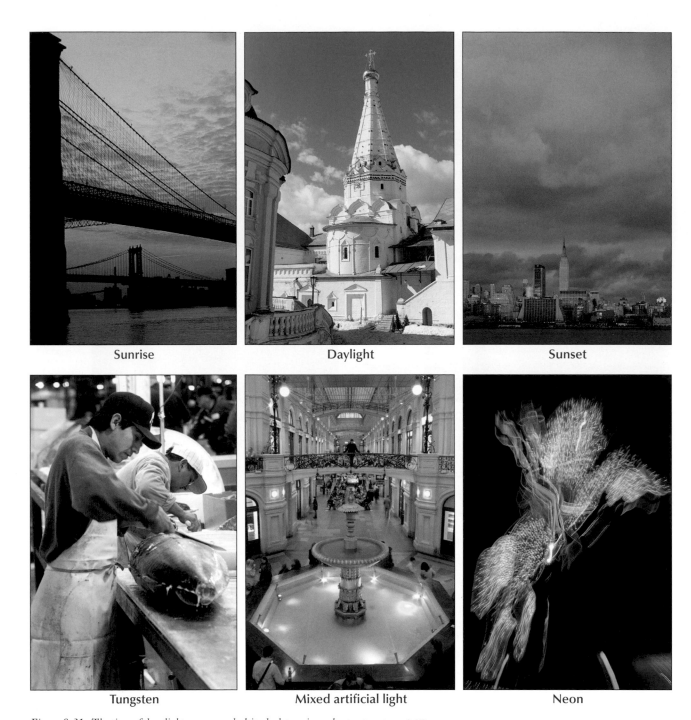

Sunrise | Daylight | Sunset

Tungsten | Mixed artificial light | Neon

Figure 8-31. The time of day, light source, and altitude determine color temperature. © KE

Table 8-1. Color Temperatures

Source	Color Temperature (in Kelvin)
Candle	1850-1900
Sunrise/sunset	2000-2500
Sodium vapor	2100
Household incandescent	2500-3000
Fluorescent	4000-4500
Electronic flash	4500-5500
Daylight	5000-5500
Cloudy, overcast sky	6000-6500
Summer shade	7000-8000
High-altitude blue sky	12,000 and higher

When working with color film, photographers can choose from two primary color temperature film stocks: daylight or tungsten-balanced films. With the use of a color meter and Kodak Wratten color correction filters, photographers would measure and compensate for the light's color temperature to capture neutral images. With digital cameras, you have a number of color temperature presets including Auto, tungsten, fluorescent, daylight, and open shade, and you can also build a custom white balance that acts similarly to the filters photographers use to place on the lens to balance the light when working with film. When shooting in the raw format you can also choose a color temperature setting after the fact in the raw conversion software to apply a false or, shall we say, "creative color temperature" that alters the mood of a scene, as explained later in this section.

Neutral is overrated

In most cases the goal of processing digital files is to create color-neutral and well-exposed images, but in many cases neutral is simply not the best choice for an image. Take a look at the comparison in Figure 8-32, which shows how Katrin saw, and the camera recorded, the pre-sunrise shot of the Brooklyn Bridge, and then how a raw converter set to automatic sucked all the passion out of the scene. Adding creative color interpretations during raw processing is a very subjective and emotional progression that can be a welcome break from the dogma of neutral, picture-perfect image production.

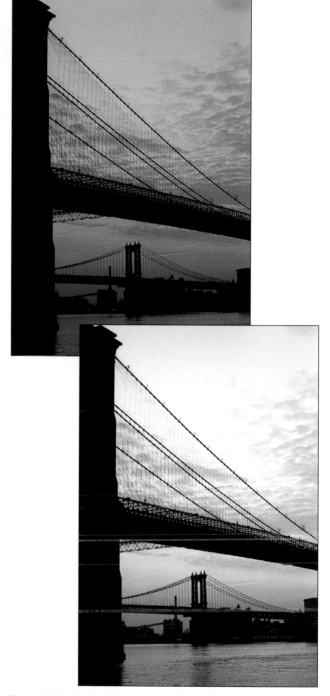

Figure 8-32. Pay attention to the light around you and be careful when using auto white balance and auto color correction in the raw conversion process, as it can leech the life out of an image.

Adobe Camera Raw and Photoshop Lightroom are tremendous tools to enhance the emotional aspect of images by letting you bend the rules of reality-bound image processing to create subtle and moody images. The advantage of doing creative work in Adobe Camera Raw or Photoshop Lightroom is you can rework and reinterpret the same image many times without ever degrading the original file. Additionally, the benefit of experimenting in the raw processor is that all the controls to influence color, contrast, and exposure are close at hand, enabling you to work very fluidly as you tweak one setting and then refine another. For a thorough overview of the Adobe Camera Raw features, see Chapter 3: "Scan, Develop, and Organize."

Creative raw processing

Some of the methods to use raw processing to explore creative interpretations include;

- Applying technically incorrect but aesthetically appropriate false color temperature settings.
- Starting with a neutral image and adjust the color temperature sliders.
- Using the White Balance tool on an area that is not naturally neutral.
- Exploring color interpretations via the color adjustments, split toning, and calibration sliders.
- Combining raw file interpretations to create the ideal image

> When experimenting with extreme creative raw processing work it is best to work with graphical images rather than images with very subtle transitions and fine detail.

Now you may be wondering, "Why would I want to interpret the image in Adobe Camera Raw or Photoshop Lightroom when I can achieve similar effects in Photoshop or Photoshop Lightroom?" For us, the advantage of doing creative work in Adobe Camera Raw or Lightroom is that we have all the tone, contrast, and color controls in one interface or module, which enables us to bounce back and forth and react to the image rather than digging through endless palettes or panels. Of course this fluidity comes with the caveat that all changes are made to the entire file, as neither Adobe Camera Raw nor Photoshop Lightroom supports selections, layer, and layer masks. At the end of this section we'll show you how to work around this limitation using Smart Objects and compositing skills to create the ideal image by processing a file more than once and combining multiple renditions in Photoshop.

False color temperature. The most straightforward method of experimenting with false color temperature to create a large variety of image interpretations is seen in Figure 8-33.

ch08_tombstone.dng

Working Smart with Smart Objects

Before you dive into the world of creative color, always put on your water wings or life preserver to keep your head above the raw waters. In this case, we highly recommend working with Smart Objects, which in Photoshop CS3 with Adobe Camera Raw 4 (or later) is both an easy and convenient feature that gives you access to Adobe Camera Raw controls even after the image is in Photoshop.

To create a Smart Object in Photoshop CS3 from any file format that Adobe Camera Raw supports (raw, DNG, JPEG, and TIFF), in the Camera Raw dialog box, shift-click on the Open Image button to change it to the Open Object button. For the greatest flexibility and highest image quality it is best to start with either a raw or DNG file created from a camera raw file, as they are always true high-bit files.

To create a Smart Object in Photoshop CS2, start with a new empty file and use File→Place to navigate to the desired raw file. Upon clicking the raw file, Adobe Camera Raw will open, and clicking Open will place the raw file into the Photoshop document. Tap the Enter or Return key to accept the placement, and continue as described in the following section.

At present, Photoshop Lightroom 1.3 does not support the creation of Smart Objects, which is a shame. On the other hand, all of the creative camera raw processing approaches and effects shown in this section can be created in Photoshop Lightroom.

Figure 8-33. Experimenting with "incorrect" or false white balance settings reveals unexpected and creative color interpretations.

1. Open a raw file in Adobe Camera Raw, and use the White Balance pull-down menu, as circled in Figure 8-34, to select a new color temperature.

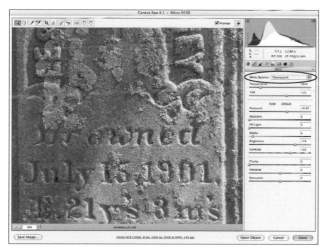

Figure 8-34. Use the White Balance pull-down menu to see a variety of color interpretations and inspirations.

2. After the color best reflects the mood, adjust the exposure, shadow, and brightness of the image to render your vision.

3. Shift-click the Open Image button to bring the raw file into Photoshop as a Smart Object.

4. To experiment with multiple iterations select Layer→ Smart Object→New Smart Object via Copy. Although this seems like the long way to duplicate a layer, simply dragging a Smart Object to the new layer icon creates a duplicate that references the original Smart Object. Making a change to this dragged copy in Camera Raw will also apply the change to the original. You can also use the Layers palette context-sensitive menu by Cmd/right-clicking the name of the Smart Object, and selecting New Smart Object via Copy.

5. Double-clicking the layer icon will open Adobe Camera Raw, allowing you to adjust or change the white balance of the duplicated file.

6. As the layer palette in Figure 8-35 shows, Katrin experimented with each white balance and named the layers after the White Balance setting she used.

Interestingly enough, while creating the different Smart Objects, she thought that the tungsten setting was the best, but after some consideration, the fluorescent setting adds the appropriate lonely mood to the image of the tombstone. This goes to show that you have to see the modified image before jumping to conclusions.

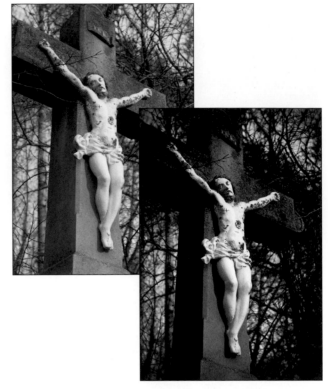

Figure 8-35. *Experimenting with the White Balance variations reveals new interpretations of the same image.*

Figure 8-36. *Photographed on a November afternoon and reorchestrated with creative color to better render the original perceptions.* © KE

Adjusting White Balance. As Figure 8-36 proves, what the camera recorded and what Katrin perceived are very different. For greater control over the color rendition of your images try this method that starts with a neutral image and then interprets it by shifting the white balance in Adobe Camera Raw or Photoshop Lightroom.

🖱 ch08_crucifix.dng

1. Use the White Balance tool and click the part of the image that should be neutral, such as white or gray studio backdrops, white or light clothing, eye whites or teeth, concrete, gray rocks, or the second white square of a known reference such as a Macbeth Color Checker. In this example, clicking the white leg, as seen in Figure 8-37, neutralizes the image.

Figure 8-37. *Neutralizing an image creates a fresh palette for color interpretation.*

2. Adjust the color temperature and tint sliders to create the color you desire. The Temperature slider controls the blue (left) to yellow (right) hues, and the Tint slider is responsible for the green (left) to magenta (right) tints, as shown in Figure 8-38. There is no right or wrong color shift, as this all depends on your goals and creative expectations.

Figure 8-38. Adjusting the Temperature and Tint sliders establishes the overall color palette.

3. After the color best reflects the mood you want, adjust the exposure, shadow, and brightness of the image (Figure 8-39) to push the sunny afternoon walk into the darker evening hours.

4. Increasing the Clarity slider to 30 adds a contrast boost just to the midtones, which helps to separate and define the figure very nicely.

Figure 8-39. Darkening the image enhances the moodiness of the scene.

5. Click the Lens tab to darken the image edges by taking the Vignette slider all the way to the left and moving the Midpoint to the left to increase the vignette effect (Figure 8-40).

6. Refine the image with the HSL/Grayscale controls, as you can see in Figure 8-41, to define the exact shade, saturation, and luminance of blue to best portray the dusky evening mood.

Figure 8-40. Adjusting the Lens Vignetting to darken the edges of the image creates an intriguing tunnel effect.

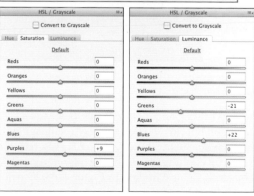

Figure 8-41. Adjusting the hue, saturation, and luminance of the blues and purples allows the wooded background to recede and the figure to become more prominent.

The not-neutral white balance. The following technique works especially well in Photoshop Lightroom as it takes advantage of the White Balance tool and the Navigator window to explore and preview white balance interpretations to create the image seen in Figure 8-42. You can create similar results in Adobe Camera Raw but it requires a few more mouse clicks.

🖱 ch08_cherub.dng

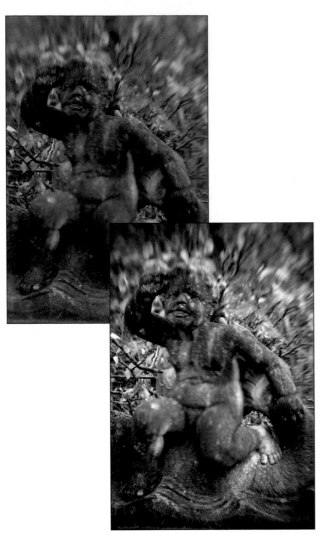

Figure 8-43. Moving the White Balance tool across the image without clicking updates the Navigator window.

2. When you see a color rendition that you like in the Navigator window, click the mouse, and that white balance will be applied to your image (Figure 8-44).

Figure 8-44. Clicking with the White Balance tool on areas that are not neutral skews the color rendition beautifully.

Figure 8-42. Photographed on a drab gray day, creative raw processing produces a completely different scene. © KE

1. In Phtoshop Lightroom, use the White Balance tool and place it on but do not click a part of the image that should not be neutral such as green leaves, red rocks, colorful clothing, or any of the colored squares of the Macbeth Color Checker. In Figure 8-43, Katrin discovered that white balancing a darker area under the figure's arm created a very nice blue wash, as seen in the Navigator window.

3. In both Adobe Camera Raw and Photoshop Lightroom clicking different image areas will apply a new white balance to your image.

4. Adjust the exposure and vignetting controls to create the image in your mind's eye. In this example, Katrin refined the exposure, vignetting, and color rendition by adjusting the blues and desaturating the orange leaves to place more emphasis on the stone figure, as seen in Lightroom's split before/after view shown in Figure 8-45.

Figure 8-45. *Viewing the image in the before/after split enables you to compare your progress with the original.*

Variations on one image. When evaluating prints in the traditional darkroom it was easier to compare the present print with the previous print to judge the progress of changes in exposure or color filtration. In Photoshop you can compare versions by using Cmd/Ctrl-Z or by making a history snapshot of the newest version to compare progress with previous snapshots. Take advantage of Photoshop Lightroom's Virtual Copies and Survey View to view and review processing variations in Lightroom.

1. In the Library module, click an image and select Photo→Create Virtual Copy or Ctrl/right mouse click and choose Create Virtual Copy, as seen in Figure 8-46. The Virtual Copy references the original image and does not create an actual copy, which could quickly fill your hard drive with redundant files.

Figure 8-46. *Creating a virtual copy.*

2. A bent lower-left corner and a number in the upper-left corner that shows which copy it is (as seen in Figure 8-47) signifies the virtual copy. Many times, Katrin will create two to three virtual copies to process one realistically, one creatively, and one as a black-and-white image.

Figure 8-47. *The virtual copy behaves exactly like the original file and is signified with the bent corner and a number.*

3. Working with a virtual copy is identical to working with the original file. After adjusting the individual virtual copies, return to the Library module to compare the processing variations by selecting them and pressing the N key, or by clicking the Survey View button to compare them, as seen in Figure 8-48.

Figure 8-48. Comparing the original with a blue version with a split toned version shows creative progression and encourages additional experimentation. © KE

Our visual system is very good at comparing images and less good at evaluating a single image. Using the Virtual Copies feature is a fantastic tool to experiment and learn without creating endless duplicates of high-resolution files.

Multiples of raw. Working with camera raw files enables you to revisit a file to reprocess it, exploring creative interpretations and, as explained here, process the same file more than once. With this approach you can bring out color attributes that can be combined to create a better image. In Figure 8-49 you see two interpretations of the same shot of the World Trade Center Memorial Lights. The final image in Figure 8-50 shows the results combining the two images with the Blend If command and some retouching to best reflect the photographer's vision. Working with raw or DNG files as Smart Objects, as explained here, allows for endless experimentation and creative discovery.

🖱 ch08_911Memorial.dng

Figure 8-49. Processing the same image twice with different color settings creates the foundation material for the final image. © KE

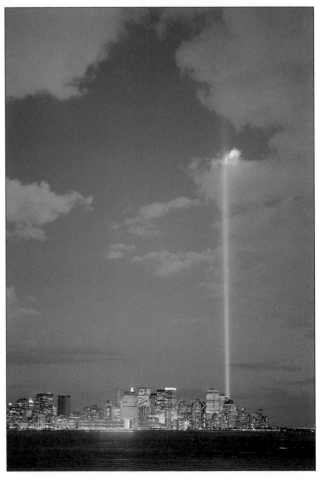

Figure 8-50. Combining the two interpretations and retouching the bright lights creates the final image. © KE

1. Open the image in Adobe Camera Raw and in this example use the Cloudy White Balance setting to enhance the blue sky. Adjust the color temperature slider to the left to bring out even more blue, as seen in Figure 8-51.

Figure 8-51. Processing the first rendition of the image to accentuate the blue values.

2. When working on your own images make sure to adjust the additional settings to create the best image possible while still in Adobe Camera Raw. In this example, we added a hint of additional contrast to the image and used the Lens Vignetting slider to lighten the corners of the image ever so slightly.

3. Shift-click the Open Image button in the lower-right side of the Adobe Camera Raw interface, and Photoshop will create a new document and place the raw file as a Smart Object.

To have Adobe Camera Raw create Smart Objects by default, click on the resolution workflow options link at the bottom center of the dialog box and check 'Open in Photoshop as Smart Object' as seen in Figure 8-52.

Figure 8-52. Determining how Adobe Camera Raw opens images as Smart Objects.

4. To reprocess the same file it is very important that you select Layer→Smart Objects→New Smart Object via Copy to create an independent duplicate of the first Smart Object file.

5. Double-click the copied layer icon to open Adobe Camera Raw again. In this instance, process the image to enhance the orange clouds. Increase the Color Temperature slider to the right towards the yellows, and use the HSL controls to refine the hue and saturation of the reds, oranges, and yellows, as seen in Figure 8-53. When experimenting with color like this there are no right or wrong settings. If it looks and feels right, it is right. You be the judge—without being judgmental.

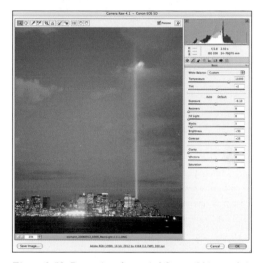

Figure 8-53. Processing the copied Smart Object to bring out the oranges and yellows in the clouds adds an otherworldly effect to the Memorial Lights.

6. To blend the two layers to create one image you could use layer masking to hide and reveal image areas. But it's much simpler and very effective to use the Blend If command to hide and reveal colors. Click the topmost layer and select Layer→Layer Style→Blend Options.

7. Use the Blend If drop-down menu to select Blue and, since the rich blue values are on the underlying layer, move the Underlying Layer highlight slider to the left, as seen in Figure 8-54. In this example, we moved the slider to 125, which tells Photoshop to reveal or punch through all blue values that are lighter than 125.

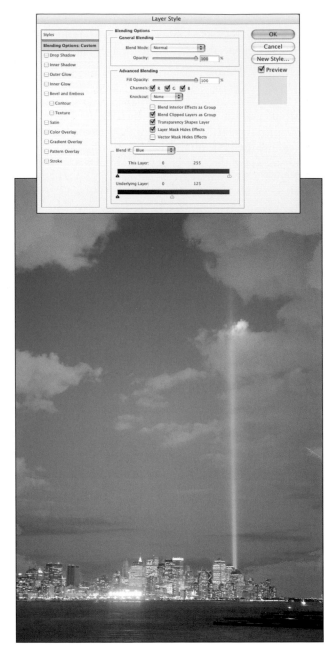

Figure 8-54. Adjusting the blue channel of Blend If pops the blue through to the upper layer.

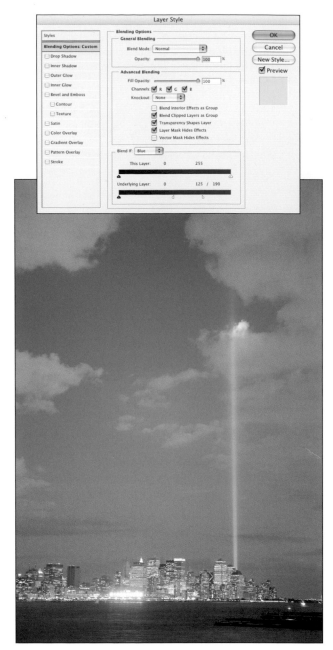

Figure 8-55. Separating the sliders creates a subtle transition.

8. To create a subtle transition between the blue and the orange, press Opt/Alt, and pull the right side of the highlight slider triangle to the right to separate the sliders. This creates a beautiful transition between the values of 125 and 190 (Figure 8-55).

9. Since both layers are still Smart Objects, you can still double-click either layer icon and refine the raw conversion. For example, you may prefer the orange clouds to be more saturated. Since this is easily accomplished in ACR we recommend refining the image as best as possible in ACR rather than adding additional adjustment layers. Whatever can be done in raw processing should be done in raw processing.

10. Retouching the file will require separate pixel-based layers to conceal the bright lights and remove the dotted streaks caused by an airplane passing through the frame during the long exposure. Make sure that the file is at the desired image resolution. Double-click on either Smart Object layer icon and double-check that the camera raw resolution settings are the right size for your print requirements. If you change one, you'll need to change the other. If you've increased the image resolution, select Image→Reveal All to increase the canvas size to contain the larger image.

11. After adjusting the image resolution, add a new layer and name it "retouch." Use the Clone Stamp and Healing Brush to repair the sky and to tone down the extreme highlights that were caused by the strong spotlights along the river edge, as seen in Figure 8-56.

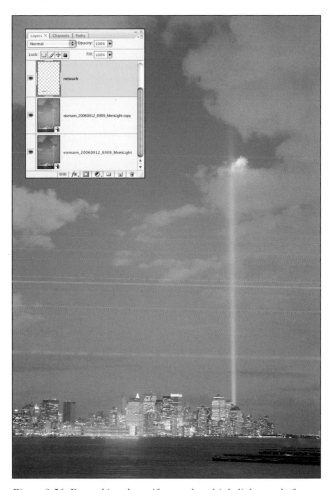

Figure 8-56. Retouching the artifacts and multiple light streaks focuses the image.

12. To offset the softness of the long exposure, click the topmost layer and press Cmd-Option-Shift-E on a Mac, or, Ctrl-Alt-Shift-E on a PC, to merge all visible layers up onto a new layer. Select Filter→Other→High Pass with a radius of 5. Change the layer blend mode to Soft Light to tighten the image edges to insinuate sharpness and create the final image (Figure 8-57).

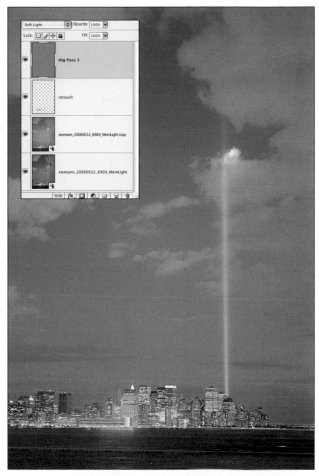

Figure 8-57. The High Pass layer set to Soft Light adds needed crispness.

The ability to revisit an image with new ideas and updated software is one of the primary reasons that we both shoot in the raw format. As our creative vision grows we can rework images to better render our perceptions, and as the raw acquire software is improved we can reprocess files with better results.

Exploring Image Mode Blending

Most color images that photographers work with are in RGB mode, but this doesn't mean we're limited to having only three channels to work with. Dan Margulis has expounded on this idea in his books and seminars, and he maintains that every color image can be composed of ten channels: RGB, CMYK, and Lab. Combining RGB and Lab images with image mode blending techniques can make a lackluster image pop off the page. Best of all, this technique requires only a little experimentation to create breathtaking results very quickly. We find it works especially well when enhancing greens, golds, and light modulation in landscape photography.

Blending Color and Light

This technique requires you to duplicate the file and convert the duplicate to Lab, and then blend the "a" or "b" channels back onto the original RGB image with Apply Image. To extend the potential, you can take advantage of the History Brush to further refine the image, as explained here and seen in Figure 8-58. Each step provides a lot of visual feedback for you to respond to, making this technique very easy to experiment with while producing creatively satisfying and dramatic effects.

⌐ ch08_fountain.jpg

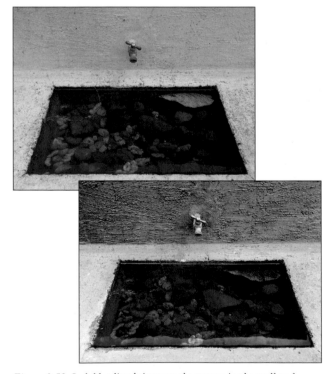

Figure 8-58. Lab blending brings out the texture in the wall and enhances the colors in the water. © KE

1. Select Image→Duplicate, and we suggest adding the letters "LAB" after the file name (Figure 8-59) to help reduce confusion when using Apply Image.

Figure 8-59. Adding "LAB" after the image name alleviates confusion in the process.

2. With the duplicate file active, select Image→Mode→Lab Color.

3. Return to the original file and select Image→Apply Image. Use the Source pull-down menu to choose the duplicated Lab color file, and in the Channel menu select the "a" channel. Set the Blending pull-down menu to Softlight to add a subtle tweak of contrast and color.

4. Experiment by changing the channel to "b" and checking Invert, as seen in Figure 8-60.

Figure 8-60. Experimenting with the "a" or "b" channel and the Invert checkbox often produces excellent results.

5. To increase the dramatic effect, change the Blending to Vivid Light, as seen in Figure 8-61. In many cases you'll need to reduce the Opacity when using Vivid Light. But it is worth it to experiment with each "a" or "b" channel, checking the Invert box, and seeing what the Overlay, Soft Light, Hard Light, and Vivid Light create.

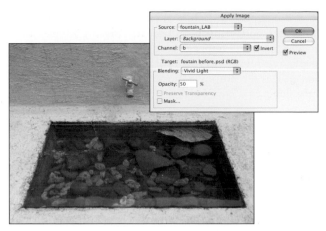

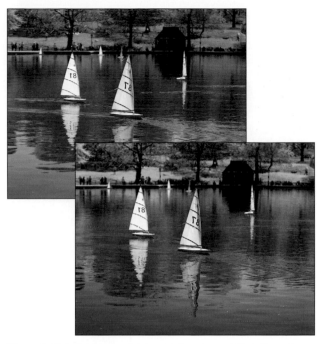

Figure 8-61. Vivid Light increases the contrast and punch of the color.

6. After clicking OK use Cmd/Ctrl-Z repeatedly to see the before and after versions. If there are areas in the "before" version that you like more, use the History Brush to paint them back in. Click the column next to the desired History State, and paint from the past into the present, as we did in this example to bring back the details in the water (Figure 8-62).

Figure 8-62. Use the History Brush to restore the detail in the water.

Color Blending with Layer Masks

Combining variations of the same color-blended image with layers and layer masks enables you to refine specific parts of an image, as seen in Figure 8-63, in which Katrin first applied an overall blend to enrich the color and light, and then added an additional blend to deepen the color of the water.

☞ ch08_sailboats.jpg

Figure 8-63. Lab blending brightened the colors, adding vibrancy to the image. © KE

1. Select Image→Duplicate and add the letters LAB after the duplicated file name.

2. Return to the original file and duplicate the background layer to allow for greater flexibility.

3. Select Image→Apply Image. Use the Source pull-down menu to choose the duplicated Lab file and the Channel menu to select the "b" channel. Use the Blending pull-down menu to select Overlay to enhance the contrast and color, as seen in Figure 8-64.

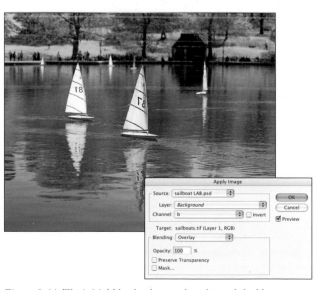

Figure 8-64. The initial blend enhances the color and the blue water.

4. Duplicate the blended layer, select Image→Apply Image, and use the same settings with the "b" channel and Overlay. In this example, too much contrast has been added to the background (Figure 8-65).

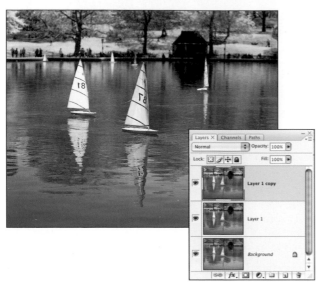

Figure 8-65. Duplicating the layer and repeating the blend strengthens the effect nicely.

5. Add a layer mask by clicking the layer mask button on the bottom of the Layers palette, and use the gradient tool set to Black, White to draw the gradient from just below the horizon straight up to the top of the image, as seen in Figure 8-66, to block the added contrasts and still let the water pop.

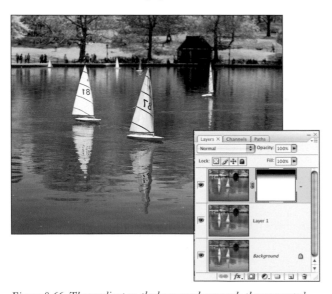

Figure 8-66. The gradient on the layer mask conceals the unwanted contrast of the image background, focusing the viewer's eye on the blue water and the sailboats.

The beauty of the Lab blending is the results are often surprising and inspiring. In all honesty, we often cannot predict what will happen based on which channel or blend mode we choose. After years of massaging every pixel in an image, this serendipity is sincerely welcome and creatively refreshing.

Create Cross-processing Effects

When working with color film, we both enjoyed cross-processing color film, which entailed processing slide film in color negative chemistry or color negative film (shot with a 2 stop over-exposure) in E6 chemistry. This resulted in higher contrast, very saturated, and intriguing false color, as seen in Figure 8-67. Using Photoshop to create a similar effect, as seen in Figure 8-68, requires a lot less luck and can be refined at any time. The three primary characteristics to emulate are: contrast, color shifts, and highlights and shadows that lack detail.

ch08_CrossProcess.jpg

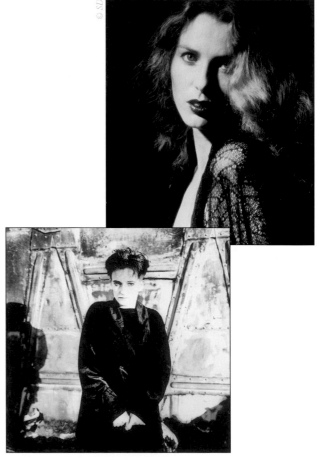

Figure 8-67. Two examples of traditionally cross-processed film. © KE

When experimenting with cross-processing effects, we recommend working with colorful and graphical images with large surfaces. In our experience, images with fine detail tend to be less successful for this technique because the added contrast obliterates the delicate details.

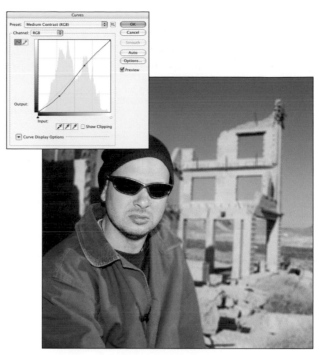

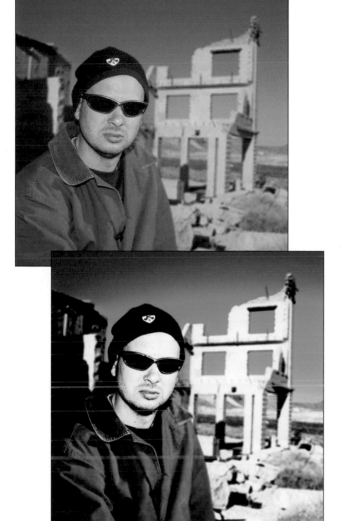

Figure 8-68. Cross-processed in Photoshop. © SD

1. Start by adding a Curves adjustment layer and, in Photoshop CS3, use the Preset Strong Contrast. If you're working with an earlier version of Photoshop you can achieve a similar effect by adding a strong S curve that emulates the curve seen in Figure 8-69.

Figure 8-69. Start by increasing overall image contrast.

2. Cross-processing requires ruining the real color, which is achieved by changing each color channel. Add a new Curves adjustment layer used to modify the individual color channels. In the red channel increase the contrast by pulling the darker 3/4 tones down and the lighter 1/4 tones up, as seen in Figure 8-70.

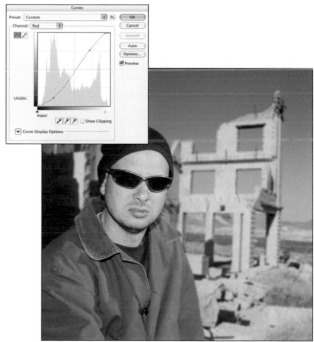

Figure 8-70. Increasing the red channel contrast.

3. In the green channel pull the midtones up to offset the strong red cast (Figure 8-71).

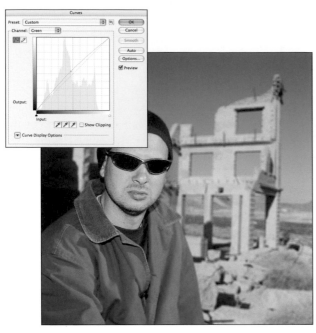

Figure 8-71. *Lightening the green channel to create false color.*

4. Use the blue channel to make the shadows and highlights murky and give them a color cast by moving the shadow point up and the highlight down. Bumping the midtones, as seen in Figure 8-72, changes the color of the light towards the blues.

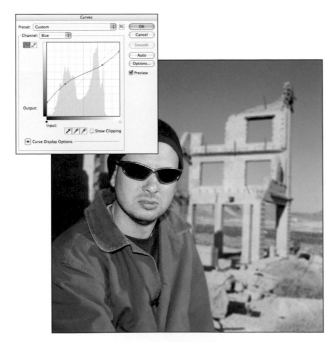

Figure 8-72. *Flattening the blue shadow and highlight values.*

5. Add a Solid Color layer and choose a deep rich yellow. In this example, Seán used RGB 255, 215, 100 and, after clicking OK, changed the Blend Mode to Color and reduced the opacity to 20%. To create the effect seen in Figure 8-73, Seán used the Blend If slider to allow the deeper values of the underlying layer to show through. Of course you can experiment with the color and the opacity, as it feels right to you.

Figure 8-73. *The modified yellow color fill layer creates the classic cross-processing effect.*

6. Add an additional Curve layer and pull down the red curve to push the image into an otherworldly color mood. In this example, Seán also pulled down the blue channel ever so slightly, to let the yellow shine through, as shown in Figure 8-74.

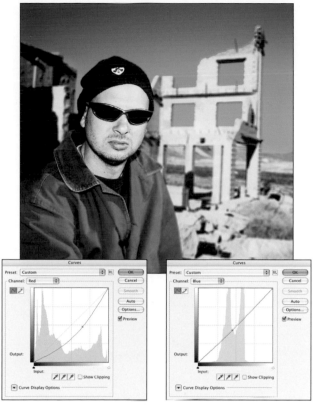

7. To deepen the shadows further, add a new Curves adjustment layer, use the Preset Strong Contrast, and reduce the layer opacity to 75% (Figure 8-75).

Cross-processing may not be everyone's cup of tea, but for pop-art, graphical-effect aficionados it can be very appealing and, when used carefully, can imbue images with an edgy, retro feeling.

It's a Colorful World

No magic recipe, secret sauce, "make good" command, or perfect picture setting exists that would work on every image. Enhancing color is a very subjective endeavor that involves some trial and error to learn what works best for your images. Start with the basic warming and cooling techniques, and then move on to working with blend modes and layer masks to make your images sing out in full color revelry. Paul Gauguin said it best, "It is the eye of ignorance that assigns a fixed and unchangeable color to every object—beware of this stumbling block."

Figure 8-74. Adjusting the red and blue color channels pushes the image into the cyan and yellow spectrum.

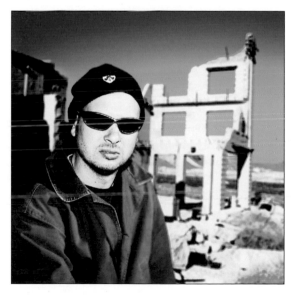

Figure 8-75. Adding an additional overall contrast Curve ties the image together by blocking the shadows and forcing the highlights to a lack of detail.

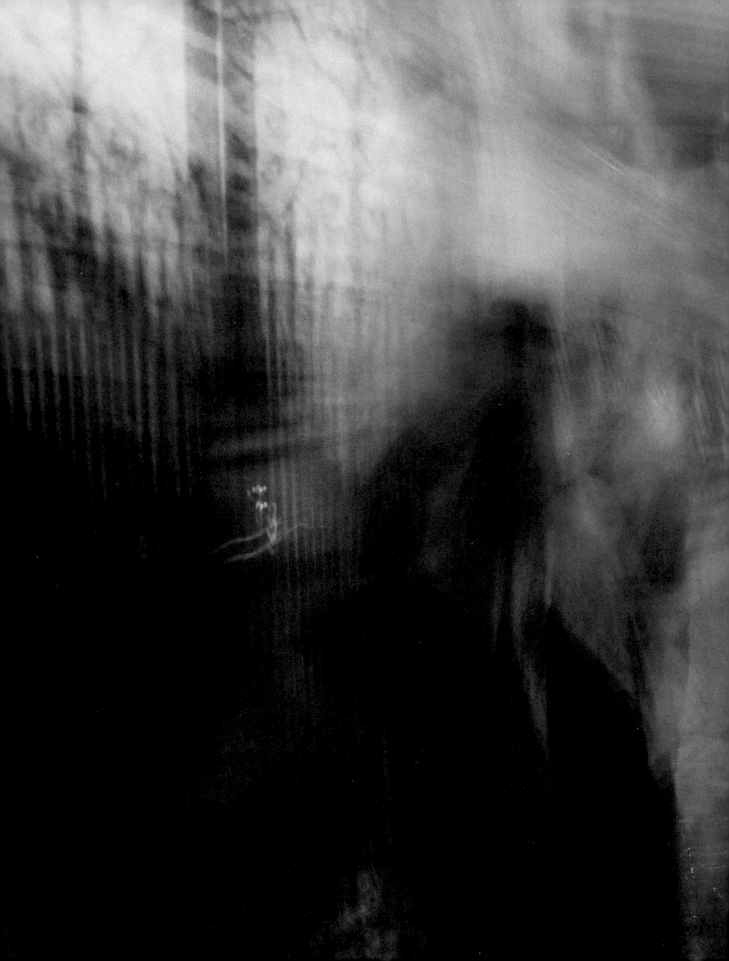

Creative Enhancements

As photographers, we make images so that we can bring them back to our digital darkrooms and revisit that fraction of a second captured in a photograph through the filter of creative consideration. The enhancement of the images we make begins with the photographic act itself, through the use of filters, tripods, and specialized exposure techniques, or waiting at a location for a few extra hours until the light gets better. Creative enhancement continues in the digital darkroom even if that enhancement is subtle and minor, designed only to create an image that is as faithful as possible to what we remember we saw (or what we think we remember we saw) at the moment we pressed the shutter button.

Even though the pixel is steadily replacing the silver halide crystal as the stardust with which we make our images, we still look to the world of film, darkrooms, and texture for inspiration to enhance our photographs. In this chapter, we explore digital techniques that address:

- Optical and Film Effects
- Darkroom Special Effects
- Adding Texture
- The Distressed Image
- Creative Edge Treatments

In a way, the focus of this book has been centered on this one topic: how to enhance your images—and your experience with the images—in the digital darkroom. We have covered a lot of ground and have delved deep into many fundamental and essential techniques for getting the most out of your photographs and making them look better. In this chapter we treat the photograph as a story, and consider how we might embellish and enhance that story to transform the photograph into something just beyond the literal document of what was in front of the lens when the shutter opened.

Chapter 9

Optical and Film Effects

Over the years, photographers have used filtration techniques and film choices to create images with a specific look. Many photographers tell us that digital captures look "too perfect" and smooth, and they look for ways in the digital darkroom to take some of that polish off so the images look more film-like. In this section, we take a look at digital techniques for creating classic photographic visual treatments such as diffusion and soft focus, film grain, and the black-and-white infrared image effects.

Diffusion and Soft Focus

In the past we used glass filters on the camera to create a diffusion or soft focus effect. Now, we use Photoshop. Although such filters are still available for the camera lens, in most cases we would rather capture a sharp image and decide later if it needs a little softening. Adding diffusion or soft focus with Photoshop is easy, but removing it when it is part of the original image is not. Photoshop provides a variety of ways to create soft focus and diffusion effects, some involving a filter effect and others that use blurring and blending modes.

Gaussian Blur

🖐 ch09_DiffusionFarm.jpg

1. Choose Filter→Convert for Smart Filters to turn the active layer into a Smart Object, and then choose Filter→Blur→Gaussian Blur. In the Gaussian Blur dialog box, set the Radius to 8, and then click OK.

2. In the Layer panel, double-click the blending options button to the right of the filter name to bring up the Blending Options dialog. Set the Opacity to 60%. This creates a blend of the blurred layer with the original sharp image (Figure 9-1). Vary the opacity as needed for the particular photo.

3. Now, set the blending mode to Lighten and leave the Opacity at 60%. This creates a more subtle soft focus effect that is similar to using a soft focus filter on the camera lens (Figure 9-2).

4. For experimental exploration, change the mode to Overlay and leave the Opacity at 60%. As is always the case with Overlay, there is an increase in contrast and color saturation. In this image, the natural colors create a warming effect (Figure 9-3). If the increase in contrast is too pronounced, set the mode to Soft Light.

5. Click Cancel and then Delete the Smart Filter layer (just the filter effect and not the Smart Object layer of the farmhouse).

Figure 9-2. Setting the blending mode for the Gaussian Blur layer to Lighten and the opacity to 60% refines the diffusion effect contrast.

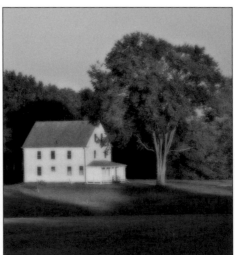

Figure 9-1. The original image is on the left. The diffusion effect on the right was created by adding a slight Gaussian Blur, and then lowering the Smart Filter opacity to 60%. © SD

When working with Photoshop CS2 or earlier, please duplicate the background layer to experiment with filter effects.

Figure 9-3. *Setting the blending mode for the Gaussian Blur layer to Overlay and the opacity to 75% creates a diffusion effect with more contrast.*

Remember that Smart Filter layers come with a layer mask that can be edited to further refine where in the image the filter effect shows up. We'll explore that in the next example.

Surface Blur

The Surface Blur filter can be used for subtle softening or for a more pronounced diffusion effect (Figure 9-4). In this example, we'll take the latter approach.

Figure 9-4. *The Surface Blur diffusion technique adds a painterly effect.*

1. The main layer in the file should still be a Smart Object. If not, choose Filter→Convert for Smart Filters. Choose Filter→Blur→Surface Blur. Set the radius to 20 and the Threshold to 75. This will create a very strong blur that will obliterate some of the fine details in the image (Figure 9-5). We'll fine-tune the effect in the next step. Click OK.

The "surface" in Surface Blur refers to areas in the image that do not contain edge details. At lower settings than we are using here, this allows you to blur areas that are tonally very similar, or that have gradual transitions, leaving hard, distinct edges unaffected.

Figure 9-5. *The initial effect created by the Surface Blur filter is quite strong.*

2. Double-click the blending options button to the right of the filter name. Lower the Opacity to 80% to soften the blur. Click OK.

3. Click the layer mask for the Smart Filter layer. Choose the Brush tool, set black as your foreground color, and lower the brush opacity in the Options Bar to 30%. Brush over areas where you want to further minimize the soft focus effect created by the Surface Blur filter. In the image of the farmhouse, we masked out some of the blur on the house and the tall tree (Figure 9-6).

Figure 9-6. The Surface Blur filter layer is set to 80% opacity and a layer mask is used to prevent the house and parts of the tree from becoming too soft.

Diffuse Glow

Diffuse Glow is actually two filters in one since it allows you to add grain as well as to create a bright glowing effect on lighter areas in the image. It can be used as a stand-alone filter effect or in conjunction with blending modes to customize the effect (Figure 9-7).

Figure 9-7. Combining the Gaussian Blur and Diffuse Glow filters, blending modes and a layer mask created this effect.

1. If you're still using the same image from the previous example, throw away any Smart Filter effects. If you are using a different image, be sure that the layer has been converted for Smart Filters using that option in the Filter menu. Choose Filter→Distort→Diffuse Glow.

2. The Graininess slider controls how much grain is apparent. The Glow Amount increases the glow around the lighter areas in the image. The Clear setting removes the glow from darker areas in the image. Set the Graininess to 6 and the Glow and Clear Amounts to 8, and then click OK. In addition to the bleached-out diffusion effect, there is also a muting of the colors in the photo (Figure 9-8).

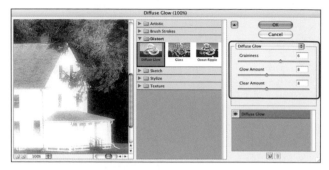
Figure 9-8. The settings for the Diffuse Glow filter.

3. The farmhouse has become a bit too light. We can fix that by painting on the layer mask for the Smart Filter. Click the layer mask to make it active. Choose the Brush tool and make black the foreground color. Set the Brush opacity to 30%. Paint on the mask in the areas where you want to minimize the Diffuse Glow effect.

4. Now let's add another filter effect. Click back on the Smart Object layer to make it active. Choose Filter→Blur→Gaussian Blur. Set the radius to 12, and then click OK.

5. In the Layers palette, double-click the blending options button to the right of the Gaussian Blur filter name. Set the blending mode to Overlay and the Opacity to 75%, and then click OK (Figure 9-9).

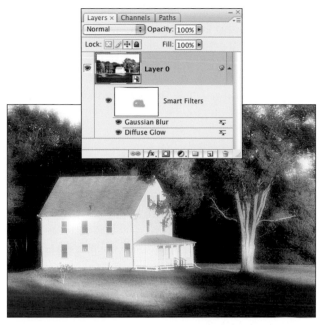

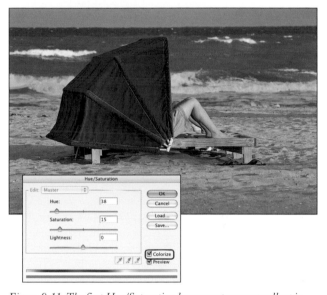

Figure 9-9. The final effect from combining the Diffuse Glow filter with the Gaussian Blur filter set to Overlay and 75%.

Sepiaesque Diffusion Toning

The technique described here is one that Seán developed for use with color photographs to create a faded, sepia-flavored color palette combined with a soft diffuse glow (see Figure 9-10). (The name *sepiaesque* is his own description of the technique and does not refer to any specific Photoshop feature.) Like many techniques for modifying the character of color or contrast in an image, the magic of blending modes is a key ingredient. This technique is not a one-size-fits-all procedure, however, and images that already have a lot of strong contrast may not fare as well as more low-contrast photos. Since everything is created using separate layers and adjustment layers, the layer masks can be modified easily to customize the effect for each individual image.

ch09_sepiaesque.jpg

1. Add a Hue/Saturation adjustment layer. Turn on the Colorize checkbox in the lower-right corner. Set the Hue to 38 and the Saturation to 15 (See Figure 9-11). Click OK.

2. Set the blending mode for the Hue/Saturation layer to Overlay, and lower the Opacity to 70% (See Figure 9-12). If the contrast is increased too much by the Overlay blending mode, you can either lower the opacity more or try the Soft Light blending mode.

Figure 9-11. The first Hue/Saturation layer creates an overall sepia tone.

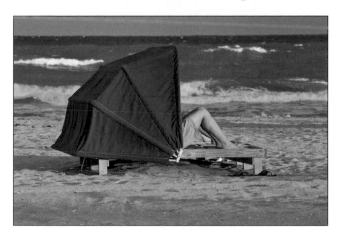

Figure 9-10. Sepiaesque diffusion toning. Before and after. © SD

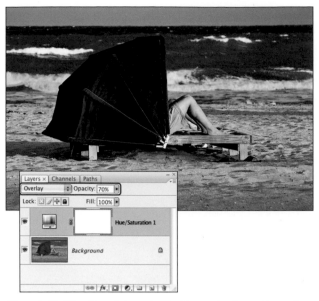

Figure 9-12. The effect of the sepia Hue/Saturation layer after setting the blending mode to Overlay and lowering the opacity to 70%.

3. Use Cmd/Ctrl-J to duplicate the Hue/Saturation layer. A double dose of this layer creates an interesting effect, but on some images it is likely to produce too much contrast and shadow details will become too dark, as can be seen in the blue cover over the beach chair. Lower the opacity to 30% and set the blending mode to Normal. The main purpose of this layer is to further tone down the color saturation and also to add some additional sepia seasoning (Figure 9-13).

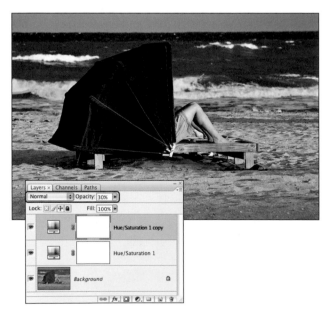

Figure 9-13. The second Hue/Saturation sepia layer is set to Normal at 30% opacity.

4. Make a merged copy of the existing layers by pressing the Option/Alt key while selecting Merge Visible from the Layers palette submenu. Keep the Option/Alt key down until you see the new layer thumbnail appear in the Layers palette.

5. With the merged duplicate layer active, choose Filter→ Convert for Smart Filters to turn the layer into a Smart Object.

6. Choose Filter→Blur→Gaussian Blur and set the radius to 10. Click OK (Figure 9-14).

7. Change the blending mode for the blurred layer to Overlay, and lower the opacity to 50% or 60%. If the effect seems too contrasty or the shadows get too dark, try using Soft Light for the blending mode.

8. For this image of the beach chair, the blue cover has gotten a bit too dark. To modify it, we'll use a layer mask. With Layer 1 selected (the merged, blurred layer), click the Add Layer Mask button at the bottom of the Layers palette. Choose the Brush tool from the Tool palette, and use a large, soft-edged brush to paint with black at 40% brush opacity over the blue canopy. The first Hue/Saturation layer is also causing some of this darkness, so click its layer mask and paint over the canopy again to further restore some of the original color and tone (Figure 9-15).

Since the diffusion blur is applied as a Smart Filter, you can also use its layer mask if there are areas in the image where you want to scale back the diffusion.

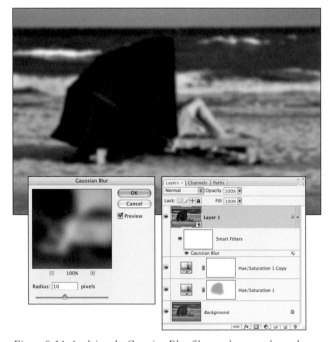

Figure 9-14. Applying the Gaussian Blur filter to the merged copy layer.

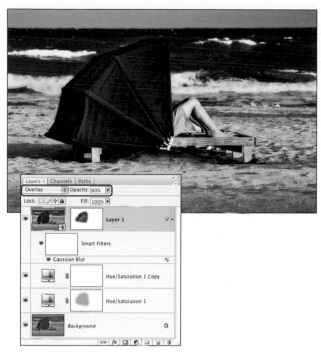

Figure 9-15. The final image, after modifying two of the layer masks to lighten the blue canopy.

Adding Film Grain

Since the invention of film, its manufacturers worked to refine their film formulas to reduce grain, a visible artifact of the granular structure of the light-sensitive silver halide crystals that are used in film emulsions. But over the years, many photographers developed an appreciation for certain types of grain and would specifically use certain types of film or special processing techniques to add grain to their images. Digital cameras don't produce grain, but it can be added in Photoshop (Figure 9-16). As with all such effects in the digital darkroom, we try to create a film grain effect in a non-destructive way.

⌐ ch09_filmgrain.jpg

The Add Noise filter

1. Choose Filter→Convert for Smart Filters, and then choose Filter→Noise→Add Noise. In the Add Noise dialog, set the Distribution to Gaussian and the amount to between 5 and 10. Choose the Monochromatic option (Figure 9-17).

2. The grain effect can now be modified by altering the opacity of the Smart Filter effect or by painting in the layer mask to tone down the appearance in certain areas.

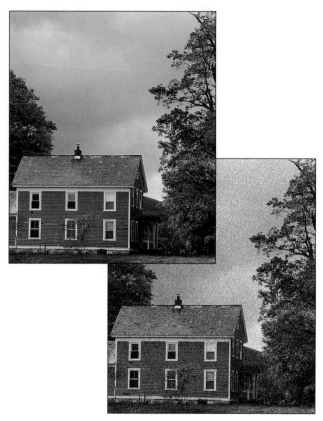

Figure 9-16. The original is on the top, and the version with a film grain effect on the bottom. © SD

The actual noise amount you decide on will depend on the size of the image you're working on and how much grain you want. Values over 10 tend to get very grainy and begin to obscure image details.

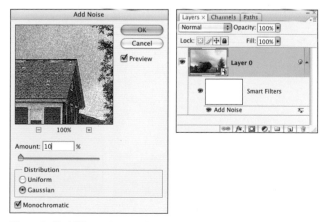

Figure 9-17. Adding noise non-destructively using a Smart Filter layer.

Creating softer grain to mimic an enlarged negative

While the Add Noise filter does a good job of simulating a grainy look, the effect is a bit too sharp for some people. The solution to this is to put the effect on a separate layer so that a slight blur can be introduced to soften the grain. The result more closely resembles the appearance of actual film grain in an enlarged print, which is softened as the negative is enlarged.

1. Option/Alt-click the New Layer button at the bottom of the Layers palette. In the New Layer dialog, set the Mode to Overlay, and then click the check box for "Fill with overlay-neutral color (50% gray)." Click OK and zoom in to 100% (View→Actual Pixels).

2. Choose Filter→Convert for Smart Filters to turn the gray layer into a Smart Object. From the Filter menu, choose Noise→Add Noise, and then configure the dialog settings as needed to produce the desired amount of grain. Click OK. The Overlay blend mode, which does not show areas of 50% gray, now shows only the noise in the image. If the noise effect seems too pronounced with Overlay, try using the Soft Light blending mode, lowering the layer opacity, or modifying the layer mask.

3. To add a slight softening to the noise effect, choose Filter→Blur→Gaussian Blur, and set the radius to 0.4 pixels. Click OK (Figure 9-18).

The blurring effect is very subtle, and you have to look closely to see it. Also, the radius value you use will vary depending on the size of your image. Larger files can take a slightly higher radius. If you've ever felt that the Add Noise filter produced "grain" that was just a bit too sharp, then this is one way to take some of that edge off.

Black and White Infrared

In addition to the visible spectrum of light, infrared films or digital sensors used with an infrared filter are also sensitive to the infrared portion of the spectrum. This renders scenes quite differently from the way we are used to seeing them. Vegetation reflects a great deal of infrared light that the human eye cannot see, and green foliage is recorded in ethereal white or very light tones. Blue skies and water are rendered as very dark tones since they reflect little or no infrared light. There is something magical about photographing the actual infrared light in a scene and never knowing exactly how the image might come out that lends an appealing air of mystery and serendipity to the process.

Although Photoshop does not have a one-stop "infrared filter," it does have a preset in the Black & White adjustment dialog box that can get you started, and there are additional techniques you can use to transform a color photograph into a pretty convincing infrared image. The process starts with knowing the visual qualities of an infrared image and then finding the best ways to duplicate those in the digital darkroom. Figure 9-19 shows an image that was photographed on black-and-white infrared film. The enlarged detail section reveals the noticeable grain that is common in infrared film. Figure 9-20 is a photo taken with a digital SLR that has been specially modified to shoot only infrared images. In both photos, the foliage is rendered in classic, light silvery tones with a bit of a glow. The digital infrared shot, however, has no grain to speak of.

Figure 9-18. On the left, the noise is applied normally. On the right, a slight Gaussian Blur has been applied to the noise layer to soften the grain.

Figure 9-19. This photo of a eucalyptus grove was photographed on 35mm black-and-white infrared film. © SD

Figure 9-20. The same location photographed with a digital SLR modified to shoot only black-and-white infrared. © SD

The steps to create a black-and-white infrared interpretation of a color image, as in Figure 9-21, require a black-and-white conversion that renders the green colors very light, some glow around the highlight areas, the addition of some grain, and a final contrast adjustment. Let's get started.

ch09_BWinfrared.jpg

Black-and-white adjustment for the initial infrared conversion

1. The first step is to convert the color photo to black and white. Open the Add Adjustment Layer menu at the bottom of the Layers palette, and then choose Black & White.

2. In the Black & White dialog box, open the Preset menu at the top and choose Infrared. This gets the settings headed in the right direction, which is why we're using it, but it always needs some customization. For example, in the image of the eucalyptus grove, the infrared preset renders the highlights in the green grass much too bright (Figure 9-22).

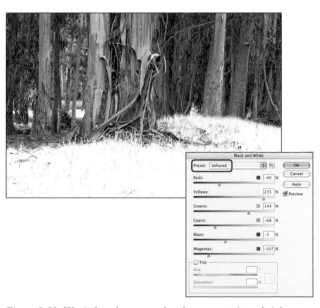

Figure 9-22. The infrared preset makes the grass much too bright.

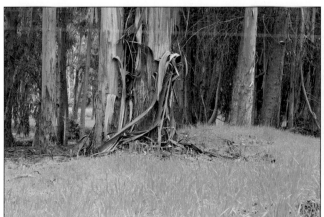

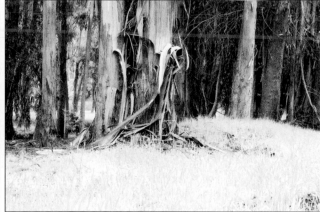

Figure 9-21. The eucalyptus grove photographed in color and converted to black-and-white infrared in Photoshop. © SD

3. For this photo, we still want the green grass to have the classic silvery white look, but we also want to see a bit of detail there, so we lowered the Yellows and Greens slider to +150 each. We also increased the Cyans setting to +250 as this helped to lighten up areas in the background where some foliage is visible.

4. In the Infrared preset, the Reds are at a negative value, which makes no sense at all, since red areas, such as the reddish bark on the tree, will record as very light in an actual infrared shot (refer to the film and digital infrared exposures in Figures 9-19 and 9-20). We raised the red value to +150, which helps to brighten the ribbon of reddish bark that is peeling off the tree (Figure 9-23).

5. Finally, we lowered the Blues to –75, since blue values typically do not register very bright in infrared. Click OK to apply the black-and-white conversion.

> The actual Black & White adjustment settings you use will vary depending on the nature of the image you're working with and also your own preferences for how you want the infrared conversion to appear. Use the Infrared Preset to get started, but customize the sliders to get the look that *you* want, rather than just relying on a preset.

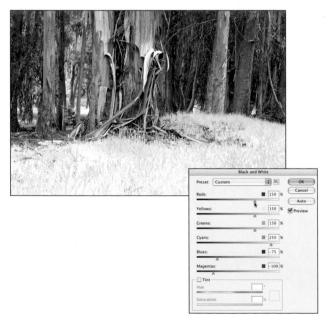

Figure 9-23. This adjustment tones down the brightness in the grass and lightens the red values (note the peeling bark on the tree), which would be rendered light by an actual infrared exposure.

Add the glowing highlights

The next step is to create a glowing effect around the highlight areas. As with so many Photoshop techniques, there is more than one way you might go about this. We'll show you two different ways. Both create the requisite glowing foliage, but each has its own flavor.

Method 1: The Diffuse Glow filter

1. Make the Black and White adjustment layer active and hold down Option/Alt while selecting Merge Visible from the Layers palette submenu. Keep the Option/Alt key down until you see the new layer thumbnail appear in the Layers palette. This will create a new layer at the top of the stack that is the merged result of all the visible layers.

2. Choose Filter→Convert for Smart Filters. Then choose Filter→Distort→Diffuse Glow. Set the Graininess to 5 (we'll be adding a separate grain layer later in the process), the Glow Amount to 10, and the Clear Amount to 15, and then click OK.

3. The initial effect is much too bright (Figure 9-24). In the Layers palette, double-click the blending options button to the right of the filter name. In the Blending Options dialog box for the Diffuse Glow filter, set the Mode to Overlay and the Opacity to 50% (Figure 9-25). The use of the Overlay blend mode here accomplishes two things: in boosting the contrast it adds to the glow effect, but it also darkens the shadow areas of the scene, which is typical of an infrared exposure. Click OK.

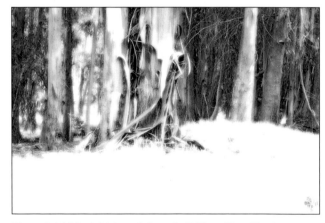

Figure 9-24. The initial result from the Diffuse Glow filter is interesting but much too bright.

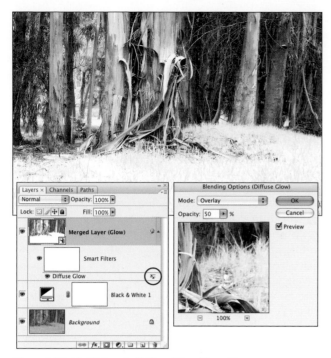

Figure 9-25. Modifying the Diffuse Glow filter effect.

Figure 9-26. Creating a diffuse glow effect by blurring only the green channel on the copy layer.

Method 2: Blurring the green channel.

We learned this method for creating an infrared glow from Martin Evening. It uses a duplicate layer of the original color image and applies a subtle blur to only the green channel. Here's how it works:

1. After applying the initial Black & White adjustment as described earlier, create a copy of the background layer (Cmd/Ctrl-J). In the Channels palette, click the thumbnail of the green channel to make it active.

2. Choose Filter→Blur→Gaussian Blur, and apply a 5-pixel blur to the green channel. If you want more obvious flaring in the image, then use a higher setting. Click OK (Figure 9-26).

3. Choose Edit→Fade Gaussian Blur, and set the blending mode to Screen and the Opacity to 25%. Click OK.

Add a grain layer

Photographs made with black-and-white infrared film are generally quite grainy, and that is one of the classic qualities associated with the black-and-white infrared image. To keep the grain separate from the other visual components of the image, use the Add Noise filter on a 50% Gray layer set to Overlay, as described in the previous section on "Adding Film Grain." Zoom in to 100% (View→Actual Pixels) for the most accurate evaluation of how much noise to add. If you want the option to be able to change the Noise settings, then apply it as Smart Filter. Modify the grain effect using the layer opacity slider or painting in the layer mask if you need to minimize the grain in certain areas.

Customize the contrast with curves

To fine-tune the infrared effect, you almost always need to apply some contrast curves, either globally or locally. For the photo of the eucalyptus grove, we added a curves adjustment layer to the top of the layer stack and slightly increased the contrast with an S-curve (Figure 9-27).

Figure 9-27. The final image after adding grain and a curves layer to increase contrast.

Photoshop infrared vs. real infrared

As this example shows, with the right techniques in Photoshop, and the knowledge of what real black-and-white infrared looks like, you can create a pretty convincing effect. One area where the faux infrared does not match the real exposures, however, is in the hanging leaves in the background areas. In the real infrared exposures—both film and digital—these leaves show up as a much lighter tone, since they were reflecting infrared light that the film or filtered camera sensor recorded. In the version made from the color image, these background leaves did not have much green in them, so they were not lightened by the initial Black and White adjustment.

Darkroom Special Effects

In a traditional darkroom, the image is created through a mixture of light, chemistry, and time. The amount of light, the specific dilution and temperature of the chemical solutions, and how long the film or print is immersed in those solutions all contribute to the final appearance of the image. Some photographic effects have their roots in the special alchemy of the chemical darkroom. While creating these effects traditionally was often a process of trial and error, creative experimentation is much easier in the digital darkroom. In this section we'll take a look at the digital versions of some classic darkroom effects.

Creative Accidents

Anyone who has ever worked in a traditional darkroom knows that mistakes are sometimes a part of the darkroom experience. If the chemicals are mixed incorrectly, or the light is turned on at the wrong moment, prints—or worse, unexposed film—can be ruined. Most of the time, these mistakes are merely an annoyance and a temporary setback that can be remedied by making a new print or mixing a new batch of chemicals. Sometimes, however, mistakes result in an unexpectedly altered image that can look very interesting. For some photographers, the accident they first curse becomes a creative catalyst that starts a new visual journey.

Solarization

Solarization is the common name for a process that is technically known as the Sabatier effect, after Armand Sabatier, the French photographer and scientist who is generally credited with its discovery in the 1860s. Exposing the film or paper to light during the chemical development process creates the Sabatier effect. The result is an image that appears to be half negative and half positive. The midtones and shadows appear normal, but the highlights are reversed and turn dark, leaving a thin, white outline around the original highlight edge. As with many such "discoveries," a mistake most likely led to the first solarized print and, since accidentally turning on the lights is one of the most common darkroom mistakes, we imagine that many photographers in the early years of the medium "discovered" this interesting visual treatment. In the 1930s, the noted surrealist photographer Man Ray elevated solarization to a creative technique that he used in many of his most famous photographs.

The Solarize filter

Photoshop has had a Solarize filter for many years (Filter→Stylize→Solarize), but it's a simple formula effect with no options for customizing how it works.

⌐🐭 ch09_solarize.jpg

1. To apply the filter non-destructively, choose Filter→Convert for Smart Filters. Then choose Filter→Stylize→Solarize.

To get insight into just what the solarize effect does, take a look at the Histogram palette after you apply the filter (Figure 9-28). All the values in the image are below the midtone point. The filter takes any values at level 128 or above and inverts them, remapping them to below level 128. Original image values below the midtone point are not changed.

Curves is the key to this effect, both in terms of enhancing the basic Solarize filter as well as creating your own custom solarize treatment, which we'll get to shortly. If you do choose to use the canned filter effect, you can always improve on it by adding a simple contrast curve.

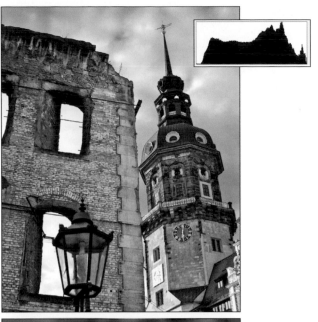

3. In the Layers palette, double-click the blending options button to the right of the filter name. In the Blending Options dialog box, open the Mode menu and choose Pin Light. This lightens the image quite a bit and creates better tonal separation between the steeple and the dark sky (Figure 9-30). Other blending modes that can be useful with the Solarize filter and grayscale images are Hard Light and Difference.

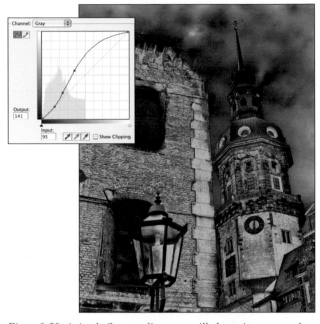

Figure 9-29. A simple Curves adjustment will always improve on the default solarization treatment.

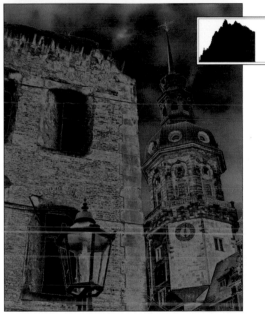

Figure 9-28. The results of applying the Solarize filter. The histogram for the solarized image reveals what the filter is actually doing to the tonal values in the image. © SD

2. Add a Curves adjustment layer and create a curve that increases contrast by raising the highlight section of the curve and lowering the shadow section. Click OK (Figure 9-29).

Another way to modify the basic solarize effect is to modify the Smart Filter by changing the opacity or the blending modes.

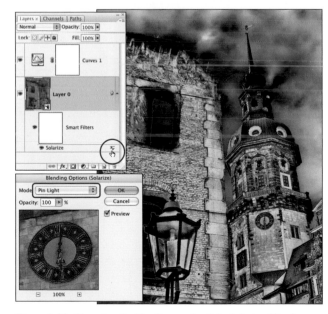

Figure 9-30. Changing the blending mode of the Solarize filter layer can also create interesting variations. Here, we're using the Pin Light blending mode.

Custom solarization with Curves

You can also brew your own custom solarize effect with more control using a Curves adjustment layer.

1. Bring up the History palette and click the opening snapshot at the top of the palette. This will return the image back to where it was when you first opened it.

2. Add a Curves adjustment layer. In the Curve Display Options at the bottom of the dialog, make sure "Show Amount of" is set to Light. Click in the center of the curve grid to add a control point. Drag down the highlight point in the upper-right corner and reposition it in the lower-right corner (Figure 9-31A).

3. Now click the curve to place two control points on either side that reshape it into the shape of an inverted V. Use the baseline to guide you on the left side, and then simply copy the basic positions of the control points on the right side (Figure 9-31B).

This is the curve to create the basic solarized effect. The shadow and midtone values are unchanged, but every tonal value above level 128 is now inverted, producing the classic half-positive, half-negative look of solarization. Experiment with modifying the curve to see how you can alter the solarization effect. Some examples of different curves and their effects on the image are shown in **Figure 9-32**.

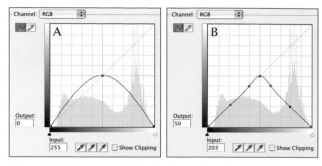

Figure 9-31. To create a solarization curve, drag the highlight point down to the lower-right corner (A), and then add anchor points to create an inverted V shape (B).

Solarization curves with color photos

The process for solarizing color photos is the same as for black and white, with the added twist that in addition to strange tonal inversions, you will have color inversions as well (Figure 9-33). The use of customized curves and blending modes, and adjusting the individual red, green, and blue curves will also create interesting results.

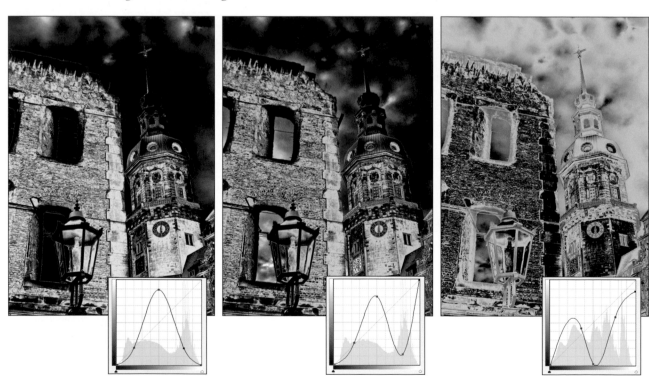

Figure 9-32. Custom solarization curves.

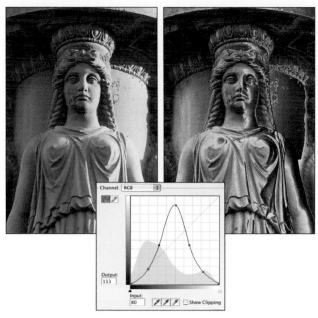

Figure 9-33. *Solarization of a color image.* © SD

Reticulation

Reticulation is the term used to describe the cracking and warping of the thin film emulsion layer due to a sudden change in process temperatures during development. Reticulated film typically suffers from increased grain and uneven striations that appear as a tightly woven pattern of tiny squiggles that degrades fine details. But the creative muse appears in unlikely moments, and at some point someone probably looked closely at the reticulated film and thought, "Hey, that looks kind of cool!" And so, a permanent, detail-degrading, film-damaging mistake was adopted as an artistic effect.

Traditional reticulation in the wet darkroom is a burn-your-bridges, say-a-Hail Mary, no-turning-back kind of affair because the effect is introduced as the film is being developed. Fortunately, Photoshop reticulation is not only much easier to do, but it's also non-destructive and you can fine-tune the effect after you have applied it, or you can combine it with other effects (Figure 9-34). Let's take a look at how it works.

✍ ch09_reticulation.jpg

1. Open a photo you want to work with or use the lighthouse image in this example. Images with fine, intricate details are probably not the best choice since the details usually suffer in this process. To apply the filter non-destructively, choose Filter→Convert for Smart Filters.

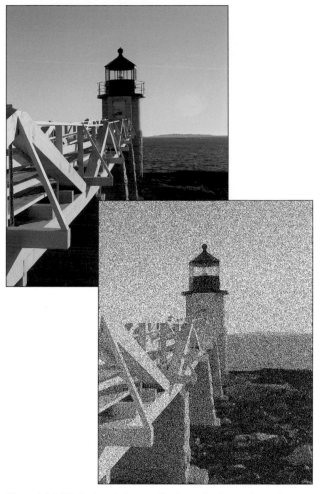

Figure 9-34. *The basic reticulation effect is not that interesting on its own, but it can be effective when combined with other techniques.* © SD

2. Like all of the Sketch filters, Reticulation uses the foreground and background colors to create its effect, so press the D key to set these to the default colors of black and white. For the most accurate preview in the image window, zoom up to 100% (View→Actual Pixels).

3. Choose Filter→Sketch→Reticulation. In the filter dialog box, Density controls how close together the squiggles (some call them termite trails) are grouped. The Foreground and Background Level sliders refer to the foreground and background colors and control the balance between the two. Density settings below 25 result in a darker image while settings above 25 yield a lighter image.

4. Set the Density to 25, the Foreground Level to 5, and the Background Level to 20, and then click OK (Figure 9-35).

Figure 9-35. The Reticulation controls in the Filter Gallery dialog.

The basic reticulation effect is not really that exciting, but when combined with the original image using blending modes and varying the opacity of the filter effect, things get a little more interesting.

5. In the Layers palette, double-click the blending options button to the right of the filter name. In the Blending Options dialog box, set the mode to Overlay. If the effect seems too strong, lower the Opacity to 50% or 60% (Figure 9-36).

6. Leave the Opacity set to about 60% and try Soft Light, Hard Light, and Pin Light (Figure 9-37). Each one creates a slightly different effect in how the reticulation pattern is blended with the image.

Figure 9-36. Modifying the Reticulation filter layer by lowering the opacity to 60% and using the Overlay blending mode.

7. Set the blending mode to Luminosity. This takes the brightness values from the reticulation pattern and the color values from the underlying photo, creating a version that is similar to a Seurat painting (Figure 9-38). Increasing the opacity will only add to the pointillism effect.

Figure 9-37. Modifying the Reticulation filter layer using the Pin Light blending mode.

Figure 9-38. Setting the blending mode to Luminosity creates an effect reminiscent of pointillism.

Combining reticulation with adjustment layers

Don't forget to experiment with adjustment layers to further refine the effect. Sometimes a little bit of tonal modification or the addition of a toning effect might be just what the image needs. Double-click the blending options button for the Reticulation filter, and set the mode to Luminosity and the opacity to 20%.

1. Add a Hue/Saturation adjustment layer. In the Hue/Saturation dialog box, turn the Colorize option on in the lower-right corner. Set the Hue to 38 and the Saturation to 30. This will create a strong, brown tone effect. Click OK.

2. In the Layers palette, set the blending mode for the Hue/Saturation layer to Overlay and lower the opacity to 75%. This will increase the contrast and combine the sepia tones with the original colors in the image (Figure 9-39). If the contrast increase is too pronounced, try using Soft Light for the blending mode.

Figure 9-39. Combining the Reticulation effect set to Luminosity with a sepia Hue/Saturation layer set to Overlay.

As you can see from this example, by adding to a basic filter effect, you can modify the result and come up with a look that has more subtlety and nuance. Creating a customized filter treatment with layers, layer blending modes, varying opacity, and adjustment layers is much more interesting than relying on a canned filter effect.

Adding Texture

Modern digital cameras are great at capturing images with good exposure and little or no noise. But sometimes they can be just a bit too smooth and perfect, especially if you are trying to express images that speak to the intangible qualities of emotion, metaphor, or the shifting landscape of memory. Adding texture can be an effective way to add personal significance to images where the creative intent is to express something that cannot be expressed with the accurate sharpness produced by modern lenses.

In previous sections in this chapter, we have already been working with textures in our explorations of techniques for adding film grain and reticulation effects. In this section we'll fully immerse ourselves in the world of textures and combining them with your photographs. We'll start out with a look at some of the classic textures used for decades with photographs and then venture into grittier territory as we take a look at using textures and other effects to create an aged and distressed look.

Classic Textures

Of all the textures that have been used with photographs over the years, some have become almost like "standards" that never go out of style. Two of these are the classic canvas texture (Figure 9-40) and the look of rough watercolor or art paper. Of course, with watercolor and other fine art papers available for desktop inkjet printers, you can always print directly on these papers to achieve an art paper look, but there may still be times when you need to simulate it for other purposes.

Figure 9-40. A canvas texture is a classic treatment for portraits. © SD

🖑 ch09_canvas.jpg

1. Convert your main image layer into a Smart Object by choosing Filter→Convert for Smart Filters. Zoom up to 100% (View→Actual Pixels), so you will be able to accurately evaluate the effects of the texture. Choose Filter→Texture→Texturizer.

2. In the Texturizer dialog box, open the Texture menu and choose Canvas (Figure 9-41). Of the other available textures here, Sandstone is the most useful, and we'll explore that shortly. Brick is just silly (when was the last time you were moved to add a brick texture to one of your images?), and Burlap has an obvious patterned look.

3. Set the Scaling to control the size of the texture in relation to the image (we chose 150% for this example). The Relief controls how pronounced the texture is on the surface of the photograph. If you set this too high, it will be hard to see fine details in the image. The default of 4 is a good starting value, and you may find that it works quite well for most applications of this filter.

4. The Light option controls the direction of the hypothetical light that is illuminating the texture. For the Canvas texture, the differences between a direct (that is, Top, Bottom, Left, Right) and a diagonal direction (Top Right, Top Left. Bottom Right, Bottom Left) create a noticeable difference in the canvas texture. The diagonal direction settings reveal more of a weave appearance in the texture (Figure 9-42).

5. Leave the Texturizer filter dialog box open and proceed to the next step.

Light Direction: Top **Light Direction: Top Right**

Figure 9-42. The direction of the light will affect the look of the canvas texture.

Watercolor paper

1. If you have closed the Texturizer dialog, double-click the Smart Filter name in the Layers palette to reopen it. From the texture menu at the top of the controls, choose Sandstone. Although it certainly does work for sandstone, it is also a pretty convincing stand-in for a rough surface, cold press watercolor paper (Figure 9-43). Adjust the Scaling and Relief controls as desired, but generally you will want to use a fairly high value for the Scaling to ensure the texture is visible in the image.

Figure 9-43. Using the Sandstone texture as a stand-in for rough watercolor paper.

Using Custom Textures with the Texturizer Filter

You can use any PSD image file as a texture map for the Texturizer filter. With this approach, you can build a collection of images of interesting textures you come across, and then use them to create custom textures.

Figure 9-41. The Texturizer dialog box.

⌇ ch09_watercolor_paper.jpg

1. Apply the Texturizer filter as a Smart Filter as in the previous steps. In the Texturizer dialog box, open the flyout menu, choose Load Texture, and navigate to the file you want to use. For this example, we are using an actual scan of a sheet of rough-surface watercolor paper (Figure 9-44). Adjust the Scaling, Relief, and Light controls to customize the look of the texture as desired.

> The Texturizer filter uses only grayscale information from PSD files for a custom texture map. If the image is in RGB mode, then only the tonal information from the red channel will be used.

Later in this chapter we'll explore additional methods for creating custom textures from scratch to create a more weathered and aged look.

Figure 9-44. Using a scanned file of an actual sheet of watercolor paper as a custom texture.

Fading Away: The Distressed Image

Old photographs have a mystery about them that is undeniable. In part, this is from the look back into history they provide to a slice of time captured in the distant past. Each image—worn, tattered, and fragile—is like a time machine. Sometimes we know the people in the photographs, or they may be distant relatives of whom we have only vague childhood memories, or they are total strangers who lived long ago. In addition to the glimpse back into the past, some of the mystery of old images comes from the uneven marks of damage and fading that are the direct, physical manifestation of the passing decades. And since old photographs began their lives by fading into existence in a tray of developer, in their long, slow decline, they sometimes begin to fade away, becoming fainter and less distinct with each passing year.

The marks of age and the worn crumpled traces of the passing years of time speak directly to our sense of memory and nostalgia, just as the warm brown of a sepia tone is so often used to convey nostalgia and a vintage flavor. Adding a distressed or faded look to an image transforms it from a photographic document of the now to a musing on memory and emotion, on past times, or on present times that will one day be only memories.

Photoshop is well known for the many ways it can make photographs look better, but it also excels at making them look worse. In this section we'll explore some of these methods, from quick and easy techniques to more intricate tinkerings with our photographic time machines.

The Faded Image

There are several ways to create a faded look. The one you choose will be influenced by just how you want the fading to appear, including whether the image will be fading out to light or fading into darkness. In the following tutorials, we'll explore techniques for fading color and black-and-white images. These techniques are short and are intended to be potential digital darkroom building blocks that can be used to create more complicated transformations when used with other steps, as we shall see in a bit.

Faded color photo

When old color prints fade, the cyan and blue dyes always seem to go first, leaving an image that is not only fading, but also overly reddish yellow (Figure 9-45). This damage can be replicated using a Color Fill and a Curves adjustment layer.

⌇ ch09_fadedcolor.jpg

1. Using the adjustment layer menu at the bottom of the Layers palette, add a Solid Color Fill layer. In the Color Picker, enter RGB values of R230 G150 and B50. This will create an orange-red color. Click OK.

2. Set the blending mode for the Color Fill layer to Screen, and lower the opacity to 65% (Figure 9-46). This creates a washed-out faded look and adds the reddish-yellow tint to the image to suggest color dyes in critical condition.

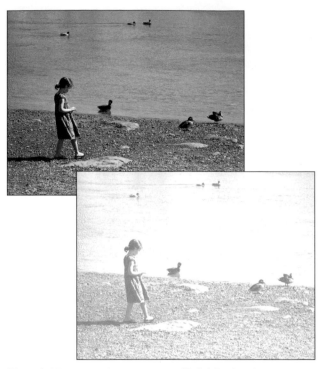

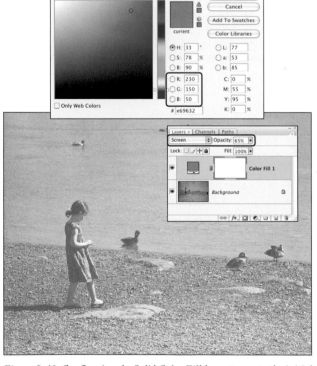

Figure 9-45. *A treatment to suggest an old, faded color photo.* © *SD*

3. Add a Curves adjustment layer. Make sure the grid is set to 10×10. Drag the highlight point in the upper-right corner across the top of the grid to the left. The highlights become much brighter and washed out. At a certain point you will begin to lose detail in the highlights. That's OK because, after all, the object here is a faded image (we moved the highlight point until the water began to wash out). Drag the shadow point in the lower-left corner up the left side one grid square. This lessens the contrast in the darker shadows. Drag up slightly on the middle part of the curve to further add to the washed-out, faded look (Figure 9-47). Click OK. For this example, we also lowered the blue curve a bit to increase the yellow color cast.

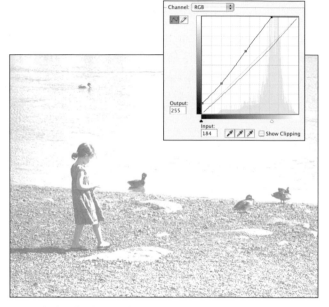

Figure 9-47. *The Curves adjustment to create a harsh, washed-out effect.*

Figure 9-46. *Configuring the Solid Color Fill layer to create the initial reddish-orange fading effect.*

If you want faded colors without any reddish-yellow color casts, skip the Color Fill layer step, add a Hue/Saturation adjustment layer and lower the Saturation values as desired (**Figure 9-48**). Depending on how you want the image to look, you may still need a Curves layer to create the faded, washed-out effect (**Figure 9-49**).

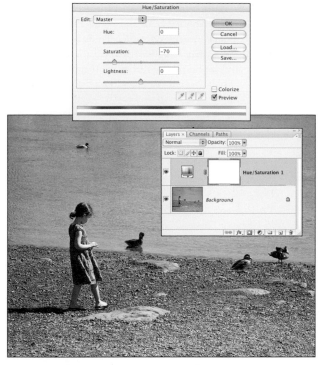

Figure 9-48. *The saturation is lowered to −70.*

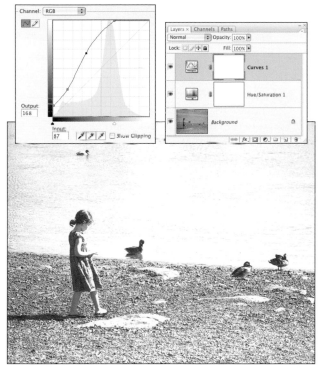

Figure 9-49. *A Curves layer is added to the desaturation effect to create the faded, washed-out look.*

Faded black and white

For fading a black-and-white image, we'll explore both fading out to white and fading to a dark, murky result. For our example image, we'll use a photograph taken on the Queen Mary in 2005 (Figure 9-50). Later, we'll use this same image to match to a vintage shot taken of the same ocean liner more than 50 years earlier.

🖰 ch09_queenmary2005.jpg

Figure 9-50. *Fading to light with Color Dodge; before and after.* © SD

1. Add a Curves adjustment layer. In the Curves dialog box, click OK without making any changes. At the top of the Layers palette, set the blending mode to Color Dodge.

2. The initial effect is pretty extreme; so lower the layer opacity to 70% to tame the fading a bit. This creates an interesting fade where the highlights are fading away, but the darkest shadows remain (Figure 9-51).

3. The blacks in old faded photos are rarely so rich and dark. To lighten them, add a Levels adjustment layer and move the Output Levels shadow slider in to 50. Click OK (Figure 9-52).

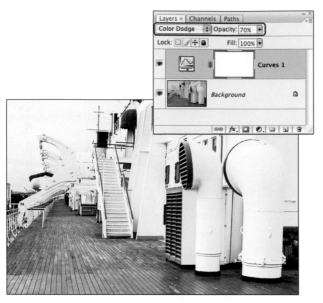

Figure 9-51. *The initial Color Dodge fade effect set to 70% opacity.*

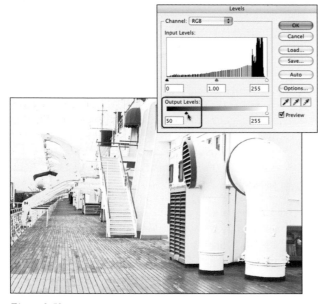

Figure 9-52. *Fading the shadow density with Levels.*

If you want to fade with a darkening effect instead of the lightening shown in this example, use an empty Curves layer and set the blending mode to Linear Burn. This will create an overall darkening as well as diminished contrast. Adjust the opacity as needed. Further fine-tuning can be applied by modifying the curve in the empty adjustment layer.

Fading to dark with blur layers and blend modes. This effect uses a blurred copy layer of the photo and a blending mode to create a dark, murky effect that lends itself to moody atmospheric images that suggest mystery and intrigue, or perhaps just really poor exposure technique (Figure 9-53).

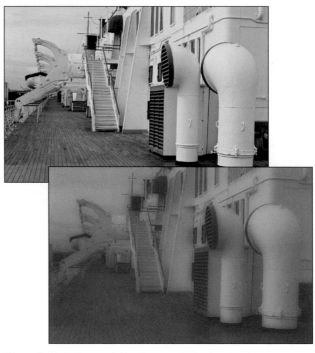

Figure 9-53. *Fading with blur layers and blend modes, before and after.*

1. Make a copy of the Background layer with the Cmd/Ctrl-J shortcut. Choose Filter → Convert for Smart Filters to turn the layer into a Smart Object.

2. Choose Filter→Blur→Gaussian Blur, and set the radius to 30 pixels. Click OK. Now set the blending mode for the blurred Smart Object layer to Multiply. This creates an interesting darkening fade that also has a hint of diffusion to it (Figure 9-54).

3. Let's explore a further modification to the contrast. Add a Curves adjustment layer. Make sure that the grid size is set to 10x10. Drag the highlight point in the upper-right corner down the right side one grid square. Then drag the shadow point in the lower-left corner up the left side three grid squares. Drag down slightly on the lower section of the curve. Click OK (Figure 9-55).

This last Curves modification results in an image that is hazy and dark with muddy shadow tones and poor contrast. This is certainly not the ideal photographic image, but for some imaging projects, precise tonal perfection may not the best approach for creating a certain mood.

Figure 9-56. Adding some grain and tilting the angle of the image suggests some rough weather on the Atlantic crossing.

Figure 9-54. A blurred copy of the image set to Multiply darkens and creates a hazy diffusion effect at the same time.

Matching a Modern Image to a Vintage Print

Let's continue with this same image of the Queen Mary, circa 2005, and compare it to a photo taken on the Queen Mary almost sixty years earlier. Figure 9-57 shows the photo taken in 1947 as the Queen Mary docked in New York City after a voyage from Southampton, England. The third man from the right just below the diagonal wire is Seán's father, James Duggan, arriving from Ireland. In the following exercise, our goal is to get the modern image to match the tones and feel of the vintage photo. We have even prepared a file that you can download containing a blank paper background that matches the one in the vintage photo. You can use this as a new background for the modern image (Figure 9-58). We'll approach this project by addressing three main areas: matching color and contrast, matching the focus, and finally, matching the texture.

Figure 9-55. A Curves adjustment drastically flattens the contrast and adds to the murky atmosphere.

For some final atmospheric fun, we added a film grain layer using the 50% Gray layer set to Overlay, as described earlier in this chapter. Then we chose Image→Rotate Canvas→ Arbitrary, and entered a value of 9° CCW. The final step was to crop to just inside the tilted image border. This creates the look of an underexposed photo, hastily taken as the ship pitched and rolled in high seas (Figure 9-56). Photographs are all about telling stories. With a little imagination and some creative digital darkroom technique, you can create new stories for your images.

Figure 9-57. The Queen Mary arrives in New York, November 1947.
© Duggan Family Archives

Figure 9-58. Matching a modern image to a vintage print, before and after.

🖰 ch09_vintage photopaper.jpg

🖰 ch09_queenmary2005.jpg

Matching color and contrast

1. The first step is to add the 2005 Queen Mary photo to the vintage photo paper image (use the unaltered image, not any versions you have already faded). Use the Move Tool to drag and drop the ship photo on top of the old photo paper. Position the ship layer so you can see the typewritten "Photographed on board H.M.S Queen Mary" notice (Figure 9-59).

2. Use the Rectangular Marquee tool to draw a selection around the photo of the ship. Create the selection so that it overlaps onto the background but does not include the typewritten notice at the bottom. Activate the Background layer and use Cmd/Ctrl-J to copy the selection onto a new layer. Drag this layer above the ship photo in the Layers palette and set the blending mode to Color (Figure 9-60).

3. Click the ship photo (Layer 1) to make it active. Option/Alt-click the adjustment layer button at the bottom of the Layers palette, and choose Levels. In the New Layer dialog box, turn on the option for "Use previous layer to create clipping mask." This will apply the Levels adjustment only to the previous layer. In the Levels dialog box, set the Output Levels black point value to 45 and the Output Levels white point

value to 240. In the vintage Queen Mary photo, the darkest shadow values fall around 45, so the purpose of this adjustment is to create a similar level of shadow density (Figure 9-61). Click OK.

Figure 9-59. Adding the photo to the vintage photo paper file.

Figure 9-60. The Color blending mode adds the color of the paper to the image, but the contrast is still a bit too crisp.

Figure 9-61. *Matching the tone and contrast of the newer image to the contrast levels in the vintage photo.*

Matching focus

4. The color and contrast of the image is matching very well to the photo paper background and to the overall contrast of the actual image taken in 1947. Now it's time to address focus issues. Click Layer 1 (the ship photo) to make it active, and then choose Filter→ Convert for Smart Filters. Choose Filter→Blur→ Gaussian Blur, and set the radius to 0.8 pixels to add a very slight blur. The object here is not to actually blur the image, but to take away some of the sharpness created by twenty-first-century camera technology (Figure 9-62).

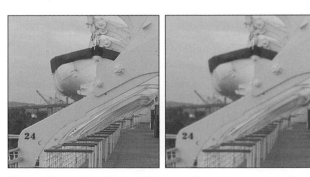

Figure 9-62. *A slight blur is added to match the sharpness (or lack thereof) in the 1947 photograph.*

Matching Texture

5. The final step to complete the illusion is to add some of the worn paper texture into the modern image. Click the top layer of the paper overlay that is adding the slightly yellowed color to the image. Use Cmd/ Ctrl-J to make a copy of this layer. Double-click its name, and rename it "Texture Overlay." Change the blending mode to Normal, and then choose Image→ Adjustments→Desaturate to remove all the color values from the layer (Figure 9-63).

6. Apply Levels directly to the Texture layer by choosing Image→Adjustments→Levels. Use the following values for the Input Levels: Shadows, 100; Midtone, 0.50; Highlights, 195 (Figure 9-64). Click OK. This adjustment compresses the tonal range of the texture layer and enhances the dark cracks and smudges of the original photo paper. More importantly, it makes much of the texture layer white, which is a neutral color for the blending mode we are about to take advantage of.

Figure 9-63. *Preparing the texture layer.*

Figure 9-64. *Increasing the contrast on the texture to show the smudges and scratches more.*

7. Set the blending mode for the Texture layer to Multiply to reveal the worn texture over the ship image (Figure 9-65). Drag the Texture layer below the color overlay layer. Choose Layer→Create Clipping Mask to add it to the clipping group of the levels layer and the ship photo. Since the photo layer of the ship is the base of the clipping group, the transparent areas for that layer establish the visibility for all the layers that are clipped to it.

8. Adjust the opacity of the Texture layer as needed. We decided to lower it to 80% to make the smudges and cracks a little more understated (Figure 9-66). You could also add a layer mask and hide some of the texture if it interfered with important image areas.

Figure 9-65. *The cracks and dirty texture from the original paper are added to the new image using the Multiply blending mode.*

Figure 9-66. *The final version of the image.*

Creating Textures for Use in Photoshop

Photoshop can be used to create textures, and, with customization, some of them can be useful, as we saw with the earlier examples on canvas and watercolor paper. However, others end up having the canned look of digitally generated textures. Rather than rely on Photoshop to create textures for you, it's much more interesting to go and find your own, either by photographing interesting textural surfaces you run across, or by collecting your own analog, real-world textures and scanning them. Here are a few examples of things that we have used in our low-fidelity, texture-generation process:

- Blank 120 film and film sleeves, stepped on and scraped across rough concrete
- A gloriously degraded 35mm film leader, found on a New York sidewalk
- Paper, stained with coffee grinds, crumpled and left out in the sun for a day (Figure 9-67)
- Paper, imprinted with inky fingerprints and other smudges
- Semi-translucent, beautifully scuffed plastic
- Handmade art paper
- Aged-stained blank pages from 175-year-old books

Figure 9-67. *A used coffee filter filled with wet grounds created the stains on the paper (top). It was combined with the photograph using the Overlay blending mode and the Blend If sliders.* © SD

Creating digital textures from all of these was much more fun and interesting than using Photoshop to make textures for us! And the results look real because the textures are real. We've already had a hint of real-world texture in action with the smudged and cracked surface of the photo paper that was used in the faux vintage Queen Mary image. In the next few examples, we'll take a look at how different real-world textures add character and depth to the photographs they are blended with.

Combining Photos with Art Paper

For this texture we scanned a sheet of rough-surface art paper with torn edges. Combining it with an image is a simple procedure when blending modes and layer clipping masks are used (Figure 9-68).

Figure 9-68. A photograph blended with a sheet of art paper. © SD

⍌ ch09_finart_paper0.jpg

⍌ ch09_treeroots.psd

1. The first step is to bring the two images together into one file. Using the Move Tool, drag and drop the roots image on top of the art paper image.

2. With the top layer of the roots active, choose Layer→Create Clipping Mask. Since the art paper is already a separate layer, when it becomes a clipping mask for the roots layer, the transparent areas of the art paper layer determine the visible shape of the roots image (Figure 9-69).

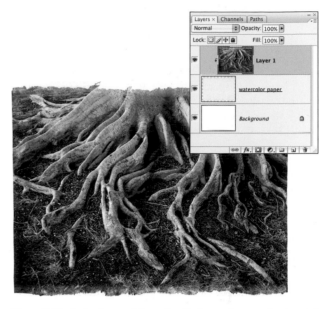

Figure 9-69. A clipping mask is used to fit the tree layer to the shape of the art paper layer.

3. Change the blending mode for the roots layer to Color Burn. This creates a pretty interesting washed-out blend with the underlying art paper texture (Figure 9-70).

4. Add a Curves adjustment layer and click OK without making any changes. Set the blending mode for this layer to Multiply to darken the roots layer (Figure 9-71).

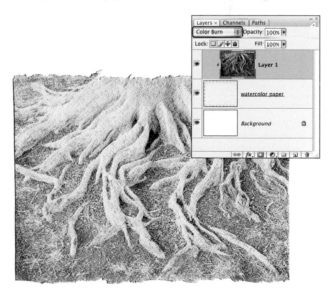

Figure 9-70. The tree layer is set to Color Burn.

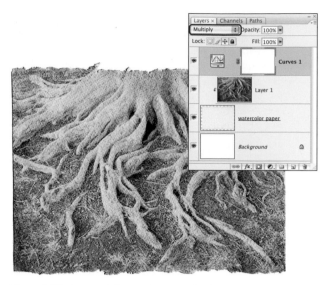

Figure 9-71. An empty Curves adjustment layer set to Multiply is used to darken the tree image.

Blending Textures into Skies

When Seán was teaching at the Maine Photographic Workshops one summer, one of his students asked how to combine a texture into the sky of a landscape photo. To help answer her question, he photographed some peeling paint on a wall later that afternoon (Figure 9-72). Since the wall was close to white, he knew this would blend very easily with the sky in the photo of Marshall Point lighthouse, which had been taken the day before (Figure 9-73). This tutorial, which was developed to answer the student's question, is a hybrid between adding a texture and creating a simple collage.

Figure 9-72. Peeling paint on a wall…waiting for a sky.

🖱 ch09_peelingpaint.jpg

🖱 ch09_lighthouse.jpg

1. As with the last example, the first step is to combine the two images into a single file. Drag the peeling paint image on top of the lighthouse file. Double-click the layer name and rename this layer "paint."

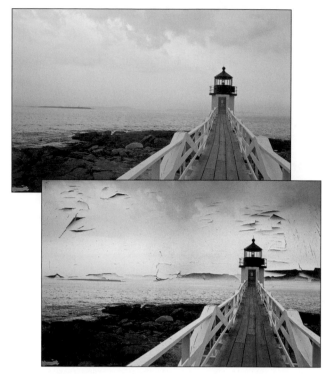

Figure 9-73. Peeling paint combined with a landscape photo. © SD

2. Use the Move tool to reposition the paint layer to align it with the top of the image. Change the blending mode to Darken (Figure 9-74). The use of the Darken blending mode does most of the work in creating a composite of the two images because it compares the pixels on both layers and only displays the darkest ones. Since the peeling paint texture is darker than the sky below it, it shows up perfectly. And since the lighthouse tower is darker than the wall, it shows up as well.

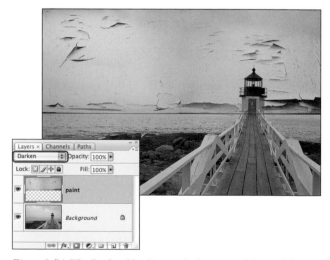

Figure 9-74. The Darken blending mode does most of the work in combining the texture with the sky.

3. At the bottom of the Layers palette, click the Add Layer Mask button to add a layer mask to the paint layer. Use a soft-edged brush tool and paint with black at 100% opacity to disguise the hard edge at the bottom of the paint layer. You can also touch up the few areas where the peeling paint is visible on top of the lighthouse tower (Figure 9-75).

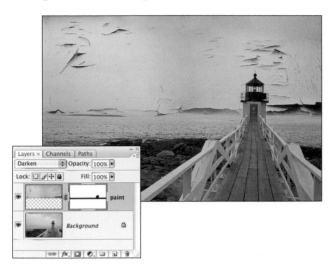

Figure 9-75. A layer mask is used to disguise the hard lower edge of the peeling paint layer.

Currently missing in the image are the clouds from the original lighthouse image. Although we could certainly use the existing layer mask to show them again, that might also hide some of the peeling paint texture. We'll go about this using another method that will allow us to have our clouds and texture, too.

4. Make the Background layer active. Use the rectangular marquee tool to create a selection of the sky in the lighthouse photo from the top of the image down to just above the horizon. Copy this to a new layer with Cmd/Ctrl-J. Rename the layer "Sky," drag it up to the top of the layer stack, and change its blending mode to Multiply (Figure 9-76).

5. Add a layer mask to the Sky layer. With the Brush tool and a large, soft-edged brush, paint with black over the lower portion of the sky, including the area where the lighthouse tower was made too dark by the Multiply blending mode (Figure 9-77).

6. As a final step, add a Hue/Saturation adjustment layer to the top of the layer stack. Click the Colorize checkbox and set the Hue to 38 and the Saturation to 15 to add a sepia tone. Click OK, and then change the blending mode to Overlay and the Opacity to 80%. This adds a hint of the sepiaesque flavor to the image (Figure 9-78).

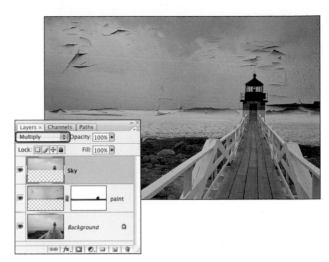

Figure 9-76. A section of the sky is copied to a new layer and set to Multiply.

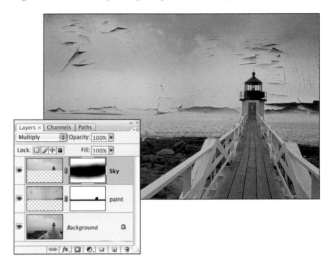

Figure 9-77. A layer mask is used to show only the clouds on the sky layer.

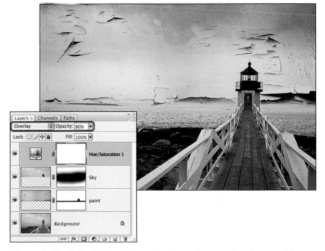

Figure 9-78. A final Hue/Saturation layer is set to Overlay to add a touch of sepiaesque.

Creative Edge Effects

Creative edge effects are the finishing touches you can use to dress up an image with a subtle or bold border. These techniques can be used to draw attention to the image or to extend it beyond the standard boundaries of the rectangular or square photographic format. Some edge effects can be subtle and understated, such as a simple black keyline or stroke to make the image stand out more on paper. Other edge effects are almost works of art in their own right, lending rough and sculpted borders to the photo to suggest filed out negative carriers, brushed-on emulsions, and Polaroid transfers. In this final section of the chapter, we take a look at some ways to add a little something extra to the edge.

A Simple Black Stroke

We typically do not add a keyline stroke to our layered master file because the size of the stroke is sometimes influenced by how large of a print is being made. This step is typically applied after a flattened copy of the master file has been made and resized to the final print dimensions.

1. Choose Layer→Duplicate Layer to make a copy of the Background layer. Click the original Background layer to make it active. Make white the foreground color, and then press Option/Alt-Delete to fill with the foreground color.

2. In order for the keyline stroke to show up, you first have to add some extra canvas around the image. Choose Image→Canvas Size. In the Canvas Size dialog box, open one of the menus that show the unit of measurement and change it to percent. Change the width and height to 110%. Make sure the Canvas Extension color is set to white and click OK (Figure 9-79).

3. Make the main image layer active and zoom up to 100% (View→Actual Pixels) so you can see the stroke well once it is applied. Click the Layer Style button (the small, italicized fx) at the bottom of the Layers palette, and then choose Stroke.

4. The default color is red, which, while quite noticeable, is not really useful. Click the color swatch and, in the Color Picker, choose black for the stroke color. In the main Layer Style dialog box, set the Position to Inside and the size to 2 pixels. The size is governed by how large a print is being made and how wide you want the stroke to be. Adjust the opacity of the stroke if you don't want it to be totally black, and then click OK (Figure 9-80).

Figure 9-80. Adding a thin black keyline stroke as a Layer Style.

Figure 9-79. Adding extra white canvas around the image. © SD

Filed-out Negative Carrier

Many photographers like to print their negatives full frame, with no cropping at all. Apart from taking away the decision of how to crop the shot, it shows that the photographer used the camera viewfinder to determine the crop as the photo was taken. Most photography courses make students shoot full-frame at some point to drill home the importance of seeing the composition in the viewfinder and not relying on cropping afterwards.

An interesting method that some photographers use to show that the image has not been cropped is to file out the edges of the metal negative carrier. When the image is printed using an enlarger, this means that the entire film frame is visible, down to the black border around the image. The result is a rough-edged black border that creates a custom built-in frame for the image (Figure 9-81). Some photographers even go so far as to file out the neg carrier so that portions of the film sprocket holes are visible.

Figure 9-82. The filed-out negative carrier custom border. © SD

Figure 9-81. This portrait from a series on the 1991 Gulf War was printed using a filed-out negative carrier. © SD

If you still have your old black-and-white darkroom gear stored away somewhere, the best way to get a filed-out carrier look is to either scan an actual filed-out carrier or photograph it on a light box. Another analog idea would be to cut a rectangular opening into a piece of tin or sheet metal in a specific aspect ratio (for example, 3:2 for 35mm), and then file the edges of the opening to create the roughened border. If neither of those alternatives is an option, then there are ways of creating a faux filed-out neg carrier in Photoshop (Figure 9-82).

1. Create an 8-bit new file that is close to the size, resolution, and orientation you normally like to print at. It doesn't have to be exact, since the alpha channel mask we will create can be scaled up a bit with no significant loss of quality. In this example, we'll create a neg carrier mask to fit a standard 35mm aspect ratio.

2. Choose the Rectangular Marquee tool. In the Options bar, set the feather value to zero and set to Style to Fixed Aspect Ratio. Enter 3 for the width and 2 for the height. Drag out a rectangular selection that fills most of the empty file, leaving a little border around the edges (Figure 9-83).

Figure 9-83. Creating the initial rectangular selection.

3. In the Channels palette, click the Save Selection as Channel button to create an alpha channel from the selection. Choose Select→Deselect (Figure 9-84).

Figure 9-84. The saved alpha channel.

4. Press D on the keyboard to return to the default colors. Choose Filter→Sketch→Torn Edges. The Filter Gallery will open using the default settings for Torn Edges. Configure the settings as follows: Image Balance, 25; Smoothness, 3; Contrast, 10 (Figure 9-85).

5. At the bottom right of the Filter Gallery dialog, click the new effect layer button (circled in red in Figure 9-85) to add another filter to the effect. By default it will be a duplicate of the current filter. In the center panel in the Sketch folder, click Photocopy. Set the Detail to 15 and the Darkness to 6 (Figure 9-86).

Figure 9-85. The settings for the Torn Edges filter.

Figure 9-86. The settings for the Photocopy filter are combined with the Torn Edges filter.

6. If you like the way the smooth outer edge looks, then you can click OK. To roughen up the outer edge a bit more, click the New Effect Layer button one more time, and then choose the Conté Crayon filter from the Sketch folder. Set the Foreground and Background Levels to 12, the Texture to Canvas, the Scaling to 150%, and the Relief to 5. The Light direction is not that critical (Figure 9-87). Click OK to apply the combined three-filter effect. Save this file so you can use it again.

Figure 9-87. The Conté Crayon filter effect is added to the Photocopy and Torn Edges effects.

The key thing to take away from this tutorial is that you can combine multiple filter effects using the Filter Gallery. This allows you to build up an edge effect that's not based on any single filter. Many of the Artistic and Brush Strokes filter groups can be used to cook up a customized edge effect. The ones we are showing here are just to give you an idea of how to get around the kitchen and find the different ingredients.

7. Before you import the neg carrier frame into an image, make sure that the pixel dimensions of the neg carrier file are either the same as, or similar to, the photograph.

8. In the file with the alpha channel active, choose Select→All, then Edit→Copy. Switch over to the image file where you want to use the filed-out neg carrier and choose Edit→Paste. The alpha channel will be pasted down as a new layer (Figure 9-88).

9. Choose the Magic Wand from the Tool Palette and click in the center of the neg carrier frame. From the Select menu, choose Modify→Expand, and enter a value of 1 pixel. This will prevent any white fringes from showing along the inner edge. Press the Delete key to reveal the image underneath. Deselect the selection.

10. If you need to resize the neg carrier frame, choose View→Full Screen Mode with Menu Bar, and then zoom down so you can see the entire image with plenty of gray around it. Choose Edit→Free Transform, and then drag on one of the corner handles to scale the carrier frame larger to reveal more of the underlying image. Hold down the Shift key if you want to preserve the original aspect ratio of the neg carrier frame. Press the Enter key to complete the transformation or press Escape to cancel the process (Figure 9-89).

Figure 9-88. The copied neg carrier template is pasted down as a new layer on the image file.

Figure 9-89. Resize the neg carrier frame using the Free Transform command. Hold the Shift key down to constrain the proportions.

Hand-painted Emulsion Edges

In the world of platinum, palladium, and other alternative photo processes, photographers mix their own emulsions and then hand-coat the emulsion onto fine art papers. When the print is developed, the areas outside the boundaries of the image reveal the rough black edges created by the brushstrokes (Figure 9-90). The analog way to recreate this technique is to paint a rough rectangle or square onto a sheet of paper with black poster paint (actually, it doesn't even have to be black paint since you can change it to black in Photoshop). When the paint dries, scan the paper and use that as a custom hand-painted edge. Of course, it's pretty easy to do it in Photoshop, too.

1. Open an image you want to work with. Use Cmd/Ctrl-J to copy this image onto a new layer.

2. Select the Background layer to make it active. Make white the foreground color, and use the Option/Alt-Delete shortcut to fill with the foreground color.

3. Choose Image→Canvas Size. Change the units to percent and add 150% to the height and width. Make sure the canvas extension color is set to white. Click OK to add the extra canvas (Figure 9-91).

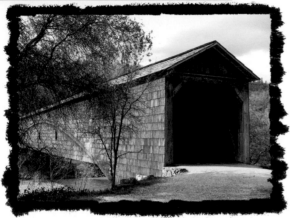

Figure 9-90. *A custom edge that creates the look of photographic emulsion that has been applied by hand.* © SD

4. Press D to set the default colors and make black the foreground color. Select the Brush tool. Open the Brush picker and click the brush submenu button to open the menu of additional choices. Near the bottom of this menu, click Thick Heavy Brushes, and then choose Append. Open the Brush Picker and near the bottom of the list is a 104-pixel Rough Round Bristle brush (Figure 9-92). Choose this, and then increase the Master Diameter to a size that will allow you to cover the edges without using too many brushstrokes (our brush was 160 pixels).

Figure 9-92. *Selecting one of the Thick Heavy brushes.*

Figure 9-91. *Adding extra canvas to the image.*

5. The Background should still be the active layer. Start brushing over it so that the black brushstrokes extend beyond the edges of the image. Continue brushing in the same direction until you have covered all the edges. Don't worry about covering the interior areas since those can be easily filled with black using a selection (Figure 9-93).

Figure 9-93. The completed brushstrokes defining the edges underneath the image layer.

6. When you have finished covering the edges with brushstrokes, turn the visibility off for the image layer by clicking the eye icon. Make a rectangular selection of the area that is still white. With black as the foreground color, press Option/Alt-Delete to fill the selection with black. Choose Select→Deselect (Figure 9-94).

Figure 9-94. Filling the interior with black.

If you just want to have roughened, brushed on edges behind the image layer, then you are done. This is how it would look if a large negative had been contact-printed on hand-coated paper. If you want to explore adding a roughened edge to the image itself, read on.

7. Turn the image layer visibility back on and click the layer to make it active. Click the Add Layer Mask button to add a layer mask to this layer. With the Brush tool active, open the Brush Picker and change the Master Diameter to 50 pixels. Paint with black on the layer mask over the edges of the image to mask the edges using the rough brushstrokes (Figure 9-95).

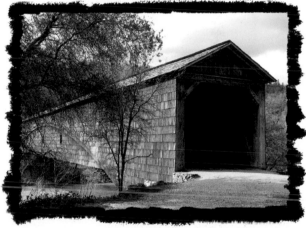

Figure 9-95. Adding the rough brushstrokes non-destructively to the edges of the image using a layer mask.

> The rough round bristle brush tip that we used for this example is only one of many potential Photoshop brushes that can work for this type of technique. Explore some of the other brush sets and see which brushes work well with this technique on your images.

Enhancing the Visual Story

Good photographs tell a story and make the viewer want to know more about the scene or ideas portrayed within the frame of the image, or generate curiosity about what happens next or what transpired just before the shutter button was pressed. Sometimes the creative path you decide on will include enhancing the photograph in various ways to create a mood, add emphasis to certain elements within the image, or hint at intangible qualities such as memory, dreams, or emotion.

As we have seen in this chapter, some of these techniques can suggest the appearance created by traditional photographic filters, film types, and darkroom processes. These can be subtle—a slight accent or a little added seasoning for a photo—or they can transform an image into something very different from the original source material. But the image and the story it tells should always come first. Create the story first, and then build on it, enhance it. In a way, image enhancements are like the well-chosen words and finely crafted sentences that a writer uses to add depth, detail, and nuance to a story. They help to create a richer narrative experience for the reader. In a photograph creative enhancements can be used to accomplish the same goal for the visual story presented within the image.

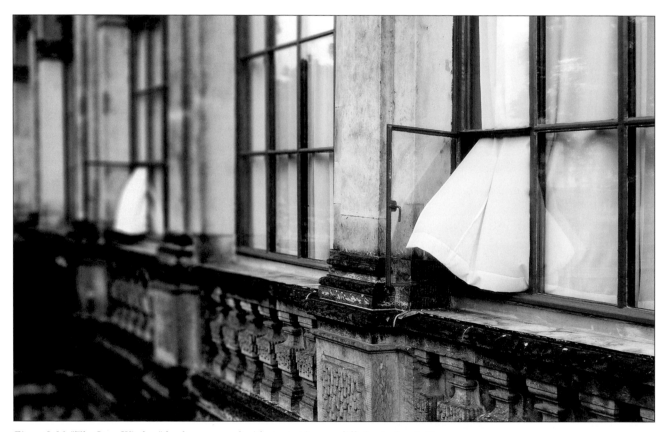

Figure 9-96. "The Open Window" has been seasoned with some sepiaesque diffusion toning. © SD

Figure 9-97. To create a nostalgic mood and suggest memories of a distant summer, "A Measure of Longing" has been enhanced with diffusion, selective blurring and toning. © SD

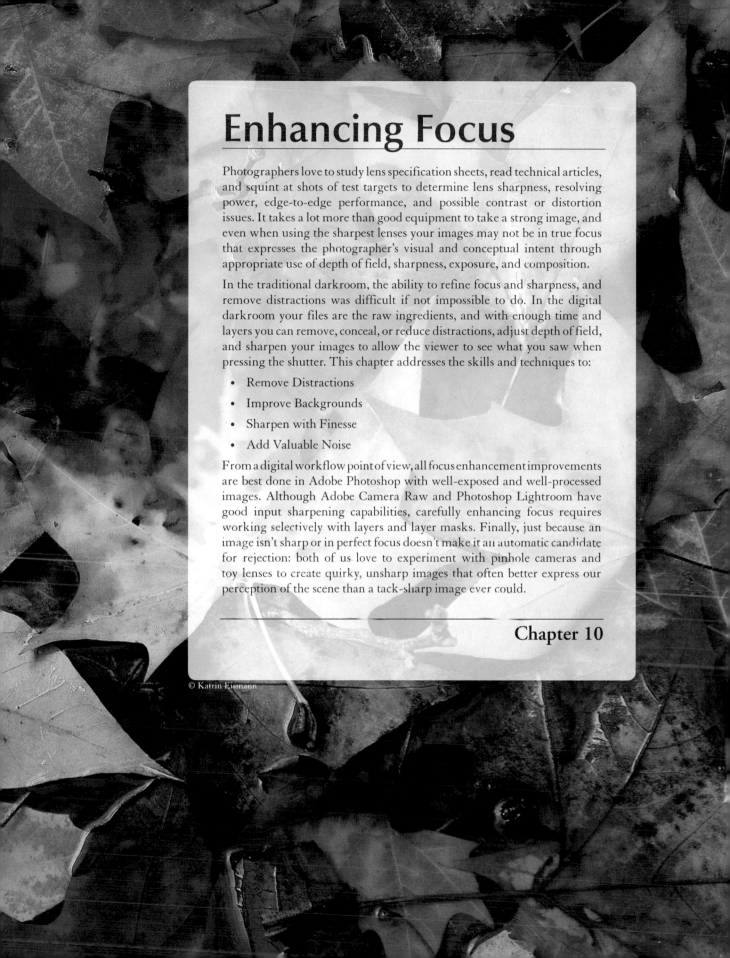

Enhancing Focus

Photographers love to study lens specification sheets, read technical articles, and squint at shots of test targets to determine lens sharpness, resolving power, edge-to-edge performance, and possible contrast or distortion issues. It takes a lot more than good equipment to take a strong image, and even when using the sharpest lenses your images may not be in true focus that expresses the photographer's visual and conceptual intent through appropriate use of depth of field, sharpness, exposure, and composition.

In the traditional darkroom, the ability to refine focus and sharpness, and remove distractions was difficult if not impossible to do. In the digital darkroom your files are the raw ingredients, and with enough time and layers you can remove, conceal, or reduce distractions, adjust depth of field, and sharpen your images to allow the viewer to see what you saw when pressing the shutter. This chapter addresses the skills and techniques to:

- Remove Distractions
- Improve Backgrounds
- Sharpen with Finesse
- Add Valuable Noise

From a digital workflow point of view, all focus enhancement improvements are best done in Adobe Photoshop with well-exposed and well-processed images. Although Adobe Camera Raw and Photoshop Lightroom have good input sharpening capabilities, carefully enhancing focus requires working selectively with layers and layer masks. Finally, just because an image isn't sharp or in perfect focus doesn't make it an automatic candidate for rejection: both of us love to experiment with pinhole cameras and toy lenses to create quirky, unsharp images that often better express our perception of the scene than a tack-sharp image ever could.

Chapter 10

Remove Distractions

Distractions come in many shapes and sizes, and the simplest way to find them is to defocus your eye, as illustrated in Figure 10-1. Notice how your eye is drawn to the white clump in the lower-middle part of the image and how, after it has been removed, your eye now remains on the subject of the image, as seen in Figure 10-2. Our eyes are attracted to color, contrast, and light, and distractions often intrude in on the edge of the frame or are high-contrast elements such as light against dark shapes or dark against white shapes. Classic distractions include: background elements that are uncomfortably close to the subject such as tree branches protruding from a head, specular highlights, and edge elements that, in the rush of taking a photograph, were unavoidable.

Figure 10-2. After removing the scrap of white paper, the image focuses on the turning pages.

For some photographers, removing distractions such as a soda can in a landscape is unethical and does not render the scene as it originally was. For us, photography is about creating the best image, and we can either move the soda can before pressing the shutter button or afterwards with Photoshop. In most cases, we'll opt for picking up the can, throwing it into a trash bin, and then taking the picture. Photoshop is a continuation of the photographic process, and many times it isn't until we're back in front of the computer that some distractions become glaringly obvious. Each photographer needs to think about how they interact with the scene. Is it OK to bend a grass stem down so that it doesn't interfere with the frame, or is that manipulation? Is it all right to clone out a bit of trash, or does that change the image?

> Please see the Cropping and Straightening Images section in Chapter 4, "File Preparation" for valuable information on the importance of cropping to refine image composition.

Essential Clean up

We don't live in a perfectly pristine world; people still litter and, as the before image in Figure 10-3 shows, animals litter, too. The white flecks on the red carpet are very distracting, and by removing them, the visual focus of the image falls onto the eagle, as seen in the after image. The most common tools for cleaning up an image are the Clone Stamp and Healing Brush tools.

Figure 10-1. Defocusing your eyes as you look at a print or a file emphasizes the distractions. © KE

Figure 10-3. Removing the out-of-focus white specks allows the visual focus of the image to return to the eagle. © KE

When cleaning up image backgrounds with little detail, the Patch tool is also excellent at quickly removing dirt, dust, and small pieces of litter.

🖰 ch10_eagle.jpg

1. If working with a single-layer image, duplicate the background layer, or, if working with a multilayer image, click the topmost layer, and then press Cmd-Option-Shift/Ctrl-Alt-Shift+E to merge all working layers up.

2. Select the Patch tool and make sure that the options are set to Source and that Transparency is not selected.

3. Generously circle the distraction with the Patch tool, as seen in Figure 10-4, and then drag the selection to a clean area in the image. For best results, choose a clean area near the dirty area that matches the tonality and texture of the area to be cleaned up.

4. Move onto the next piece of dirt and repeat the circle and drag process for each piece of dirt. We find that using the Patch tool is much faster than cloning or healing the individual spots.

Figure 10-4. Circle the offending area and drag it to clean areas to quickly remove spots, specks, and distractions.

In addition to removing trash, take a moment to look at your images to double-check if out-of-focus or distant birds, bothersome electrical wires, distracting highlights or reflections, or flyaway hair should be removed with a combination of cloning, healing, and patching.

Improving Backgrounds

The primary methods to improve backgrounds are clean up, darken, blur, or replace—with the first three being more straightforward than a complete background replacement, which is addressed thoroughly in Katrin's *Photoshop Masking & Compositing* book. Of course, many of these attributes can be controlled in the camera by using a wider aperture to soften the background or using a flash to overpower the sun and darken the background, but admittedly we often see these possibilities much later in our images.

Removing unwanted elements

In the rush of the moment, it's easy to lose sight of the entire image composition, as Katrin did in Figure 10-5, in which she was concentrating on the little boy playing in the puddle and didn't notice that the jungle gym in the background was going right through his head. In the after image, you can see how much cleaner the image is, and, more importantly, that the heavy contrast of the iron in relationship to the little boy has been removed, allowing you to see what Katrin saw on a late winter day.

> Avoid the temptation of removing the biggest distraction first. Many times cleaning up the smaller distractions creates more suitable replacement material that you can use to conceal the larger areas.

🖱 **ch10_childs-play.jpg**

1. If you are working with a single-layer image, add a new layer, or if working with multilayer images, click the topmost layer, and then add a new layer.

2. Activate the Clone Stamp tool and make sure that "Current & Below" is active in the sample option. This instructs Photoshop to sample all visible layers and place the new information onto the new active layer. In earlier versions of Photoshop, this is called "Use All Layers," and it was very important to have the clone or heal layer above all the adjustment layers to avoid having the repairs being adjusted twice.

> In Photoshop CS3 you can now instruct the Clone and Healing tools to ignore adjustment layers when working with multi-layer images by clicking on the button with the adjustment layer icon and a slash though it. When the button is dark, cloning and healing will not include adjustment layers and the repair layer can be placed anywhere in the layer stack.

3. Clone over the smaller pieces of trash from the lawn in the upper-right corner, as seen in Figure 10-6.

4. To conceal the jungle gym, continue cloning the jungle gym and don't be afraid of getting too close to the boy's face. In fact, it is better to add a bit too much information than too little. To clean up any unneeded cloned grass, use the Eraser tool with 50 percent Hardness to remove any telltale grass from his face. In most of our creative image enhancement work, we

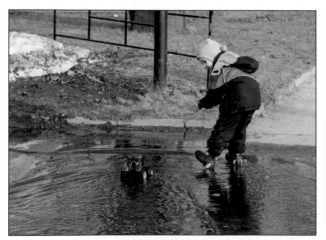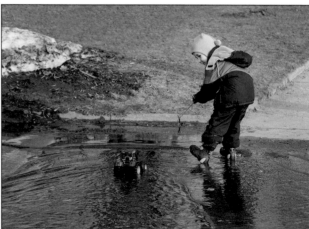

Figure 10-5. By removing the heavy iron poles in the background, the image concentrates on the playing boy. © *KE*

both opt to use the layer mask to hide and reveal image information—but when doing cleaning up, careful use of the Eraser can be quicker and just as effective.

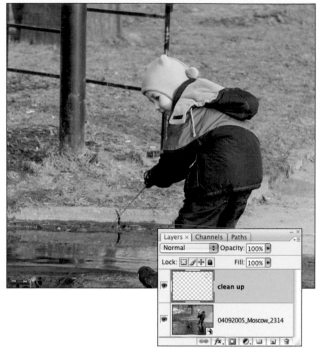

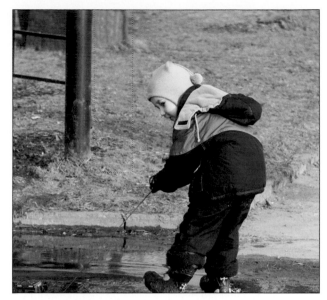

Figure 10-7. Selecting an area to be used to conceal distractions.

Figure 10-6. By cleaning up the simpler areas first, you can "get to know" the file and plan the strategy to tackle the more challenging areas. © KE

Depending on your sensibilities, removing the vertical bar that was intersecting with the boy's head may be all that is needed to improve the image, or you may be more ambitious and want to remove the entire jungle gym. To remove larger pieces, we find it more effective to copy good image information and paste it onto a separate layer to conceal unwanted image elements.

5. To remove larger distractions, select suitable replacement material and, when working with multilayer images, use Edit→Copy Merged to copy all of the visible image information. In this example, use the Marquee tool with a 2-pixel feather to select the area adjacent to the vertical pole (Figure 10-7) followed by Edit→Copy Merged and Edit Paste.

6. Use the Move tool to move the piece into position and, in this case, use the Edit→Free Transform to scale and size the piece as needed. By scaling the top down and skewing the left side down, the lower shadow aligns perfectly with the existing shadow, as seen in Figure 10-8.

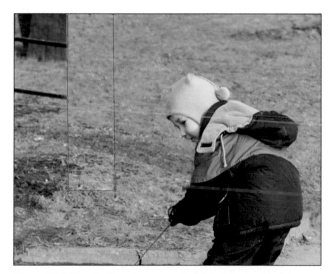

Figure 10-8. Use the Transform controls to bend the new layer into place.

7. Continue selecting and using Edit→Copy Merge and Edit→Paste to quilt additional pieces of information over the jungle gym. In the process, the replacement pieces may look clumpy, but use the copy paste technique to build up initial image information that will be refined in the final step.

8. After building up the replacement material, turn off the background (Figure 10-9) and choose Layer→ Merge Visible to combine all the layers that contain new background material.

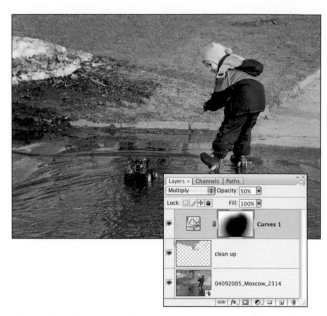

Figure 10-10. Darkening the edges of the image emphasizes the little boy.

Figure 10-9. Merging the concealing layers into one.

9. Use the Healing brush and Clone Stamp tools to paint over obvious seams, and use the Eraser tool to erase away unneeded image remnants.

10. Darkening down the background is an optional final step to focus the viewer's eye on the little boy. Add a Curves adjustment layer and change the blend mode to Multiply.

11. Choose Image→Adjustments→Invert and use a White, Transparent gradient on the layer mask to pull from each corner to the center of the image. Use a large black brush to conceal any darkening that fell on the little boy. Lastly, adjust the layer opacity to darken down the background ever so slightly (in this case, we used 50 percent), as seen in Figure 10-10.

To clone or to heal?

The Clone Stamp tool replicates pixels and is best used to build up new information when concealing large distractions. The Healing brush is a texture replacement tool, best used for smaller details and as a refinement tool after cloning or pasting in image information. When using the Healing Brush, avoid areas of high contrast to reduce the potential of adding unwanted smudging.

To create realistic replacement areas, avoid repeating patterns by Option/Alt-clicking different source areas in the image. Also, be sure to remove shadows of image elements you have removed.

Darkening backgrounds

Darkening down background elements is an effective method to reduce distractions and, in many cases, darkening is combined with blurring techniques to deemphasize the background even more effectively.

To blur or to sharpen?

Whenever you blur an image area to reduce visual importance, you can accentuate the blurred effect by sharpening the image's opposite areas. The sharper areas will make the blurry areas look softer, and the soft areas will make the sharp areas look even sharper.

In the example seen in Figure 10-11, the colorful splotches in the background distract from the bird handler's bracelet and bag. As you can see in the after figure, removing and darkening the distractions makes the image more coherent. After improving the background, Katrin also sharpened the silver bracelet and leather details to accentuate the texture.

🖰 ch10_hawk-handler.jpg

Figure 10-11. Simplifying the background focuses the eye on the subject. © KE

1. Add a new layer and use a 50-percent hardness Clone Stamp tool with "Current & Below" active, and clone over the out-of-focus red sleeve of a person in the background, as seen in **Figure 10-12**.

Figure 10-12. Cloning over distractions to conceal them.

2. To darken the lower area, use a 1-pixel feathered Lasso to select the lower area, as seen in **Figure 10-13**.

Figure 10-13. Selecting the background is the first step in darkening it.

3. Add a Curves adjustment layer and, as Jeff Greene likes to say, the selection will "auto-magically" be transferred to the layer mask – so that only the selected areas will be affected. Darken down the selected area, as seen in **Figure 10-14**. After clicking OK, use a small black or white brush on the Curves adjustment layer mask to refine the edge of the darkening. Painting with white will add more darkening, and painting with black will remove darkening.

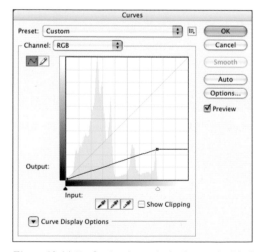

Figure 10-14. Darkening down the background with Curves.

Blur This!

Photoshop features many blurring filters, with some offering more control than others, while some blur the entire image and do not blur image edges. In Photoshop CS3, choose Filter→Convert for Smart Filters to non-destructively experiment, adjust, and refine the filter settings. To efficiently experiment with the blur filters with versions of Photoshop prior to CS3, try the filter on a smaller section of the image by:

1. Selecting a section of the image with the Marquee tool (no feather required).

2. Using the desired Blur filter and settings.

3. After applying the filter, studying the effect and if it needs adjustment, undoing the effect and trying again with a new Blur filter setting.

4. After determining the desired filter settings, making sure to undo the change to the selected area. Select→Deselect and use Cmd/Ctrl+F to apply the last used filter to the entire image.

Understanding what each filter does increases your options to create unique images.

Filter→Blur

- Average: Analyzes the color values in a selection or layer and creates one "average" value. Not very useful for focus enhancement, and best used for colorcast removal.

- Blur: Smoothes transitions by averaging the pixels next to the hard edges of defined lines and shaded areas. Best used for mild noise reduction.

- Blur More: Three to four times stronger than the Blur filter. We use Blur and Blur More only for quick noise reduction, as these filters do not offer any control or adjustments.

- Box: Blurs an image based on the average color of adjacent pixels. Higher settings increase the blurring effect.

- Gaussian: A fast and adjustable blur filter that adds a hazy effect. Best used on layers and channel masks to create feathered transitions.

- Lens: Used to mimic the appearance of a wider aperture. The Lens Blur filter works best on backgrounds that have natural highlights as the filter over-brightens them very nicely as a wide-open lens would. Sadly, the Lens Blur filter does not work on a Smart Filter layer.

- Motion: Smears the image as when using a slow shutter speed. Works best on image elements that are isolated on transparent layers.

- Radial: Adds zooms or spin-effect motion blurs with higher settings creating a more pronounced effect. Drag the grid in the Motion Blur interface to define the blur origin.

- Shape: Uses a shape from the custom shape presets to form the blur. Higher settings enlarge the shape the filter uses to create a more blurred effect. Circular shapes can create interesting lens-like effects.

- Smart: A very precise and controllable blur filter that sadly doesn't work in 16-bit and can be painfully slow to use. The Radius value determines the size of the area searched for dissimilar pixels. The Threshold value determines how dissimilar the pixels must be before they are affected. To see an initial effect you need to increase both the Radius and the Threshold sliders.

- Surface: Blurs while preserving edges. The Radius slider controls the strength, and the Threshold slider controls how much tonal values have to differ to be included in the blur. Higher values increase the effect. Useful for removing noise and for creating hazy effects while maintaining edges.

Filter→Noise

- Median: Averages tonal and color values while maintaining edges. The filter searches for pixels of similar brightness, discards pixels that differ too much from adjacent pixels, and replaces them with the median brightness value of the searched pixels. Median is useful for reducing the effect of motion and noise reduction.

Filter→Other

- Custom: Used to brighten, darken, blur, and sharpen images. For additional information, please see the Custom Filter sidebar later in this chapter.

- High Pass: Works on duplicate or merged layers. When used in conjunction with Overlay, Soft Light, or Hard Light blending modes, it is an effective sharpening filter. To create a beautiful blur, use Cmd/Ctrl+I to invert the High Pass layer, which unsharpens the sharpening effect wonderfully.

4. To sharpen areas selectively, merge all layers up with Cmd-Option-Shift/Ctrl-Alt-Shift+E. In Photoshop CS3, select Filter→Convert for Smart Filter. (If you're working with an early version of Photoshop, skip the Convert for Smart Filter step.)

5. Choose Filter→Sharpen→Smart Sharpen and start with a moderate Amount of 150 percent with a Radius setting of 1.0, and make sure to select Remove: Lens Blur.

6. These settings sharpen the entire image, which is not desired. Click the Smart Filter layer mask and Cmd/Ctrl+I to invert the white mask to black. For earlier versions of Photoshop, add a layer mask and invert it.

7. Use a soft-edged white brush and paint over the silver bracelet and the leather details of the bag and glove to paint the sharpening onto the select details, as seen in Figure 10-15.

When photographing on location and on the move, it can be difficult to control every image element. Darkening the background as described is an effective technique to show the viewer what you saw.

Adjusting Depth of Field

Controlling what is and what is not in focus is an essential component of effective image composition that is primarily controlled with the lens aperture. Larger apertures (smaller numbers) create a shallower depth of field, as seen in Figure 10-16, in which the young girl is in focus and the unimportant background is out of focus. You can mimic this effect with the Lens Blur filter to create the effect seen in Figure 10-17, which focuses your attention on the handsome man in the image.

Due to fundamental lens construction and size relationships, creating shallow depth of field effects is easier done with both longer lenses and larger sensors or film formats. The depth of field decreases as:

- A lens is opened up—that is, the f/number is decreased.

- The focal length of the lens increases. Wide-angle lenses have a greater inherent depth of field than telephoto lenses.

- As camera-to-subject distance increases. The closer you are to the subject, the shallower the depth of field is. As magnification increases, depth of field decreases.

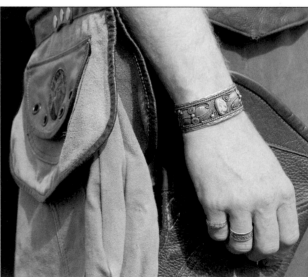

Figure 10-15. Selectively sharpening the silver jewelry and leather details gives them greater visual importance as the close-ups reveals.

Figure 10-16. Using a large aperture created the shallow depth of field. © *Mark Beckelman*

> To control blurring effects, work on duplicate layers, which allows you to use higher filter settings and the ability to refine the filter effect using the layer opacity and blending modes.

To create this effect, you start by creating a depth map that defines the parts of the image that will be in focus and out of focus. The depth map is an alpha channel that controls what is in and out of focus, with the dark or black areas remaining in focus and the white or lighter areas being out of focus.

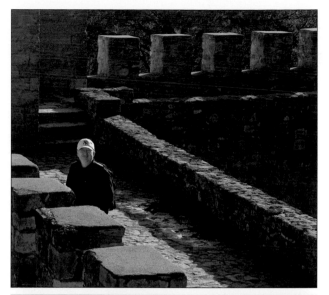

Figure 10-17. A shallower depth of field can be created with the Lens Blur filter. © *KE*

ch10_castle-visit.jpg

1. In the Channels palette click the Create New Channel button and make sure that the channel mask is white. If yours is black, use Cmd/Ctrl+I to invert it. Click the View column next to the RGB icon to see the image through the mask, as seen in Figure 10-18.

Figure 10-18. Creating and viewing the alpha channel mask.

2. Reset the foreground and background colors by tapping D. Use the gradient tool with the reflected gradient setting (circled in **Figure 10-19**), and pull from the man's face to the top of the first stone wall, as seen in **Figure 10-19**.

3. To make sure that the subject's face remains in focus, in the alpha channel use a soft-edged black brush and paint over his face, as seen in **Figure 10-20**. Soften the alpha mask with a Gaussian Blur of 10.

Figure 10-20. Painting over the man's face insures that he will remain in focus.

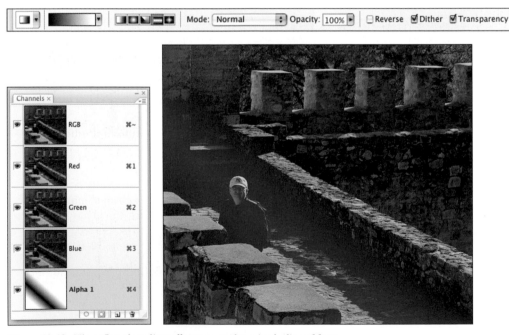

Figure 10-19. The reflected gradient allows you to draw in the line of focus.

4. In the Channels palette, click the View column next to RGB to turn off the translucent view and return to the Layers palette, and then click the Background layer. Duplicate the Background layer, and select Filter→Blur→Lens Blur.

5. Near the top of the Lens Blur control column is a Depth Map Source pull-down menu. Choose the Alpha channel you created, which is simply called Alpha 1.

6. Allow the filter to update, and study the effect before adjusting the sliders. If too much is being blurred, adjust the Radius.

7. Adjusting the Blur Focal Distance shifts which area in the image is in focus and is best used to refine what is in and out of focus. Higher Blur Focal Distance raises the focus area, while lesser values lower what is in focus in relationship to the edge of the frame, as seen in Figure 10-21.

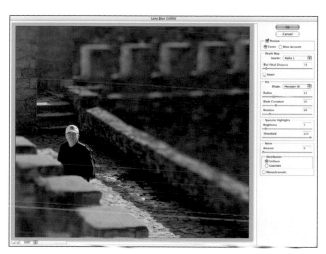

Figure 10-21. Refining the position of the Lens Blur with the Blur Focal Distance slider.

In case you're not satisfied with the Lens Blur effect, you can either add a layer mask and apply a black brush to the blurred layer to paint out areas that are too blurred, or exit out of the Lens Blur filter, adjust the alpha mask, and then reenter the Lens Blur dialog box.

Blurring image backgrounds can be subtle or dramatic; as long as you work on duplicate layers, you can always either refine the effect or return to the original image and start over.

Creative depth of field effects

A very popular effect is to create a very shallow depth of field to make the in-focus areas look like a child's toy model as seen in Figure 10-22 and Figure 10-23, which were photographed with a Canon perspective control lens with tilt and shift movements. You can create a similar effect without

the expensive lens, as seen in the comparison featured in Figure 10-24. This technique is most effective with images that were photographed from an elevated point of view and can be especially fun when people or cars are in the image.

Figure 10-22. Photographed with a perspective control lens with settings to exaggerate the size relationships forces the background to recede. © *John McIntosh*

Figure 10-23. Photographed with a perspective control lens to not be in perfect perspective changes the size relationships in the image. © *John McIntosh*

Figure 10-24. Aggressively blurring the back- and foreground makes the row of houses look like a toy model. © KE

⚲ ch10_model-village.jpg

1. In the Channels palette click the "Create new channel" button. Click the View column next to the RGB icon to see the image through the mask.

2. Use a large, soft-edged black brush to paint over the row of houses, as seen in Figure 10-25.

Figure 10-25. Painting over the sections in the image that should remain in focus.

3. Uncheck the RGB View column, and then click the RGB icon to return to the full color view. Click the Layer palette, duplicate the background layer, and select Filter→Blur→Lens Blur.

4. Near the top of the Lens Blur control column is a Depth Map Source pull-down menu. Choose the Alpha channel you created.

5. Before adjusting any additional sliders, allow the filter to update and study the effect. In case too much of the houses or your own subject is being blurred, it is best to cancel and return to the Alpha channel and paint in some more black to protect more of the image. Then select Filter→Blur→Lens Blur to continue.

6. Adjusting the Specular Highlights sliders increases the highlight blur effect. Change the Threshold slider first to be able to see the effect that the brightness slider is having, as seen in Figure 10-26. Lower and lower Threshold settings instruct the Lens Blur filter to consider more tonal values in the brightening process. Higher brightness settings push the highlights towards pure white.

Figure 10-26. Adjusting the Specular Highlights sliders mimics using a wide aperture, as highlights blur out more strongly than darker tones.

Experimenting with the Lens Blur filter can often make up for limitations of equipment or camera settings that you couldn't control while shooting.

Blurring backgrounds

Combining a shallow depth of field while sharpening the subject matter effectively makes the subject look even sharper than it really is, which also draws more attention to what you took the picture of in the first place. In the example seen in Figure 10-27, Katrin was intrigued by the pet cemetery in the Presidio Park by San Francisco Bay, but upon viewing the image on the monitor, she realized she needed to emphasize the grave memorial as seen in the after version in Figure 10-27. By blurring the background and foreground and sharpening and brightening the grave, the image is closer to what Katrin saw in her mind's eye when she pressed the shutter.

☝ ch10_pet_graves.jpg

1. Duplicate the background layer and use the Lens Blur filter to aggressively defocus the image.

2. Click the layer mask button to add a white layer mask.

3. To create a shallow depth of field effect, use a reflected gradient on the layer mask and pull from the top of the picket fence up to the top of the tombstone. Since the reflected gradient tool effect is not perfectly predictable, you may need to try a few drags to create the desired effect.

4. Use a large, soft-edged black brush to paint over the top of tombstones on the layer mask to conceal any undesired softening, as seen in Figure 10-28.

Figure 10-27. Combining blurring and sharpening emphasizes the graves. © KE

7. Use the Smart Sharpen filter with a high Amount of 125 and a low Radius value of 0.8, and Remove Lens Blur, as seen in Figure 10-29. To accentuate the texture of the picket fence and tombstones, check More Accurate, which internally instructs Photoshop to run the filter twice with lower settings to build up the sharpening.

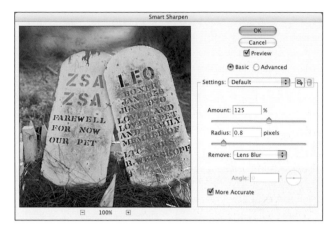

Figure 10-29. High Amount and low Radius values are best used for low-noise digital camera files.

8. To balance the sharpened image information with the blurred image areas, press Cmd-Option-Shift/Ctrl-Alt-Shift, and drag the layer mask from the blurred layer into the layer mask slot next to the sharpened layer icon. This transfers, duplicates, and inverts the layer mask in perfect registration, as seen in Figure 10-30.

9. Brightening the sharper area will draw more attention to it, and this is easily achieved by changing the sharpened layer blending mode to Lighten to create the final image.

Figure 10-28. Painting on the layer mask with black conceals the softening effect from impacting the tombstones.

5. To strengthen the softening effect, duplicate the blurred layer, and change the blending mode to Darker Colors.

6. With the topmost layer active, press Cmd-Option-Shift/Ctrl-Alt-Shift+E to merge all layers up, and then select Filter→Convert for Smart Filters.

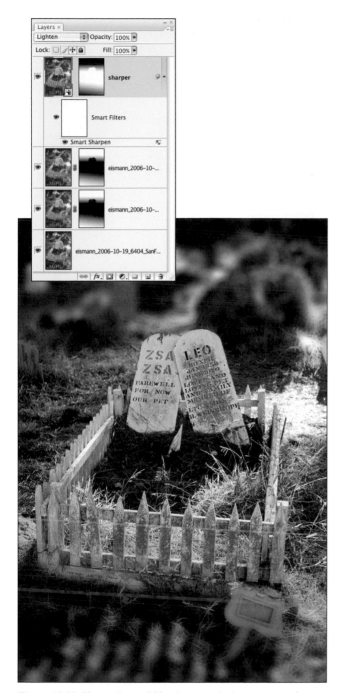

Figure 10-30. Sharpening and blurring opposite image areas enhances the effect of both.

Darkening and blurring backgrounds

Our eyes move from dark to light, soft to sharp, and less color to more color. Knowing this enables you to recompose images that appeal to how our perceptual system works naturally. Whenever we blur a part of an image, we make sure to sharpen the opposite area, and when we lighten a section of the image, we darken its counterpart section of the image. By delicately balancing sharpness and tonality, you can guide the viewer's eye to see the image of your intent.

Take a look at the before image in **Figure 10-31**—a quirky portrait of a curious sheep—and now compare it to the after image. Which image do you think is more effective and best concentrates your eye on the subject of the image? Applying both blurring and darkening allows the background to recede even further. To replicate this effect or to apply it to your own images, you'll use a combination of image adjustment layers, sharpening and blurring filters, and some slight retouching to conceal distracting highlights and unnecessary details. In the following example, we'll use the Smart Filter feature that does not support the Lens Blur filter. However, Smart Filters do support the Shape Blur, enabling you to add beautiful and creative blurs as described here.

> When experimenting with sharpening or blurring effects, it is essential to work on a duplicate layer. If Smart Filters support the desired filter, we recommend taking advantage of this incredibly flexible and non-destructive Photoshop CS3 feature.

ch10_sheep.jpg

1. Start by duplicating the background layer and converting it to a Smart Filter layer.

2. Choose Filter→Blur→Smart Blur, and click a shape to see its effect using a Radius setting of 15, with higher Radius settings creating more blur.

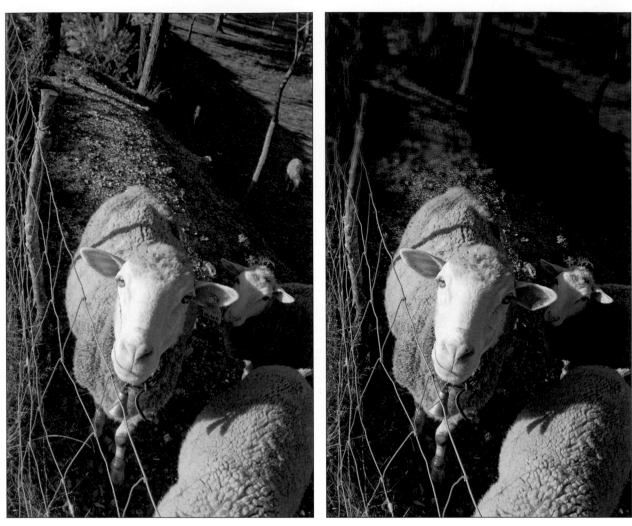

Figure 10-31. Judicious use of the Surface Blur filter and distraction removal emphasizes the sheep's curious gaze. © *John McIntosh*

3. To best mimic lens diffusion we've discovered that using geometric shapes with internal spaces, such as the circles or squares, yield pleasing results, as seen in Figure 10-32. To experiment with more shapes, use the small, black triangle flyout menu to load additional shapes including "frames" and "shapes"; make sure to click "Append" to add the shapes to the Shape palette.

4. Add a layer mask to the blurred layer and, using the Black, White gradient, start the gradient slightly above the sheep's rump and drag down to the top of its head. The top of the layer mask is white, which allows the blur to show through, and the bottom part is black, which blocks the sheep from being blurred, as seen in Figure 10-33.

5. To darken the blurred area, add a Curves adjustment layer and click OK. Change the layer blending mode to Multiply and reduce the opacity to 50 percent, which darkens the entire image. To transfer the layer mask from the blurred layer to the darkening layer press Option/Alt as you drag the layer mask from the blurred layer to the Curves layer. Click Yes to the Replace Layer Mask? pop-up window to create the image seen in Figure 10-34.

6. To emphasize the sheep, apply subtle sharpening and lightening to draw the viewer's eye towards its face. To sharpen just the sheep, duplicate the blurred Smart Object sheep layer, and drag the Shape Blur smart filter into the small trash can in the Layers palette.

Figure 10-32. Changing the shape influences the overall effect and increasing the Radius number strengthens the blur.

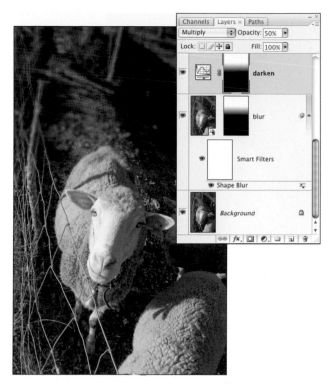

Figure 10-34. Darkening the blurred areas forces them further into the distance.

Figure 10-33. The layer mask controls where the blur is visible.

7. Click the layer mask, and press Cmd/Ctrl+I to invert the layer mask. So far it doesn't look as if anything has changed, but by choosing Filter→Sharpen→Smart Sharpen, and using very mild settings of 75 percent, 0.8 pixels, and then removing the Lens Blur, the details are made crisper without looking over-sharpened, as seen in Figure 10-35.

8. To lighten the sharpened sections, add a Curves adjustment layer and click OK. Change the layer blending mode to Screen, and reduce the layer opacity to 50 percent. Option/Alt-click the thin line in the Layers palette between the sharp layer and the Curves layer to clip the Curves layer with the sharper layer, as seen in Figure 10-36. Adjust the lightening layer opacity to taste—in this example we needed only 20 percent to create the desired effect.

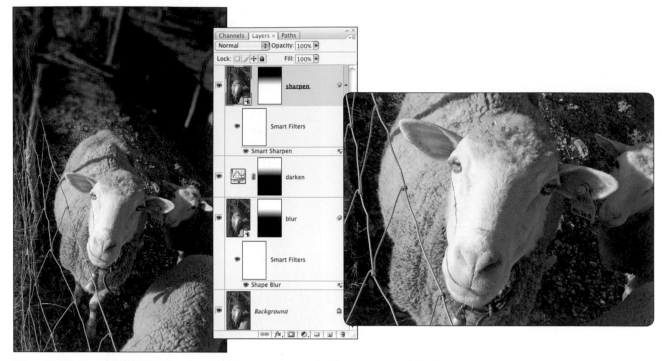

Figure 10-35. Sharpening the lower section of the image accentuates the blurring effect of the background.

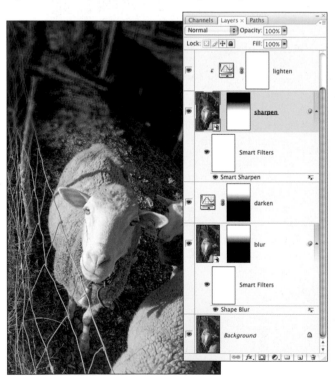

Figure 10-36. Clipping the Curve adjustment layer to the sharpened layer limits its lightening effect to the sharpened image areas.

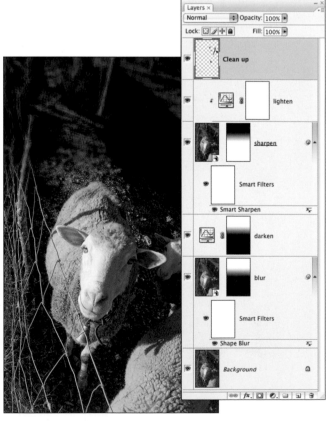

Figure 10-37. Concealing distractions in the background encourages your eye to remain on the image subject.

9. Add a new layer at the top of the layer stack. Use the Clone Stamp and Healing brush set to "Current & Below" to edit out distracting elements such as the highlight on the tree, the sheep in the background, and the ear tag on the primary sheep to create the final image, as seen in Figure 10-37.

Tinting, darkening, and blurring

In addition to blurring and darkening, you can use a color tint to create a mood, as seen in Figure 10-38, in which Katrin created a cool "day for night" effect to better express the sense of loss felt at a child's grave.

🖰 ch10_childs_grave.jpg

1. To create the dark-blue mood, add a Photo Filter adjustment layer, and use the Cooling Filter (80) at 75-percent density. Of course, with your images, the color and density decision depends on the image.

2. To enhance the dark-blue effect, change the layer blending mode to Multiply, as seen in Figure 10-39.

3. Use a soft-edged, black brush on the Photo Filter layer mask and roughly paint out the primary flowers on the grave. This mask doesn't need to be super-precise as the blueness can affect some of the flowers, too.

4. To create an even more solitary mood, Katrin opted to use an additional Curves layer, which illustrates the fact that working creatively is as much about knowing what to do but also includes responding to the image and being open to trying new approaches and ideas. Use the Curves layer to darken the image even more by first pulling the highlight and then the midpoint down, as seen in Figure 10-40. While still in Curves, use the pull-down menu to select the blue channel and increase the blue component, as seen in Figure 10-41.

Figure 10-38. The "day for night" effect enhances the feeling of sadness at the child's grave. © KE

Figure 10-39. The Multiply blending mode darkens the blue effect.

Figure 10-40. The Curves layer darkens the image to create a more somber mood.

5. Transfer the layer mask from the blue Photo Filter layer to the Curves layer by pressing Option/Alt as you drag the layer mask from the blue layer to the Curves layer. Click Yes to the "Replace Layer Mask?" pop-up window to create the work-in-progress image seen in Figure 10-42.

6. With the topmost layer active, use Cmd-Option-Shift/Ctrl-Alt-Shift+E to merge all the working layers up onto a new layer.

7. Select Filter→Blur→Gaussian Blur and use an aggressive setting; in this example we used 15. Change the layer blending mode to Darker (CS2 or before) or Darker Color if using CS3, as seen in Figure 10-43.

8. Add a layer mask to the blurred layer and coarsely paint over the grave of the child. To increase the transition of blurred to sharp use a soft-edged brush, followed by an aggressive dose of the Gaussian Blur filter to create the image seen in Figure 10-44.

9. To add the final polish to the image, select the enamel picture of the little boy with the Elliptical Marquee tool, and use Edit→Copy Merged to copy all visible layers, followed by Edit→Paste, which drops the little boy exactly on top of the original image.

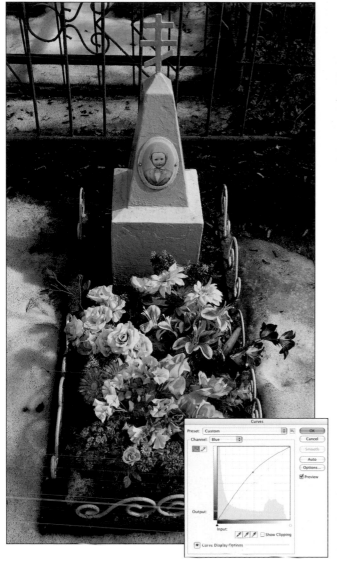

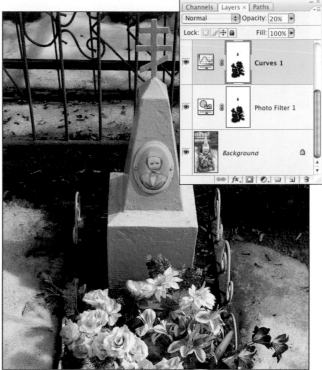

Figure 10-42. Transferring the layer mask insures perfect registration and edge consistency.

Figure 10-41. Increasing the blue component in the scene.

10. Select Filter→Other→High Pass with a setting of 3. Change the layer blending mode to Overlay, Soft Light, or Hard Light to sharpen the enamel photograph. In this example, we used Overlay at 100 percent, as seen in Figure 10-45, to give him a hint of emphasis.

All the blur and focus enhancement methods are best used in support of your initial vision, and we've learned that not every image needs a lot of heavy-handed manipulation when a touch of subtle enhancement is much more effective.

Figure 10-43. Softening the merged layer in combination with the Darker Color blending mode conveys a sense of the mother's view of her child's grave.

Figure 10-44. Blocking the softening from affecting the grave focuses your eye on it.

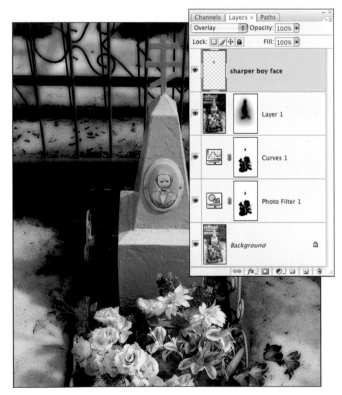

Figure 10-45. The final touch is to sharpen the enamel picture of the little boy.

Sharpen with Finesse

Not sharpening an image enough is just as bad as over-sharpening an image and, as discussed in Chapter 4, we practice a three-step sharpening process of input sharpening, creative sharpening, and output sharpening. The creative sharpening includes the blurring and softening techniques discussed up to this point. Creative sharpening is used to draw the viewer's eye to the subject of your photograph, and it is always applied selectively.

Image sharpening algorithms find an image edge and increase the contrast along that edge by exaggerating the light/dark relationship of the edge. Over-sharpened images have an unpleasant halo-like look that has given digital imaging a bad reputation. In fact, over-sharpening an image is probably worse than not sharpening an image at all.

To minimize the possibility of undesired sharpening artifacts:

- Work on a duplicate layer and use layer masks to conceal the sharpening and prevent it from affecting undesired areas.

- Control the sharpening effect with layer opacity, and use the Luminosity blending mode to avoid exaggerating color fringing.

- Avoid sharpening shadow areas, as they do not contain a lot of edge information and often do contain noise, which is something you rarely want to sharpen.

- Use the Blend If sliders to sharpen the midtones without affecting the shadows or highlights, as described in Chapter 6 in the High Pass Contrast Enhancement section.

- Print your sharpening tests with the printer and paper that you'll use for the final document to see the actual sharpening effect.

- Avoid resizing or retouching a sharpened file.

- When you send files to a service bureau, tell them if you've already applied sharpening or you want them to do it. Too much sharpening can be just as bad as no sharpening.

- In Photoshop CS3, choose Filter→Convert for Smart Filters to non-destructively experiment, adjust, and refine the filter settings.

Photoshop comes with a variety of built-in sharpening filters that range from the most basic and rarely used to very sophisticated with tremendous control as listed in this overview that includes in-depth information on the Unsharp Mask and Smart Sharpen filters.

Filter→Sharpen

- **Sharpen:** A brusque filter that offers no control—we never use it.

- **Sharpen More:** Sharpens more than Sharpen, which you cannot control, which is why we never use it.

- **Sharpen Edges:** We never use this one either, as the interface offers no control. Sharpens only edges while preserving the overall smoothness of the image.

- **Unsharp Mask:** The venerable sharpening filter, which (unlike its name) does an excellent sharpening job of sharpening by allowing control over the Amount (strength), Radius (width), and Threshold (details) that are sharpened. Behind the scenes, first the picture is smoothed or blurred slightly (unsharpened) and the contrast is reduced to conceal fine noise. Then the unsharp mask filter increases the contrast of adjacent pixels to create the sharpening effect.

 - **Radius:** The most crucial of the three controls, Radius determines how many pixels on either side of an edge will be exaggerated. The strength of the Radius setting is influenced by the resolution of the image, with high-resolution images tolerating higher Radius settings. Set the radius large enough to create distinct borders, but not so large as to create a noticeable outline around objects.

 - **Amount:** Low Amount settings introduce low levels of contrast to neighboring pixels with high Amount settings adding higher contrast levels.

 - **Threshold:** Determines the tonal value differences needed to recognize an edge. For example, if you set the threshold to 6, neighboring pixels with gray values of 120 and 124 will not be sharpened because the difference between them (4) is below the threshold. However, neighboring pixels with values of 120 and 130 will be sharpened, because the difference of 10 is above the threshold. We usually set our Threshold values between 3 and 7 to avoid sharpening noise, skin pores, and subtle shadows and delicate highlight transitions.

- **Smart Sharpen:** A fantastic sharpening filter that is supported by Smart Filters. It can be slow to apply, but the control offered is well worth the wait. The Smart Sharpen filter enables you to set which sharpening algorithm is used and to control the amount of sharpening in the shadow and highlight areas. Plus, by clicking the small floppy disk-like button, you can save successful settings for reuse, which will speed up your image workflow.

Inside the Smart Sharpen Filter

- **Amount:** Sets the amount of sharpening. A higher value increases the contrast between edge pixels, giving the appearance of greater sharpness.

- **Radius:** Determines the number of pixels surrounding the edge pixels affected by the sharpening. The greater the Radius value, the wider the edge effects and the more obvious the sharpening—meaning the more visible the light/dark halo will be, which is something you want to avoid.

- **Remove:** Sets the sharpening algorithm used to sharpen the image from the following three options.

 - **Gaussian Blur** is the method used by the Unsharp Mask filter and is the fastest.

 - **Lens Blur** detects the edges and detail in an image, and provides finer sharpening of detail and reduced sharpening halos. In our opinion, Lens Blur produces the best results.

 - **Motion Blur** attempts to reduce the effects of blur due to camera or subject movement. If you plan on using the Motion Blur option, measure the angle of blur with the Measure tool before entering the Smart Sharpen interface, and enter the measured angle in the Angle control.

- **More Accurate:** Processes the file twice for a better removal of blurring. Do not use this option on grainy or noisy files as it has a tendency to over-crunch unwanted image texture.

Smart Sharpen Advanced Mode

This mode uses all of the previously addressed basic mode settings and enables you to reduce dark or light sharpening halos.

- **Fade Amount:** Adjusts the amount of sharpening in the highlights or shadows—100-percent fade conceals the sharpening, and decreasing the fade reveals the sharpening amount.

- **Tonal Width:** Controls the range of tones in the shadows or highlights that are modified. Lower values restrict the adjustments to the darker areas for shadows and only the lighter regions for highlight correction. Think of this as the spread—how far out do you want the sharpening to take place? Lower settings are more delicate.

- **Radius:** Controls the size of the area around each pixel that is used to determine whether a pixel is in the shadows or the highlights. Moving the slider to the left specifies a smaller area, and moving it to the right specifies a larger area.

The true challenge in working with the Smart Sharpen filter is to find the right balance between the Amount and the Radius settings. For digital camera files or scans with minimal grain, use high Amount settings between 75 and 200 and low Radius settings between 0.3 and 1.5. This may look too crisp onscreen, but you have to print the file to see the results that really matter. For images with noticeable grain, use low Amount settings of 10 to 40 and high Radius settings of 10 to 20 to help avoid exacerbating noise or grain.

Filter→Other

In addition to the commonly used sharpening filters, the Custom and High Pass filters can also be used to sharpen and blur images.

- Custom: Please see the Custom Filter sidebar later in this chapter.

- High Pass: Is an edge detection filter that works on duplicate or merged layers. Use a setting between 1 and 3, change the layer blending mode to Overlay, Soft Light, or Hard Light, and adjust layer opacity to create the desired effect.

Figure 10-46. Sharpening the textural details emphasizes the plant's interesting biology. © KE

Sharpening the Details

Selective sharpening draws the viewer's eye in and should be subtle without being distracting. In the example seen in Figure 10-46, Katrin photographed the lily with an extremely shallow depth of field and, by selectively sharpening the pistil, was able to enhance the original photograph to match her original photographic intention. In this example, Katrin started with a Smart Object from a camera raw file; to follow along, you'll start by converting the background layer to a Smart Filter layer, something which is not necessary when starting with a Smart Object from a camera raw file.

Figure 10-48. Only the areas of the image where the layer mask is white will be sharpened.

⌐ ch10_Lily.jpg

1. Select Filter→Convert for Smart Filters.

2. Select Filter→Sharpen→Smart Sharpen, and since this file was captured with a medium-format digital camera back and has very little noise, use a high Amount with a low Radius setting, as seen in Figure 10-47.

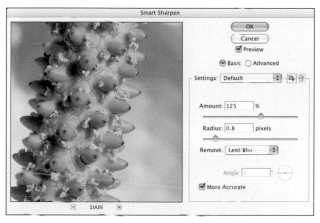

Figure 10-47. The high Amount and low Radius values sharpen the detail without creating aggravating noise.

3. To sharpen only the pistil, select the pistil of the flower with the Quick Selection tool or the Lasso tool. There is no need to be absolutely perfect as it is easier to refine the mask with the Brush tool in the following step than to spend a lot of time making a perfect selection.

4. Choose Select→Inverse, and, with the Smart Sharpen mask active, select Edit→Fill with Black, and then Select→Deselect to create the image seen in Figure 10-48.

5. To include more of the flower in the sharpening pass, use a white brush to paint in additional sharpening. To exclude areas from being affected, use a black brush on the mask.

6. To avoid an artificial "this area is sharper than this one" look, use Filter→Blur→Gaussian Blur with a setting of 3 to 5 on the layer mask to blur the transition between what has been sharpened and what has not been sharpened, as viewed in Figure 10-49, which shows the Smart Filter mask.

Figure 10-49. Option/Alt-click the layer mask icon to view the layer mask.

Adding Sparkle and Sheen

In portrait retouching, maintaining the sparkle in the subject's eyes keeps the portrait lively. In the example seen in Figure 10-50, Katrin softened the skin and sharpened the eyes with separate High Pass layers as described here.

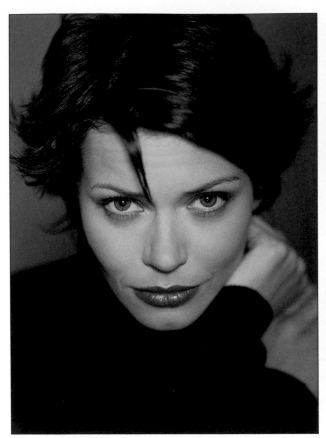

Figure 10-50. Sharpening the eyes creates the illusion of moisture and sparkle. © Computer Arts Stock

🖱 ch10_portrait.jpg

1. Duplicate the background layer, select Filter→ Other→High Pass, and use a setting of 5. Change the layer blending mode to Overlay, and select Image→ Adjustments→Desaturate to remove unwanted color from this layer. Name this layer "sharp."

2. Duplicate this sharp layer, change the blending mode to Soft Light, and select Image→ Adjustments→Invert to create a subtle and beautiful softening effect. Name this layer "soft," and turn its visibility off.

3. Click the sharp layer and Option/Alt-click the layer mask button to add a black layer mask. Use a 50-percent hardness white brush on the layer mask to paint over the eyes, which will add the sparkle of the sharp layer.

4. To transfer an exact duplicate of the sharp layer mask while inverting it, press Cmd-Option-Shift/Ctrl-Alt-Shift, and drag it into the layer slot of the soft layer, as seen in Figure 10-51.

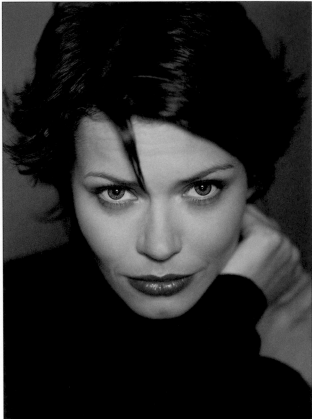

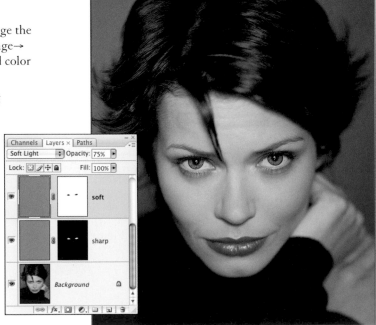

Figure 10-51. Each layer mask hides and reveals the desired sharpening or blurring effect.

Experiment with adding sparkle to images with water droplets or high tech equipment; kicking up the highlights with sharpening can make your images pop off the page.

Softer Can Be Sharper

As odd as it sounds, you can use the Gaussian Blur filter to sharpen an image. I learned the basics of the following technique from Dan Margulis, who is an expert at color correction, offset printing, and working with the Lab image mode. In a nutshell, the following technique uses the Gaussian Blur filter on duplicate files and layers with a variety of blending modes to create finely detailed edge masks, which control the darkening and lightening effect to make the image sharper, as seen in Figure 10-52.

⌖ ch10_ostridge.jpg

1. Open an image, select Image→Duplicate, and name the duplicate file *Dark Edges*.

2. Duplicate the background layer of the duplicated file twice.

3. Select Image→Duplicate, and name the duplicate file *Light Edges*.

4. On the Light Edges image, click the middle layer and Filter→Gaussian Blur with a setting of 1.5, and change the layer blending mode to Darken.

Figure 10-52. Sharpening without using any sharpening filters. © Scott Loy

Figure 10-53. The initial Lighten Edges file will show the faintest of outlines.

Figure 10-54. Duplicating the layers and using the Screen blend mode strengthens the white lines.

5. Click the topmost layer, change the blending mode to Difference, and flatten the image. It should be very dark with a few delicate white outlines, as seen in Figure 10-53.

6. Duplicate the background layer once, change the blending mode to Screen, and duplicate this layer again to strengthen the edge lines, as seen in Figure 10-54. Flatten this file and save it.

7. Return to the Dark Edges file and, on the middle layer, use the Gaussian Blur filter with a setting of 2 and change the layer blending mode to Lighten.

8. Click the topmost layer and change the layer blending mode to Difference. Flatten the image.

9. Invert this image with Cmd/Ctrl+I and duplicate the background layer once, change the blending mode to Multiply, and duplicate this layer again. Flatten the file, and save it to create the file seen in Figure 10-55.

Figure 10-55. The Darken Edges file.

10. On the Dark Edges file, choose Select→All followed by Edit→Copy. Click the original file and choose Edit→Paste, and then change the layer blending mode to Multiply.

11. On the Light Edges file, choose Select→All followed by Edit→Copy. Click the original file and choose Edit→Paste, and then change the layer blending mode to Screen to create the image seen in Figure 10-56.

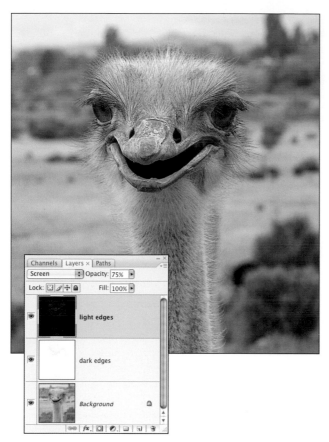

Figure 10-56. Adjusting the opacity of each layer controls the final sharpening effect.

12. Adjust the opacity of each layer to create a pleasing contrast and sharpening of the file.

Creating two files to increase selective contrast may seem like a lot of effort, but after running through the steps a few times they will become faster and easier to apply. In the end, the results of this fine-edged contrast definition technique are ideal for very detailed images.

Soften then sharpen with the Custom Filter

In the traditional darkroom, if a chrome was too contrasty to print, a photographer would make an intermediary negative by sandwiching the chrome with black-and-white film; between the two pieces of film was a piece of tissue paper or glassine that would soften the resulting black-and-white film image. After processing the black-and-white film, the photographer would sandwich the softer black-and-white film with the contrasty chrome to make a print with a reduced but reproducible dynamic range that also looked sharper than the original chrome.

The Custom Filter

The primitive grid interface hides a powerful tool used to create darkening, lightening, blurring, and sharpening effects. The center box describes the brightness of the pixel being analyzed, with lower numbers being darker and higher numbers lighter. Inserting numbers into the adjacent boxes calculates the pixels against each other while simultaneously creating interesting High Pass, emboss, blur, and sharpening effects. Ian Albert posted both the math and very useful tips (as featured here) on how to use the custom filter: *http://ian-albert.com/graphics/customfilters.php*. We've posted Custom kernels you can load to start experimenting with blurring and sharpening effects.

General guidelines for using the custom filter:

- The scale should be equal to the sum of all the weights.
- If the sum of the weights divided by the scale is 1, then the offset should be 0.
- If the sum of the weights is 0, then the offset should be 128.
- If the sum of the weights divided by the scale is -1, then the offset should be 255. The image will be inverted from what it would be if the sum were +1.
- The sum of the weights divided by the scale should generally not be more than +1 or less than -1. Otherwise, the image will come out very dark or very bright.
- The scale can't be less than 1 (you can't divide by zero).
- If the filtered image is very dark, the scale is probably too high. If it's very light, the scale is probably too low.

High-end glamour retoucher Chris Tarantino taught us that blurring an image ever so slightly and then sharpening with the custom filter creates an artifact-free sharpening effect that he uses for high-end cosmetic and celebrity retouching. The example seen in Figure 10-57 is perfectly in focus, yet the eyes and hat could be sharper to enhance the crispness of the winter's day.

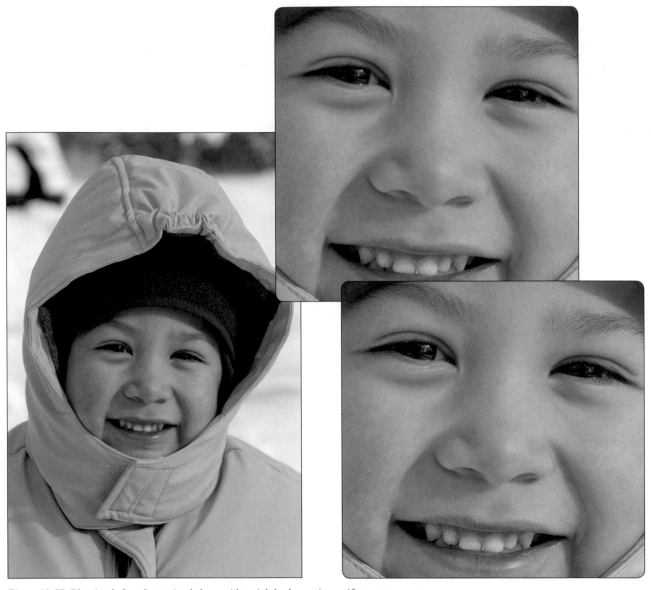

Figure 10-57. Blurring before sharpening helps avoid unsightly sharpening artifacts. © Mark Beckelman

🖱 ch10_snow-boy.jpg

🖱 ch10_CustomBlurSharpen

To work along with the Custom Filter exercise, either download the Ch10_CustomBlurSharpen filter presets and extract them to your hard drive or use the numeric values shown in the illustrations to create similar effects.

1. Select Filter→Convert for Smart Filters. If working with earlier versions of Photoshop, please duplicate the background layer.

2. Select Filter→Other→Custom and load Blur50%.AFS, or use the settings seen in Figure 10-58 to gently soften the image. Concentrate on an area with fine detail such as eyelashes. Click OK.

Figure 10-58. Use the custom filter to soften the image before sharpening.

3. Select Filter→Other→Custom, and load Sharpen200%. AFS, or use the settings seen in Figure 10-59. To judge the effects, turn off both Smart Filters by clicking the view icon next to the Smart Filter layer mask. To view the effect of a single filter, click the respective view icon.

Figure 10-59. Sharpening after blurring is useful to avoid unsightly sharpening artifacts along fine, detailed edges.

4. Use a large, soft-edged black brush on the Smart Filter layer mask to paint over the little boy's skin so that it remains soft, as seen in Figure 10-60. If working with earlier versions of Photoshop, add a layer mask and paint over the little boy's skin to protect it from the sharpening.

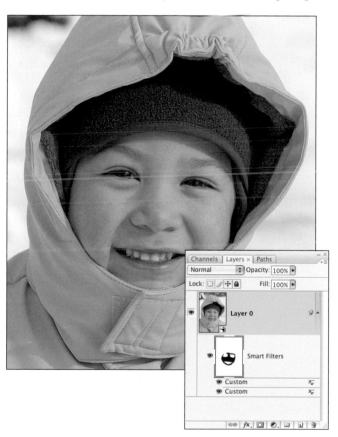

Figure 10-60. Masking the sharpening from the boy's skin makes the eyes look even sharper.

The beauty of the Smart Filters is that you can adjust or load new settings to improve the final outcome, which allows for tremendous creative freedom to experiment and improve your images.

Focusing on History

The history feature keeps track of your steps as you work, and in combination with the History brush, enables you to paint back and forth between different versions of your images. Just knowing that the History palette lets you step backwards is very reassuring as you delve into creative experimentation. To take advantage of History, in General Preferences→Performance increase the number of History states to at least 50-100. In the History palette, use the fly-out menu to make sure that in the History Options "Allow Non-Linear History" is selected.

In the example seen in Figure 10-61, Katrin softened the entire image, and then used the History brush to paint the original flowers back in as follows.

ch10_Bride.jpg

1. Duplicate the background layer, select Filter→Other→ High Pass, and use a very high setting. In this example we used 50.

2. Change the layer blending mode to Soft Light and Cmd/Ctrl+I to invert the sharpening to create a beautiful softening effect. Click the "Create a new snapshot" button (it looks like a little camera in the History palette), and name it *soft*, as shown in Figure 10-62.

3. Flatten the image and click the small square next to the original snapshot in the History palette. Use a soft-edged History brush to paint over the flower bouquet to bring it back into focus, as seen in Figure 10-63. In case you paint back parts of her dress, click the History source next to the soft snapshot and paint the softer areas back.

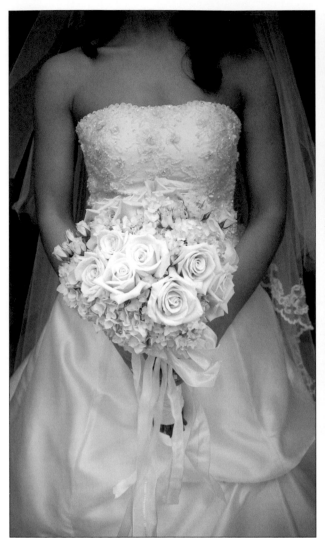 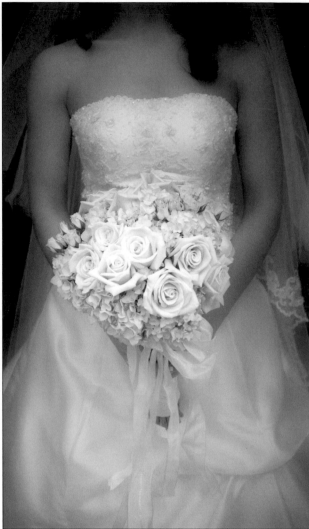

Figure 10-61. Softening the dress emphasizes the bouquet. © *Mark Beckelman*

When using History for creative experimentation, make sure to use the Save As command and a new file name to not overwrite the original image.

The History feature enables you to work in a painterly fashion with photographs, and for many users the fluidity lets them discover unimagined surprises. Keep in mind that as soon as you close the image the history is lost. If you've created a snapshot or a history state that you would like to save, click the "Create new document" button on the bottom of the History palette and save this new document.

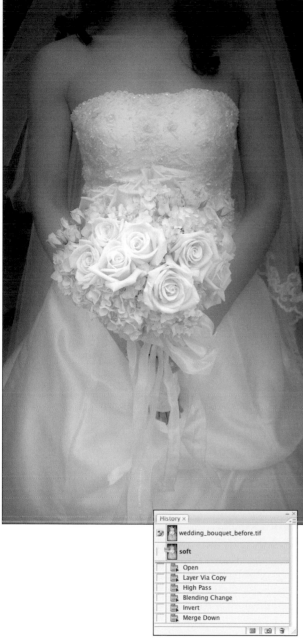

Figure 10-62. Soften the entire image and add a Snapshot of the softened version.

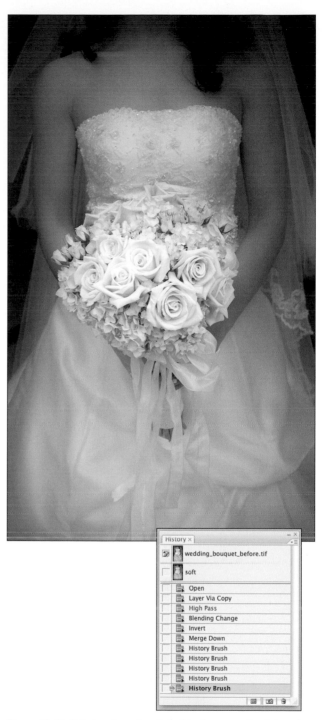

Figure 10-63. Painting from the original in-focus snapshot brings the flowers back into focus.

Figure 10-64. Adding a hint of noise adds visual tooth to the flatter surfaces of the flowers. © *KE*

Valuable Noise

Film is made with carrier layers with embedded silver halide molecules. When the film is exposed and developed, the silver halide molecules clump together, forming metallic silver, which creates the grain. Depending on the film used—from low ISO fine-grained films to higher ISO or even infrared films—push processing film (especially black and white) may accentuate the grain, which many photographers would take advantage of for creative effect. When making darkroom prints, photographers would focus on the film grain when focusing the enlarger head. Even where the image is unfocused or has a shallow depth of field, you could still see the film grain. Of course, in a digital camera there are no silver halides and when working with low ISOs the images are very smooth—so smooth that some photographers feel that the image looks artificial or computer generated. Increasing the ISO of a digital camera has a tendency to increase the noise, which many photographers—ourselves included—do not find as attractive as crisp film grain.

Adding a hint of noise speaks to our visual memory of fine photographic prints. It is the very last step in the creative imaging process and often the noise fools our eyes into perceiving that the image is sharper than it really is. Noise is always added on a separate layer, enabling you to refine its strength with layer blending modes, opacity, and Blend If sliders. The two primary Photoshop filters to add noise are Filter→Noise→Add Noise and Filter→Artistic→Film Grain. After adding the noise, you can modify its appearance with the Median and Motion Blur filters, adjust its contrast with Levels or Curves, and enhance its acutance with sharpening filters, as explained in the following section.

Basic Noise

Noise is always added on a separate neutral Soft Light layer insuring the greatest flexibility and control. When working in 8-bit you have access to the standard Add Noise and Artistic Film Grain, which sadly does not work in 16-bit. To add the most basic noise, as seen in Figure 10-64, follow these steps.

🖰 ch10_daffodils.jpg

1. To create a working surface for the noise, select Layer→New Layer or Option/Alt-click the new Layer button on the bottom of the Layers palette. Name the layer *Noise*, change the Mode to Soft Light, and make sure to check "Fill with Soft-Light-neutral color (50% gray)" and leave the Opacity at 100%.

2. Choose Filter→Convert for Smart Filters. If you're working with an earlier version of Photoshop, continue with step 3 to achieve similar results.

3. Choose Filter→Noise→Add Noise, and check Monochrome and Uniform for a milder effect (Figure 10-65) and Gaussian to add a stronger, more random noise. Use a higher setting than you think you need, as the effect of the noise is always reduced in the print, and you can always refine the strength by adjusting the Smart Filter or reducing the layer opacity to taste after seeing a test print.

4. With black-and-white film, noise is less visible in the shadows and more prevalent in the midtones and highlights with tone. To recreate this effect, select Layer→Layer Style→Blending Options, and move the underlying layer shadow slider to the right to approximately 65. Press Option/Alt, separate the left section of the triangle, and move it completely to the left, as seen in Figure 10-66, to create a transition between the areas with noise and the shadows areas that should have less visible noise.

Figure 10-65. Adding noise to a Smart Filter neutral layer allows for both experimentation and control.

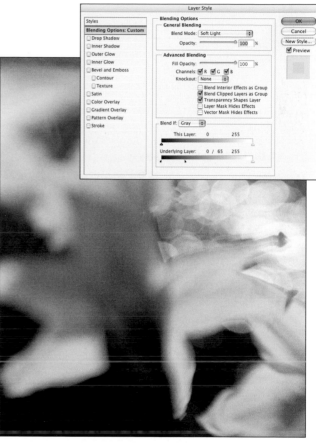

Figure 10-66. The Blend If sliders create a transition of the noise from the midtones into the shadows.

When applying print output sharpening, turn off the Noise layer or add it after print sharpening.

The Add Noise filter's look is rather limited while the Artistic→Film Grain filter offers greater variety and better mimics real film grain, as seen in Figure 10-67. The problem is that the Film Grain filter works only in 8-bit. To sneak around this limitation, use the following trick.

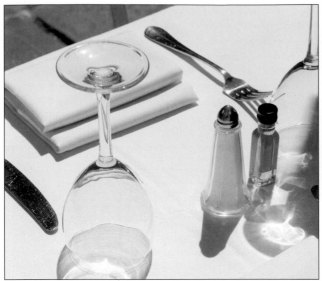
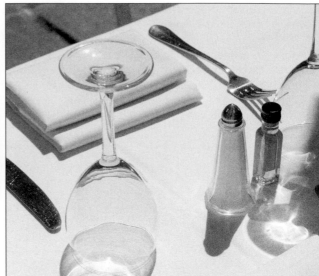

Figure 10-67. Adding faux film grain reduces the computer generated look and feel. © KE

🖱 ch10_table-setting.jpg

1. Open the image you want to add noise to and select File→New. In the New File dialog box, use the Preset pull-down menu to select the open image, as seen in Figure 10-68 and check that the file is in 8-bit.

Figure 10-68. Make sure to create the new file in 8-bit.

2. Choose Edit→Fill, and use 50-percent gray with Normal blending at 100-percent opacity.

3. Choose Filter→Artistic→Film Grain, and adjust the sliders to create the desired grain, as seen in Figure 10-69.

Figure 10-69. Adjust the sliders to create random film grain.

4. Drag and drop or copy and paste the Noise layer to the original image, and change the layer blending mode to Soft Light to conceal the gray and reveal only the noise, as shown in Figure 10-70. As you drag and drop or copy and paste the 8-bit file onto the 16-bit, a dialogue will pop up that warns about possible image quality loss. In this instance you can safely click Yes and keep on working. By adding noise so late in the creative image process, you will not see any image degradation.

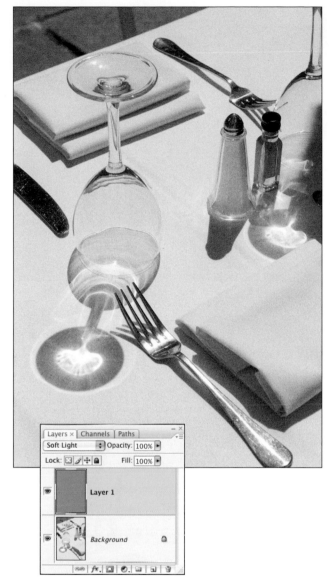

Figure 10-70. Using the desired Artistic Film Grain on the high-bit image.

Experiment with the amount of noise, Gaussian Blur, and sharpening with the Unsharp Mask filter, as well as changing the Blend If options. Adding faux film grain can help to mitigate retouching and compositing artifacts and conceal softness from upsampling a file.

Creative Noise

Once you're comfortable with the two basic noise techniques, it's time to experiment a bit more to customize your own film grain with the Median and Sharpening filters. In the example seen in Figure 10-71, Katrin enhanced the image to accentuate the light and emphasize the modern crucifix. To add a grittier feel to the image background, as seen in Figure 10-71, she followed these steps.

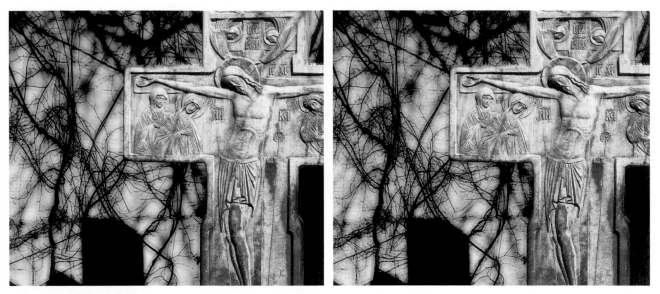

Figure 10-71. Adding rougher and more unique textures adds a personal style to the image. © *KE*

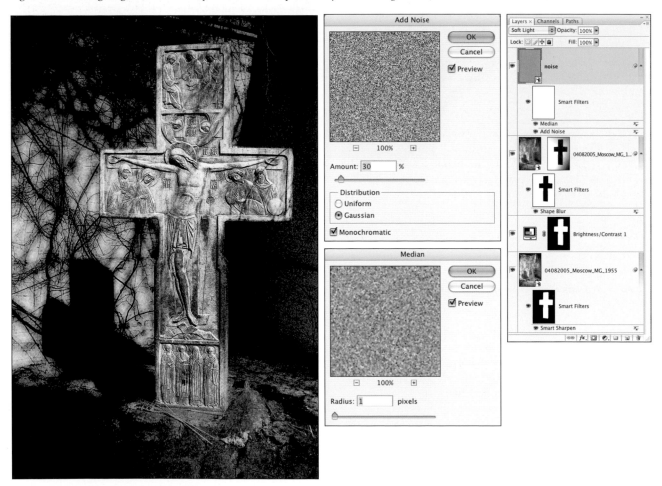

Figure 10-72. Combining the Noise and the Median filters creates a more textured surface.

1. With the topmost layer active, she Option/Alt-clicked the New Layer button and named the layer Noise, changed the blending mode to Soft Light, and select the "Fill with Soft-Light-neutral color (50% gray)" checkbox and leave the layer Opacity at the default of 100%.

2. Next, she chose Filter→Convert for Smart Filters, and then Filter→Noise→Add Noise with a high setting of 30 and Monochrome selected. To make the noise clumpier (that is, less digital-looking), she chose Filter→Noise→Median and with a setting of 1, as seen in Figure 10-72.

3. To apply only the noise to the image background, she took advantage of an existing layer mask to create a mask for the crucifix that blocked out the noise from impacting the delicate relief on the crucifix (Figure 10-73).

Take a few minutes to doodle on the neutral gray Noise layer to create your own look and feel. In addition to the Median filter, you can add another pass of Noise or use the Motion Blur filter to create a streaked effect. Try using the Unsharp Mask filter to make the noise even crunchier. Since you're working on a separate layer, your imagination is the only limit to the textural grain effects you can create.

Your Vision Comes First

Relish experimentation, which always includes making so-called mistakes, which in reality are simply wonderful learning opportunities. Be open, doodle, and push the digital tools and techniques further than we can imagine. Your craft, your image, and your vision come first.

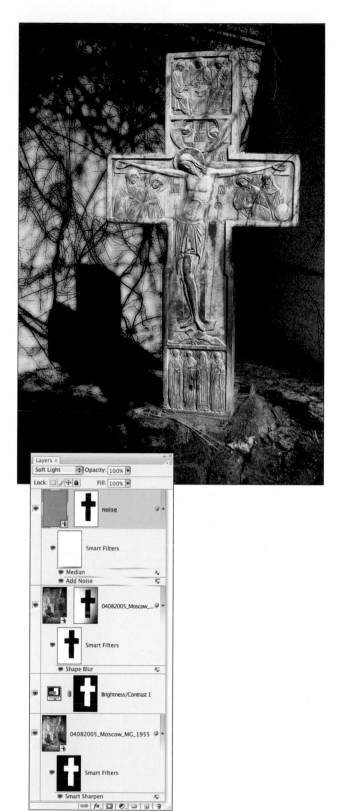

Figure 10-73. Blocking the noise from affecting the delicate relief emphasized the crucifix appropriately.

Index

distressed effects, 339–348

faded black-and-white photos, 341–343

fading to dark with blur layers and blend modes, 342–343

faded color photos, 339

matching a modern image to vintage print, 343

color and contrast, 344

focus, 345

texture, 345

DNG Converter, 62

DNG files, 60

advantages, 60

conversion, 56, 60–62

multiple files, 61

Photoshop Lightroom, 61

disadvantages, 60

dodging, 11, 174

(*see also* dodging and burning)

dodging and burning

empty adjustment layers and blending modes, 179–183

automating with an action, 181–183

DoubleSight, 18

downloaded images, multiple copies, 56

downsampling, 21

duplication of images, 6

dustbusting images, 10

dust spotting, 118

DxO Optics Pro, 8

dynamic range, 208–214

combining multiple exposures with layer masks, 212–215

multiple raw processing of a single exposure, 208–212

E

edge burning, 9

edge effects, 350–355

filed-out negative carrier, 351

hand-painted emulsion edges, 353

simple black stroke, 350

edge mask, 102–104

edges and corners, refining, 9

edit and select process, 6

editing, non-destructive, 133–134, 174–224

16-bit editing, 133

adjustment layers, 134

dodging and burning (*see* dodging and burning)

layer masks (*see* layer masks)

neutral fill layer, 174–175

Smart Filters (*see* Smart Filters)

starting with raw file, 133

effects, 322–357

black-and-white infrared (*see* black-and-white infrared)

creative edge (*see* creative edge effects)

cross-processing, 316–319

darkroom special effects (*see* darkroom special effects)

diffusion and soft focus (*see* diffusion and soft focus)

distressed (*see* distressed effects)

film grain (*see* film grain)

filters (*see* filters)

reticulation (*see* reticulation)

sepiaesque diffusion toning, 325–327

textures (*see* textures)

EIZO ColorEdge CG220, 18

Elliptical Marquee tool, 184, 190, 275

Enable Large Document Format (.psb), 24

enhancing overall tone, contrast, and color, 10

Eraser tool, 362, 364

Ergotron, 18

evaluating images, 4

EXIF metadata

sRGB color profile in, 23

Export Clipboard, 21

exposure, 52–54

JPEG files, 54

raw files, 54

what digital exposure is all about, 54

(*see also* contrast and exposure control)

Exposure controls, 70

Extensis Portfolio

keywords, 57

F

file duplication, 6

file formats

digital cameras, 50–51

(*see also* JPEG files; TIF files; raw files)

file navigation, 36

file organization, 55–62

batch renaming (*see* batch renaming)

DNG files (*see* DNG files, converting to)

importing (*see* importing)

keywords (*see* keywords)

labels (*see* labels), 56

ratings (*see* ratings)

raw files (*see* raw files, initial adjustments)

file preparation, 8–10, 93–127

chromatic aberration (*see* chromatic aberration)

cropping (*see* cropping)

noise reduction (*see* noise reduction)

optical and perspective distortion (*see* optical and perspective distortion)

sharpening (*see* sharpening), 93

spotting and cleanup (*see* spotting and cleanup)

fill flash techniques, 203

Fill Light control, 203

Fill Light control, 203

Fill Light slider, 72

film grain, 327–328

Add Noise filter, 327

creating softer grain to mimic an enlarged negative, 328

film recorders, 44

film scanners, 19

filters

Add Noise, 327

cooling, 259

Custom (*see* Custom filter)

Diffuse Glow, 324–325, 330

Where innovation, creativity, and technology converge.

There's a revolution in how the world engages ideas and information. As our culture becomes more visual and information-rich, anyone can create and share effective, interactive, and extraordinary visual and aural communications. Through our books, videos, Web sites and newsletters, O'Reilly spreads the knowledge of the creative innovators at the heart of this revolution, helping you to put their knowledge and ideas to work in your projects.

To find out more, visit us at digitalmedia.oreilly.com

O'REILLY®

 Capture. Design. Build. Edit. Play. **digitalmedia.oreilly.com**

Try the online edition free for 45 days

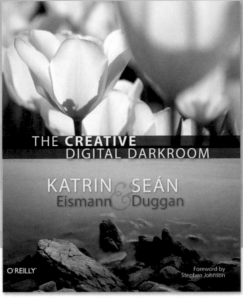